PIRANESI

PIRANESI

Jonathan Scott

ACADEMY EDITIONS · LONDON / ST. MARTIN'S PRESS · NEW YORK

Piranesi was a strange and neurotic genius, wayward in his theories and difficult to handle, but he was a brilliant draughtsman and one of the greatest masters of the art of etching. He has always been popular in Britain: in many country houses the library shelves sag under the weight of his archaeological tomes and the passages and landings are dark with stained copies of his most popular prints; in some rooms we can still see examples of his interior decoration or of the antiquities which he sold to visiting *milordi* on the grand tour. It is surprising, therefore, that no full account of his life and work has appeared in this country since 1910. It is odder still that no Italian has attempted the task. In recent years, however, as the neo-classical age has been subjected to increasing scholarly scrutiny, several articles have been written on different aspects of Piranesi's work and more detailed analyses have been made of some of his contemporaries.

I am too fully occupied in other fields to undertake a complete study of his career – a task that will always be difficult until more of his papers and correspondence come to light – but I have gathered together all that I have been able to find of his life and have added some background material on the Rome which he knew and which I love. I hope that the selection of etchings and drawings will give some idea not only of his scope as an artist but also of his antiquarian and architectural aspirations.

Since this book went to press there has been an excellent exhibition at the Iveagh Bequest, Kenwood, devoted to British artists in eighteenth-century Rome, with a useful catalogue by Miss Lindsay Stainton. In addition, the June 1974 issue of *Apollo* contained a fascinating series of articles by Mr Brinsley Ford on six distinguished British visitors to the city, while the article in *Country Life,* 8 August 1974, illustrates the marble chimneypiece bought from Piranesi in 1774 for 371 *scudi* by Patrick Home for Wedderburn Castle in Scotland (the one referred to on page 224). I have located the chimneypiece from the music room at Stowe at Benham Park in Berkshire.

Lasborough, 1974

ACKNOWLEDGEMENTS

I should like to thank the friends who have helped me with the preparation of this book: Anthony Bryer, Richard Snow and my wife, who were rude about the text, various secretaries, but principally Lynn Gayler, who typed it, Marina Henderson, who pertinaciously amassed the illustrations, and the staff of various libraries, almost all of whom, but the Ashmolean in particular, were extremely helpful. I am grateful also to the owners and trustees of the various collections whose properties are illustrated for permission to reproduce them.

First published in Great Britain in 1975 by
Academy Editions 7 Holland Street London W8

SBN 85670 050 9

First published in the U.S.A. in 1975 by St. Martin's Press Inc.
175 Fifth Avenue New York N.Y. 10010

Library of Congress Catalog Number 74–81701

Printed and bound in Great Britain by Burgess & Son (Abingdon) Ltd

Contents

CHAPTER ONE Early Life 7

CHAPTER TWO Views of Rome 16

CHAPTER THREE The Capricci 45

CHAPTER FOUR The Antiquities and Lord Charlemont 105

CHAPTER FIVE The Antichità Romane 117

CHAPTER SIX The Greek Controversy 149

CHAPTER SEVEN The Archaeological Works 163

CHAPTER EIGHT Works of Architecture and Design 215

CHAPTER NINE The Last Years 239

CHAPTER TEN Piranesi the Artist 293

Notes to the Text 301

Notes to the Illustrations 321

Index 334

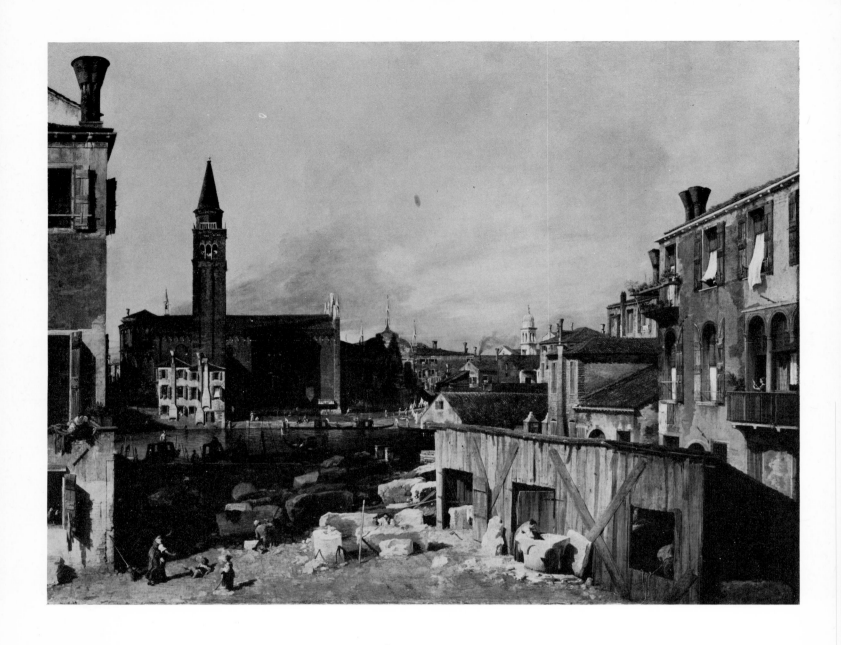

1. Canaletto, *The Stonemason's Yard*

CHAPTER ONE
Early Life

'IF the stormy life of Giambattista Piranesi could be written with freedom and propriety, it would be as amusing and savoury a book as the autobiography of the famous Benvenuto Cellini,' wrote Piranesi's obituarist, Bianconi, in 1779, the year after he died. It was a strong hint because he went on to mention the existence of 'a bundle of many pages' containing Piranesi's memoirs. This autobiography was never published (it would doubtless have been too libellous) but the manuscript probably served as a basis for 'the memoir of him written by one of his sons' which in 1831 was in the possession of James Kennedy, the editor of the *Library of the Fine Arts*. Kennedy abridged it for his periodical and it then, tantalisingly, vanishes from sight. Fortunately, however, Legrand, the brother-in-law of Piranesi's friend, Clérisseau, made use of the same material for a biography which was intended as a preface for a French edition of Piranesi's works some twenty years after his death; even that was never published, although the manuscript of some forty-five pages is still preserved in Paris. As a result our knowledge of Piranesi's early life is disappointingly scant.[1]

He was born on 4th October, 1720, at Mogliano, a village midway between Mestre and Treviso on the Venetian *terra firma*, and was baptised in Venice in the church of S. Moise on 8th November.[2] His father, Angelo Piranesi, was a stone mason, *tagliapetra* as the S. Moise register describes him. Since he was blind in one eye his workmates nicknamed him in their Venetian dialect the *orbo celega* or blind sparrow, but he was well above the ordinary craftsmen whom we see chipping the rough lumps of stone into column capitals for the new church of S. Vitale in Canaletto's *Stonemason's Yard*. He was a master builder, capable of supervising the construction of a church or a palace and responsible to the architect for the work carried out.[3] The godparents at the christening were Zuanne (Giovanni) Widman and Madalena Facchineri. The Widmans were rich and cultivated with a fine palace near S. Casciano in Venice, a villa on the Brenta and another at Bagnoli di Sopra, where the playwright Goldoni spent a happy summer en famille doing amateur theatricals. They were related to the Rezzonico family, Piranesi's future patrons, and finally inherited the Ca' Rezzonico on the Grand Canal when senator Abbondio, the last of the family, died.

Such distinguished connections must have come not from Angelo Piranesi's artisan background, but from his wife, Laura. She was the elder sister of Matteo Lucchesi, an architect and a hydraulics engineer, who moved in aristocratic circles and attended the cultured house parties of families like the Giustiniani Recanati.[4] As surveyor to the Water Magistrate, he was responsible for the construction and upkeep of the Murazzi, the sea walls protecting the Venetian lagoon, a vast undertaking started in 1713 and not completed until 1751. The visitor to Venice who wants a break from sight-seeing can take a boat across the Valle dei Sette Morti and walk along these still formidable ramparts composed of huge blocks of Istrian granite which Goethe, who made the trip, describes: 'First come some steep steps, then a gently inclined surface, then another step, then another incline and finally a vertical wall with coping on top. The rising sea climbs the steps and slopes and only when exceptionally violent does it break against the wall and its coping.' Piranesi's vivid interest in the technicalities of building construction and his feeling for the massive grandeur of the engineering masonry of the Romans

2. A. Visentini, S. Simeone Piccolo

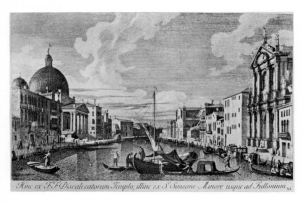

may well have been inspired by visits to the Murazzi when his uncle was on duty there.[5]

Lucchesi also had a conventional neo-Palladian architectural practice but, since his known works were all started after Piranesi had left Venice, it is likely that when his nephew was with him he was principally occupied with his engineering duties under the Water Magistrate. In view of his nephew's enthusiasms it is interesting that he wrote a tract attacking the literary lion of Verona, Scipione Maffei, and claiming that the Etruscans were the originators of Greek art since they had invented the Doric order.[6] This was not a new theory because Scamozzi, another Venetian, had made a similar claim over a century earlier, but, as we shall see later, the primacy of the Etruscans as promulgated by his uncle became an accepted article of faith for Piranesi. The pamphlet with its references to Scamozzi 'the ornament of the last century' and Palladio 'who deserved so well of architecture that he should be its prince', show the direction of Lucchesi's architectural sympathies, but, although he talked about those 'venerators of antiquity who prefer to make mistakes as long as they imitate the Romans rather than produce sensible work, following nature', his own later architectural productions are quite straightforward.

The young Piranesi probably did not have a prolonged formal education but his skill with a pencil doubtless showed itself at an early stage. The family hoped that he would become an architect like his uncle, and his career began in his uncle's office where he learned to draw. It was not a very satisfactory apprenticeship because they were both of an eccentric temperament and, after a series of quarrels, Piranesi walked out. Perhaps even at this stage he was dreaming of vast Roman extravaganzas that would have been quite irreconcilable with Lucchesi's practical engineering and conventional Palladianism. Then came a spell under another architect, Giovanni Antonio Scalfarotto, best known for the very odd green copper dome of his church of S. Simeone Piccolo opposite the railway station in Venice *(2)*: with a gay disregard for consistency he combined a portico which goes back to the Pantheon with a Byzantinish dome and an interior derived from Palladio, just the sort of eclectic blending of elements in defiance of Vitruvius which Piranesi himself was later to advocate, and, in fact, he always spoke of Scalfarotto with great respect.[7]

Although Piranesi always longed to be an architect and in fact used to sign his early etchings *'architetto Veneziano'*, he was training for another career when he went to work for Carlo Zucchi, one of a large family of Venetian etchers. He may already have been attracted by etching, but it is perhaps more likely that at this stage he wanted to study the art of perspective for stage design. In either case, this was probably the way in which he first became familiar with the etching needle and copper plate. Zucchi, rather surprisingly, combined the engraving of seals for elegant fobs with the etching of *vedute* and he wrote several theoretical works on perspective, particularly for the theatre. Together with his brothers Andrea and Francesco he had been one of the six engravers who in 1719 had applied to the censors of the Venetian press, the Riformatori dello Studio di Padova, for permission to form a closed guild or *arte serrata*. The purpose of this trade union was to secure exclusive rights to the sale of all prints in Venice for the shop which they opened and to prevent the pirating of their work by non-unionists. By the time Piranesi joined Zucchi's workshop the number of union members had almost trebled, reflecting the prosperity of the trade, and now included three women – and one prisoner.[8]

Architecture and etching or stage design, this was Piranesi's early background. With a different temperament, he might have spent his life building elegant villas along the Brenta for the Venetian gentry's summer retirement *in villeggiatura;* or he might have settled down to turn out Rococo vignettes for the booklets which greeted marriages, deaths, governorships, elections as Procurator or Doge, or any other occasion which in Venice could not be passed over without a slim volume of verse, the poetry indifferent but the printing and presentation

3. Canaletto, *The Market at Dolo*

4. G. Vasi, Palazzo Venezia

the acme of elegance. Or he might have designed stage sets for the charming little Venetian theatres which rather incongruously took their names from the nearest church – S. Cassiano, S. Benedetto, S. Moise. The Venice of such delightful frivolities seems infinitely remote from the gloom of Piranesi's *Carceri* or his vision of the grandeur of Rome – until we remember that Venice was more than a *città galante;* it was also the historic *città di libertà* which considered itself as the true successor to the Caesars.

We seldom think of Venice as the *città di libertà* because we tend to see the Serenissima only through the eyes of the visiting tourist. The result is as misleading as a view of modern London gleaned by a foreigner whose package tour is restricted to Westminster Abbey, the Changing of the Guard and Soho – although some parallels are uncomfortably close. After a series of heroic wars against the Turks the former imperial power had lost most of her overseas territories, Venetian galleys no longer kept *Pax Veneta* in the Mediterranean, trade was depressed by the competition of Trieste and Ancona on the Adriatic and of Leghorn on the west coast, while commercial enterprise was hampered by ancient guild privileges. To make up for declining trade revenues, the state actively promoted tourism, relying on an irresistible combination of pageantry, gambling and courtesans. Since the visiting tourist seldom had an opportunity of meeting the native Venetians and hearing their rather archaic views, it is not surprising that he only regarded the city as a beautiful Sybaris to be enjoyed under the decorous cover of the study of Titian and Palladio. The nobles who strolled up and down the Liston, wearing their enormous old-fashioned wigs and an ell of cloth over the left shoulder like a waiter's napkin, were advised to keep strictly apart from visitors who might give them dangerous radical ideas, rather as it might be in an East European country needing Western hard currency but not a Western questioning of the status quo. Strangers, as the French visitor de Brosses complained, were not easily admitted into the social part of Venetian life; they might frequent the same coffee houses as the gentry in the evening, but they were seldom invited into their houses. It was rare for a foreigner to be admitted to one of the private *casini,* the intimate salons maintained by patrician families in the neighbourhood of S. Marco for their gambling parties; the excluded tourist, who saw masked couples going in or heard gay laughter upstairs, imagined the worst, while the system of the *cicisbeo,* the gentleman attendant of every married woman, was easily misinterpreted as condoned adultery. The wearing of masks was the final straw. Venice seemed wholly abandoned to frivolity and dissipation. 'Some writers assert', wrote John Moore, the father of the Corunna General, 'that the Government encourages profligacy to relax and dissipate the minds of the people, and prevent their planning or attempting anything against the constitution. They first erect a despotic court to curb the public liberty and next they corrupt the morals of the people to keep them from plotting against the State.' Moore did not quite believe this himself but most others did. We get a fairer picture from Dr. Johnson's friend, Mrs. Piozzi, who had been able to meet the natives through her Italian husband's musical connections. She noted that, however late the patrician might have been at the previous night's party, he was always punctual for his Council meeting the following morning; the Venetians' inherent patriotism preserved the State from decay. 'They say themselves that the style of old Rome has transmigrated to Venice.'

This was certainly the light in which the Venetians saw themselves. Although the city was traditionally founded in A.D. 421, eleven years after the fall of Rome, the Venetian nobility gave themselves antique Roman airs. The Contarini (not to be out-done by the French family of Mirepoix who modestly claimed descent from the family of the Virgin Mary) traced their ancestry to Aurelius Cotta, the Giustiniani to the Emperor Justinian, the Corner to the gens Cornelia. Self-identification with antiquity was quite straight-faced because the Venetians took themselves completely seriously. They saw nothing incongruous in the amazing apotheoses painted for them by Tiepolo: on the ceiling of their palace on the

Grand Canal he showed a young Rezzonico and his bride orbiting in the white horsed chariot of Apollo, while in the ballroom at Strà trumpeting angels spread to the four corners of the earth the merits of Alvise Pisani and his pretty family, encushioned in heavenly clouds. The very same Rezzonico and Pisani families gave brilliant fêtes and balls and were no less a part of the *città galante* but the traditions of antiquity need to be stressed in contrast to the dazzling Venice of Canaletto's festivals or the lascivious Venice of Casanova's escapades.

The magniloquence of the architectural gestures of this age are also worth recalling: that truly imperial Villa Pisani at Strà was going up in the 1730s when Piranesi was first studying architecture, while at the same time the Manin family was building a palace near Passariano with a spreading forecourt to rival the *piazza* of St. Peter's in Rome. Venetian architecture was itself Roman based. Massari, Rossi, Tirali, Temanza, Scalfarotto and the rest all looked for their inspiration to the sixteenth-century master, Andrea Palladio, whose work was derived both from a reinterpretation of Vitruvius, the most important writer on architecture to survive from antiquity, and from a practical examination of the antiquities of Rome. In this rather austere neo-Palladian revival, as actively promoted in Venice at this time as in the England of Lord Burlington, the writings of the Roman master and his Vicentine disciple were canonical. Further impetus was given in 1730 when Burlington published Palladio's thesis on Roman baths, which he had found in Daniele Barbaro's villa at Maser. Scholars were turning to a serious study of the 'sumptuous edifices, by which we are able to get a certain knowledge of Roman virtue and grandeur, which perhaps had not otherwise been believed'.[9]

This was the background to Piranesi's apprenticeship. His enthusiasm for antiquity had another source; his elder brother, Angelo, a Carthusian monk, used to read to him, when he was still a boy, the heroic account of Rome's origins in the histories of Livy. The tales of Aeneas and the kings, of the Horatii, of Regulus and Cincinnatus, first fired him to visit the city of the seven hills. He had to wait until he was nineteen before the opportunity came. In February 1740, the miserable, blind and bullied Pope Clement XII died aged eighty-eight. When Venice sent a new ambassador to pay the compliments of the Serenissima to Prospero Lambertini, who had succeeded as Pope Benedict XIV, the promising young draughtsman secured a place in the ambassadorial train, rather as a good young photographer might be taken on a millionaire's Mediterranean cruise.

5. G. and D. Valeriani, A. Balestra and G. B. Cimaroli, *Allegorical tomb to William III*

He lodged at first in the Venetian embassy, the Palazzo Venezia, at the far end of the Corso, a battlemented palace which he later illustrated. Rome went straight to his head; he drew and studied and drew everything, the temples, the palaces, the bridges, the aqueducts, the fragments of Rome's past at that time only just emerging from centuries of neglect and use as a quarry for building materials. 'I need not describe again', he wrote three years later, 'the marvels . . . the exact perfection of the architectural form of the buildings, the rarity and the immeasurable quantity of marbles which are to be seen on every side and the enormous areas which were once occupied by the Circuses, the Fora and the imperial palaces. . . . These eloquent ruins filled my mind with images which no drawings, however accurate could have expressed, even those of the immortal Palladio which I always kept before my eyes.' Legrand says that 'he carried his passion for study to such an extent that he regarded time spent on eating as time wasted and so, with his companion, the sculptor Corradini, he used to cook a big pot of rice on Sundays to provide meals for the whole week and do instead of bread. The grand contrivance of two crazy brains resulted in a very serious illness. Piranesi was even more violently affected because the physical disorder was accompanied by an almost total collapse of his mental powers, caused by chagrin at not being able to pursue his studies.' If Legrand is right, Corradini was a surprising companion because, although he also originated from Venice, he was a very successful sculptor with a reputation from Austria to Portugal and he was fifty-two years older than Piranesi.[10]

Piranesi's first employers at Rome were probably the Valeriani brothers, Domenico and Giuseppe, the ruin painters and stage set designers.[11] They had worked in Venice when Piranesi was a boy and possibly he got an introduction through Carlo Zucchi who had collaborated with them in the illustrations to a picture book of Venice in the 1720s. However, he had not been in Rome for much more than a year, when the Empress Elizabeth Petrovna summoned Giuseppe to St. Petersburg as her theatrical architect and engineer and Piranesi had to make his next move. Wanting to learn the art of etching, he approached Giuseppe Vasi, a Sicilian ten years his senior, who had come to Rome in 1736 and was probably already at this stage working on his series of etched views, the *Magnificenze di Roma,* the first volume of which appeared in 1747.[12] The fact that Piranesi wanted to learn etching from Vasi implies that he had been studying something else, presumably perspective, under Zucchi. In six months he had learned all that Vasi could teach but that did not satisfy him and he attacked his teacher in a fit of fury because he thought he was hiding from him the true secret

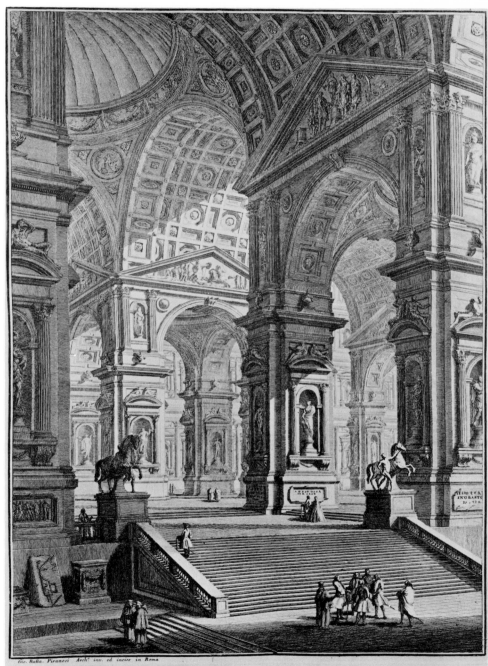

6. Grand Sculpture Gallery, Prima Parte

of using the etching acid. Vasi survived the onslaught and 'released his dangerous pupil with thanks to God'. There was not much of a secret to hide because Vasi was a competent but pedestrian performer whose skills Piranesi would have speedily absorbed. It was another clash of temperament. "You're too much a painter to become an etcher," was Vasi's criticism.

Perhaps it was after this disagreement that Piranesi moved in with his fellow countryman, Felice Polanzani, who, from 1742, was employed as engraving master at the orphanage of S. Michele in Rome.[13] 'The pair of them drew till late into the night', wrote Bianconi, 'only taking a few hours' sleep on a wretched straw mattress that was perhaps the best piece of furniture in their house. Piranesi lived like this for some time in the greatest distress but instead of studying the nude and the best statues of Greece . . . he set about drawing the most rickety cripples and hunchbacks he had seen in Rome during the daytime . . . He also liked drawing ulcered legs, dislocated arms and disjointed hips. Whenever he came across one of these freaks in a church he thought he had found a new Apollo Belvedere or Laocoon, and rushed straight home to draw it. When he wanted a loftier and more heroic theme he used to draw foodstuffs, butcher's meat, pigs' heads and goats' heads.[14] One has to admit', Bianconi grudgingly concluded, 'that he did such things extremely well.'

The first production of these early years was the *Prima Parte di Architetture e Prospettive* published by the twenty-three year old *'architetto Veneziano'* in July 1743. The work was dedicated to a mason, Nicola Giobbe, because, as he explains in the very awkward dedicatory letter, 'I wanted before my departure to leave a clear testimony of the obligations which I owe to you in that you have always most kindly welcomed me to your house throughout my stay in Rome and have aided me on all those various occasions when a foreigner in a strange city usually needs help; but this dedication is small recompense for the singular and frequent assistance which I have received from you in the exercise of my profession. You have always put at my disposal your rich and well chosen collection of pictures, drawings, books and prints. There is perhaps no richer collection in these dominions and certainly none has been assembled with more taste and knowledge . . . Above all I acknowledge my debt to your instruction. You have not only pointed out to me all the most beautiful examples of ancient and modern art in Rome each in turn, but also by the example of your excellent drawings you have shown me how it is possible in new ways to make praiseworthy use of what our ancestors invented.' To crown his other virtues Giobbe had introduced his young friend to two of the most distinguished architects then living in Rome,

7. Design for pulpit

Nicola Salvi, whose Trevi fountain had been started some ten years earlier, and Luigi Vanvitelli, who was later to construct the huge Bourbon palace of Caserta outside Naples and who had just completed work on the papal harbour and hospital at Ancona.[15] This paragon of patrons subsequently disappeared from Piranesi's life. Perhaps the young architect was disgruntled that he put no commissions in his way or perhaps, as Bianconi suggests, he did not pay sufficiently generously for the dedication.

The *Prima Parte* is a thin collection of twelve etchings of imaginary temples, palaces, ruins and a prison, as well as the dedicatory title page and the letter to Giobbe. In his introduction Piranesi complained that 'since it is not to be hoped that an architect of these times could execute any (grand ideas) either because Architecture itself has fallen from that happy perfection which it reached in the age of the greatest grandeur of the Roman Republic and of the powerful Caesars who succeeded it, or because those who should be patrons of this art are to blame, . . . there is no course open to me or to any other modern architect but to set out in drawings our ideas and thus regain from Sculpture and Painting the advantage which, as the great Juvarra says, they have gained over Architecture'. This is no more than a literary excuse: neither contemporary nor, for that matter, ancient Rome would have had any use for the huge public spaces which Piranesi conjured up in the *Prima Parte (75–79)*. In any case, he had arrived just too late for the final flowering of the Roman Baroque which culminated in the rebuilding of the façades of S. Giovanni in Laterano, S. Maria Maggiore and S. Croce, and the creation of the Trevi fountain, the Piazza di S. Ignazio and the Spanish Steps. The extreme rarity of the first edition of the *Prima Parte* indicates that it was not a great success.[16] Disheartened, and perhaps hoping to take up introductions from Corradini who accompanied him, or from Vanvitelli, he packed his copper plates, and set off for Naples, the capital of the Bourbon kingdom of the Two Sicilies.

Both Legrand and Bianconi stress that Piranesi went to study painting, particularly the works of Luca Giordano and Francesco Solimena.[17] It is a surprising move from cripples begging outside churches to triumphant Baroque skyscapes humming with angels. The link with his earlier artistic career could be the illusionistic flights of stairs and columned temples from which the martyr's heavenly assumptions are staged. He may have thought of becoming a painter of such architectural backgrounds, like the Valeriani and like his pre-eminent fellow Venetian, Girolamo Mengozzi – Colonna, the collaborator of Tiepolo. Luckily he was deflected by the irresistible attraction of yet more antiquities. Naples was at this time the centre of archaeological excitement. Since 1738 excavations had been going on in near-by Herculaneum, the city buried in the eruption of Vesuvius in A.D. 79, and the disinterment of the ruins was as great a sensation to the eighteenth century as the finding of Tutankhamen to the twentieth. For the first time the domestic life of the ancients which Pliny recorded was being uncovered in the ruins of the very disaster which Pliny had chronicled. All scholars were hoping that the missing books of Livy or perhaps a lost play of Aeschylus or Aristophanes would somehow emerge unscathed from the debris and, failing that, there was a

8. Design for festival gondola

marvellous haul of antiquities, not just statues and paintings but everyday furniture and household utensils. Piranesi made for the museum of the excavations at Portici where he quickly made the acquaintance of Camillo Paderni, the museum director.[18] Paderni looked at the young man's drawings and stage sets; he noted the skill with which he tackled architectural subjects, his enthusiasm for the antique. Why not devote himself to drawing the antiquities of Rome? he suggested, it would be a great success.

Piranesi took his advice but had a lucky escape on his way back to Rome, because, when crossing the Garigliano, he nearly lost all his plates in the river. If he had done so, he declared, he would have given up etching altogether. His father, however, thought that it was high time for him to come home to earn a proper living in Venice and he threatened to cut off his tiny allowance of six *scudi* a month.[19] (150p. was the decimalised eighteenth-century equivalent.) Since the ambassador who had brought him to Rome had by now left the city, he could no longer enjoy free accommodation in the Palazzo Venezia. He was defeated. By the 29th May, 1744, he was back in Venice and composing a very stilted letter to Giovanni Bottari, the keeper of the Corsini library and print collection, 'Illustrious and reverend Monsignore', he wrote, 'The many obligations which I owe you for the favours I have received in Rome compel me not to fail in the essential task of informing you of my safe arrival in Venice. I take this opportunity of demonstrating my devotion and of declaring that wherever I can be of service to you I shall do it with pleasure. I still value our meetings which, I declare, will keep me always mindful of the favours I have received from you, and with all due respect I remain, illustrious and reverend sir, your most humble and obedient servant, Giambatista Piranesi.'[20] Despite the advertisement of the *Prima Parte,* and his undoubted skill as a draughtsman, no architectural commissions were forthcoming, or, if they were, none are now traceable. Some delightful pen and wash sketches for Rococo decoration do, however, survive from this period – urns, wall panels to be executed in stucco, a fantastic pulpit blazing with sunbursts and stalactites that would be more at home in Zwiefalten or Ottobeuren *(7),* and, best of all, a stunningly exotic and unnavigable *bissona* or festival gondola of the sort we see in the carnival scenes of Guardi and Canaletto *(8).* The cabin of this astonishing creation is heaped high with crowns and cartouches, medallions and wings, and is so guarded by writhing sea deities that the owner could scarcely have stepped aboard without tripping against an ankle-catching scroll and his wife could not have managed at all. As for the gondoliers, there is hardly room for them to stand – much less ply their oars amid the dragons.[21]

More fruitful than his architectural endeavours was a period spent in the studio of the greatest painter of his time, Giovanni Battista Tiepolo. By coincidence Tiepolo had probably just finished a work which Piranesi would have found particularly congenial, a series of scenes from Roman history destined for the court at Dresden. What is more, under the watchful eye of Francesco Algarotti who was overseeing the commission, he had been forced to observe strict antiquarian accuracy in his costumes and armour: Maecenas could not wear sixteenth-century Veronese ruffs when he presented the Fine Arts to Augustus and Caesar's cuirass had to be taken from antique statues. It was at this time also that, for his own relaxation, Tiepolo was producing his marvellous etchings, the *Scherzi di Fantasia* and the *Varj Capriccj.* The chronology of these two series is uncertain but it seems most probable that, by 1744/45, Tiepolo had finished the *Scherzi* and was engaged on the second series which Anton Zanetti had published by 1749.[22] The studio was certainly much occupied with etching at this period and the master's eldest son, Domenico Tiepolo, was soon to start to produce his own exercises in the medium.

Even if Bianconi had not mentioned the connection, we might have conjectured Piranesi's link with Tiepolo. In contrast to the rather rigid drawings related to the *Prima Parte,* his later sketches became much lighter and freer, he adopted the mellow bistre wash of the Venetian master, and his swift bold

9. G. B. Tiepolo, *Scherzi di Fantasia*

10. Design for a title page

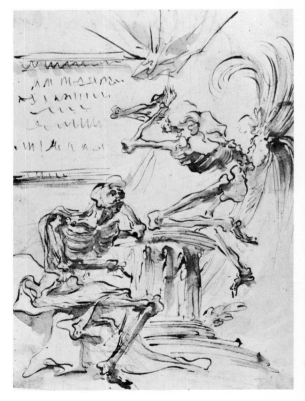

11. Drawing of orientals

calligraphy. The Ashmolean Museum in Oxford has a Piranesi sketch that is just like one of Tiepolo's ideas for the *Scherzi di Fantasia,* a cluster of magicians or oriental philosophers or perhaps the three kings, identifiable by their turbans and square topped hats, peering down at a baby on the ground, while in the British Museum there is his drawing of a pair of dancing skeletons which might derive from some variation of Tiepolo's etching of *Death giving Audience.*

Piranesi was not to stay in Venice: Rome had caught his imagination and to Rome he must return. There were also good commercial reasons. At Venice, the market was saturated and competition was intense. As early as 1703, Luca Carlevaris, Canaletto's predecessor as chief view-painter for the visiting tourists, had produced a series of over a hundred etchings of scenes of the Canals. His book, *Le Fabriche, e Vedute di Venetia* maintained its popularity and went through several editions during the century. Lovisa's two volumes of the masterpieces of Venetian painting and architecture came next and they had been followed by Canaletto himself who, in 1735, got Antonio Visentini to engrave the views of the Grand Canal which he had painted for Joseph Smith, the British collector *(2).* Although Canaletto no doubt hoped that the work would serve as a good advertisement for his much more lucrative canvases, it was obviously a commercial venture in its own right – the prints were meant to sell. In the year of Piranesi's return to Venice, Canaletto produced a small collection of his own etchings, partly topographical views of Venice and the surroundings and partly imaginary *capricci* of ruins and countryside. Admittedly Michele Marieschi, who had published some attractive prints of his own paintings in 1741, had died recently but there was still Gian Francesco Costa at work on his views of the villas of the Brenta.[23]

Piranesi was not to know that Canaletto was to leave for England the next year but, all the same, the message was clear. In Venice there was an abundance of good etchers, in Rome there was only Vasi and a few hacks employed by the booksellers; furthermore, the Roman subject matter was more congenial. In 1745 he set off again, with the backing of Joseph Wagner, an influential print seller who had set up in Venice in 1739 and wanted a distributor for his editions in Rome.[24] Angelo Piranesi, whose family commitments did not permit him to renew the monthly allowance, was very anxious. "How will you get a living in a foreign country?" he asked. "If I've got my head screwed on straight, I won't go wanting" was his son's reply.[25]

CHAPTER TWO
Views of Rome

IN Rome, Piranesi established himself in lodgings in the Corso opposite the French Academy where he could display Wagner's stock for sale. Although he diverted himself on his return with two beautiful sets of imaginative etchings, the *Grotteschi* and the *Carceri,* they were not very saleable; if he was to win his living from etching he had to sell his own work because the commissions he earned from distributing Wagner's prints would not have provided an adequate income. He turned, therefore, to etching views of Rome which he produced, according to Legrand, at the rate of one a day and sold to his publisher for 12 francs each (almost 50p, taking an exchange rate of 25 francs to the pound). His first series consisted of forty-eight little plates, about four and a half inches by seven in size, which were folded down the centre and inserted as illustrations into bulky pocket guide books to Rome. Paolo Anesi and three young artists from the French Academy, François Duflos, Jean Laurent Le Geay, and, subsequently, Charles Bellicard were also commissioned to provide some sixty other views; the whole collection was published without any text as *Varie Vedute di Roma Antica, e Moderna* by Fausto Amidei, a Roman bookseller in the Corso, first in 1745 and again in 1748, and was then taken over and reissued by Jean Bouchard as *Raccolta di Varie Vedute di Roma.[1]* Selections of these prints continued to be used in various other guide books right on into the nineteenth century until the plates wore out and indifferent unsigned facsimiles were substituted.

The chronology of this series is confusing because a different guide book, *Roma moderna distinta per Rioni,* dated 1741, contains five of Piranesi's views, while the 1748 *Varie Vedute* includes plates by Bellicard dated 1750. Legrand, however, is quite specific that Piranesi started this work after his return from Venice and certainly the quality of, for instance, the views of S. Sebastiano and S. Giovanni in Laterano, which were included in the 1741 guide, seems incompatible with the earlier date. The explanation is probably quite straight forward: the plates were originally available in Amidei's bookshop in the Corso rather like a rack of picture postcards. The visiting tourist could come in to select the views he wanted and he would either take them away loose to be pasted into his album or he might ask the shop to bind them into the guide book he was using. Perhaps Amidei had a selection of guide books like *Roma moderna* already made up with prints from his stock. The little views were so popular that they were later issued in book form but, when further plates were added, the date on the title page was left unaltered. Piranesi is unlikely to have had much choice in the selection of sights which he was given to etch. Amidei commissioned his artists to reproduce views which he thought would sell to the tourist and he started Piranesi on some of the Renaissance and Baroque palaces. Piranesi did not even retain the copper plates and take his own impressions; they all went straight to the publisher. His views were certainly much more interesting than the wooden efforts of Anesi or Le Geay, who, in disappointing contrast to his architectural invention, was very uninspired when he came to depict the contemporary scene, and Duflos was equally rigid and pedestrian. Bellicard, on the other hand, was a much better performer. His use of light and shade was imaginative and he came close to Canaletto in his views of the inside of the portico of St. Peter's and of the chapel on the Via Flaminia.

Piranesi's style varied widely at this stage. The earliest plates were almost as

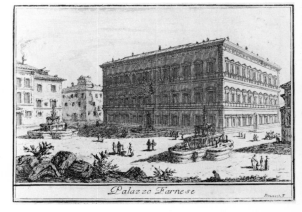

12. Palazzo Farnese, *Varie Vedute*

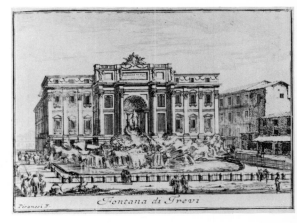

13. Trevi Fountain, *Varie Vedute*

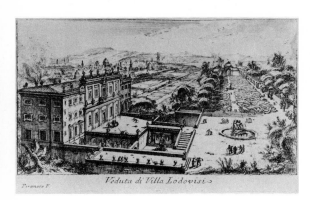

14. Villa Lodovisi, *Varie Vedute*

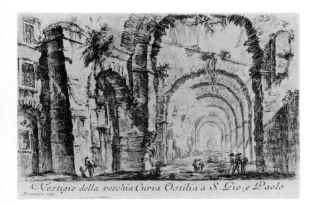

15. Curia Hostilia, *Varie Vedute*

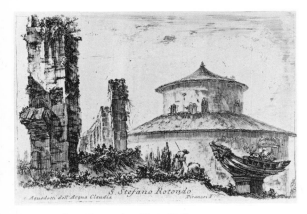

16. S. Stefano Rotondo, *Varie Vedute*

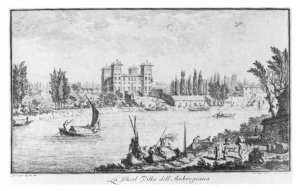

17. Villa dell'Ambrogiana, *Vedute delle ville e d'altri luoghi della Toscana*

dull and conventional as the efforts of Duflos or of his master, Vasi. Some were real pot-boilers, dashed off in haste, no doubt, and rushed round to Amidei to get some money for a meal – it is quite an achievement to make the Trevi fountain look as uninteresting as he did in his first attempt. Most of the early views, however, were exact and painstaking, carefully reproducing each twist of topiary in the gardens and every statue's gesticulation. Such small plates could not be overcrowded with figures and so, to break the geometric monotony into which architectural scenes can easily fall, he spread the roof levels with flecks like tiny spikes and banded the columns with little horizontal dashes of shading to give an almost furry effect. When Amidei released him from Renaissance palaces onto the ruins of antiquity the effect was instantaneous. His style altered immediately, his enthusiasm burst over the edges of the plate, the people in the landscapes changed from sheep-like blobs to the hunched figures characteristic of his later prints, the sky was no longer streaked with exact parallel clouds but covered with free hatching, vegetation sprouted and the plates came to life.

An alternative dating for these small *vedute* does, however, appear to be possible. He could have produced some of the less imaginative views during his first stay in Rome because his skill in this medium was well enough known at that time for him to be asked to etch Giuseppe Zocchi's drawing of the Villa dell'Ambrogiana for *Vedute delle ville e d'altri luoghi della Toscana,* published in 1744 by Giuseppe Allegrini – a series to which Michele Marieschi and Joseph Wagner also contributed. His etching of the villa, in which he was already using the 'furry' technique, is signed 'Piranesi incise in Roma, 1744' and must have been finished shortly before his return to Venice. The freer etchings would thus date from soon after his return to Rome in 1745. I prefer, however, to follow Legrand's account and to place all these small views after 1745 blaming the perfunctory treatment of some views on his haste and lack of interest in Renaissance or more modern buildings.[2]

The later series of ruins leads on to his next work, the twenty-five views of *Antichità romane de' tempi della repubblica, e de' primi imperatori,* which were dedicated on 20th July, 1748, to his old friend, the assistant Vatican librarian, Monsignore Giovanni Bottari, in a tribute as stilted as the artist's letter to him from Venice four years earlier. This first *Antichità romane* consists of two sections, one containing some of the principal antiquities of Rome and the other a selection of monuments outside the capital. When he re-issued the views in about 1765, he avoided confusion with his *magnum opus* (the four volumes of *Antichità romane* published in 1756) by entitling the reprint *Alcune vedute di archi trionfali ed altri monumenti* and the book is generally known by this title. A small addition was made ten years later in 1775, when Sir Roger Newdigate, an English friend and client, showed him his own drawing of the arch of Augustus at Aosta in Piedmont. Piranesi 'would scarcely be persuaded there was such an Arch in Italy but beg'd leave to take it with him & in a few days returned it with an elegant print taken from it which he has inserted among his Archi Antichi'[3]. Already in 1748 he was showing his archeological bent; perhaps at Bottari's instigation the dedication was followed by two plates simply recording all the inscriptions on the monuments in the following pages. Surprisingly, however, the names of some of the buildings scratched onto fallen masonry in the corners of the plates contain a number of elementary solecisms which suggest that his knowledge of Latin and hence, presumably, his early education were both fairly rudimentary.[4] The views, which were his own version of the series he had worked on for Amidei a couple of years before, comprise not only his favourite selection of Roman antiquities but also the results of his travels outside Rome. Some of them were taken from sketches made on his way back to Venice or on the return trip to Rome. He may have taken the road home over the Apennines, passing the temple of Clitumnus, near Spoleto, and may have returned part of the way by boat, stopping at Pola on the Yugoslav coast in Venetian Istria and then crossing the Adriatic to Rimini and Ancona in the Papal States.[5]

The *Archi trionfali* contains some of the most attractive of all his etchings. Although the plates are only about ten and a half inches by five, they convey at least as well as the more famous larger views the grand scale of the antiquities. He was now the complete master of the etching technique and could control exactly the biting of the acid to give the desired effects of shading and sunlight. The composition was strikingly original: to emphasise the height of the arches, he drew from a worm's eye view, in some cases burrowing almost below street level or below the centuries' accretions to the original level of the classical Forum so that he was peering right up into the under side of the arches. Alternatively he took imaginary flight for an aerial view of the amphitheatre of Verona *(34)*. Quite unnecessarily he cut off the top of arches and pediments as if they were too large to fit within his plate. Everything was seen dramatically at an angle. He now used much stronger contrasts. The frame of a view, often the corner of another building in the foreground or a group of trees, is in heavy shade, while the far distance is lightly and delicately bitten to give the soft blur of an umbrella pine or the campanile or columns at the further end of the Campo Vaccino. The sky is scratched with free strokes for clouds that slip over the plate mark but leave clear areas of radiant sky. The rhythmic arcades of the bridge at Rimini and the arch of Trajan at Ancona, silhouetted between the masts and rigging of the boats in the harbour, are among his very finest work and I should add the arch of Titus *(33)* looking towards the three columns of the temple of Vespasian in the Forum and the view of the same three columns with S. Francesca Romana and the portico of the temple of Antoninus and Faustina in the background *(32)*. 'The work was favourably received by the public', Kennedy records in the *Library of the Fine Arts,* 'It was the first attempt to treat architecture in engraving with skill and taste, and the strangers in Rome, especially the English, with alacrity hastened to

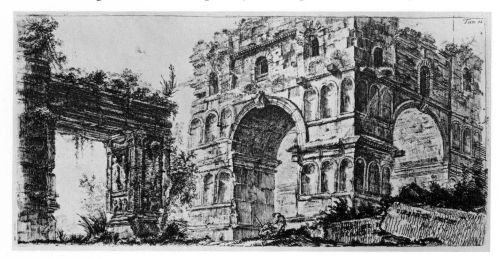

18. Arch of Janus, *Archi trionfali*

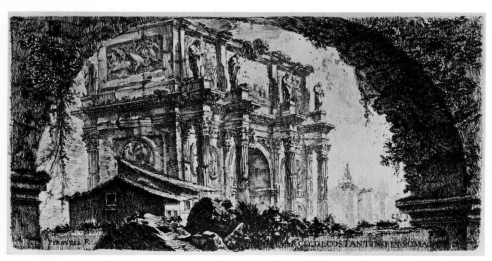

19. Arch of Constantine, *Archi trionfali*

procure his engravings. Notwithstanding this, however, he had great difficulty, with the utmost economy, to find the means of subsisting for many years, and purchase the materials necessary for the prosecution of his favourite studies.'

Also in 1748 he provided two vignettes as ornamentation for a large map of Rome, one of the *piazza* of St. Peter's and the other a *capriccio* grouping in the manner of Pannini consisting of the Trevi fountain, S. Maria Maggiore with its column, S. Croce, Bernini's river fountain from the Piazza Navona and the base of Trajan's column. The style is that of the *Archi trionfali* with the background lightly etched like a thumb print contrasting with the dark ruins in front. The map *(22)* was produced by Giambattista Nolli, from Como, 'geometrician and architect' as he is described on his funeral monument, and was dedicated to the influential Cardinal Alessandro Albani. Piranesi was to copy it exactly in later years both when he produced his own map of Rome and the Campus Martius in the *Antichità romane* and when he issued an expanded and annotated plan of the principal monuments in about 1774. Nolli's map is well worth examining, because it shows the extent of the city in the eighteenth century and gives a very good idea of the layout which remained largely unchanged and unspoiled until, lamentably, the enthusiasms of the Risorgimento established there the capital of reunified Italy in 1870.[6]

In Piranesi's day the city was comparatively small, far smaller than it had been under the Caesars. The population, which had exceeded a million under Augustus, then amounted to some 150,000 inhabitants, and it was a moot point whether the numbers were not positively declining. The trouble was that, apart from attending the churches and servicing the tourists, the inhabitants had no employment. De Brosses, an observant visitor, laid the whole blame on the papal system. 'It would be impossible to imagine a worse government . . . Imagine a

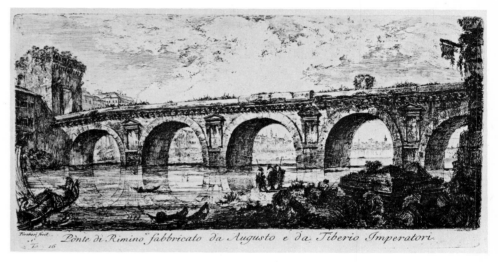

20. Bridge of Augustus at Rimini, *Archi trionfali*

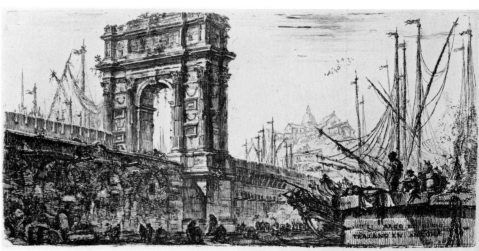

21. Arch of Trajan at Ancona, *Archi trionfali*

population, a third part of which is composed of priests who do absolutely nothing; the peasants work little, there is no agriculture, no commerce, no manufactures. And this occurs in a fertile country with a navigable river, where the sovereign, always an old man, incapable generally of doing anything himself, is surrounded by relatives whose sole idea is to make as much as possible out of their connection with the prince.' Rome was not even the market town for the agricultural produce of the Campagna, the flat territory beyond the walls, because that too was deserted. It was the only country in the world, said John Moore, 'where the fields become more desolate as you approach the capital . . . no houses, no trees, no inclosures, nothing but the scattered ruins of temples and tombs, presenting the idea of a country depopulated by a pestilence. All is motionless, silent, forlorn.' It was a standard joke that Romulus must have been drunk when he thought of building a town on so ugly a site. The reason for this dreary desolation was not papal incompetence but the prevalence of malaria which effectively emptied the countryside.

Roman society was stagnant and provincial. Power was vested in the hands of the Pope and his circle, the Roman nobility (both the old feudal houses like the Colonna, the Massimo and the Orsini families, and the descendants of papal *nipoti* like the Chigi, the Pamphili and the Borghese) had no real raison d'être. Their nightly receptions were on a very modest scale and, as the foreign visitors who procured an invitation complained, there were no introductions, there was no food and there was no entertainment but cards. It was the tourists themselves who gave life to the scene and whose lavish spending made a substantial contribution to the economy of Rome. From Russia and Ireland, from Sweden and Spain came the visitors who wanted to escape that feeling of inferiority which, according to Doctor Johnson, was suffered by anyone who had never been to Italy. There were even rare transatlantic migrants from the American colonies. Their education was not complete until they had seen the Colosseum by moonlight, admired the grotesques of Raphael in the Vatican and bought through their *cicerone* or bear-leader a noseless bust of Brutus and a murky canvas that might be by Guercino or one of the Carracci. A Papal Audience with an opportunity to kiss the pontifical slipper was the one dispensable item in what was now a cultural, not a religious, pilgrimage.

It was fortunate that Rome was not a success as a commercial centre because it provided for these tourists an unspoiled and incomparably picturesque medley with the Renaissance and Baroque splendours of the papacy trumpeting beside the melancholy dilapidation of imperial magnificence and all engarlanded in orchards and vineyards, green fields and the pleasure grounds of the truly sub-urban villas of the nobility. The charm of these unplanned contrasts has been steadily destroyed by lumpish late nineteenth-century bureaucratic citadels, by Mussolini's misguided clearances and by the unchecked building sprawl of post-war Rome. Two centuries ago it was quite different. If we follow Nolli's map and enter from the north by the Porta del Popolo, as most visitors did, the *piazza* in front presented the famous theatrical view of the three streets fanning out between the helmet-domed churches on either side of the Corso *(23)*. To the left, the Via del Babuino led to the tourists' haunt round the Piazza di Spagna, known as the 'ghetto degli Inglesi' *(41)*, to the right the Via della Ripetta led to the Tiber. Valadier's monumental ramp to the Pincian hill was unbuilt and the opposite side of the *piazza* was lined with hay barns. The Ripetta was the way to the old Campus Martius, the most populous district of Rome which basically retains its medieval form. Most of the palaces Piranesi knew still survive: the Palazzo Borghese, where the grandest soirées were given, the houses in the Piazza Navona *(40)*, the Cancelleria, the Renaissance palaces of the Via Giulia, the Palazzo Farnese *(12)*, where Vasi was lodged by the King of the Two Sicilies, the Palazzo Spada, the Palazzo Mattei with its beautiful collection of ancient marbles and the fortress of the Orsini, clamped within the Theatre of Marcellus *(26)*. There were also, of course, innumerable old churches, most of them rebuilt behind the

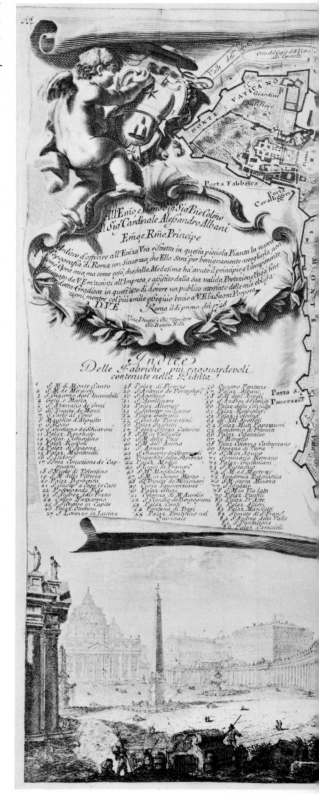

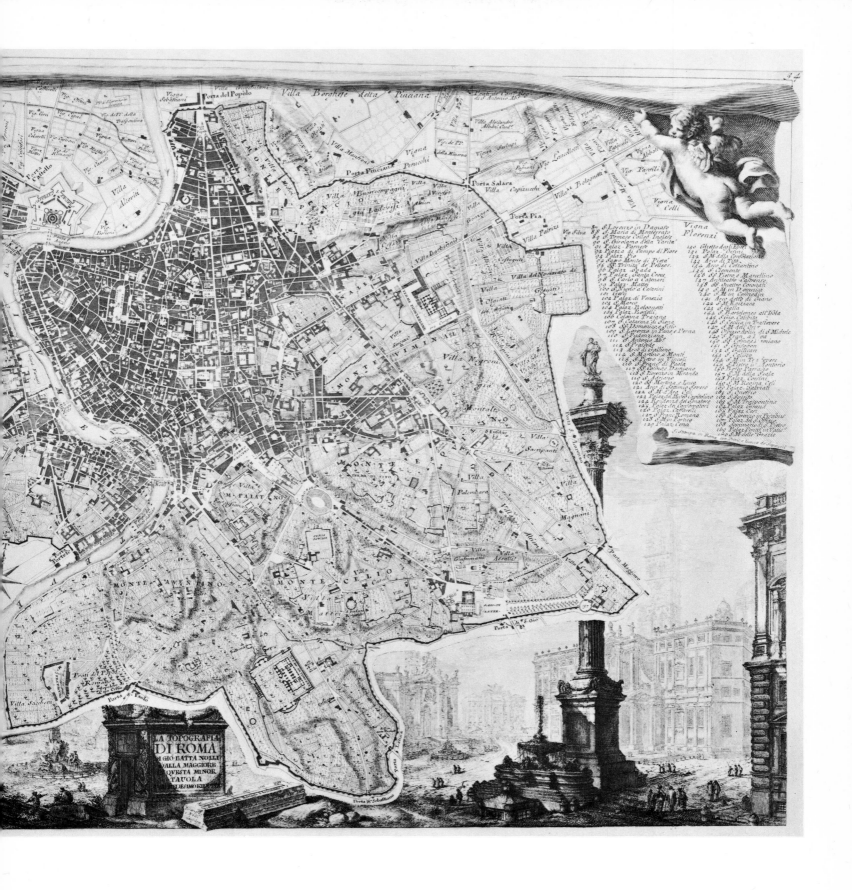

22. G. B. Nolli and Piranesi, Map of Rome

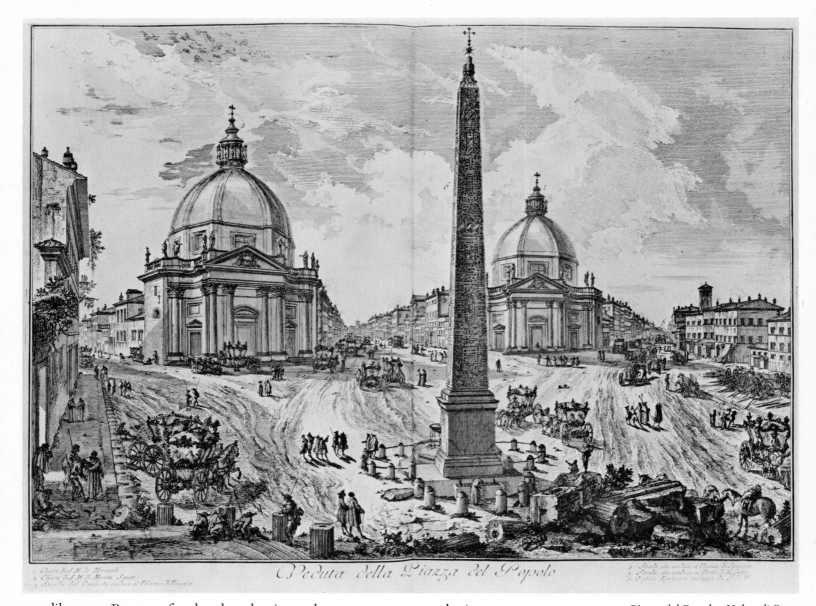

Veduta della Piazza del Popolo

23. Piazza del Popolo, *Vedute di Roma*

grandiloquent Baroque façades that dominate the narrow streets and *piazze*. From a line roughly opposite the island in the Tiber, the streets continued round the foot of the Capitol to the Piazza Venezia at the far end of the Corso, which had not been opened up at that time for the enormous absurdity of the Vittorio Emanuele monument. On the Capitol was a scene unchanged since the Renaissance; the seat of the civil governor, the Senator of Rome, and the Capitoline Museum, one of the oldest in the city, looked onto the *piazza* designed by Michelangelo round the majestic equestrian statue of the Emperor Marcus Aurelius *(25)*.

If, however, the visitor took the Via del Babuino from the Piazza del Popolo to the Piazza di Spagna, he was already on the outskirts of the city; there was only the Strada Felice (now the Via Sistina) where Piranesi was later to live, leading from the top of the Spanish Steps to the dingy cottages that surrounded the Triton fountain in the Piazza Barberini. To the north lay vineyards and villa gardens. The grisly Capuchin church at what is now the foot of the Via Veneto was the limit of the built-up area. If he went up the hill past the Palazzo Barberini and the Scottish Seminary to the Four Fountains there was a fine complex of palaces and gardens which stretched from the Pope's residence on the Quirinal *(28)* down to the Piazza Venezia again, but in the other direction, towards the Porta Pia, development only reached as far as the churches round the Acqua Felice fountain and the convent built into the Baths of Diocletian. Meagre houses lined the road to Fuga's new apse of S. Maria Maggiore and then there was a broad strip of

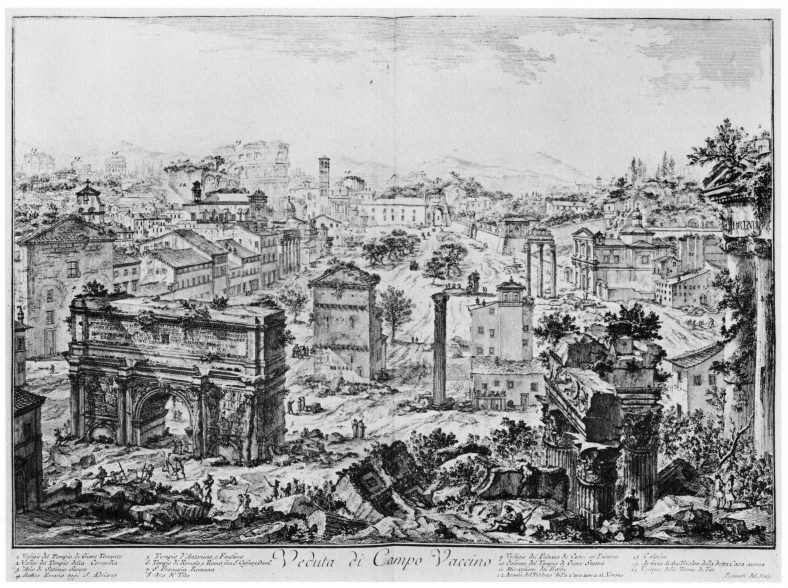

24. The Forum or Campo Vaccino, *Vedute di Roma*

development going westwards back to the Forum. The tie lines of this part of the city were the prospect avenues centred on the obelisks and basilicas which were the great achievement of sixteenth and seventeenth-century papal town planning, but gardens and fields covered the whole of the area beyond these limits as far as the City wall, a quarter depopulated since the time of the Gothic wars in the sixth century. The grounds of the Villa Medici were continued by the huge villas of the Buoncompagni, the Altieri and the Barberini families. The site of the Castro Pretorio, the barracks of the Pretorian guard, was occupied by the vineyards of the Jesuits, the Esquiline hill was deserted and there were only a few mean houses and taverns round S. Giovanni in Laterano to cater for pilgrims making the circuit of the seven great basilicas *(327)*. The Baths of Caracalla looked onto a field of cabbages *(324)* and monks were the sole inhabitants of the Caelian and Aventine hills. The green and even spread of vines was punctuated by nothing more than the red brick of an isolated medieval campanile and the march of the battered aqueducts that used to bring water from the Alban hills for the Roman baths and fountains.

Now that the centre had shifted west, the hub of the imperial city was deserted; the Roman Forum took its name of Campo Vaccino from the cattle market which was established there *(32)*. No one had bothered to dig away the accumulated debris from the ruins which were covered with creepers and bright with wild flowers. 'It seems extraordinary', wrote de Brosses, 'that considering the immense sums that have been spent in making Rome splendid, no attempt

has yet been made to clear out this place or to excavate and attempt to preserve the ancient ruins with which it is covered.' With pedantic municipal zeal the Ministry of Public Instruction has now cleared away all picturesque accretions and uprooted from almost every crevice the flora seeded from exotic plants brought out of distant provinces as fodder for the wild beasts of the arena. In Piranesi's time vegetation abounded and no one cared for the antiquities. To quote de Brosses again, 'in the galleries which envelop the exterior of the Colosseum are the booths of a number of small trades people, who here display their wares, which hang from sticks placed in the holes from which the bronze rivets have been torn out.' The other monuments were treated with equal disregard: the Circus Maximus was an undrained swamp, a smithy poured black smoke from the misnamed temple of Cebele as if it were a shrine to Vulcan *(317)*, the portico of Octavia was a fish market, corn was stored in the Baths of Caracalla, and the tomb of the Emperor Augustus was used first as a vineyard and then as a bullring.

The Tiber, which was not embanked, could only be crossed in four places, by the Ponte S. Angelo to the Castle *(44)*, by the Ponte Sisto, by the bridges to the Tiber island and by the Ponte Palatino to Trastevere. This area at the foot of the Janiculan hill was, as it were, the cockney quarter where the real Romans of Rome lived, as they continue to do, still within the circuit of the walls. Their folk memory (or ability to invent one) was prodigious. When the Queen of Naples was visiting the city, a herb woman who saw her pass was overheard muttering, "Poor old Rome! In years gone by Queen Zenobia came through as a captive; that was another kettle of fish, my friend; quite a different outfit from this little queenie."

25. The Capitol, *Vedute di Roma*

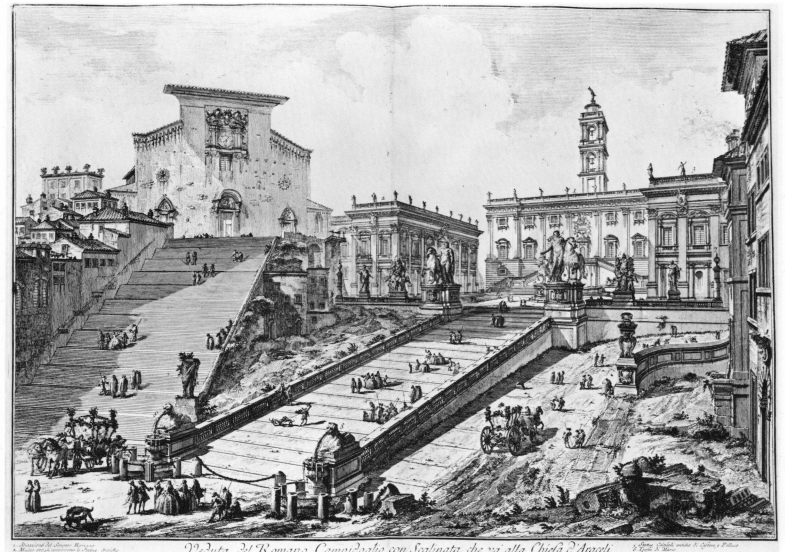

Veduta del Romano Campidoglio, con Scalinata che va alla Chiesa d'Araceli

Trastevere was joined to the Vatican by a single street and there was another old quarter, the Borgo Vaticano, between St. Peter's and the Castel S. Angelo. Such was the extent of the city in the eighteenth century and so it remained until about a hundred years ago. Beyond the walls there were a few villas, the Casino Borghese, for instance, and Cardinal Albani's new palace *(173),* and the villas on the Janiculan hill *(328).* Then came the desolate sheep and goat runs of the Campagna reaching as far as the hill *castelli,* Albano and the Pope's summer residence at Castel Gandolfo, Frascati, the Barberini's Palestrina and Tivoli.[7] This was the Rome which Piranesi was to preserve for us in the long series of *Vedute di Roma,* one hundred and thirty-three in all, including a few views outside the city.[8]

The dating of the early *Vedute* is a complex problem.[9] It seems probable that Piranesi started to issue the plates on his own account quite soon after his return from Venice, using Bouchard, the French bookseller on the Corso, to distribute them. They were intended as accurate tourist souvenirs and, from their instant popularity, he had obviously judged the market well. The plates were far larger than those produced by his rival, Vasi, the first volume of whose *Magnificenze di Roma* appeared in 1747. There were no copyright regulations in those days and the very size of Piranesi's plates gave some protection against their being pirated by copyists. It is probable that the earliest views are the nineteen which are signed 'Piranesi del. scol.' or 'Piranesi del. inc.' or some variation on this formula and which are all the same size as the *Carceri* plates. They comprise a good selection of obvious popular sights: St. Peter's and S. Maria Maggiore, the Piazza del Popolo

26. Theatre of Marcellus, *Vedute di Roma*

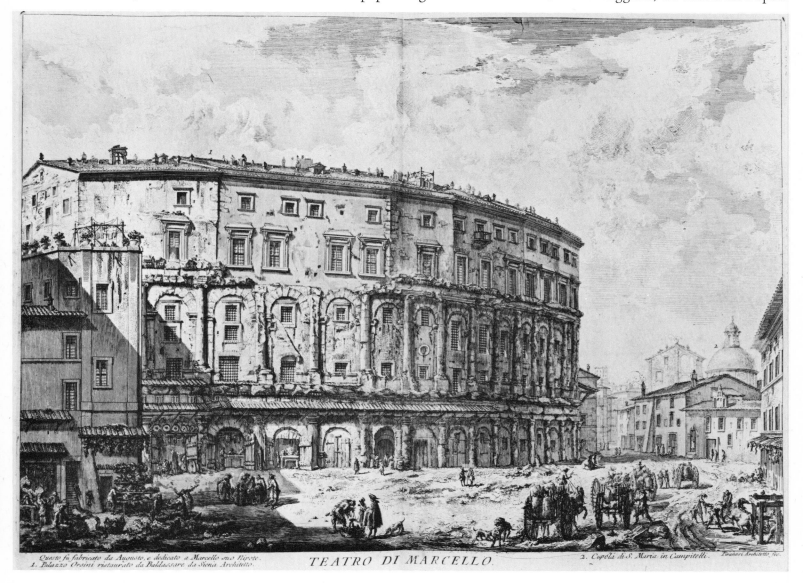

Questo fù fabricato da Augusto, e dedicato a Marcello suo Nipote.
1. Palazzo Orsini ristaurato da Baldassare da Siena Architetto. 2. Cupola di S. Maria in Campitelli. Piranesi Architetto fec.

TEATRO DI MARCELLO.

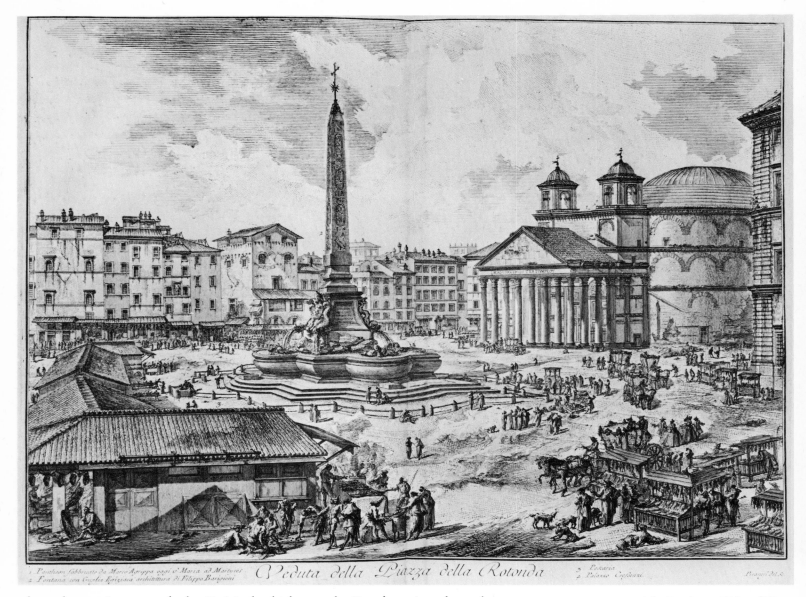

27. The Pantheon, *Vedute di Roma*

where the tourists entered, the Quirinal which was the Pope's main palace, the
Piazza Navona and the Trevi fountain (still two of the most popular views of
Rome), the Capitol, the Pantheon and a few other classical antiquities such as the
Campo Vaccino, the Colosseum and arch of Constantine, the temple of Venus
and Rome, the pyramid of Caius Sestius and the two famous columns, those of
Trajan and of Marcus Aurelius. To these should probably be added the view of
S. Giovanni in Laterano and the interiors of St. Peter's and of St. Paul's. It is
slightly surprising to find the latter before he had done an exterior view of the
basilica, but the reason is antiquarian: the magnificent columns down the nave
were said to have been stripped from the tomb of Hadrian, the Castel S. Angelo.
These first plates were probably all completed by about 1748. The next batch of
fifteen plates, signed 'Piranesi Architetto fec.', contain only three views of con-
temporary Rome (St. Peter's again, the Piazza di Spagna and the Porto di
Ripetta) and twelve views of antiquities.

These first thirty-four views were published in a single volume by Bouchard
in 1751 as *Le Magnificenze di Roma*. With them were bound the *Grotteschi* and an
enlarged version of the *Prima Parte* (which had already been reissued by Bouchard
the previous year as *Opere Varie di Architettura, Prospettive, Groteschi, Antichità*).
The *Carceri* and the *Archi trionfali* were also included in this volume. Soon after
publishing the *Magnificenze* he completed two further plates (the Hadrianeum
and the ruins of the fountain of the Acqua Giulia) and these were added to a few
copies. To judge from its rarity, the *Magnificenze* was an unpopular collection of

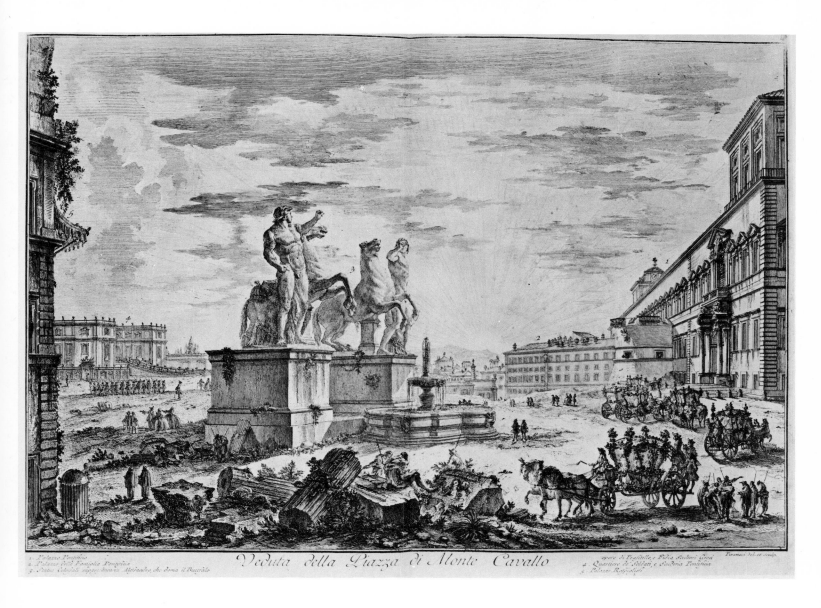

Veduta della Piazza di Monte Cavallo

28. The Quirinal, *Vedute di Roma*

prints, most people preferring to select the tourist views they wanted without buying the imaginary scenes as well. Over the next five years he was so busy on the *Antichità romane* that he only had time to add three more *Vedute*. Then, between 1756 and 1761, when he first produced a catalogue of his work, a further twenty plates were completed.

In the early years he used to go round to Bouchard's shop daily to see how his sales were doing and to hear how the customers had praised or criticised his latest plate. As his reputation grew, curious collectors started to interrupt him at work by calling at his lodgings which were only a short distance away from Bouchard. To avoid these importunate visitors, he moved 'for greater quiet,' as Legrand explains, 'to a little house behind the Monte Cavallo to a quarter called the Boschetto.[10] He refused to see anyone so that he could have time to study and think and practise his art.' There, alone in his studio, he used to talk to his plates as the rough drawings which he had made during the day were transferred to the copper. "Ah, we'll see," he would mutter, "how you can bring out the sunshine of Italy. You shall be brick and you shall be marble." Even here he was pestered by visitors. "Piranesi isn't in," he would shout through the door when they knocked. "You'll find him at Bouchard's one evening."

The impressionistic freedom of the *Archi trionfali,* which was more a series for the connoisseur, was not suitable for the scale adopted (approximately $21\frac{1}{2}$ by 16 inches) in the large *Vedute*. Instead, we have a careful and accurate delineation of the principal sights in an even cloudless summer light. Perhaps he deliberately

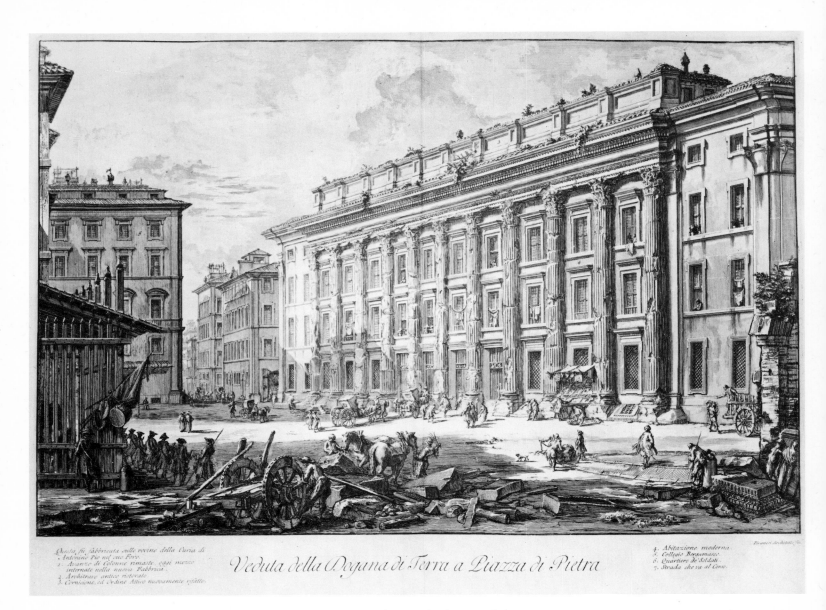

Piranesi Architetto fec.

Questa fù fabbricata sulle rovine della Curia di
 Antonino Pio nel suo Foro.
1. Avanzo di Colonne rimaste oggi mezzo
 interrate nella nuova Fabbrica.
2. Architrave antica restaurato.
3. Cornicione, ed Ordine Attico nuovamente rifatto.

Veduta della Dogana di Terra a Piazza di Pietra

4. Abitazione moderna.
5. Collegio Bergamasco.
6. Quartiere de' Soldati.
7. Strada che va al Corso.

avoided night scenes and sunsets because these were something which Vasi did rather well in his Roman views and he would not want to be seen as a plagiarist. The only sunset he allows himself is one over the horse tamers of the Quirinal. There are none of the heavy black shadows and jagged clouds with which he streaked the later *Vedute,* nor are there the slight exaggerations and distortions of scale which augment their drama. At this stage, Piranesi was an imaginative but strictly accurate recorder.[11] Not only was he accurate but he was prepared to up-date his plates to take account of structural changes. The view of the Trevi fountain, for instance, started off with one set of statues *(43),* but was revised when the sculpture was changed some ten years later.

In these first views he discarded the distorted viewpoints of the *Archi trionfali.* The principal subject was drawn from some distance so that it was clearly set in its context. The little figures scurrying round the streets are not the dateless urchins or scarecrows that figure in the subsequent plates, they are the everyday people and visitors of contemporary Rome. There are fishmongers' stalls in front of the Pantheon *(27),* makeshift stages for Pulcinello and Capitano Malagamba are erected in the Piazza Navona *(40),* mudlarks sift the river ooze for treasure below the Castel S. Angelo *(44),* soldiers drill outside the Quirinal *(28),* and the grandly ornate coaches of the nobility lumber up and down the streets. We see the visitors regimented by their bear-leaders to admire the antiquities, one tourist shouts to another from the top of Trajan's Column, newcomers arrive at the Dogana or Customs House (lodged behind the crumbling façade of the Hadrianeum) to

claim their baggage and argue with the officials.[12] Although the little numbers which pick out the subsidiary buildings in each plate distract, they refer to footnotes that provide much useful information for the intelligent tourist. Take the view of S. Giovanni in Laterano, for instance *(38)*: Piranesi not only lists Galilei as the architect (the façade had been rebuilt in 1734-6, after a hotly disputed public competition) but he points out the dome of the Corsini chapel (also built by Galilei in 1740 to house the porphyry urn taken from the Pantheon as a tomb for Clement XII), the Lateran palace (built by Sixtus V and at that time used as an orphanage), the Scala Santa (with the stairs of the house of Pontius Pilate), a fallen obelisk, and the city walls which frame the view. Similarly, in the plate of the Campo Vaccino *(24),* each of the antiquities is itemised so that the scholar could go over all the ruins to check the accuracy of his memory or that of his *cicerone*. These views firmly established Piranesi's reputation and gave him the initial financial stability which enabled him to tackle grander themes.

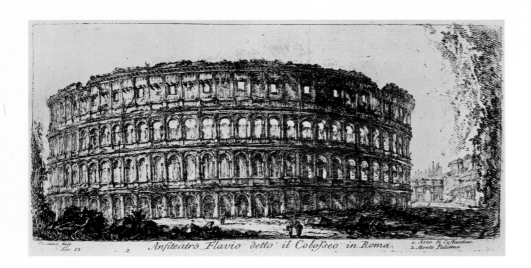

Anfiteatro Flavio detto il Colosseo in Roma.
1. Arco di Costantino.
2. Monte Palatino.

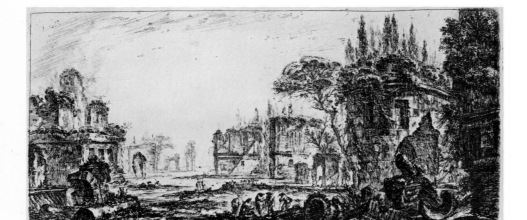

Parte dell'antica Via Appia fuori di Porta S. Sebastiano circa tre miglia

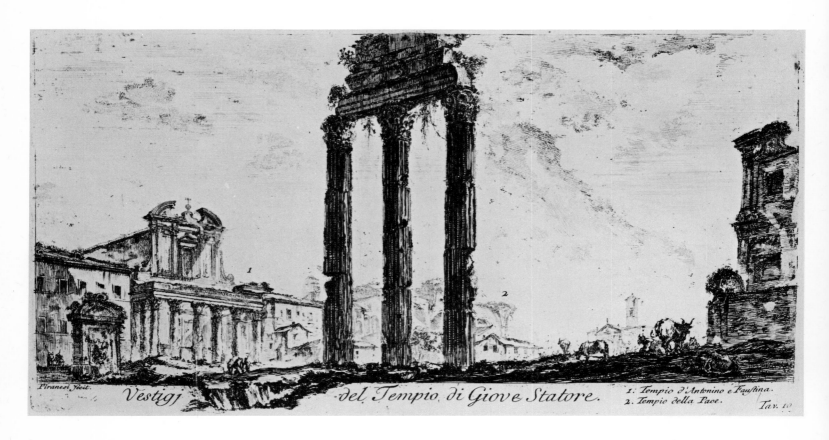

Vestigj del Tempio di Giove Statore.
1. Tempio d'Antonino e Faustina.
2. Tempio della Pace.

30. The Colosseum, *Archi trionfali*

31. The Appian Way, *Archi trionfali*

32. View of the Forum, *Archi trionfali*

33. Arch of Titus, *Archi trionfali*

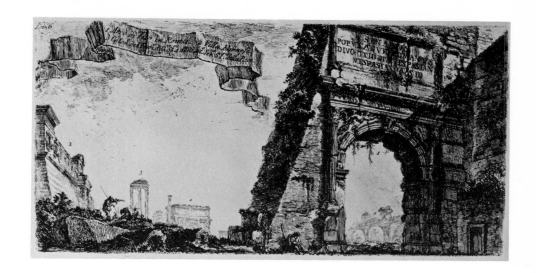

34. The Amphitheatre at Verona, *Archi trionfali*

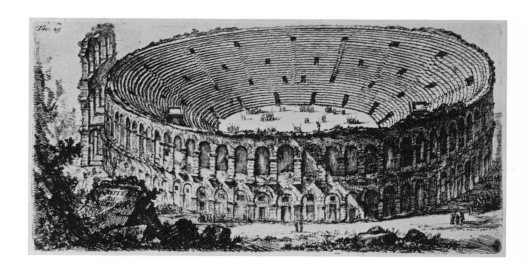

35. Temple at Pola, *Archi trionfali*

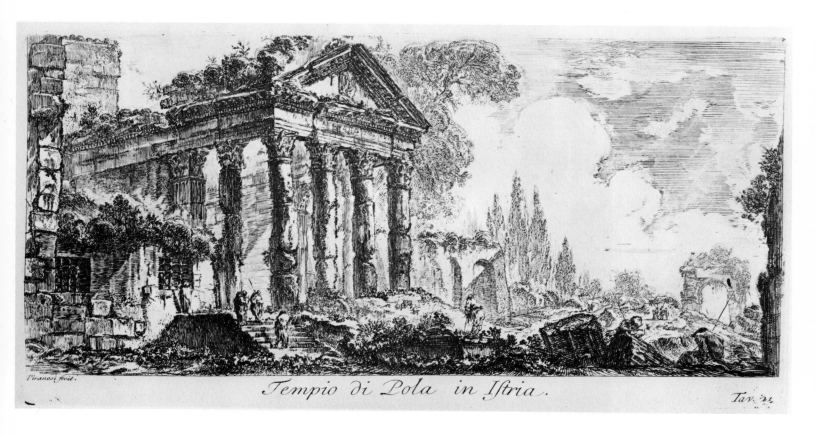

Tempio di Pola in Iſtria.

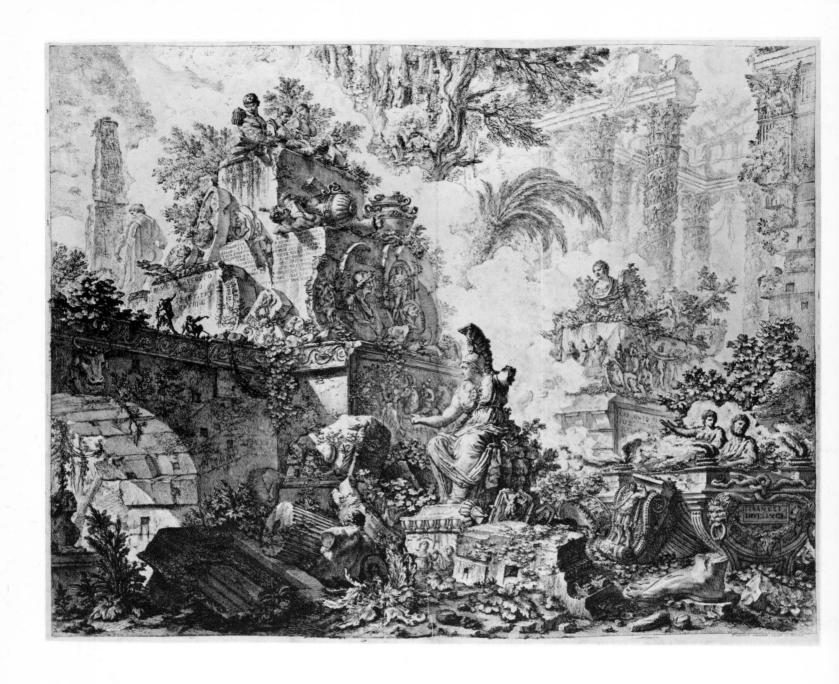

36. Frontispiece, *Vedute di Roma*

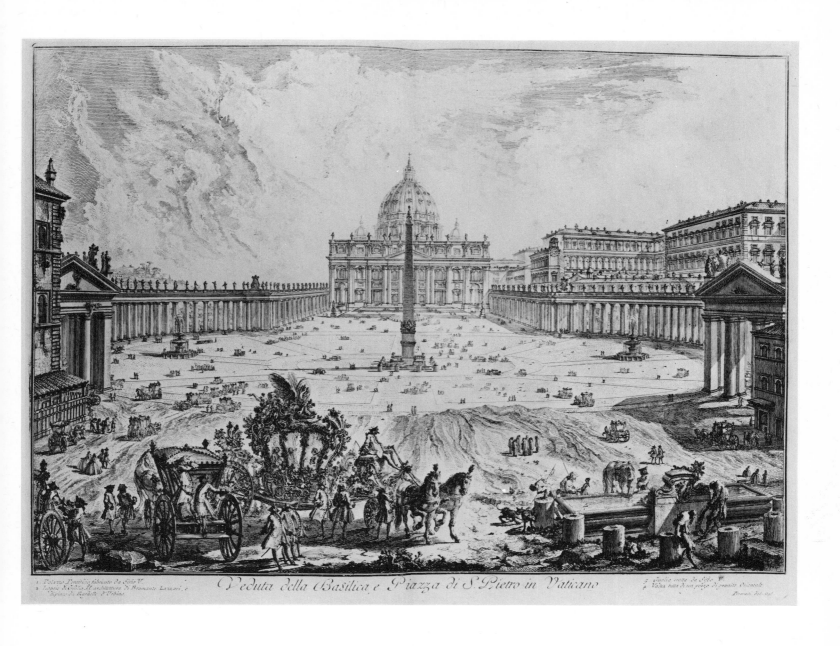

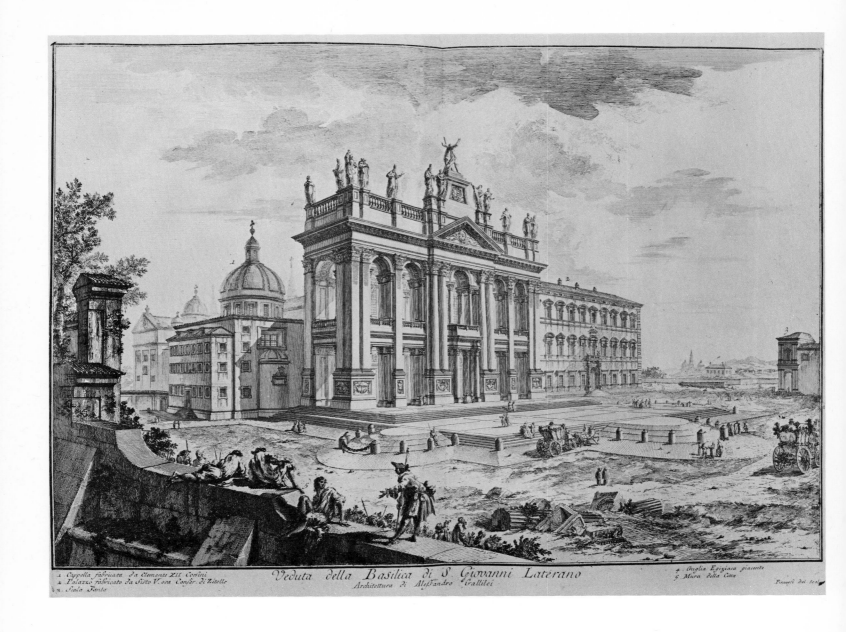

38. S. Giovanni in Laterano, *Vedute di Roma*

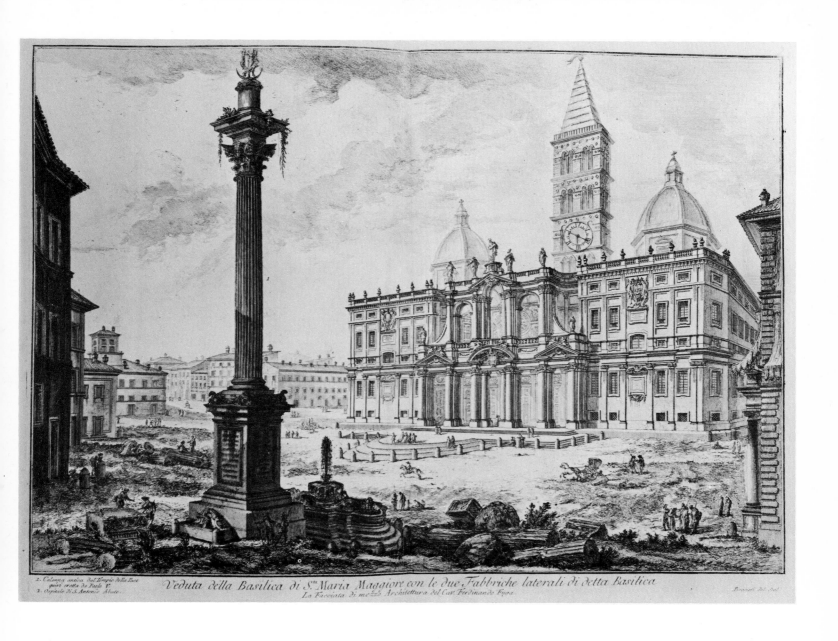

1. *Colonna antica del Tempio della Pace quivi eretta da Paolo V.*
2. *Ospitale di S. Antonio Abate.*

Veduta della Basilica di S.ta Maria Maggiore con le due Fabbriche laterali di detta Basilica
La Facciata di mezzo Architettura del Cav.r Ferdinando Fuga

Piranesi del. Sc.

39. S. Maria Maggiore, *Vedute di Roma*

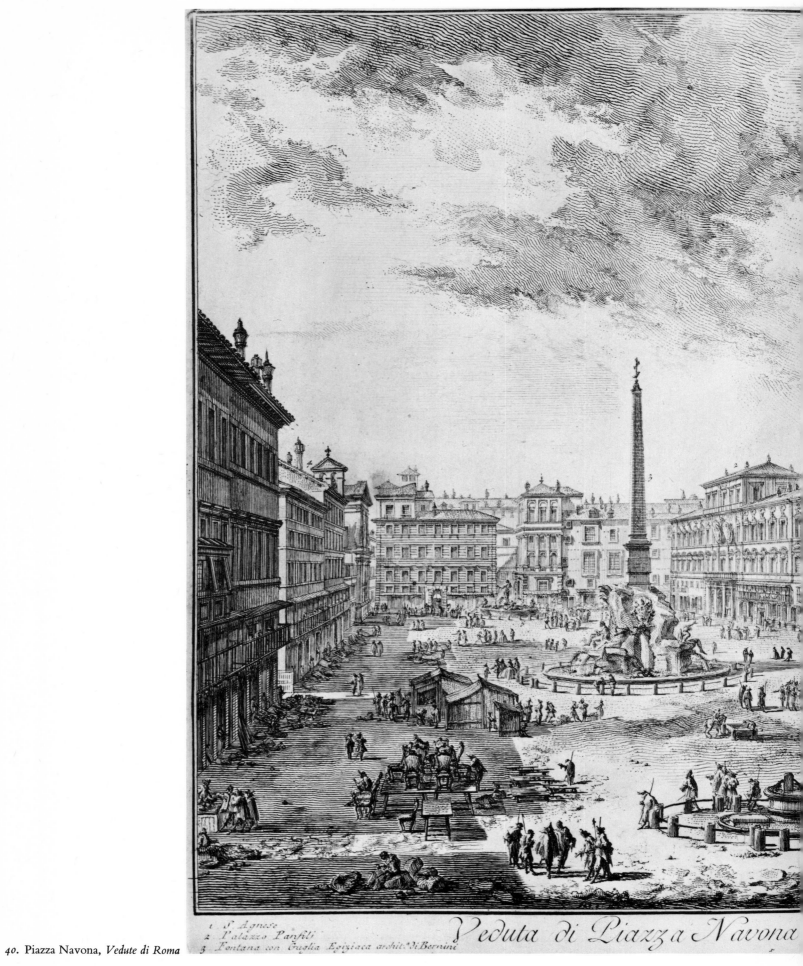

1. S. Agnese
2. Palazzo Panfili
3. Fontana con Guglia Egiziaca archit.o di Bernini

Veduta di Piazza Navona

40. Piazza Navona, *Vedute di Roma*

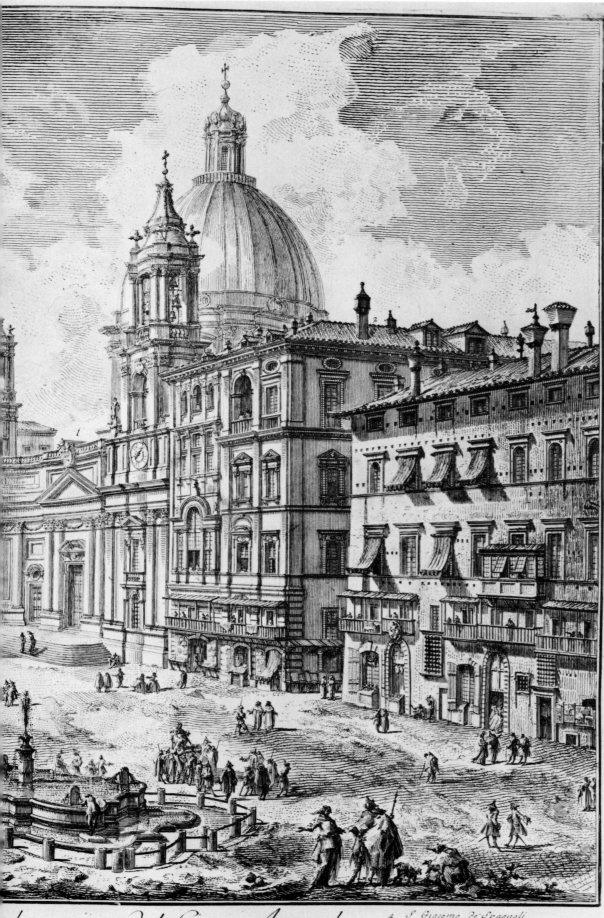

le rovine del Circo Agonale

4 *S. Giacomo de' Spagnoli*
5 *Fontana Architettura di Michelangelo*

Piranesi del sc.

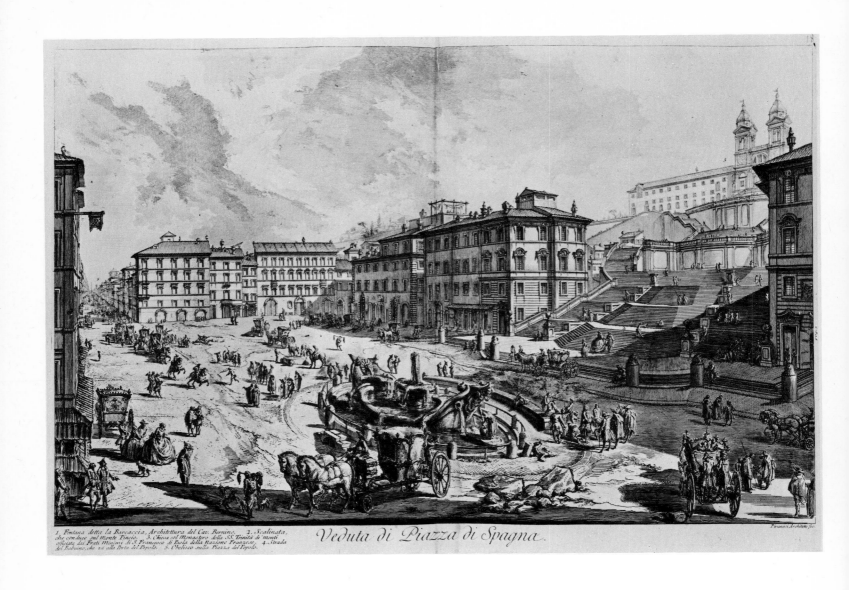

1. Fontana detta la Barcaccia, Architettura del Cav. Bernino. 2. Scalinata, che conduce sul Monte Pincio. 3. Chiesa col Monastero della SS. Trinità de'monti officiata dai Frati Minimi di S. Francesco di Paola della Nazione Franzese. 4. Strada del Babuino, che va alla Porta del Popolo. 5. Obelisco nella Piazza del Popolo.

Veduta di Piazza di Spagna

41. Piazza di Spagna, *Vedute di Roma*

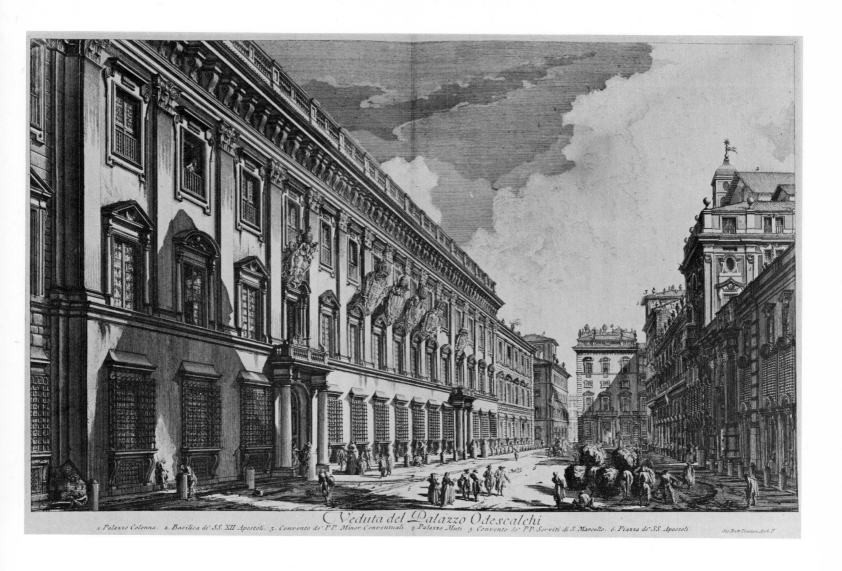

Veduta del Palazzo Odescalchi

1 Palazzo Colonna. 2 Basilica de' SS. XII Apostoli. 3 Convento de' PP. Minor Conventuali. 4 Palazzo Muti. 5 Convento de' PP. Serviti di S. Marcello. 6 Piazza de' SS. Apostoli. Gio. Batt. Piranesi Arch. F.

42. Palazzo Odescalchi, *Vedute di Roma*

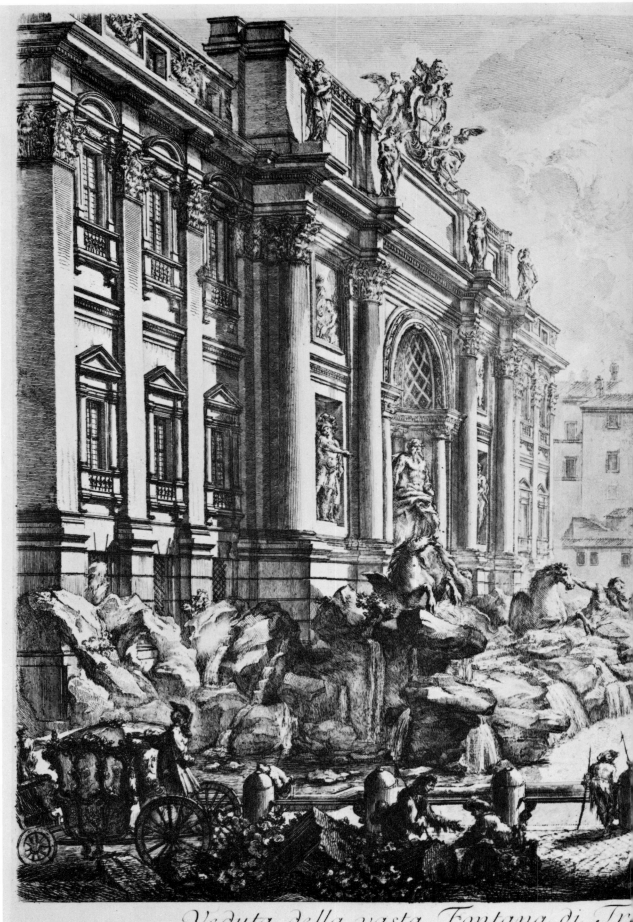

Veduta della vasta Fontana di Tr
Architett

43. Trevi Fountain,
Vedute di Roma

...nticamente detta l'Acqua Vergine.

...la Salvi.

Piranesi Del Scolp.

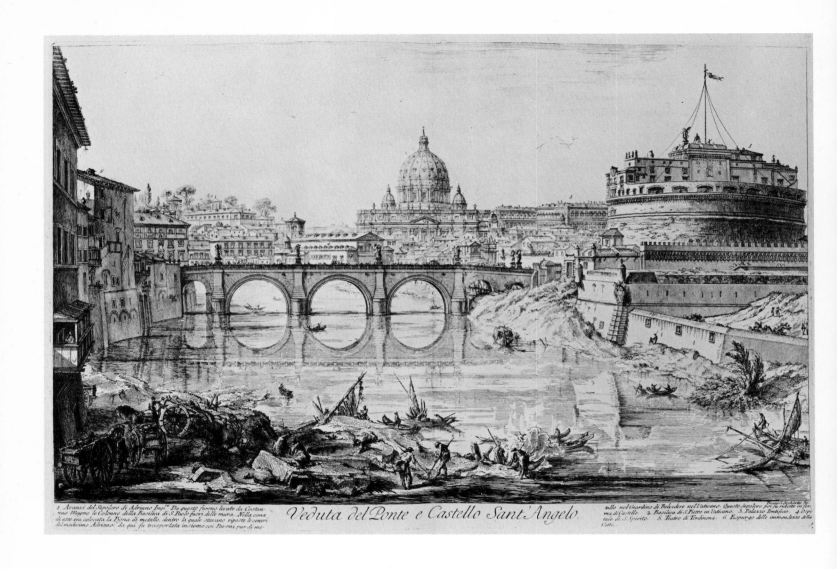

1. Avanzi del Sepolcro di Adriano Imp.re Da questi furono levate da Costan-
tino Magno le Colonne della Basilica di S.Paolo fuori delle mura. Nella cima
di essa era collocata la Pigna di metallo, dentro la quale stavano riposte le ceneri
del medesimo Adriano: di qui fu trasportata insieme coi Pavoni pur di me-

zallo nel Giardino di Belvedere nel Vaticano. Questo Sepolcro poi fu ridotto in for-
ma di Castello. 2. Basilica di S.Pietro in Vaticano. 3. Palazzo Pontificio. 4.Ospi-
tale di S. Spirito. 5. Teatro di Tordinona. 6. Espurgo delle immondezze della
Città.

Veduta del Ponte e Castello Sant'Angelo.

44. Castel S. Angelo and its bridge, *Vedute di Roma*

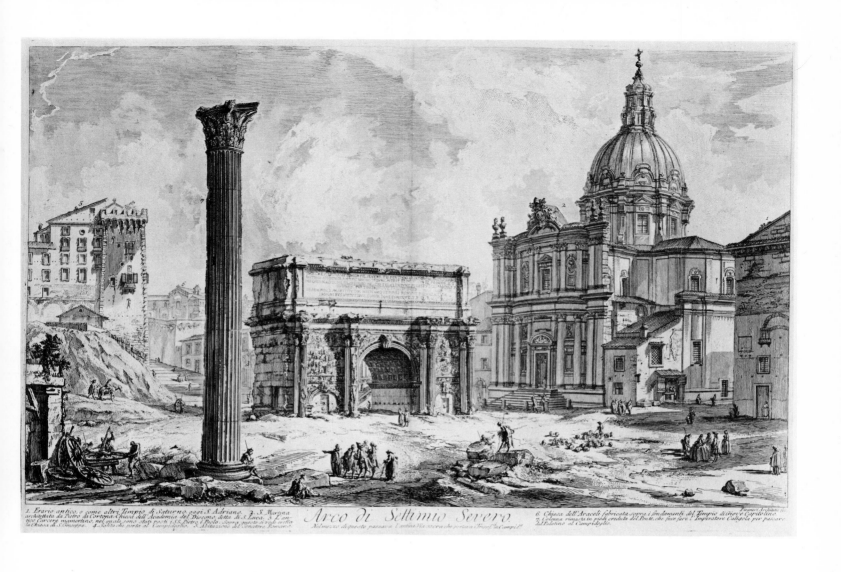

1. *Erario antico, o come altri Tempio di Saturno, oggi S. Adriano.* 2. *S. Martina* *6. Chiesa dell'Araceli fabricata sopra i fondamenti del Tempio di Giove Capitolino.*
architettata da Pietro da Cortona Chiesa dell'Academia del Disegno detta di S. Luca. 3. *Lan-* *7. Colonna rimasta in piedi creduta del Ponte, che fece fare l'Imperatore Caligola per passare*
tico Carcere mamertino, nel quale sono stati posti i SS. Pietro e Paolo. Sopra, questa si vede eretta *dal Palatino al Campidoglio.*
la Chiesa di S. Giuseppe. 4. *Salita che porta al Campidoglio.* 5. *Abitazione del Senatore Romano.*

Arco di Settimio Severo.
Nel mezzo di questo passava l'antica Via sacra che portava i Trionfi al Campid.º

45. Arch of Septimius Severus, *Vedute di Roma*

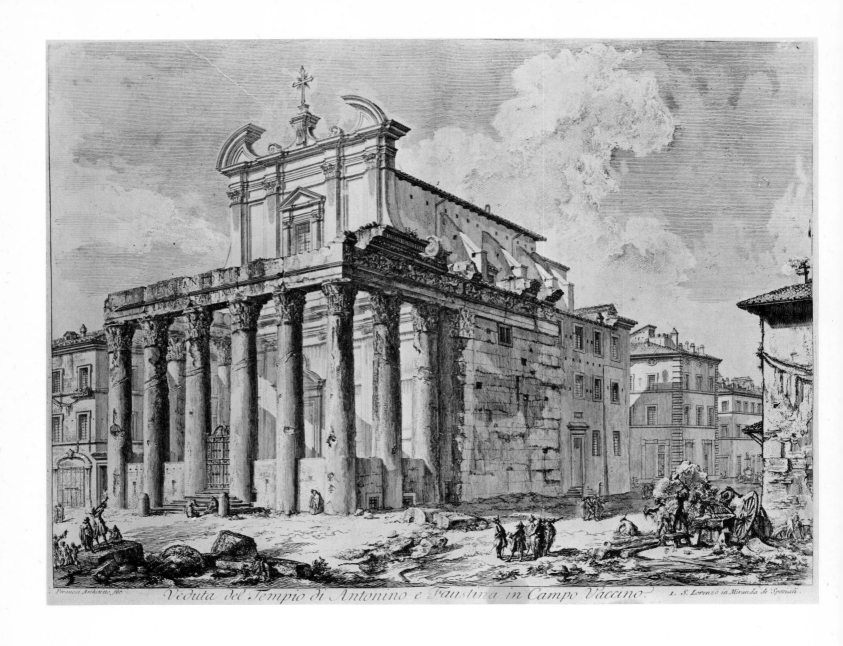

Veduta del Tempio di Antonino e Faustina in Campo Vaccino.

1. S. Lorenzo in Miranda de 'Spreciali.

46. Temple of Antoninus and Faustina, *Vedute di Roma*

CHAPTER THREE

The Capricci

ON his return from Venice in 1745, Piranesi earned his living by producing *vedute,* but such work did not give enough scope for his fertile genius which found its expression at this time in two groups of *capricci* etchings, the *Grotteschi* and the *Carceri,* and in a mass of exuberant drawings. These early exercises of the imagination are best considered together with the *Prima Parte* designs which he had published in 1743. The *Prima Parte* originally consisted of the dedicatory letter, the title page and twelve plates.[1] When Piranesi republished the work in *Opere Varie,* his first collected edition of etchings, in 1750, he omitted one of the plates (perhaps it had become damaged), reworked several others and added five extra designs which may have been the start of a *Seconda Parte* abandoned because the first had been so unsuccessful. He also withdrew the dedication to Giobbe and revised the title page.[2] The whole series clearly shows the mark of his training as a designer of stage sets. He positively emphasised the theatrical derivation in his original dedicatory letter to Giobbe: 'In all these drawings you

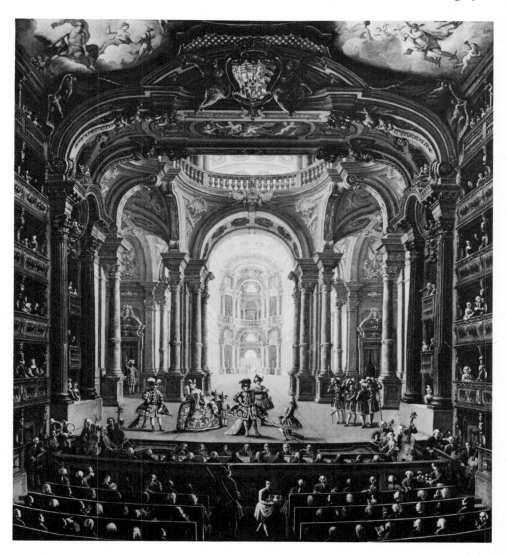

47. P. D. Olivero, Interior of the Teatro Regio, Turin

will see the great contribution of Perspective . . . I would add that if a man cannot recognise its use and importance in Architecture he cannot appreciate the source from which it draws its most considerable beauty.'

The work of the artist in the Baroque theatre is only now beginning to be appreciated once more. It was inevitably an ephemeral art, the stage sets have all crumbled away and many of the operas for which they were designed, being written for *castrati,* have until recently been considered unsingable and are only now being disinterred, although the large number of drawings and designs for the theatre that survive show the enthusiasm of contemporary patrons. The most famous designer of stage sets was Ferdinando Galli Bibiena who, first for the theatre of the Farnese court at Piacenza and then for the Viennese Hapsburgs, devised a superb series of ingenious fantasies which won him an international reputation and established his family as the leading stage designers in Europe throughout the eighteenth century.[3] The secret of his success was the 'manner of looking at things at an angle'. Until his time, a frontal view of the façade of the palace of Cyrus or the temple of the muses had been painted on the backcloth with symmetrical, slightly stepped wings extending from this to the proscenium arch. His innovation was to switch the axis so that you saw not only the façade but the façade and one side of the palace painted on the backcloth with one corner projecting towards the audience. Alternatively you looked into the corner of a courtyard, two sides of which were extending diagonally towards the wings, or at the intersection of two colonnades that crossed to form an X. At the same time he re-arranged the disposition of the side wings to heighten the perspective effects. Skilfully contrived, this *scena per angolo* seemed to deepen the stage and gave the illusion of endlessly receding galleries and arcades. The simple device was enormously successful. Throughout the century, helped by the deluding flicker of dim candlelight, architects could conjure up in a world of fantasy the cloudy Baroque palaces no mason could have constructed and no monarch afforded.

Legrand states that Piranesi actually worked under Ferdinando Bibiena in Bologna but this is unlikely because the designer was in his eighties when Piranesi was in his teens. It is probable, however, that he knew his stage designs published in *Architettura Civile* and used his handbooks for students; the first of these, after a brisk introduction to geometry, proceeds to the five orders after Vitruvius, Serlio and Palladio and then continues with his own 'Divisions of Architecture'. The second, *Prospettiva Teorica,* explains the way to construct perspective views in a series of complicated diagrams based on some of his own stage creations. It is also probable that Piranesi would have known the work of Ferdinando's son, Giuseppe Bibiena, who succeeded his father in Vienna as 'First Theatrical Engineer and Architect' to the Emperor Charles VI. In 1740, the year Piranesi

48. F. G. Bibiena, Diagram from *Prospettiva Teorica*

49. G. Bibiena, Stage set from *Architetture, e Prospettive*

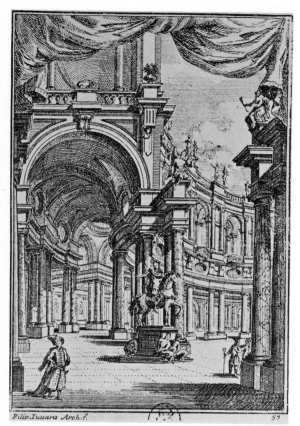

50. F. Juvarra, View of stage set for *Teodosio il Giovane*

arrived in Rome, Giuseppe published *Architetture, e Prospettive,* a miscellaneous collection of stage designs, catafalques for dead royalty and chapel settings for Passion oratorios.

In addition to the work of the Bibiena family, Piranesi was familiar with the designs of the great Baroque architect, Filippo Juvarra, from Messina, who produced a large number of stage sets both for Cardinal Ottoboni's little private theatre in the Cancelleria in Rome between 1708 and 1713 and for the court theatre of the King of Sardinia in Turin when he was working there subsequently. The British Museum has several drawings by Piranesi which are adaptations of Juvarra's settings for Amadei's opera *Teodosio il Giovane,* produced in Rome in 1711; these drawings may be taken from the engravings in the published edition of Amadei's libretto, but since, as we shall see, there are also striking correspondences between some of Juvarra's designs and the *Carceri,* Piranesi may have known the Sicilian's sketches at first hand. An obvious link are the Valeriani who were employed in the early 1730s to paint the central *salone* in Juvarra's stag crowned hunting palace, the Stupinigi, just outside Turin. They might easily have acquired some of his designs for their repertoire at this period and Piranesi could have seen them when he was working for the Valeriani at a later date.[4]

Once we are aware of eighteenth-century stage compositions the theatrical derivation of most of the *Prima Parte* etchings becomes obvious. They are the industrious exercises of a promising student brought up on Palladio and the Bibienas. In some plates, however, he is more ambitious: the *Grand Sculpture Gallery (6),* the *Group of Columns* and the *Ancient Mausoleum (79)* are vast compositions blown up to the superhuman scale which he already considered to be the only one appropriate to antiquity and which is emphasised by the decorous periwigged midgets pirouetting beneath the towering arcades. A different influence is, perhaps, to be traced here.

It is possible that, during his first stay in Rome, Piranesi met Jean Laurent Le Geay, a *pensionnaire* at the French Academy, who was also producing *vedute* for Amidei. By all accounts, Le Geay made a quite remarkable impact on his contemporaries. When he returned to Paris in the summer of 1742, the director of the Academy, François de Troy, reported that he was bringing back some excellent drawings both of public buildings and of his own designs; the latter were 'full of fire and brilliance'. Cochin went much further and attributed the purification of French taste from the frivolities of the Rococo to the homecoming of the young architect. 'He was one of the most remarkable architectural geniuses there has been, but for all that, he lacked restraint and, one might say, method. He could never keep within the bounds of what he was asked to do, and the grand Mogul

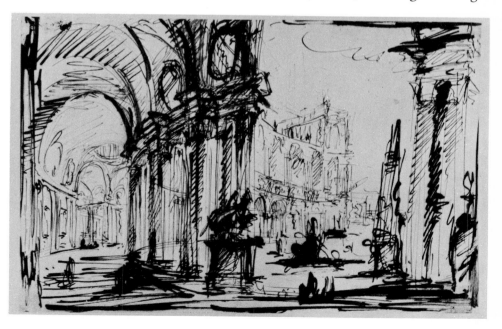

51. Drawing from Juvarra's set for *Teodosio il Giovane*

would not have been rich enough to build the palaces which he used to project.' He sounds a character after Piranesi's heart and it is tempting to see the influence of Le Geay's optimistically megalomaniac designs for huge circular buildings in some of Piranesi's plates in the *Prima Parte*, in the *Temple of Vesta (78),* for instance, and in the enormous *Ancient Mausoleum.* It is tempting, but it may be that both were coincidentally letting their imagination run free on themes from a popular German encyclopaedia of the wonders of the ancient world, Fischer von Erlach's *Entwürff einer historischen Architectur* from which Piranesi certainly made a number of drawings and which Le Geay may have used as the source of some of his vase designs. One further straw of evidence for a connection between the two artists is to be found in the inventory of the effects which Piranesi's sons left behind them in Rome when they fled to Paris in 1799. They included 'a trunk containing a large quantity of drawings by the famous architect Legacq'. Legacq is unknown and is surely a misreading for Le Geay.[5]

Certainly on Piranesi's return from Venice in 1745, when he was living

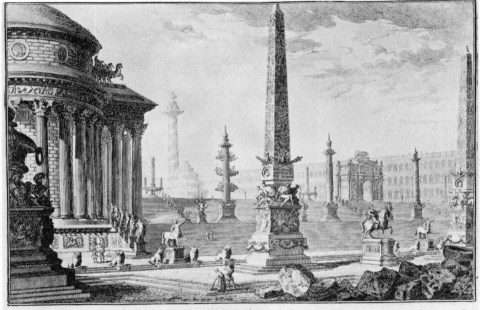

52. Ancient Capitol, *Prima Parte*

53. Fischer von Erlach, the Mausoleum at Halicarnassus

54. J. L. Le Geay, Vase

opposite the French Academy and using a French publisher, Jean Bouchard, he was in close contact with the *pensionnaires* and, even if he did not join the Academy himself, he probably accompanied their architectural sketching parties to make detailed ground plans and cross-sections of the principal buildings of the city. Legrand says that he was a friend of artists such as Vernet, Challe and Petitot and of Vien who alone could gain access to his studio by a special way of knocking on the door. We know that he was responsible for designing the firework display given to celebrate the recovery of the rather unappealing sculptor Saly in 1746. He may even have met Pannini, the internationally famous recorder of Rome's ceremonies and painter of imaginary groupings of the City's monuments, who had been attached to the Academy since 1732. Later on he was a friend of Pannini's star pupil, Robert, and of the Academy's trouble maker, Clérisseau. Since de Troy was a fairly ineffective director of the Academy whose main object was not to instruct his students but to ensure that they executed a steady supply of copies of Raphael frescoes as cartoons for the royal tapestry works, the young academicians turned enthusiastically from this official chore to their own devices, giving rein to their invention in a series of boldly original neo-classical designs, possibly under the spell of work left behind by their former fellow student, Le Geay. Although no one transferred their ideas for temples and mausolea into solid marble, they made spectacular painted backdrops for Rome's open air festivals, such as the Chinea, and the firework displays that were an extension of stage design. The chief exponents of this new style were Le Lorrain, Dumont, Petitot and Challe and the latter's drawings in particular are remarkably close to those of Piranesi both in imaginative scope and in actual technique.[6]

Piranesi's headlong enthusiasm for antiquity and his real feeling for the greatness of Rome's past must have made him a most exciting and stimulating companion, but his French friends did not let him lay down the law entirely without question as an anecdote of Sir William Chambers shows. 'A celebrated Italian Artist, whose taste and luxuriance of fancy were unusually great, and the effect of whose compositions, on paper, has seldom been equalled, knew little of construction or calculation, yet less of the contrivance of habitable structures, or the modes of carrying real works into execution, though styling himself an architect, and when some pensioners of the French academy at Rome, in the Author's hearing, charged him with ignorance of plans, he composed a very complicated one, since published in his work, which sufficiently proves that the charge was not altogether groundless.' This characteristically carping comment by the British architect refers to the elaborate *Plan for a Magnificent College (83)* which first

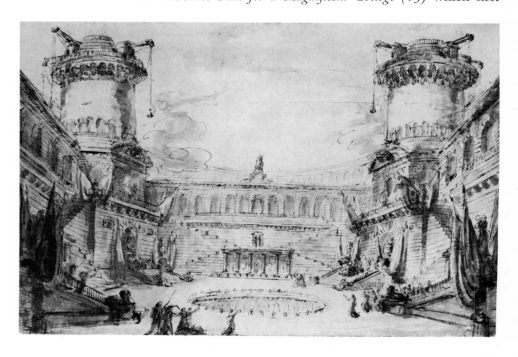

55. C. M. Challe, Stage set

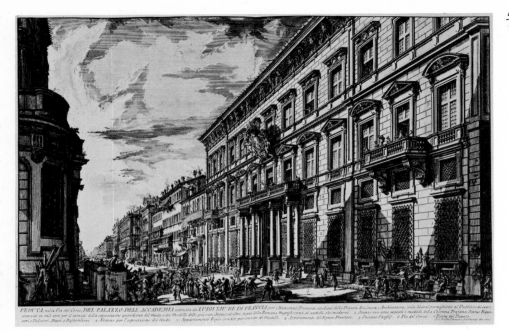

VEDUTA nella Via del Corso, DEL PALAZZO DELL'ACCADEMIA instituita da LUIGI XIV RE DI FRANCIA per i Nazionali Francesi studiosi della Pittura Scultura e Architettura, nella liberal permissione al Pubblico di esercitarsi in tali arti per il comodo della esposizione quotidiana del Nudo e dei Modelli delle più rare Statue d'altre opere della Romana Magnificenza si antichi che moderni. 1 Stanze ove sono esposti i modelli della Colonna Trajana Statue Equestri e Pedestri Busti e Bassirilievi. 2 Stanze per l'esposizione del Nudo. 3 Appartamento Regio eretto parimente de Modelli. 4 Appartamento del Signor Direttore. 5 Palazzo Panfilj. 6 Porta del Popolo. 7 Via del Corso.
Gio Batta Piranesi Architetto dis. ed inc.

appeared in the *Opere Varie*. It is easy to imagine how the boldly implausible visions Piranesi was producing at this period might have stuck in Chambers' academic gullet.[7]

Despite the grandeur of the ideas, the style of the *Prima Parte* etchings tends to be rather stiff and lifeless; they are not really very decorative or interesting. The exceptions to this are the dedicatory plate *(72)* and the four other ruin scenes, the *Ruins of Ancient Buildings (73)*, the *Ancient Altar*, the *Ancient Tomb (74)* and the *Burial Chamber*. These are similar in theme to the *capricci* etchings of another Venetian, Marco Ricci, although in style they are more akin to the seventeenth-century Genoese master, Castiglione, whose work was highly prized by Roman and Venetian connoisseurs at this time.[8] Already we see the morbid preoccupation with mortality and decay, lively figures clamber in the ruins of antiquity and vegetation exultantly splits open the heroic monuments.

These etchings lead straight on to the four *Grotteschi*, first published in the *Opere Varie* but probably executed several years earlier when he was working on the *Archi trionfali*. It is a mysterious series, the key to which is as hard to find as that to the *Scherzi di Fantasia* and the *Varj Capriccj* of Tiepolo. An examination of the fourth plate for instance, reveals the most diverse elements. The design centres on a large altar on which rest a trumpet and a fanfare of ostrich plumes; a curved cartouche and a shield with a howling Medusa's head are looped on tasselled ropes between this altar and a bull's head in the corner, a very dead bull's head, newly sacrificed and hung up to become a bucranion; beside it appear a quite detached pair of eagle's wings. There is a second altar with an unintelligible inscription in the other corner, and some barrels beside which a disembodied hand pours out a glass of wine. The foreground is littered with Pan's pipes, Mercury's staff, Hercules' club, but also an hour glass, a smoking antique lamp, a bull's horn and a couple of mossy skulls. Finally, we notice that the whole thing is, as it were, suspended on a hanging cloth (only equalled in improbability by the battle of Lepanto staged against a stucco curtain in Serpotta's Palermitan Oratory of S. Zita). There is no obvious theme to this imaginative collage and perhaps there was not intended to be one.

The other three plates *(85–87)* are equally cryptic. What is Hercules doing, standing there, sunk in thought, the golden apples of the Hesperides hidden behind his back? Why does he ignore the frantic skeleton gesticulating under the signs of Scorpio and Sagittarius? What have the soldiers found beneath the stone at the foot of the mocking herm? Why is a dolphin stranded on the hill top above the broken altars and sarcophagi where the serpents coil and couple? The only

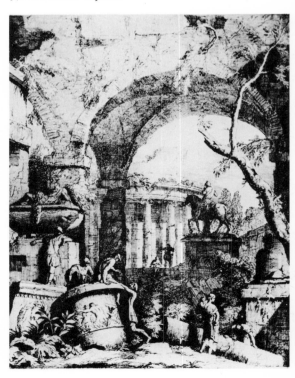

58. Capriccio, *Grotteschi*

59. Drawing of Satyrs

60. Burial Chamber, *Prima Parte*

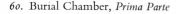

thing that is clear is the mark of Tiepolo's studio, revealed in the quick bold strokes of the etching needle and the bright airiness of the designs, which are flooded with Venetian light. There are also many pictorial reminiscences; laughing herms, fallen sculptured reliefs, writhing snakes, the grimace on the Medusa shield, back views of broad-shouldered nudes are all found in Tiepolo's etchings too. Closely related to the *Grotteschi* is a drawing by Piranesi of three satyrs who squat among fallen columns in an architectural setting, one of them bending over a spring that pours from an urn into a large basin; there is the same drifting smoke and chains of medallions. Satyrs feature in Tiepolo's etchings but not elsewhere in Piranesi's work. The artist's palette and brushes in the third plate are a final reminder of the Venetian master's studio.[9]

My tentative explanation for the series is that they were conceived as pictorial poems, or rather as illustrations to the poetic effusions of the Arcadians of the

Bosco Parrhasio. The Arcadians were a literary and artistic club in which the nobility and the prelates used to meet poets and artists on equal terms. Their gatherings took place in a little stone theatre at the top of a shady garden of laurels and pines on the slope of the Janiculum, where they recited their well-studied sonnets to the accompaniment of a harpsichord and the plash of the fountains watered from the Acqua Paola above. One of the Arcadians' recreations was 'the Sibyl's game'. Someone was selected as the oracle and would answer whatever questions were put to him with a single word, after which two 'interpreters' would explain the replies in impromptu verse. Each member adopted a bucolic pseudonym and had to obey the laws of the grove which had been laid down by the philosopher Gravina and were supervised by an elected head shepherd and two deputies. Piranesi was a member of this society by 1750, under the name of Salcindio Tiseio, probably on the introduction of Bottari a year or two earlier. The mythological allusions and the rustic setting of the *Grotteschi* and their riddling and elegiac subjects would certainly be appropriate to the Arcadian gatherings.[10]

His most ambitious efforts did not yet always succeed. In the Calcografia Nazionale in Rome where the original plates of most of his etchings are preserved, there are two scenes which, since they are etched on the reverse of two of the early *Vedute,* must have been executed by about 1748. Obviously he had had trouble with the biting of the acid in these two plates which join together to form a tremendous panorama of ancient buildings into which Phaethon, child of Apollo, crashes headlong in the chariot of the sun (the theme of another Arcadian poem?) Piranesi was reluctant to jettison these designs even though they were not technically good enough to publish and so, instead of burnishing them off, he simply turned the coppers over and used the other sides of the plates for the two *Vedute.*[11] It is tantalising to speculate what other grand conceptions must have been destroyed.

Probably Piranesi started on the *Carceri,* today the most famous of all his works, soon after his return to Rome. Quite a number of drawings survive to show the endless variations on the theme of massive and inchoate subterranean structures which he was dashing out at this period. He was bursting with invention and, to work off his energy as an architect manqué, he loaded his sketch pad with soaring arcades and stairways, designs for palaces and sweeping bridges and designs for sombre, heavily barred prisons. Some of the ideas poured out so swiftly that, in the transfer from the initial pen and ink sketch to the etching on

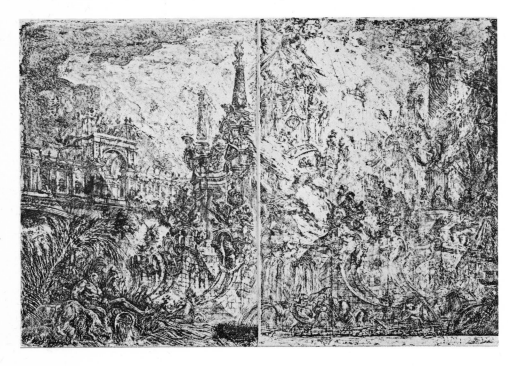

60a. Fall of Phaethon

the copper plate, he lost himself in the speed of his conceptions. The British Museum, for instance, has a preliminary sketch in the reverse direction for Plate XIV of the *Carceri,* but in the etching *(112),* by altering the flow of the steps emerging between the central pier and that on the left, the upper flight of stairs is launched into a non-existent space, starting at the back of the central pier and descending in front of the left-hand one, although apparently intended to be parallel to both. Sometimes (in Plates XI and XV, for instance), he almost seems to have attacked the plate direct without any preliminary drawings. By contrast, other, probably early drawings in Hamburg *(63)* and Madrid are very close to the final versions which emerged as Plates VIII and XII.

The first edition is described on the title page as *Invenzioni Capric di Carceri.* It was published in about 1750 and did not even carry Piranesi's name but only that of his publisher, Bouchard. A few copies of the title-page contain a revealing

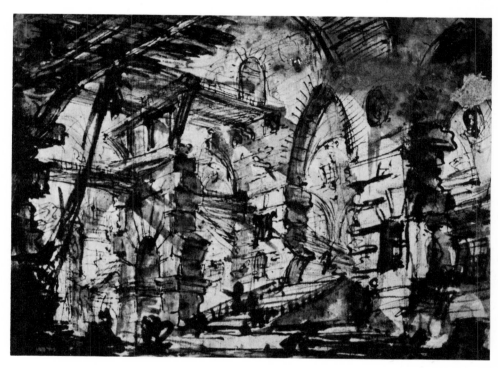

61. Drawing of a prison

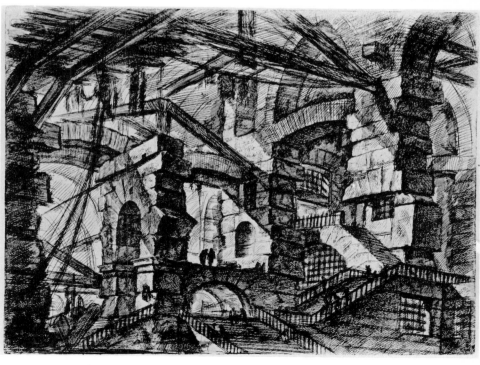

62. Carceri, Plate XIV, first state, reversed

53

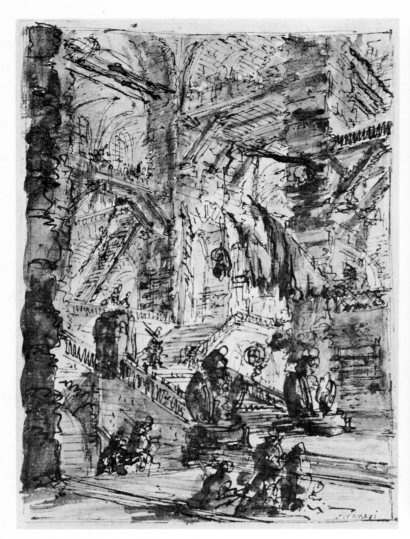

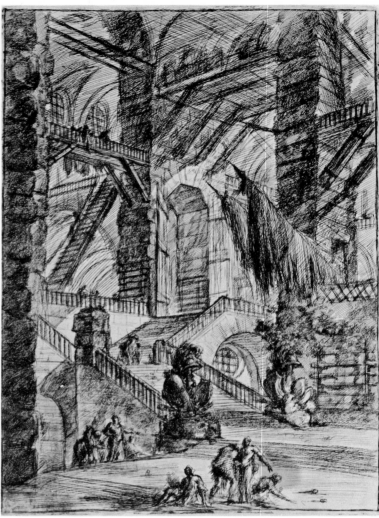

misprint: Bouchard is spelled Buzard, Piranesi's Venetian dialect softening the 'ch' to a 'z', an error that was soon corrected. But the turbulent splendour of the young artist's vision was disregarded by contemporary Rome. The designs were too abstract, too unadorned; for that matter, many of the structures looked only half completed and then abandoned in mid course. They were certainly not ruin-pieces because they lacked the necessary drapery of romantic creepers, while the connection with antiquity was tenuous, to say the least, and no one would want to erect such buildings or even transfer them to canvas as stage sets. The plates proved unsaleable, even though they were priced at one *paolo* each (or $2\frac{1}{2}$p, as against $2\frac{1}{2}$ and later 3 *paoli* for the similar sized views of Rome). There are few surviving copies of the original set of fourteen etchings in their first state, which is an indication of their unpopularity.

Over the next ten years or so, his imaginative efforts were devoted to vaster and yet vaster reconstructions of Roman and even Egyptian ports and palaces and gymnasia which were to appear as an ambitious continuation of the themes of the *Prima Parte*, either as part of the *Opere Varie* or as later insertions to it *(80–2)*, or as frontispieces to the four volumes of *Antichità romane*. But the images of the *Carceri* continued to haunt him. Undeterred by the earlier lack of popular success, he returned to his original plates in about 1760 and proceeded to rework them entirely. Perhaps in response to criticism that the first series was insufficiently gaol-like, he dramatically darkened the former silvery lights, scoring in black shadows and adding the sinister paraphernalia of the torture chamber. Plates XI and XVI were changed beyond recognition and in the latter the effects have really been rather overdone *(117)*. The pair of little men on the central flight of steps have been swept away and replaced by a colossal milestone which is the receptacle for the

63. Drawing of a prison

64. Carceri, Plate VIII, first state, reversed

heads of two decapitated giants, dripping blood from their niches over an inscription 'To impiety and the black arts'. Other inscriptions carved into the stonework refer to passages in Livy describing the institution of the prison in Rome by Tullus Hostilius and the trial of one of the Horatii for the murder of his sister. Plate XI, however, which was one of the weakest in the first series, was superbly reinforced: the background is hatched with an infinite series of receding arches and rising stairways while a vast platform is cantilevered out over the leaping bridge that spans the central void; round watch houses are set at the corners of the platform as if for invisible custodians on guard over this mysterious limbo, and, behind it and the bridge, the mass of a gigantic pier bearing the thrust of the encircling arches descends in a space so ambiguous that it appears at first to crush through the centre of the platform (107).

It is curious that he did not take this opportunity of removing some of the formal inconsistencies like the impossible flight of stairs in Plate XIV. In fact he introduced yet more anomalies: in Plate XI, for instance, a rope hangs vertically from the end of the projecting beam under the arch to the left, and yet it is looped through the rungs of a ladder propped against the middle of the same beam. Was he creating these spatial ambiguities deliberately?[12] Was he experimenting with optics? I don't believe it. He was quite verbose enough when he had a theory to expound and I am sure that if he had had such ideas he would have rushed them into print. Besides, Picassoist effects a century and a half before their time would have been alien to the eighteenth-century mentality. It is rather a measure of his contemporaries' disregard for the *Carceri* that no one examined the first series sufficiently closely to spot the anomalies and point them out to the artist who worked too quickly to notice them himself. Such inconsistencies are paralleled later on in the contradictory shadows in some of the plates of his later works like *Diverse maniere* and *Vasi, candelabri, cippi*.

The two additional plates, II and V, transfer the new prisons from a timeless gloom to the period of classical antiquity (90, 91). In the extra Plate II we seem to be in the upper vaults of a prison that is sunk below the main level of a forum, but it is a forum of very novel architecture; the huge Tuscan colonnade that fronts the principal building is joined below the capitals by an extraordinary continuous frieze that jinks up into the pediment to crown four colossal Corinthian columns centred there. A gaoler, egged on by spectators from above, is heaving away at a prisoner on the rack, and the names of his previous victims are inscribed on plinths or under their busts all around him. Piranesi must have been reading the description of Nero's purges in the *Annals* of Tacitus but, as in *Archi trionfali*, he spelled some of the names just slightly wrong. The new Plate V consists of a subterranean arcade, vaguely based on the Curia Hostilia, which stands as a substructure to yet more springing arches. Again, there are glimpses of public buildings high above and Piranesi adds forbidding sculptured reliefs of lions and of barbarian captives. There are plenty of ropes and chains on the beams all around but no prisoners this time, only gesticulating pygmies who have over-run the whole building like a coach load of camera-toting tourists. Neither of these additional plates have the spontaneity of his first endeavours. As he reworked the original plates, he experimented with new effects, deepening the gloom in one corner, strengthening the lines in another to give the emphasis he wanted; he even seems to have dabbed at the paper with his thumb to get the right shading in the proof pulls. The revised edition with the two extra plates was published as *Carceri d'Invenzione* under his own name at the slightly higher price of 20 *paoli*, or 50p, in about 1761.[13]

The new edition sold rather better than the first, but it still did not make much immediate impact. The visiting tourists only wanted the picturesque views of Rome while the cognoscenti were more interested in his fanciful reconstructions of antiquity or the Greek controversy. It is not surprising to find that one of the first people who seems to have taken any notice of the *Carceri* was the young William Beckford, later to become the highly unbalanced Caliph of Fonthill and

author of *Vathek*. When in Venice in 1780, two years after Piranesi's death, his gondola floated under the Bridge of Sighs: 'I shuddered whilst passing below; and believe it is not without cause, this structure is named PONTE DEI SOSPIRI. Horrors and dismal prospects haunted my fancy on my return. I could not dine in peace, so strongly was my imagination affected; but snatching my pencil, I drew chasms and subterraneous hollows, the domain of fear and torture, with chains, racks, wheels and dreadful engines in the style of Piranesi.' The terrifying splendours of Eblis, the oriental palace of hell, in *Vathek* had the same inspiration.

Beckford's mention is the first that I have come across. There is, of course, Horace Walpole's rhapsody in the introduction to the fourth volume of *Anecdotes of Painting in England,* published in 1765, in which he exhorts artists to 'study the sublime dreams of Piranesi, who seems to have conceived visions of Rome beyond what it boasted even in the meridian of its splendour. Savage as Salvator Rosa, fierce as Michael Angelo, and exuberant as Rubens, he has imagined scenes

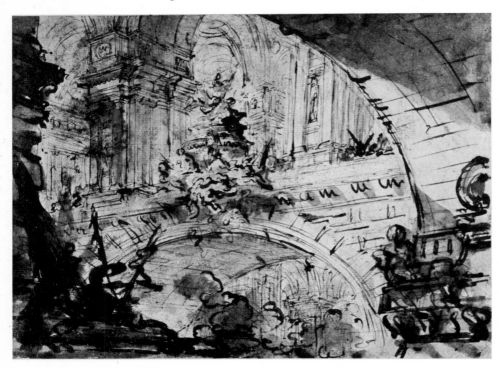

65. Drawing of bridges

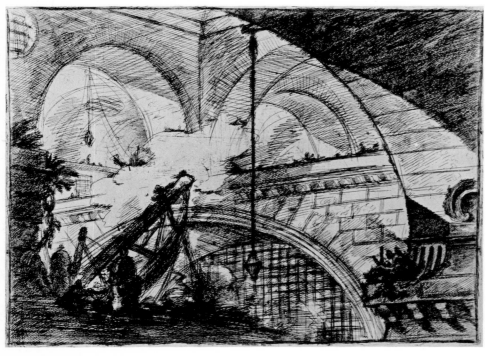

66. *Carceri,* Plate XI, first state, reversed

that would startle geometry, and exhaust the Indies to realise. He piles palaces on bridges, and temples on palaces, and scales Heaven with mountains of edifices. Yet what taste in his boldness! what grandeur in his wildness! what labour and thought both in his rashness and details!' This must, however, refer to *capricci* like the *Magnificent Port* or the dedicatory plates of the *Antichità romane* and related drawings and not to the *Carceri (84, 123 and 125)*.

Legrand says that the *Carceri* designs were actually used in the theatre. This seems unlikely but later eighteenth-century stage designers like Badiali and the Galliari family were certainly influenced by them. It was not, however, until the romantic movement in the nineteenth century that the *Carceri* really came into their own. The gloomy visions appealed to French writers like Théophile Gautier (who wanted to stage Hamlet in a Carcerian setting) and Victor Hugo with his 'effrayantes Babels que rêvait Piranèse'.

The English romantics were equally appreciative: de Quincey, for example, referring to the prisons as 'Dreams' in his *Confessions of an English Opium Eater,* compared their limitless architecture to the illusions he experienced while under the influence of the drug: 'Many years ago, when I was looking over Piranesi's "Antiquities of Rome", Mr. Coleridge, who was standing by, described to me a set of plates by that artist, called his "Dreams", and which record the scenery of his visions during the delirium of a fever. Some of them . . . represented vast Gothic halls, on the floor of which stood all sorts of engines and machinery, wheels, cables, pulleys, levers, catapults, etc., etc., expressive of enormous power put forth, and resistance overcome. Creeping along the sides of the walls, you perceived a staircase; and upon it, groping his way upwards, was Piranesi himself; follow the stairs a little further, and you perceive it comes to a sudden, abrupt termination, without any balustrade, and allowing no step onwards to him who had reached the extremity, except into the depths below. Whatever is to become of poor Piranesi? – you suppose, at least, that his labours must in some way terminate here. But raise your eyes, and behold a second flight of stairs still higher, on which again Piranesi is perceived, by this time standing on the very brink of the abyss. Again elevate your eyes, and a still more aërial flight of stairs is beheld; and again is poor Piranesi busy on his aspiring labours: and so on, until the unfinished stairs and Piranesi both are lost in the upper gloom of the hall. With the same power of endless growth and self-reproduction did my architecture proceed in my dreams.'

Like all works of genius, the *Carceri* are capable of many layers of interpretation in which each generation can discover the expression of its own doubts and fears. Concentration camps of recent wars are a terrible reminder of the physical horrors of captivity but the dark shadows of the *Carceri* have also been seen as prisons of the mind. Disorientated by the complexities of twentieth-century existence and by the immense and Kafkaesque forces that surround us, we can feel an immediate affinity to the faceless cyphers who wander, unchained but still captive, in the labyrinth of Piranesi's incomprehensible structures. To the physical misery of imprisonment is added the extra dimension of mental anxiety and doubt. Aldous Huxley went further and roundly stated that Piranesi's concern is with states of the soul. 'All the plates in the series,' he claimed, 'are self evidently variations on a single symbol, whose reference is to things existing in the physical and metaphysical depths of human souls – to acedia and confusion, to nightmare angst, to incomprehension and a panic bewilderment.'[14] We are at liberty to enjoy the frissons of such interpretations in terms of our own condition but they would, I think, have been unintelligible to Piranesi himself. We cannot entirely reconstruct the creative processes behind the *Carceri,* but to see them solely in terms of psychological disorder is easy, exciting and wrong. Piranesi was not a manic depressive reproducing images of the collective subconscious in drug addicted spasms of creation.

Once again, we must go back to the stage set and indeed to the whole convention of the prison on the stage. *Prometheus Vinctus* might be described as the

first prison drama, which the followers of Aeschylus flattered by imitation in other plays that sought to rack the audience with pity and terror at the miseries of captivity. The theme of the prisoner has a long subsequent history through the Richards and Edwards of our Elizabethan theatre via the *Beggar's Opera* and *Fidelio* to films like *The Cardinal*. There is always, however, one difficulty in presenting a prison drama on stage. Prisons today, as in antiquity, are small and constricting: the *piombi* underneath the lead roof of the Venetian state gaol, from which Casanova made his notorious escape, consisted of the tiniest cells; papal state prisoners were confined in cramped slits in the Castel S. Angelo; the Mamertine, the most famous prison of antiquity, sanctified by a legendary (and inevitably miracle working) sojourn of St. Peter, still consists of two diminutive crypts, one above the other, below the church of S. Giuseppe dei Falegnami at the back of the Capitol. Such surroundings offered little scope either to the actor or to the stage designer and so the convention arose of presenting prison scenes not in the cells but in the prison yard, or, since many prisons were located in castles, in the castle court. The hero could thus harangue his long-suffering gaolers with arias of patriotic devotion or loving constancy on his way to the dungeons and not from behind the bars. This had obvious dramatic advantages besides giving the stage designer the chance to devise, as an alternative to the usual Baroque palaces and garden vistas, a series of forbidding castle scenes, bristling with gloom and proto-Gothick horror.

A typical early example of this layout is the *Prison d'Amadis* published in 1702 with five other more conventional palace or garden scenes in *Livre de decoration diferante* by Daniel Marot, who was the Hugenot architect responsible for many of the palace interiors for William and Mary, both in England and in Holland. The Marot prison consists of a hall of robust masonry, half vaulted but open to the sky as if only partially completed; the piers in the wings which support the vaulting contain the cells, all heavily barred, and the set is scattered with spikes, chains, gibbets, pulleys and ladders, the gloomy disarray of which is in contrast to the elegance of the turbaned and knee-breeched gaolers who run on stage, jangling like castanets their appropriate bunches of keys. Ferdinando Bibiena also produced prison sets, one of which was rather crudely engraved *(70)*,

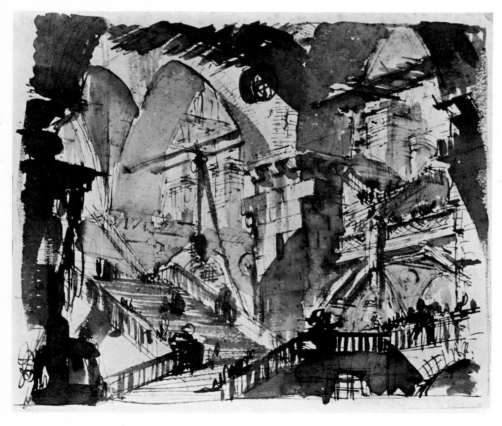

67. Drawing of a prison

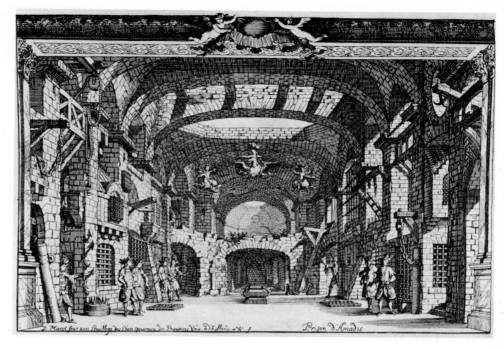

68. D. Marot, *Prison d'Amadis*

69. Dark Prison, *Prima Parte*

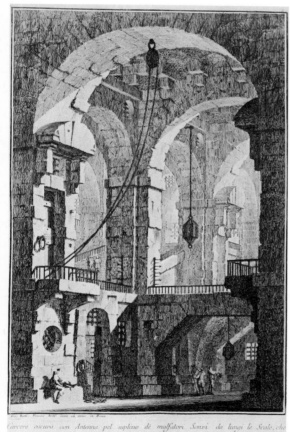

a view of a prison yard seen through an enormous arch, one pier of which, set *a l'angolo,* contains stoutly grilled cells. Such views were a regular part of the Bibiena stock in trade and there are drawings of more elaborate castle settings both by Ferdinando and by Giuseppe.

Prison stage sets were already in Piranesi's mind when working on the *Prima Parte.* The *Dark Prison with tackle for punishing criminals* echoes Bibiena quite closely: it has the same rugged masonry, thick grills and a hanging lightless lantern but Piranesi adds to the scene a bridge and a winding flight of stairs that appear throughout the later prison series. The elements of the *Carceri* are there in embryo, although such a development could not have been anticipated from the *Prima Parte* design.[15]

We can see some obvious affinities between the *Carceri* and earlier stage sets but when we turn to the first state of the prints, which represent Piranesi's original conception, and to the related drawings that survive, there are problems. The immediately striking feature about this first series is how few of the scenes are recognisably prisons, even eighteenth-century stage prisons. The background to Plate IV, for instance, seems to be the colonnade of St. Peter's. Obvious prisoners only appear on the title page and in Plates IX, X and XIII *(102, 104, 110).* In fact, were it not for the grills in the windows, we should not connect half of these structures with prisons at all, and quite probably the contemporary Roman might not have done so either. After all, there were massive iron grids across the ground floor windows of many Roman palaces as we can see from Piranesi's *vedute,* and most of them are still in place. The chains and rings set in the *Carceri* walls are of a size to moor a man of war rather than the shady wanderers in Piranesi's huge halls. This may be a clue; Plates X, XI and XV are similar in detail though not in style to the water front of the *Magnificent Port (84),* published in 1750, and the British Museum has an early drawing of a boat passing under a high vaulted arch into a colonnaded canal. The bollards and wooden posts which feature in the *Carceri* are more naturally part of a quayside than a prison. Perhaps Piranesi had in the back of his mind the water gates to one of the Venetian palaces where the visitor's gondola passes under a grill like a portcullis and into an internal court. Furthermore, in these plates and in several related drawings, there are views of great bridges seen from below in the looming aspect which rises above you a dozen times on any gondola journey through Venice, a subject already treated in the *Magnificent Bridge (77)* in the *Prima Parte.*[16] But such memories of the Venetian canal sides can only be one amalgam in the foundry of Piranesi's

imagination and we must analyse the castings for traces of other compounds which might have been added to the basic ore of the theatrical prison.

One such compound appears to be derived from the sketches of Juvarra which, as we have seen, might well have been known to Piranesi through the Valeriani. The Sicilian produced a number of prison stage sets, typical of which is the design for 'Subterranean arches and a prison' produced for *Ciro* in Cardinal Ottoboni's Roman theatre; the drawing for this is in Turin and it was also engraved with some alterations. The drawing shows a view through an arch in the top of which is a circular grilled opening; at the back of a small court, which rises to the open sky, we can see two passages and a curving stair winds off to the right; above the entrances to the passages there is a balustrade with grilled openings and further flights of stairs climbing upwards. It has all Piranesi's ingredients but not his scale. However, numerous other designs of Juvarra show his experiments at defining space with enormous staircases (these were rather a speciality of his as a practising architect) with winding spiral flights and with broad unbalustered sweeps which branch off at right-angles. Perhaps the most interesting from our point of view is a sketch for an imaginary architectural composition which Juvarra entitled 'A dream I had on 25th August of finding a great treasure'. Stairs rise from subterranean levels and others zig-zag in rising flights to one side; there are round openings in the walls and a pulley as well as a quantity of statues, busts and some obelisks like those that appear in Piranesi's Plate XV. Such *capricci* of Juvarra, if known to Piranesi, would have been just the sort of invention to catch his imagination.[17]

A further compound could be the 'rigorist' ideas of the radical Venetian theorist, Carlo Lodoli, a Friar of the Observants of S. Francesco della Vigna. In 1706, this intriguing character ran away to the church at the age of sixteen because his family, of minor Venetian nobility, wanted him to enter the navy to provide dowries for his sisters. He was sent to Rome in 1709 and on his return to Venice eleven years later he became involved in literary work, ultimately becoming one of the censors. From 1735 until about 1750 the 'walking library', as he was called, ran courses for young Venetian nobles, instructing them at his monastery in logic, metaphysics, architecture, geometry, mechanics, history, poetry, oratory and all other gentlemanly accomplishments. Piranesi would not have been one of the select band of aristocratic pupils but he would certainly have been aware of the iconoclastic anti-ornamental theories of this 'Socrates of Architecture' who insisted that the most important thing in building was to pursue the logic of functionalism; every structure must conform to the nature and essence of the material from which it is built and no element must be added for decorative purposes if it is not structurally necessary.

The powerful unadorned masonry of the *Carceri* may be Piranesi's interpretation of Lodoli's triple canon of Commodity, Strength and Durability, and the heavy blocks that compose several of the prison window frames and doors are akin to the design for a rather mannerist doorway illustrated in a pocket edition of Vignola which is cited by Andrea Memmo, one of Lodoli's pupils, as having received the master's approbation. More to the point, perhaps, the squat cabin of massive stonework in Plate IX might have been drawn to illustrate Lodoli's view that stone, if used simply in the form in which it is dug out of the earth, cannot fulfil the requirements of Architecture. 'Stone by its very nature . . . cannot bear up to a superimposed weight if it is formed in an architrave or cross-beam of any great length but is promptly broken to pieces. Doors and windows would thus be unattractively narrow and inconvenient if you did not have such massive stones to prop the side jambs, that only a prince could afford to look for them and he would be lucky to find them.' Hence, he went on, it is necessary to use vaulting which is the method of building most suited to stone, imitating natural caves. Similarly, the contrasting staircases and gangways, some of rickety wood, others of stone, and the grills which appear in so many of Piranesi's plates could spring from memories of another passage where Lodoli says that marble stair-

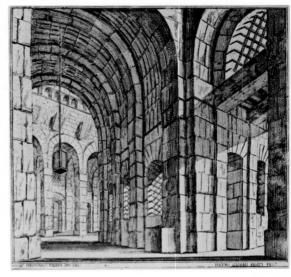

70. F. G. Bibiena, Prison stage set

71. Drawing of a colonnaded canal

cases originated from tree-trunks placed on an inclined slope, while bannisters and galleries derive from ladders or grills propped outside the huts in early times to keep children or domestic animals from straying.[18]

Although Piranesi may have known the theories of the Venetian friar by hearsay, we can draw no certain inferences and we can only conjecture that Edmund Burke's *Philosophical Enquiry into the Origin of our Ideas of the Sublime and the Beautiful* contributed at least a colour ingredient to the darkness of the second series. The *Enquiry* was published in 1757 and must have been a topic of conversation at any rate among the British visitors soon afterwards. Some of Burke's chapter headings could well provide titles for the revised *Carceri*, 'Terror', 'Obscurity', 'Privation', 'Vastness', 'Infinity', 'Magnitude in Building', 'Difficulty', 'Magnificence', 'Feeling Pain' and so on, and the text is equally illustrative: 'To make any thing very terrible, obscurity seems in general to be necessary.' 'All *general* privations are great, because they are terrible: *Vacuity, Darkness, Solitude* and *Silence.*' 'When any work seems to have required immense force and labour to erect it, the idea is grand . . . The rudeness of the work increases this cause of grandeur.' 'All edifices calculated to produce an idea of the sublime ought rather to be dark and gloomy.' It is tempting to relate to the spatial illogicalities Burke's dictum that 'No work of art can be great, but as it deceives; to be otherwise is the prerogative of nature only.' But Piranesi's confusions exist in the first states of the *Carceri* which antedate the *Enquiry*.

There is also the possibility that Piranesi was recording visions which he had seen under the influence of opium. Laudanum, an opium based medicine, was regarded as a standard panacea throughout the eighteenth and nineteenth centuries and, as such, might well have been administered to the young artist during the dangerous fever of his first Roman visit. We have seen that de Quincey was immediately able to recognise the labyrinthine structures of his own opium-induced dreams from Coleridge's description of Piranesi's plates. Many features from the *Carceri* recur in the accounts which opium takers have given of their hallucinations, the huge subterranean chambers wreathed in smoke, spiral staircases that lead nowhere, drawbridges opening onto an abyss, vast walls and towers that reduce the dreamer to puny insignificance. In opium reveries the memory selects familiar objects and transforms them into vast and frightening complexities. Perhaps a prison stage set was thus transformed into the catacombs of the *Carceri* and Piranesi went back to his plates some fifteen years later to re-define his visions with greater intensity. The haze of opium could even account for those visual inconsistencies. We must be careful, however, about uncritically accepting any such theory. The illness mentioned by Legrand occurred on Piranesi's first visit to Rome whereas the *Carceri* seem to have been produced after his return from Venice. Furthermore, if he was addicted to the drug in his youth, none of the contemporary sources mention it, and he must have broken the habit or succeeded in gaining complete control of it, because his enormous artistic output, to say nothing of his archaeological and polemical work, seems beyond the capacity of an ennervated opium addict.[19]

Far the strongest element, however, was Piranesi's own saturnine genius and his abiding fascination with underground structures which dates back to the *Burial Chamber* in the *Prima Parte* and continues as a consistent theme throughout his work – the Curia Hostilia which he drew for Amidei (the most Carceri-like building in Rome), the Tullianum prison cut into the foot of the Capitol, underground tombs on the Appian Way, the buried cisterns at Castel Gandolfo, the crypto-portico at Albano, subterranean rooms of Hadrian's Villa at Tivoli. In such subjects he could best display his unrivalled ability to convey the effects of darkening shadows, of the interplay of light penetrating from aloft and of receding arcades vanishing into the limitless gloom. Put all these ingredients together and fuse them with Piranesi's fiery imagination, and then recast them with the addition of the sombre melancholy of his later ruin scenes and the product, still swirling in smoke, is the series of *Carceri d'Invenzione*.

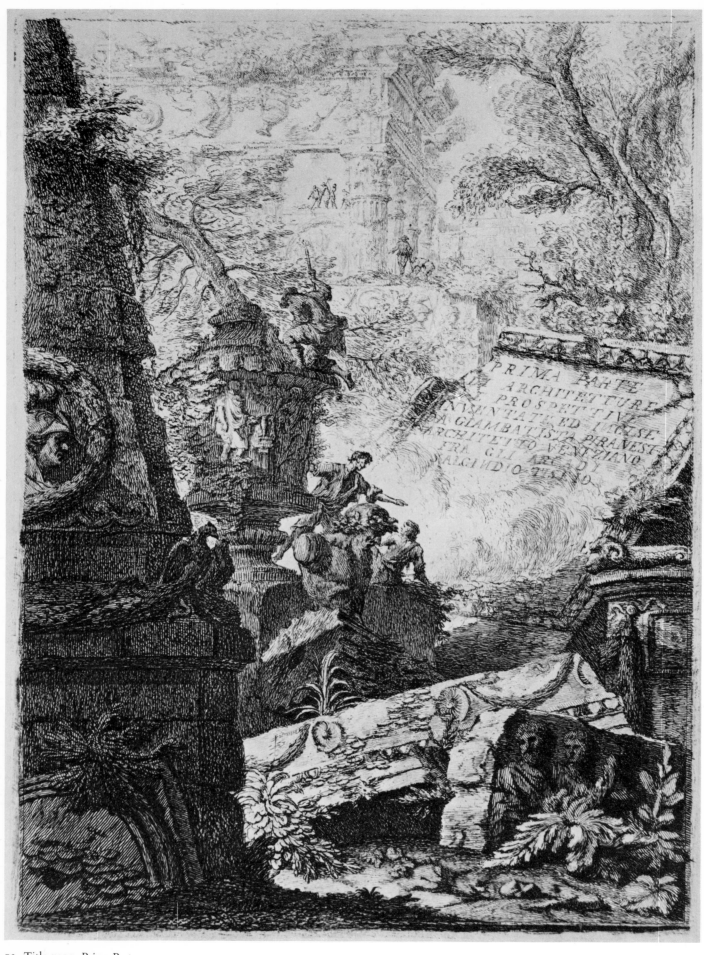

72. Title page, *Prima Parte*

Vestigi d'antichi Edificj fra i quali evvi l'Urna Sepolcrale tutta d'un pezzo di porfido di Marco Agrippa che oggi serve per il Sepolcro di Clemente XII. Si vede anche un pezzo di Guglia con caratteri Egizi, ed in lontano un Vestibulo di antico Tempio rovinato.
Gio: Batta Piranesi Architetto inventò, ed incise di Roma. 5.

Ruine di Sepolcro antico posto dinanzi ad altre ruine d'un Acquedotto pure antico; sopra gli archi del medesimo v'è il canale, per cui si conduceva l'acqua in Roma.
Gio: Batta Piranesi Architetto inventò, ed incise in Roma. 6.

73. Ruins of Ancient Buildings, *Prima Parte*

74. Ruins of an Ancient Tomb, *Prima Parte*

Foro antico Romano circondato da portici, con logge, alcune delle quali si uniscono al Palazzo Imperiale ed altre alle Carceri.
Questo Foro dappertutto e attorniato di magnifiche scale presso alle quali vi stano Cavalli, e Fontane che servono di ornamento alle medesime.

75. Ancient Forum, *Prima Parte*

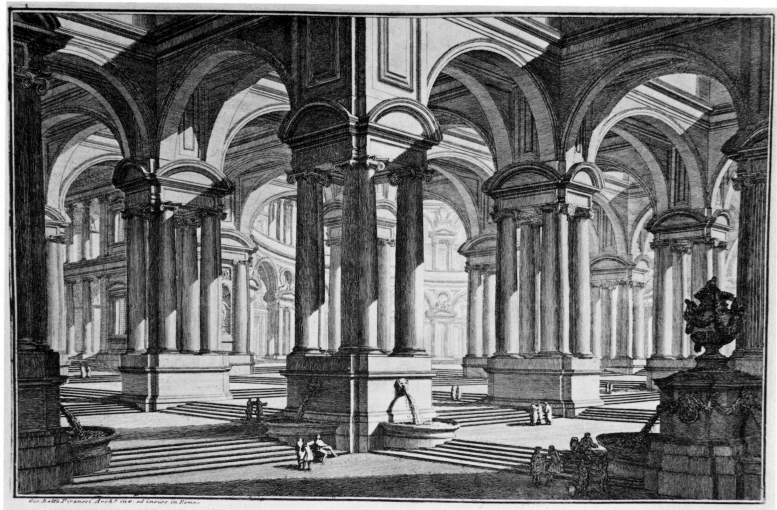

Gruppo di Scale ornato di magnifica Architettura, le quali stanno disposte in modo che conducano a varj piani, e specialmente ad una Rotonda che serve per rappresentanze teatrali.

76. Group of Stairs, *Prima Parte*

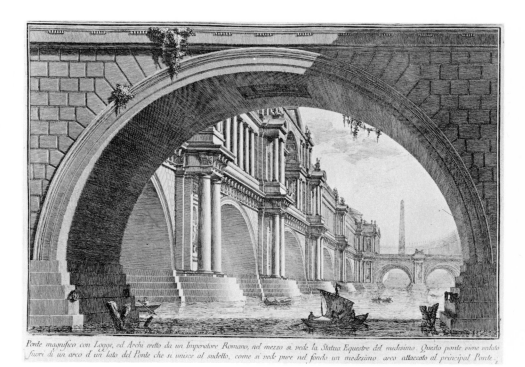

Ponte magnifico con Logge, ed Archi eretto da un Imperatore Romano, nel mezzo si vede la Statua Equestre del medesimo. Questo ponte viene veduto fuori di un arco d'un lato del Ponte che si unisce al sudetto, come si vede pure nel fondo un medesimo arco attaccato al principal Ponte.

77. Magnificent Bridge, *Prima Parte*

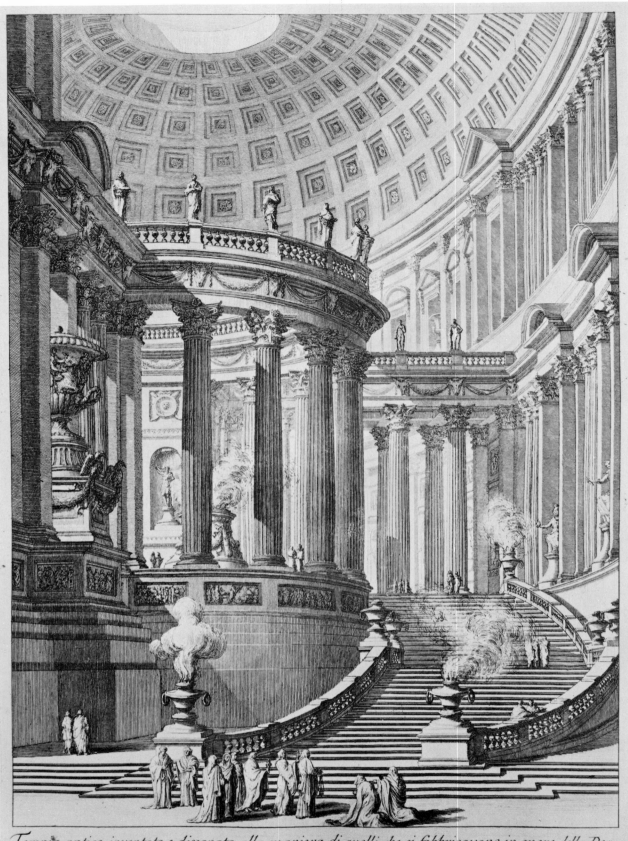

Tempio antico inventato e disegnato alla maniera di quelli che si fabbricavano in onore della Dea Vesta: quindi vedesi in mezzo la grand'Ara, sopra della quale conservavasi dalle Vergini Vestali l'inestinguibile fuoco sacro. Tutta l'opera è Corintia ornata di statue e di bassi rilievi, e di altri ornamenti ancora. Il piano di questo Tempio è notabilmente elevato dal suolo: vedesi in mezzo la Cella rotonda, come lo è pure tutto il gran Vaso del Tempio stesso: quattro loggie portavano ad essa, e per altrettante scale vi si ascendeva. Le parieti del gran Tempio hanno due ordini, sopra il secondo s'incurva una vasta Cupola con isfondati, e rosoni, e termina in una grande apertura, dalla q.te dipende il lume alla Cella che le sta sotto.

Gio Batta Piranesi Arch.º inv., ed incise in Roma l'Anno 1743.

78. Ancient Temple of Vesta, *Prima Parte*

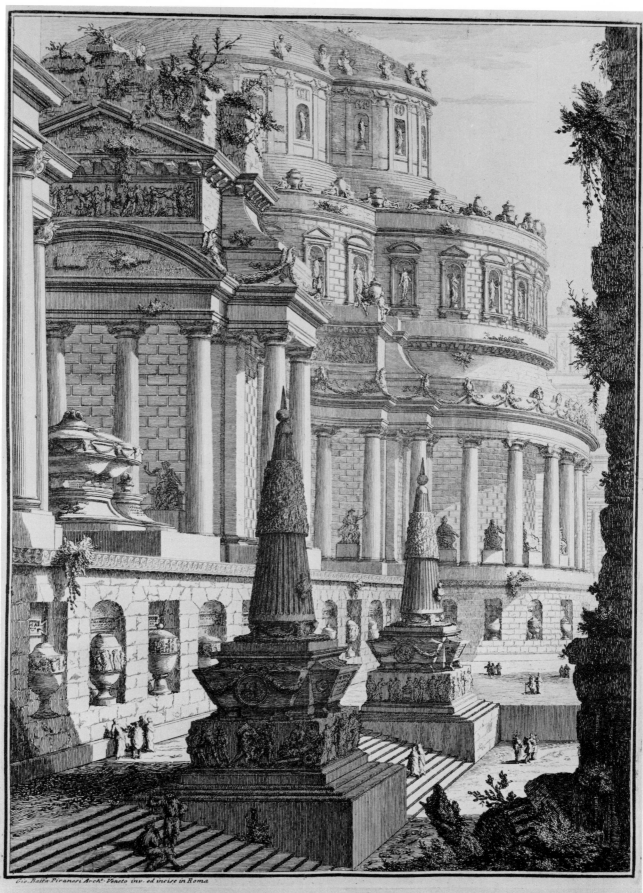

Gio. Batta Piranesi Arch.º Veneto inv. ed incise in Roma

Mausoleo antico eretto per le ceneri d' un Imperadore Romano. All' intorno di questo vi sono dè Sepolcri piramidali
per altri Imperadori. Vi sono pure dell' Urne dè Famigliari dette anche Olle Sepolcrali, in cui si ponevano le loro
Ceneri. Ve ne sono pure dell' altre pè Servi, e Liberti. Questo Mausoleo, è attorniato di magnifiche Scale, ai cui
piedi si vedono ornamenti Sepolcrali secondo il costume degli antichi Romani.

3.

79. Ancient Mausoleum, *Prima Parte*

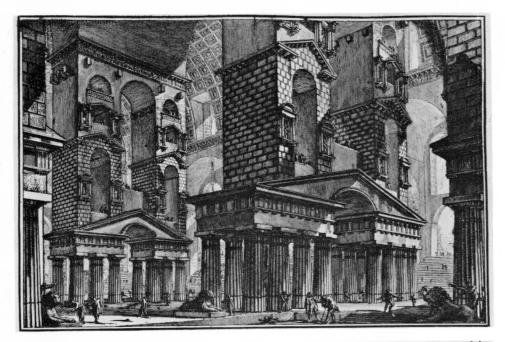

80. Ancient baths, *Opere Varie*

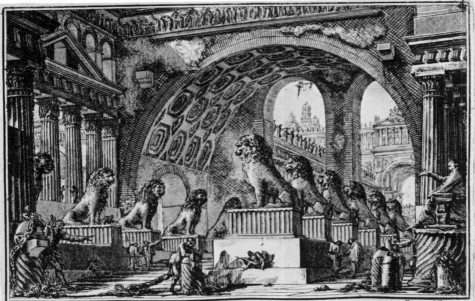

81. Entrance to an ancient gymnasium, *Opere Varie*

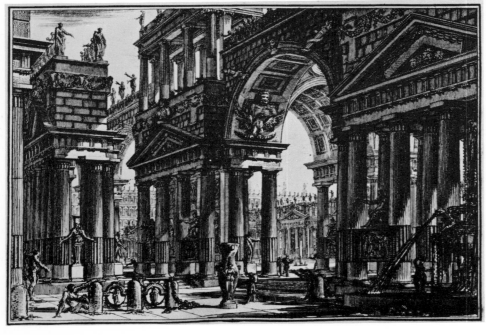

82. Porticos round a forum, *Opere Varie*

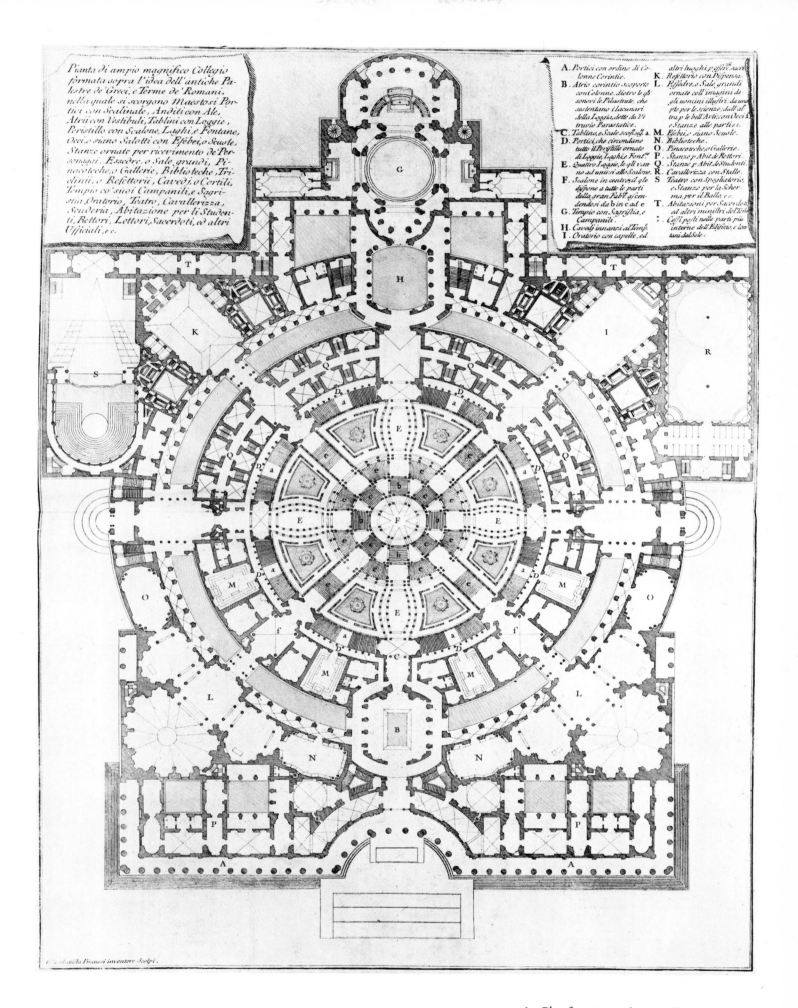

Pianta di ampio magnifico Collegio formata sopra l'idea dell'antiche Palestre de' Greci, e Terme de' Romani, nella quale si scorgono Maestosi Portici con Scalinate, Anditi con Ale, Atrii con Vestibuli, Tablini con Loggie, Peristillo con Scalone, Laghi, e Fontane, Oecj o siano Salotti con Esebei, o Scuole, Stanze ornate per ricevimento de' Personaggi, Essedre, o Sale grandi, Pinacoteche, o Gallerie, Biblioteche, Triclinii, o Refettorii, Cavedi, o Cortili, Tempio co' suoi Campanili, e Sagristia, Oratorio, Teatro, Cavallerizza, Scuderia, Abitazione per li Studenti, Rettori, Lettori, Sacerdoti, ed altri Ufficiali, e c.

A. Portici con ordine di Colonne Corintie.
B. Atrio corintio scoperto con Colonne, dietro le qli sonovi le Pilastrate, che sostentano i Lacunari della Loggia, detti da Vitruvio Parastatice.
C. Tablina, e Scale scoflesi a.
D. Portici, che circondano tutto il Peristillo ornato di Loggie, Laghi, e Font.
E. Quattro Loggie, le qli vanno ad unirsi allo Scalone.
F. Scalone in centro il qle dispone a tutte le parti della gran Fabr. ascendendosi da b in c ad e
G. Tempio con Sagristia, e Campanili.
H. Cavalli innanzi al Temp.
I. Oratorio con capelle, ed

altri luoghi posti sacri
K. Refettorio con Dispensa.
L. Essedre, o Sale grandi ornate coll'imagini de gli uomini illustri da una pte per le scienze; dall'altra p le bell'Arti; con Oecj e Stanze alle parti.
M. Esebei, o siano Scuole.
N. Biblioteche.
O. Pinacoteche, o Gallerie.
P. Stanze p Abit. de Rettori.
Q. Stanze p Abit. de Studenti.
R. Cavallerizza con Stalle.
S. Teatro con Spogliatorio, e Stanze per la Scherma per il Ballo e c.
T. Abitazioni per Sacerdoti ed altri ministri del Temp.
∴ Cessi posti nelle parti più interne dell'Edificio, e lontani dal Sole.

Giambattista Piranesi inventore Scolpi.

83. Plan for a Magnificent College, *Opere Varie*

69

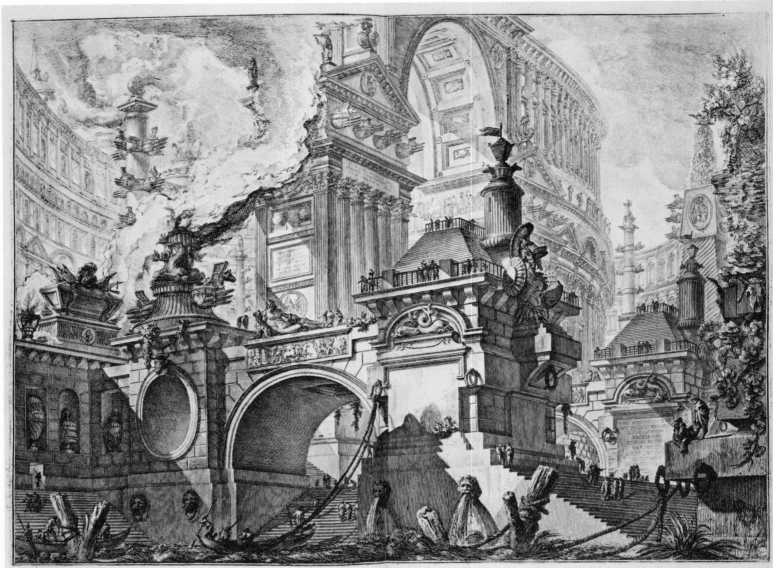

Parte di ampio magnifico Porto all'uso degli antichi Romani, ove si scuopre l'interno della gran Piazza pel Comercio superbam. decorata di colonne rostrali, che dinotano le piu segnalate vittorie marittime. Le Pareti, che sono d'intorno alla gran Piazza vanno formando molti Archi trionfali ornati parim. di trofei navali, quali Archi si uniscono dalla parte opposta al Tempio della Fortuna, sopra la cui cima sta collocato il gran Fanale per guida de' naviganti. Le dette Pareti sono difese ed atterniate da Contraforti, che gli fanno argine e nel medesimo tempo gli servono di solido maestoso ornam. Sopra di questi forti in qualche distanza sonovi distribuiti i posti di guardia per le sentinelle con a piede de' mascheroni per espurgo delle immondezie. Le grandi Scalinate che veggonsi, portano alla gran Piazza ornata di Portici, Basilica, e altri nobili edifici con l'aria di Perfume insensibilmente dedicata a Nettuno Dio del mare. Si vedono ancora sepolcri ed urne colle ceneri de' benemeriti Capitani, estinte ne' conflitti navali, situate a miglior vista del Porto per eccitamento di gloriosa emulazione. Questa vasta Fabrica tutta di sola architettura composta e nobilitata di Statue, Fontane, Trofei, Bassirilievi, e di tutto cio, che può servire non meno d'ornamento, che di comodo per la navigazione, resta molto bene difesa dagl'insulti del mare per mezzo del Molo, de' Lazzaretti, e Magazzini che la circondano.

84. Magnificent Port, *Opere Varie*

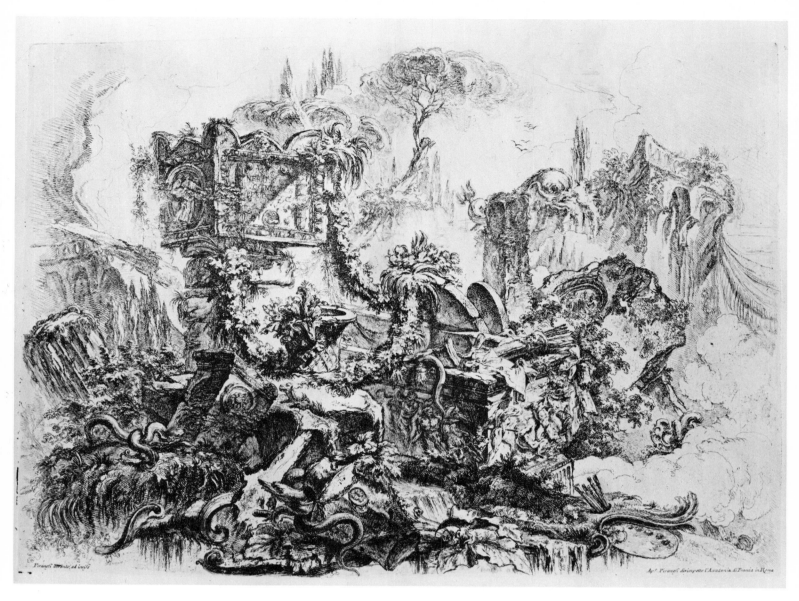

85. Capriccio, *Grotteschi*

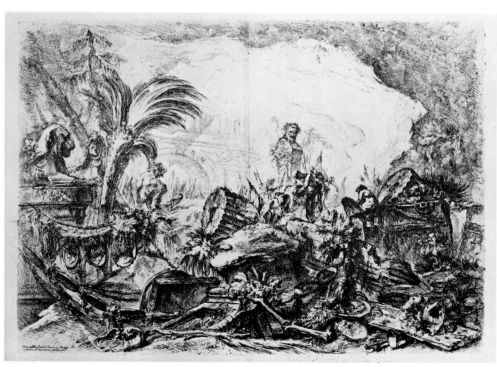

86. Capriccio, *Grotteschi*

87. Capriccio, *Grotteschi*

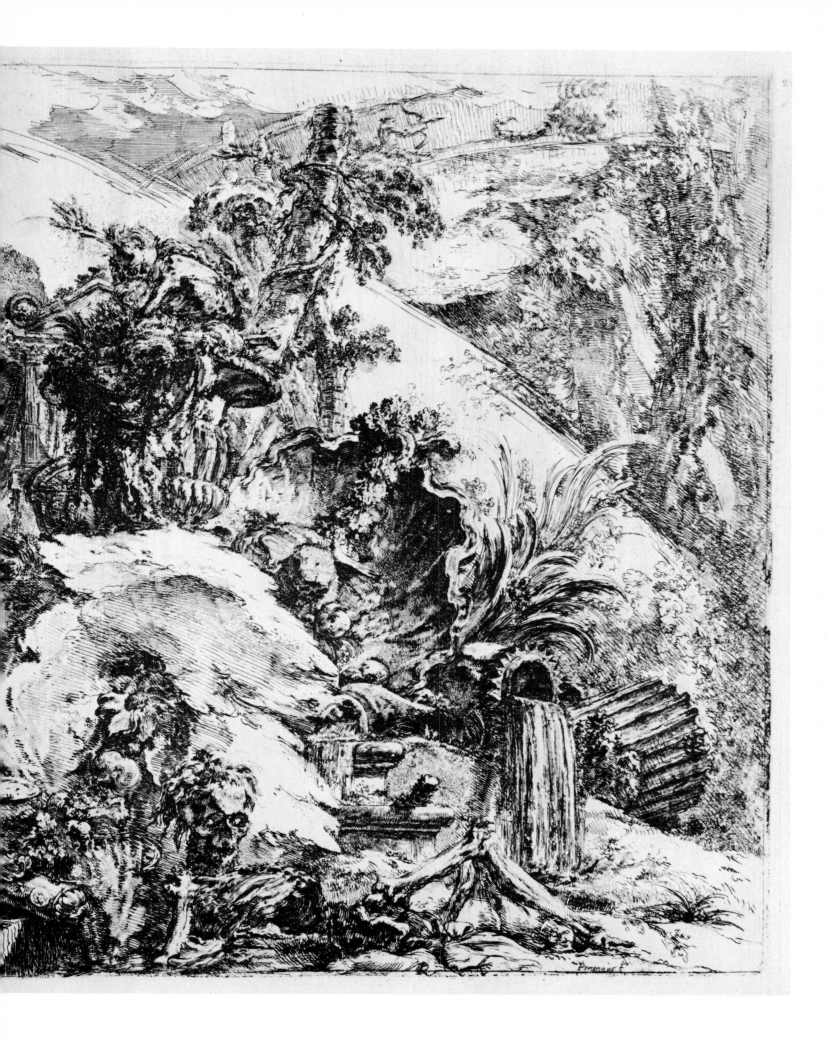

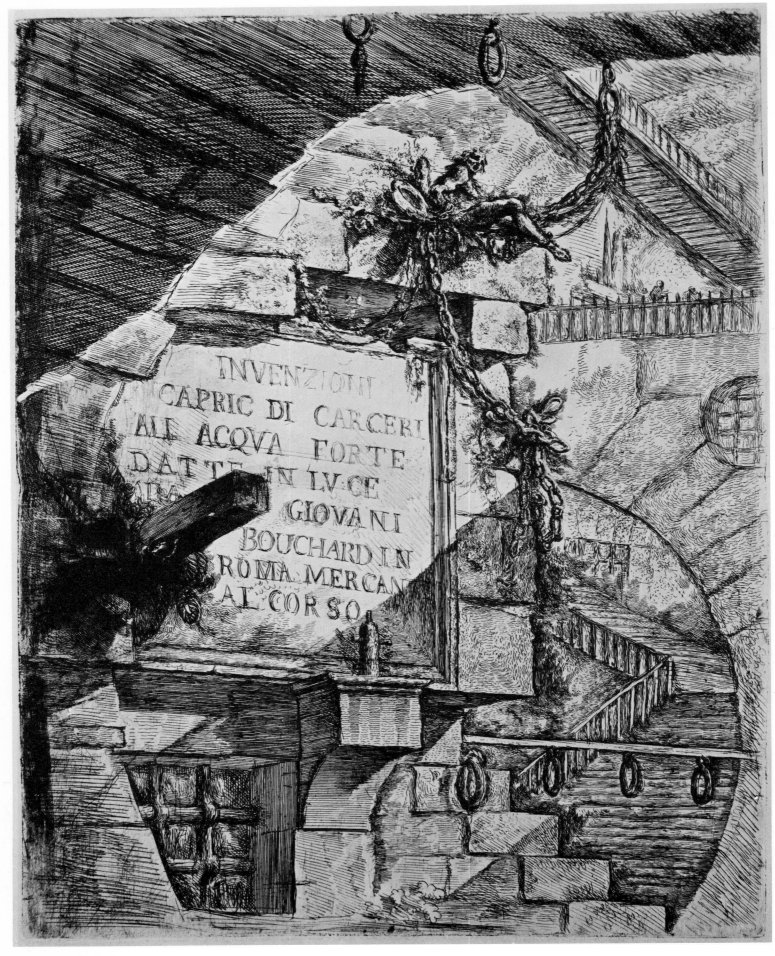

INVENZIONI
CAPRIC DI CARCERI
ALL ACQVA FORTE
DATTE IN LVCE
GIOVANI
BOUCHARD IN
ROMA MERCAN
AL CORSO

88. Carceri, Plate I, first state

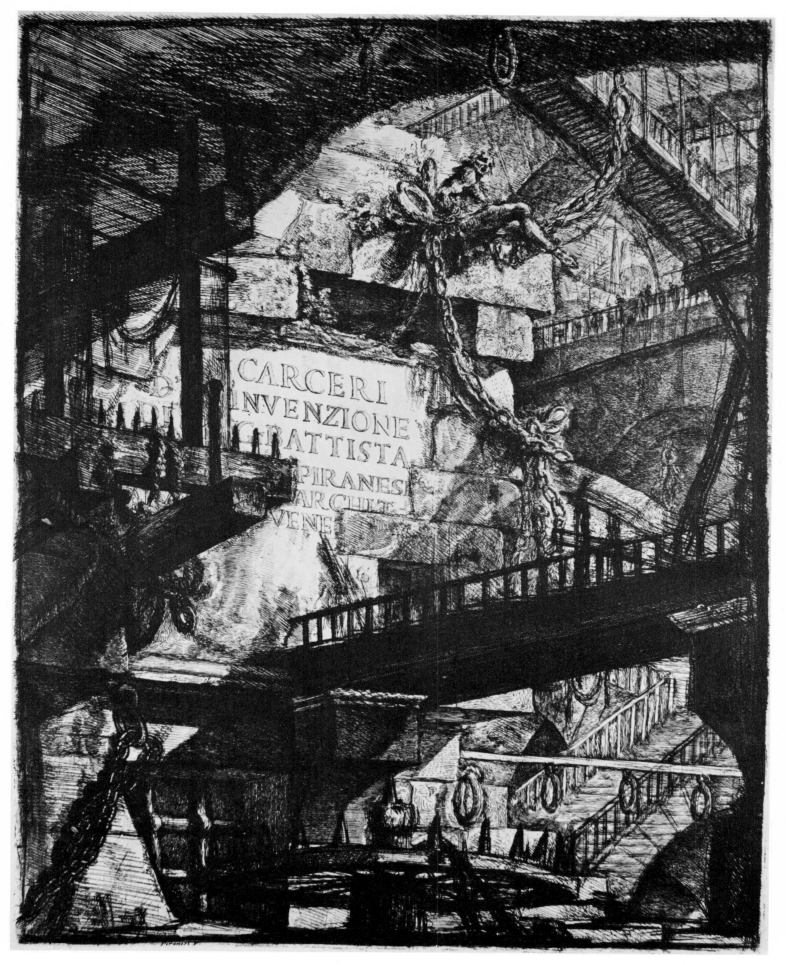

CARCERI
INVENZIONE
G. BATTISTA
PIRANESI
ARCHIT
VENE

89. *Carceri*, Plate I, second state

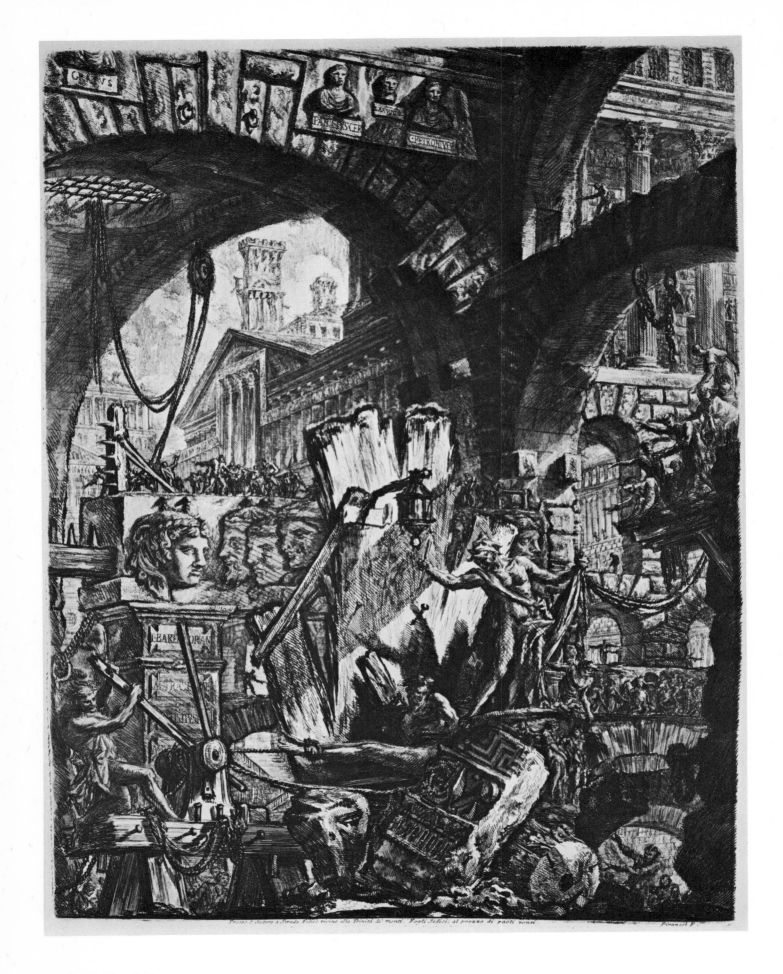

90. Carceri, Plate II, first state

76

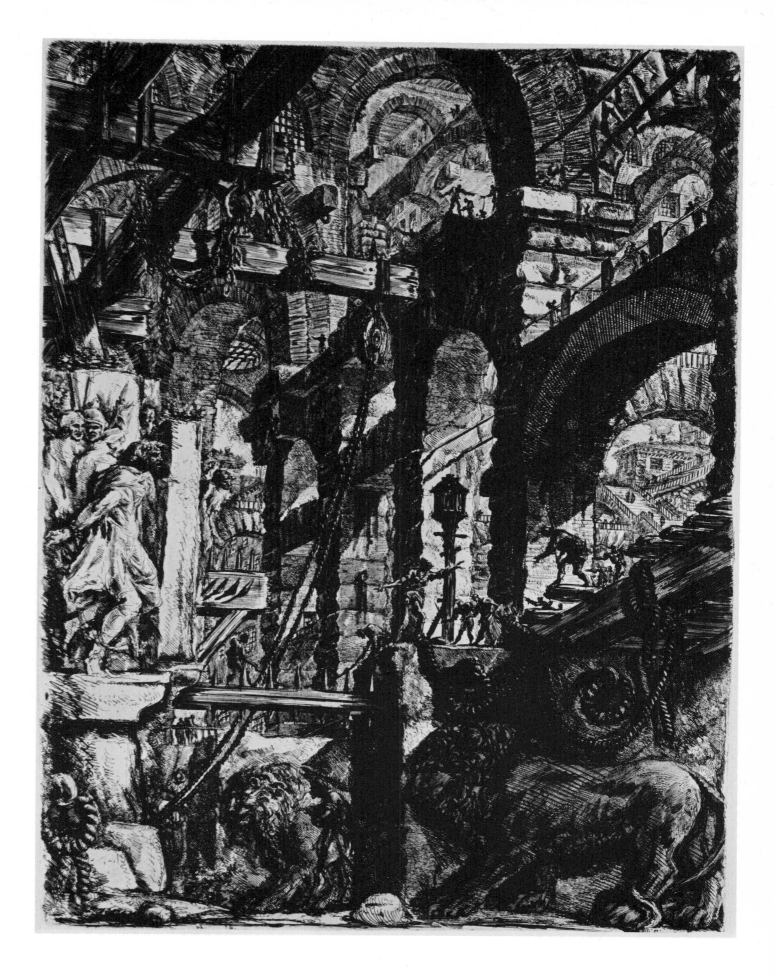

91. Carceri, Plate V, first state

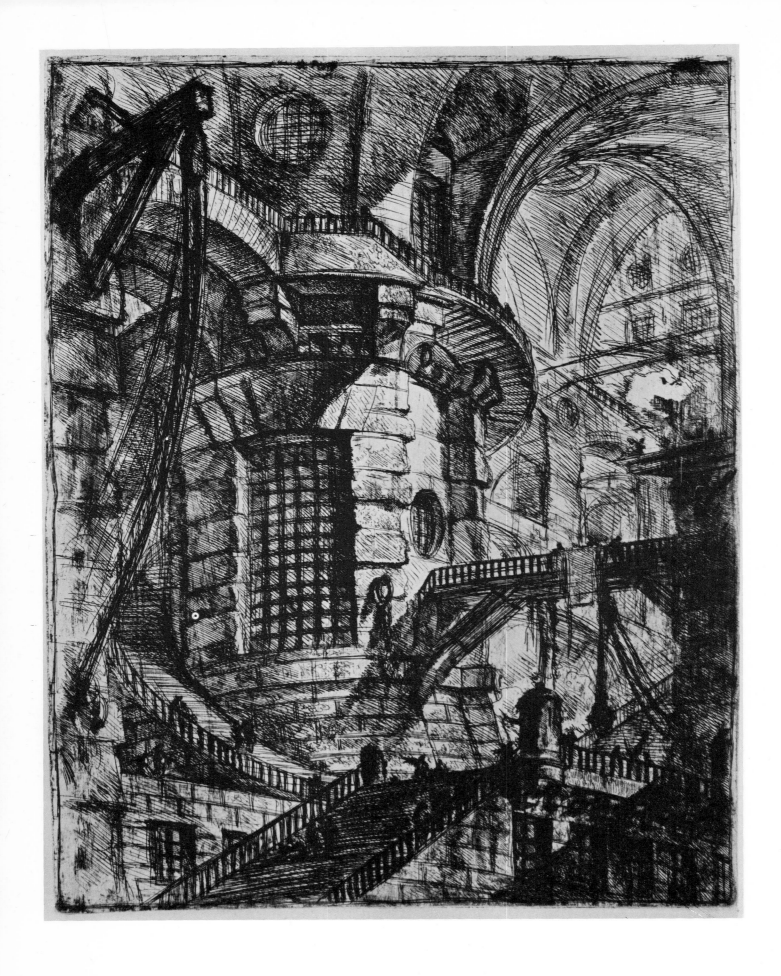

92. *Carceri*, Plate III, first state

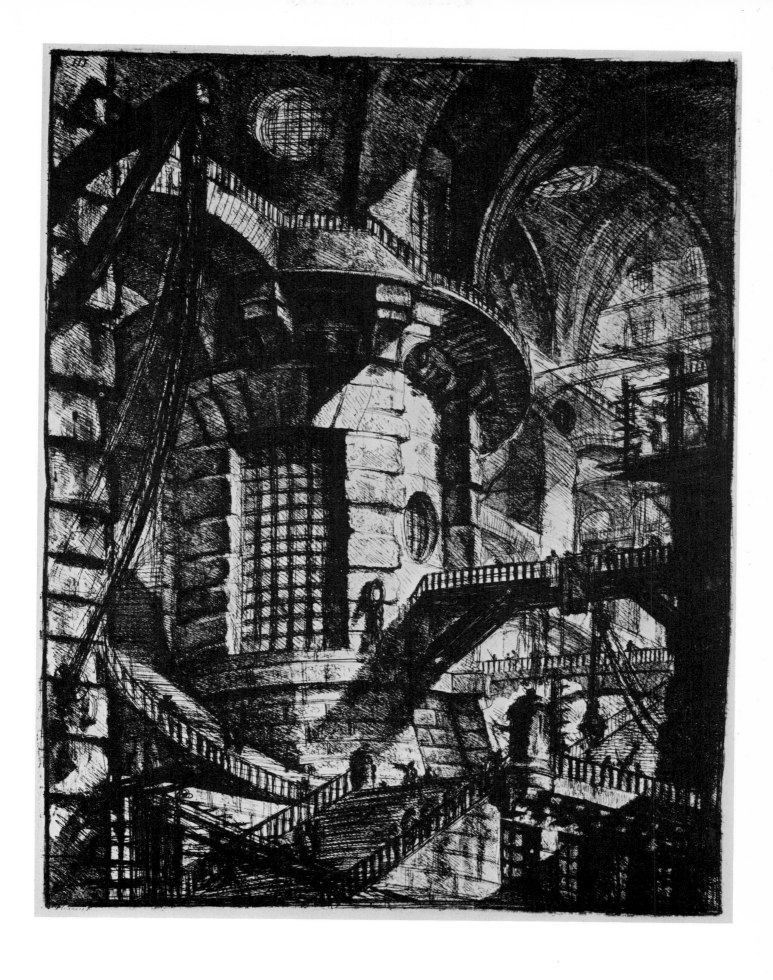

93. *Carceri*, Plate III, second state

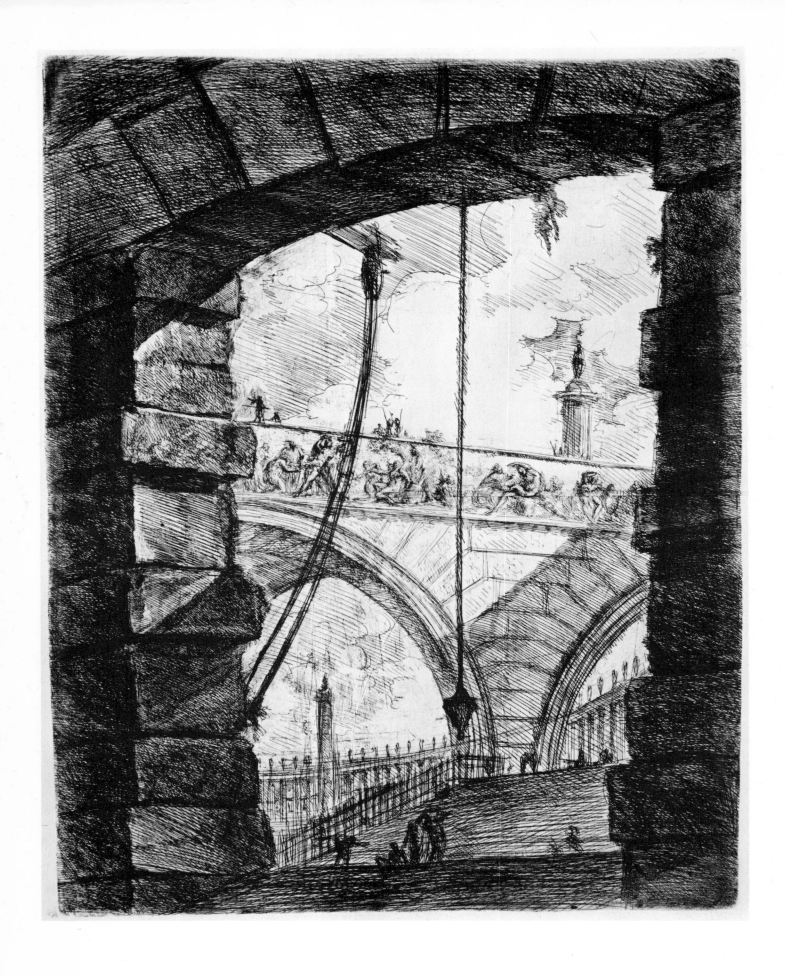

94. *Carceri*, Plate IV, first state

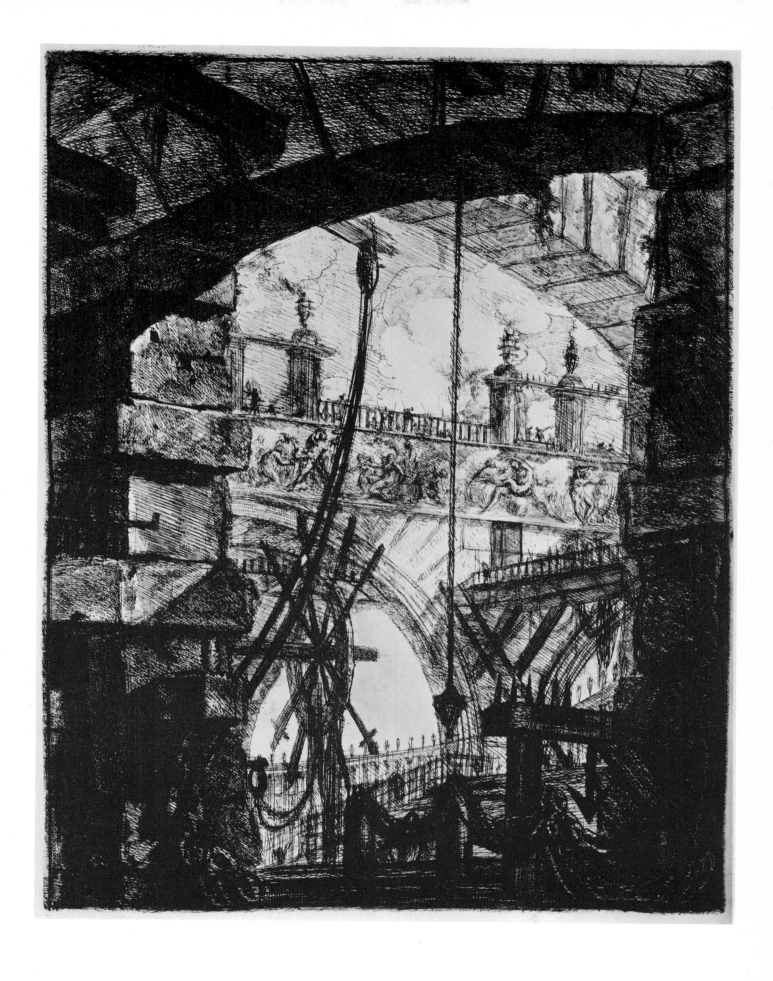

95. *Carceri*, Plate IV, second state

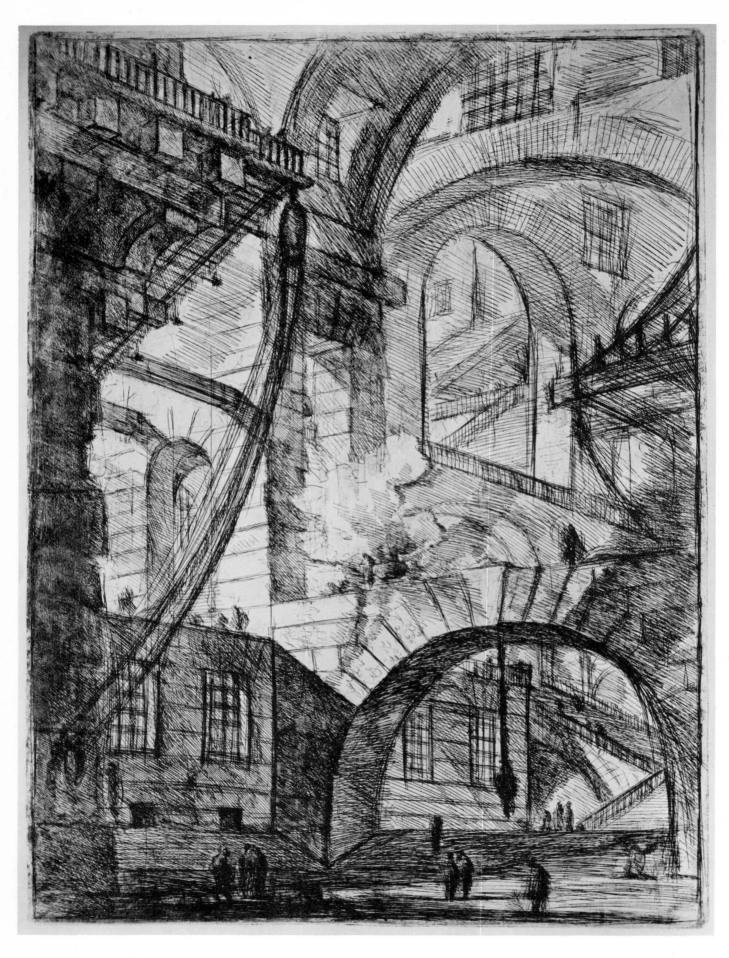

96. Carceri, Plate VI, first state

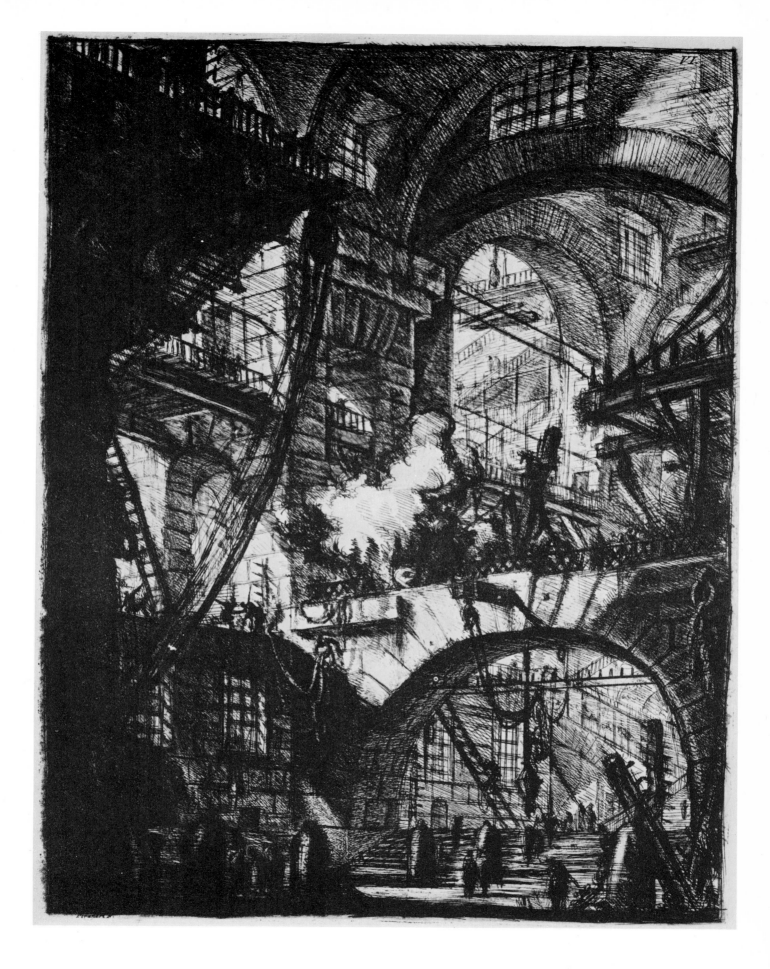

97. *Carceri,* Plate VI, second state

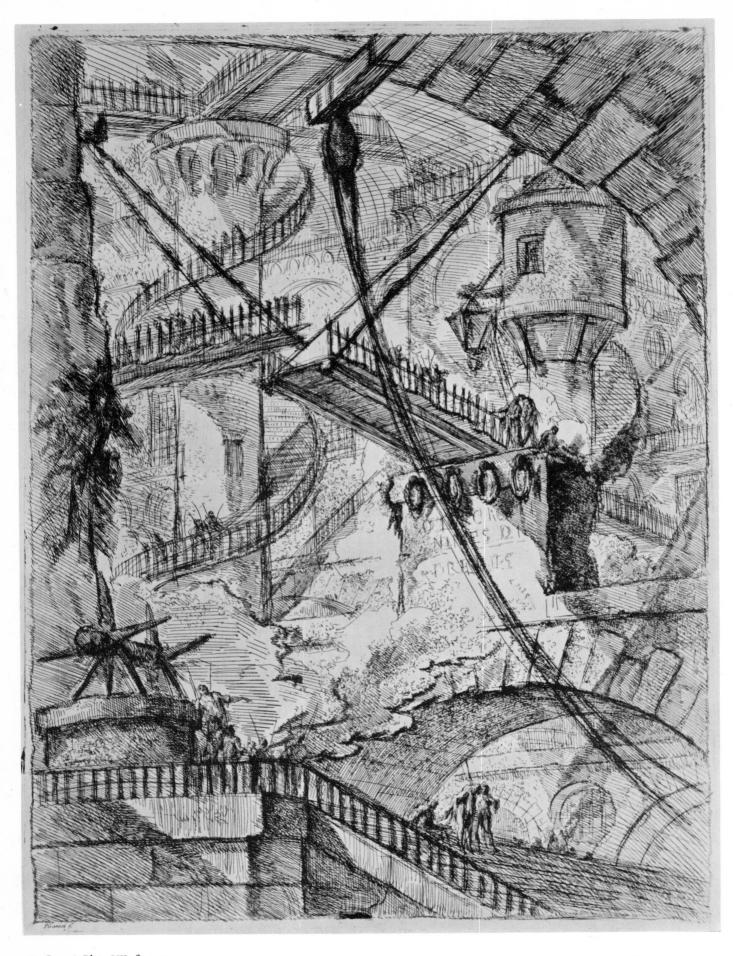

98. Carceri, Plate VII, first state

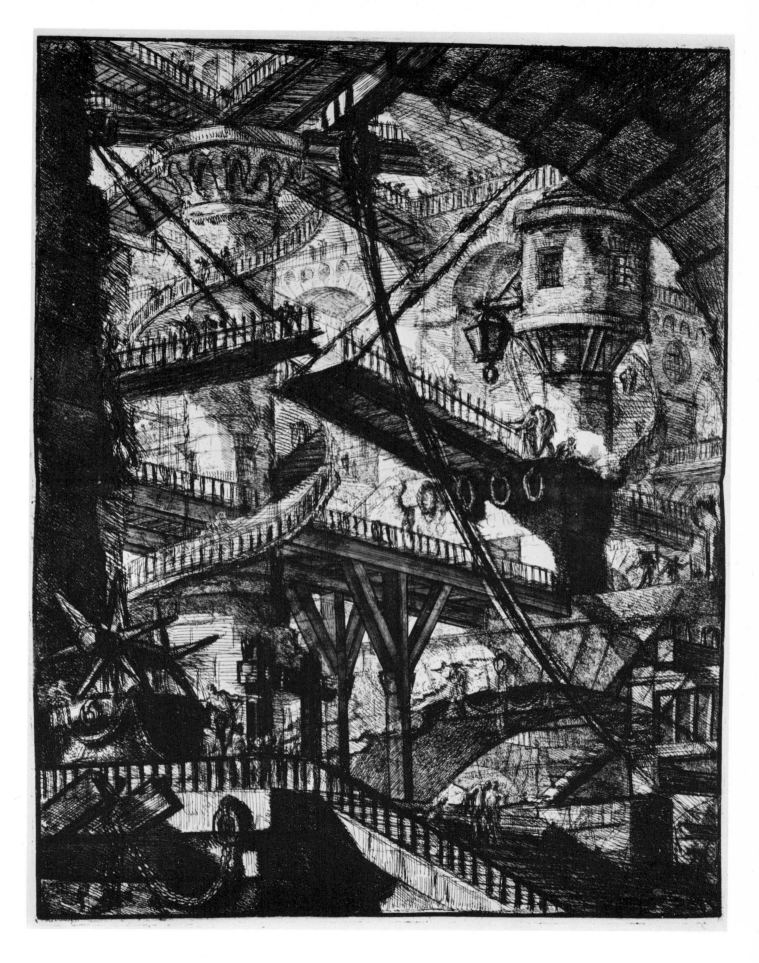

99. *Carceri*, Plate VII, second state

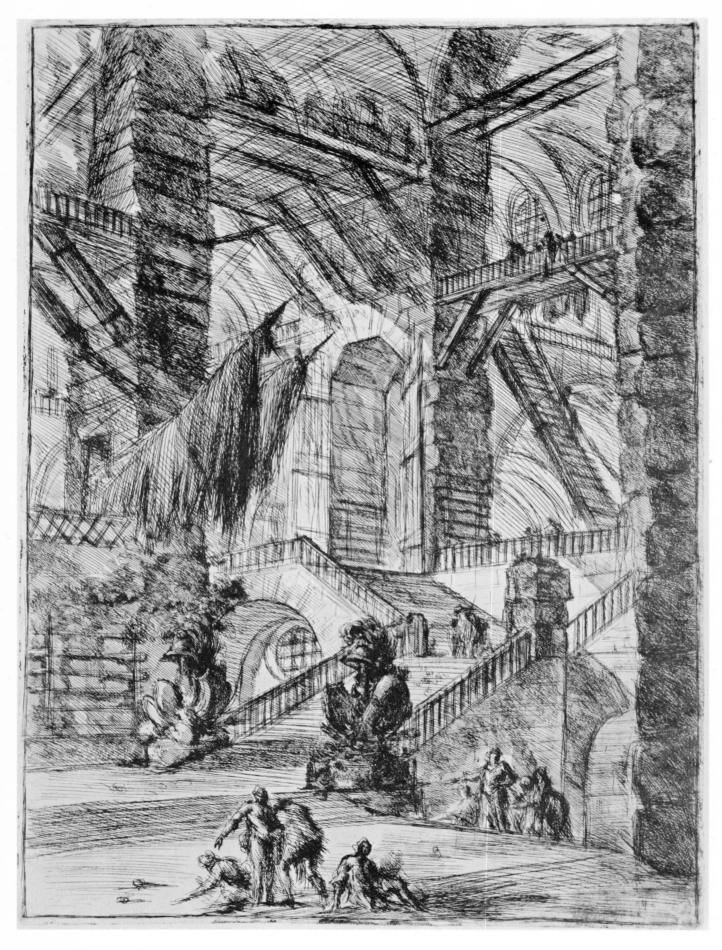

100. Carceri, Plate VIII, first state

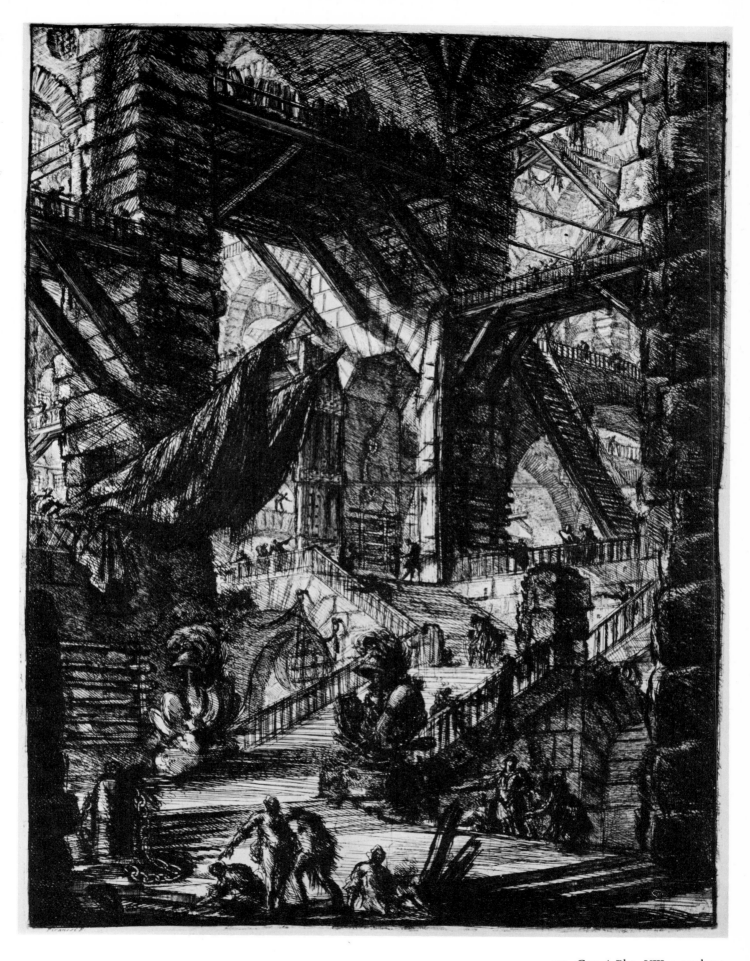

101. *Carceri*, Plate VIII, second state

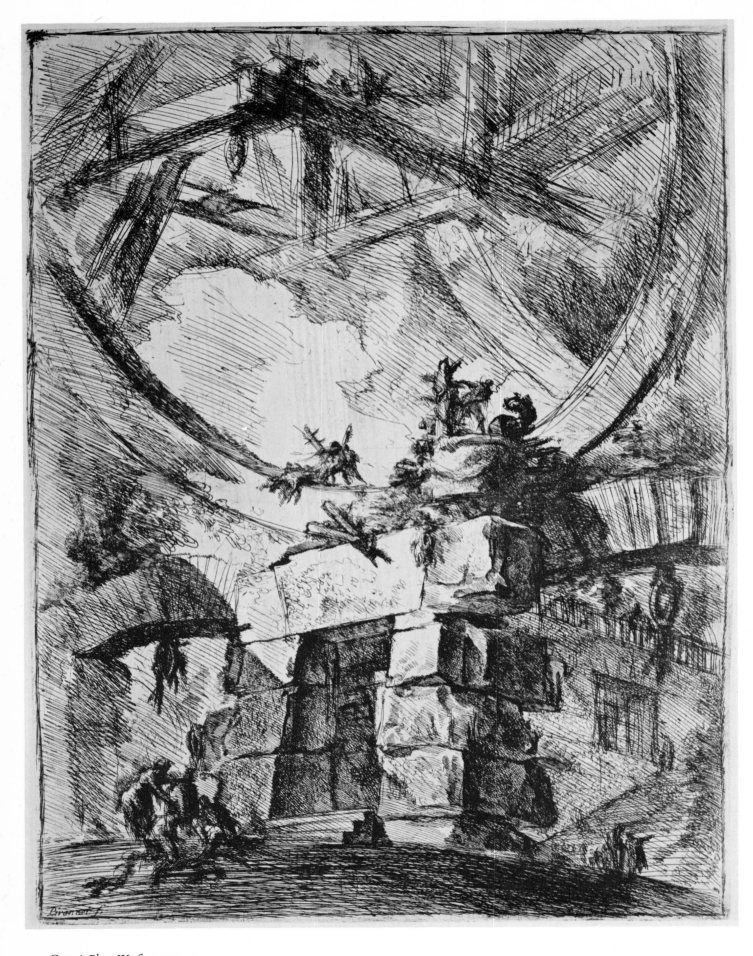

102. Carceri, Plate IX, first state

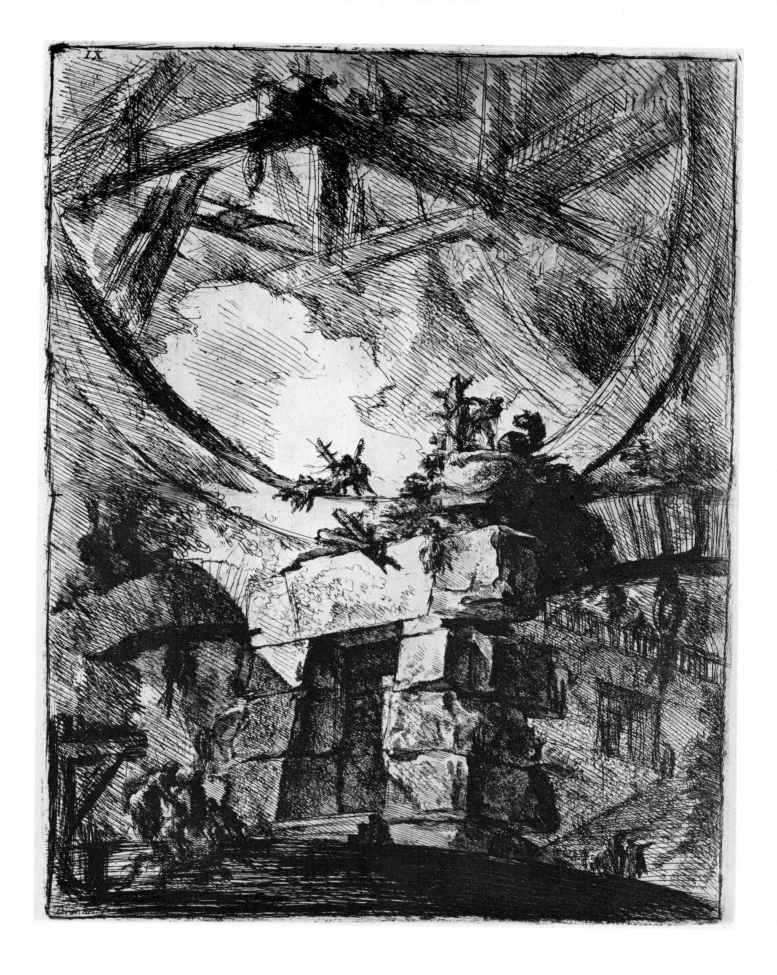

103. Carceri, Plate IX, second state

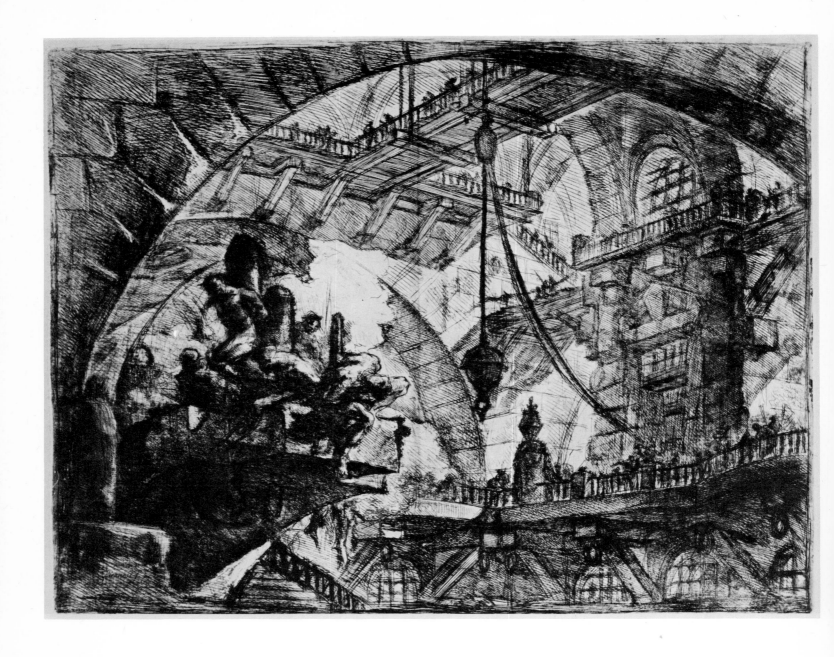

104. Carceri, Plate X, first state

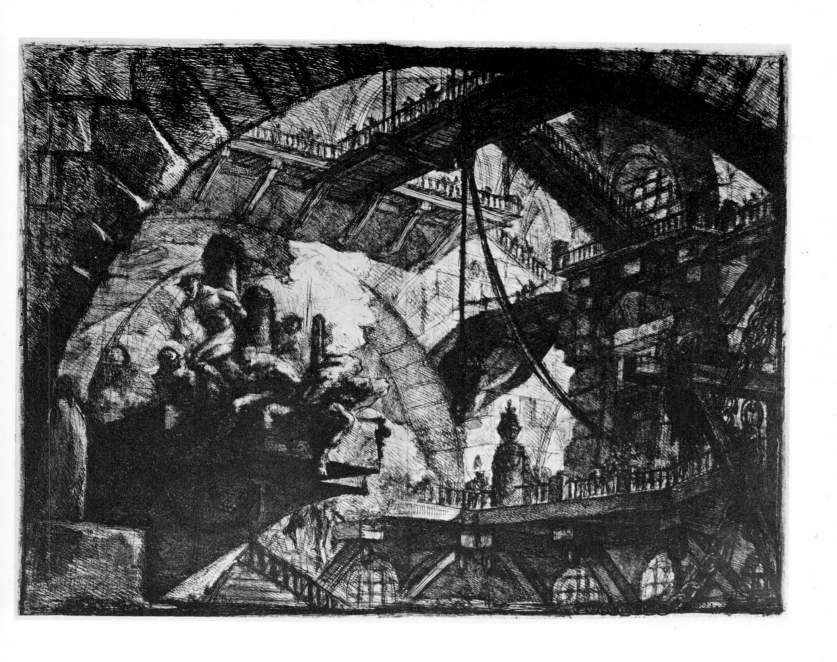

105. *Carceri,* Plate X, second state

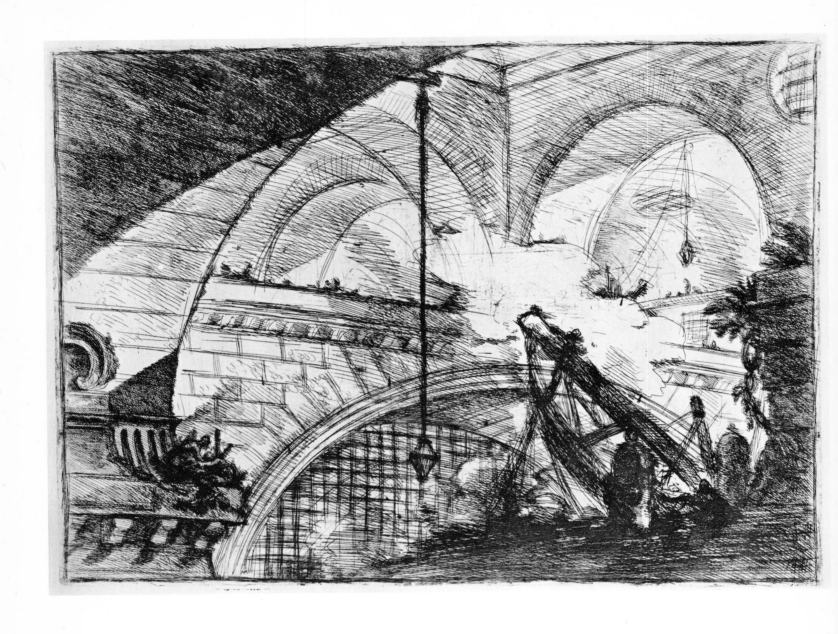

106. Carceri, Plate XI, first state

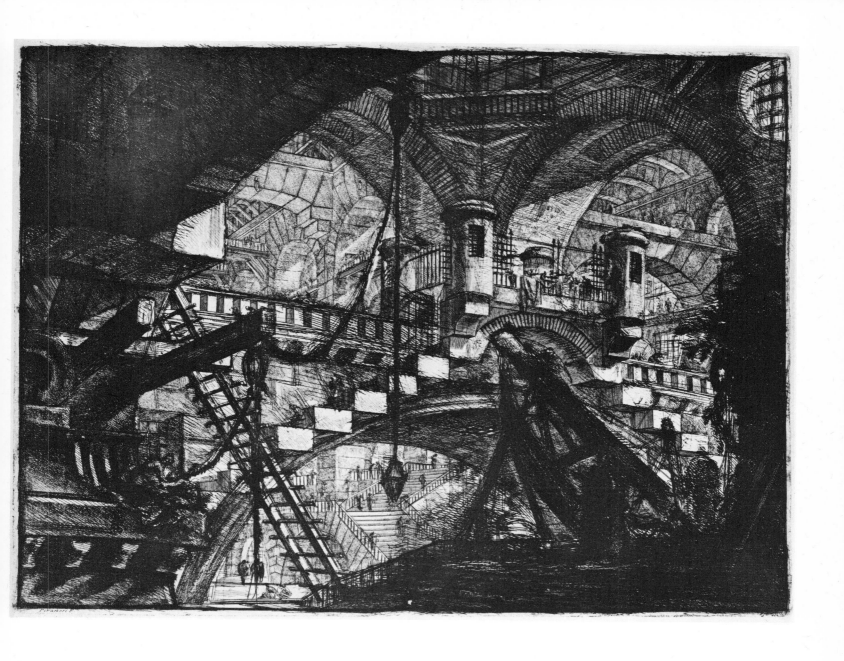

107. *Carceri,* Plate XI, second state

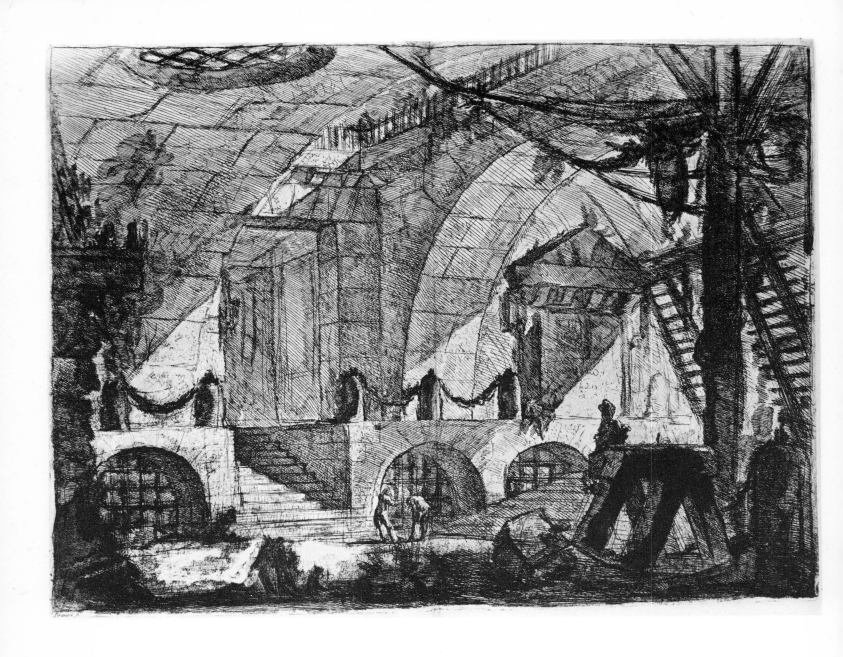

108. Carceri, Plate XII, first state

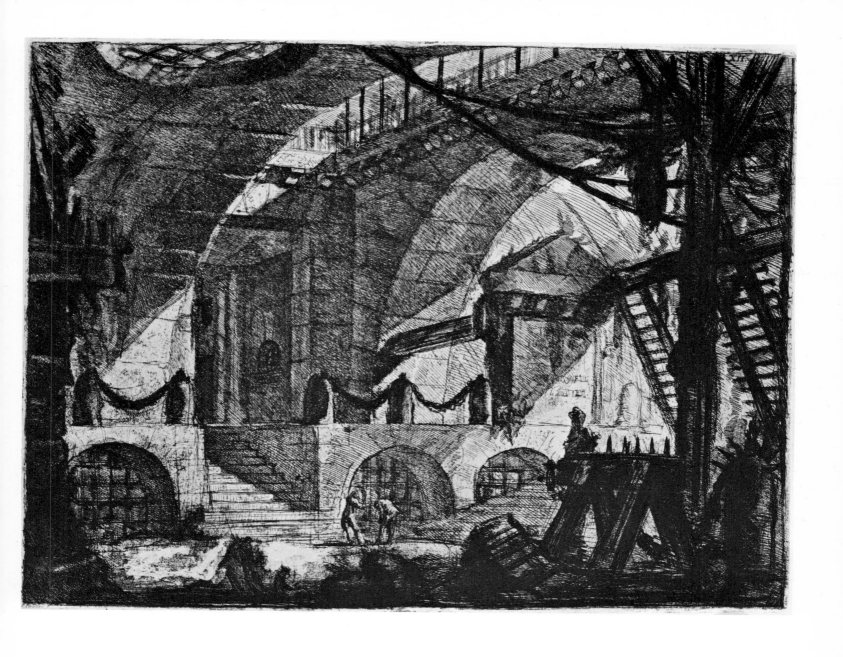

109. Carceri, Plate XII, second state

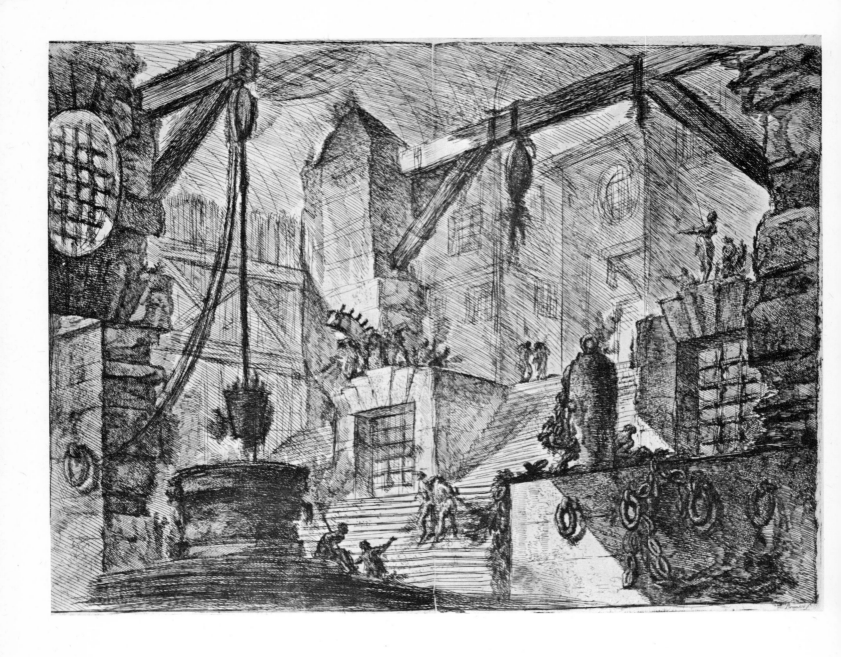

110. *Carceri*, Plate XIII, first state

96

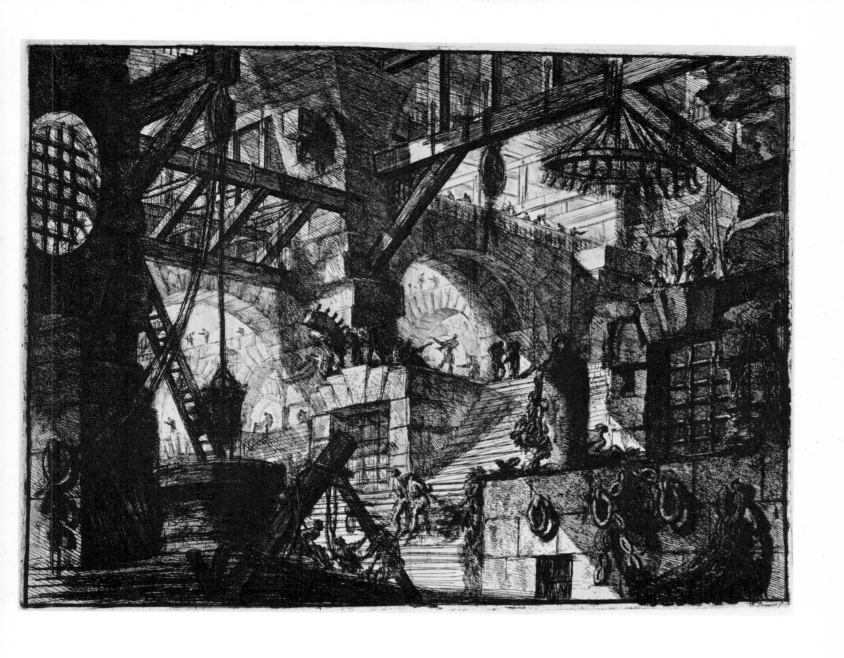

111. Carceri, Plate XIII, second state

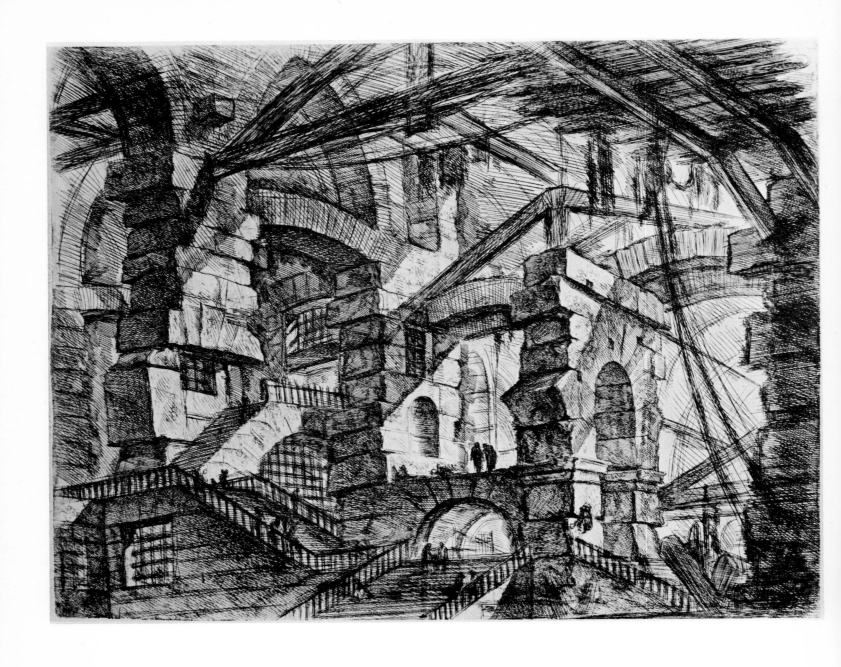

112. Carceri, Plate XIV, first state

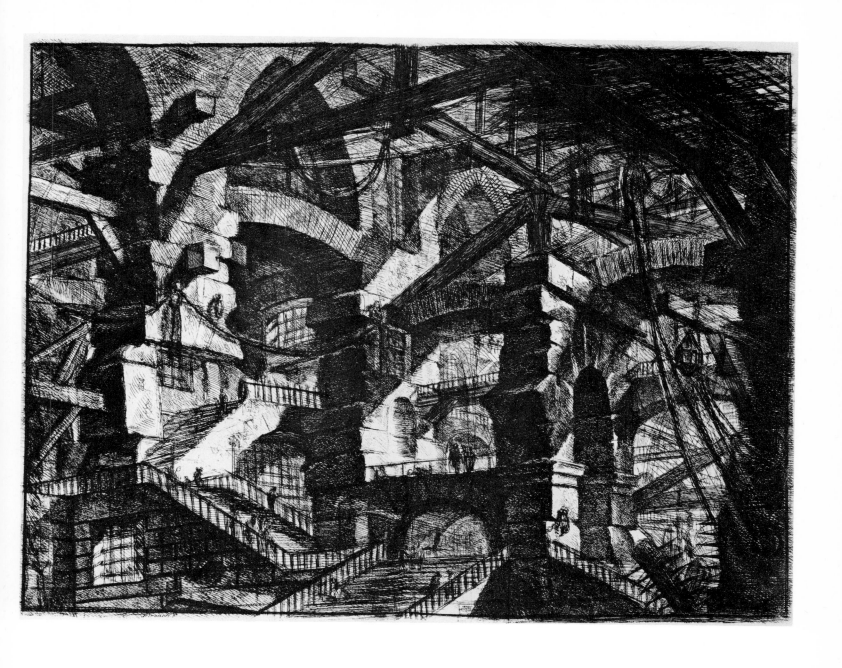

113. Carceri, Plate XIV, second state

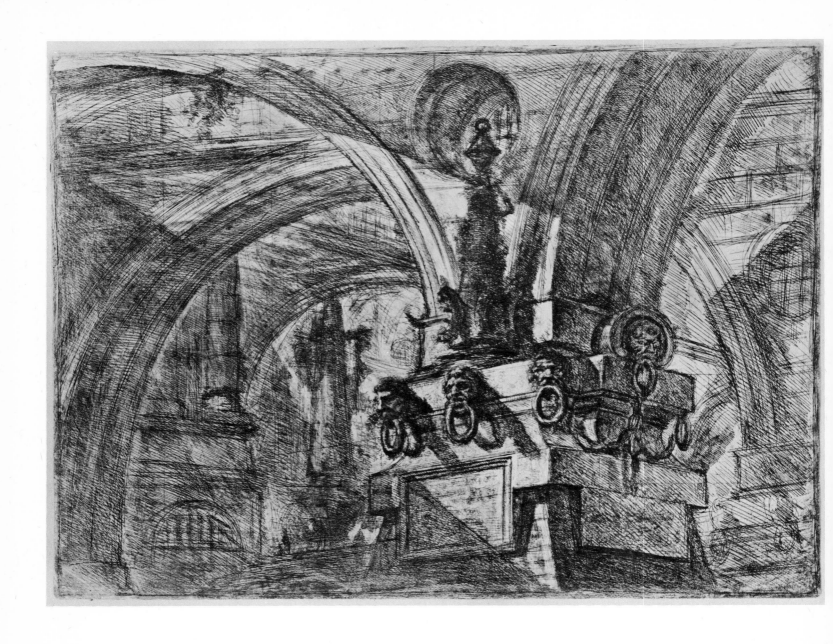

114. Carceri, Plate XV, first state

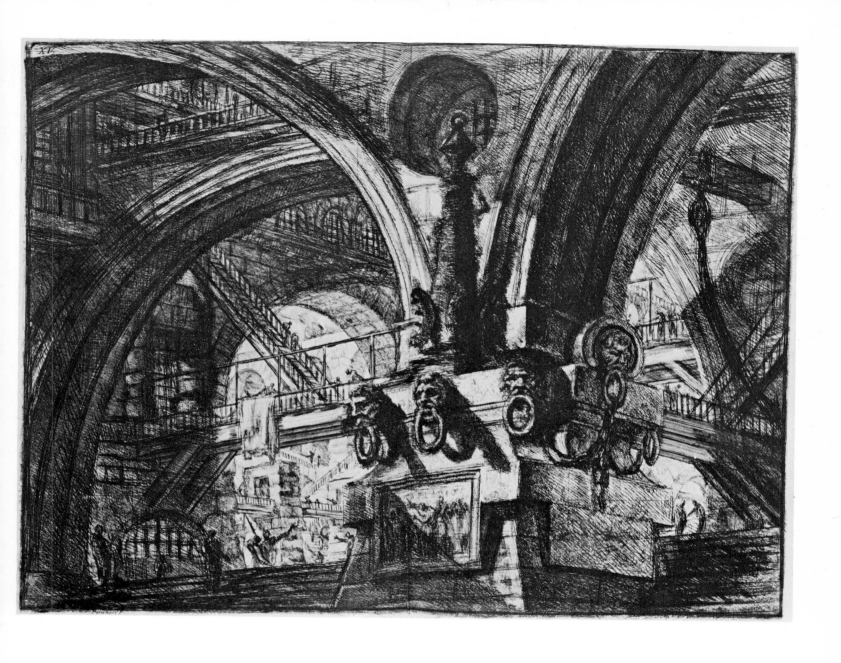

115. *Carceri*, Plate XV, second state

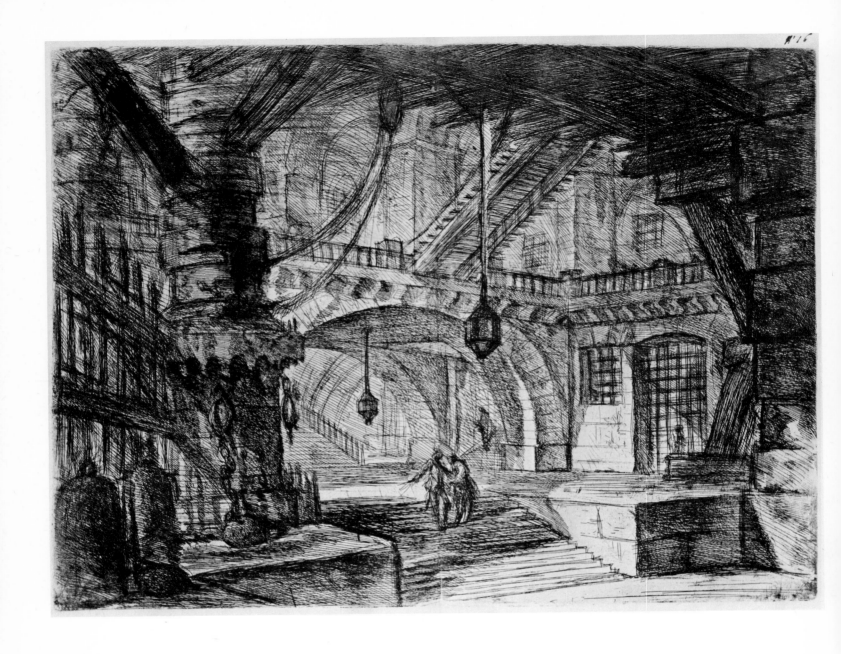

116. *Carceri*, Plate XVI, first state

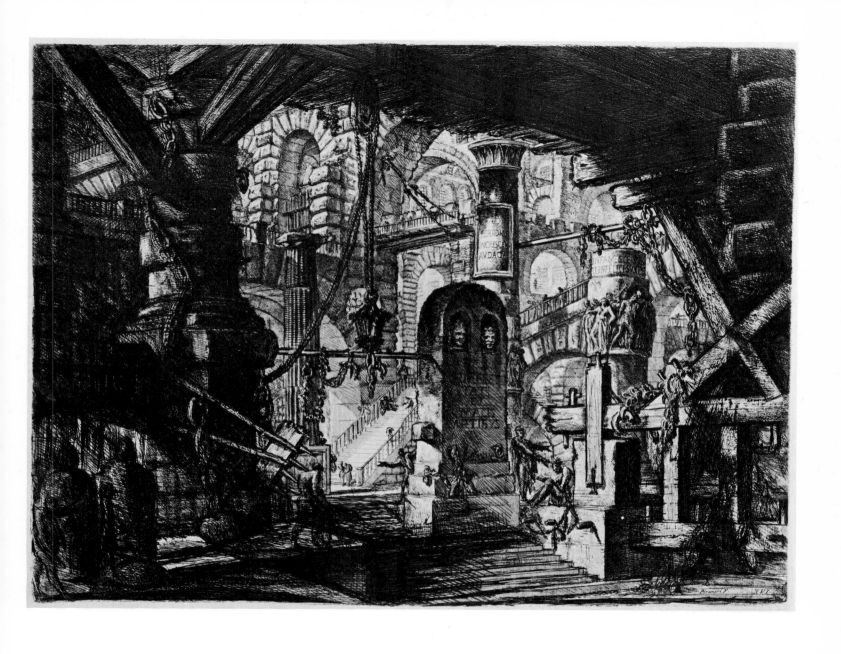

117. *Carceri*, Plate XVI, second state

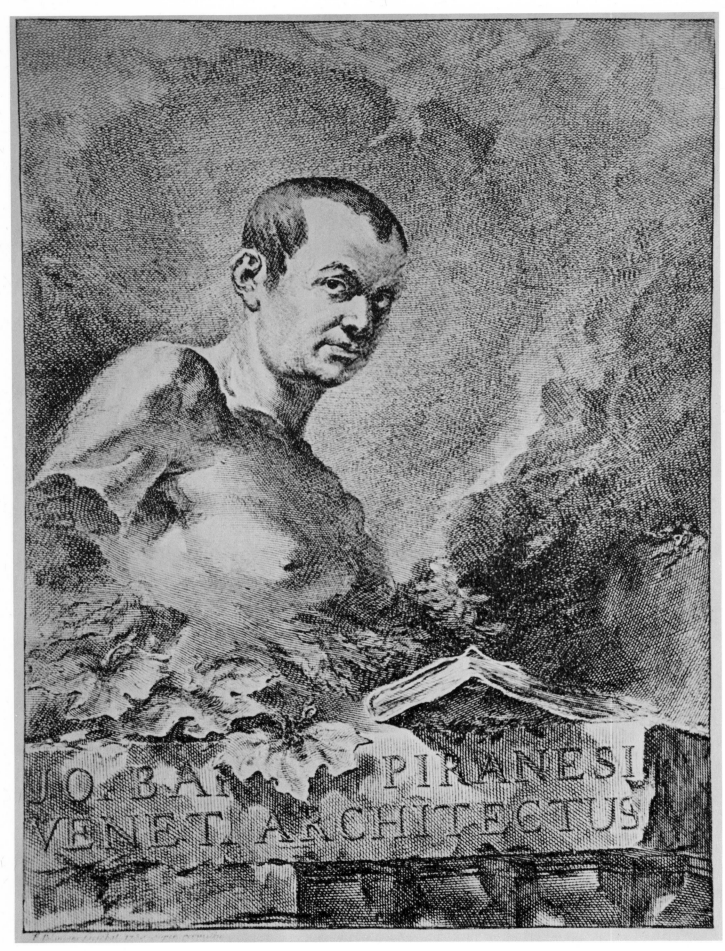

JO. BAP. PIRANESI
VENET ARCHITECTUS

118. F. Polanzani, Portrait of Piranesi

CHAPTER FOUR

The Antiquities and Lord Charlemont

DESPITE the manifestos of the *Opere Varie* and the *Magnificenze,* Piranesi had not won any architectural commissions as he might have hoped, but he had firmly established his reputation as the leading delineator of Rome. The *Archi trionfali* and the large *Vedute* were selling well and when his publisher, Bouchard, cashed in on their success by republishing the series of little views originally done for Amidei, he proudly advertised that they were 'for the greater part etched by the famous Gianbatista Piranesi'.

The frontispiece to the *Opere Varie* provides a portrait of him at this time, dated 1750, when he was thirty; it is by Polanzani who represented his old mess-mate in the manner of an antique bust. His fleshy torso is bare and, in sculptural convention, one arm is rather disturbingly amputated at the elbow, but there is nothing sculptural about the very sharp and suspiciously staring features above. His close cropped hair is receding at the temples, his features are large and rather coarse, especially the broad nose and thick lips, and he is already heavily jowled. Bianconi adds to the picture that he was 'rather tall, with a dark complexion and very lively eyes that were always roving round. His expression was pleasant but grave and reflective.' Polanzani's portrait is of a man of action, a pugilist almost, rather than a scholar or a visionary, and certainly a dangerous person to cross.

In 1752, with characteristic impetuosity, he embarked on marriage to a young girl named Angelica Pasquini, ten years his junior. The *Library of the Fine Arts* biography gives this account: 'He happened one Sunday to see the daughter of the gardener to the Prince Corsini, whose features, and especially her black eyes, perfectly convinced him that she was possessed of genuine descent from the ancient Romans; nor was her dowry of 150 piastres of small consideration in the scale, though the jealous watchfulness he maintained, sometimes much to her discomfort through life, would prove that the marriage was not entered into with merely mercenary motives. At the very first interview he asked her hand in marriage; and though his ardour frightened her at first, he contrived to obtain the consent of all parties to the celebration of their nuptials within five days afterwards. After the ceremony, he placed beside her dowry his finished plates and his unfinished designs, observing that their whole fortune was before her, but that in three years her portion should be doubled.' Such whirlwind courtships were in fashion among the artistic community in Italy. In 1748 Raphael Mengs, the German painter, passing a pretty eighteen year old in the street, cried, "There's the Madonna I've been looking for," asked her back to his studio and married her soon afterwards.[1] Goldoni's proposal to a girl spotted on a balcony above the street was equally brief and to the point, although in his case it was capped by an offer of theatre tickets to his prospective father-in-law. Kennedy's account of Piranesi's marriage, clearly based on rather painful memories of his sons, goes on to say that they 'lived on the whole happily though his notions of the rights of a husband and father founded on those of a pater-familias of the Romans, were no doubt carried to the extreme'. The trouble was that, when Piranesi was at work, he tended to forget about meals 'in which case his young children, who did not

dare to interrupt him, were often deprived of that nourishment which their tender age demanded, while in other respects his system of coercion and discipline was carried to an extreme beyond their strength'.

There were at least eight children of the marriage of whom five survived: Laura, the eldest, born in 1755, three sons, Francesco, Angelo and Pietro, born in 1758, 1763 and 1773 and a younger daughter, Anna, born in 1766.[2] The doctor who failed to save the life of one of the children was nearly killed in a typical Piranesian outburst. As Legrand says, he was liable to make the most extraordinary scenes 'both with his wife Angelica who was very pretty and with his neighbours and closest friends. These scenes threw him into deep depression when his blood had cooled. The fire with which he worked engulfed him more and more so that he was no longer in control of his actions.' He was desperately jealous over Angelica; he did not allow Zucchi to finish a portrait of her, and he could never see one of the pupils of Pecheux, Giuseppe Vasconi, pass his house without thinking that he was plotting some intrigue.[3] In this he may have had good grounds for suspicion. Ten years after the marriage, in January 1762, James Adam, younger brother of the more industrious architect Robert, wrote home to his sister Jenny explaining that Piranesi was advancing the volume on the Campus Martius due to be dedicated to Robert 'as fast as the distrest situation of his private affairs will allow him, being at present extremely distressed with the irregular conduct of his wife, who as we say in Scotland has been too great with another man & so he has put her in a Convent for her amusement'.[4] The resultant child, if it was born, must have been sent to an orphanage. There is no Piranesi christening recorded in the parish register of S. Andrea delle Fratte between that of Faustina Clementina in January 1761 and that of Angelo Domenico in December 1763. Whatever her infidelities may have been, Angelica was a vain creature. When the family moved into their house in Strada Felice in 1761 her age is recorded as thirty in the *Stato delle Anime* registers; fifteen years later she is recorded as thirty-five although her husband's age is correctly stated!

The first work following Piranesi's marriage was a slight exercise, issued in 1753 and consisting of a title page and nine other plates under the title of *Trofei di Ottaviano Augusto* 'raised for the victory of Actium and the conquest of Egypt with various other decorative pieces carefully taken from the ruins of the most valuable ancient buildings of Rome, useful', as he significantly continued, 'to painters, sculptors and architects, drawn and engraved by Gianbattista Piranesi, architect of Venice. On sale in Rome at the bookshop of Giovanni Bouchard in the Corso near the church of S. Marcello.'

Piranesi's selection included one straight topographical plate of the ruins of a monumental fountain, once part of the acqueduct system of Rome and now a picturesque ruin in the Piazza Vittorio Emanuele II. The ruin fascinated Piranesi: he not only added this actual plate to his series of large views of Rome but he returned to the subject some years later and based his theories on the system of Roman acqueducts on an examination of its structure. There remained embedded in the fragments until the sixteenth century the so-called Trophies of Marius which were subsequently moved to the balustrade of the Capitol. Piranesi was convinced that these trophies, which provide the title to the 1753 publication, were neither those of Marius (which were of gilded bronze) nor of Domitian (whose trophies were destroyed by decree of the senate) nor of Trajan (because they do not exactly correspond to those on the base of his column) but of Agrippa. Having once embarked on this theme, he was quite carried away by the eloquence of his convictions. 'Now who can deny that these famous and magnificent monuments represent the conspicuous victories won by Octavian against Mark Antony? Who can fail to recognise the grand arms of the vanquished pretender to the empire? Who would not acknowledge in this figure (in reality an allegorical one) the portrait of Queen Cleopatra as it was carried in triumph with those of her two little sons?' Actually the trophies are probably of the Flavian period and Piranesi was wrong, but, as he intended, the trophies were to prove of use to

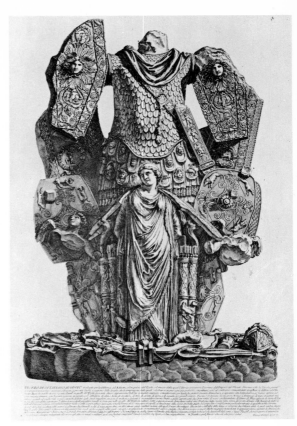

119. Trophy from Acqua Giulia, *Trofei di Ottaviano Augusto*

119a. Detail of decorative design for Syon House, *Works in Architecture*

120. A. Buonamici, View of the tomb of the freedmen of Livia

at least one architect: they make a superb appearance on the gilded stucco panels in Robert Adam's grand ante room at Syon.

The other illustrations in the *Trofei* are a very unusual choice. Instead of anthologising the decorous elements of Roman antiquity which best illustrate the strict canon of ordered architecture laid down by Vitruvius and codified by Palladio, Piranesi went out of his way to select the unusual and the bizarre. He was deliberately offering as models to contemporary artists columns wreathed in leaves or with triple rings at the foot, and capitals, fitting no text book at all, in the shape of baskets or cornucopias. Some of his columns sprout prancing horses or are capped with victory spirits sustaining martial trophies like the supporters of heraldry. In each case, he carefully listed where each of these oddities is to be found, 'in the corner of a building near the church of S. Francesco di Paola', 'in the Palazzo Mattei', 'in the vineyard of the Marchese de' Cavalieri on the Aventine'. Already at this stage he was offering, as examples to be imitated, novel forms which had good antique precedents but were not included in the copy book patterns of the recognised authorities.

The money from Angelica's dowry enabled him to dilate on antiquity on a rather grander scale. Immediately prior to marriage he had been at work on a series of plates of some of the ancient tombs outside the city. It was not uncommon for a farmer laying out a new vineyard to drive his mattock through the roof of a subterranean burial chamber. Such discoveries were promptly exploited. The sarcophagi were prised open in optimistic search for treasure, any statuary was sold off to eager collectors and minor oddments, the bronze or earthenware lamps, tear bottles, brooches and any other finds were soon disposed of to antiquarian dealers; then the inconvenient fragments were levelled and viticulture succeeded.

Piranesi's interest in these ruins was not just a morbid necrophilia but a genuine antiquarian desire to preserve records of some of the main tombs, following the excellent precedent of Francesco Bianchini, a scholar and more particularly an astronomer from Verona, whose work, *Camera ed Inscrizioni sepulcrali de' Liberti, Servi, ed Ufficiali della Casa di Augusto,* had been published in 1727.[5] Late in 1725, a smallholder with property on the Appian Way outside Rome between the Domine Quo Vadis chapel and S. Sebastiano had been persuaded by a Spaniard, Don Giovanni de Angulo, to form a partnership as a commercial speculation, sharing the cost of digging some promising bumps in his vineyard and the profit on the sale of any discoveries. They were lucky enough to strike into a large communal tomb, dating from the first century A.D., used for the ashes of the freedmen and slaves of the household of the empress Livia, wife of Augustus. Although the burial chamber 'was not as rich in valuable works as the partners had perhaps hoped', there was quite a good haul of antiquities, most of which were bought by Cardinal Alessandro Albani, while some of his fellow cardinals generously made a contribution to the preservation of the ruins at least in print, something which never entered the heads of the exploration partnership. As Bianchini sadly explained, 'The marble tomb was also discovered to be decorated with sculpture and reliefs and the whole of the floor was covered in mosaic work, but the haste of those concerned in the exploration and the unwillingness of the individuals to spend any money was highly prejudicial to the proper preservation of the building and its ornamentation.' Bianchini's description of the tomb served in many ways as a model for Piranesi. He gave an exact account of the location of the discovery and who had been involved as well as the history of the persons buried, he quoted in full the text of all the funerary inscriptions which had been discovered, and he illustrated his text with plates to show not only, as it were, a photographic view of the interior of the tomb with an excavator at work and a scholar perched on a step-ladder to copy the inscriptions, but also cross-sections of the burial chamber, the ground plan and some profiles of the mouldings and the settings of the funerary urns. Antonio Buonamici was the artist and his drawings were engraved by Girolamo Rossi.

Piranesi was sufficiently impressed by this work to acquire the actual copper plates for the illustrations in addition to a large stock of unsold prints for Bianchini's book and he combined Buonamici's drawings with seven of his own views of a couple of other tombs and published them in about 1752 under the title *Camere sepolcrali degli Antichi Romani le quali esistono dentro e fuori di Roma*.[6]

Now, however, he wanted to expand this series into a general survey of the principal tombs surviving in and around the city. This was to be his first major work and, despite the backing of Angelica's dowry, he needed a patron to whom he could dedicate his labours. In those days a dedication meant more than a coy inscription 'To my wife who typed these pages'. Publishers did not make cash advances to their authors and the patron to whom a work was dedicated was normally expected to provide funds to finance the work in progress up to publication. Lord Chesterfield had signally failed to do this only a couple of years before in the case of Samuel Johnson's *Dictionary*. 'Is not a Patron, my Lord', the great Cham thundered, 'One who looks with unconcern on a man struggling for life in the water, and, when he has reached ground, encumbers him with help?'

A suitable person seemed to be James Caulfield, Lord Charlemont, a young Irish peer, whose bland podgy features grin amiably at us from Hogarth's portrait.[7] He had started his grand tour at the age of eighteen in 1746; three years later he had reached Turkey with an entourage that included as professional architectural draughtsman Richard Dalton, the future librarian and keeper of antiquities to George III.[8] In Constantinople they attended the Grand Vizier's levée, disguised as Greeks, and then, passing through the Ionian isles, reached Egypt before returning to Italy by way of Rhodes and Athens. This unusually extensive tour does not seem to have made much impact on Charlemont. "How little does travelling supply to the conversation of a man who has travelled", commented Johnson, and, when Boswell duly instanced Charlemont, he added "I never but once heard him talk of what he had seen, and that was of a large serpent in one of the pyramids of Egypt." For the next four years, from 1750 to 1754, Charlemont travelled round Italy, striking up a friendship with David Hume in Turin and with Scipione Maffei in Verona. He spent some time in Rome as well, having an audience with Benedict XIV and meeting his chief librarian, Cardinal Passionei. Besides being a cheerful and charming socialite he was also a man of considerable taste and discernment as we can judge from the work he commissioned on his return to Ireland from Sir William Chambers, an architect whom he probably first met in Rome. Although his town house in Dublin has been much altered in its conversion to an art gallery, the little neo-classical casino or temple at Marino near Clontarf is outstanding even among the occasional buildings of a century which excelled in such designs. Charlemont appeared to be an ideal patron, young, rich, and enthusiastic, and such opinions were confirmed when he set up a new British school of art under the directorship of an English artist, John Parker, to give British students their own establishment in Rome on the lines of the Accademia di S. Luca beside the church of SS. Martina e Luca near the Forum, or the French Academy in the Corso.[9]

It seemed providential that this potential Maecenas was visiting Rome at the time that Piranesi was looking for a patron. Early in 1753, he approached Parker to ask if Milord would accept the dedication of the work that was under way. Parker procrastinated for a year without giving a definite answer, but, as Charlemont was travelling around the country, the delay may not have been entirely his fault. Eventually, Piranesi secured a meeting and was delighted with the unspecific promises he was given on his reception. Charlemont told him to come back another day with drawings for the proposed dedicatory plate but, when he arrived at Charlemont's lodgings, he was not granted admission. This may have been through Parker's jealousy or purely through error. Charlemont certainly did not intend to insult Piranesi because he went round subsequently to the artist's house for a meeting. Unfortunately, there were other visitors present on this occasion which prevented Piranesi from questioning him about his

121. W. Hogarth, Portrait of Lord Charlemont

122. Copy of dedicatory plate published in *Lettere di giustificazione*

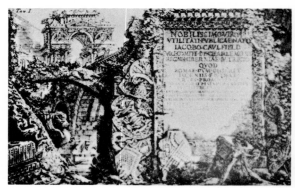

embarrassing exclusion, and he still had not come to any firm agreement when Charlemont left Rome for good shortly afterwards in March, 1754. Parker, however, asked for the drawings for the dedicatory plate which he said he would pass on to Charlemont. Piranesi handed them over but it took four months to recover them and they had certainly not been forwarded to Charlemont in the interval. Eventually Parker sent him an inscription to go on the title page composed, it was said, by Charlemont himself.

By the following year, 1755, Piranesi had decided to expand his original plan from a survey of *Sepolchri antichi* in one volume to a full coverage of the *Antichità romane* in four. Perhaps the flood of publications on the antiquities of Herculaneum which were coming out at this time had stirred him to adjust the balance with a magisterial work that would bring Rome back to its rightful prominence and outweigh the Vesuvian *opuscula* even if Pancrazii's two lavish volumes of *Antichità siciliane* were thrown into the other scale as well. He wrote explaining the change of plan to his patron and received in acknowledgment and presumed acquiescence a revised dedicatory inscription. Apart from this there was ominous silence from both Charlemont and Parker. Since Piranesi was receiving other tempting cash offers for the honour of the dedication of the work, he wrote to Charlemont asking for 200 *scudi* (about £50) as an advance to make sure that Milord was still interested in the project now that he was back in Ireland. Perhaps rather to his surprise, part of the sum was forthcoming but he was reprimanded through a mutual friend for writing direct to his lordship instead of dealing through his agent. On returning to Rome Parker told him that an advance of no more than 100 *scudi* was appropriate because the work had been so delayed, and he would get a further 100 *scudi* on completion. Parker obviously resented letting Piranesi have any money at all because the more Charlemont spent on subsidising archaeological works, the less he had to spend on pictures and antiques on which the agent could make a useful commission. Parker's offer was, in any case, well below the going rate. Adam told his family that the proposed dedication of the plan of the Campus Martius would normally have cost him £100 to £150. The meanness of Piranesi's official patron contrasted very unfavourably with the generosity of the Pope who allowed the artist to import two-hundred bales of paper duty free, a saving of 1,200 *scudi* (£300).

Parker's reply infuriated Piranesi because the struggle for survival in his first years in Rome had made him very sensitive about money matters. If he was going to be paid at all, he felt that he ought to be paid properly; the work itself deserved it, and besides, he had taken great pains over the dedicatory plates, honouring not only Charlemont but the British nation also. The first one contains

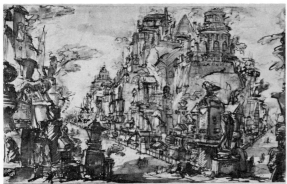

123. Dedicatory plate to *Antichità romane* II

124. Drawing for dedicatory plate

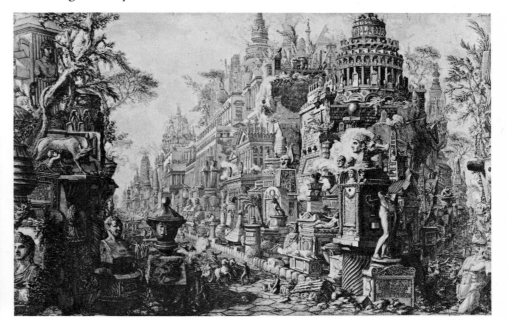

the inscription and his lordship's coat of arms against a background of antique ruins, setting the general theme of the series; the second, appropriate to a volume on tombs, is a huge and fanciful reconstruction of the monuments on the old Appian Way, with an imaginary sepulchre to Charlemont placed beside those of the family of the Scipios and of Cicero's daughter, alluding to the patriotic wisdom and eloquence necessary for a patrician. The third, again for a volume of tombs, shows a scene on the tomb-lined Appian Way, the Circus of Maxentius, illustrated because of the British enthusiasm for horses and racing, while the fourth, coming at the start of a volume on bridges, illustrates a triumphal bridge (a design resurrected, probably, from his *Seconda Parte* portfolio) and a harbour scene, recognising, as does a naval column included in the third plate, Britain's recent triumphs at sea.[10]

Piranesi swallowed his indignation and pressed on with his survey of the city. At this time he fell in with a new ruin-enthusiast, the young Scottish archi-

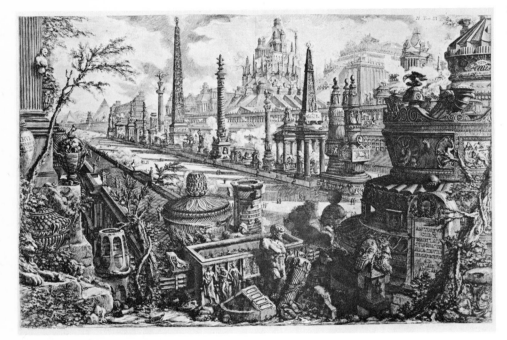

125. Dedicatory plate to *Antichità romane* III

126. Dedicatory plate to *Antichità romane* IV

127. Drawing for dedicatory plate

tect, Robert Adam, who had arrived in Rome to pursue his architectural studies in February, 1755. They were probably introduced by Charles-Louis Clérisseau, an amusing character who had left the French Academy the previous year after a tempestuous studentship and had just been taken on by Adam as both drawing master and view recorder. 'Piranesi who is I think the most extraordinary fellow I ever saw', Adam wrote home on 21st June, 1755, 'is become immensely intimate with me as he imagined at first that I was like the other Englishes who had love for Antiques without knowledge upon seeing some of my Sketches, and Drawings, was so highly delighted that he almost run quite distracted, and says I have more genius for the true noble Architecture than any Englishman ever was in Italy'.[11]

Adam became an inseparable companion in the pursuit of ancient Rome. 'I am going out tomorrow Morning', he wrote on 5th July, 1755, 'being Sunday on a party of antiquity hunting with Piranesi, Clerisseau & Pecheux, my three friends Cronys & Instructors'. A week later he had to make excuses for curtailing his letter home because he had been visiting the baths of Caracalla with Piranesi and Clérisseau and 'was so occupy'd haranguing, and contriving the Different uses of the Different Chambers, Courts, & Halls' and as if that was not enough, the following day as well he was intending 'to view the remains of antiquity on the Appian Way where we will be very merry with Piranesi who is always Brisk always allegro'.

Piranesi may have taken up Adam with such enthusiasm not entirely because he was a congenial companion with whom to visit ruins. The young architect with his grand coach and staff of draughtsmen was extremely careful to differentiate himself from the ordinary run of students and artists; he had arrived in the company of an earl's son and was on such familiar terms with the visiting British aristocracy and was so well received by the Roman nobility that he was quite clearly an armigerous *cavaliere* if not actually a *milord* himself. In such circumstances he was a possible source of future patronage and Piranesi offered to dedicate to him a plan of ancient Rome on which he was engaged. Adam was beside himself with pleasure because such a dedication from the famous Piranesi would serve as an excellent advertisement for him on his return to architectural practice in Scotland but, unlike Charlemont, he fully realised the financial implications of such an honour. 'This fancy of Piranesi of dedicating his plan to me', he wrote to his brother James in July 1755, 'in preference of all the Nobility here, & of all the English & of Mr. Wood so famous for his Palmyra, I have considered in every light, & can't find any bad affect from it. . . . It will however cost me some Sous in purchasing 80 or 100 coppys of it, which I propose sending to England & Scotland to be resold, & imagine, David Wilson & Baillie Hamilton may make something of it by adding a trifle of additional price to each coppy, as so amazing & ingenious fancys as he has produced in the Different Plans of the Temples Baths & palaces and other Buildings I never saw, & are the greatest Fund for Inspiring and instilling invention in any lover of Architecture that can be imagin'd. Chambers who courted Piranesi's friendship with all the Assiduity of a Lover never could bring him even to do him a Sketch of any one thing, and told me I never would be able to get anything from him. So much is he out of his Calculation that he has told me that whatever I want of him he will do for me with pleasure, & is just now doing two Drawings for me which will be both Singular and Clever.'[12] One of these drawings may well be the splendid red chalk and ink composition of soaring imperial grandeur now in the Soane Museum *(131a)*. There was also a more immediate public mark of friendship. Piranesi inserted Adam's name on a tombstone in the imaginary view of the Appian Way, destined as the dedicatory plate to the second volume of the *Antichità*. Allan Ramsay, the Scottish portrait painter, and Parker were similarly honoured *(123)*.

From the letters of Adam it is clear that it was only after first completing his survey of the tombs and bridges that Piranesi started working on the reconstructions of the Baths of Caracalla and of Diocletian and the palace of the Caesars

on the Palatine which appear in the first volume of the *Antichità*.

Eventually the great work was completed; it went to the censors and received the papal *imprimatur* on 25th January, 1756. In early May, at long last, it appeared for sale in Bouchard's shop at a price of 15 *zechini* (£7·50) for the four volumes. When Piranesi hurried round with two sets, an extremely heavy load, to ask what further orders Charlemont would make, Parker replied coolly that he should send as many copies as would be covered by the advance he had already received but 'Milord did not require the dedication'. Piranesi indignantly offered to repay the advance but restrained his temper because, having already published the set complete with the four dedicatory plates all addressed to Charlemont, he was committed too far to draw back and he must have hoped that, when his patron saw the splendour of the work bearing his name, he would override the troublesome Parker and pay as handsomely as the *Antichità* deserved. When he called on Parker some days later to ask what he thought of the volumes, the agent said he had not yet looked at them, which was actually untrue because he had already written to Charlemont on 22nd May saying that it was 'a very fine work'. Since Parker persisted in ignoring his enquiries and there was no word from Charlemont himself, Piranesi decided, not unnaturally, that his intended patron was no longer interested and, if that was the case, he could hardly permit the continued issue of the volumes with a fulsome dedication to someone who had so evidently spurned their author.

He therefore addressed a very long letter to Charlemont in August, 1756, copies of which he exhibited in the libraries of the Vatican and of the Corsini and Barberini families. He outlined the history of the whole business from his first approach to Charlemont through Parker (who is cast as the villain misleading the innocent absentee) to the rejection of the work by the agent and the still only threatened revocation of the dedicatory inscription. 'If I am to be forced to cancel the inscriptions that are still in place, I beg you to understand, Milord, that I do no wrong to the name of your ancestors but that it is an act due to mine . . . As a man of honour I cannot, without making myself an object of public ridicule, call you Protector of the Arts and say that I am under your protection; and if I have said this in seventy or so copies already disposed of, I am unhappily compelled to blame my folly and to justify myself before the world; because, as I beg you to consider, if a great nobleman should have at heart the name of his forebears, a professional man, who leaves his name after him, should have at heart his reputation and that of his descendants. A great nobleman is, for the time being, the last of his name, a professional man is the first of his, and both should have the same feelings of delicacy. If this letter is ever published (and I shall only publish it with the greatest regret) I beg those who read it, future generations, and you too, Milord, not to think that I lack respect for your grace, for I declare that I do not intend to place my name on a level with yours, but only my reputation. . . .'

The letter certainly reached Charlemont because the original is among his papers in Dublin, but it elicited no response. Consequently, apart from the seventy copies issued at first, Piranesi held up distribution of the work, including two-hundred copies ordered for Paris, while he resolved the problem. When Parker went to Bouchard's shop in January, 1757, to order two further copies against the advance already paid to Piranesi, the author refused to allow them to be issued and sent his lawyer round to return Charlemont's money. Meanwhile, as there was still no reply from Ireland, Piranesi resolved to copy the example of antiquity and erase the inscription to Charlemont from the title page just as Caracalla had hacked away the name of his murdered brother, Geta, from the arch of Septimius Severus in the Forum. He therefore reworked the dedicatory plate of the first volume, deleting Charlemont's name and excising his coat of arms, leaving only the crest and coronet untouched; Charlemont's name was also removed from two of the other three dedicatory plates. In February, he wrote again to Charlemont informing him that as a preliminary step he had suspended the dedication and that he intended to publish his first two letters; if

there was no response he would substitute a dedication to the public. Disingenuously he appended a copy of a letter from 'a foreign nobleman well known in Court circles in London where he has been three times' who had offered him 700 *scudi* for the dedication if Charlemont was not forthcoming.

At this stage Peter Grant tried to intervene.[13] He was the convivial, talkative Scottish Catholic agent, 'dear old Grantibus' as Adam called him, or, on account of his gross figure 'abbate Grande'. He knew everyone in Rome, could arrange introductions anywhere, and so, although suspected of Jacobite leanings, was visited by all the British tourists, for some of whom he dealt in pictures and antiquities. What happened at his meeting with Piranesi is unclear; Grant reported to Charlemont that 'he had communicated to him with all the smoothness and coolness of temper imaginable your sentiments with regard to the dedication'. Piranesi, by contrast, in a letter to Grant dated 31st May, 1757, gave a different and odder version of events according to which the abbé brought a letter from Charlemont, signed with his seal, and added dark hints that an assassin might be arranged; he then changed his tune and confessed that the letter was a forgery (the bizarre excuse for which being that Charlemont had paralysis in his hands and could not write) and that the agents had acted without his knowledge and suppressed Piranesi's letters – all this in the hearing of a mysterious concealed witness.[14] Piranesi later excused Grant from being one of the guilty parties in causing the misunderstanding with Milord and suggested that he had only intervened to try to extricate his friend Parker and his colleague, Murphy, another of Charlemont's set, from their embarrassment.

Shortly after this meeting, Grant secured an injunction from the governor of Rome forbidding Piranesi 'under the most rigorous and severe penalties of galleys' to publish anything against Charlemont. Undeterred, however, Piranesi started to insert copies of his first two letters to Charlemont in the first volume of each set of the *Antichità*. A further letter in June, 1757, gave Charlemont four months to reply: if there was no response Piranesi would publish the whole correspondence and substitute a completely new dedication. This letter also failed to receive an answer and so Piranesi kept his word. Where he had already cleared the name of Charlemont from the inscription on the dedicatory plate of the first volume he substituted a new dedication 'To the present, to posterity and for the use of the public' and he took a sledge hammer to shatter in pieces the coat of arms of the Caulfield family, leaving only the crest and coronet recognisable to mark the act of disgrace. It was all great sport and, of course, the

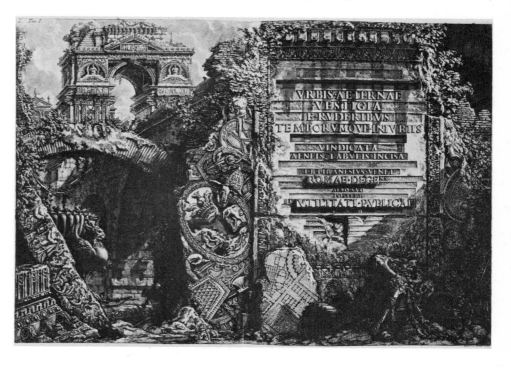

128. Dedicatory plate to *Antichità romane* I, third state

scandal must have boosted Piranesi's sales very satisfactorily.

In February, 1758, he went further and issued the *Lettere di giustificazione scritte a Milord Charlemont e a' di lui Agenti,* a splendid pamphlet comprising the first two letters to Charlemont and the letter written to Grant immediately after his interview. The letters are illustrated with some classically allusive satyrical vignettes and scaled-down versions of the four dedicatory plates. The wretched Parker got wind of this impending publication, the illustrations for which must have given the Piranesi faction many evenings' ribald enjoyment, but the governor of Rome's lieutenant refused to grant a warrant to search Piranesi's house unless a witness could be procured to swear to having seen the prints. Since, however, the only people who had seen them were Piranesi's friends, and they naturally refused to testify, Parker was foiled. When the pamphlet appeared he was mortified to see as the headpiece, in his own words, 'Time, discovering Truth; and a fat fellow, with a swelled leg, his hat fallen off, passing under the three spears, to characterize me, follows my dear friend, Mr. Murphy in a despairing action, and after comes an abbé, for Mr. Grant, over our heads in a label "In Aequimelio".' Another

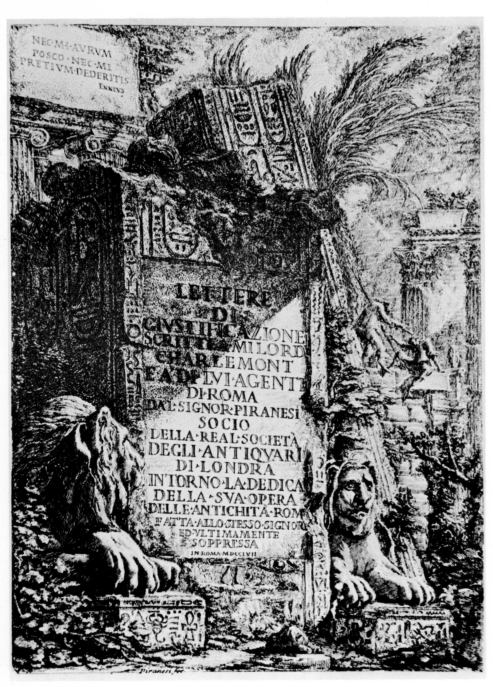

129. Title page, *Lettere di giustificazione*

headpiece, that to Grant's letter, again in Parker's words, shows 'the abbé, supposed dead, carried to the funeral pyre, and a view of some torments in hell. This is a copy of an antique basso-relief,' while the endpiece is 'a view of the Campus Esquilinus, several figures carrying dead bodies into the puticoli', quotations from Horace referring to the use of the Esquiline as a burial place for slaves in classical times and a tombstone with the initials of Parker, Murphy and Grant – a parody of the honorific tombs in the dedicatory plate to the second volume of the *Antichità*. Piranesi sent free copies of this pamphlet 'to all the cardinals, monsignori and other persons of quality, natives and foreigners' as well as 'to all English painters, Italian, French and Germans, and where abroad God knows'. He even sent a copy to the Pope, who had already been given a specially bound set of the *Antichità* in July of the previous year.

Parker and Grant at once presented a memorandum to monsignor Caprara, the civil governor of Rome, as a result of which Piranesi was ordered to prison. He, however, had placed himself under the timely protection of Cardinals Corsini, Orsini and Alessandro Albani 'by virtue of which', as Grant complained 'no sbirro dared to lay hands on him'. In retaliation the governor ordered the bookseller, presumably Bouchard, to tear the offending letters out of the *Antichità* and wanted to have him 'corporally punished but was soon given to understand that therein he was not to be gratified'. The best he could get was the issue of a recantation by Piranesi, which, though still unsatisfactory to Charlemont's party after no less than fifty drafts, was eventually published in March 1758. 'Seven of the high communites', including the Irish friars, submitted a memorial to Corsini protesting on Charlemont's behalf but, although the cardinal said he would 'punish Piranesi as my lord shall think proper', Parker had been resoundingly defeated. The free copies of the *Antichità* which Piranesi had distributed in in-fluential quarters, including to the governor, had done their work and, more important, the old Pope was dying. No one knew who might succeed and it was far too dangerous to risk offending any cardinal who might emerge as Pontiff. Such fears were well based; on 3rd May, 1758, Benedict XIV died and was succeeded as Clement XIII by Carlo Rezzonico, a Venetian and an enthusiastic patron of his fellow countryman. The affair was expensive for both parties. Parker claimed that it cost Piranesi £500 in bribes while he himself had had to

130. Vignette from *Lettere di giustificazione*

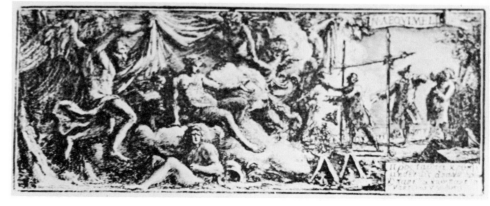

131. Vignette from *Lettere di giustificazione*

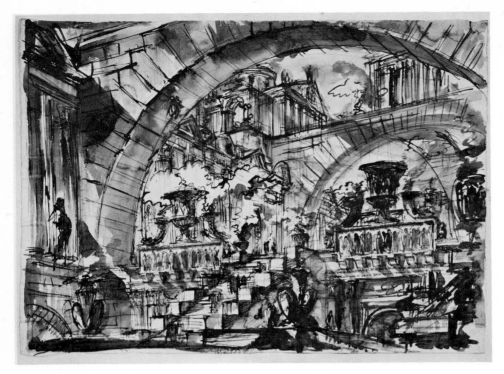

131a. Capriccio drawing

spend substantial sums on Charlemont's behalf. He, however, came off worst, losing all his British patrons through the influence of Piranesi's friends and being forced to return to England in distress. It is hard to sympathise with him. He later admitted to Charlemont that he had suppressed Piranesi's letters 'having received but too many impertinent ones, and equally lying'.

Charlemont does not come out of the business well; probably when he left Rome in 1754 he had not realised the animosity between Parker and Piranesi, he accepted Parker's recommendations on money matters, and, since Parker stopped many of Piranesi's letters, he did not hear the other side of the case. By the time he was aware of the true state of affairs, it was too late to rectify them and so he passed over the whole business in embarrassed silence. He cannot, however, be wholly excused because he certainly gave some instructions to Parker who claimed that he had not 'erred in the least from your order by letter as Mr. Grant found on examination'. The storm in a tea-cup is intriguing not only because it involved a British visitor in one of the literary *causes célèbres* of the century, but also for the light it gives on the system of patronage, and still more on the character of Piranesi himself; anglophile, financially grasping, quick-tempered, intensely proud of the status conferred on him by his work on the antiquities, boldly assured of the Horatian immortality secured by his monumental labours.[15]

CHAPTER FIVE
The Antichità Romane

'SEEING that the remains of the ancient buildings of Rome, scattered for the most part in gardens and fields, are being day by day reduced by the injuries of time or by the greed of their owners who, with barbarian licence, secretly demolish them to sell the rubble for modern houses, I decided to preserve them in these plates. . . .' says Piranesi in the preface to the first volume of the *Antichità*. After acknowledging Benedict XIV's enthusiasm for preservation and for encouraging the study of antiquities, he continues: 'I have delineated the ruins in these volumes as attractively as possible, giving in many cases the ground plans and interior views as well as the exterior, showing the structure by means of cross-sections, and indicating the materials and methods of building, as far as I have been able in the course of many years' ceaseless and most accurate observation, excavation and research; such an undertaking has never before been carried out and it should serve particularly to illustrate by means of the ruins here portrayed the precepts of Vitruvius on the division, durability, grandeur and beauty of buildings. In pursuing my task, which has involved a great deal of painstaking and important investigation, I have not only given the names of all the ruins, but also the location of many ancient buildings of which no trace survives and for this purpose I have reproduced a map.'

The first volume, which was probably the last to be completed, starts off with this map of Rome within the bounds of the Aurelian walls based on that of Nolli which Piranesi had illustrated in 1748. Superimposed on it are the ground plans of the main buildings of antiquity then surviving and the numbered positions of no fewer than 315 monuments of one sort or another which Piranesi had located. The map is surrounded by some of the larger fragments of the *Topographia* or Plan of Rome, arranged like pieces of an unassembled jigsaw puzzle, which is more or less what they were. The *Topographia* was a large map

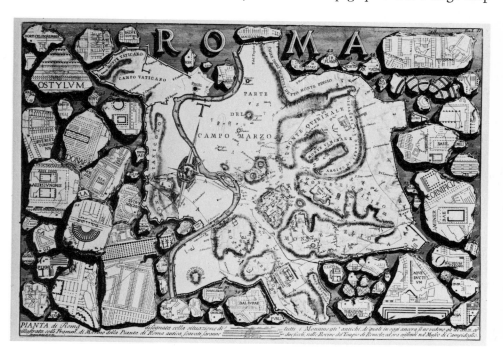

132. Map of Rome, *Antichità romane* I

133. Aurelian wall, *Antichità romane* I

of the city dating back to the second century A.D. which had been discovered in fragments in the Temple of Romulus in the Forum and had been transferred to the Capitoline Museum. The next few plates are devoted to the other fragments of the *Topographia* and a commentary on them and some textual suggestions which are not of great interest although Piranesi was obviously much intrigued by the tantalising scraps even if he could not make much of them – nothing is more bewildering than a jigsaw which has half the pieces missing. There follow some forty pages of text listing each of the monuments numbered on the map with his brief comments on their date and construction and his explanations if he differed from other authorities as well as cross-references to the numerous illustrations at the end of this or in the succeeding volumes.

He started the tour with a circuit of the city gates in the Aurelian wall, pointing out which parts were built by Constantine or Aurelian and the additions of Belisarius or of Popes in later times. The circuit makes a very exhausting day's walk which I cannot really recommend – footweariness soon dulls the impressive effect of these towering brick fortifications. After this he covered the relics in the Campus Martius, crossed the Corso to the Quirinal, toured the fields towards the Castro Pretorio, and then zig-zagged across the old city bounds from Trastevere to the Palatine, noting every scrap observable: the substructure of the palace of Elegabalus in the gardens of the Colonna family, the Roman bath to be seen in a chapel of the church of S. Cecilia, complete with its heating system, the ruin-studded medieval house of Crescentius which 'on account of its unusual construction and the skilful grouping of the fragments was the wonder of its time', the theatre of Balbus traceable where the street curves round the Palazzo Cenci, the slaves' quarters on the Palatine in the garden of Natoire, the new director of the French Academy. He also gave useful pieces of archaeological information: the exact spot where the famous equestrian statue of Marcus Aurelius had been discovered, the section of the Corso where the same emperor's arch had stood until its demolition by Alexander VII in the previous century (and he pointed out that the reliefs from it were to be seen in the Capitoline Museum), the site of the gardens of Sallust in the Villa Belloni and the Villa Verospi where a great cache of antiquities had been found some ten years previously.

He was a thorough investigator, blithely trespassing in the gardens and vineyards of the city to pry out tumbled and unrecognised ruins and button-holing surprised farmers to discover exactly where some fragment had been unearthed years previously. He personally undertook the considerable task of excavating part of the lower arcade of the Curia Hostilia, the substructure of the

134. House of Crescentius, *Antichità romane* I

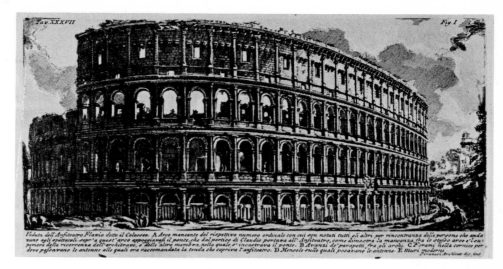

135. The Colosseum, *Antichità romane* I

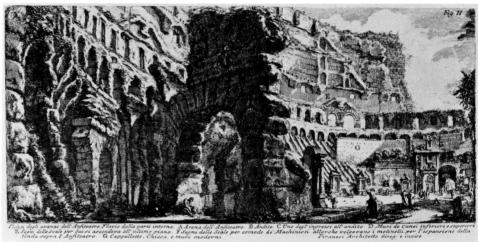

136. Interior of the Colosseum, *Antichità romane* I

temple which the notorious Agrippina raised to the deified emperor Claudius on the Caelian hill. In the eighteenth century only the upper arcade of the huge Carcerian structure was visible beneath the campanile of the church of SS. Giovanni e Paolo and Piranesi identified it as a menagerie which, he believed, must have been used for the animals of the Colosseum. To prove that the Cloaca Maxima, the main sewer of Rome, was used to drain the springs of the Palatine hill, he persuaded a local boy to penetrate the tunnel and trace its course through the many subterranean chambers towards the church of S. Anastasia at the foot of the hill; it is rather disappointing to find that he did not go himself.

His notes are painstaking and he made careful use of both ancient and modern authors, although it is more than likely that a bevy of friendly abbés guided him through the original sources. They were perhaps responsible for some of the catty polemics against other scholars whose errors he or they derided and for the learned and not strictly relevant *excursus,* in which, for instance, he refuted doubts on Agrippa's responsibility for the Pantheon by explaining the relevant passage of Dio Cassius' *History* or used Tacitus to show (perversely) that the Via Flaminia left Rome by the Porta Pinciana and not the Porta del Popolo.[1] Usually, however, his observations are sharp and interesting. He demonstrated how class distinctions were made to work in the Theatre of Marcellus so that senators, knights and the plebs were segregated even in the exits from their seats. He identified the entrance to the imperial box in the Colosseum, marked by the scars where it had been joined to the portico of Claudius. His arguments are sensible, too, and based on well-researched evidence, as when he proves that the basilica which he described (wrongly) as the gallery of Nero's Golden House overlooking the Forum cannot have been the temple of Venus (because it does not have a *cella* or shrine, and does not resemble the representation of the temple

of Venus on a coin which he reproduced) or when he demonstrated that the temple of Nerva, used by Paul V as a quarry for the Acqua Paola fountain on the Janiculum, cannot have been part of Nerva's forum as some scholars claimed (because Palladio had drawn a plan and elevation of the building before it was demolished and had quoted part of the original inscription).

The illustrations to this volume are mostly small plates, set two on a page, and liberally sprinkled with letters to mark the different parts and dates of the buildings and to distinguish the modern accretions. Some are perfunctory little sketches of purely archaeological interest and a number of drawings, if not the actual etchings, must date back as much as ten years previously: the views, for instance, of the tomb he recorded in the Casali vineyard just before it was demolished in 1746 and of the interior of the Pantheon which must have been drawn before 1747 when pediments were placed on the niches of the attic. Most of the plates are stylistically akin to the small earlier *vedute* and the *Archi trionfali* although there are already indications of the more dramatic shadow effects which he was to use increasingly in future years.

The illustrations are followed by another map in two sections giving the detailed layout of the Roman aqueduct system, each water course being marked in a different code like a London Transport plan of the Underground. This was a very intricate piece of research which could well have taken six months as he claimed in his first letter to Charlemont. A seven-page essay on the organisation of the aqueducts is given a postscript on a quite unrelated subject which had caught the author's fancy, the bounds of the Campus Martius, which he wanted to extend to the Milvian bridge on the authority of the ancient geographer, Strabo.

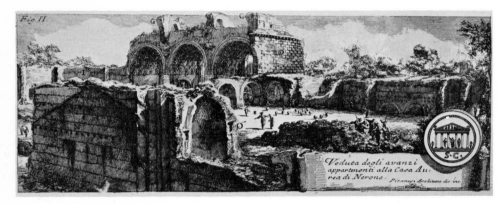

137. The Basilica of Maxentius, *Antichità romane* I

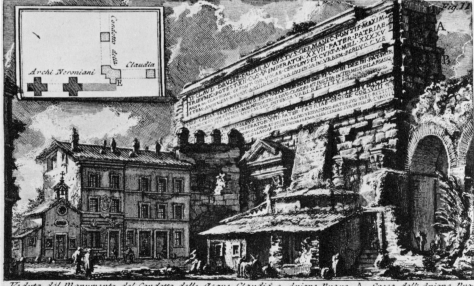

138. Porta Maggiore and the aqueduct systems, *Antichità romane* I

139. Interior of the Pantheon, *Antichità romane,* I

Veduta dell' interno del Pantheon

140. Plan of Castro Pretorio, *Antichità romane* I

The first volume concludes with plans of some public buildings as Piranesi would have reconstructed them. Those of the Baths of Diocletian and of Caracalla are quite accurate. The ruins themselves are well preserved and, besides, it would not have been easy to clash with the published drawings of Palladio. Piranesi sensibly pointed out that the original ground level of some of the rooms in the Baths of Caracalla would have been lower and he was therefore able to make rather better suggestions about the uses of the various chambers, an exercise on which, as we have seen, he was assisted by Robert Adam. His reconstructions of the Castro Pretorio, of Nero's works on the Caelian hill, of the Forum and of the Capitol are, however, completely arbitrary. Perhaps the oddest of these plans is that of the Castro Pretorio which was the barracks of the pretorian guard. Here Piranesi actually shows on the same page the ground plan both of the surviving fragments and of an elaborate Baroque tribunal and curving walls supposedly reconstructed from the evidence of the Arch of Constantine, of medals and of ancient authorities. In fact there is no resemblance between the surviving fragments and the reconstruction. His designs for the Capitol and the periphery of the Forum are even more crowded and fanciful, scattered with vistas theatrically set *a l'angolo* and magnificent circular temples in a layout wholly foreign to the muddled triumphs of the ancient city. He gave a numbered key to every imaginary colonnade and portico in his plan which lends it a spurious but amusing air of accuracy. It is perhaps surprising that he did not also include a bird's eye view of what his Rome would have looked like in the manner of his reconstructions of the Appian Way and the Circus of Maxentius in the dedicatory plates but this was probably due to lack of time rather than enthusiasm. The work was already long enough delayed.

The three succeeding volumes are quite different in content and in presentation. There is no text as such, just a series of illustrations accompanied by long notes of explanation under the plates. In detailing the parts of the cross-section of the Castel S. Angelo he wrote, 'It would take too long to describe these minutely, section by section, and would in any case be outside this book's purpose which is to give a brief description of each plate with some notes. The exact reproduction of the subject together with the explanatory text should enable the serious reader to work out for himself the details which I have had to omit for the sake of brevity. A study of the internal and external features of these buildings will give the most exalted concepts of architecture and excellent and reliable precepts for durability and beauty.' The second and third volumes are devoted to the tombs outside Rome which is not such a macabre subject as it sounds. By law, burials in classical times had to be beyond the boundaries of the city (exceptions only being made for the imperial family) and, for this reason, tombs were usually situated along one of the main roads leading out of Rome, the Appian Way being the most popular. After the body had been cremated, the ashes were

collected in an urn, or, if the family was a rich one, in a marble chest or sarcophagus which was then placed in a free-standing building. Each of the great families had its own mausoleum, which was splendidly decorated in stucco work and mosaics, and marble and sculptures were freely used both outside and within the sepulchral chamber where the urns and sarcophagi were placed in niches round the walls. The superb eighteenth-century mausoleum at Castle Howard (which Horace Walpole said would tempt one to be buried alive) or the pyramidal temple in the woods at Cobham best evoke the atmosphere if not the actual form of such ancient tombs.[2] Other burial chambers were commercial speculations, erected by entrepreneurs who hoped to sell off urn niches at a profit, and some great families even erected separate buildings for the ashes of their retainers and freedmen. At the other end of the scale were the humble tomb stones not unlike the lichened monuments in our own country church yards. It was a subject well

141. Plan of the tomb of Constantia, *Antichità romane* II

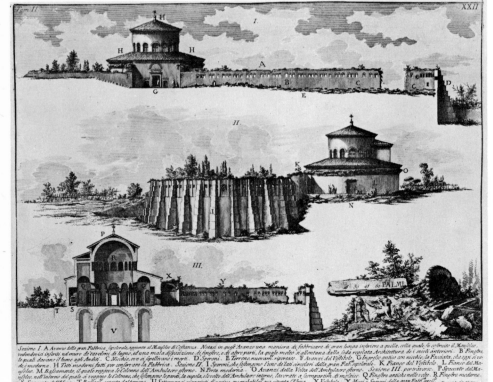

142. Cross-section of the tomb of Constantia, *Antichità romane* II

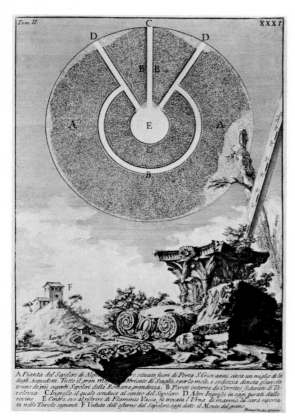

143. Plan and view of the tomb supposedly of Alexander Severus, *Antichità romane* II

worth illustrating.

Piranesi made a collection of some thirty of the principal tombs, mostly those down the Appian Way, but including the mausoleum of Constantia the daughter of Constantine (now the church dedicated to a nun of the same name), the pyramid of Caius Sestius by the Protestant cemetery, the so-called tomb of the Curiatii at Albano and several other prominent examples. He provided first of all a ground plan and a careful cross-section of all the main buildings, generally on the same plate, with a rule to show the scale, and then he added one or more picturesque views, similar in size and detail to his large *Vedute,* either of the interior of the burial chamber or of the exterior, whichever was the most appropriate, and sometimes of both. In many cases he also included facsimiles of the inscriptions and reproductions of the sarcophagus and urns, or the stucco work or minor items like the lamps and tear bottles found while the tomb was being excavated.[3] He was always careful to give the exact site, the date of discovery if recent, and when, for instance, the sarcophagus had been moved, he noted the collection or church in which it was then to be seen.

The third volume concludes with the tomb of Cecilia Metella or Capo di Bove on the old Appian Way. This monument, which Goethe said made him 'realise for the first time what solid masonry means', gave an excellent opportunity for Piranesi to show the originality of his approach to antiquity. Nearby he had found several blocks of cut stone which seemed to have been rejected by the builders of the tomb and never cleared from the site. Some of these contained small squared recesses, either in the top or, more surprisingly, in the side faces, as well as rough projecting bosses deliberately left on the ends. The recesses on the upper face were obviously for the insertion of a wedge with a hole in the top through which the lifting tackle could be slipped. The recesses in the side and the projections were a puzzle; he came up with a solution, however, and drew some minute diagrams showing how grappling clamps might have been fitted into the recesses so that, by means of carefully balanced rope-work hooked round the projections, the stone could have been lifted into position. A pictorial inset shows the tackle in operation for the construction of the monument. Only someone with Piranesi's practical experience would have bothered about such problems or even noticed their existence, and the following plate, the last in the volume, is even more original. It consists of a large spread showing one of the lifting wedges devised by Brunelleschi, which is probably the same as the *forfex*

144. Reconstruction of building the tomb of Cecilia Metella, *Antichità romane* III

Modo, col quale furono alzati i grossi Travertini, e gli altri Marmi nel fabbricare il gran Sepolcro di Cecilia Metella, oggi detto Capo di Bove.

The illustration contains numerous engraved letter and numeral annotations (VI, IV, VII, X, II, T, S, O, V, N, R, P, Y, etc.) and a dense explanatory caption in Italian at the base beginning with "A Avanzo del Mausoleo d'Elio Adriano Imp..."

mentioned by Vitruvius, together with refinements on it which Piranesi hoped would be of use – presumably to practising architects who turned to his volumes for models of correct ancient taste because such practical details would hardly have concerned the bulk of his readers, the learned abbés and visiting *milordi*. At any rate, the illustration is a remarkable demonstration of his skill in magnifying even the humblest objects so that the mason's blocks and tackle appear as massive as the armoury of the Cyclops(*148*).[4]

The fourth volume is a curious medley; it opens with the grandest tomb of all, Castel S. Angelo, the mausoleum built to receive the ashes of the emperor Hadrian and converted, in later times, to a fortress. He devoted two enormous fold-out plates, each nearly four feet long, to cross-sections of the tomb, to the bridge joining it to the Campus Martius and, in particular, to the foundations of both structures. These were, of course, deeply buried so that the reconstructions are wholly imaginary. That, however, was no inhibition; he showed everything, starting with the rows of iron-tipped stakes rammed into the ground and ascending through the layers of stone superstructure complete with buttressing spurs of rough masonry up to ground level. When he listed the building materials in an inset, he even included a handful of gravel such as might have been used as bedding for the stakes. It is all so accurately detailed that we can almost believe that he followed the example of Hadrian himself and either diverted the Tiber or dammed off part of its course one summer to enable him to pursue his investigations on the river bed. The most remarkable plate is an imaginary view of the foundations of the mausoleum which he drew as they

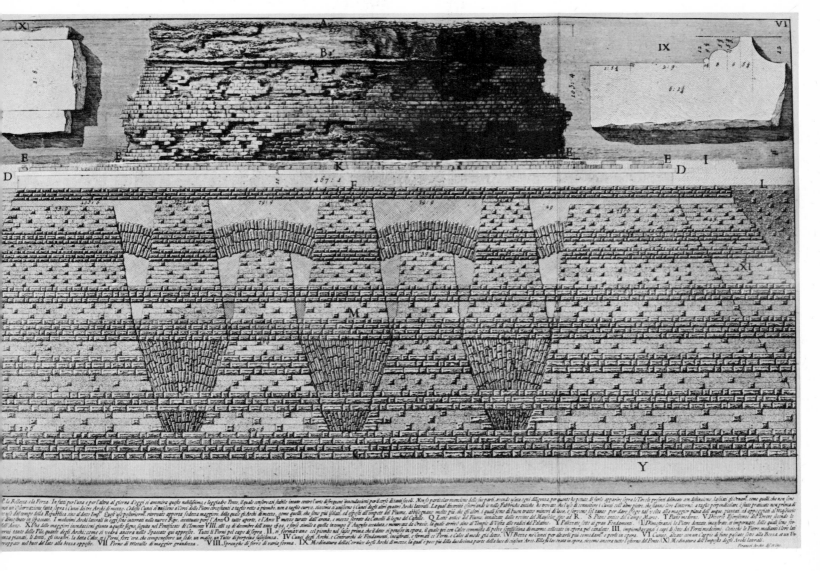

would have looked if they had been newly excavated and laid bare to the curious gaze of visiting tourists, some of whom he pictured stranded, gesticulating, half-way up this great cliff of massively-buttressed stonework *(149)*. Such reconstructions must surely stem from personal observation of the building of the great sea walls of Venice on which his uncle, Matteo Lucchesi, had been employed. Nowhere else could he have seen building work of this type in progress.

The volume continues with a survey of the other ancient bridges of Rome, again showing cross-sections of the foundations as well as some very attractive large views, taken from the water level. Then he crossed the Tiber to the Theatre of Marcellus which he also excavated in imagination to the foundations *(150)*, this time showing the bedding stakes as forest tree trunks packed together. The remaining plates are quite different in style and purpose, consisting of carefully measured architectural drawings of details of the theatre and several nearby buildings, as well as the Curia Hostilia on the Caelian hill. The volume concludes with a completely irrelevant view of the site where an uninteresting inscription had been discovered some miles out of Rome. The extra plate was added in 1757 as an attack on a fellow antiquarian, Ridolfino Venuti, who had dared to publish a pamphlet the previous year immediately after the publication of the *Antichità* disagreeing with Piranesi's description of one of the monuments. Piranesi was delighted to get his own back by showing that the unfortunate scholar had slipped up in one of his own publications where he had described the inscription in question as coming from the Aventine whereas it had been excavated four miles beyond the Porta Maggiore. Piranesi's schoolboy squib makes an odd envoi.[5]

125

The publication of the *Antichità* was something of an international event. The monuments of Rome still held a pre-eminent position in European taste which was not yet seriously challenged and which, despite scholarly controversy with the champions of Greece, was to continue supreme for the next half century. Piranesi was thus able to draw reflected glory from his subject matter and his reputation as the foremost propagator of Rome's antiquities was confirmed beyond question. Natoire wrote back to Antoine Duchêne, the inspector of the royal works in Paris, saying what a stir the publication had made and adding, interestingly, that two of his best pupils, Moreau-Desproux and de Wailly, were deeply immersed in Piranesi's account of Roman building techniques.[6] On the strength of this publication the Society of Antiquaries in London elected Piranesi a fellow on 7th April, 1757, and, as he proudly noted in the first letter to Charlemont, requests for copies of the four volumes came in from as far as Russia and Scandinavia.[7]

In some ways the uncritical enthusiasm is surprising. The *Antichità* is indeed a remarkable work; its very size distinguished it from the average antiquarian tome – four heavy volumes some seventeen by twenty-one inches, with about two-hundred-and-fifty illustrations and maps. But since Piranesi lacked the ability to organise the enormous mass of available material, the *Antichità* is not so much a systematic treatise as an anthology of the various enthusiasms which seized the author as the work progressed. It is rather unbalanced, for instance, to give such cursory treatment to the Forum and the Palatine, the official centre of ancient Rome, while minor tombs down the Appian Way fill two volumes. Similarly, in the fourth volume his preoccupation perversely seems to be with the buried foundations of the buildings depicted rather than their superstructures which could still be seen.

Moreover it was not true, as Piranesi claimed in his preface, that such an undertaking had not previously been attempted. The standard work on the antiquities of Rome was still the *Edifices antiques de Rome,* published in 1682 by a French scholar, Antoine Desgodetz. This consists of minutely reproduced details of the principal ruins with exact measurements of every twist of acanthus leaf as well as notes on the buildings themselves. Admittedly, the measurements were not always accurate and, in fact, Robert Adam was at this very period setting his staff of draughtsmen to work, re-measuring all the buildings with a view to a revised edition and Moreau-Desproux and de Wailly were similarly engaged. Nevertheless, Piranesi used the reconstructions of Desgodetz as the basis for some of his own such as those of the tomb of Constantia. More to the

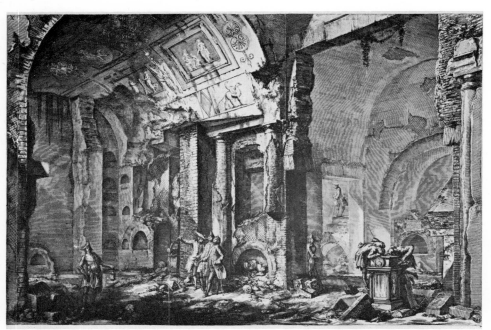

146. Tomb of L. Arruntius, *Antichità romane* II

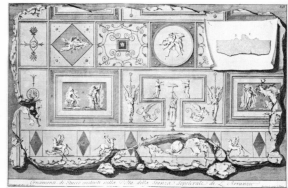

147. Stucco work on the tomb of L. Arruntius, *Antichità romane* II

148. Lifting tackle, *Antichità romane* III

point, the tombs of antiquity had received extensive treatment in *Gli Antichi Sepolchri* by Pietro Santi Bartoli in 1697, an excellent picture book which covers even more tombs than the *Antichità* and must certainly have been known to Piranesi who copied the author's technique of reproducing both the ground plan and a cross-section of the monuments in addition to external views. Santi Bartoli in some cases also gave his own imaginative reconstructions (which, apart from the dedicatory plates, are so disappointingly absent from the *Antichità*) and he provided many additional illustrations of the mosaics, paintings, reliefs and sculpture found in the tombs.[8] A similar picture book is the *Camere Sepolcrali de' liberti e liberte di Livia Augusta* by Lorenzo Filippo de' Rossi, published in 1731 as a pictorial supplement to Bianchini's work on the tomb of the freedmen of Livia. The illustrations were by Pier Leone Ghezzi, better known as the amusing caricaturist of eighteenth-century Rome, but also a keen collector of cameos and antiquities. In the section of the *Antichità* devoted to the tombs covered by this earlier work, Piranesi copied Ghezzi in reproducing pages of inscriptions in facsimile, instead of just giving the text as Bianchini had done, and he illustrated precisely the same fragments of stucco and sculpture although he altered the random arrangement in his plates. There is no originality of technique here.

Where Piranesi does differ from his predecessors is his interest in the building methods of the ancients. He was able to throw further light on his archaeological field work by drawing on his youthful training as an architect and on the knowledge of construction which he had picked up when accompanying his father, the master mason, or his uncle, the hydraulics engineer, on their site inspections in Venice. He was the first scholar to bring such practical experience to bear on the question of how the Romans actually set about erecting the huge mountains of stonework which previous investigators had treated more as natural phenomena to be measured and surveyed than as man-made edifices presenting considerable technical problems to the builders. It was only when he came to reconstruct the ground plans of some of the public buildings that his early architectural studies misled him into devising enormous Baroque ensembles that went far beyond the evidence of the surviving fragments, those 'amazing and ingenious fancys' to which Adam referred as being 'the greatest Fund for Inspiring and instilling invention'.

The other essential ingredient in his success was, of course, his own poetic vision of the grandeur of Rome's past. His plates are not the dry, boneless, two-dimensional cut-outs that illustrate the tomes of his predecessors: they are a vivid personal reaction to the Titanic scale of the works of the ancients and the melancholy Ichabod of the desolation into which they had fallen. There is no comparison between the illustrations from Bianchini's book, with its wooden, almost toy-town figures, and Piranesi's large *vedute* of tomb interiors. It is not simply that Piranesi knew how to dramatise the sepulchral gloom with dark shadows and send a contrasting ray of sunshine streaming down into the charnel house; he brought the scenes alive with details which the visitor would remember as immediately authentic – the pair of young tourists, bored by their *cicerone's* explanation of the stucco work, who scramble on marble fragments to peer ghoulishly into a monument for bones, the dishevelled beggars, hunched in their rags, as decrepit as the ruins in which they waylay the visitors, the goats that skip up the tombs like an Alpine peak in search of fodder, the barges moored below the Ponte Ferrato grinding corn in the water mill on the Tiber. In addition to these picturesque views, as popular as the large *Vedute* of the city, there were imaginative creations like the thunderous stone cataracts of the foundations of Hadrian's Mausoleum and of the Theatre of Marcellus.[9] No other author before or since was capable of visions of grandeur that could so excite and inspire the enthusiast. He alone, as Robert Adam wrote, might be said 'to breath the Antient Air'.

127

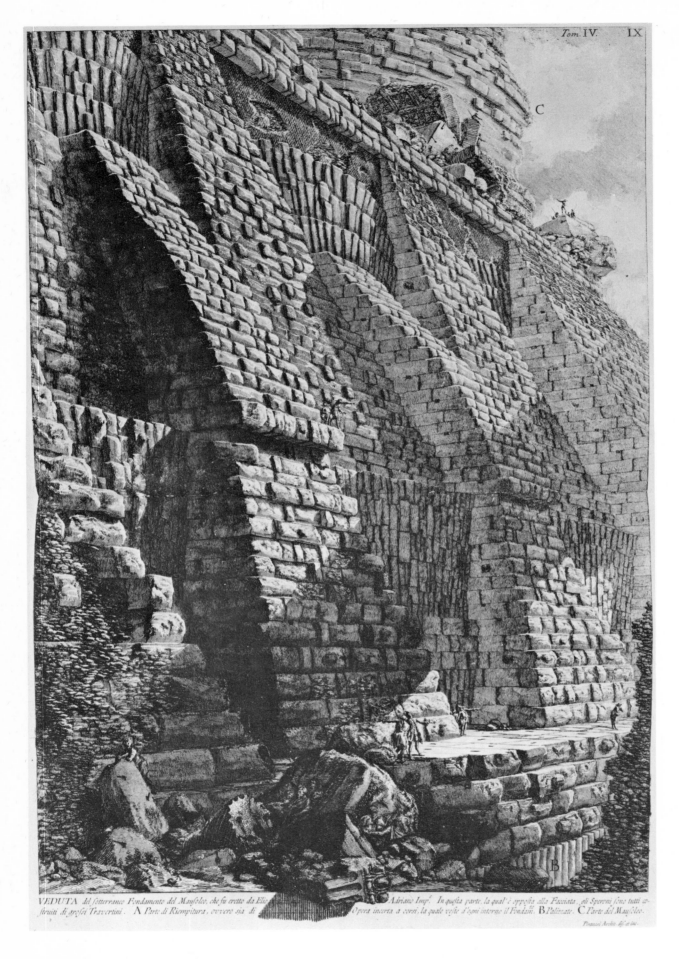

VEDUTA *del sotterraneo Fondamento del Mausoleo, che fu eretto da Elio* *Adriano Impe. In questa parte, la qual'è opposta alla Facciata, gli Speroni sono tutti co-* *struiti di grossi Travertini .* A *Parte di Riempitura, ovvero sia di* *Opera incerta a corsi, la quale veste d'ogni intorno il Fondam.* B *Palizzate.* C *Parte del Mausoleo.*

Piranesi Archit. diss et inc.

149. Foundations of the Castel S. Angelo, *Antichità romane* IV

128

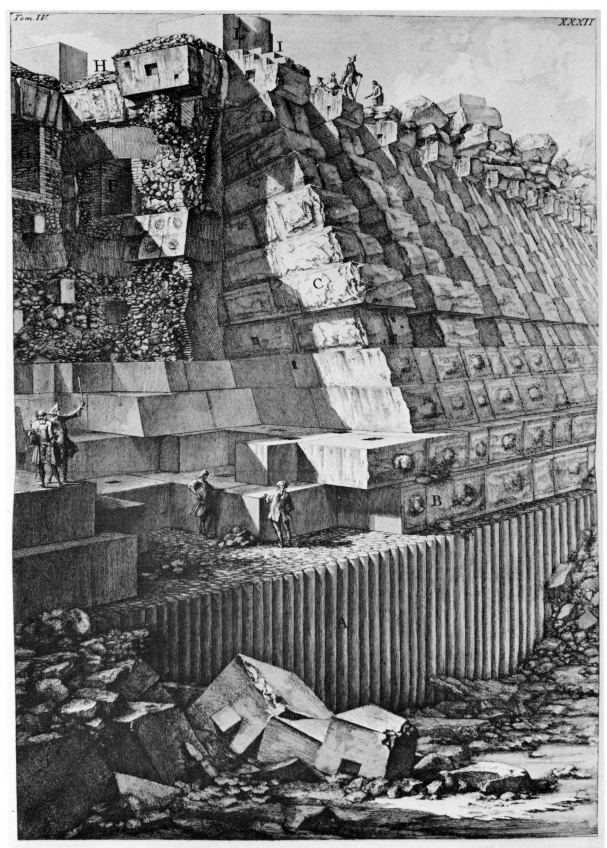

Veduta di una parte de' fondamenti del Teatro di Marcello

A. *Palizzate piantate nel terren vergine per sicurezza de' fondamenti.* B. *Base fondamentale di quattr' ordini di peperini.* C. D. *Speroni, ovvero barbacani.* E. *Fondamenti interni di opera incerta.* F. *Cloaca maestra sotto l'ambulacro de' portici destinata allo scolo delle immondezze, e delle acque piovane.* G. *Una delle cloache sotto i cunei del Teatro destinate al medesimo fine, e corrispondenti colle anzidetta.* H. *Lastrico dell' ambulacro suddetto.* I. *Dimostrazione de' tre gradi circolari esterni del Teatro, che incominciavano dal piano antico di Roma.* L. *Dimostrazione di una parte di uno de' pilastri del Teatro.*

Piranesi Archit. dis. et feel.

150. Foundations of the Theatre of Marcellus, *Antichità romane* IV

151. Ruins of aqueducts, *Antichità romane* I

*Avanzo del Castello dell'Acqua Claudia e Anione Nuovo A. In— —cavi per le fisto:
le dell'Acqua. B. Orificio di uno de' bottini. C. Segni de' corsi de' —— pilastri. D. Monu-
mento delle stesse acque a Porta Maggiore E. Avanzo del Condotto dell— —cque Marcia Tepula e Giulia
Piranesi Archit. dis. inc.*

152. Baths of Diocletian, *Antichità romane* I

*Veduta degli avanzi delle Terme Diocleziane, e Massimiane, colla odierna Chiesa, e Monastero de' P.P. Certosini, fabbricata
fra gli stessi avanzi: l'una indicata colla lettera A, l'altro colla B
Piranesi Architett. dis. inc.*

153. Baths of Titus, *Antichità romane* I

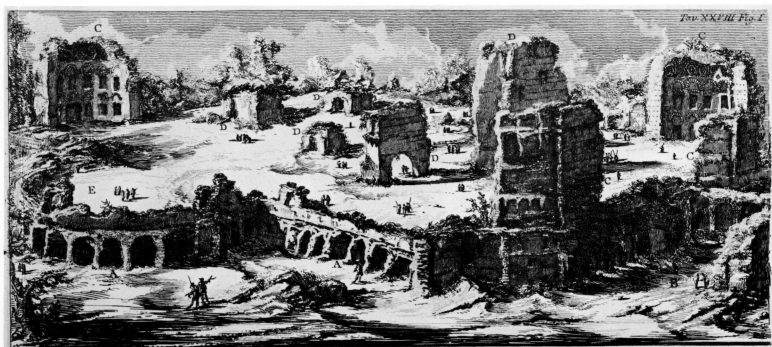

*Veduta degli Avanzi delle Terme di Tito. A Anditi del primo piano delle Terme. B Casa di Tito. C Emicicli del secondo piano
corrispondenti alla palestra. D Cella Soleare. E Teatro nel piano superiore
Piranesi Architett. dis. e inc.*

154. Forum of Trajan, *Antichità romane* I

Veduta del second' ordine di una parte della Calcidica del Foro di Trajano. A Porta antica appartenente al terz'ordine. B Muro moderno. C Giardino del S.r Marchese Ceva. D Fabbriche moderne sopra le rovine del Foro di Nerva. Piranesi Architetto dis. inc.

155. Trajan's Column, *Antichità romane* I

Colonna Trajana. A Ripari fatti dal Pontefice Sisto V. al moderno piano di Roma. B Chiesa di S. Maria di Loreto. C Chiesa del Nome di Maria. Piranesi Architett. dis. inc.

156. The Palatine from the Circus Maximus, *Antichità romane* I

A e B Veduta degli Avanzi delle Case de Cesari sul Palatino. C Avanzi della Casa Augustana. D Avanzi della Casa Tiberiana. E Avanzi della Casa Neroniana. F Luogo ov'era il Circo Maßimo. G Avanzi delle costruzioni de Sedili del medesimo Circo. H Marana o sia Acqua Crabra. Piranesi Archit. dis. inc.

131

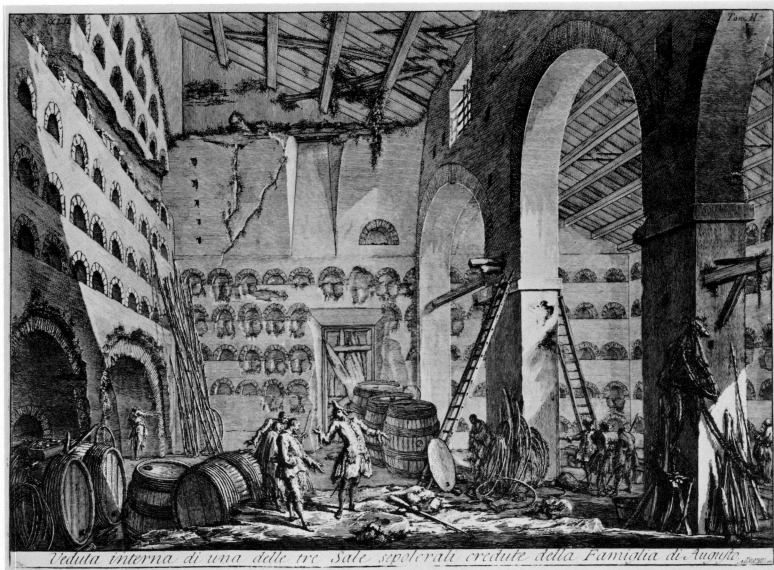

XLII

Tom. II

Veduta interna di una delle tre Sale sepolcrali credute della Famiglia di Augusto.

Questa Sala sepolcrale spogliata non solo di tutti i suoi ornamenti più riguardevoli, ma ancora d'ogni pezzo di marmo, e della stessa intonacatura, resta per la maggi.
parte sepolta sotto il terreno, come lo dimostrano i due nicchioni, che si scorgono da un lato. Veggonsi girar intorno le pareti con ordine distribuiti i Colombai senza veruna iscri-
zione, anzi nemmeno vi apparisce alcun segno d'esservene stata giammai. La ragione di questo però è facile a conietturarsi, essendo caduta affatto da muri l'intonacatura, dentro la qua-
te sol tanto incassate erano le tavole delle Iscrizioni, ne si permetterà lo scavare il muro in conto alcuno, per non indebolirlo, sull'idea, che questi antichi avevano di perpetuar le loro
Fabbriche, e particolarmente quelle de' Sepolcri, a bello studio fatte per custodire in perpetuo le ceneri ivi riposte. Con che essi credevano non solamente di tramandare a posteri
per tutte l'etadi avvenire la memoria de' loro defonti; ma ancora di mantenere all'Ombre di quelli ne' Campi Elisii un più sicuro riposo. Ora serve questa Sala per uso di Tinello.

Piranesi Architetto fece ed inc.

157. Tomb of the household of Augustus, *Antichità romane* II

VEDUTA dell'Ingresso della CAMERA SEPOLCRALE di L. ARRUNZIO e della sua Fa-
miglia. L'Anno 1736 nello scassare una vigna, situata a mano sinistra prima d'uscir
da Porta maggiore furono scoperte da Fran.co Bolardi Affittuale molte Camere sepolcrali le quali sono
state demolite a riserva della presente, e d'un altra a questa vicina conservate ad istanza dell'Antiquario Ficoroni
In questa per tanto contigui alle pareti, le quali sono d'opera reticolata, veggono inalzati molti Sepolcri di varia gran-
dezza e costruttura, per la quale, come ancora per la forma alterata de Caratteri delle Iscrizioni apposte a ciascun

LIBERT. ET
FAMILIAE
I. ARRVNTI·L·F
TER

de medesmi danno a divedere d'essere stati fabbricati in secoli diversi. Ogni Sepolcro secondo la sua capacità
contiene due quattro e più Olle nelle quali furono riposte le ossa e le ceneri de corpi abbruciati. Negli Angoli poi
e quà e la sparsi, furono trovati de Sarcofaghi con dentro, gli scheletri, dall'Urne di marmi preziosi, de Cine-
rarii, de Cippi, Are funebri, Vasi lacrimatori, Teschi coperti di tavoloni di cotto, e molti altri sepolcrali
monumenti. Nell' esterno della Camera era situata la qui interposta Iscrizione, la quale in ogni caso resta nulla
nuova entrata, per cui si discende nella stessa Camera.

158. Tomb of L. Arruntius, *Antichità romane* II

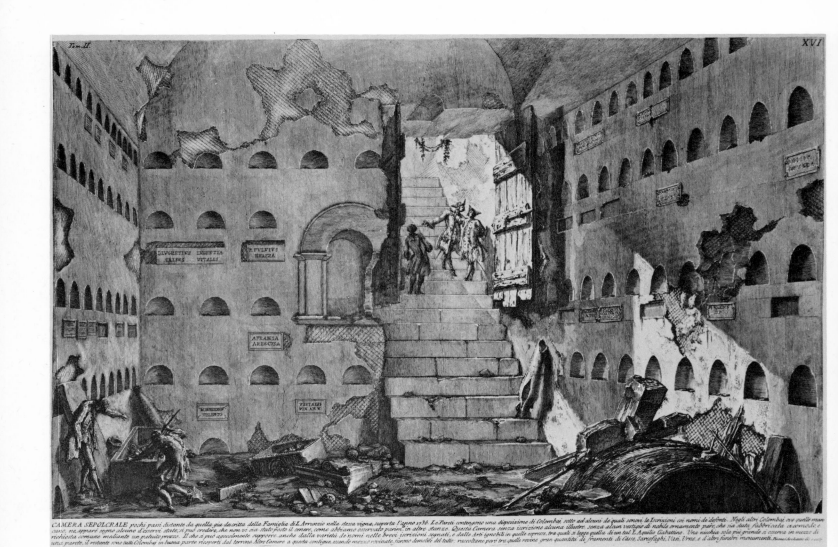

159. Communal tomb, *Antichità romane* II

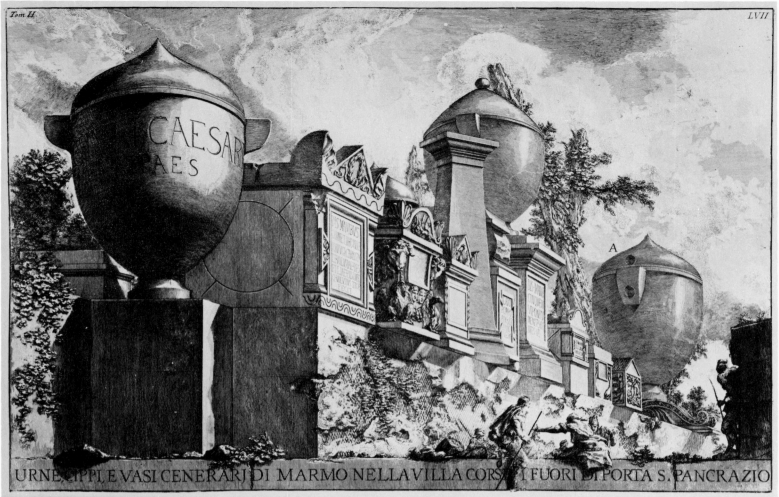

160. Cinerary urns from the Villa Corsini, *Antichità romane* II

VEDUTA dell'Avanzo del Sepolcro de'Scipioni, fuori di Porta S.
spogliato delle sculture de'marmi, che lo coprivano, e d'ogni altro suo Or
Nicchie poi disposte in circonferenza, l'altezza del vano delle quali è

161. Tomb of the Scipios, *Antichità romane* II

A

pra l'antica Via Appia nella Vigna in faccia alla Chiesa; Domine quò vadis. Questo rinomato Edifizio in oggi resta, come si vede, non solam.^{te}

ra nel Finimento di sopra è del tutto rovinato. Fu ridotto ne' secoli bassi ad uso di Fortezza, come lo dimostra la Torricella A, piantata nel mezzo del gran Masso. Le

larghezza, contenevano per avventura de' Cippi, dell'Urne, de' Vasi cenerarj, e d'altri consimili Sepolerali Monumenti. Piranesi Archit. dis. ed inc.

OSSA
AGRIPPINAE·M·AGRIPPAE
DIVI·AVG·NEPTIS·VXORIS
GERMANICI·C·CAESARIS
MATRIS·C·CAESARIS·AVG
GERMANICI·PRINCIPIS

162. Ruins of the Tomb of Augustus, *Antichità romane* II

VEDUTA degli Avanzi di Fabbrica magnifica sepolcrale co'sue Rovine, la quale si vede vicina a Torre de'Schiavi un miglio e mezzo in circa
fuori di Porta Maggiore

Piranesi Archit. del. et inc.

163. Tomb in the Campagna, *Antichità romane* II

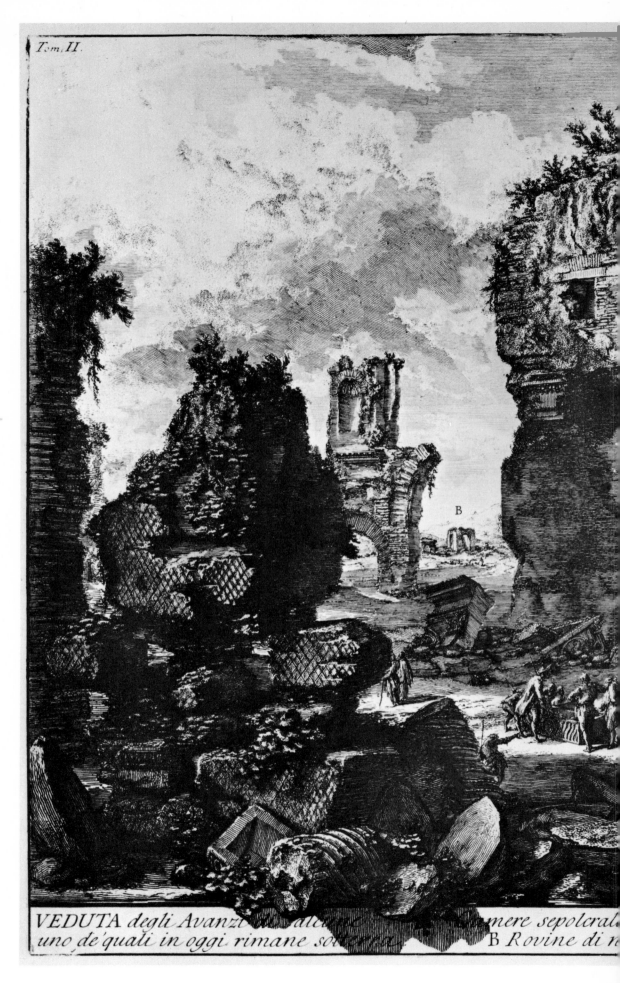

B

VEDUTA degli Avanzi *di alcun**e* *C**a**mere sepolcral**i*
uno de'quali in oggi rimane so*tterra* B *Rovine di* *r*

164. Tombs on the Appian Way,
Antichità romane II

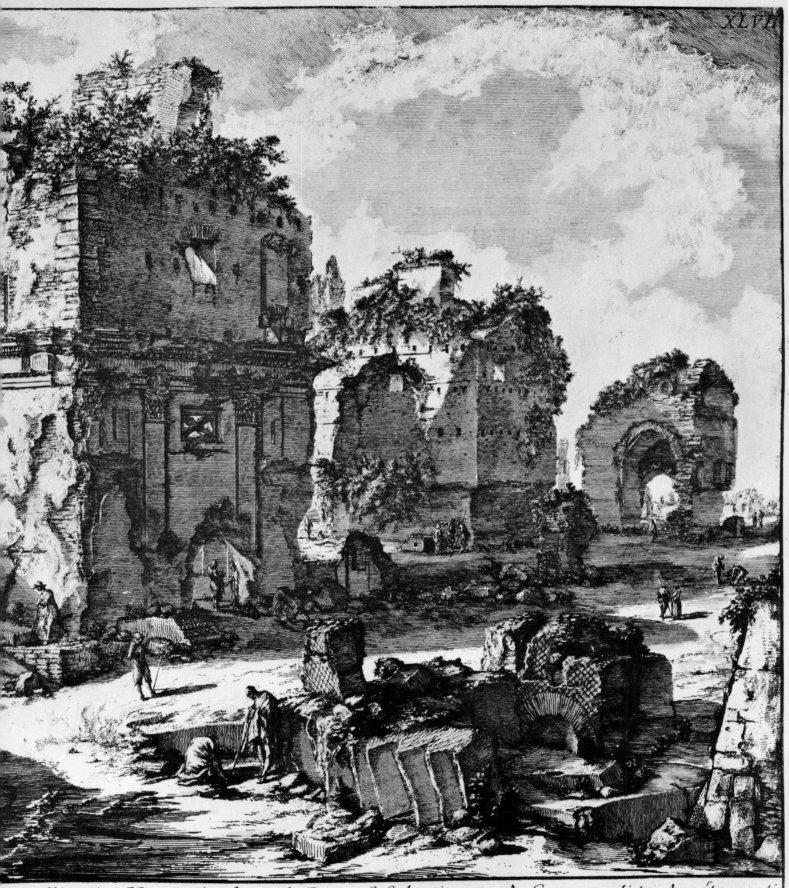

XLVII

ti sull'antica Via Appia fuori di Porta S. Sebastiano. A Camera di tre Appátamenti,
na Villa degli antichi Romani. C Selci dell'antica Via Appia.

Piranesi Architetto dif. ed inc.

VEDUTA *degli Avanzi sopra terra dell'antico Ustrino, e delle Fabbriche pertinenti al medesimo. 1 La grand'Area dell'Ustrino. 2 Muraglia costruita di corsi di grossi Peperini, la quale circondava la grand' Area. 3 Altra parte di Muraglia quasi del tutto rovinata. 4 Avanzi de Portici dinanzi all'Ustrino. 5 Rovine, e Frammᵗⁱ di Fabbrica, contigua alla Muraglia dell'Ustrino: la qual Fabbrica serviva di abitazione à Custodi, et ad altri Ministri. 6 Torricella moderna, fabbricata sulle rovine dell'Ustrino. 7 Rovine di un Sepolcro antico.*

Piranesi Archit. del. et inc.

165. Crematorium on the Appian Way, *Antichità romane* III

142

VEDUTA di un gran Masso, Avanzo del Sepolcro della Famiglia de' Metelli sulla Via Appia cinque miglia in circa fuori di Porta S. Sebastiano nel Casale di S. Maria Nuova . Queste nobile Sepolcro fu spogliato non solamente de' suoi più magnifici ornamenti, ma ancora d'ogni altro marmo, che lo copriva, e fu talmente scavato all'interno nella parte di sotto presso terra, che sembra miracolo a vedersi come possa sussistere quasi affatto per aria una mole sì grande. A Avanzo di muro reticolato, il quale può credersi, che servisse di recinto alla Villa de' Metelli, dentro la quale, era fabbricato il Sepolcro, acciòcche fosse meglio custodito. B Altri Avanzi de' Sepolcri

Piranesi Archit. del inc.

166. Tomb of the Metelli, *Antichità romane* III

143

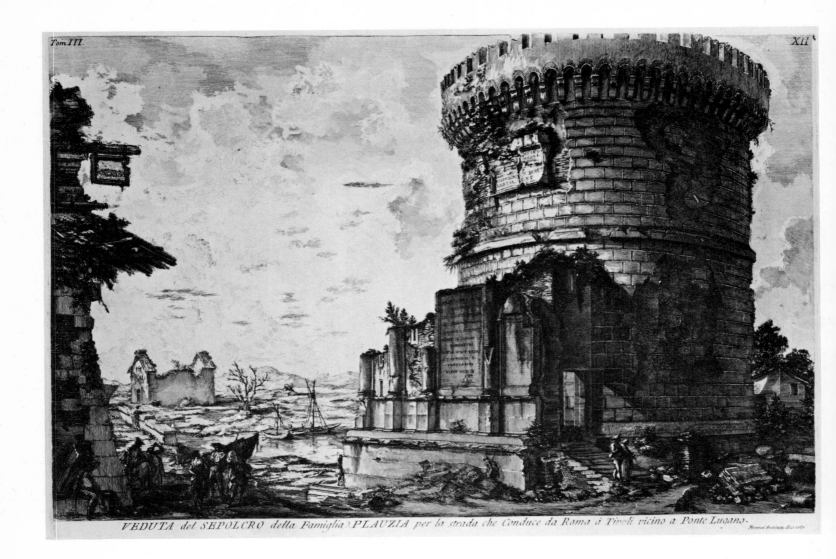

VEDUTA del SEPOLCRO della Famiglia PLAUZIA per la strada che Conduce da Roma à Tivoli vicino a Ponte Lugano.

167. Tomb of the Plautii, *Antichità romane* III

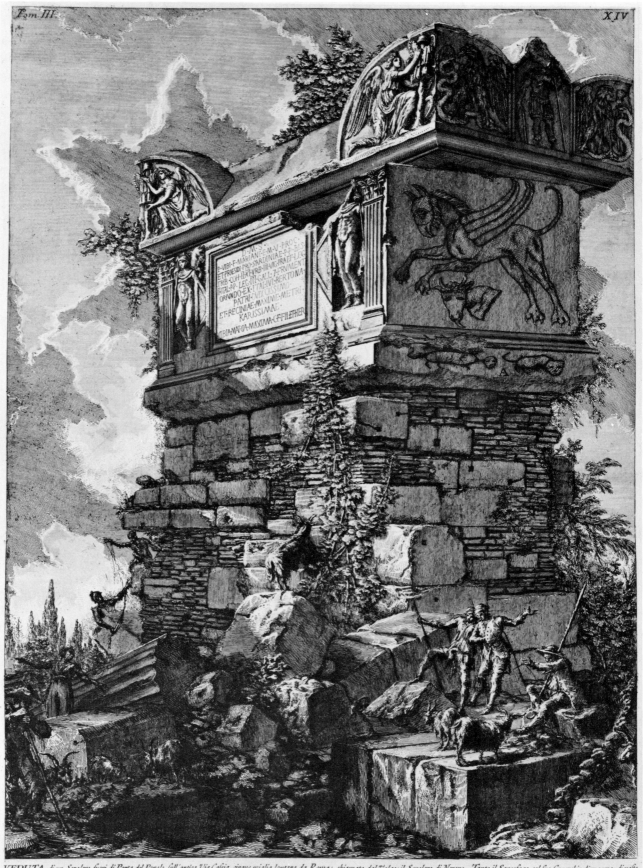

VEDUTA di un Sepolcro, fuori di Porta del Popolo, sull'antica Via Cassia, cinque miglia lontano da Roma; chiamato dal Volgo: il Sepolcro di Nerone. Tanto il Sarcofago col suo Coperchio di marmo di vasta mole, quanto i grossi Pezzi di Tufo, e d'altre Pietre, i quali si veggono giacere ivi d'intorno, danno a conoscere, ch'egli sia stato un superbo Mausoleo. Le Sculture però del Sarcofago, sono di mediocre Scalpello, come le due Figure a lato all'Iscrizione in piedi di Castore e Polluce, ovvero di Alessandro, che doma il Bucefalo: le due Vittorie alate in atto di appendere due Trofei militari, scolpite verso gli angoli del gran Coperchio: delle stesso merito sono l'Aquile, che lottano co Serpi, e l'uomo armato con asta e scudo in mano, nel lato del Coperchio sfregati. Il Griffo poi nel lato del Sarcofago, e la testa di Toro, che gli sta sotto, rilevanti un mezzo sito in piano, sembrano piuttosto grotteschi d'ordinarie Artefice. Ma questi Animali informi, segnati, A, nella Base dell'Urna sono affatto puerili, e potrebbe credersi, che fossero stati graffiati ivi da qualche oziofo bifolco. Piranesi Archit. del et inc.

168. The so-called Tomb of Nero, *Antichità romane* III

145

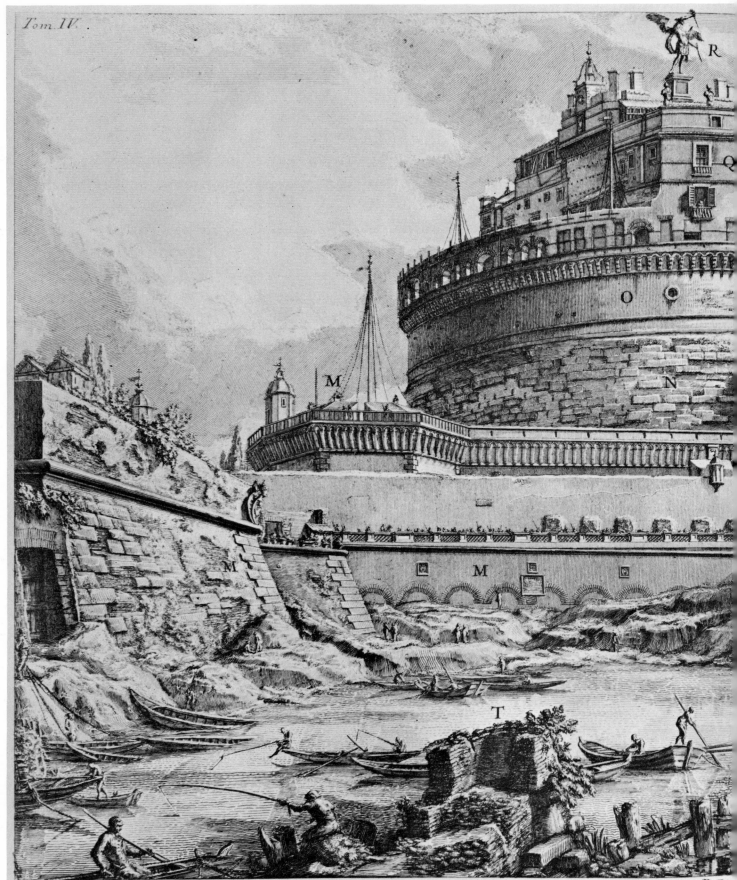

VEDUTA *del Ponte, e del Mausoleo, fabbricati da Elio Adriano Imp.* A *Speroni, o Contraforti semicircolari del Ponte nella parte dietro al corso dell'acqua.* B *Pile derno fabbricato sopra l'Arco antico.* G *Speroni contra la corrente.* H *Cloaca antica del Mausoleo, la quale scaricavasi nel Fiume.* I *In questa parte il Piano del Pon i Confini delle moderne Regioni.* M *Recinti di Mura, e Baloardi, fabbricati da sommi Pontefici in diversi tempi.* N *Masso antico, oggi chiamato il Maschio.* C per condurre l'acqua di Mulini. T *Rovine antiche.* V *Il Pelo più basso dell'Acqua per ordinario nel Mese d'Agosto d'ogni Anno.*

169. Castel S. Angelo, *Antichità romane* IV

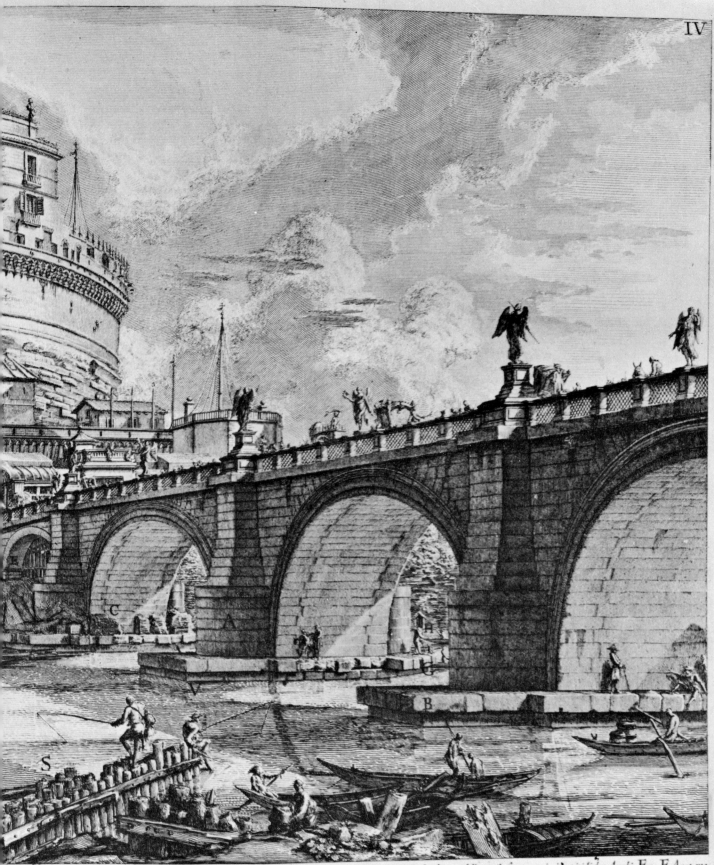

IV

ni di Mutelli di mattoni fatti da moderni per riparo. D Arena portata dal Fiume in tempo dell'escrescenze, della quale sono quasi riempiti li due Archi E. F Arco mo-
due Archi è stato alzato per renderlo pari al Piano moderno della Città. K Corpo di Guardia reale, per cui entrasi nel Castello. L Una delle quattordici Pietre, le quali segnano
toni sopra il Masso antico. P Arme di Alessandro VI. Q Parte dell'Abitazione del Castellano. R Angelo di metallo posto in centro del Maschio. S Palizzate

Piranesi Archit. dis. et inc.

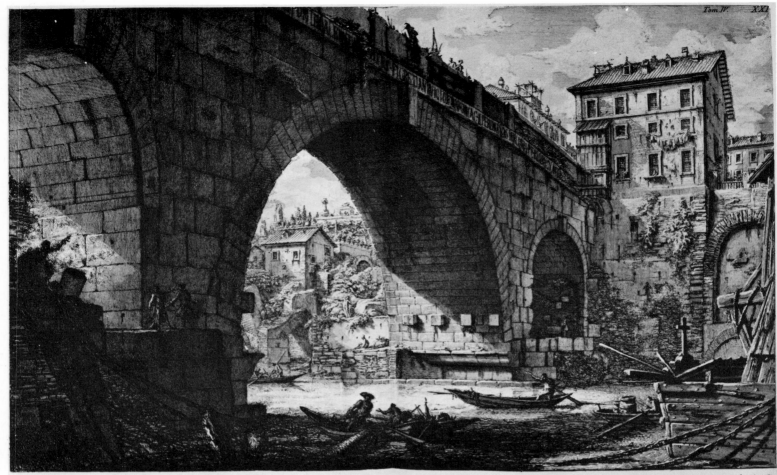

Veduta del Ponte Ferrato dagl' Antiquarj detto Cestio. Dalla parte verso la corrente 1. Sperone moderno 2. Case, ed Orticelli nel Trastevere 3. Rovine di fabriche antiche 4. Catene, che tengano ferme le barche, su le quali si macina il grano 5. Pelo d'acqua in tempo d'Agosto

170. Ponte Ferrato, *Antichità romane* IV

171. Gate inside Castel S. Angelo, *Antichità romane* IV

CHAPTER SIX

The Greek Controversy

IN the five years following the publication of the *Antichità* Piranesi continued his archaeological studies, particularly in connection with the ruins surviving in the Campus Martius and with the aqueduct systems, and he produced some twenty more large *Vedute,* completing the series of the seven pilgrimage basilicas and adding a number of the main palaces as well as some bolder, darker views of antiquities, the Arch of Titus *(318),* for instance, and the powerful rhythmic arcades of the Colosseum. Towards the end of this period he also republished the new edition of the *Carceri.* Increasingly, however, his energies were being diverted to a campaign against the rising influence of the philhellenes. Once again he was involved in a battle of books but this time his opponents were of far higher calibre than Parker and Charlemont, while his own allies had more enthusiasm than judgment and brought up artillery that was as apt to misfire as to reach its target. Eventually he was forced to abandon the exposed position into which he had entrenched himself and retire to an equivocal neutrality.

The battle of the styles, Greek versus Roman and Gothick versus Greek, fought with all the fervour of religious wars, seems infinitely remote to our styleless age. In any case, the conventional wisdom of our nineteenth-century forebears has imposed itself so firmly upon us that, although we no longer canonise Pericles as the first propounder of the ideals of the British empire nor Plato as the exponent of our educational system, we still respond to Byronic calls for Greek liberty and, on a different and less emotional level, we do not question the primacy of the artistic achievements of fifth-century Greece over the subsequent triumphs of Rome. Such attitudes are a complete reversal of the earlier consensus. The literature of Greece had been read and admired since the Renaissance, but Greek art and architecture were relatively unknown. To make things worse, chronology was so sketchy that Greek was a generic term that swept in the cumbersome work of the Byzantines. Rome was the unchallenged source of all that was worth imitating.

Ignorance, not prejudice, was the cause of this neglect. The whole of the eastern Mediterranean and, following the expulsion of the Venetians from the Peloponnese in 1717, all Greece as well were part of the Ottoman empire, ruled by the unreliable pashas of the Sublime Porte. It was not easy to secure a *firman* or passport from Constantinople and pestilence, brigands and slave traders were real hazards. As a result, Hellenic antiquities were seldom visited and there were no proper illustrated records of them. As the political situation became more settled in the aftermath of the Venetian wars, eighteenth-century travellers and, in particular, the bibulous but intrepid members of the British Dilettanti Society began to extend their tours from a circuit of Italy and Sicily to Greece and the Levant. As we have seen, Lord Charlemont, who was an early traveller to such parts, took Richard Dalton with him on his expedition and Dalton's resultant *Museum Graecum et Aegypticum,* published in 1751, was one of the first books to describe the monuments of Athens in any detail. Also in 1751, after three years of preparation and fund raising, James ('Athenian') Stuart and Nicholas Revett, with Dilettanti support, set off for a tour of Greece, embracing the west coast, Corinth, Megara and Athens. They spent three years among those 'professed enemies to the Arts', the Turks, 'whose ignorance and jealousy make an undertaking of this sort still somewhat dangerous', but they returned with the first accurately

measured drawings of the buildings of Athens. Unfortunately, since Revett lacked ambition and Stuart sobriety, the first volume of their *Antiquities of Athens* did not appear until 1762 and the second until 1789.[1] This delay enabled Julien David Le Roy, a former scholar of the French Academy in Rome, to make a quick visit to Athens in 1754 and publish four years later an inaccurate but illustrated account of the principal ruins under the title of *Les Ruines des plus beaux monuments de la Grèce.*[2]

Le Roy came forward as a resolute champion of the Greeks; above all he singled out their simplicity, quoting Montesquieu: 'A building loaded with ornaments is an enigma to the eyes, as a confused poem is to the mind.' Roman architecture, he claimed, derived from the Etruscan, which in its turn was derived from the Doric. 'The Romans did not approach perfection in the Arts before they started to mix with the Greeks . . . it seems that the Romans lacked that creative genius by which the Greeks made such great discoveries; they invented no new order of note, the Composite which they claimed to have invented being only a poor mixture of the Ionic and the Corinthian.' In this Le Roy was only following his patron, the great connoisseur and scholar, the Comte de Caylus, the first of whose seven volumes of *Recueil d'antiquités Egyptiennes, Etrusques, Grècques Romaines et Gauloises,* had appeared in Paris in 1752.[3] The *Recueil* consists of detailed notes on a large number of plates of statues, cameos and other antiquities, but in his introductory essays Caylus expanded his general theories. He traced Greek art back to that of Egypt but 'the Greeks diverged from the taste for the grand and the immense of which the Egyptians provided examples. They reduced the scale and added elegance and harmony in the details. To these foundations of art they united grace and those masterly liberties which are only achieved by a rare intuition, an intuition which we find that the Greeks continued to possess for several centuries.' Caylus was not quite sure whether the Etruscans imitated the Greeks, albeit deviating from their 'noble simplicity' or whether they invented their Tuscan order simultaneously but independently. He insisted, however, that Roman art was wholly derivative; the Romans were only introduced to civilisation after their sack of Corinth in 146 B.C., and, being preoccupied with affairs of state, they 'almost always left to their slaves the study and practice of fine arts which came to them from the Greeks. And what could they expect from the artists they had bought since their genius had been stifled with the loss of their freedom? . . . As a result Roman taste is generally ponderous and flabby, without delicacy . . . and almost all the works of any elegance in Rome are owed to the Greeks.'

Vue du Temple d'Erecthée à Athènes.

172. J. D. Le Roy, View of the Erectheum, Athens

Piranesi must have come across the heresies of Caylus through his friends in the French Academy and he had clearly read the *Recueil* (although he only quotes favourable passages from it in his own work) but it was Le Roy's book that was the main target for the first cannonade of his angry polemic, *Della Magnificenza ed Architettura de' Romani*. Since he owed his name and fortune to the antiquities of Rome, and since he had never visited Greece and was unable to conceive that any other nation could have produced architecture superior to that of the Romans, he weighed in heavily in defence of his adopted city. He also took the opportunity, while he was about it, of attacking a harmless and probably by then quite forgotten pamphlet, *A Dialogue on Taste,* which his friend, the Scottish artist, Allan Ramsay, had published anonymously under the pseudonym of 'The Investigator' in 1755. Ramsay had originally come to Italy in the 1730s to study painting under Imperiali in Rome and Solimena in Naples but in 1754 he returned for a second visit to Rome where he lived, to the faint surprise of his friends, on the quiet and unfashionable Viminal hill. He was a frequent dinner companion of his fellow countryman, Robert Adam, during the latter's Roman stay, and no doubt the pamphlet was the topic of cheerful disagreement among their circle.[4]

It takes the form of a dialogue between Colonel Freeman, a whimsical propounder of iconoclastic paradoxes, and the conventional Lord and Lady Modish and Lady Harriot. Freeman declares that there are no absolute standards of taste, rules being 'no more than the analysis of certain things which custom has rendered agreeable. . . . I should be exceedingly glad', he continues, 'to hear the reason why a Corinthian capital clapt upon its shaft upside-down should not become, by custom, as pleasing a spectacle as in the manner it commonly stands.' Taste is only a matter of what we are used to, and, he explains, 'in history we shall find that every nation received its mode of architecture from that nation which, in all other respects, was the highest in credit, riches and general estimation'. He follows Caylus' account of architectural evolution, ending with the subjugation of Rome by the arts of Greece. 'An admiration to a degree of bigotry seized the Roman artists and connoisseurs, and put an effectual stop to any further change or improvement in architecture. Their sole study was to imitate the Grecian buildings and the being like or unlike to them became soon the measure of right and wrong. Rules so compiled were committed to writing, and continue to this day . . . to be the standard of taste all over Christendom . . . There is almost nothing which can be imagined to give it a total overthrow, unless Europe should become a conquest of the Chinese.'

Ramsay's pamphlet had caused little stir and Le Roy's work was acknowledged to be full of inaccuracies. The heavy bombardment of *Della Magni-*

173. Villa Albani, *Vedute di Roma*

174. Tempietto Greco, Villa Albani

ficenza was intended to reach a further target. Piranesi was bidding defiance to a new protagonist behind the Greek lines whom he does not mention by name, Cardinal Albani's new librarian, the abbé Winckelmann.[5]

This brilliant and complex character had arrived in Rome in 1756, the year of the publication of the *Antichità*. Son of a poor Prussian cobbler, he had drudged away his early life as an assistant schoolmaster and it was not until 1748, when he was already thirty-one, that he gained his first scholarly post as research assistant to a dull historian of the Holy Roman Empire. Six years later he moved to Dresden where, at last, he was exposed to a collection of genuine antiquities and works of art. The excitement of this contact generated the brief essay which immediately made his reputation, *Gedanken über die Nachahmung der Griechischen Werke in der Malerey und Bildhauerkunst,* published in 1755. Winckelmann was an enthusiast for Greek art, especially for Greek sculpture, and, above all, for the sculpture of the male nude on which he rhapsodised with passionate homosexual enthusiasm. The following year, reckoning that Rome was worth a mass, he joined the Roman Catholic church to secure his financial position and moved to the holy city as librarian, first to Cardinal Archinto and then to Cardinal Albani.[6] He was given lodgings in the latter's palace in the Via Quattro Fontane on the Quirinal. Alessandro Albani, the nephew of Pope Clement XI, had started life as a soldier, but was taken into the church as a cardinal at the age of twenty-nine. He was not a very ardent churchman and turned his energies to his collections, first of coins which he sold to Innocent XIII and Augustus the Strong of Saxony in the 1720s, then of old master drawings, which James Adam managed to acquire on behalf of George III in 1762, and finally, his chief love, of an enormous quantity of antiquities. To house these he started to build a suburban villa *(173)* with Carlo Marchionni as architect in 1746.[7] The villa was nearing completion when Winckelmann joined his household and he may well have influenced the conception not only of Raphael Mengs' stilted *Parnassus* on a ceiling inside, but of the two *tempietti Greci* and the ruined temple which completed the ensemble of what he considered 'the most beautiful building of our time'. These garden follies, two attached to the wings of the villa and the third standing in picturesque ruin elsewhere in the grounds were probably built around 1760. They are partly composed of genuine antique fragments, but their scale and fussy over-decoration are very far removed from the rugged solidity of the genuine article at Paestum or Athens. Piranesi did not consider them worth mentioning in the *Della*

175. Angelica Kauffmann, Portrait of Winckelmann

Magnificenza (indeed it would not have been tactful to do so in view of the protection given him by Albani during the Charlemont affair) but if he took them as being truely representative of Greek architecture they cannot have improved his opinion of the Greeks.

Since coming to Rome Winckelmann had published several essays on sculpture and one, in 1759, *Anmerkungen über die Baukunst der alten Tempel zu Girgenti in Sizilien,* on the Greek temples at Agrigento for which he had suborned one of Piranesi's protegés, the Scottish architect, Robert Mylne, to provide drawings of the ruins.[8] His influence and prestige increased rapidly. He was elected to the Academy of Cortona in 1760 and to the Accademia di S. Luca in Rome and the London Society of Antiquaries shortly afterwards. In 1763, he was to be appointed *Commissario delle Antichità della Camera Apostolica* or Papal Antiquary. The presence of this powerful champion for the philhellenes increased

176. Title page, *Della Magnificenza*

Piranesi's determination to rebut the Greek challenge and uphold the supremacy of Rome.

Della Magnificenza was finished early in 1760 and it received the *imprimatur* in May, but publication was held up until the following year because of delays in completing the portrait which was included of the Pope, to whom the work was dedicated. Such a delay was diplomatically necessary since, as Piranesi explained to Mylne in a letter, his 'sovereign beneficence had contributed 1000 Roman *scudi* towards the costs'. It is Piranesi's longest work, consisting of a hundred pages of verbose Italian text, with a Latin crib opposite for the international scholar, and forty illustrations in addition to the two title plates and the portrait of Clement XIII *(244)*[9] It was not, I am afraid a great success; Piranesi's polemic was muddled, pedantic and repetitious. He made as vigorous attacks on the trivial errors of 'The Investigator' and Le Roy as he did on their main thesis and, since he took quite seriously the whole of the light-hearted *Dialogue on Taste* (which, among other things derived Gothic architecture from the 'Parthian' minarets of Isfahan), he was constantly tilting at windmills. Worse still, in his efforts to show that the Etruscans were Rome's artistic mentors and not the Greeks, he ended up by denying that Greek architecture had any merits at all and extolling instead a squat and unappealing Tuscan style *(180)* even though, embarrassingly for his case, the Romans themselves had not thought that any examples of it were worth preserving.

The confused jumble of argument may not be Piranesi's sole responsibility. Bianconi, his obituarist, who was writing only a few months after he died, says that he wanted learned descriptions and research but lacked knowledge of Latin and Greek. 'He cleverly enrolled some eminent men of letters who, in admiration for his genius and his etchings, were not above working for him, composing texts to fit his excellent prints, and generously permitting him to publish them under his own name. These writers included Monsignore Bottari, the learned Jesuit father Contucci and various others. Huge volumes of prints appeared in Rome with scholarly dissertations under the name of someone who could hardly read them although he could explain them in his own way in conversation. But he ended up by putting off almost all these scholars either by his native intolerance and rudeness or because they were not prepared to adopt his extravagant ideas. Eventually Piranesi persuaded himself that these books, composed by so many distinguished hands, were entirely his own work and woe betide anyone who did not agree – even the true authors themselves. The only person who could always keep him in check to the day of his death was the noble Monsignore Riminaldi, auditor of the Rota. Like Neptune silencing Aeolus and the winds with a blow of his trident, his learning and his moderation had such control over him that he only had to raise his voice for Piranesi to fall silent.' Bianconi exaggerates and he was not an impartial commentator; before coming to Rome he had been court physician to Augustus III in Dresden where he had befriended Winckelmann and he was also a correspondent of the French scholar, Mariette, with whom Piranesi was shortly to cross pens in this controversy. Legrand adds to the list of Piranesi's learned friends Clemente Orlandi, the keeper of the Kircher Museum, and abbé Pirmei 'who lodged with him and was responsible for setting down his ideas for publication'.[10] To say that Piranesi employed ghost writers is not the whole truth. Draft notes for *Diverse maniere,* one of his later works, which survive on the back of a sheet of drawings show that he was fully capable of composing his own texts. It is highly probable, however, that the abbés to whom Bianconi refers provided the research into the ancient authors for suitable quotations in support of his arguments and they must have supplied whole passages of historical pedantry in some sections of *Della Magnificenza*.

In the first dozen or so pages Piranesi set out to prove from a minute examination of the ancient authors that the Romans did patronise the arts prior to their conquest of Greece, that their early buildings were not very elaborate only because they had a different order of priorities and that, in any case, they took

177. Cloaca Maxima, *Della Magnificenza*

178. Roman column capitals, *Della Magnificenza*

179. Roman column bases, *Della Magnificenza*

their architecture, painting and sculpture from the Etruscans and therefore their art was indigenous to Italy. He then jettisoned his scholarly apparatus and produced a more original line of argument. Almost inevitably the temples and basilicas of republican Rome had all been swept away and rebuilt in imperial times. There were, however, a number of engineering works which, because of their practical nature, survived untouched from the republican era and, more significantly for his argument, from before the conquest of Greece. The most important of these was the Cloaca Maxima or Great Drain which carried the sewers of ancient Rome from the Forum out into the Tiber where its opening can still be seen near the Ponte Rotto much as he illustrated it. He was very impressed both by its size (it was large enough to take a hay waggon) and by the regularity of the stonework and he drew the conclusion that 'if Tarquin thought that something which was to be built underground and which was to carry the drains of the city, should be built with such magnificence and elegance and strength and with all the rules of architecture, the magnificence and perfection of a work that everyone was to see would obviously have been far greater'. Similar engineering feats were the city walls, built with blocks of stone each of which was as much as a cart could carry, the excavation of the Circus Maximus, the substructure of the Capitol, and, especially, the aqueducts and the paved road system. In another passage he added the tunnelled drain of Lake Albano.

Vitruvius said that strength, usefulness and beauty were the three main requirements in architecture. The Romans had obviously constructed immensely strong and very useful public works and Piranesi argued that they were also beautiful. 'There remains the question of beauty. I believe that in building this comes about from giving to the whole work a form that is fitting and attractive, and in distributing the parts with such advantage and elegance that they combine with one another in a manner that produces a certain natural beauty and which attracts the admiration of the onlooker. But I believe that one should principally consider the nature and purpose of a work because, just as beauty in children differs from beauty in adults, so one should use ornamentation more sparingly in buildings which require an air of severity and dignity because their very dignity and grandeur provide a form of decoration. On the other hand a less sparing use of ornamentation in buildings intended for pleasure would not be a cause for complaint. If we consider the nature and purpose of the Roman aqueducts and if we examine them as a whole and in their parts, who could not agree that they have all the beauty required in such a work? And who would not agree that there is beauty in the sewers rather than a lack of it?' This enthusiasm for the elegance of a drainage system must have seemed decidedly odd to Piranesi's contemporaries but the sentiments are an echo of padre Lodoli's functionalism. Piranesi agreed that the Romans decorated some of their buildings but this decoration was simple, in the Etruscan fashion, and the ornaments were only of terra cotta. He defended this simplicity quoting his opponent Caylus: 'Luxury in the arts is almost always the enemy of taste; it dazzles vulgar minds but makes only a slight impression on true connoisseurs.'

He took up this argument again later on. 'The Greeks in their use of decoration, their division of the parts of a building and their carving achieve an empty grace but no impression of dignity. There is no species of bush or tree which they do not cull for their architectural ornaments; every kind of fruit or flower or animal appears in their friezes; every kind of animal skin or trophy or whatever else fancy may suggest is to be found carved on their pedestals and architraves . . . It is as realistic, to use Horace's words, as painting a cypress tree in mid ocean while depicting a shipwreck. Such things are the opposite to what one should put there, and thus to architectural truth and, I will add, to decorum. . . . I know that the use of such decoration was introduced from the earliest times, that is to say, from the date that architects first started to treat the caprices of the Greeks as gospel. . . . The church of S. Marco in Venice, built in the tenth century, gives abundant specimens of such inventions; it is decorated with an infinite number of columns,

capitals, cornices and marble panels, which were once in Greece. It is easy to judge from such examples how irregular was the Greek architectural genius. . . . In Rome also there are many similar things to be seen which have either been brought from Greece or were designed by Greek architects, and I have collected some of them in my *Antiquities of Rome* while others are illustrated in Plates VI to XX.'[11]

Poor Piranesi! The spoils of Byzantium looted by his Venetian forebears during the fourth crusade were completely irrelevant to the debate with Le Roy. He was hopelessly muddled. While his text argued for the grand simplicity of the Romans, the whole sense of the fifteen plates which illustrate the supposed debasing influence of the Greeks points directly the other way. He had lovingly compiled a glossary of the most ornate and inventive column capitals and bases he had found in Rome either in private collections or stripped from their original temples and re-erected in churches, and he compared them with the far less elaborate equivalents illustrated by Le Roy from the ruins of Athens and Delos *(178, 179)*. In fact these plates could well be taken from his earlier work *Trofei di Ottaviano* 'useful for painters, sculptors and architects'; they were certainly intended to be examples of 'the magnificence of the Romans' whatever his text says. Perhaps the uncleared confusion can be blamed on the abbés. Despite the angry polemics at least in the illustrations he could keep his sense of humour: in Plate XX, where he contrasts with Le Roy's Ionic capital ten elaborate variations to be seen in Roman churches, he inserts without comment an illustration of the *Bocca della Verità* or Mouth of Truth from S. Maria in Cosmedin *(178)*. This ancient drain cover in the form of a human face is supposed to bite off the hand of any liar rash enough to put his fingers in its mouth – a novel challenge to the philhellenes! With another characteristic gesture he imprisoned a solitary Doric column in the last of the *Carceri* plates which he was reworking at this period *(117)*.

Since he firmly rejected the early influence of the Greeks, he had to attribute all Rome's architectural beginnings to their Etruscan neighbours in Tuscany who in their turn had learned from the Egyptians, dismissing any similarities between Greek and Etruscan art as being due to Divine Providence. It was rather awkward for him that the Romans themselves thought so little of their Etruscan masters' work that no example of the Tuscan order survived in Rome.[12] 'It was not that the Romans disliked Tuscan architecture, it was just that they liked something new. . . . Why do we buy vases of porcelain from far-off China when we have equally good and better worked silver ones? Is it because we do not care for silver? No. But silver vases are from our own country and the porcelain comes from abroad.' It is not a very convincing excuse. He went on, however, to reinterpret Vitruvius' description of a Tuscan temple and illustrate it with his own reconstruction. He seems to have felt that critics who complained that it was too low and squat had some justification and in fact all he could really say was that the Greeks sometimes used even stumpier columns.

Although much of the time he was on the defensive, warding off the attacks of 'The Investigator' and Le Roy on Rome, he also launched counter offensives against the Greeks. He criticised their building methods in lengthy and technical detail and with the help of numerous diagrams to show that the triglyphs and architraves of Doric temples are structurally illogical and thus bad architecture and, turning from the general to the particular, made mock of the caryatids of the Erechtheum on the Athenian Acropolis and the poverty of its Ionic capitals. As for the stocky columns of the temple of Apollo on Delos, he compared them to peasants in their sack-like smocks at harvest time. He was even able to call to his aid one of the principal philhellenes. 'I questioned Mr. Dalton on his return from Greece,' he wrote, 'and asked his opinion about the monuments. He told me with his usual frankness that the Caryatids were the work of a mediocre mason and that some of the remains of the reliefs on the tympanum of the temple of Minerva were beautiful, but that if everything else described by Le Roy were to

180. Reconstruction of a Tuscan building, *Della Magnificenza*

181. Reconstruction of a Greek building, *Della Magnificenza*

156

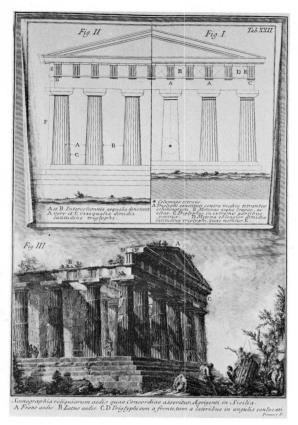

182. Temple of Concord at Agrigento, *Della Magnificenza*

183. Title page, *Osservazioni . . . sopra la lettre de M. Mariette*

vanish, lovers of the fine arts would suffer no loss at all.' So much for the Parthenon. In conclusion he reiterated Rome's superiority in all respects but one. He granted that Greek temples have grander stairs but stairs so impractically high that the less nimble must have had to bring their step-ladders to climb them, and he provocatively cited as an example the temple of Concord at Agrigento which Winckelmann had described two years before.

The artist should have stuck to his etching needle; as a scholar he was out of his depth and as an architectural critic he was blinded by prejudice. The Romans freely admitted their debt to the Greeks and the Etruscans, despite his denials, were much influenced by the arts of the Greek colonists who had settled in southern Italy and in Sicily. Not surprisingly Winckelmann writing to a friend in Hamburg in March 1762, dismissed Piranesi's publication as 'valuable for its illustrations but of little worth for the text which accompanies them'. Even the visiting tourists like Tobias Smollett were aware that the celebrated artist whose views of Rome they bought was 'apt to run riot in his conjectures, and, with regard to the arts of ancient Rome, has broached some doctrines which he will find it very difficult to maintain'. The only immediate effect of *Della Magnificenza* was to create the demand for a second edition of *A Dialogue on Taste*.

The polemic might have been forgotten but the whole affair was accidentally stirred up again a couple of years later. In November 1764 the Parisian *Gazette Littéraire de l'Europe* published a short essay by the French scholar and connoisseur, Pierre Jean Mariette, in which he gave a precis of *Della Magnificenza's* defence of the Romans and then repeated the standard French doctrine of Caylus that Roman architecture depended on Greek slaves and was decadently over-ornate.[13] It was a very slight essay of no originality and Mariette sounds as if he is telling the truth when he protests in a letter to Piranesi's friend, Bottari, that the *Gazette* published it without his knowledge and that he had the highest opinion of Piranesi's other work even if he did not agree with him on this issue.

Piranesi was extremely angry and rushed into print again with another pamphlet published in 1765 entitled *Osservazioni . . . sopra la Lettre de M. Mariette*, incorporating as well an essay entitled *Parere su l'Architettura* and *Della Introduzione e del Progresso delle Belle Arti in Europa* which was intended as a preface for a companion volume to *Della Magnificenza*[14]. The illustrated title page of the *Osservazioni* compares his own credentials, the architect's square, the mason's mallet and the artist's tools with Mariette's scholar's pen – held in the left hand! He then reprinted Mariette's essay in one column and, beside it, his detailed refutation, paragraph by paragraph, complaining, with some justification, that the Frenchman did not seem to have read *Della Magnificenza* properly.

Mariette was embarrassed by the turn the controversy had taken and wrote to Bottari complaining that he had not meant to attack Piranesi as the latter would have realised if only he had been able to understand French properly. 'I hope that my informant is wrong', he continued, 'in saying that the bitter note throughout his publication was not a plant from his own garden, but that he was covering up the weakness of others who are hiding behind the curtain to broadcast their paradoxes and make disparaging remarks with impunity. I am afraid that the retorts will land back on him. That is my view, but he need not worry about me. I value my peace and quiet too highly to get involved in arguments. . . .' This further hint at ghost writers supports Bianconi's remarks in the obituary and Mariette was in touch with the latest Roman gossip from the French Academy, but I feel that his informant was wrong. The *Parere* is far too individualistic a work. In fact it is probably the source of those 'extravagant ideas' which, according to Bianconi, made the scholars abandon their mouthpiece. It is notably free from learned quotations and it is a complete reversal of the attack on over-decoration propounded in *Della Magnificenza*.

Like *A Dialogue on Taste*, it is cast in conversational form, the protagonists being Didascalo or Pupil, Piranesi's advocate, and Protopiro or Novice, who is a supporter of the rigorist school which traced architecture back to first principles

and took as its starting point the primitive wooden hut. Protopiro says that he has just seen some of Piranesi's latest designs which he considers overloaded with decoration and inconsistent with his earlier attack on the mania for covering buildings with ornamental impossibilities. 'What are all those hippogryphs doing', he asks, 'and those sphinxes from the realms of mythology? The dolphins and lions and all the wild beasts from Libya?' He considers the only suitable decorative details to be those that develop from the structural components of the building like the triglyphs and modillions of the Greeks. Didascalo forestalls his criticism that Piranesi has 'abandoned himself in these designs to a crazy liberty of working as his fancy takes him. . . . You dictate to Architecture rules that it never had. What will you say if I prove that severity, rationalism and imitation of the primitive hut are incompatible with architectural principles?'[15] He proceeds to show that if the rigorists' argument is pursued to its logical conclusion so that all inessential features are stripped away, the result will be 'buildings without walls, without columns, without pilasters, without friezes, without cornices, without vaults, without roofs; an empty space, a space, just a bare field'. Nothing could be more monotonous than the rationalistic huts to which the rigorists wanted to return and architecture would be reduced, to quote Le Roy, to 'a vulgar trade restricted solely to imitation'. Didascalo insists on the importance of freedom in design with the qualification that ornaments should not be disproportionate to the building they decorate or to each other, and that they should have the right emphasis. 'In truth if these ornaments which are used in Architecture are beautiful in themselves, Architecture will likewise be beautiful.'

184. Drawing for *Parere*

The plates which illustrate the *Parere* (186–190) are some of the most extraordinary creations of the whole of the eighteenth century.[16] If the *Carceri* are one extreme of fantastic but unadorned architecture, the seven designs for decorated façades are at the bizarrest opposite end of the spectrum. Some of these structures, or fragments of structures, start from basic classical prototypes of pedimented or Pantheon-domed temples, others are solid blocks of window-less masonry; Piranesi then covers every inch of surface with boldly exaggerated ornamentation from Egypt and the tombs of the Etruscans as well as from the monuments of Rome – urns and sarcophagi, tragic masks, swags and wreaths and garlands, scallop shells, feathers and fans, lions' heads, gryphons, dolphins, snakes, trophies of arms, Pan's pipes, torches, fasces, pigs, peacocks, putti, a vast pair of sandalled feet, angels, dancers and sacrificial processions. He invented strange new architectural forms, amorphous wedges and cartouches, sculptural panels applied to the façade like advertisement hoardings, columns tapering at the base, bound up in fasces, with clawed feet and Janus capitals, and friezes of foliage that are laid in stripes across the buildings like the hemming of braid on a curtain. Decorative Pelion is heaped on the embellishments of Ossa, and the Apennines are added for good measure. The only comparable chaos of ornamentation that I know is to be seen in the golden Baroque façades of Lecce down in Apulia, façades which, like these designs, are a delightful curiosity rather than serious architecture.[17] Oddly enough the only building in Rome which bears any resemblance to Piranesi's creations, both in silhouette and in decorative detail, is the huge and hideous Synagogue, built in 1904, which dominates the old quarter of the Ghetto by the Theatre of Marcellus.

Why ever did Piranesi produce such extravaganzas? And why did he throw over the rigorist line he had adopted in the first polemic? I think that he was never a very convinced enthusiast for the simple style. It was just that the unadorned engineering works of the early Romans could be used to prove that a knowledge of architecture in Rome predated the conquest of Greece, and the argument for simplicity then carried him further than he intended. As we have seen, the plates of *Della Magnificenza* are at variance with the text. It was not that Piranesi disapproved of the simple style – after all he had only recently reworked the *Carceri* – but he much preferred the 'magnificence' of Roman ornament. He was not content, however, to be a passive copyist in 'a vulgar trade restricted

185. Temple of the London Society of Antiquaries, *Parere*

solely to imitation' as he contemptuously quotes Le Roy again on one of his façade *(189)*. Determined to escape the strict rules of his Palladian upbringing, he tried to create a new and original style by drawing together the most interesting decorative features from the whole of antiquity and rearranging them in novel patterns. 'They despise my originality, I their timidity' he quotes from Sallust on another façade *(186)*. Such a determination to find new forms was characteristic of the times (Blondel, Adam and Clérisseau all make similar assertions) but Piranesi was the boldest innovator – on paper at least.[18]

There was a further reason why he abandoned the rigorist camp. He was at this time undertaking his first major architectural commissions for the Pope's nephew, Cardinal Giovanni Battista Rezzonico, and, as a practising architect, he was clearly not interested in the abstract geometrics of a Boullée or a Ledoux. Finally there was the shadow of Winckelmann who had industriously produced a number of works of aesthetic criticism during this period. The German scholar, not surprisingly, was an advocate of unadorned simplicity. 'In architecture,' he wrote, 'beauty . . . consists principally in the *proportion:* for a building can become and be beautiful through that alone, without decoration.' In another passage he does agree that decoration is theoretically desirable, but he goes on to say that the increased use of ornamentation in antiquity coincided with a decline in taste. 'Architecture suffered the same fate as the old languages, which became richer when they lost their beauty . . . and as architects could neither equal nor surpass their predecessors in beauty, they tried to show that they were richer.'[19]

The designs of the *Parere* are Piranesi's answer to this indirect challenge. Decoration culled from the most luxuriant splendours of antiquity could be valid in its own right.

159

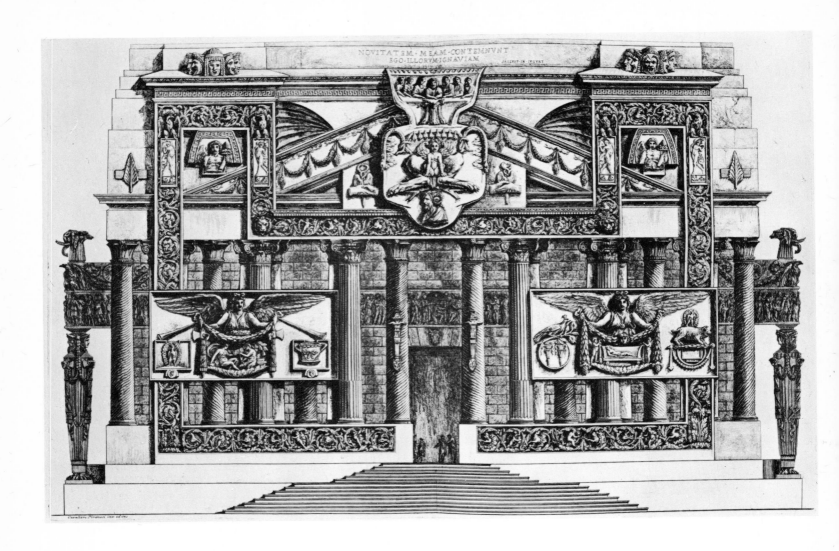

186. Architectural fantasy, *Parere*

187. Architectural fantasy, *Parere*

188. Architectural fantasy, *Parere*

189. Architectural fantasy, *Parere*

190. Architectural fantasy, *Parere*

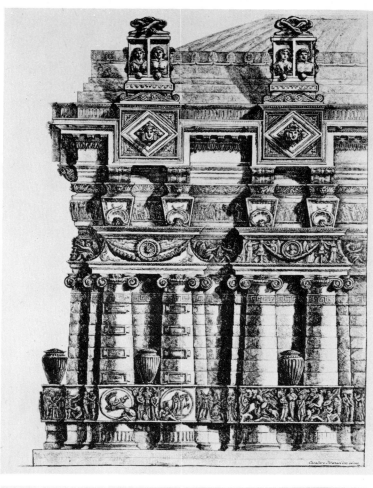

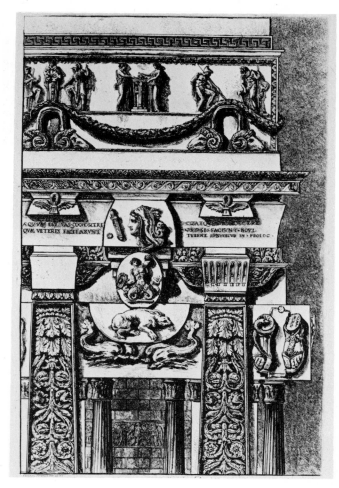

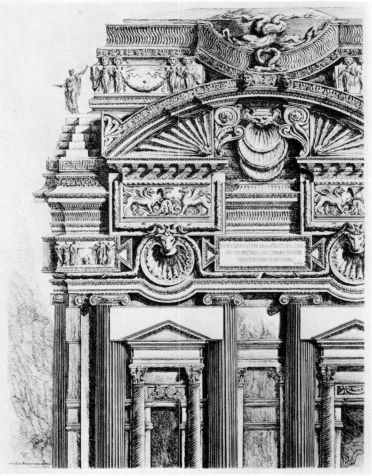

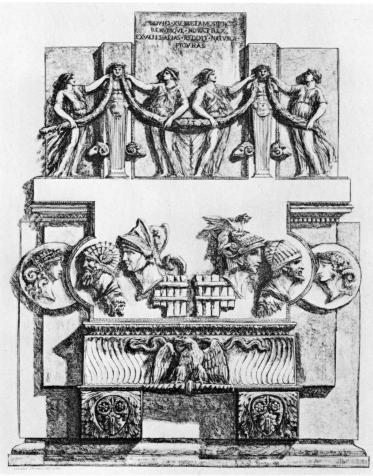

191. Catalogue

CHAPTER SEVEN
The Archaeological Works

IN 1761 Piranesi moved into new lodgings in the house of the Conte Tomati, in Strada Felice near the church of Trinità dei Monti at the top of the Spanish Steps.[1] It was conveniently close to the haunts of his best clients, the tourists staying in the neighbourhood of the Piazza di Spagna, but it was above the clatter and bustle as their coaches arrived and rumbled away again, and it was also close to the cool groves of the Pincian hill. Sir William Chambers had lived in the house some six years earlier and Thorvaldsen, the Danish sculptor, was to occupy it in the following century. Piranesi sold his work on the premises and he started some modest advertising with a printed hand list of all his books and loose plates which was updated periodically as new works were published.

The next five years or so were the most creative period of his career. Admittedly his polemics won notoriety rather than scholarly acclaim but he was able to put his architectural theories into practice in a number of commissions of which the only one to survive is the little church of S. Maria del Priorato and its highly original *piazza*. After the new edition of the *Carceri* he produced some of his most beautiful and poetic views of antiquity not only in the additions to the large *Vedute* but also as illustrations to the archaeological essays which he issued in these years on subjects which caught his fancy.

These archaeological works fall into two parts; some are more or less a continuation of the *Antichità romane,* while the others developed from his investigations into the relics of the Etruscans and the earliest surviving architectural remains of Rome, research which he had originally undertaken in connection with the publication of *Della Magnificenza.* The first of these is *Le Rovine del Castello dell' Acqua Giulia . . .* published in 1761.[2] It is a brief essay concerning the Roman aqueducts, based on his field work on the different water courses which he had carried out while preparing the *Antichità.* It had been a thorough examination which included mapping all the fragments and measuring the height of each arcade to check the direction of the water flow and to prove which ruins belonged to which system, the Acqua Marcia, the Acqua Claudia, the Acqua Felice and all the rest. He also included a description of the fountain on which the trophies illustrated in the *Trofei di Ottaviano* had formerly stood. This fountain, long ago stripped of the trophies and all other marbles, stands a forgotten hulk of brick, surrounded by palm trees and the scruffy open-air market of the Piazza Vittorio Emanuele II. Only someone with his Venetian background in hydraulic engineering could have pieced together such an elaborate reconstruction from the battered ruins that survive. He took obvious pleasure in detailing each section of the plumbing system, complete with pipes and trap doors, and minutely itemised his plans and cross-sections *(192, 193).* To this work he appended an exposition of a passage of Frontinus, a writer of the first century A.D., describing how the water magistrates of ancient Rome regulated the flow of supplies from the public aqueducts. (It was done by means of bronze cups with apertures of stipulated sizes which connected the public pipes to private houses.) It is a highly technical work but it includes several attractive views of the ruins and the frontispiece is a really beautiful composition: a cascade pours down into antique vases, two of which are shaped like enormous horns, but they terminate not in points but in bulls' heads, through the mouths of which the water gushes *(211).*

Also in 1761 he completed *Lapides Capitolini*.[3] These Capitoline marbles are the fragments of a large inscription listing all the consuls and also the Triumphs and great games of Rome; they had been removed from the Forum about two centuries previously and placed in a frame designed by Michelangelo in the Palazzo dei Conservatori on the Capitol where they are still to be seen. Piranesi reproduced the lettering of the inscription exactly and, to enliven what would otherwise have been a very large and dull plate, he filled the numerous lacunae with fragments of sculpture, the wolf and the twins, trophies, sacrificial implements and other pieces of classical bric-a-brac. The text is in Latin, describing the history of the inscription and the scholars who had commented on it. There is also a transcript of the fragments and the gaps where years have been lost are completed from literary sources. To pad the work out, he added a massive index listing all known consuls first under their *praenomina* (all the Lucii, all the Marci), then under their *nomina* and finally their *cognomina*. 'Anything can be accomplished by hard work' is the motto in the colophon, the Virgilian quotation referring, I feel sure, to the toil of an unfortunate Jesuit set as a penance by father Contucci to the task of compiling the monster index!

192. Cross-section of fountain, *Acqua Giulia*

193. Plumbing system of fountain, *Acqua Giulia*

ROBERTO·ADAM·BRITANNO
ARCHITECTVRAE·CVLTORI

194. Detail of map with portraits of Piranesi and Adam, *Campus Martius*

195. Plans of Campus Martius, *Campus Martius*

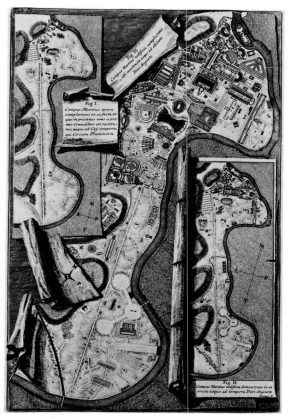

A more substantial work is the *Campus Martius,* a description of the buildings surviving from classical times in the Field of Mars. This was a large area of the ancient city between the residential quarters and the Tiber and roughly corresponding to the section lying to the west of the Corso. It was originally a sort of Hyde Park, a parade ground and the scene of the elections, but it was gradually built over by theatres, temples and other public buildings. However, after the Goths had cut the aqueducts and broken off the water supplies which had been carried on their huge brick arches to the hills of Rome, the population shifted down to the riverside where it was easier to bore wells, and private houses took-over the decaying public buildings. The *Campus Martius* is really a fifth volume of the *Antichità;* like that work, it had a long gestatory period and the eventual product was far more ambitious than the original concept. It developed from Piranesi's offer, made in July 1755, to dedicate to Robert Adam a map of the area which was to have been included in the *Antichità,* but which Adam persuaded him to publish separately so that the honour done him would not be put in the shade by the grander introductory dedication to Lord Charlemont. Piranesi was too busy completing the *Antichità* and dealing with John Parker in the spring and summer of 1756 to have much time to work on the map, and the publication was further postponed when he found that Adam was himself intending to publish detailed plans of the Baths of Caracalla and of Diocletian. This was competition on his own ground. 'Jamie wishes to know of the Dedication', wrote Adam on 9th October, 1756, 'But realy I fancy he may dispair of it as I do, for that Piranesi is a most Changeable, interested Madman, whom there is no depending on. And I believe Jealousy may now prevent his doing what may be to my honour or advantage for as he sees I am doing things, that interfere with his Province, viz making drawings of the Antique Baths &c. here, to much better purpose than he is capable of He suspects I may publish them, & so hurt his sale of these things, which no doubt I intend time & place convenient to do.' He mellowed, however, towards the end of Adam's stay in Rome and showed him the proposed dedicatory plate before he left. Piranesi then became embroiled in the Charlemont affair and, although he must have continued work on the *Campus Martius* intermittently, the *Acqua Giulia* and, more importantly, *Della Magnificenza* occupied his attention. Nothing more was heard of the promised dedication until James Adam came out to Rome four years later. He, no doubt, raised the question because such a work was good publicity for the family architectural firm. Piranesi hinted instead at a further dedication to James who as gently hinted that he would not accept anything until the work for his brother was finished. Apparently Piranesi had been cheapening the market by offering his dedications around to

other potential patrons but they seem to have been deterred either by the fate of Charlemont or by the author's polemical belligerence.

Although the text of *Campus Martius* received the *approbatio* for publication on 16th June, 1761, the book was not issued until the following year. Again a missing portrait seems to have been to blame (in the end they did not wait for it) and James, as we have seen earlier, attributed part of the delay to Piranesi's troubled matrimonial affairs. When it finally emerged it had grown far beyond the simple map which had been promised originally. The treatment of the subject is like that in the first volume of the *Antichità* and, as in *Della Magnificenza,* there is a Latin translation on the facing page which doubles the amount of text.

The dedicatory letter to Robert Adam is an advertisement for the author's thoroughness and, in prelude to the *Parere,* an argument for setting aside the strict rules of Vitruvius as the ancients had done; it is also a warm tribute to the Scotsman whose feeling for antiquity he found so sympathetic. 'I remember', he writes, 'when we were in Rome together a few years ago, how enthusiastically you examined each of the many surviving monuments of the Romans and contemplated their beauty and their magnificence, especially when we explored the Campus Martius. You often asked me to engrave the remains of the buildings in that famous part of the city and to produce a bird's eye view of the whole area. . . . It would be a long task to enumerate all the different buildings which used to exist in the Campus. Most of them have completely vanished while the remains of others lie buried or are broken by the foundations of houses and are so scanty that it is hard to recognise their original purpose . . . I can promise you that no part of the Campus was too insignificant for me to examine frequently and minutely, and I even penetrated the cellars of the houses, not without some trouble and expense, in case anything should escape me. When I had collected the remains of these buildings and copied them with the greatest care, I showed them to the best antiquarians to get their opinions and then I compared them with the old plan of the city in the Capitol because I hoped that if I did so no one would claim that I had followed my own whim rather than sure reasoning or probable conjecture in setting out the names, the appearance and the position of these monuments. I am rather afraid that some parts of the Campus which I describe should seem figments of my imagination and not based on any evidence: certainly if anyone compares them with the architectural theory of the ancients he will see that they differ greatly from it and are actually closer to the usage of our own times. But

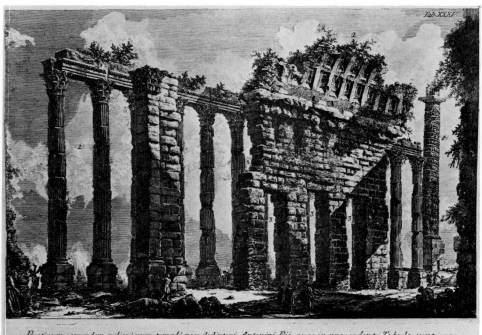

1. *Posticum earundem reliquiarum templi pseudodipteri Antonini Pii, quae in praecedente Tabula sunt expositae.* 2. *Rudera cellae ipsius templi.* 3. *Ostia recentia.* 4. *Columna cochliodes M. Aurelii.*

196. The Hadrianeum stripped of later building, *Campus Martius*

before anyone accuses me of falsehood, he should, I beg, examine the ancient plan of the city which I have just mentioned, he should examine the villas of Latium and that of Hadrian at Tivoli, the baths, the tombs and other ruins, especially those beyond the Porta Capena, and he will find that the ancients transgressed the strict rules of architecture just as much as the moderns. Perhaps it is inevitable and a general rule that the arts on reaching a peak should then decline, or perhaps it is part of man's nature to demand some licence in creative expression as in other things, but we should not be surprised to see that ancient architects have done the very things which we sometimes criticise in buildings of our own times. Here then, my dear Adam, is the Campus Martius, not as perfect perhaps as you wanted but as complete as I could manage, given the complexities of the subject and the lapse of time. . . . Whatever your judgment may be about this little work, I am happy to have done as you asked and to have provided for posterity a monument to our friendship.'

This excuse for architects who break the rules which the ancients did not keep themselves was a definite shift of emphasis from that adopted in the *Antichità* where, for instance, he had berated the builder of the tomb of Cecilia Metella for setting a bad example by allowing the architrave to dip down into the upper course of stonework. 'Such licence, which is contrary to the best rules, has been imitated by the most fashionable modern architects', he had complained '. . . and blindly used not only in private but in the most sumptuous public buildings.'

The text of the *Campus Martius* consists of six short chapters in which he discusses the extent and layout of the area, its consecration and then its gradual development under the republic and in imperial times. There is a long list of monuments with cross-references to the plan, the text and the ancient authorities in which they are mentioned. As in the *Antichità*, Piranesi was a thorough investigator, combing the back streets for fragments of a cornice set into a wall or a crypt built on ancient foundations. He was quick to point out the errors of others, and the evidence of modern authors was sifted as well as that of the ancient writers. Even if he was assisted by the backroom abbés, their scholarship was tempered by a robust common sense attitude and a sharp observance of detail that is undoubtedly his own. Thus a single stone was enough for him to reconstruct the seating arrangements in Pompey's theatre, and he was not misled by sentiment or the mere name into linking the columns built into S. Nicola in Carcere with the temple of Piety (dedicated in memory of the daughter who breast-fed her starving father in prison) although, as he admitted, 'I almost fell into this error . . . but when I looked closer I could easily see that they were not the ruins of a temple but of a basilica.' (Actually he was wrong; S. Nicola does incorporate a republican temple but it would be tedious and unprofitable to enumerate the many instances where subsequent discoveries have superseded the theories of the eighteenth century.)

There are several maps. One is marked with numbers to identify the monuments cited while three smaller plans are laid out round the margin to show the

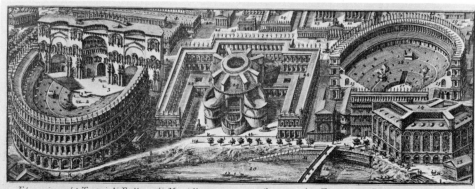

197. Reconstruction of the Theatres of Balbus and Marcellus, *Campus Martius*

different stages of development over the centuries *(195)*, and a further plate takes the story up to the time of Augustus. There is also a bird's eye view, showing the whole Campus as it might have been if the houses of the dark ages had not encroached on the antiquities and if the principal monuments such as the Pantheon and the Theatre of Marcellus were free-standing ruins gauntly towering in the empty fields like the Baths of Caracalla.

The original plan with the dedication to Robert Adam is a huge plate in six sections which unfolds to about four feet eight inches by four feet ten. It is similar to the earlier Baroque fantasies of the Forum and the Capitol at the end of the first volume of the *Antichità* and bears as little resemblance to the actual layout of the old city. It is easy to see why the preface is so defensively worded in order to forestall the criticism which had probably been levelled against his over-enthusiastic imagination in the earlier maps. There is a medallion in one corner showing the joint heads of Adam and Piranesi *(194)*. In the first design for this plan there was a second medal on which, to quote Adam's smug description in a letter to his sister, 'Fame points to a piece of Architecture and Leans on My Shoulder in the attitude of going off to proclaim my Praises', but, before publication, the plate was altered and Fame lost her prop.[4]

Some of the plates are original if not positively eccentric. Following the device of his large bird's eye map, Piranesi pretended that the street level had not risen since the sack of Rome and treated the ruins as if they had never been incorporated into later structures but had just fallen into slow decay, to be ravaged by time and, more destructive in Rome, the native Romans: Cosmati mosaicists, Renaissance prelates or the humble burners of lime. He dived into the crypt of S. Maria in Via Lata (a church by Pietro da Cortona on the Corso) and the cellars of the adjacent Palazzo Doria – Pamphili to draw the pillars of what he called the Saepta Julia buried below the street level and then represented them, stripped of later impositions and covered with vegetation, as a neglected ruin *(215)*. He disentangled the Theatre of Marcellus *(216)* from the fortifications with which it was overlaid and showed it like the green fragments out in the Campagna, the desolate feeding place of goats. The most striking of all these effects is the Temple of Hadrian (converted in his day into the Customs House); in one view he demolished the modern walls, leaving only the ancient pillars, and in the next *(196)* he stood, as it were, inside the building, looking out into the street between the columns of the façade to draw, silhouetted against the sky, the large blocks of masonry built into the inner walls and the vaulting concealed overhead. There are also some conventional *vedute* including a beautiful if exaggerated view of the

198. Baths of Sallust, *Campus Martius*

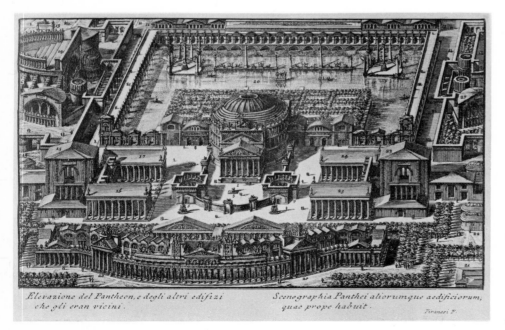

199. Reconstruction of the Pantheon, *Campus Martius*

200. Title page, *Emissario del Lago Albano*

Baths of Sallust and another of the Tiber island.

In conclusion there are three small views of his reconstructions of the Theatre of Marcellus *(197)*, of the Pantheon and of the Amphitheatre of Statilius Taurus, each with its adjacent colonnades and arches. The first two more or less correspond to the large plan although they depend on his imagination rather than on any archaeological evidence for their details, but the amphitheatre and the huge horologium of Augustus are as independent of the map as of probability. It is amusing to note that the arcade with which he screens the portico of the Pantheon is composed of enormous caryatids, although in *Della Magnificenza* he had made mock of the Greeks for using such supports.[5] These little views are already on the way to the strange creations in the *Parere* and are in keeping with his plea for greater architectural licence.

The work was favourably received although, not surprisingly, the reconstructions were taken with a pinch of salt. Natoire writing on 7th April, 1762, to Marigny, the Director of the King's Buildings in France, said, 'This industrious artist is flattered by the kind letter which you wrote to him, and asks me . . . to send you the *Campus Martius* which has just been published. His fantasy has had something on which to work in those imaginary spaces but, despite his theories, I think that one can gain some insights from them, and his method of execution is always a pleasure to the eye.'[6] Robert Adam's comments have not survived and we only hear the grumbles of his brother James at the need to dispose of 'such a cursed number' of copies which they had agreed to take.

While working on *Campus Martius,* Piranesi was also investigating the tunnel used to drain Lake Albano. He had illustrated this in *Della Magnificenza* as an example of grand Roman building and he now returned to a subject ideally suited to his graphic skills. Livy and other historians record that in 398 B.C. when the Romans were besieging Veii, they were given a Birnam Wood to Dunsinane sort of oracle that they would not capture the city until they had reduced the level of Lake Albano. It was a particularly wayward oracle because Veii is miles away from Albano on the other side of Rome. All the same, the Romans went ahead and proceeded to bore through the hill side, under the modern town of Castel Gandolfo, a tunnel about five feet high and three feet broad and fifteen hundred yards long, a massive engineering accomplishment which was finished within a year. The level of the waters and the distant city fell simultaneously. Such is the story. The date and more serious purpose of the drain are still unknown; it may have been intended to reduce malarial swamps on the upper shores of the lake or to provide water for irrigation systems. It is certainly a very ancient work, probably as old as the siege of Veii, and it still provides an outlet for the lake. The entrance to the tunnel is visitable if you can locate the cottage on the hill and find someone to open the little iron door off the lakeside road leading into the chamber of craggy masonry.

Piranesi was fascinated by the skill of the ancient engineers and the magnitude of their undertaking. He worked out exactly how they had contrived to bore the

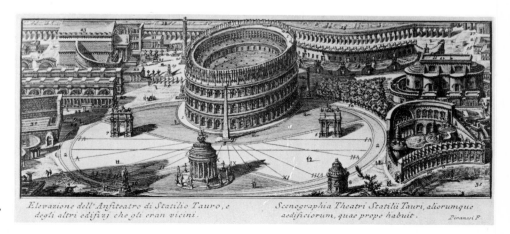

201. Reconstruction of the Theatre of Statilius Taurus, *Campus Martius*

Elevazione dell'Anfiteatro di Statilio Tauro, e degli altri edifizj che gli eran vicini.

Scenographia Theatri Statilii Tauri, aliorumque aedificiorum, quae prope habuit.

Piranesi F.

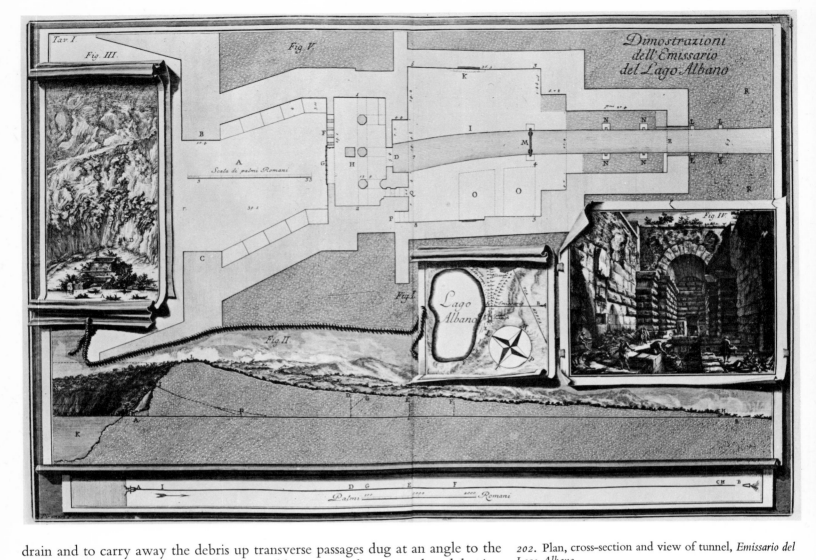

drain and to carry away the debris up transverse passages dug at an angle to the main tunnel. He found an eighty-year-old peasant who remembered having come across the opening of one of these passages in a vineyard of the Jesuits and who showed him the entrance on the hillside high above the lake. He made a thorough examination of the inlet where the waters were channelled from the lake into the drain but, as in the exploration of the Cloaca Maxima for the *Antichità*, he employed a proxy to investigate the tunnel itself. 'I procured a fisherman to enter this part of the tunnel with a torch', he writes, 'and got him to advance as far as the depth of the water allowed . . . with instructions to look carefully for the bottom end of one of the bore holes with its passage. The fisherman advanced as far as he could and he told me that after going some way he found that the arch of the tunnel was pierced from above by a horrifying void reaching upwards with a square opening that was far larger than the tunnel itself.' The explorer retreated but Piranesi persuaded him to return and measure the distance between the entrance and the first bore hole so that he could calculate where it would emerge up above. He plotted the course of the tunnel and also surveyed its exit into the fields at La Mola from a little building that had been converted into a tannery. The principal attraction to him of this monument was the fact that it had been carried out long before the Roman conquest of Greece and was composed of massive and regular blocks of stone which implied a knowledge of architecture, and he indignantly refuted the suggestion that the work had been executed under Domitian in the first century A.D.

Descrizione e disegno dell' Emissario del Lago Albano is the resultant work, published in 1762. He recounted the historical background and his own exploration and illustrated it excellently with five large plates subdivided to give a

202. Plan, cross-section and view of tunnel, *Emissario del Lago Albano*

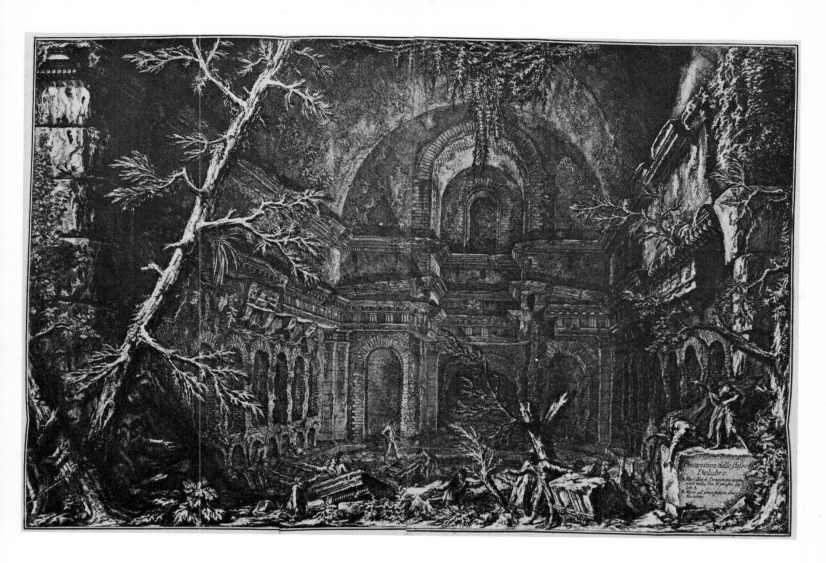

203. Grotto by Lago Albano, *Di due Spelonche*

number of very detailed ground plans and cross-sections which are juxtaposed to demonstrate exactly how the tunnelling was executed, where the bore holes emerged and what the buildings at the entrance and exit look like. He also included four *vedute,* two of the entrance of the tunnel and two of the other end. There is a dramatic scene *(220)* in which fishermen set their nets under the dark pillars at the inlet from the lake, and a similarly murky view *(221)* of tanners working on their hides by the troughs in the stone house, also illustrated, which marks the spot where the water debouches into the open countryside on the other side of the hill. The best of these plates is the view of the Cyclopean arch built into the face of the hill over the entrance to the tunnel *(219)*. He delighted to reproduce the craggy rusticated stonework and the enormous slabs of tufa lining the channel through which the water flows. Gnarled trees, as antique seeming as the work of the Romans, twist their roots round the upper courses of the stone, thick ivy and creepers have gained a hold on the lower walls. A slanting beam of sunshine streams down on the keystone of the arch and one section of projecting cornice also catches its rays to make a dramatic interplay of light and shadow. Several fishermen are sitting around sheltering from the lakeside winds; one of them explains the water course to an elegant antiquary who has penetrated this spot with a friend. But Piranesi has tricked us. He has deliberately reduced the size of the human figures to exaggerate the scale of the arch and the massiveness of the stonework. Despite the careful archaeological plans, this splendid plate, redolent of the *Carceri,* is highly misleading. It was indeed a frequent complaint of eighteenth-century visitors that the ruins of Rome did not live up to their expectations because Piranesi had depicted them larger than life. The early views were all quite fair, but from this period on he occasionally succumbed to the

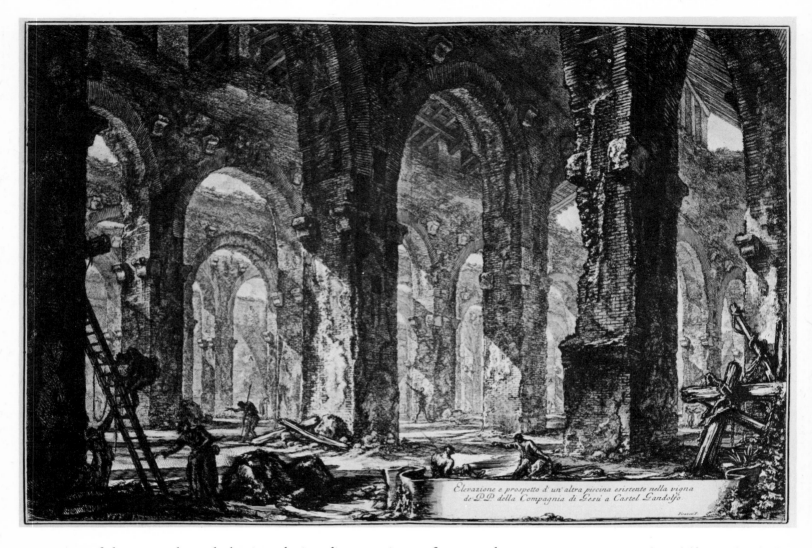

Elevazione e prospetto d' un' altra piscina esistente nella vigna
de' PP della Compagnia di Gesù a Castel Gandolfo.

204. Cistern near Castel Gandolfo, *Antichità d'Albano*

temptation of distorting the scale by introducing disproportionate figures and exaggerating the angle from which the ruins were drawn.[7]

While investigating this curious piece of antiquity beneath Castel Gandolfo, he explored the rest of the neighbourhood and came across two grottoes by the lakeside which he also drew and published a few months later as *Di due Spelonche ornate dagli antichi alla riva del Lago Albano*. This little work contains an essay on *nymphaea* or grottoes of the nymphs, in which he speculated that the orgies of Clodius which Cicero castigated might have taken place in one of these lakeside caverns. There are the usual accurate plans and cross-sections and two beautiful views each taken from the mouth of the grotto and looking into the dim gloom of the interior. The larger of them is a marvellous double plate framed by weirdly gesticulating trees of uncertain botanical but romantically picturesque origin and by a tangle of creepers pouring down from the roof *(203)*. The grotto is populated by ragged urchins and a bearded philosopher, all waving as eccentrically as the trees. Piranesi captures superbly the atmosphere of the cool luminous darkness after your eyes have become accustomed to the contrast with the sun's glare outside which reflects through to the interior and picks out the dusty cornice and the niches at the furthest recesses of the cave.

The entrance to the drain was just below the Pope's summer residence of Castel Gandolfo. Clement XIII, who was sufficiently intrigued by these neighbouring antiquities to pay them a visit, asked Piranesi to complete the series of views of the district, which he did in *Antichità d'Albano e di Castel Gandolfo*, published in 1764. The charms of the lake had attracted many distinguished Romans of antiquity long before the Popes chose to stay there. Piranesi illustrated the house of Pompey, the amphitheatre of Domitian and two huge subterranean

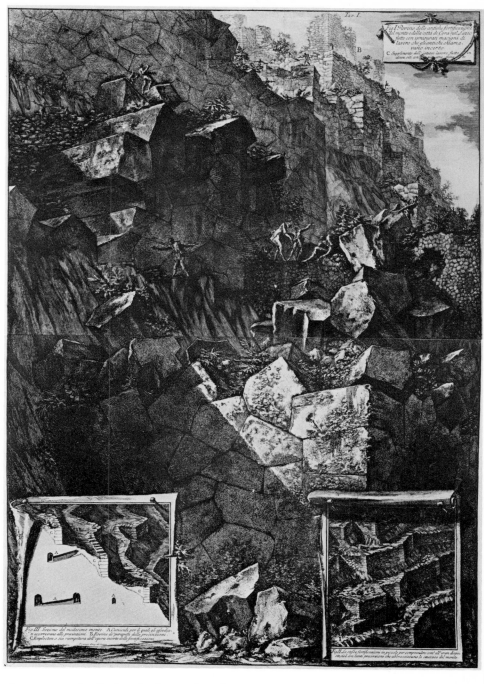

205. Fortifications of Cori, *Antichità di Cora*

cisterns, one built for the barracks of Septimius Severus at the end of the second century A.D. He also included some monumental tombs *(223, 226)* and a particularly well-preserved section of the Appian Way *(227, 228)*. As usual he provided a couple of dozen pages of text to explain the plates with uncomplimentary references to the errors of previous scholars; interestingly, in discussing the barracks, he refers to the *Itinerarium Septentrionale* of a Scottish antiquary, Alexander Gordon, a work that he must have been given by Adam or Mylne or some other Scottish friend, eager to show that Italy was not the only nation to describe its antiquities.

The two sides of Piranesi's work come out excellently in this Albano volume. He included methodical technical plates showing precisely how the Romans lined their water cisterns or how the courses of brick were laid in the amphitheatre, but a couple of pages later there are magical subterranean views, vistas through dark stone tunnels to glimpses of daylight overhead where feathery trees and festoons of ivy spread their delicate curtain across the opening. Perhaps the best of these illustrations is of a different cistern in a vineyard of the Jesuits.

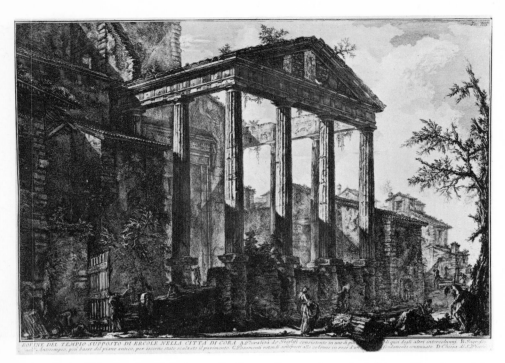

206. Temple of Hercules, *Antichità di Cora*

It is a beautiful perspective view of tall receding arches, their bases illuminated by slanting sunlight and the upper arches disappearing in the darkness above. He has caught exactly the contrasting textures of brick and wood and stone, and the little figures that declaim in the shadows bring out the enormous scale of this forgotten monument *(204)*.[8]

The Albano volume was almost Piranesi's last. The story, as usual, is Legrand's. 'He was drawing a grotto called del Bragantino, and was measuring the sections, perched on a ladder, accompanied by one Petrachi. The weather was stormy and for eight days the thunder had been grumbling almost without a break. A fisherman had been watching him for a long time in his odd dress (our artist was wearing an enormous hat with the brim turned down and a little hunting coat, very short, which gave him rather a fierce appearance) and he imagined that this singular character, who was gesticulating, writing and often talking to himself, must be a sorcerer, and that he was moreover responsible for the bad weather which had gone on continuously since his arrival; he spread the idea, the alarm was given and the villagers armed and went off to do away with the sorcerer.' Piranesi's protest that he was a friend of His Holiness went unheard and he might have been lynched but for the timely arrival of a papal officer.

The last of this series was the *Antichità di Cora* which also appeared in 1764. 'After visiting the antiquities of Albano and Castel Gandolfo,' he wrote, 'I went to draw the antiquities of Cora, another city of Latium.' Cori is a very ancient city which still retains part of its surrounding walls of the sixth century B.C., composed of huge irregular stones. He admired the strength and durability of this *opus incertum* although he admitted that it lacks something of the third Vitruvian requirement, beauty, and he called attention to the jointing of the masonry which is so perfect that it appears natural, not artificial. His first plate is a very large and rather fanciful reconstruction of these remains as they might have been before the medieval town obscured their outline *(205)*. The chief attraction of Cori, however, was the ancient Doric temple of Hercules, which he described and illustrated in detail. It still stands in a magnificent position at the top of the town and yet, with their uncanny capacity for such acts, the modern Italians have carved a huge quarry out of the olive groves across the valley directly aligned with the temple's portico, ruining a panorama which otherwise not only Piranesi but the ancient devotees of Hercules would have recognised.

He often used to go sketching with Hubert Robert, the French artist whose soft red chalk views of the minor antiquities of Rome are among the most attrac-

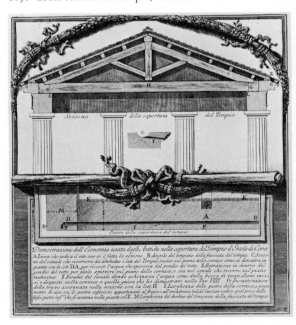

207. Cross-section of temple, *Antichità di Cora*

174

tive topographical drawings of the century. The visit to Cori must have been one such joint expedition because a sketch book of Robert's is preserved dating from the last months of 1763, in which he has drawn the ruins from the same angle and in the same perspective as Piranesi's etchings.[9] The similarities are too close for coincidence.

Promising a further work on the antiquities of the Etruscans in which he intended to show the variety of Tuscan architecture and decoration, Piranesi next spent some time surveying the tombs at Chiusi and Corneto in Tuscany. The only results, however, were three pages of decorative friezes published at the end of the preface to *Della Introduzione delle Belle Arti* in 1765. One plate asks the question 'A problem of interest to masons. Did the Etruscans or the Greeks invent these sorts of bands which Piranesi has discovered in the grottoes of Corneto and Chiusi?'. He probably decided that the ruins were not sufficiently picturesque to make readily saleable prints and that the decorative details would have needed colour like the illustrations to the folios of Sir William Hamilton's vases. Besides, as he wrote in the introduction to *Diverse maniere d'adornare i cammini* in 1769, 'the very learned M. James Byres, architect, and antiquarian from Scotland, . . . is about publishing the designs of them in a work in which will appear his extraordinary knowledge'. Although Byres' *Hypogaei* was not published until the following century, his rather dull plates suggest that Piranesi was right not to have continued his own enterprise.[10]

This was not the only project to fall by the wayside. He had difficulty in bringing any archaeological study to completion; the *Campus Martius,* as we have seen, had a seven-year production span, and a double plate on the drain of the Fucine lake, which is mentioned in *Dell'Emissario del Lago Albano* as being well under way, was only issued by Francesco Piranesi after his father's death.[11] The only other separate archaeological series to be finished, apart from the views of Paestum to which we shall come later, were the short works on the columns of Trajan, of Marcus Aurelius and of Antoninus Pius.[12] Trajan's column, dedicated to Clement XIV, was probably completed in 1774 and the other two were added subsequently but there is no descriptive text and most if not all of the plates are by Francesco Piranesi or by Dolcibene, who had formerly been a pupil of Pecheux and was one of Piranesi's assistants for seven or eight years. Piranesi suggested to Pecheux that he should be suspended from the top of Trajan's column in a basket to ensure the accuracy of his drawing, but, in the end, he probably contented himself with the use of plaster casts.

One other major exercise, which occupied him from 1762 right up to the time of his death, was the delineation of Tivoli. Although he did not publish a separate volume on the subject, no less than twenty-three of the large *Vedute* are devoted to the neighbourhood, one-third, that is, of the later views produced after he had moved to the Strada Felice. Starting with three aspects of the little temple of the Sibyl *(209, 233),* the most picturesque and the most painted of all the ruins of Italy, he then did some views of the temple of the Tosse, or the Coughs *(234),* of the Ponte Lucano and of Maecenas' villa, followed by a plate *(236)* of the other celebrated but now completely altered tourist sight, the grand waterfall of the Aniene.[13] Since the course of the river was diverted in the last century, the main flow has emerged on the other side of the Villa Gregoriana while the thunderous grand cascade which he depicts has been reduced to a trickle. The Cascatelle, or lesser cascade, has also been altered in the interests of a hydro-electric scheme and it now emerges in a different flow from Piranesi's view, although, seen from S. Antonio on the other side of the valley, it is still a very impressive torrent. The etching of the Cascatelle shows what he might have done as a landscape artist *(235).* Nature is paramount in many of his views, overwhelming the grandest human achievements and reducing them to ivy tumbled ruins. This is the only plate in which no man-made monument appears; it is a fiercely romantic scene with an ancestry derived from the torrents of Salvator Rosa and the stormy sea-torn cliffs of Marco Ricci and Alessandro Magnasco.[14]

208. Etruscan friezes, *Della Introduzione e del Progresso delle Belle Arti*

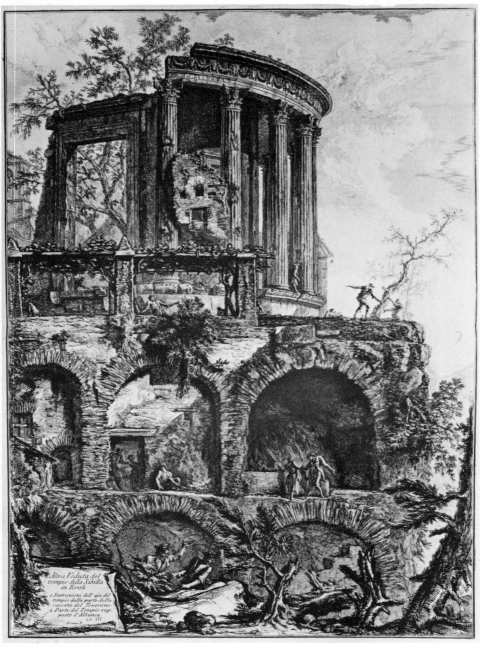

209. Temple of the Sibyl, Tivoli, *Vedute di Roma*

The difference is that those artists reproduced their effects in oils whereas Piranesi is alone in attempting such tumultuous cataracts in the far more restricting medium of etching. It is interesting to note that a landscape by Rosa was one of the few paintings to hang among the classical reliefs and fragments in the house in Strada Felice.

The most important antiquities of Tivoli are at Hadrian's villa a mile or so away. In A.D. 126, on returning from a tour of the eastern provinces, Hadrian started to build a new winter retreat on the unpromising flat land at the foot of the hill below the town, filling it with copies of the monuments that had appealed to him most on his travels: the Stoa Poecile, the Academy and the Lyceum of Athens, Thessalian Tempe and Canopus on the Nile. With the fall of the empire, the villa was abandoned to gradual decay, and despite looters and iconoclasts it preserved in its crumbling ruins a wonderful collection of sculpture which was sporadically excavated from the Renaissance onwards. In the early eighteenth century part of the site was bought by Count Giuseppe Fede to whom we owe the beautiful avenues of cypress and the pines, and he began a more methodical investigation. He was closely followed by Cardinal Albani, who was also attracted by the richness of the pickings, his most notable trophies being the celebrated

210. Satyrical map of Horace's farm, *Diverse maniere*

bust and statue of Hadrian's devoted Antinous. Then in 1769 Gavin Hamilton, the Scottish neo-classical artist, drained the area known as Pantanello and began to mine another lucrative vein of sculpture there. Hamilton was one of Piranesi's many British friends and from now on, while Hamilton was excavating, Piranesi was making the first thorough survey of the whole site.[15] Legrand, clearly recording his brother-in-law's painful reminiscences, describes how Clérisseau accompanied Piranesi on these trips to Tivoli and the pair of them used to have to attack the undergrowth with axes to clear the monuments and to burn out the scorpions and snakes with fire before it was possible to start sketching. The result of these labours consists of ten *Vedute* of the villa itself, strongly romantic dark views of the overgrown ruins, and some additional drawings *(238–243)* which were intended to continue the series but never reached the copper; there was also an enormous map of the whole site which was only published after his death.[16]

Such was his output of archaeological works, a substantial achievement even in an age when large and richly illustrated folios were the rule. His forte once again was the application of a practical architect's and engineer's experience to the how and why of ancient buildings which was quite a new departure for an antiquary. With so much to his credit he could justifiably mock the rambling volumes on the subject of Horace's Villa by Capmartin de Chaupy, 'the muddle-head' (especially since the abbé had dared to disagree about some of the antiquities of Albano: 'A dry spring and a few broken walls have produced three fat tomes. What do you say about that, my Baretti? Where's your cudgel?').[17] It is an oddly unbalanced achievement, all the same. Once he had entered the Greek-Etruscan controversy, his driving purpose was not archaeological but polemical, and the search for evidence in support of his wilful theories inevitably distorted his view-point. Dating was another weakness despite Winckelmann's new emphasis on relative chronology. There are also some surprising gaps. It is odd that he never followed up the *Antichità romane* with a more detailed study of the Forum and the Palatine. Palladio, it is true, had already written a treatise on the ancient baths but, when neither Adam nor the French produced their intended volumes on the subject, he did not attempt to fill the gap himself, leaving the Scottish architect Charles Cameron, the future architect of the Empress Catherine of Russia, to publish *The Baths of the Romans* in 1772.[18] He might also have produced an enlargement of Scipione Maffei's work on amphitheatres, covering the Colosseum and the arenas at Verona, Herculaneum and Albano. The early Christian antiquities provided further scope for his pencil and pen. No such studies were forthcoming, however; he probably found it more lucrative to concentrate on running his business at its rising level of activity. In any case, a disagreement with his ghost writers after the publication of the *Parere* may have reduced the availabilty of scholarly research and assistance.

Contemporary judgment on his archaeological productions was cautious. After the murder of Winckelmann in Trieste in 1768 it was not Piranesi who was appointed to be his successor as Papal Antiquary but Visconti, a less contro-versial figure.[19] This is not altogether surprising because Piranesi was probably already at this stage dealing in antiques which would have conflicted with the Papal Antiquary's duty of examining all antiquities due to be sent abroad before granting an export licence; for someone who was himself in the trade it would have been an invidious position. Posterity's assessment would undoubtedly have disappointed him. Piranesi the archaeologist is forgotten and it is only Piranesi the artist who survives. And yet the power of Piranesi the artist did have one effect that would have pleased Piranesi the archaeologist. The propaganda of his etchings, far more eloquent on behalf of the magnificence of the Romans than his windy polemics, by keeping the attention of scholars and tourists centred on Rome, may well have postponed full acceptance of the Greek revival for a couple of decades.

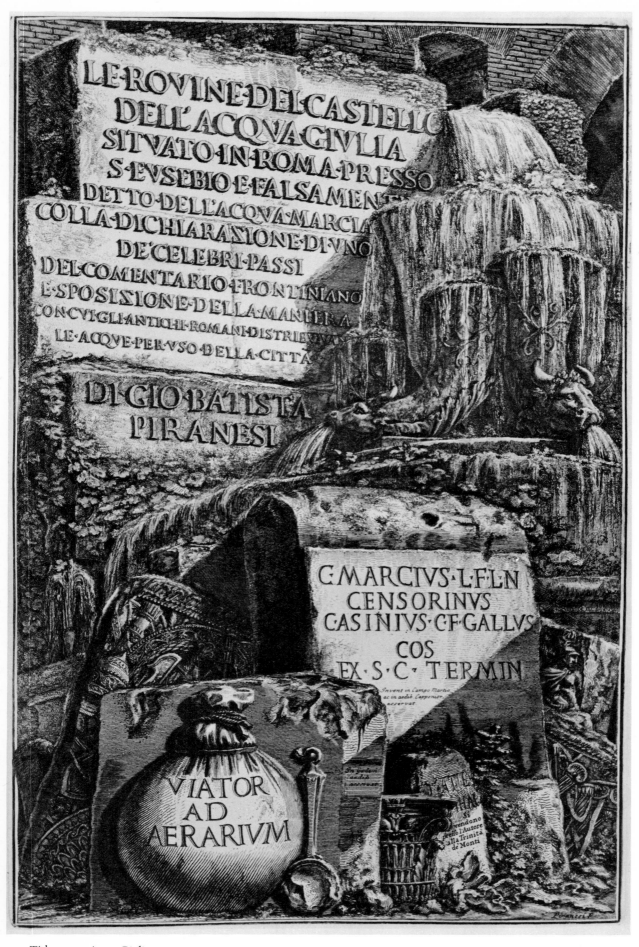

211. Title page, *Acqua Giulia*

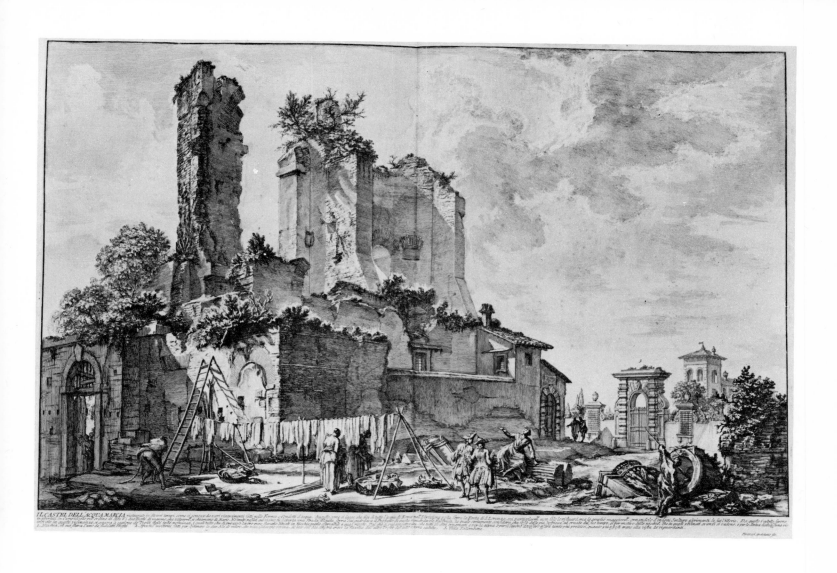

IL CASTEL DELL ACQUA MARCIA *ritenuto in diversi tempi, come si conosce da varj risarcimenti fatti nelle Forma, e Condotti d'acqua. Questa come il luogo che era di tutte l'armi di Roma nel l'Oriente, e le Terme di Porta di S Lorenzo, con particolarità non alle tre ottavi, ma le grandi maggiori, era in due li Terme, l'ordine, e forma, e prima, le le Storie. Di questo Castel Santa terminata in Campidoglio per ordine di Silla V. del Ponte de opera, che Jeffroni si chiama da di Marte. Si tratta in tre la di Centuria una Itralia Itralia. Sopra l'un antica o il Prefetto di tutto rendiamento Sylvestro, la quale veramente compiere, che V.V. delle sue bellezze, ad onesto de' loro tempo, si fare mettere delle risbatte, ma in questi abitanti avanti si volume e pre la Santa dichino, Ima es..*
tutte in questi residuati, o in opera, o opera de' Theoli fuli e colte nominati, i quali tutte che depurasse si terme pene transiti Situati in Vicchio quanto d'accorta, e quali viggio. Tra chi si viduare esteriore, che tutte Terme, quanto a com la acqua, o vari Santi largi, l'er gl'Irti tante più preziose, quanto sui e gl'di mano alla vista, le riguardanti.
I. Nichia, et sui, flora l'uno de, fuili colt Popolo. B. Spacino moderno, fatti per Scharse, in due. Ale di relieve, che son reservatione crema, le loro del Scu dichire, avea la Facelle, del aditi le sie del ante l'Aova, nobile. A. Villa Felsonalano.

Piranesi inventavit fec.

212. Fountain of the Acqua Giulia, *Vedute di Roma*

179

213. Aqueduct, *Acqua Giulia*

DEL CASTELLO DELL' ACQVA GIVLIA

Piranesi F.

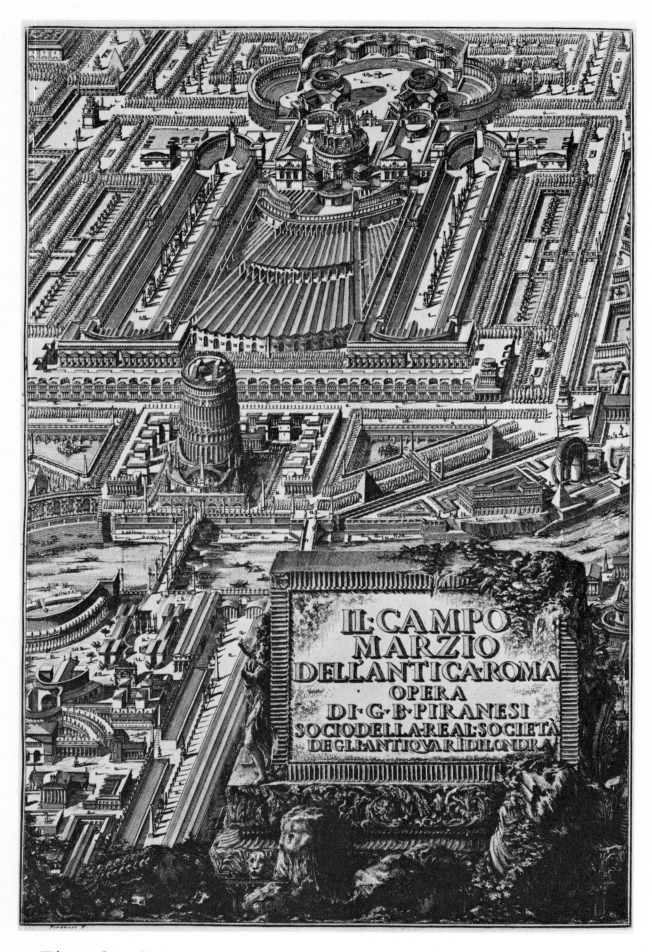

214. Title page, *Campus Martius*

Scenographia Reliquiarum porticus Septorum Iuliorum. A. Constructio porticui posterior.
B,C,D Visuntur in ædibus Pamphiliorum. E,F,G,H,I, in hypogeis templi Sanctæ Mariæ in Via Lata.

Vide indicem ruinar. num. 52. 53.

215. Remains of the Saepta Julia stripped of accretions,
Campus Martius

Reliquiae theatri Marcelli. A. Rudera porticus retro scenam ipsius theatri.
B Ruinæ substructionum graduum spectaculorum.
Vide indicem ruinarum num 62.

Piranesi F.

216. Theatre of Marcellus stripped of accretions, *Campus
Martius*

1. *Rudera viae Flaminiae.* 2. *Solum viae ab imbribus*
Vide indicem ruinar. num. 6. 7.

217. Via Flaminia, *Campus Martius*

Tab. XXXVIII.

otum. 3. Silices, et: 4. glarea, quibus via antiquitus muniebatur. 5. Iter novum.

Piranesi F.

Tab. XL.

A. *Reliquiae Pontis Milvij, sive structurae genus, ut Vitruvius ait, incertum, quo rum temporum.* C. *Reliquiae Sepulchrales cum ollarum cineraria*
Vide indic. ruinar. num. 2. 3.

218. Ruins of the Milvian bridge,
Campus Martius

B

ejusdem Pontis pila nunc devastata, et lapidibus spoliata, referta erat. B. Turricula sequic=
is. D. Pons hodie Mollis. E. Turris a Belisario ad pontem exstructa. F. Tiberis fluvius.

Piranesi F

219. Entrance to the tunnel, *Emissario del Lago Albano*

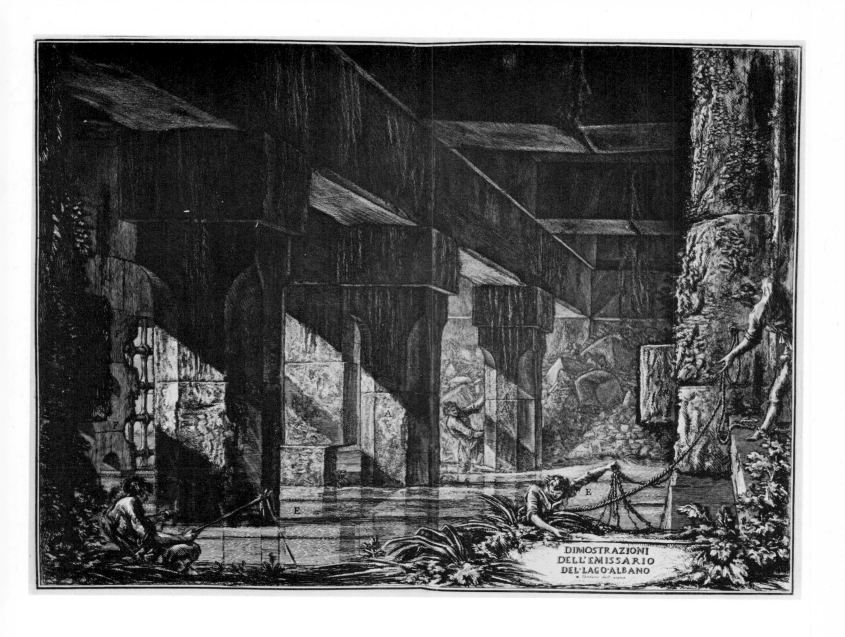

Within the engraving: DIMOSTRAZIONI DELL'EMISSARIO DEL LAGO·ALBANO

220. Inlet from the Lake, *Emissario del Lago Albano*

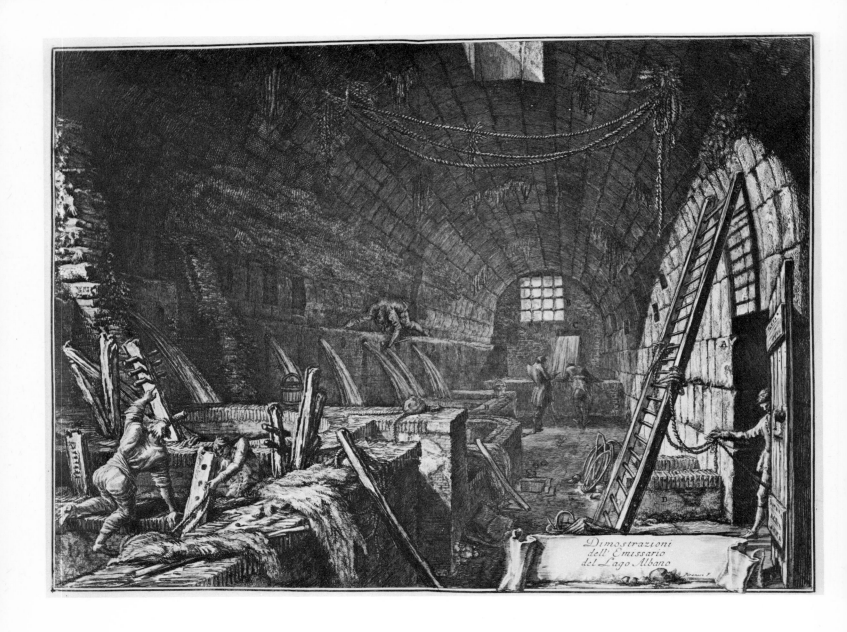

The text within the image reads:

Dimostrazioni dell' Emissario del Lago Albano

Piranesi F

221. Outlet into the tannery, *Emissario del Lago Albano*

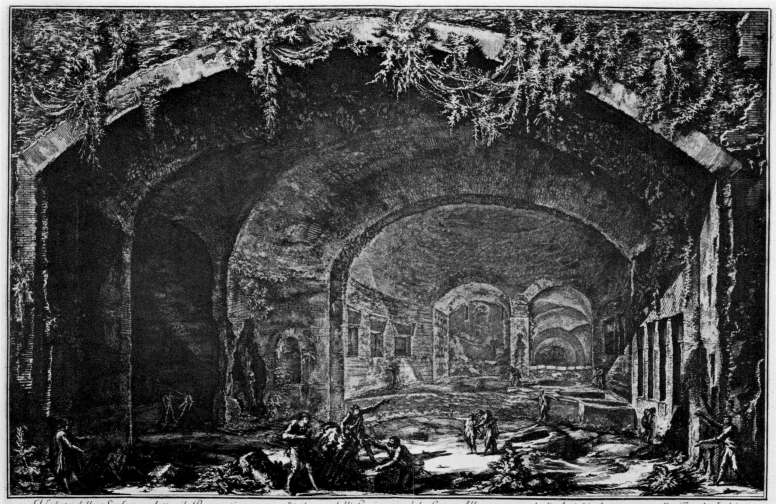

Veduta della Spelonca, detta il Bergantino, presso l'imbocco dell' Emissario del Lago Albano, ornata dagli Antichi, ed accennata nella Tavola I. de' disegni dell' Emissario medesimo alla fig. I Lett. D.

Piranesi F.

222. Grotto by Lago Albano, *Di due Spelonche*

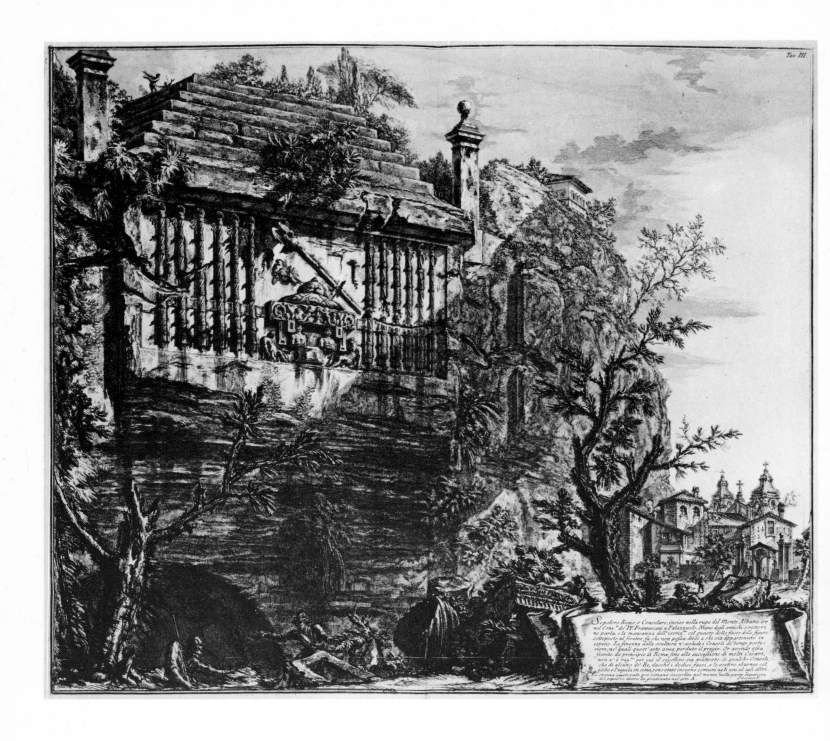

223. Tomb near Albano, *Antichità d'Albano*

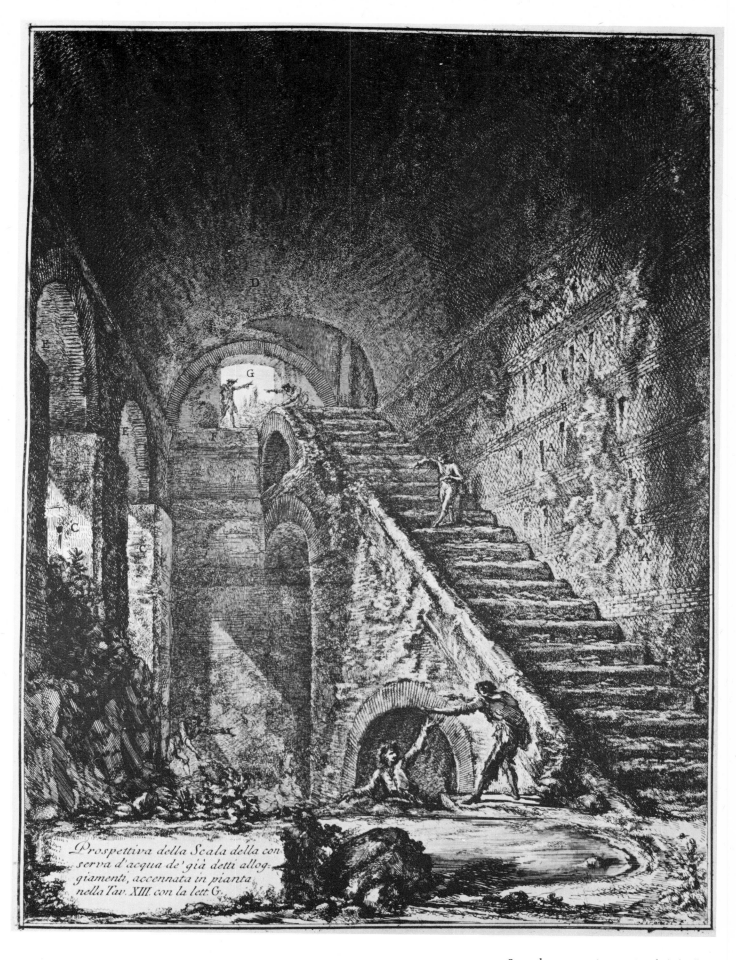

Prospettiva della Scala della conserva d'acqua de' già detti alloggiamenti, accennata in pianta nella Tav. XIII. con la lett. G.

224. Steps down to a cistern, *Antichità d'Albano*

Rovine d'antico edifizio
nella Villa Barberina
presso Castel Gandolfo

Piranesi F.

225. Ruins near Castel Gandolfo, *Antichità d'Albano*

1. Rovine d'un antico Sepolcro, fatto a modo di settizonio su la via Appia appresso la villa di Pompeo Magno, or fuori d'Albano dalla parte occidentale 2. Porta Romana d'Albano, città situata in gran parte ov'era la stessa villa. 3. Via Appia per venire a Roma, occupata in parte dai poderi e dalle ville che vi confinano. 4. Dilatazione moderna della stessa via. 5. Villa dell'Eccma Casa Altieri.

Piranesi f.

226. Tomb near Albano, *Antichità d'Albano*

195

227. Viaduct on the Appian Way, *Antichità d'Albano*

Prospetto del Lastricato e de' margini dell' antica via Appia, delineato così come si vede verso Roma poco più in quà della città d'Albano.

228. The Appian Way, *Antichità d'Albano*

Prospettiva della piscina delle medesime conserve,
fatta a seconda de num. 3, e 4. della Tavola XV.

229. A cistern, *Antichità d'Albano*

198

230. Title page, *Antichità di Cora*

ENDAM PEO SACRO OER

Piranesi F.

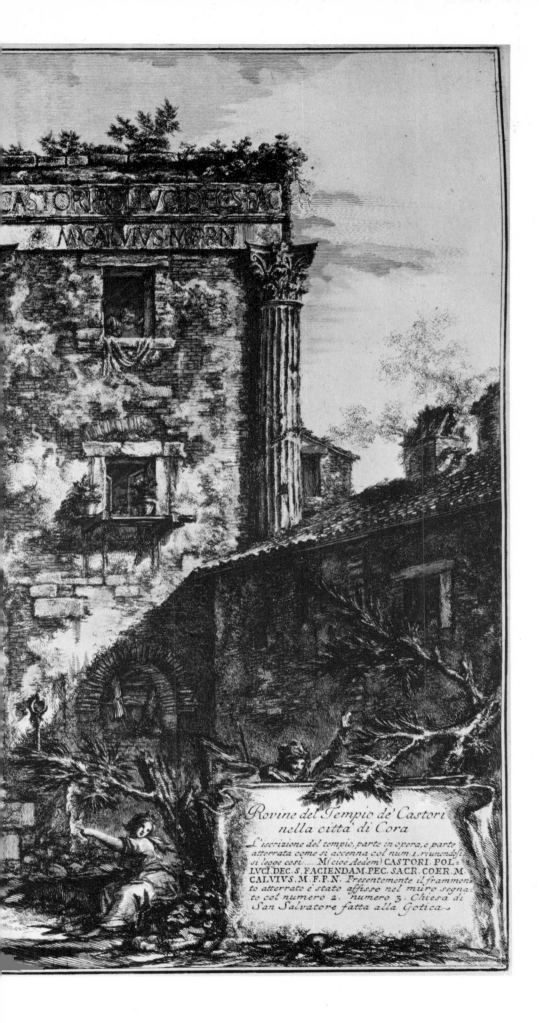

231. Temple of the Dioscuri, *Antichità di Cora*

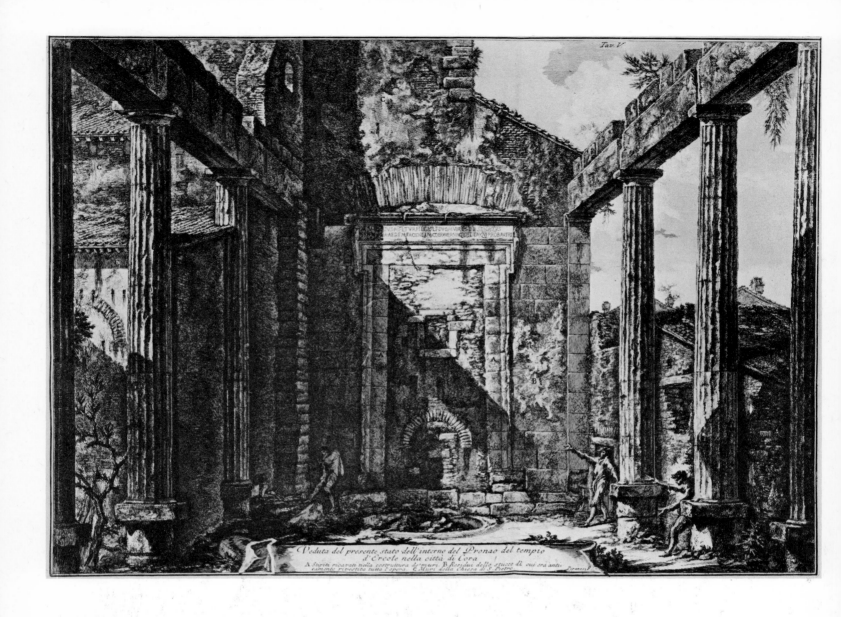

Veduta del presente stato dell'interno del Pronao del tempio
d'Ercole nella città di Cora

232. Temple of Hercules, *Antichità di Cora*

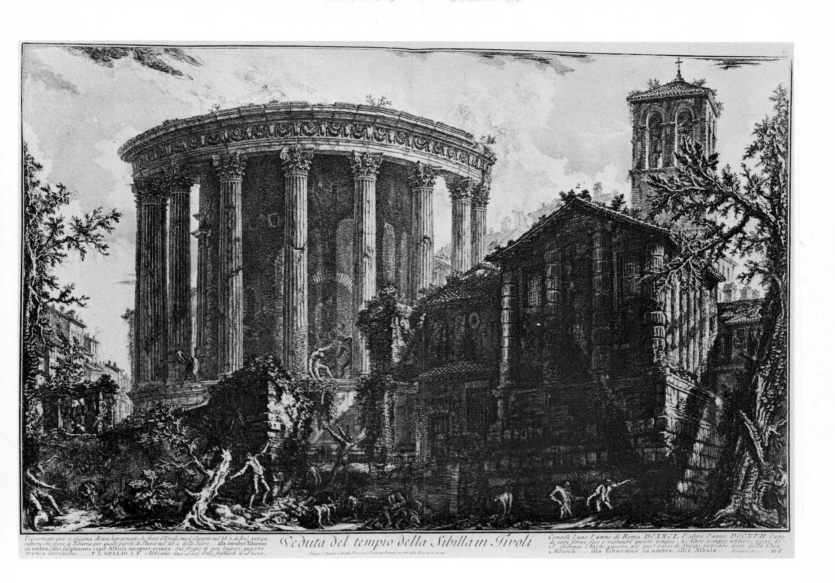

Veduta del tempio della Sibilla in Tivoli

233. Temple of the Sibyl, Tivoli, *Vedute di Roma*

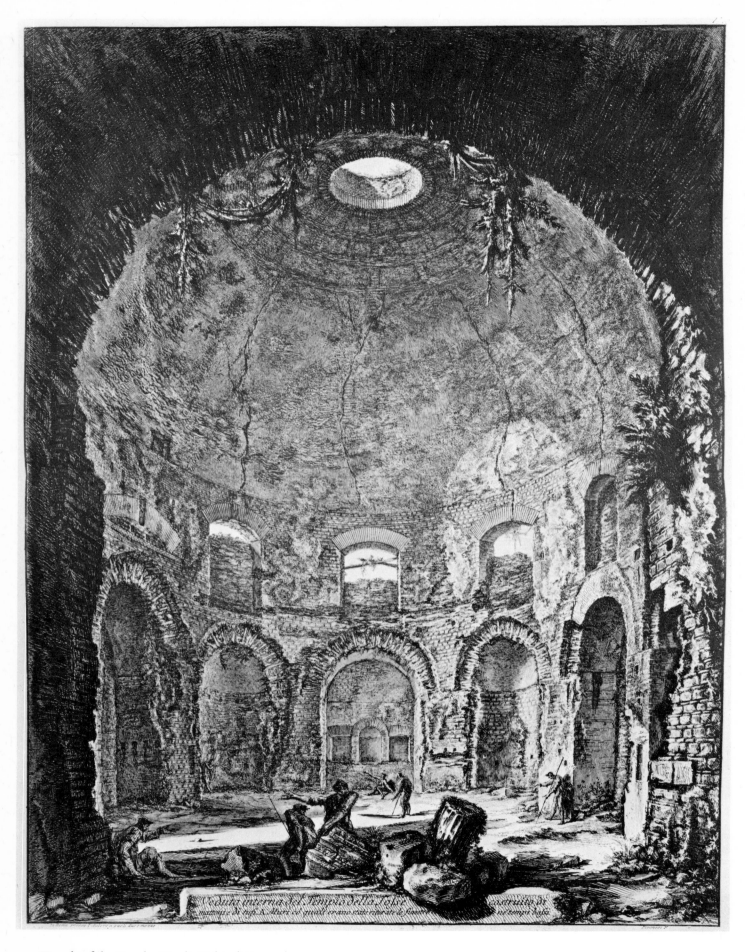

234. Temple of the Coughs, Tivoli, *Vedute di Roma*

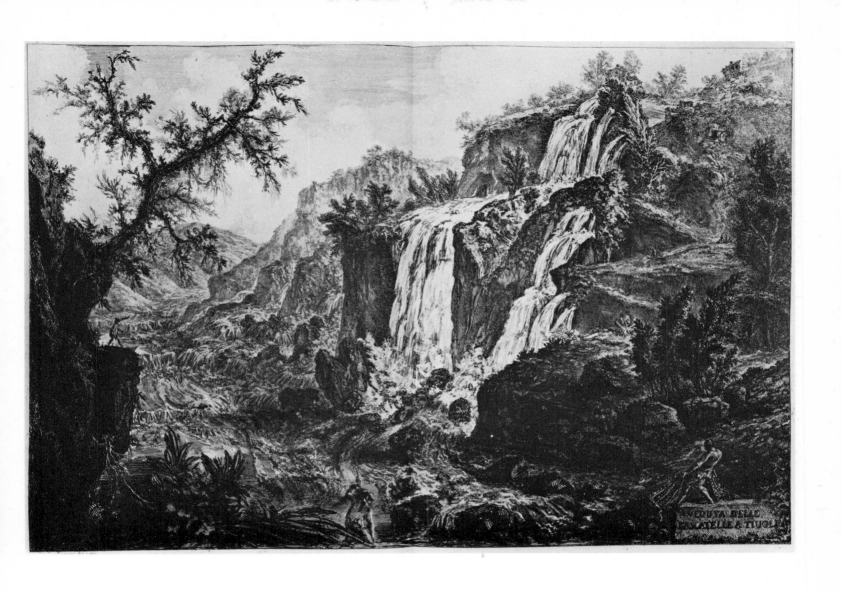

235. Cascatelle, Tivoli, *Vedute di Roma*

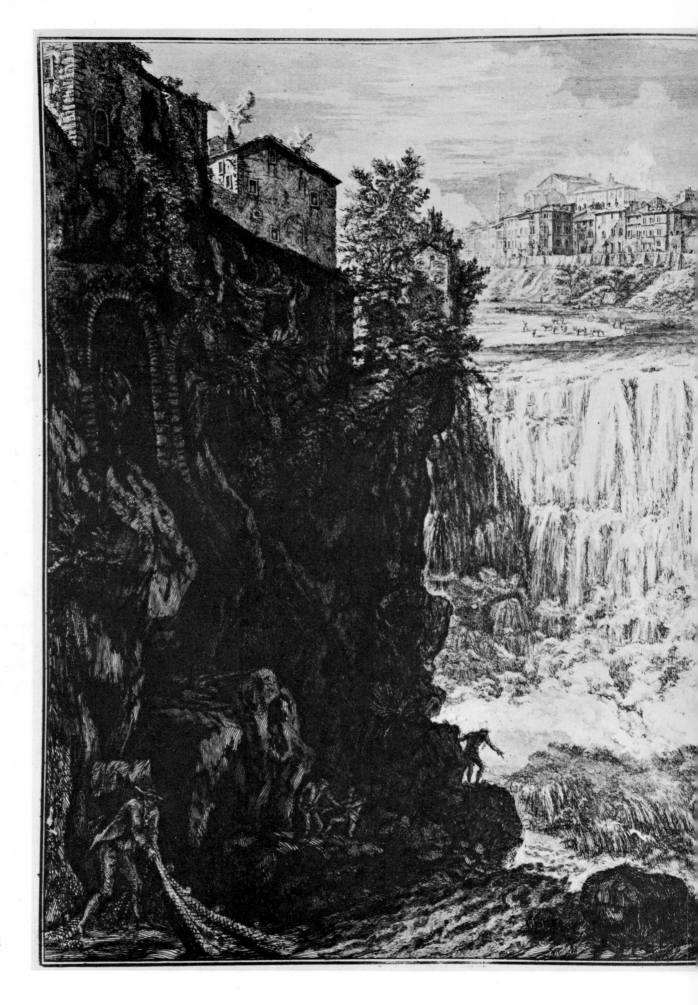

236. The waterfall
at Tivoli,
Vedute di Roma

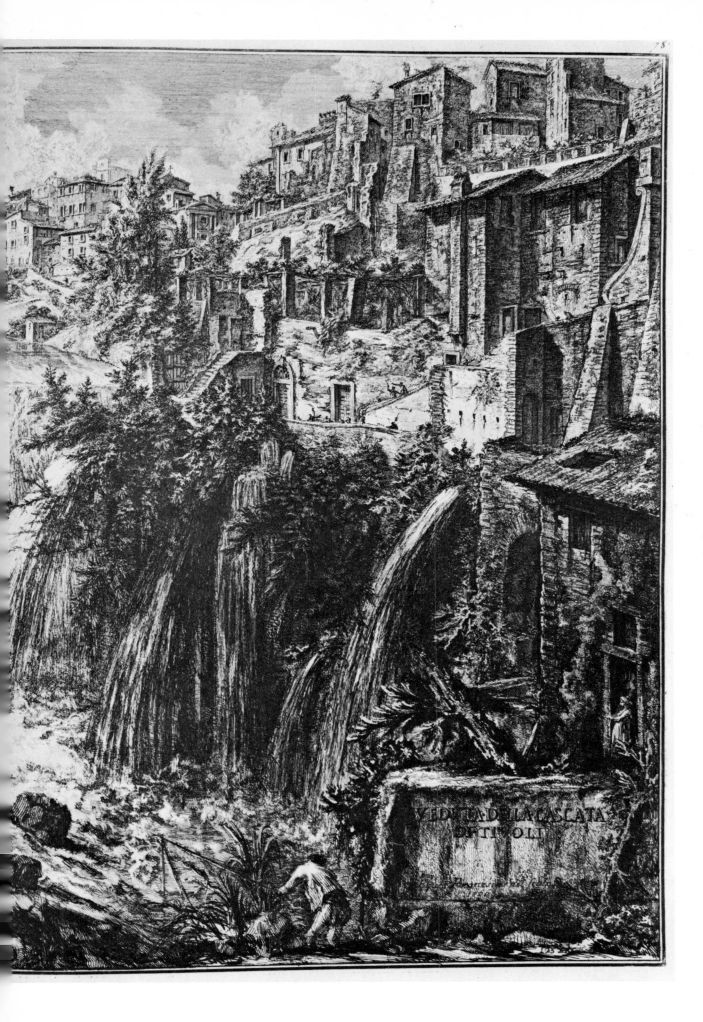

VEDVTA DELLA CASCATA
DI TIVOLI

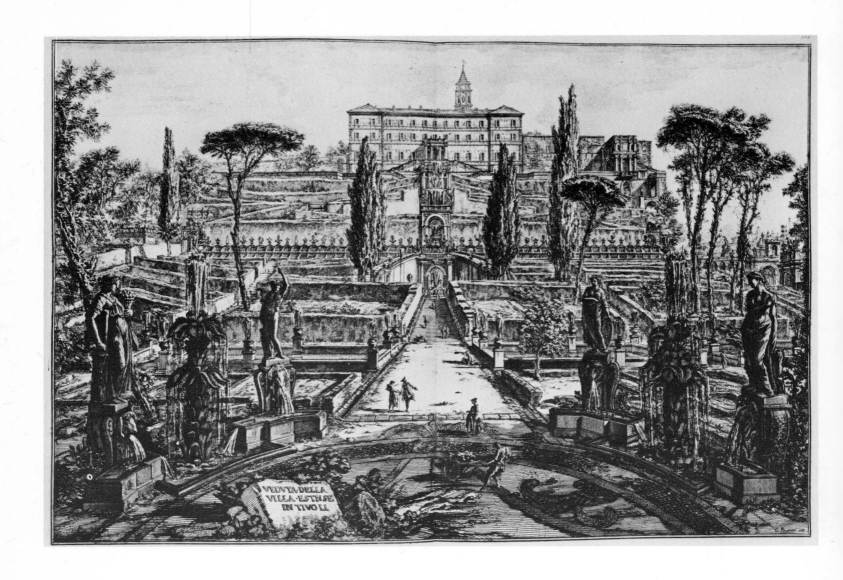

237. Villa d'Este, Tivoli, *Vedute di Roma*

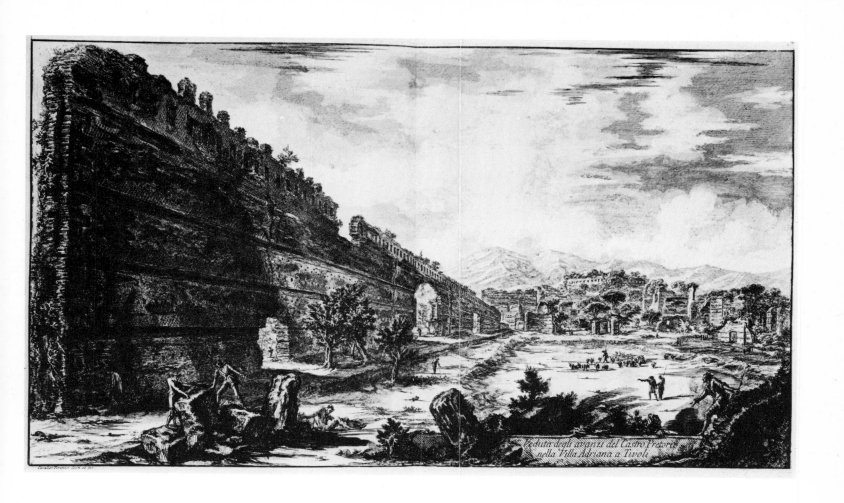

Veduta degli avanzi del Castro Pretorio nella Villa Adriana a Tivoli

Cavalier Piranesi Architetto

238. Stoa Poecile, Hadrian's Villa, *Vedute di Roma*

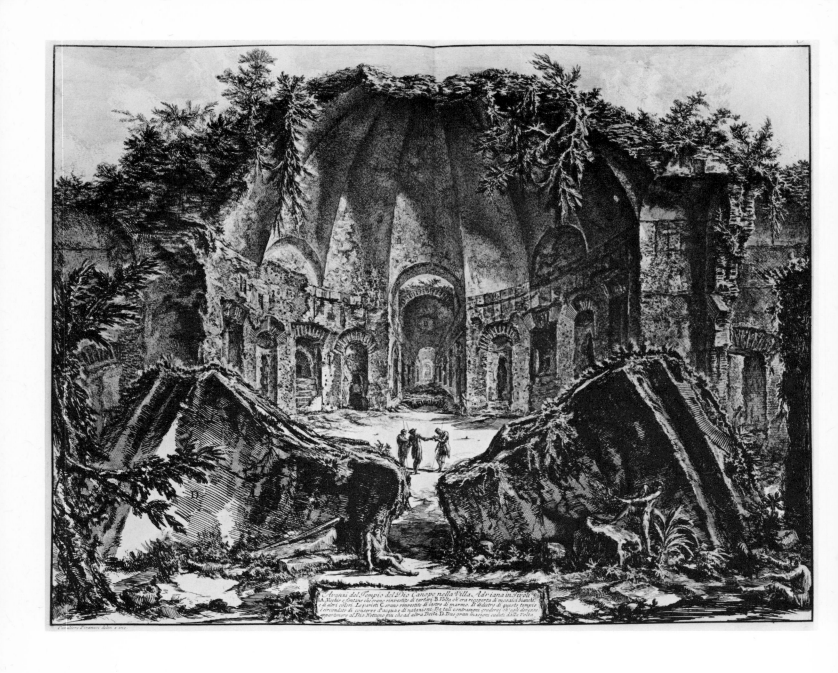

239. Canopus, Hadrian's Villa, *Vedute di Roma*

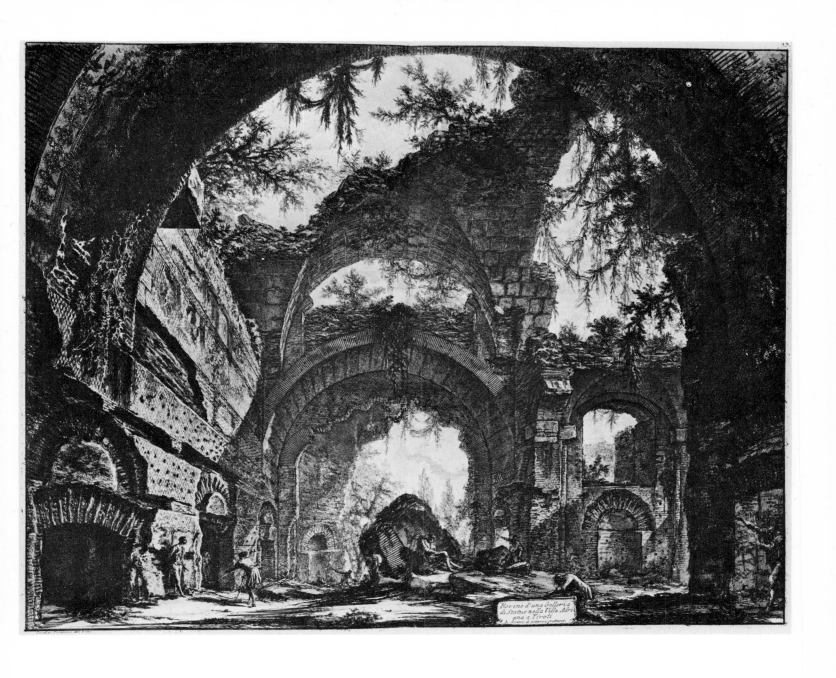

240. Baths, Hadrian's Villa, *Vedute di Roma*

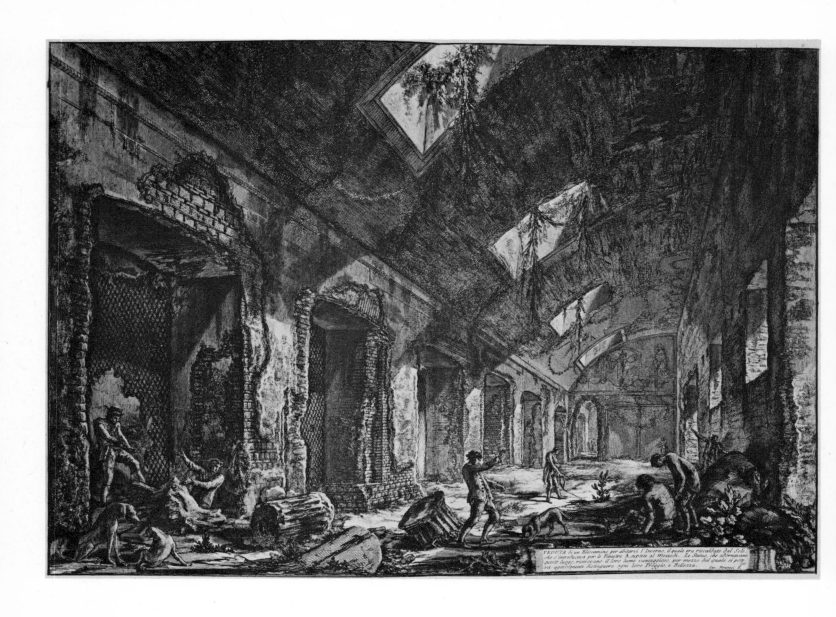

VEDUTA di un Eliocamino per abitarvi l'Inverno, il quale era riscaldato dal Sole, che s'introduceva per le Finestre A. esposte al Mezzodi. Le Statue, che adornavano questo luogo, ricevevano il loro lume vantaggioso, per mezzo del quale si poteva agevolmente distinguere ogni loro Pregio, e Bellezza. Cav. Piranesi F.

241. Heliocaminus, Hadrian's Villa, *Vedute di Roma*

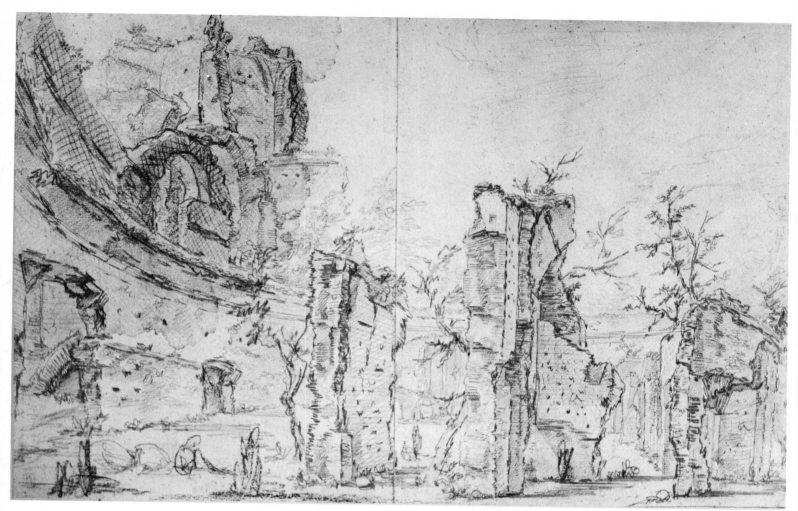

242. Drawing of a Maritime theatre, Hadrian's Villa

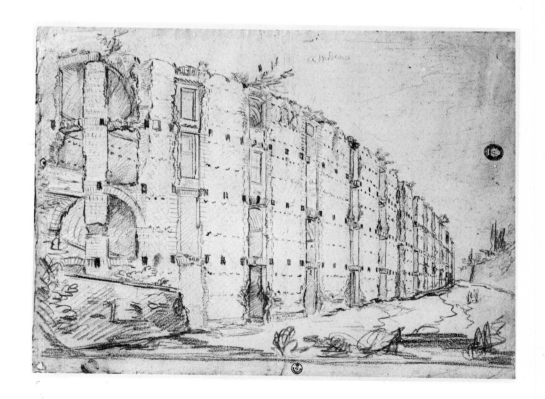

243. Drawing of Hadrian's Villa

Clemens Decimustertius
Pontifex Maximus
Venetus

Ioannes Baptista Piranesius invenit. Dominicus Cunego, et Piranesius sculpserunt.

CHAPTER EIGHT
Works of architecture and design

IN July 1758, a Venetian cardinal, Carlo della Torre Rezzonico, emerged Pope Clement XIII after a long and contentious conclave. This was important for Piranesi because the new Pope and his nephews were to be his best patrons. Clement was a stout, benevolent and pious prelate but of limited intellectual ability and wholly dependent on the opinions of his advisers. He came from a nouveau riche banking family, only enrolled in Venice's Golden Book of Nobility in 1687, and had been a popular bishop of Padua. The politics of the Jesuit problem made his pontificate a misery. First Portugal, then his most Christian Majesty of France, followed by the other Bourbons of Spain, Naples and Parma, expelled the Jesuits from their dominions, and finally this alliance called for the complete dissolution of the Jesuit Order. The Pope wanted to resist but, having summoned the College of Cardinals to take the decision for him, he died of an apoplectic stroke on 2nd February, 1769, the eve of their meeting.

In these difficult times he liked to relax in the peace of Castel Gandolfo and enjoy the companionship of his fellow countryman. 'Because of the frankness of his character', writes Legrand, 'Piranesi was often consulted on important matters and more than one prelate owed his position to the testimony which he gave as to the candidate's intelligence and ability. His success and the freedom he enjoyed enabled him to recover his natural gaiety, and the vivacity of his spirit and his flights of imagination made him a very entertaining companion; he wanted to know everything, to embrace everything at once, and he was much occupied with politics. The Pope, who found him amusing and enjoyed his conversation, often used to unburden himself to him at Castel Gandolfo of the troubles he had over the suppression of the Jesuits which was then under discussion. Piranesi used to take advantage of suitable opportunities to be of use to his friends.' This involvement in the politics of the Jesuit issue is surprising (a devotion to Jupiter Capitolinus or Minerva or even *dea Roma* seems more in keeping) but, as he was a friend of the Jesuit father Contucci and had probably enjoyed the Order's hospitality when investigating the antiquities situated on their many properties, he had cause to sympathise with the Pope's protective views.

Clement XIII's patronage provided a substantial grant towards the publication of *Della Magnificenza,* as we have seen, and in return Piranesi dedicated this volume to him as well as the *Antichità d'Albano* and the three minor works, *Acqua Giulia, Lapides Capitolini* and *Emissario del Lago Albano.* The papal nephews who inevitably followed their uncle to Rome were also Piranesi's patrons. *Diverse maniere d'adornare i cammini* was dedicated to the Pope's Majordomo, Cardinal Giovanni Battista Rezzonico, while Don Abbondio Rezzonico, who had been appointed Senator of Rome, acquired a number of Piranesi's early sketches of the grotesques he had studied when he was first in Rome, and he used to invite the artist to his palace on the Capitol where he could sketch the ruins of the Forum in the Campo Vaccino behind. More importantly, the nephews also employed him as an architect and designer within the limited opportunities then available.[1]

It must have been frustrating to Piranesi that contemporary Roman patrons had neither the funds nor the confidence to undertake grand building projects, whereas all his foreign friends could return home to a flourishing architectural

244. Piranesi and Cunego, Portrait of Clement XIII

practice. Adam was decorating Kedleston and Syon, Chambers had secured royal patronage, Mylne had built his famous bridge at Blackfriars, which Piranesi etched, while French Academy *pensionnaires* like Peyre, de Wailly and Clérisseau were all winning their laurels either in their own country or further afield. It was, however, a sign of the times that the Rezzonicos did not follow the tradition of earlier papal *nipoti* in building a Palazzo Rezzonico and founding in Rome a new princely dynasty. The old-established families had enough to do maintaining their existing state without indulging in new building work. Mrs. Piozzi did not understand that it was quite a struggle to make ends meet. 'That all the palaces', she expostulated, 'which taste and expense combine to decorate should look quietly on while common passengers use their noble vestibules, nay stairs, for every nauseous purpose; that princes whose incomes equal those of our Dukes of Bedford and Marlborough, should suffer their servants to dress other men's dinners for hire, or lend out their equippages for a day's pleasuring and hang wet rags out of their windows to dry . . . while looking in at those very windows, nothing is to be seen but proofs of opulence and splendour, I will not undertake to explain.' She might well have been shocked at the use of the stairs, but the architectural splendour had misled her: it was the creation of earlier generations. Although the city palaces built by their forebears were far grander than the town-house of any English nobleman in London, the Roman princes could not replenish their purses by lucrative government offices like the Whig grandees. The enormous estates of the largest Roman landowners, the Borghese, were almost valueless because, in the depressed state of agriculture, tenants could not be found to work them even rent-free; the principessa had to sell her diamonds to pay for her soirées. Smollett claimed that there were 'not six individuals in Rome who had so much as 40,000 crowns (£10,000) a year'. Neither Church nor State was an alternative source of patronage. The Church's self-confidence was badly shaken under a double attack, both internal from the anti-Jesuit movement, and external from the polite scoffers of the Age of Reason. Instead of countering disbelief with bold architectural gestures, or even challenging the rationalists' position as the voice of humanity and compassion, the best the Church could do was canonise St. Joseph of Copertino, the flying monk of Apulia, as if the cult of this seventeenth-century levitationist was likely to win back to the fold the disciples of Rousseau and Voltaire. The state finances were in a poor way. Foreign contributions had dwindled long ago with the decline of papal influence in European affairs, although Naples continued to pay the Chinea, the last such annual tribute, until 1776. In the absence of any commerce, tax

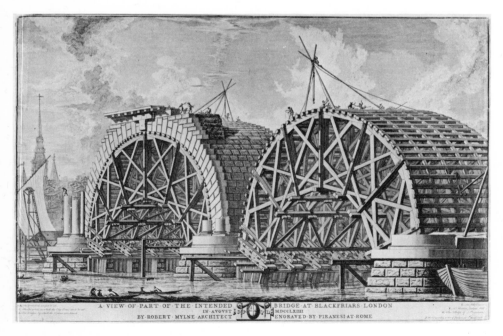

245. View of Blackfriars Bridge

revenues were low and tourist income was an insufficient supplement. To cap it all there were severe droughts in 1763 and 1764 with consequent famine and the need for an extensive relief programme. It is no wonder that the pontificate of Clement XIII saw almost no building in Rome, public, private or ecclesiastical.

In the circumstances Piranesi was lucky to secure one satisfactory commission, the rebuilding of the church of the Knights of Malta, S. Maria del Priorato, and its adjoining *piazza* on the Aventine.[2] In 1764 Cardinal Giovanni Battista Rezzonico, who enjoyed an income of 12,000 *scudi* (£3,000) a year as grand prior of the order, asked Piranesi to redecorate the church. The original building, which had been erected in 1568 was left structurally unaltered. Piranesi's work consisted of adding a new façade and completely refurbishing the interior; in the course of this redecoration, a new vault was imposed and, as a result, the foundations had to be strengthened and the walls raised. Drawings in New York show how his first lightening ideas were later worked out in meticulous detail for submission to his patron. He did not, however, superintend the actual construction; for this he employed Giuseppe Pelosini, the mason in charge, who was responsible for fixing the amount of materials used, for contracting for their delivery at a price agreed with himself, and for supervising the labour and the erection. The fair copy of Pelosini's account book, scrupulously maintained by a secretary, is

246. S. Maria del Priorato, façade

247. Drawing of façade of S. Maria del Priorato before destruction of superstructure

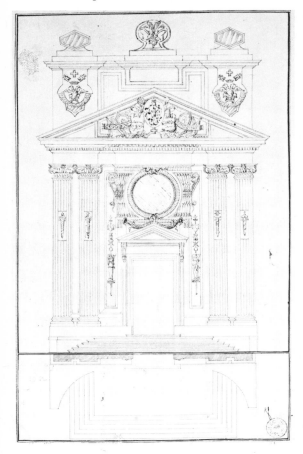

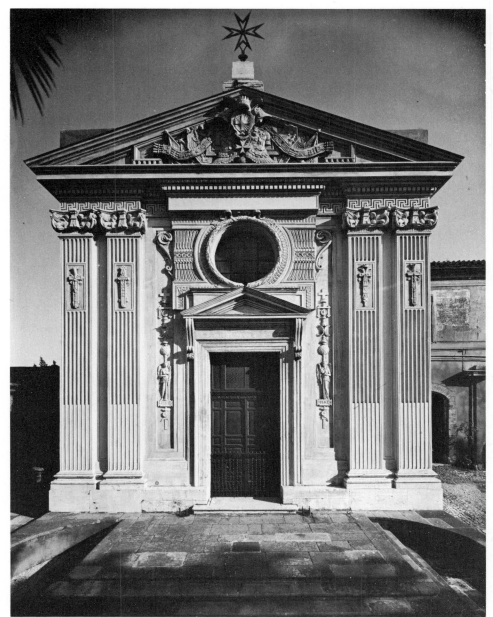

also preserved in New York. It contains detailed entries from November 1764 to October 1766; the work is then summarised and Piranesi is said to have examined and approved what had been done. In April 1767 he signed as correct the figure for the total cost of 10,947 29½ *scudi* (£2,736).

The church is as unusual as was to be expected of him. The new and highly decorated façade *(246)* faces westwards onto a narrow and precipitous terrace overlooking the Tiber. The central doorway is surmounted by a round window set in a frame derived from the panels of a sarcophagus. On either side there are pairs of pilasters, in the capitals of which winged sphinxes face each other across the tower of the Rezzonico coat of arms; some way below each capital Piranesi capriciously inserted a panel on which is carved an ornate dagger in its scabbard. Then, between the inner pilasters and the door, there are two curious compositions which are an ecclesiastical version of a Roman legionary standard, with the Maltese order's motto F.E.R.T. (Fortitudo eius Rhodum tenuit) instead of S.P.Q.R. and a cross in place of the eagle. Below the pediment the coat of arms of the order is surrounded by a panoply of martial trophies. This feature was originally considerably higher; above it there was once a square-topped block decorated with more coats of arms and itself crowned by a double helmet in the centre and two hexagonal plaques, but this has long ago disappeared, a casualty

248. S. Maria del Priorato, interior

249. Design for the altar in S. Maria del Priorato

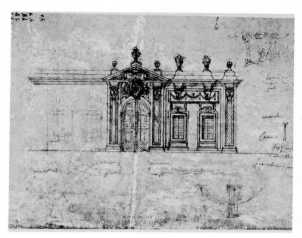

250. Drawing for the garden front of the Priory of Malta

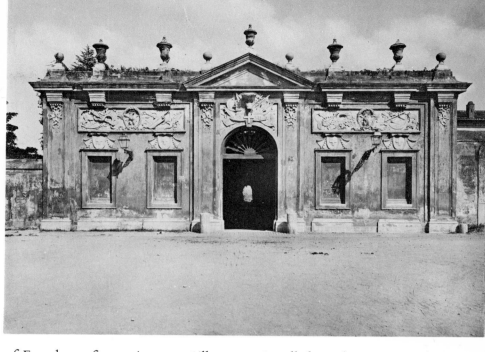

251. Garden front of the Priory of Malta

of French gunfire against an artillery post installed on the Aventine during the assault on Rome in 1849 (247). The Knights of Malta have always had a hard time under siege.

The interior is as different from the Rococo turbulence of earlier Roman churches as it is from the academic strictness of Valadier which followed them; the decoration could only be Piranesi's. Pilasters down the nave frame niches in one of which stands a more-than-life-size statue by Angelini, erected over the architect's tomb by his widow and sons. At the back of these niches there are stucco cartouches decorated macabrely with skulls, snakes and inverted torches, the symbol of mortality. The communion rails are brought into the body of the church, a Venetian rather than a Roman touch, which may have been planned so as to add greater dignity to the stall of the grand prior by the high altar. To add emphasis to the east end, the pilasters stop after the third bay of the nave to be succeeded by semi-columns in the transept and apse. There, with an inspiration from Bernini, the lofty altar of St. Basil of Cappadocia is floodlit from a window behind and from a lantern above, both concealed from the congregation. This altar is a splendid creation, first one sarcophagus and then another, the second adorned with an octagonal frame for the Virgin and child; above that rests the Lamb of God and then a huge cloud-wrapped globe upon which the saint is whirled by angels to his apotheosis. It is an extraordinary and boldly successful combination of neo-classical motifs and old-fashioned Baroque drama. The artist was Tommaso Righi who was also responsible for the beautifully crisp stucco of the vault where the emblems of the knightly order and their chivalry are emblazoned on a sun burst.[3]

All the interior and its decoration is a cool white, unconfused by variegated marbles. The only colour comes from modern additions, from the scarlet of the carpet and the grand prior's stall, and from the banners of the medieval inns of the knights, the leopards and lilies of Plantagenet England, the double-headed eagle of the Holy Roman empire, lilies again for France, the armorials of Spain and Portugal and a simple black banner with the golden word ITALIA for the myriad states of the Italian peninsula. It is for me one of the most attractive churches in Rome.

The gardens of the Priory had been laid out in the previous century by a Pamphili cardinal. Piranesi added an entrance gate onto the *piazza* outside, a feature that is usually blocked by buses disgorging queues of tourists impatient

252. Piazza dei Cavalieri di Malta

253. Design for the altar in S. Maria del Priorato

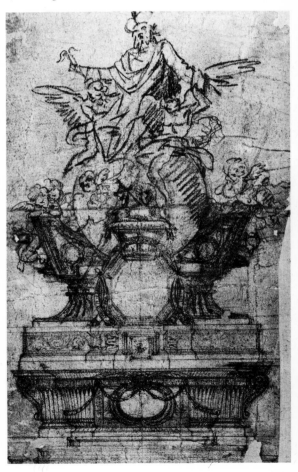

to press their cameras to the keyhole for a photograph of the pergolaed vista towards St. Peter's. Above the gate itself, under a low pediment and a row of urns, there is a stucco panoply of martial achievements and nautical prows to commemorate the heroic past of the Order. To either side are panels of more esoteric ornaments, which surround the heraldic Rezzonico eagle and include a collage of loose wings, trumpets, bows, quivers, anchors and snakes. The decorative scheme was not confined to the garden front. Beneath the tall cypress trees of the grounds of S. Anselmo opposite, the south and west sides of the piazza were also enclosed by a high wall punctuated by plaques, obelisks and a round-headed stele variously carved with the cross of the Maltese knights and a medley of symbols, many of them from Piranesi's own collection of Etruscan motifs later published in *Diverse maniere (264)*. It is a delightful little square, formal but not symmetrical (because of the need to centre the garden gate on the dome of St. Peter's). It might be a stage set or, more likely, the background for a firework display, and indeed the two dimensional surface detail both here and on the church façade are more the work of a theatrical decorator than an architect. Contemporaries were critical: Bianconi, for instance, thought that the ornamentation was overloaded and discordant, while James Barry, an English artist writing from Rome to Edmund Burke in 1769, could find nothing good to say for 'his gusto of architecture flowing out of the same cloacus [sic] with Borromini's'.[4] Nevertheless, the Pope showed the satisfaction of the Rezzonico family by knighting Piranesi when he came to visit the completed work in October 1766. Three months later, when he issued the brief conveying on him the *Sperone d'Oro*, the Order of the Golden Spur, he admonished his hot-tempered friend to use his sword in defence of the faith and not, by implication, in defence of his archaeological theories.

In the same year that the Cardinal Rezzonico commissioned the reconstruction of S. Maria del Priorato, his uncle asked Piranesi to produce a design for rebuilding the high altar and apse of S. Giovanni in Laterano. This basilica and not St. Peter's is the senior church of Rome and it was here that the new Pope took his *possessio* as bishop of the city after his election at the conclave. The grand and for him comparatively restrained nave had been rebuilt by Borromini in 1646, and Galilei had added a new façade on the east front some ninety years later; only the west end with the high altar (the normal orientation is reversed) remained from the old basilica.

254. S. Giovanni in Laterano, interior, *Vedute di Roma*

Piranesi produced a number of alternative designs, but no building orders followed. He was not however going to give up easily and in 1767 he presented a set of twenty-five large drawings (some thirty-five inches by twenty-two) to Cardinal Rezzonico in the hope that his building enthusiasm would survive the completion of S. Maria del Priorato. Twenty-three of these designs have recently come to light and been presented to Columbia University, New York, a marvellously rich and imaginative series in which the overloaded excesses of the *Parere* are adapted to provide a grand setting for the pontifical liturgies of the high altar. The drawings are beautifully prepared with elaborate borders and scrolls and trompe l'oeil decoration. There are five alternative projects for the sanctuary as well as several designs for the baldaquin over the high altar. Borromini's nave provided a congenial starting point for Piranesi's designs; the bizarre and tortuous forms and the idiosyncratic manipulation of decorative features employed by the Baroque architect were familiar to him. The spiral dome of S. Ivo appears in his *Prima Parte* designs and in the *Fall of Phaethon,* S. Andrea della Fratte with its extraordinary campanile was his parish church, and he copied in these Lateran designs the niche frame of angel wings over the doorway of S. Carlino alle Quattro Fontane. In all of the designs the articulation of Borromini's nave is maintained, and, in some of them, the Cavaliere d'Arpino's Mannerist frescoes at the crossing of the transepts are also preserved. In one project *(255)* Piranesi raises the roof of the sanctuary high above the nave and places a huge half dome over the apse. The papal altar is to be set in a free-standing horse-shoe colonnade with concealed lighting from three round clerestory windows pierced in the wall above the arch leading into the nave. In another scheme he abandons these concealed lighting effects (defeated by the difficulty of constructing so huge a vault on the awkward site) and instead extends the sanctuary about one-hundred-and-twenty-five feet, repeating Borromini's giant pilasters and frieze and his colossal niched saints for another three bays before the curve of the apse; in this project he imposes a wholly novel vault of his own device, twining thick arabesques of garlands and powdering them with six-pointed stars. The architectural derivation is from Juvarra's great churches in Piedmont but the decorative details are entirely his own and closely related to the *Parere* designs. He rolls a strip of key pattern round the bases of the columns as well as along the wall behind them, while the columns themselves are fluted in spirals and are wrapped with a frieze of figures in relief immediately below the novel Corinthian capitals which flutter with cherub wings, and he includes his favourite device, the eagles supporting heavy ropes of foliage which were taken from the base of Trajan's column and, conveniently in this case, allude to the Rezzonico armorials.[5]

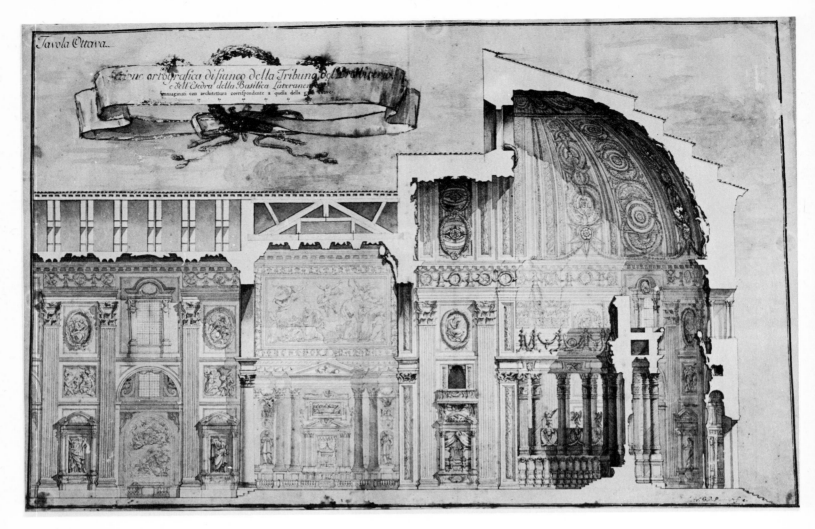

255. Design for S. Giovanni in Laterano

255a. Simonetti's Sala della Rotonda, Vatican

Any of these schemes would have been an exciting addition to the architectural treasures of Rome, but they all entailed the destruction of the mosaic in the apse, a splendid mosaic which follows the lines of the majestic portrait of Christ miraculously sketched there by an angel one night shortly after the first basilica had been built in the fourth century. Although Piranesi made a gesture to the tradition in some designs by suggesting a huge stucco head and shoulders of Christ above the high altar, I should greatly regret the loss of the angel's stern Pantocrator silhouetted against a bowl of blue and scarlet flames and I cannot be altogether sorry that the architect was frustrated.[6]

Any last hopes he might have had of executing his designs died with Clement XIII in 1769. Giovanni Ganganelli who succeeded as Clement XIV was a practical man who tried to revive commerce by cutting the number of religious holidays and spending state revenues on roads not churches, earning the title of 'the Protestant Pope' for his pains.[7] The only major building work of his pontificate was the construction of the Vatican Museum of Classical Antiquities, a valuable tourist attraction then as now, for which Michelangelo Simonetti was chosen as architect.[8] It seems unfair that Piranesi who had done so much for the antiquities of Rome should not have been selected, but he was obviously considered too eccentric a designer for this grand temple of neo-classicism. The Vatican authorities preferred a safer and more academic style although, when some of their other decorative commissions went to the chief exponent of the new order, Raphael Mengs, he proceeded to execute them in a restrained version of Piranesi's Egyptian manner.[9]

Piranesi did, however, carry out several decorative schemes which have now disappeared. There was the work he did for the Rezzonicos in the Capitoline and Quirinal palaces and at Castel Gandolfo. He also contributed to the design of a

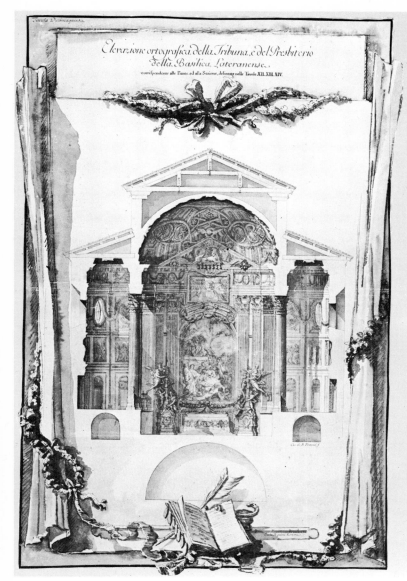

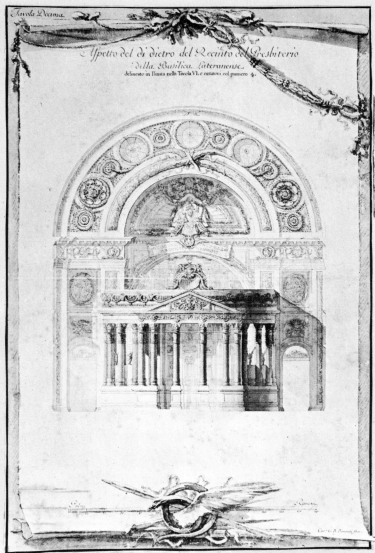

256. Design for S. Giovanni in Laterano

257. Design for S. Giovanni in Laterano

'ruin room' for the Maltese ambassador, the Baillie de Breteuil, which was based on a creation of Clérisseau (266) for two mathematical monks in the monastery attached to Trinità dei Monti close to Piranesi's house. Legrand gives us a description of this room which was a typical piece of eighteenth-century enthusiasm for antiquity. 'On entering you imagined that you were in the cella of a temple, enriched with antique fragments that had escaped the ravages of time; the vault and several parts of the wall, crumbling in places and held up by rotting timbers, seemed to let in the open air and sunlight. These effects carried out with such knowledge and truthfulness produced a completely realistic illusion. To enhance this effect further, all the furniture was in keeping: the bed was a richly decorated basin, the fireplace a composition of various fragments, the desk a battered sarcophagus, the table and seats a fragment of a cornice and inverted capitals respectively, while a damaged vase served as a kennel for the dog, the faithful guardian of these novel furnishings.' The Marchesa Gentili Boccapaduli copied Clérisseau's conceit in her town house and in her country villa and when the Baillie de Breteuil commissioned a similar room for the Villa di Malta he took scenes by La Vallée, Poussin and Robert and employed Giuseppe Barberi as his architect while 'Piranesi's advice was useful and this combination of artists produced one of the most delightful places'.[10] Piranesi intended to etch views of all these ruin rooms but was so busy on other work that he had to abandon the project. Today only Clérisseau's room survives although it has lost its mock antique furnishings.[11]

Another curious work that has disappeared was the Egyptian decoration of the Caffe degli Inglesi directly opposite the Spanish Steps in the Piazza di Spagna. The designs were published together with a description in *Diverse maniere*.[12] Piranesi shows the walls covered, probably by his assistants, with paintings of the screen of 'a vestibule decorated with hieroglyphic symbols and other objects connected with the religion and state of ancient Egypt. In the background can be seen the fertile countryside, the Nile and the majestic tombs of that nation.' On another wall 'the huge pyramids and other sepulchral buildings in the deserts of Egypt can be seen through the opening of a vestibule'. They are extraordinary scenes, covered with scarabs and locusts, bulls and crocodiles, Anubis, the Sphinx and all the priests of ancient Memphis. Some of the details seem to have been culled from the Barberini's famous mosaic of the Nile at Palestrina, others are taken from the statuary and obelisks which ancient emperors starting with Augustus had carried back with them from Egypt to Rome. The decoration was certainly an eye-catcher to attract the tourists' attention and induce them to climb the Spanish Steps to the artist's shop but it does not seem to have won any repeat commissions and it was not universally admired; 'a filthy vaulted room', said Thomas Jones, the Welsh artist, 'the walls of which were painted with Sphinxes, Obelisks and Pyramids, from capricious designs of Piranesi, more fitted to adorn the inside of an Egyptian Sepulchre than a room of social conversation'.[13] The Egyptian style was not to become a popular cult until Napoleon's Alexandrian campaign at the end of the century.

Realising that he was not going to have opportunities of undertaking major building work in Rome, he concentrated on designing smaller decorative details, and, in particular, the series of exotic fireplaces, which comprise the bulk of the designs published in *Diverse maniere* in 1769. He had been preparing these possibly as early as 1764 to judge from the sketches jotted down on the back of proof pulls of his Albano etchings (scraps of unused paper did not last long in his studio) and the designs were being circulated before the collected edition was issued. In October 1767 Sir William Hamilton, the British ambassador in Naples, wrote to thank him for some specimen plates. 'I am delighted that you have done this work for it will be very useful in my country where we make much use of fireplaces. The ornaments will be found without end there.'[14] In November, 1767, Piranesi was able to send a batch of plates, including the illustrations of the Egyptian decorations, to Thomas Hollis of the London Society of Antiquaries to demonstrate the versatility of their Italian Fellow. 'You will see in this work', he wrote, 'something that has been hitherto unknown. For the first time Egyptian architecture makes its appearance, for the first time, I stress, because until now the world has thought that it consisted of nothing but pyramids, obelisks and vast statues, and concluded that these were insufficient to form a basis for architectural ornament and design.'

A few fireplace designs were actually executed, including three of those illustrated in *Diverse maniere*, one *(267)* for Lord Exeter which is still at Burghley[15], one *(269)* for the Dutch banker, John Hope, now in the Rijksmuseum in Amsterdam[16], (both partly composed of antique fragments) and one for Don Abbondio Rezzonico, which has since disappeared from the Capitoline Palace. These three are among the most restrained of his published designs and the one which George Grenville commissioned for his uncle, Lord Temple, at Stowe was even more sober if, as seems probable, it was that removed from the Music Room after the Stowe sale in 1921.[17] We hear of a further piece being sent to Scotland and there are two examples at Gorhambury, a house built for Lord Grimston by Sir Robert Taylor in the 1770s; the one in the library incorporates a relief of an ancient sacrifice and that in the drawing room has some beautiful porphyry reliefs inset in the surround of Carrara marble. These two chimney pieces were probably the gift of Grimston's father-in-law, Edward Walter, who used Piranesi as well as Matthew Nulty as his agent for collecting antiques. There are in fact three Roman vases still at Gorhambury which were bought by Walter and his

258. Caffe degli Inglesi, *Diverse maniere*

259. Caffe degli Inglesi, *Diverse maniere*

260. Drawing of a chimney piece and chair

261. Chimney piece at Gorhambury, Hertfordshire

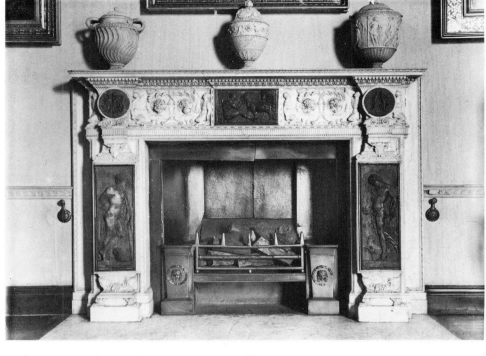

wife, Harriot, during their Roman stay.[18]

Since *Diverse maniere* was partly intended as an advertisement for new business, it was useful to be able to illustrate items which had already been sold. Piranesi did not, however, go out of his way to flatter contemporary taste with a selection of decorative schemes that were obviously acceptable to his market. The designs, which he seems to have visualised in colour, were uncompromisingly original not to say overpowering, and they were composed of so many carved and contrasting marbles and such intricate ormolu work that the finished product must have been extremely expensive. Every ornamental detail he had noted in his sketch book found a place somewhere, if not on a chimney piece then on the fire-basket or firedogs or on a chair to the side or the mirror and wall above. Some of it is a great success; the arabesques, for instance, over the mantels in the first three plates, derived from stucco ceilings of the ancient tombs and Nero's Golden House, are as delicate as the finest work of Robert Adam at this period and, indeed, Adam paid him the compliment of imitation as did his fellow countryman, Charles Cameron, in his decorations for Tsarskoe Selo.[19] The grander schemes in the succeeding plates are much more questionable; detail is chaotically overloaded and the scale of the ornamentation is muddled with the result that the figures of the caryatids, the masks, medallions and the maenads dancing in the firegrate may be half a dozen different sizes. It should be remembered, however, that if the later designs for Egyptian decoration had ever been executed they would not have been as overpowering as they appear in the plates because, although the schemes look like scenery for a Cecil B. de Mille spectacular, they were intended to be painted on the walls as in the Caffe degli Inglesi and not executed in relief. The Egyptian decoration is particularly startling coming as it does some forty years before Napoleon's eastern expedition. I think that Piranesi adopted the style partly for the sake of the novelty which he propounded in the *Parere* and partly because, for archaeological reasons, he associated it with the Etruscans. If MacPherson had derived Ossian from the seers of Etruria no doubt we should have had fireplaces coiled with weird sea monsters and intricate rope patterns taken from the Book of Kells. As it is, these Egyptian extravaganzas could hardly be more different from the light and cheerful Rococo wall panels which he had designed back in Venice a quarter of a century earlier.

The illustrations of *Diverse maniere* comprise some sixty designs for chimney pieces of which eleven are in the Egyptian style, besides the two designs for the

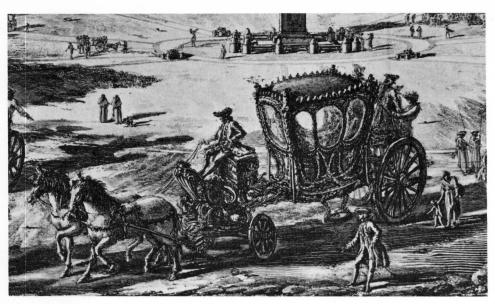

262. Detail of a coach, *Vedute di Roma*

Caffe degli Inglesi, but there are fourteen additional plates of decorative details for commodes, side tables, mirrors, tripods, candelabra, clocks, coaches, even coffee services. It is surprising to find Piranesi as a coach designer but, after all, Chambers was responsible for the State Coronation Coach and James Adam wrote from Rome in 1762 to ask his brother Robert for drawings for an equipage. In fact, Rome was justly renowned for the skill of its coachbuilders, as we can judge from three of the magnificent Portuguese state coaches to be seen at Belem, which were commissioned in Rome by Marquês de Fontes to make the short journey from his embassy to the Quirinal earlier in the century. The young Lord Carlisle, however, who obtained a design for a 'coach with antique ornaments' from Piranesi in June 1768, intended to have his built in Paris. One of these elegant two-horsed vehicles out of *Diverse maniere* is to be seen in Piranesi's *Veduta* of St. Peter's, taking a grand tourist on his stately progress round the city's monuments. It is odd that sedan chairs for which he also made designs are not similarly shown in the *Vedute*. Perhaps they were strictly a nocturnal conveyance.

Several of his furniture designs were executed for the Rezzonico brothers including a monstrous ormolu clock and a magnificent pair of gilt wood side tables, one of which is in Minneapolis and the other *(271)* in Amsterdam.[20] Although the basic shape of most of his furniture was of a standard contemporary pattern, the decoration was as unusual and as zoomorphic as that on his chimney pieces; given Piranesi's taste, the snakes and hippogryphs were almost inevitable, but he may perhaps have been influenced by memories of the gilt splendours of tritons and mermen and exotic foliage which Brustolon had created in his native Venice at the beginning of the century. Brustolon, however, produced fairly robust pieces whereas Piranesi's designs *(281)* were too delicate to have been very practical (the pendent swags shown in the design of the Rezzonico side tables had to be omitted). In this respect they were like the pattern books of Thomas Johnson rather than those of Chippendale and represented the sort of decoration he would have liked to produce and not furniture that was likely to survive everyday use.

Piranesi prefaced his illustrations to *Diverse maniere* with *An apologetical essay in defence of the Egyptian and Tuscan Architecture* in which he set out the purpose of the subsequent designs in a triple text in Italian, French and English. 'I propose showing the use that may be made of medals, cameos, intaglios, statues, basso-relieves, paintings, and such like remains of antiquity, not only by the critics and learned in their studies, but likewise by the artists in their works . . .: whoever has the least introduction into the study of antiquity must plainly see how large a field I have by this laid open for the industry of our artists to work upon . . . I flatter myself that the great and serious study, I have made upon all the happy remains

263. Various designs, *Diverse maniere*

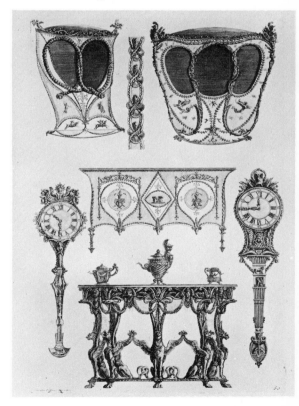

of ancient monuments, has enabled me to execute this useful, and if I may be allowed to say it, even necessary project.' He was, however, on the defensive. 'I will endeavour to obviate some of the objections which I forsee will be made against me. It will be said, for instance, that I have loaded these my designs with too many ornaments; others again will find fault, that in ornamenting cabinets (i.e. living rooms) where the agreeable, the delicate, and the tender ought only to have place, that I have employed the Egyptian and Tuscan manners, which are, according to the common opinion, bold, hard and stiff.'

He defended himself against the first accusation of the rigorists on the grounds that it is as wrong to disapprove of decoration in itself as opposed to ill-proportioned decoration as it is to blame a discordant concerto on the size of the orchestra when the fault lies with the composer or the players. Besides, some

264. Etruscan decorative details, *Diverse maniere*

objects 'are more susceptible, than any others, of a variety and multiplicity of embellishments'. As there are no examples of antique chimney pieces there can be no one pattern for them and it is absurd to restrict their decoration to that suitable for doorways. 'I am rather inclined to think that chimneys form a particular class in architecture by themselves, which class has its own particular laws, and proprieties, and is susceptible of all the embellishments, and variety which the *small* architecture can furnish, and of more than would be proper for a door, or the front of a portico. But', he continued, 'if any one should be shocked, imagining that I would have a cabinet covered from top to bottom with basso-relievos, he would be much mistaken; these ornaments which serve to make the whole uniform may be executed in painting, as I have done those of the English coffeehouse after the Egyptian taste, and those in the apartments of the Senator of Rome after the Grecian and Tuscan manners.'

265. Shells, *Diverse maniere*

He then turned to the second set of objections. 'The Egyptian and Tuscan architecture, in the opinion of many, has no other characteristic but the bold and stiff . . .' He replied that 'even the grotesk has its beauty' and, after all, 'we are delighted to have our rooms and apartments fitted up after the Chinese manner', but his main defence was a sensible and sensitive argument. 'If we would reflect a little we should find that we often accuse of hardness what is only a solidity required by the quality of the architecture. The ancients, as well as the moderns, made statues, and images of all that is to be seen in nature, some to be considered in themselves, and others for the embellishment of architecture, and to be attached to buildings: in the first they were exact in imitating nature, and in giving to each the proportion and graces which were proper to them: not so in regard to the second: these were to be subjected to the laws of architecture, and to receive such modifications as it requires. Now these modifications are what many call hardnesses, and they are brought as proofs of the inexperience of the artificers . . . So when they see an eagle carved upon a building, they will praise the invention of the artist, and the use he has made of it for the advantage of that part of architecture: but they will be displeased that the talons or head are made too large, which however agrees so well with the majesty of the building; and with the feathers of the displayed wings, disposed like the reeds of a shepherd's pipe, which so well agree with the horisontal and perpendicular lines of architecture . . . Art, seeking after new inventions, borrowed, I may say, from nature ornaments, changing and adapting them as necessity required.' He illustrated this percipient piece of criticism further by instancing the deliberate and economic stylisation of the Egyptian lions forming part of the Acqua Felice fountain.

When he came to defend the Tuscan style, his old animosity towards the Greeks had gone; Greece could be a source of decorative details for his new eclecticism just as much as Egypt even though he still had technical reservations about the Doric order. Since the Romans learned first from the Etruscans and then from the Greeks, 'the Tuscan and Grecian were mixed together, the graces and beauties of the one became common to the other, and the Romans found means to unite them both in one and the same work. This is what I likewise have pretended to do in these chimneys, . . . to unite the Tuscan, or what is the same, the Roman with the Grecian, and to make the beautiful and elegant of both united subservient to the execution of my design.' He praised the ingenuity of the Etruscans, especially in their vase shapes and in the decorative patterns which he derived from the coils and spirals of sea shells, and he listed and illustrated over a hundred 'Tuscan' designs, mainly culled from vases which he wrongly thought were Etruscan rather than Greek *(264)*.[21]

He concluded with a rousing appeal for an original approach to antiquity, 'not servilely copying from others, for this would reduce architecture and the noble arts (to) a pitiful mechanism . . . An artist who would do himself honour, and acquire a name, must not content himself with copying faithfully the ancients, but studying their works he ought to shew himself an inventive, and, I had almost said, of a creating Genius; And by prudently combining the Grecian, the

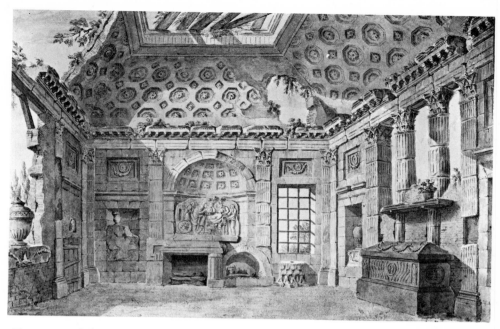

266. C. L. Clérisseau, Drawing of a ruin room

Tuscan, and the Egyptian together, he ought to open himself a road to the finding out of new ornaments and new manners.'

The detailed study of antiquity was a commonplace of the neo-classical movement, summarised in Winckelmann's famous paradox 'The only way for us to become great and, if possible even inimitable, is through imitation of the ancients.' Piranesi, who had immersed himself as no other artist in the works of the ancients, was the most original of all those who sought inspiration from this source, although the eccentricity of his approach would probably have been toned down if he had had a regular architectural practice. It is our great loss that so little opportunity came his way. His direct influence on contemporary architecture is limited to a few exotic fireplaces and some furniture. Indirectly his *vedute* were more influential: it is not wholly fanciful to see in the *architecture ensevelie* and the functionalism of the French neo-classical school the effect of his illustrations of half-buried columns and his enquiries into the constructional techniques of the ancients.[22] In a more exotic vein, we might even see wisps of his atmospheric smoke drifting round the figure of Amalthea in the inner cavern of Robert's Laiterie de la Reine at Rambouillet as if it had seeped through a rock fault from the grottoes beside Lake Albano.

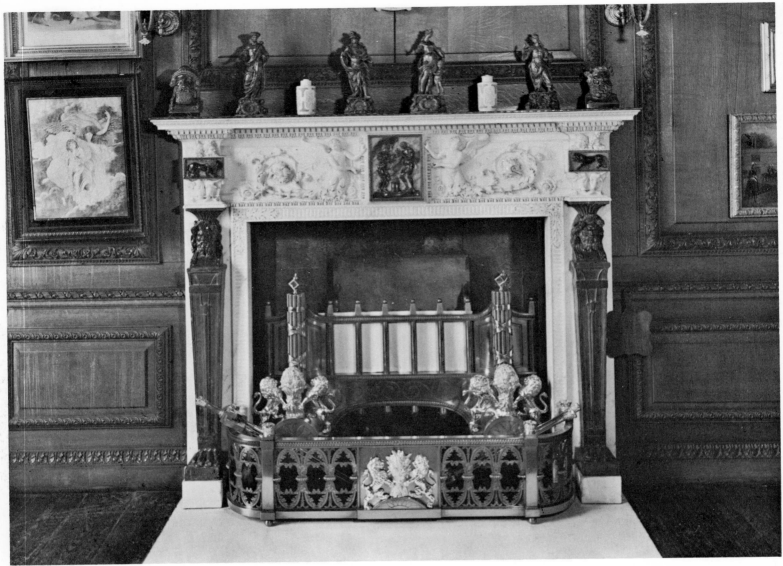

267. Chimney piece at Burghley

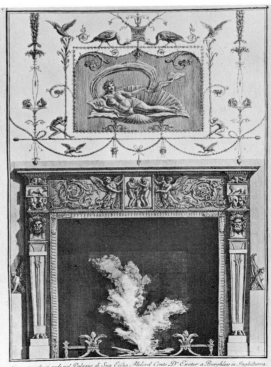

268. Chimney piece for Burghley, *Diverse maniere*

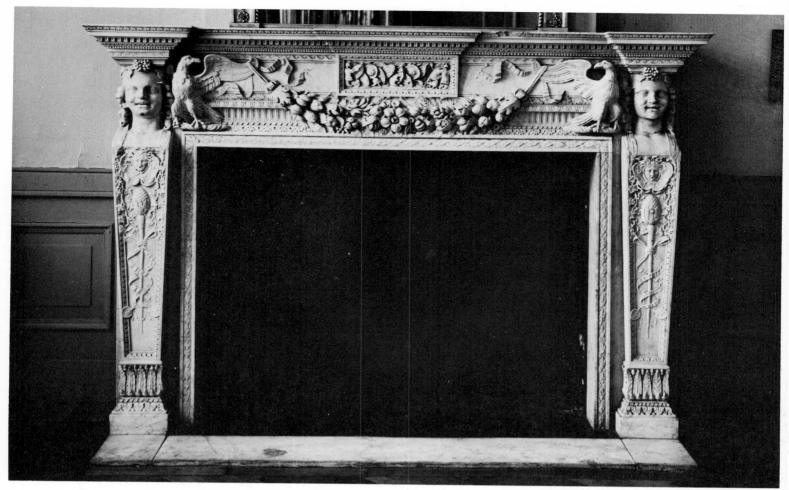

269. Chimney piece for John Hope now in the Rijksmuseum

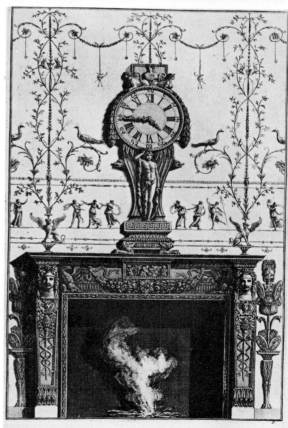

Le Cariatidi l'architrave e gli altri pezzi di marmo sono avanzi di opere antiche dal Cavaliere Piranesi uniti insieme a formare il presente camino, che si vede in Olanda nel gabinetto del Cavaliere Giovanni Hope.

Cavaliere Giovanni Battista Piranesi

270. Chimney piece for John Hope, *Diverse maniere*

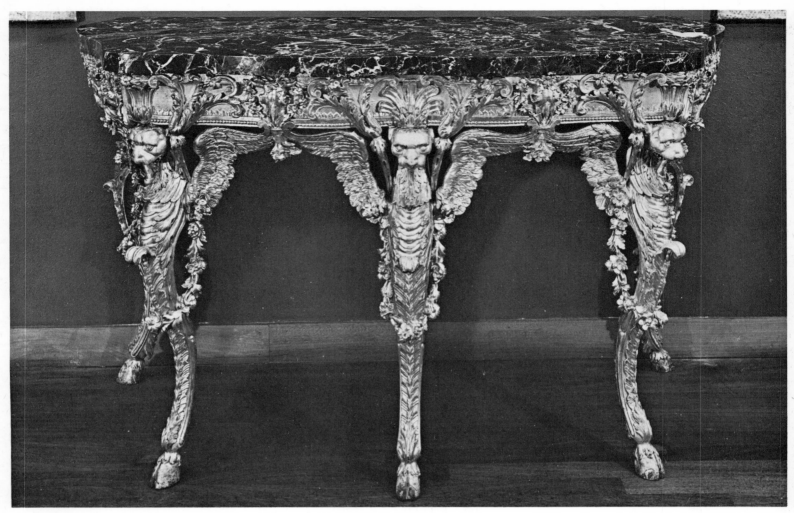

271. Side table for Cardinal G. B. Rezzonico

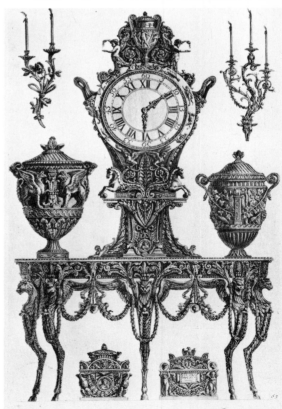

Questo tavolino ed alcuni altri ornamenti che sono sparsi in quest'opera, si vedono nell'appartamento di Sua Ecc.za Monsig.D.Gio.Batta Rezzonico Nipote e Maggiorduomo di N.S.P.P. Clemente XIII

272. Various designs, *Diverse maniere*

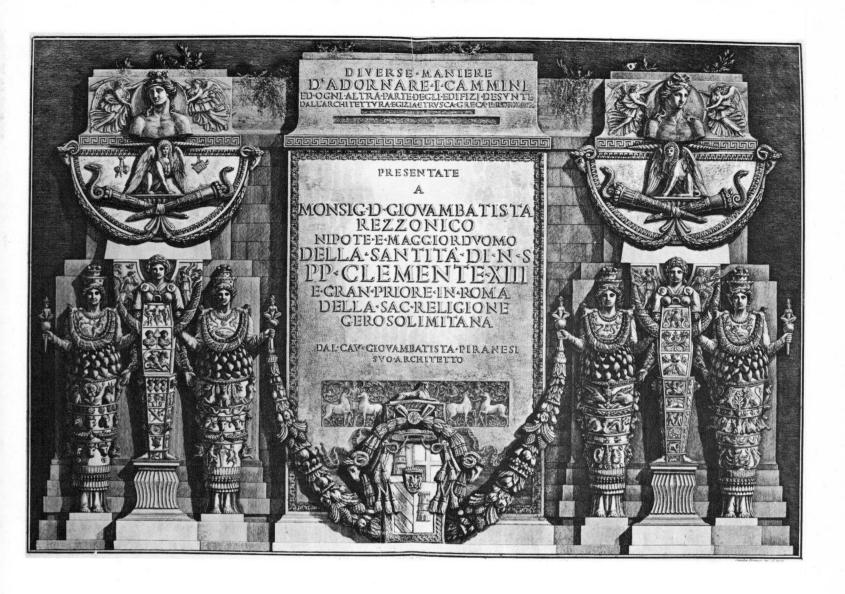

273. Title page, *Diverse maniere*

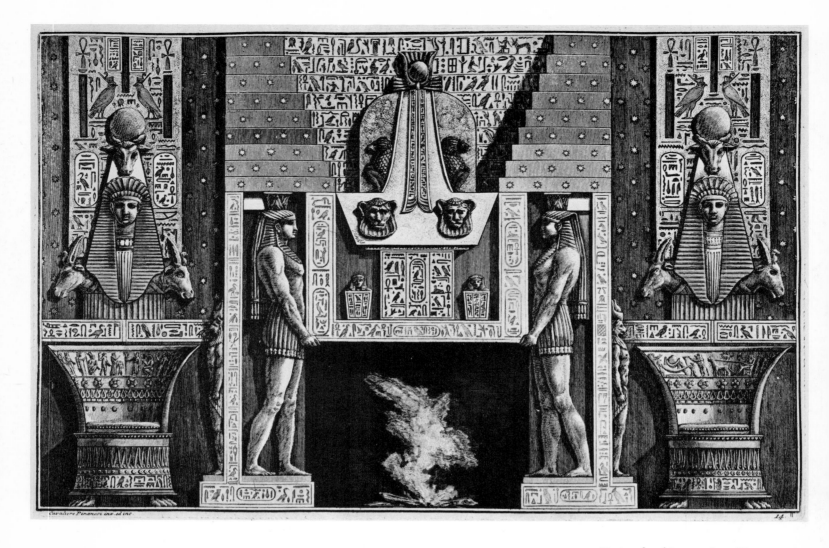

274. Design for chimney piece, *Diverse maniere*

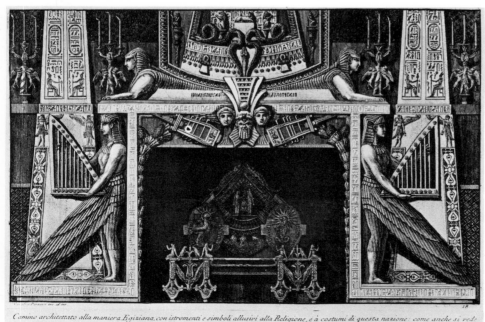

Cammo architettato alla maniera Egiziana, con istromenti e simboli allusivi alla Religione, e à costumi di questa nazione: come anche si vede
adornato con la stessa architettura il suo Focolare di ferro. Queste focolare, e tutti gl'altri che si vedono nell'altre tavole di quest'opera
alla maniera o Egiziana, o Greca, o Toscana, sono in grand'uso presso gl'Inglesi, e vengono travagliati da detta Nazione con
grande attenzione e fatica, e con gran bizzarria di trafori ne'loro intagli. Nel sito AB essi mettono il carbone per iscaldarsi

275. Design for chimney piece, *Diverse maniere*

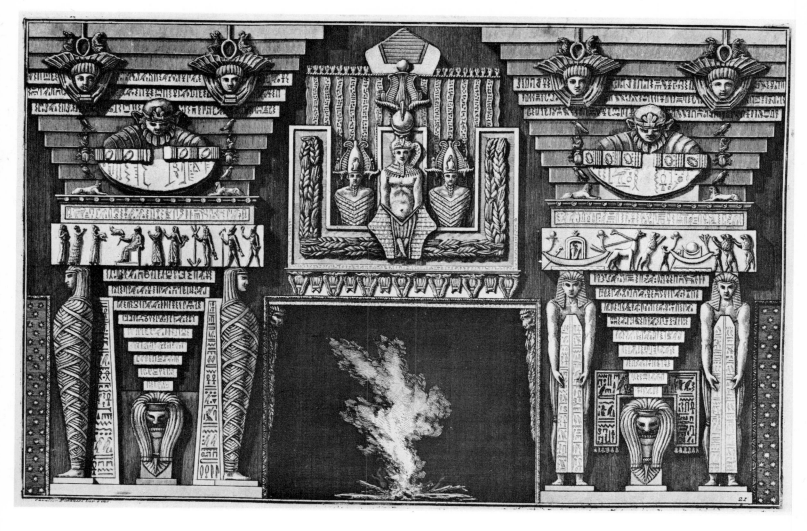

276. Design for chimney piece, *Diverse maniere*

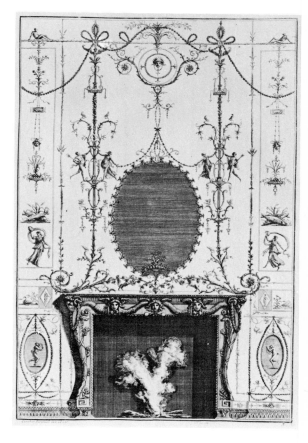

277. Design for chimney piece, *Diverse maniere*

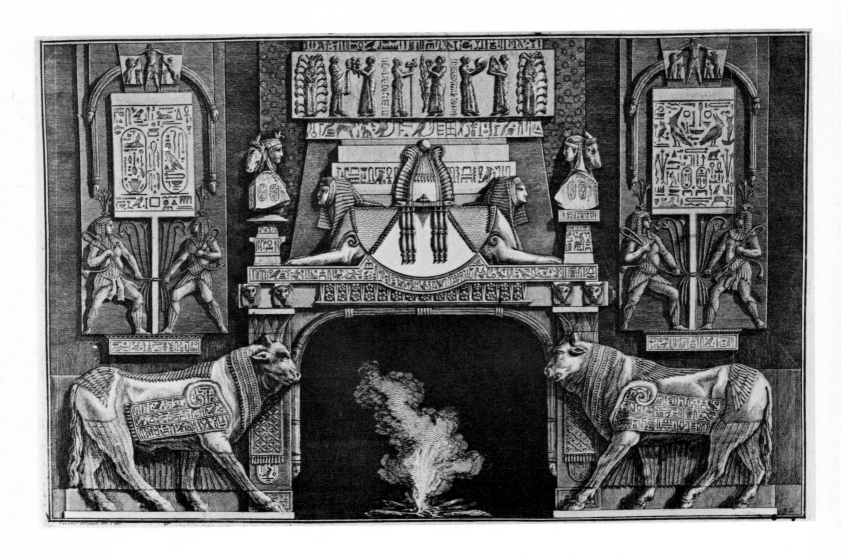

278. Design for chimney piece, *Diverse maniere*

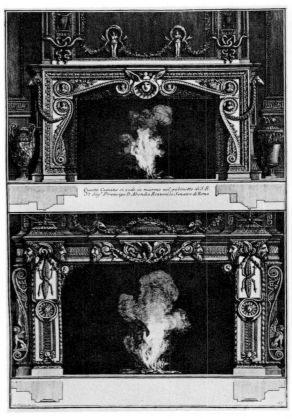

279. Design for chimney pieces, *Diverse maniere*

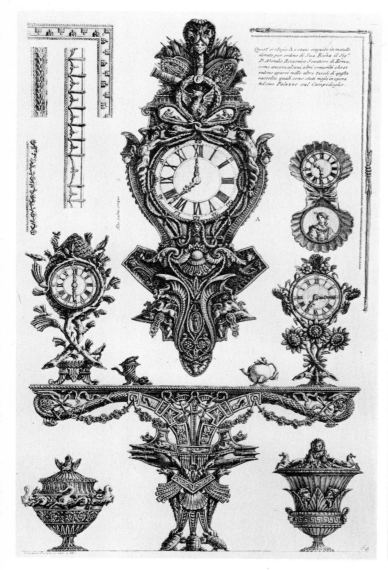

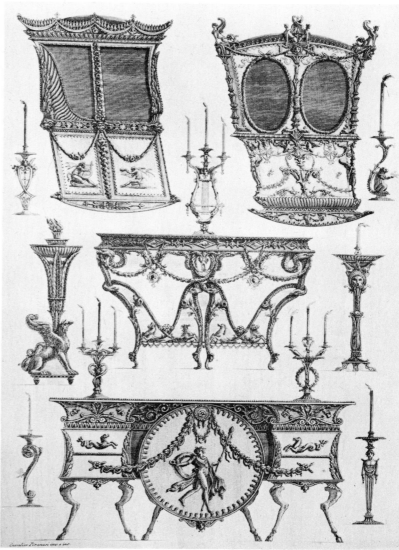

280. Various designs, *Diverse maniere*

281. Various designs, *Diverse maniere*

282. P. Labruzzi, Portrait of Piranesi

CHAPTER NINE
The Last Years

PIRANESI took great pains to ensure the continuity of his business, or rather his vocation, inspiring his pupils with an almost devotional enthusiasm for carrying on the work of studying and preserving in print the antiquities of Rome. He trained his sons from an early age and took particular care to bring on Benedetto Mori, his principal assistant, who joined the studio in 1766.[1] Legrand says that when drawing Hadrian's Villa, they 'were always up at sunrise, satisfied with a frugal meal and a straw mattress placed in the middle of the rich fragments, and they took inspiration from the memory of the great deeds that had been done on that soil. They recalled the heroes who had trodden it and said "The Scipios, the Camilli, the Caesars at the head of their legions had greater difficulties to overcome and more dangerous enemies to fight. Will their descendants be less bold?"' Such romantic and unhistorical hyperboles were quite in keeping with his attitude to his own heroic duties as self-appointed champion of ancient Rome. His only worry was that his sons might be too young to succeed him in the event of his early death.

The publishing business was now so substantial that a large number of other assistants were required for production work (carrying the heavy bundles of paper, trimming the pages, inking and wiping the copper plates and doing the actual printing). Probably one or two were even allowed a hand in the etching of some of the plates in the later volumes, *Diverse maniere* and *Vasi, candelabri, cippi,* and to copy the mechanical or repetitive details of his architectural drawings after he had worked out the main principles, 'but he always kept the difficult parts himself and maintained the overall control'.

It was indeed a sizeable business and it is interesting to examine its economics. In the last year of his life Piranesi wrote a letter to his sister in which he recorded that 'from the time he left Venice and established himself in Rome, he had made between fifty and sixty-thousand *scudi* (between £12,500 and £15,000) part of which had been profitably invested and part of which comprised the capital of his business to stock his workshop and his museum so that he would leave his wife and children well provided. He said further that his works of engraving and archaeology then comprised eighteen folio volumes, which the Pope used to buy from time to time at a cost of 200 *scudi* (£50) a set to give as presents to visiting royalty.'[2]

In his first letter to Lord Charlemont Piranesi quoted the costings on which he used to work. He calculated that he could get four-thousand pulls from each plate of the views of Rome and that these sold for $2\frac{1}{2}$ *paoli* each (about 6p but the price was later raised to 3 *paoli*); he would thus expect to make about 10,000 *paoli*, that is 1,000 *scudi* (£250), from each plate but he had to allow for the cost of paper, amounting to 40 *scudi* (£10) per thousand pages. This gave a gross profit of 840 *scudi* (£210) per plate from which there would have to be further deductions to cover printing costs, paper wastage, advertising (the catalogue) and sales commissions.[3] These commissions were a regular sales cost; he taunted Parker, for instance, with having occasionally accepted a *zecchino* (50p) for procuring the sale of some sets of the *Antichità* and he probably had an arrangement with Natoire at the French Academy who helped distribute his works in Paris. Robert Mylne, the architect, acted as his London agent, passing on any orders that he took in England.[4] If Piranesi had established personal contact with a customer, he

used to circulate him with a copy of his catalogue whenever it was updated to take account of a new work added to the list.[5] Mostly, however, he sold direct to the tourists who visited his shop in the Strada Felice.

The sale price of the individual works taken from Piranesi's last printed catalogue *(191)* is as follows:

	Price	Approximate 18th-century sterling equivalent
Antichità romane (4 volumes)	15 *zecchini*	£7·50
Lapides Capitolini	26 *paoli*	65p
Acqua Giulia	30 *paoli*	75p
Antichità d'Albano	4½ *zecchini*	£2·25
Campus Martius	4 *zecchini*	£2·00
Antichità di Cora	30 *paoli*	75p
Colonna Traiana	4½ *zecchini*	£2·25
Colonna di M. Aurelio	2·75 *scudi*	68p
Colonna di Antonino Pio	2·75 *scudi*	68p
Trofei d'Ottaviano	23 *paoli*	57p
Archi trionfali	18 *paoli*	45p
Architetture diverse (*Prima Parte* and other designs)	4 *scudi*	£1·00
Carceri (16 plates)	20 *paoli*	50p
Della Magnificenza and other polemics	5 *zecchini*	£2·50
Disegni del Guercino	40 *paoli*	£1
Diverse maniere	5 *zecchini*	£2·50
Vasi, candelabri, cippi	2½ *paoli* each	6p
Paestum	3 *paoli* each	7½p
Vedute	3 *paoli* each	7½p

The list price is for loose plates; the complete works, uniformly bound, such as the Pope's presentation sets, were necessarily more expensive. The individual plates were undoubtedly very cheap when compared, for instance, with William Hogarth's *Harlot's Progress* which sold at a guinea for the set of six engravings or Gilray's ephemeral cartoons which cost two shillings at the least.

283. Cavaceppi, A sculptor's workshop

Large volumes could be profitable, especially steady sellers like *Antichità romane,* but, unless the author went through the tedious process of collecting subscriptions prior to publication, or unless a patron could be found to provide an initial grant, it took a long time to cover the costs of an expensive and well-illustrated book. Both Sir William Hamilton and Winckelmann, for instance, found that their scholarly works made heavy demands on their own purses.[6] For all his devotion to antiquity Piranesi had a thoroughly commercial attitude towards publishing and it is noticeable that after the death of the Rezzonico Pope he produced no more large works, the publications on the three imperial columns being relatively short and inexpensive. The works of his last years, the map of Rome, the series of *Vasi, candelabri, cippi,* the final *Vedute* and the Paestum views could all be sold by the individual sheet.[7]

Occasionally he even published and distributed someone else's work. In February, 1763, for instance, we find that he had bought two plates by Dorigny from Robert Strange, the well-known Jacobite engraver then living in Paris, with a view to printing from them and selling the prints for his own account in Rome.[8] When the plates arrived, however, he was so eager to take some impressions that he used paper which had only been steeped and prepared that day with the result the first pulls were very unsatisfactory. Piranesi complained furiously that the plates either were worn-out or had been retouched but Strange's brother-in-law, Andrew Lumisden, and the inevitable abbé Grant soothed his indignation and, after consulting with the Rezzonico nephews, he apologised handsomely.[9] When later that year he happened to be chairman of the meeting of the Accademia

284. Title page, *Disegni del Guercino*

di S. Luca, at which Strange was elected, he spoke eloquently on his behalf.[10] The following year, undeterred by this incident, he bought a collection of etchings from Francesco Bartolozzi, an artist trained in Venice by his old friend Wagner, and later employed by Robert Adam in England.[11] The etchings, which were of drawings by the seventeenth-century Bolognese artist Guercino, were dedicated 'to the singular merit of Sig. T. Jenkins' and issued, with a few additional plates, as *Raccolta di alcuni disegni del Barbieri da Cento detto il Guercino*.[12] Piranesi himself contributed the title page, with a charming reproduction of Guercino's drawing of an old man asleep belonging to the sculptor Cavaceppi, and a second of another Guercino in his own collection. The *Raccolta* is something of a tour de force; the sharply defined strokes of the etching needle cannot easily reproduce the blurred line of the crayon or pen nor can they bring out the varying colour depth of a pencil line since random jots faithfully reproduced get the same emphasis as outline contours. All the same the work and particularly Bartolozzi's efforts were very well received by the connoisseurs who appreciated the attempt to achieve a two-tone facsimile effect through the use of a warm red as well as a black ink for the etchings.[13] Piranesi was also prepared to publish works in which he took no part at all such as Gavin Hamilton's *Schola Italica Picturae,* which came out in 1773, an unusually large tome devoted to a selection of the eighteenth century's favourite artists from Leonardo and Michelangelo to Guido Reni and the Carracci.

Increasingly, however, he began to diversify into a new line of business in which he could combine his antiquarian enthusiasms with the profit motive. He became an antique dealer and started to sell urns and statuary as well as the etchings and archaeological works that were his regular stock in trade. Legrand says that after winning some valuable antique fragments from Hadrian's Villa, he took up sculpture himself; 'he personally made the models for the delicate repairs and he trained some capable artists in this sort of work including Cardelli, Franzoni, Jacquietti and others who subsequently worked for the Vatican museum'.

It was not at all uncommon for an artist to act as a dealer; Sir Joshua Reynolds did as much, and many who had come to Rome as students but found no patronage turned to this lucrative side trade. It was the heyday of the great collectors. Gustavus III of Sweden competed with his uncle, Frederick the Great of Prussia; de Coch and General Schouvaloff were buying for the Empress Catherine's collection in St. Petersburg; in England numerous enthusiasts were bidding up the price of marbles against each other, Lord Shelburne for Lansdowne House, William Weddel for Newby, Henry Blundell for Ince, Charles Towneley for his London house, Lord Palmerston for Broadlands and Sir Richard Worsley for Appuldurcombe; nor were the Italians out of the running; both Clement XIV and his successor, Angelo Braschi, Pope Pius VI, were eager to stock their new museum in the Vatican and, alone among the Roman nobility now that Cardinal Albani was no longer active, Prince Marc' Antonio Borghese was adding to the treasures of his villa on the Pincian hill.[14] The principal dealers were the sculptors, Cavaceppi, Cardelli and Pacili, while the English collectors were supplied by Gavin Hamilton, James Byres, Matthew Nulty and Thomas Jenkins. Jenkins, the English banker, 'originally came here in the humble station of one of ourselves', wrote Thomas Jones, 'but soon after, his Genius breaking forth in its proper direction, he luckily contracted for part of a Cargo of an English ship at Civita Vecchia, which being disposed of to great advantage in Rome, he thereby laid the foundation of his future fortune – from his knowledge and experience in Trade Commerce manufactories &c., he became so great a favourite of the late Ganganelli that if that Pontiff had lived a little longer it is said he might have been made a Cardinal if he chose it – however by purchasing and selling, at his Own Prices, old Pictures, Antique Gems & Statues with the Profits of a lucrative banking house – he was enabled to vie with the Roman Nobility in Splendour and Magnificence.' Since incomplete statues fetched lower prices, British dealers brought in Joseph Nollekens to doctor their finds and restore missing limbs.

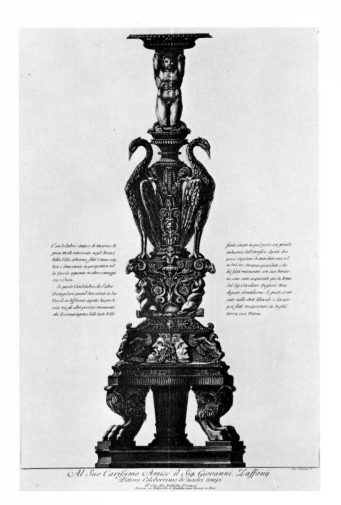

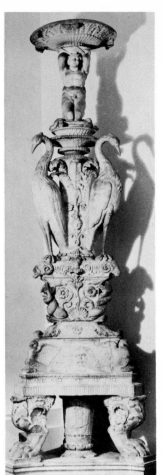

As Nollekens recalled, "I got all the first, and the best of my money by putting antiques together. Hamilton, and I, and Jenkins, generally used to go shares in what we bought; and as I had to match the pieces as well as I could, and clean 'em, I had the best part of the profits. Gavin Hamilton was a good fellow; but as for Jenkins, he followed the trade of supplying the foreign visitors with intaglios and cameos made by his own people, that he kept in a part of the ruins of the Coliseum, fitted up for 'em to work in slyly by themselves. I saw 'em at work though, and Jenkins gave a whole handful of 'em to me to say nothing about the matter to any body else but myself. Bless your heart! he sold 'em as fast as they made 'em."

Some antiquities came from Roman families prepared to sell the treasures collected by their ancestors in earlier and more prosperous times. In de Rossi's comedy, *Il Calzolajo Inglese,* the penurious conte and Rosbif, the fraudulent English antiquarian, act in concert to fleece the tourist from London by selling him their cameos and so-called old masters.[15] Mostly however, the statues came from new excavations. The dealers acted very much like mineral prospecting companies which would negotiate the lease and mining rights over promising sites. A contemporary gave this account: 'The Pope gives his permission for this kind of adventure, upon the following conditions. When an excavation is made, the antiquities discovered are divided into four shares. The first goes to the Pope, the second to the "Camera" or ministers of state, the third is the lessee's of the soil; and the last is the right of the adventurer. His holiness sometimes agrees for the pre-emption of the whole; and sometimes all the shares are bought in by the contractor, before the ground is opened.' Licences were required for the export of all major works, a problem that was evaded by smuggling or bribery of the papal authorities; sometimes a statue was dismembered and an export licence obtained for each half separately. The interregnum after the death of Clement XIV was a marvellous opportunity. 'Never was a time so apropos for sending off

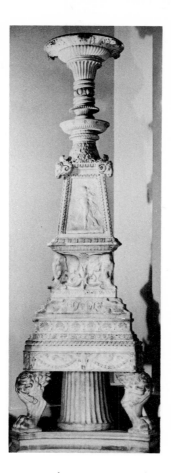

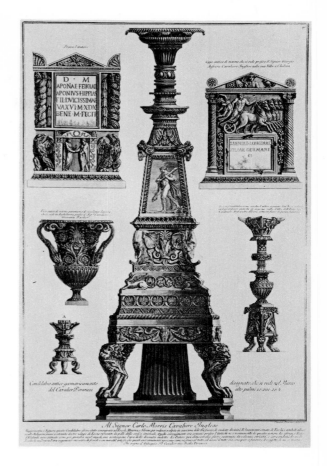

antiques', wrote Hamilton in 1775, 'having no Pope, nor are we likely to have one soon.'[16]

Generally Piranesi avoided dealing in statues or busts, the most competitive end of the trade, although he did, for instance sell Charles Towneley a large head of Hercules from Tivoli. Instead he concentrated on supplying urns, coffers, candelabra and other decorative items which could be freely exported. He ruthlessly cannibalised the decorative fragments which he bought quite cheaply to be made up into elaborate structures, tiered like wedding cakes, or to be cut into panels for his chimney pieces. These were all displayed in the museum which he laid out in some of the rooms of his house; it was an art gallery rather than a museum and most things were for sale. When an inventory was made shortly after his death over a hundred items were listed in his house and garden and a further two-hundred were kept in a warehouse in the Campo Vaccino. A few years after his death the whole collection was bought off Francesco by King Gustavus of Sweden in exchange for an annual pension of 630 *zecchini* (£315) and was shipped to Stockholm in 1783.[17] Piranesi was a hard bargainer and James Barry remarked on 'his avarice, which stimulates him to almost everything'. Gavin Hamilton also commented on his haggling over prices. He did not sell cheaply; Sir Roger Newdigate had to pay 1,000 *scudi* (£250) for the pair of candelabra now in the Ashmolean Museum, a price that Hamilton charged for a complete statue and, after restoration in his studio, Piranesi's candelabra, like the wares of some modern antique dealers, would have been unrecognisable by their ancient owners.[18]

He was a shrewd marketer of his products. James Barry considered that *Diverse maniere* was purely a piece of sales promotion. 'There is a book just now come out of cavalier Piranesi's which is exactly wrote in the same spirit of decrying the Greeks as his *Magnificenza* . . . But there is something deeper than one would suppose in this scheme: the dealers play into one another's hands, and he has heaped together a great profusion of marbles of one sort or other, which he would be glad to sell; but as nobody will be ever likely to mistake them for

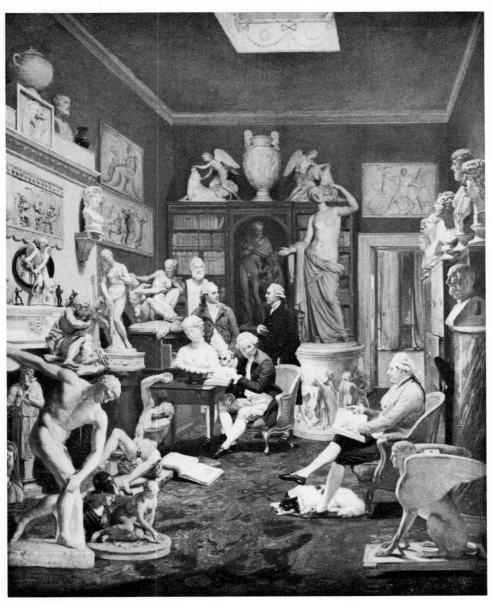

288a. J. Zoffany, Portrait of Charles Towneley

Greek workmanship for a very obvious reason, the reviving and carrying into extremes his old prejudices against the Greeks will be still the more grateful, should it contribute to facilitate the selling of his collection, for which end this book is published by way of advertisement.' This was not enough, however. He followed the example of Cavaceppi who, between 1768 and 1772, had published three volumes of *Raccolta d'antiche statue busti bassirilievi ed altre sculture (283)* illustrating statues which had passed through his hands, mostly to German or British collections – and including an essay 'On the tricks used in the sale of ancient sculptures' in which he gave hints on how to recognise fakes.[19] Taking a leaf out of this book, Piranesi started to issue a series of illustrations both of his current stock and of sculpture that he had recently sold, and including one or two favourite pieces from the Albani, Borghese and other Roman collections. Most of these plates were dedicated to past or potential customers who probably gave him a few *scudi* for the privilege. Others might have been dedicated without payment in the hope of clinching a profitable sale. The whole series was published in 1778 in two volumes, dedicated to the Russian connoisseur, General Schouvaloff, as *Vasi, candelabri, cippi*. It consists of one-hundred-and-ten or more plates, the number varying from copy to copy, and some additional antiques were included after his father's death by Francesco, who, with the studio assistants, probably did much of the etching. The work made a sumptuous reappearance thirty or forty years later when it was used as a pattern book by goldsmiths like Paul Storr who copied

some of the vases in silver or silver gilt to provide glittering wine coolers or centre pieces for Regency dinner tables.

It is interesting to look down the list of Piranesi's clients. Over fifty of those to whom plates are dedicated or who are mentioned as owners are British but there are only eight citizens of other nations, French, German, Swedish and Russian and only about a dozen Italians. Goethe's companion, the antiquary Friedrich Reiffenstein, John Zoffany, the portrait painter who so charmingly depicted Mr. Towneley among his collection of marbles, and James Byres, 'architect from Scotland', are all referred to as 'friends' in their dedicatory inscriptions. Most others, however, are addressed in the tones of grovelling respect which patrons expected. His best customer seems to have been Edward Walter of Bury Hill and his wife Harriot. 'The different fragments of antique work which are to be seen in some of the rooms of my museum have been composed with such symmetry that the modern work undertaken by me which joins the old matches so well that they both seem to have come from the same antique source. In making a choice of two of them for the decoration of your country house of Berry Hill [sic] in Surrey, you showed that you approved of my composition. You have subsequently bought my works as soon as they have been published and you have acquired additional antiquities from my collection by which you have been characterised in the sight of all to be a Man of Taste.' The flattery and the boasting are equally disagreeable. Others named include William Beckford, father of the author of *Vathek,* Abbé Grant, George Grenville and Lord Exeter, who had both bought chimney pieces, Sir William Hamilton, the ambassador in Naples, Adam's clients, William Weddell and Sir Watkin Williams-Wynn, Colin Morison, the *cicerone* who took Boswell round Rome, Charles Towneley and Lord Palmerston, both distinguished collectors, the Marchesa Gentili Boccapaduli of the 'ruin room', Monsignor Riminaldi, who alone could keep Piranesi under control, and his patrons, the Rezzonico brothers.[20]

The preponderance of the English is significant. Piranesi had become more and more estranged from his fellow Italians. In the same letter to his sister already quoted, he says that 'he called himself a son of Rome, because it was there that his talent had been recognised for its true worth and he had in consequence made there a considerable fortune and received the honour of knighthood. He assailed the meanness and sloth of contemporary Italians and praised to the sky the generosity of the English nation and the support it gave to protect all undertakings which concerned literature and the arts. He protested that if he had to pick another nation, he would prefer London to any other city in the world. He had had to leave Venice as an exile because he had been unable to secure the most humble position there, and he would not, therefore, return again, especially since that city, although adorned with the most splended buildings and paintings, was not as capable of satisfying the sublimity of his vast conceptions as Rome and the cities of Southern Italy.'

Perhaps the disillusionment with his compatriots stemmed from his dispute with the Accademia di S. Luca.[21] He had been elected a member of this long-established but rather moribund institution in January, 1761, on the same day as Gavin Hamilton, Thomas Jenkins and several members of the Rezzonico family. The argument arose out of a discussion on the form of a memorial to Pio Balestra, an architect who had left his fortune to the academy to establish a prize fund. In September 1772, ten years after the donor's death, the academy met to choose a design for a memorial to their benefactor to be erected in Pietro da Cortona's Baroque church of SS. Martina e Luca overlooking the Forum. Rejecting two schemes on the grounds of expense, they selected one by Tommaso Righi, the sculptor who had worked for Piranesi in S. Maria del Priorato; Raphael Mengs, the principal of the academy, was charged with drawing up a contract. A month later Piranesi caused an uproar in the assembly by objecting to the designs; the minutes of the meeting only state that there were 'disputes and altercations which caused disorders among the members'. Bianconi, however,

relates that Piranesi actually came to blows with his opponents. The same day he wrote a long memorandum to Mengs setting out his views. Obviously he considered that Righi's design was too formal and unimaginative; he wanted to turn the church into a pantheon for the academy's most distinguished members and benefactors with monuments to suit the architecture, and, for a start, Balestra's memorial should be full of allegorical allusions like the vigorous Baroque figures by Legros on either side of the altar of St. Ignatius in the church of the Jesuits.[22] Perhaps he was influenced by recollections of the allegorical statuary of his friend Corradini which he had seen as an impressionable youth. Certainly the sculptures in the Gesù must have seemed very dated half a century later both morally and artistically: Religion triumphs rather too robustly over Heresy as gleeful cherubs shred the works of Luther, and the Protestant fathers are tumbled hellwards by a then still confidently invincible Faith. At any rate, when Piranesi's letter was read to the assembly three weeks later, neo-classical restraint was the order of the day, his appeal for a return to old-fashioned luxuriance was voted out unanimously and Righi's conventional design of cherubs and artist's tools was duly executed. In disgust, Piranesi avoided the academy for the next six years although he did attend a meeting in October 1778, the month before he died. It was not a proper reconciliation; in contrast to the official mourning for Mengs in 1779, his death is passed over in silence in the academy's records.

Relations with his French friends also seem to have cooled. He had attacked their scholar, Capmartin de Chaupy, and trouble had started over some plaster casts of the reliefs of Trajan's column belonging to the French Academy. Natoire had moved them to his country house (presumably the one on the Palatine) but forgot to specify that they were not part of the fittings when he sold it to the Jesuits. Piranesi bought the casts from the new owners and, despite Natoire's efforts to recover them, he flatly refused to part with his new acquisition.[23] The French attitude is summarised in the reluctant praise and the carping but not unfounded criticism of the anonymous author of *Lettres écrites de Suisse, d'Italie, de Sicile et de Malthe . . . en 1776, 1777 and 1778*: 'One of the artists at Rome is the famous Piranezi who makes a great deal of commotion about the place: no one else has engraved ruins in so grand a style or with such effect. The Venetian has such a superior talent in this type of view that he sometimes makes the objects grander than nature itself. His etching needle, it is true, is not always very accurate; he is quite capable of adding to his subject when it is dull or insignificant; but that

VEDUTA DEGLI AVANZI DEL TABLINO DELLA CASA AUREA DI NERONE, DETTI VOLGARMENTE IL TEMPIO DELLA PACE

289. Basilica of Maxentius, *Vedute di Roma*

would not matter if he stuck to the line which has made his reputation and fortune. He has taken upon himself also to expound antiquity without having the ability to carry out such researches; he has produced a wholly fictitious Campus Martius: he has hired a pen as clumsy and ignorant as his own, and after doing some good things, he has written a lot of rubbish. He is also only a poor hand at drawing modern architecture. Vasi is much more accurate . . . Figure drawing is another subject which he should have avoided. I am bringing back many of his etchings: who does not? His house is a regular market every day: it is quite embarrassing to see his talent doubly degraded by his coarse meanness and his greed.'

With the British, however he remained on excellent terms. Never having adopted the excesses of the Rococo they were slower to react into the unadorned severity of neo-classicism, and they still appreciated his decorative ingenuity. Robert Adam was happy to borrow ideas from *Diverse maniere* for his Etruscan room at Osterley and for a variety of fireplaces, and Piranesi showed his continuing friendship by providing four plates illustrating decorative schemes at Syon for the Adams' *Works in Architecture,* published in 1779 *(119a)*. He helped Thomas Harrison, the Cheshire architect, to gain entry to the Accademia di S. Luca and was a friend of many other British artists and architects, like Zoffany, Barry, Jones and the young Soane. The grander British tourists were also, as we have seen, among his best patrons.[24]

Apart from one or two more views which could be extracted from Tivoli, he had now depicted almost all the main monuments in and around Rome. In many of the later *Vedute* he therefore repeated scenes which he had already drawn, St. Peter's, the Lateran basilica, the Trevi fountain, the Piazza Navona, the Quirinal and several different aspects of the Forum and the Colosseum. When he returned to an old subject, he brought his viewpoint much closer to the principal monument which looms over the spectator in more imposing bulk, and he exaggerated capriciously the contrasting shadows and sunlight on the page. Obviously he was no longer content with the bright uncomplicated *Vedute* which he had produced soon after his return from Venice a quarter of a century earlier; besides, he had educated his public to expect a darker and more dramatic scene and he reworked some of the first views, scoring in irregular streaky clouds and blacker shadows. This reworking must in any case have been necessary in the more lightly etched parts of some of the popular plates which had become worn out through continuous demand. The resultant darkening seldom enhances the

290. Basilica of Maxentius, *Vedute di Roma*

effect. Two plates were, however, more substantially reworked: the pyramid of Caius Sestius *(312)* and the view of the harbour *(314)*. Here the strengthening and simplification of the pyramid and the clearing of the overcrowded river scene are certainly improvements.[25]

As he grew older antiquity seemed to become more and more overpowering.[26] We have only to compare his early impressions of the ruins with the views he drew in his later years. The three coffered arches, all that remains of the basilica of Maxentius, are one of the most imposing of Rome's antiquities. (Go there on a summer evening for one of the open-air concerts and, while the orchestra is tuning, turn your mind away from Mozart and try to visualise the stupendous size of the basilica when the central hall and the corresponding arches onto the Forum were still standing.) His first *Veduta (289)*, one of the earliest, was a straightforward photographic record taken from a distance, as was the small view included in *Antichità romane (137)*, but when he repeated the subject *(290)* in about

291. The Colosseum, *Vedute di Roma*

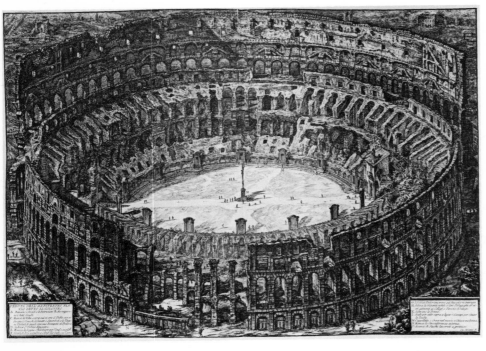

292. The Colosseum, *Vedute di Roma*

293. Drawing of the Colosseum

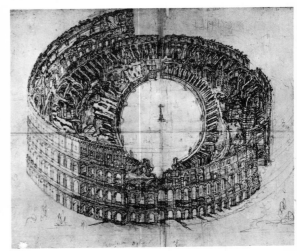

1774, his enthusiasm for antique grandeur overcame his artistic accuracy. Sketching the basilica from almost underneath the black shadow of the arch nearest the Capitol, he elongated the whole building so that the coffering on the far vault appears disproportionately small when compared with the octagons overhead, while the third bay seems to extend almost as far as the Colosseum. No such device was necessary when he tackled the Colosseum itself for the last time. Once again his first *Veduta* had been sketched from a distance and it includes the arch of Constantine and a view to the Alban hills. His last *Veduta* of the subject, dated 1776, concentrates on the amphitheatre alone. From a bird's eye view several hundred feet up he looks down into the crater of an extinct volcano, but the volcano is man-made, an eruption of the building genius of the Romans. Those towering walls, the arcades, the frozen lava flows of masonry were thrown up almost in their entirety during the reign of a single emperor. Piranesi does not depict it as a sunny curiosity for the tourist to visit, it is dark and sinister and forbidding. The circuit of great black arcades spreads right out to the margins of the plate as if its bulk could hardly be contained within it. It is Piranesi's most dramatic impression of the shattered magnificence of the Romans.

Generally, the figures in the later views are larger and less picturesque. I wonder if Francesco may not have been allowed to try his hand on some of them. Youthful inexperience could account for the mutually disproportionate jumble of coaches, pilgrims, players of bowls and tourists taking up the foreground of the view of the *piazza* of S. Giovanni in Laterano *(327)*. It is as if the artist had cut out figure sketches from a number of different drawings and scattered them over the plate to fill the *piazza* without regard to scale. The plate was done in about

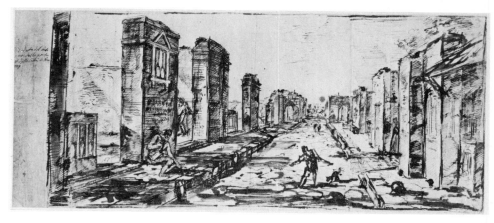

294. Drawing of Strada Consolare, Pompeii

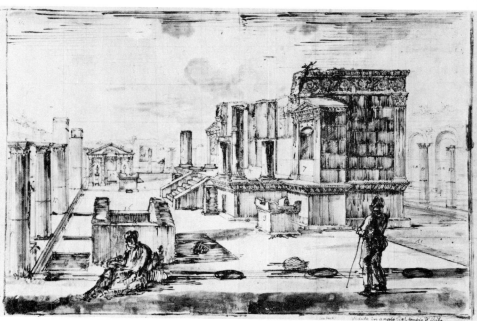

295. Drawing of Temple of Isis, Pompeii

1775 when Francesco was seventeen. Often the later *Vedute* show signs of haste as if Piranesi was working against the clock to produce them in response to popular demand. Many of the scenes of overgrown ruins are akin to the beautiful plates from *Antichità d'Albano* and yet the delicate foliage displayed against the mountains of masonry is more summarily executed, the shadow effects are less subtly contrived and the heavy striations are scored rather mechanically. This later insensitivity is a question of degree; the *Vedute* of the seventies do not all match up to his best earlier productions but he was still capable of very powerful work.

For new subjects he had to look further afield. Greece still could not tempt him but there were ample antiquities to record in the Neapolitan kingdoms. Although he did not penetrate as far as Sicily, he made several visits to Naples itself and the neighbouring ruins in the 1770s. Pompeii was the first objective. Bianconi says that he hoped to produce a major series on the excavations which had been going on there since 1745 and he certainly prepared a number of drawings of the principal sites. Pompeii was not, however, a very congenial subject. The excavations, being so recent, had not yet put on the cloak of romantic undergrowth which he loved to draw. Furthermore the scale of the buried city is surprisingly modest, not at all the grand expanses which he considered an indispensible part of the ancients' style. Since, however, the ruins had become a popular tourist sight, he could not have got away with exaggerating the dimensions of the pretty little domestic courtyards and shrinking to child size the figures of the visitors with which he peopled them. Perhaps it was in reaction to this that he thickened the outlines in these drawings *(294, 295)*. Some of his ink and wash sketches are noticeably rougher and coarser than, for instance, the more or less contemporary red chalk drawings of Hadrian's Villa *(242, 243)*. It is almost as if he was forcing his pen to add to the dimensions of his subjects by these thick strokes and dark and ugly contours.[27] Wisely he did not attempt to translate the sketches onto the copper, although the portfolio of his drawings formed the basis of Francesco's three volumes of *Antiquités de la Grande Grèce*, published in Paris between 1804 and 1807 'from the original drawings and observations of the famous architect, artist, sculptor and engraver, chevalier Jean-Baptiste Piranesi'.

It may, however, have been illness that stopped him from going ahead with the Pompeii series. A bladder complaint which he suffered for some years without consulting a doctor was becoming acutely painful. Realising that he was a very sick man he began to be obsessed with the impending shadow of death. Among the antiquities illustrated in *Vasi, candelabri, cippi* he included the candelabrum which, as he explained in the descriptive text, he intended to have erected over his

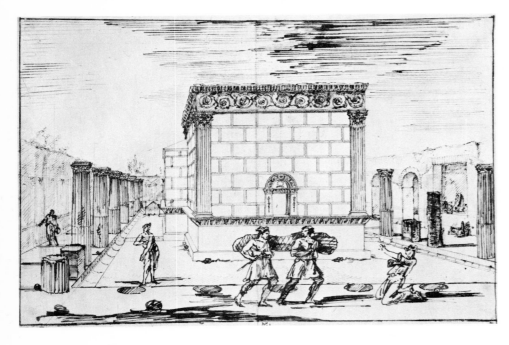

296. Drawing of Temple of Isis, Pompeii

tomb. In May 1778 he sent a letter to a friend enclosing a sketch of some idio-syncratic ideas for his own funeral monument, a relief of himself stretched at uncharacteristic ease against a background that resembles one of his fireplaces. His worries were not so much about his own death but the survival of his business while his children were so young. Would Francesco be able to cope when he was gone?[28]

There was one last work that he wanted to complete, a study of the ruins of the three Greek temples of Paestum, the ancient city of Posidonia. These temples, built in the fifth century B.C. by the Greek colonists of southern Italy, had long been forgotten in the malarial marshes near the sea some sixty miles south of Naples. When they were rediscovered in the mid-eighteenth century, they were at first regarded as no more than primitive curiosities. James Adam who visited the site with some discomfort in 1761 dismissed them as being 'of an early, an inelegant and unenriched Doric, that afford no detail and scarcely produce two good views'. Even Goethe, who made the trip a quarter of a century later, imbued with Winckelmann's Hellenic devotion, wrote that at first the 'crowded masses of stumpy conical columns appear offensive and even terrifying'. However, for those who wanted to air their views on the Greek controversy but did not want to go to the trouble of visiting Sicily or Greece, Paestum supplied the most convenient examples of Doric architecture to hand. No fewer than five illustrated works appeared between 1764 and 1769 to cater for this interest albeit in a fairly inaccurate fashion; many of the plates were misleading or positively wrong.

Piranesi must have visited Paestum on an earlier occasion. He now wanted to provide a definitive work on the temples. Late in 1777 or in the spring of the following year, he set off for Naples, accompanied by Francesco, by his veteran assistant Benedetto Mori, and by Augusto Rosa, an unsuccessful architect who made a precarious living from the sale of cork models of antiquities. It was a tiring journey that would have taken three or four days and when they arrived he turned down Francesco's suggestion that he ought to take a rest; they pressed on south to Paestum and immediately set to work sketching the ruins.

The party must have made many preliminary sketches and done some accurate measuring of the site. After this, Piranesi produced a series of finished drawings, a number of which survive, some in the Soane Museum in London, one in the Rijksmuseum, Amsterdam and one in the Bibliothèque Nationale,

297. View of the so-called College, *Pesto,* Plate V

298. Drawing of Paestum

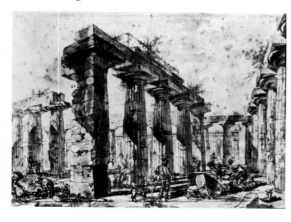

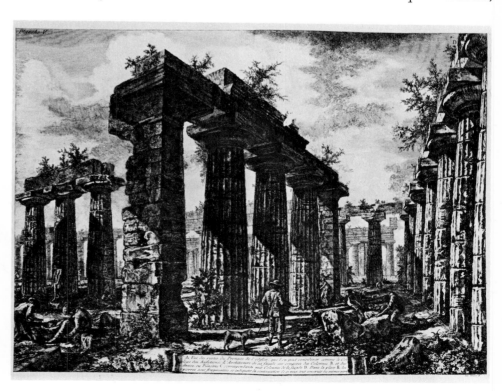

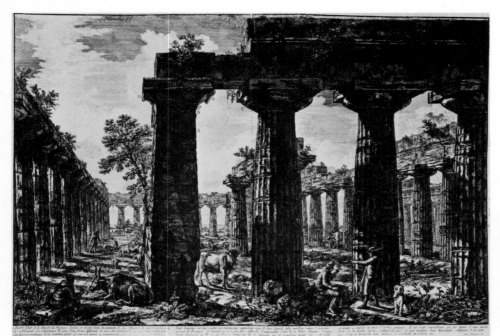

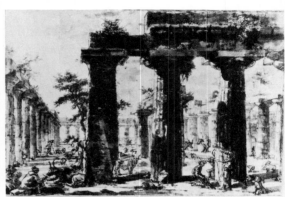

Paris. They are unusually elaborate. After sketching the outlines of the temples in black chalk, he went over them in a pale wash; the details were then secured in ink before a darker wash was applied for the shadows and the foreground. Some of the figures, which are larger and clumsier than the usual inhabitants of his scenes, seem to have been inserted after the architectural part of the drawing had been completed. The etchings derived from the drawings consist of eighteen plates by Piranesi himself and the title page and the last two plates by Francesco. Piranesi was determined to leave this series as his final monument. It was quicker to produce finished drawings than etchings and I think that he completed these very detailed sketches first so that, if he should die before finishing all the etchings, Francesco could follow his father's exact intentions from the drawings. He probably allowed Francesco to draw in some of the figures as an encouragement to the young man who was soon to take over the whole task. He had completed the first eighteen plates before he died and must have done much work on the last two and the title page because, although these are signed by Francesco, their overall effect is too close to the father's work and too dissimilar from Francesco's later unaided efforts to have been wholly posthumous productions.[29]

It is puzzling that the title (*Différentes vues de quelques restes de trois grands édifices qui subsistent encore dans le milieu de l'ancienne ville de Pesto*) and the descriptive text on the plates are in French and not in Italian, because the work was in circulation in Rome long before the move to Paris. Possibly a dedication to a rich French patron was planned and Piranesi died before the negotiations for the dedication were completed. It was certainly most unusual that he should have omitted the opportunity of dedicating such a work to a potential patron. Alternatively, French was chosen as the common European language intelligible alike to visiting Russians, Scandinavians, Prussians – and even British.

By this time all his old animosity against the Greeks had gone although his patriotism still made claims (justified in this case) that the best example of the Doric order was this Italian version. 'Connoisseurs on their travels can rest assured that in comparison with the Greek architecture of temples built in the Doric order, the temples of Paestum are more beautiful than those in Sicily and in Greece and that, without going to the trouble and inconvenience of long expeditions, they can adequately satisfy their curiosity with these.' He was deliberately vague about their origins. 'The town was originally under the domination of the Lucanians and later under that of the Romans. . . . Such monuments show that there was from a great time ago a considerable knowledge of the arts and that they

301. *Pesto,* Plate XII rejected first state

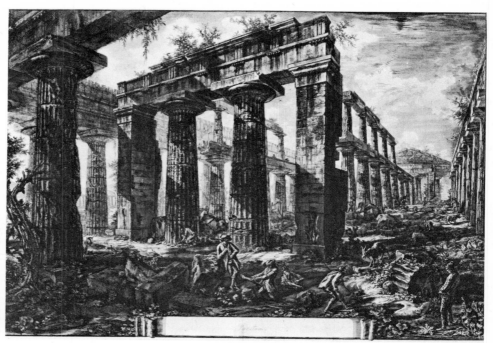

302. Drawing of Paestum

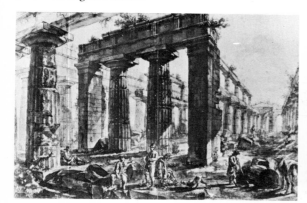

303. View of the Temple of Neptune, *Pesto,* Plate XII

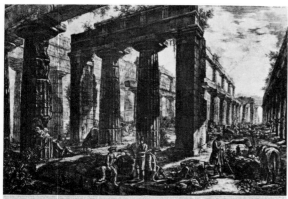

flourished no less in Italy than in Egypt and in Greece.' However, in the notes under some of the plates he tacitly acknowledged the Greek authorship of the buildings and showed a new awareness of the beauty of simple forms. 'This sober architecture is not understood today by all those visitors who would rather see more graceful orders like the Ionic, the Corinthian and the Composite which charm the eye agreably; indeed the ancient Romans, when they gave themselves up to luxury, sought out an ornate style of architecture. . . . The Greeks too, wanting to soften Doric architecture, applied decoration to it and in this they were copied by the Romans who outdid their models, because those who do not understand the true theory of art always prefer a style loaded with swags, with flowers and with other ornaments to one which has only a simple purity. . . . As for this temple, either because of the national custom which preferred sobriety and simplicity, or because of the wisdom of the architect, it is clear that the work was undertaken and completed with dignity by the suppression of most ornaments to make the building look solid and sober.' It is almost as if Winckelmann had won a death-bed convert to the 'calm grandeur' of the Hellenes.

The mood of the Paestum series is quite different from that of the contemporary *Vedute* of Tivoli and Rome. The plates are generally rather darker and closer grained, no part of the surface being left unworked. He recorded some views of the exterior of the temples but he seems to have preferred to draw them from inside the screen of columns, sketching, as it were, in the heart of a forest of petrified oak trees. Everything is solid and robust; even the vegetation is coarser than the delicate festoons of creepers in the Roman plates. The pervading atmosphere is sombre. The evening sun strikes the columns from low on the horizon and the weather is chill enough for the shepherds to wear their cloaks as they guard their flocks among the ruins. They are heavy figures, gazing moodily out towards the sea across the flat countryside where their sheep and buffaloes graze. In some plates the sky is overcast and the clouds that rise over the distant mountains are dark with an impending storm. A single herdsman plays his pipe like the lonely shepherd in Berlioz's *Symphonie fantastique* piping as the distant thunder rolls. Piranesi's work ends on an elegiac note, sober and restrained, a melancholy farewell to the antiquity he loved.

He returned to Rome a dying man, but he insisted on continuing with his etching. When a doctor was suggested, he called for his volumes of Livy: "I have no confidence in anyone but him." Towards the end, despite acute pain, he refused to stay in bed. "Rest is unworthy of a citizen of Rome; let me see my models

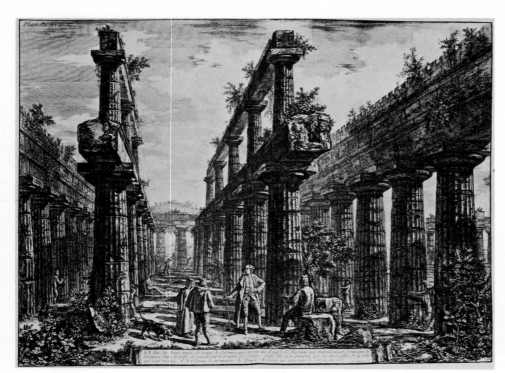

305. Drawing of Paestum

again, my drawings, my plates." He died on 9th November, 1778 and was buried not, as he had intended, in the church of S. Maria degli Angeli in the Baths of Diocletian, but in his parish church of S. Andrea delle Fratte. A couple of years later, at the request of Cardinal Rezzonico, his remains were moved to his own church on the Aventine.[30]

He need not have worried about the continuation of his business. The *imprimatur* for the Paestum series was received two months before he died and its publication soon after his death gave a good start to the new management. Francesco, who was aged twenty at the time, had been well-grounded and proved fully capable not only of carrying on his father's work, but of producing his own volumes also. Initially he brought out a couple of works which his father had left unfinished, *Dimostrazioni dell' Emissario del Lago Fucino* and the map of Hadrian's villa. He went on to add plates to reprints of his father's books and he issued several completely new works, the two volumes of *Raccolta de' tempj antichi* in 1780 and 1790, *Il Teatro di Ercolano* in 1783, *Monumenti degli Scipioni* in 1785, *Collection des plus belles statues* in 1786 and the three volumes of *Antiquités de la Grande Grèce* between 1804 and 1807. Francesco's style is fussier and more wooden than his father's but by any other standards he was a very competent artist, as was his sister, Laura, who produced some excellent miniature copies of her father's *Vedute.*[31]

The rest of the story is quickly told. The family stayed in Rome at first but Francesco, who had been appointed cultural agent for the royal collection of Gustavus of Sweden in 1784, subsequently moved to Naples as Swedish consul. He and Pietro were much involved in the revolutionary politics which swept through Italy with the Napoleonic armies; they both held office in the short-lived Roman republic established by the French in 1798. When Rome fell to the Neapolitan and British forces the family moved, under official protection, to Paris where they continued to produce their father's work and even projected a French translation of it. On Francesco's death in 1810 his enormous stock of plates was acquired by the business of Firmin-Didot which continued to produce the family's work until 1839. In that year the collection was sold for 24,000 *scudi* (£6,000) to the Camera Apostolica and transferred to what is now the Calcografia Nazionale in Rome.

306. Tripod from the Capitoline Museum, *Vasi, candelabri, cippi*

307. Vase from Hadrian's Villa, *Vasi, candelabri, cippi*

308. Throne from Piranesi's collection, *Vasi, candelabri, cippi*

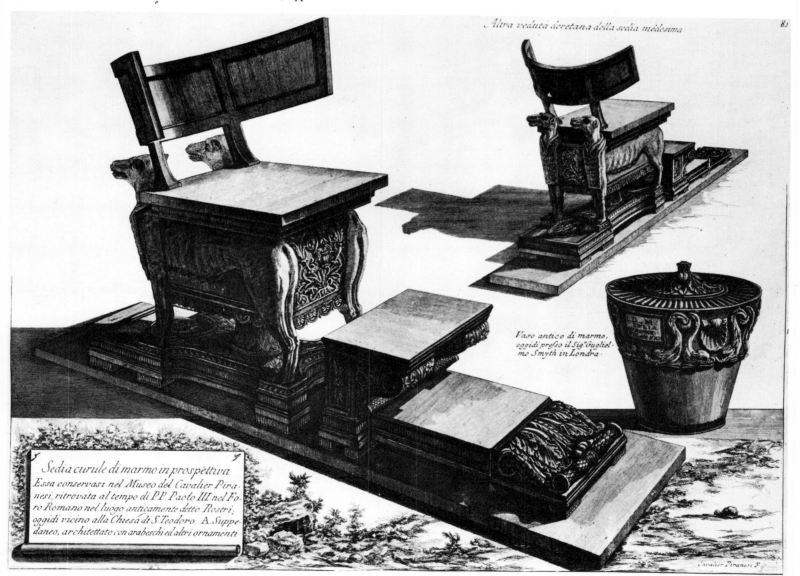

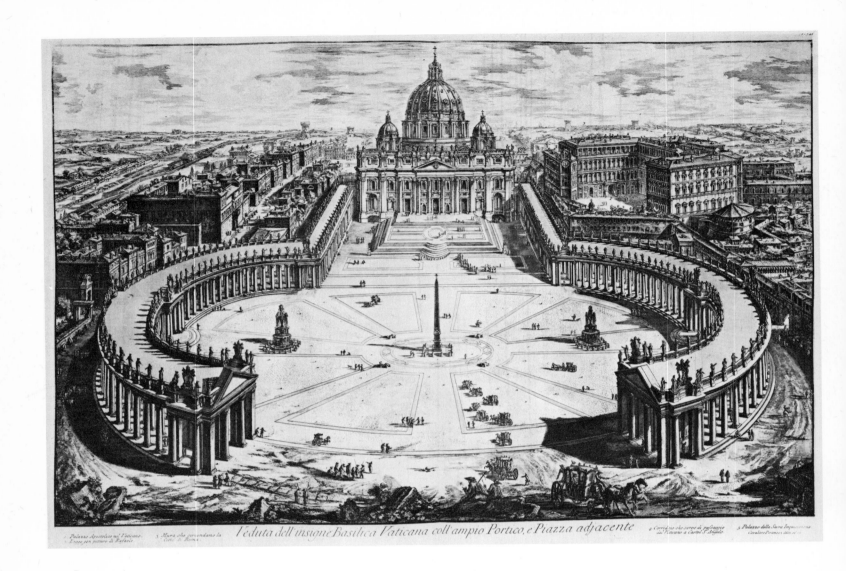

Véduta dell'insigne Basilica Vaticana coll'ampio Portico, e Piazza adjacente

309. St. Peter's, *Vedute di Roma*

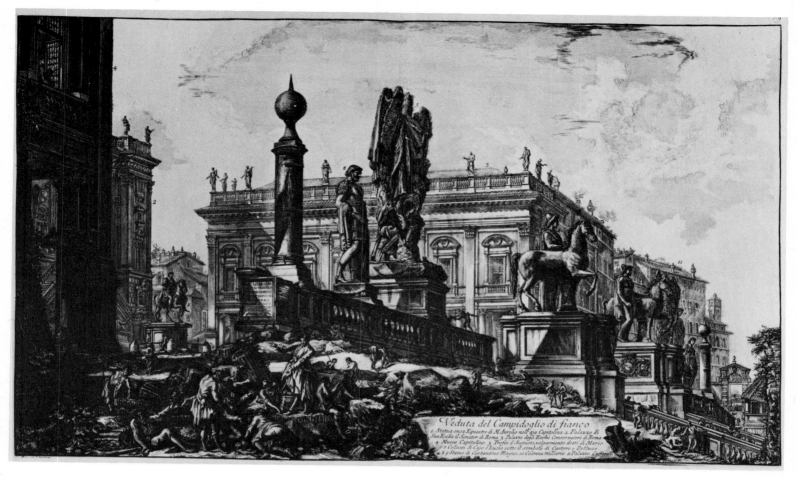

310. The Capitol, *Vedute di Roma*

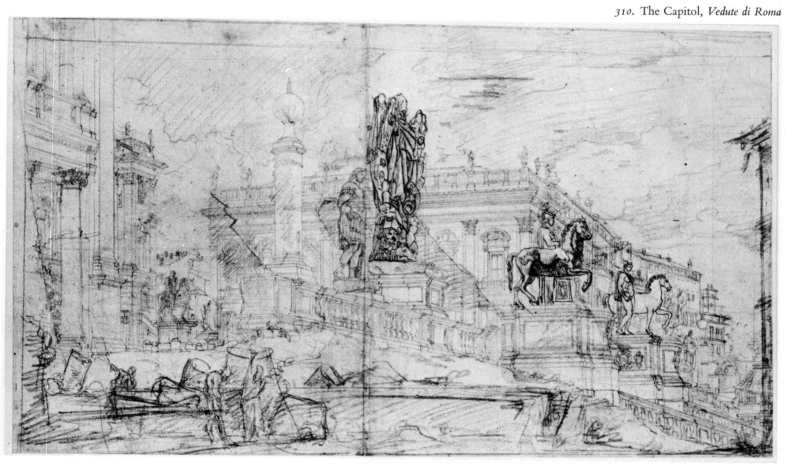

311. Drawing of the Capitol

257

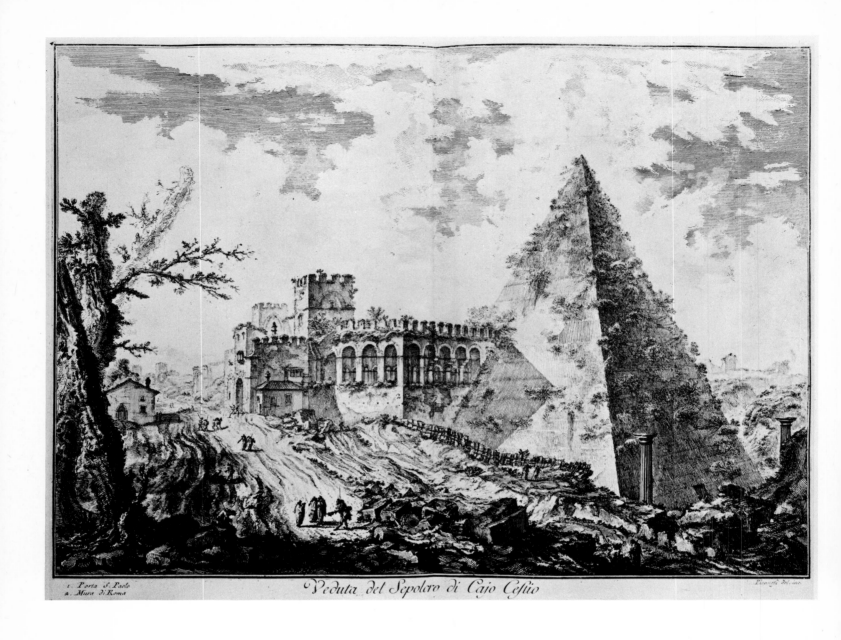

1. Porta S. Paolo
2. Mura di Roma

Veduta del Sepolcro di Cajo Cestio

Piranesi del. inc.

312. Pyramid of Caius Sestius, first state, *Vedute di Roma*

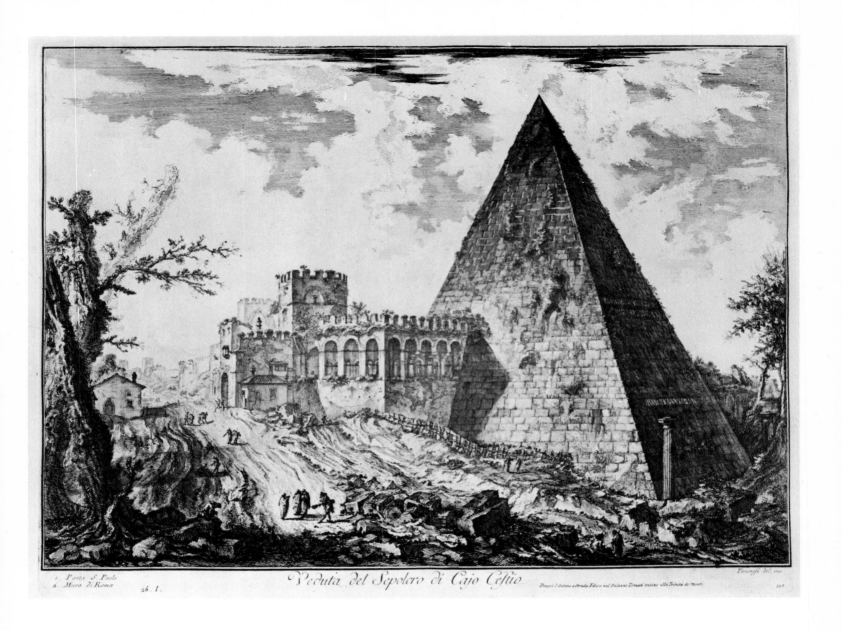

Veduta del Sepolcro di Cajo Cestio

313. Pyramid of Caius Sestius, fourth state, *Vedute di Roma*

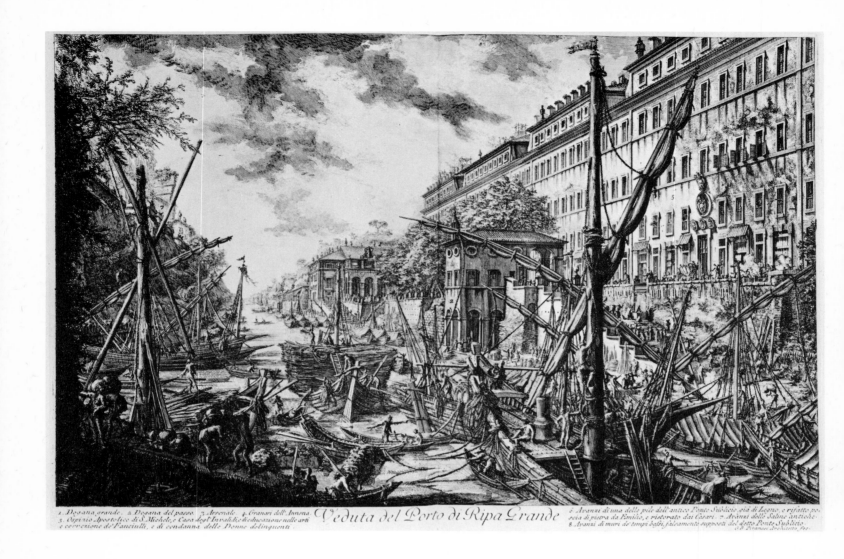

1. Dogana grande. 2. Dogana del passo. 3. Arsenale. 4. Granari dell'Annona. *Veduta del Porto di Ripa Grande* 6. Avanzi di una delle pile dell'antico Ponte Sublicio, già di Legno, e rifatto poscia di pietra da Emilio, e ristorato dai Cesari. 7. Avanzi delle Saline antiche. 5. Ospizio Apostolico di S. Michele, e Casa degl'Invalidi, e d'educazione nelle arti e correzione de'Fanciulli, e di condanna delle Donne delinquenti. 8. Avanzi di muri de'tempi bassi, falsamente supposti del detto Ponte Sublicio. G.B. Piranesi Architetto fec.

314. Ripa Grande, first state, *Vedute di Roma*

260

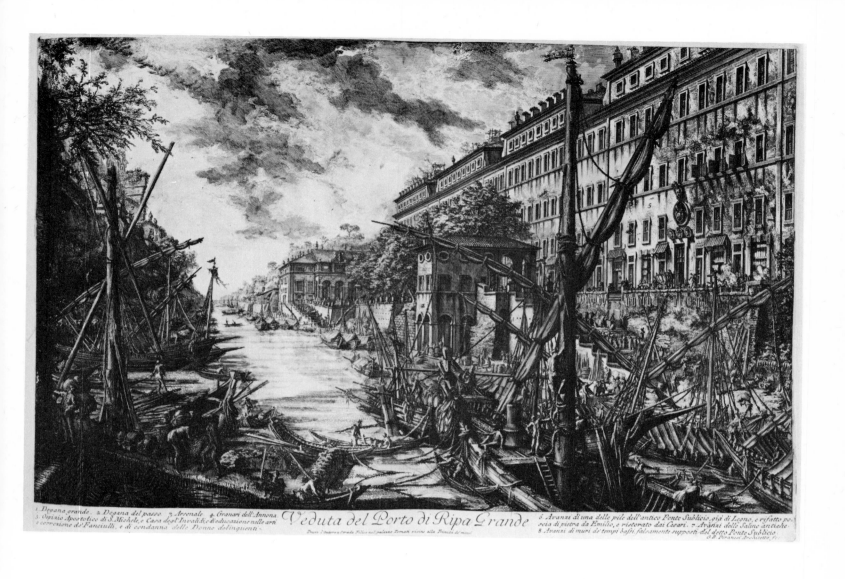

315. Ripa Grande, fourth state, *Vedute di Roma*

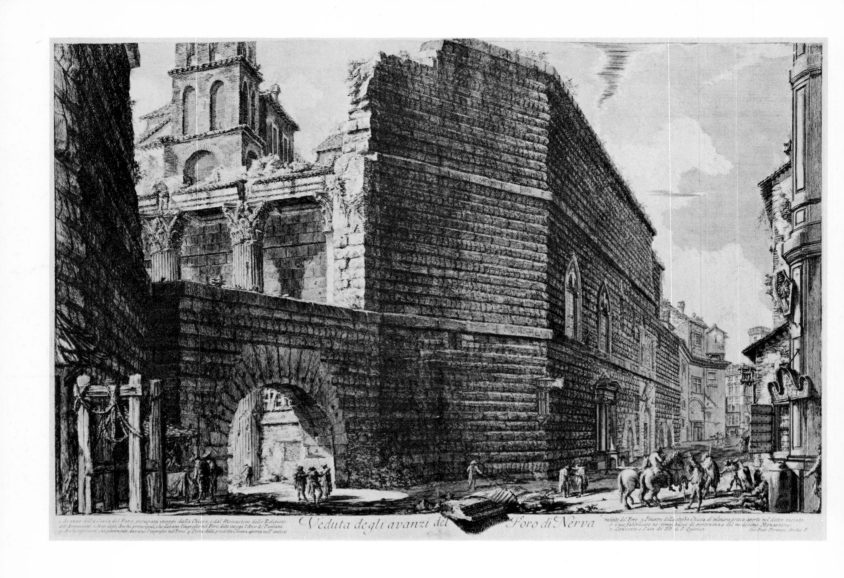

Veduta degli avanzi del Foro di Nerva

316. Forum of Augustus, *Vedute di Roma*

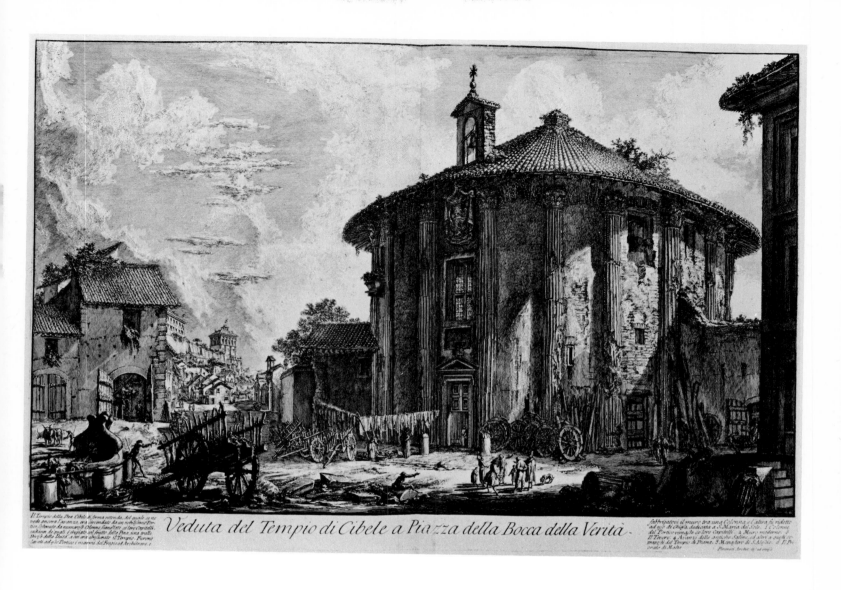

Veduta del Tempio di Cibele a Piazza della Bocca della Verità.

317. Temple of Vesta, *Vedute di Roma*

263

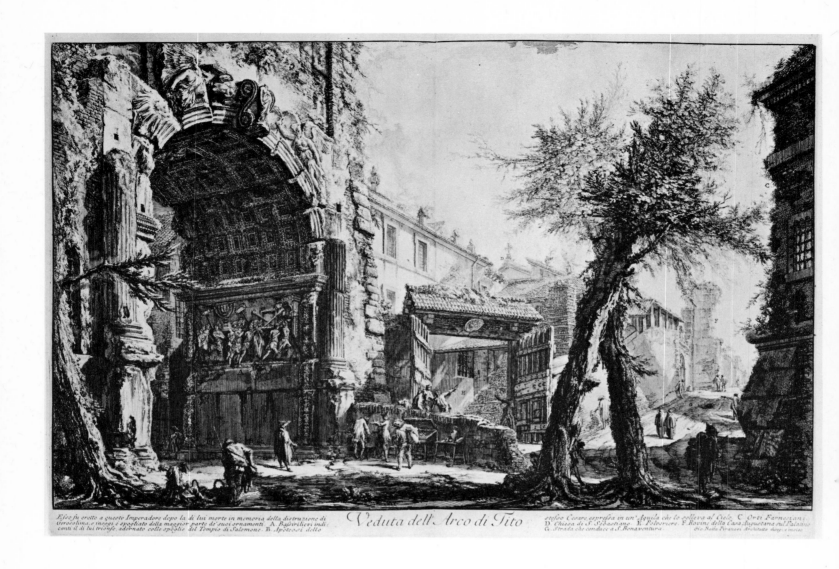

Esso fu eretto a questo Imperadore dopo la di lui morte in memoria della distruzione di Gierosolima, e inoggi e spogliato della maggior parte de' suoi ornamenti. A Bassirilievi indicanti il di lui trionfo, adornato colle spoglie del Tempio di Salomone. B. Apoteosi dello *Veduta dell'Arco di Tito* stesso Cesare espressa in un'Aquila che lo solleva al Cielo. C. Orti Farnesiani. D. Chiesa di S. Sebastiano. E. Polveriere. F. Rovine della Casa Augustana sul Palatino. G. Strada che conduce a S. Bonaventura. Gio. Batta Piranesi Architetto dis.o e inc.o

318. Arch of Titus, *Vedute di Roma*

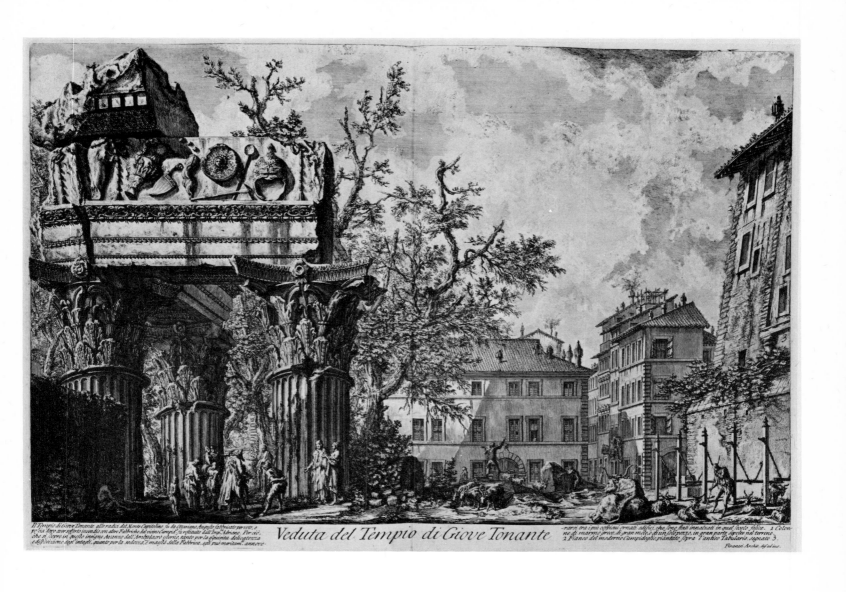

Veduta del Tempio di Giove Tonante

319. Temple of Vespasian, *Vedute di Roma*

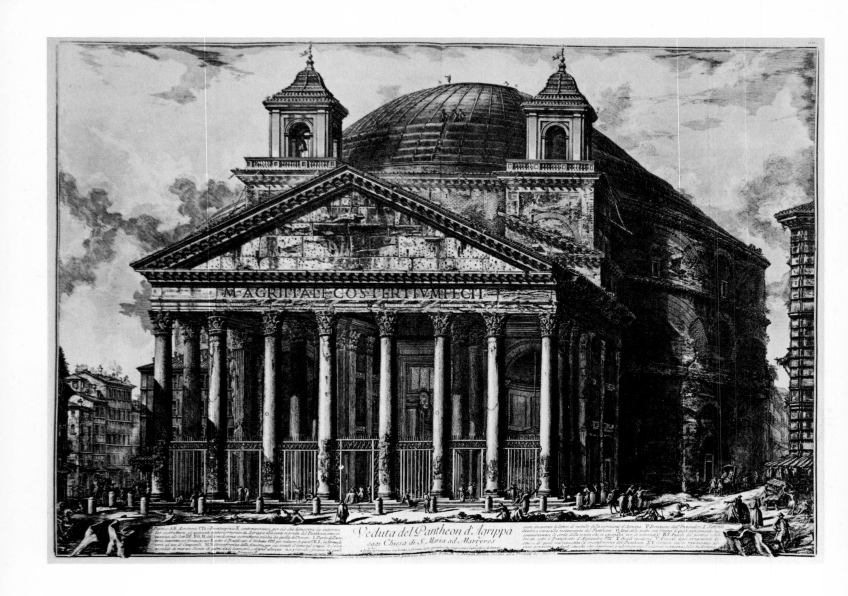

Veduta del Pantheon d'Agrippa oggi Chiesa di S. Maria ad Martyres

320. The Pantheon, *Vedute di Roma*

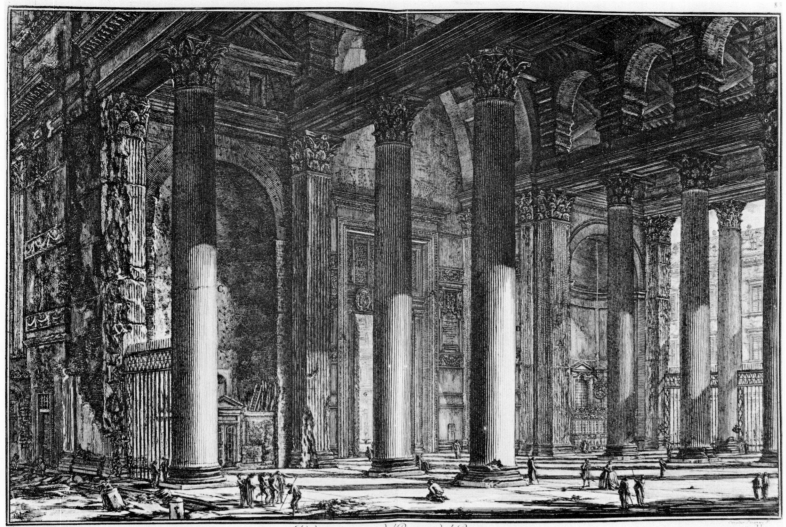

Veduta interna del Pronao del Panteon

Sostenuto da sedici colonne di granito con una di esse di un sol pezzo, grosse di diametro palmi 6.6 alte palmi 63. 8 A Pilastri architravi, e stipiti della porta composti di gran macigni di marmo greco. B Lacunari di legname anticamente di bronzo tolto via da Urbano VIII e fatto rifondere per formare la confessione di S. Pietro in Vaticano. C Nicchioni dove erano collocate le statue di Augusto e di Agrippa quali erano incrostate di marmo color... D Varieti di altre furono levate le lastre di... to al tempo di Benedetto XIV l'anno 1757 per adornare il Museo Sagro nel Vaticano E Memorie di Urbano VIII. F Porta di bronzo trasportata da altro edificio antico, ed in parte nuovamente restaurata nel detto anno 1757. G Interno del Tempio.

321. Portico of the Pantheon, *Vedute di Roma*

267

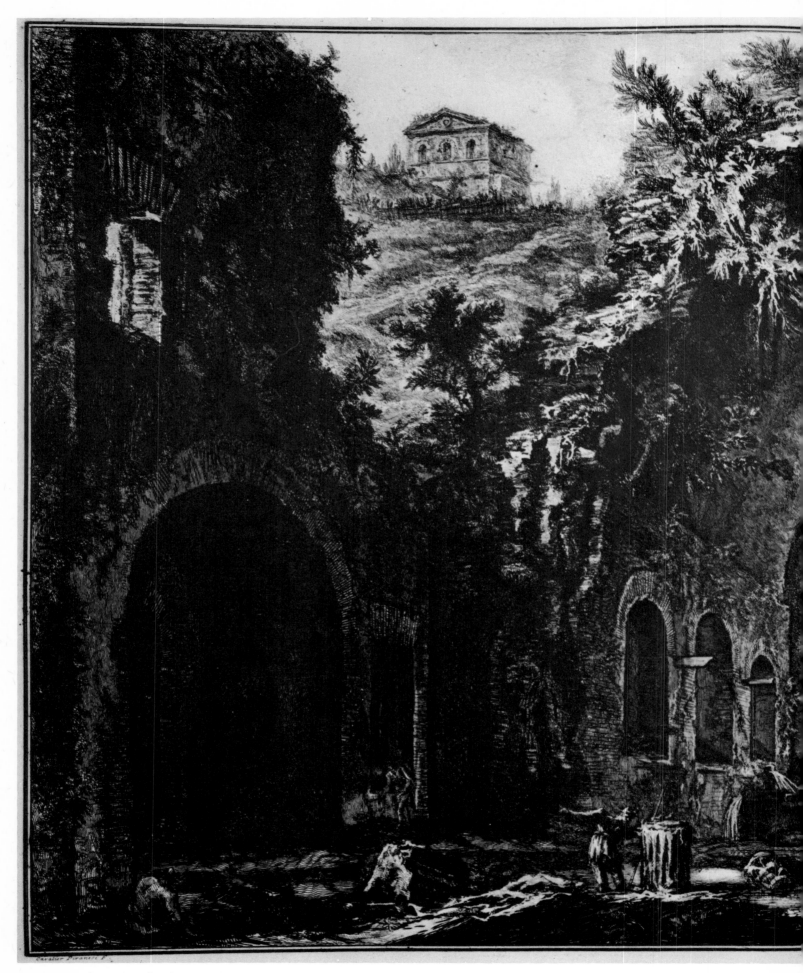

322. Grotto of Egeria, *Vedute di Roma*

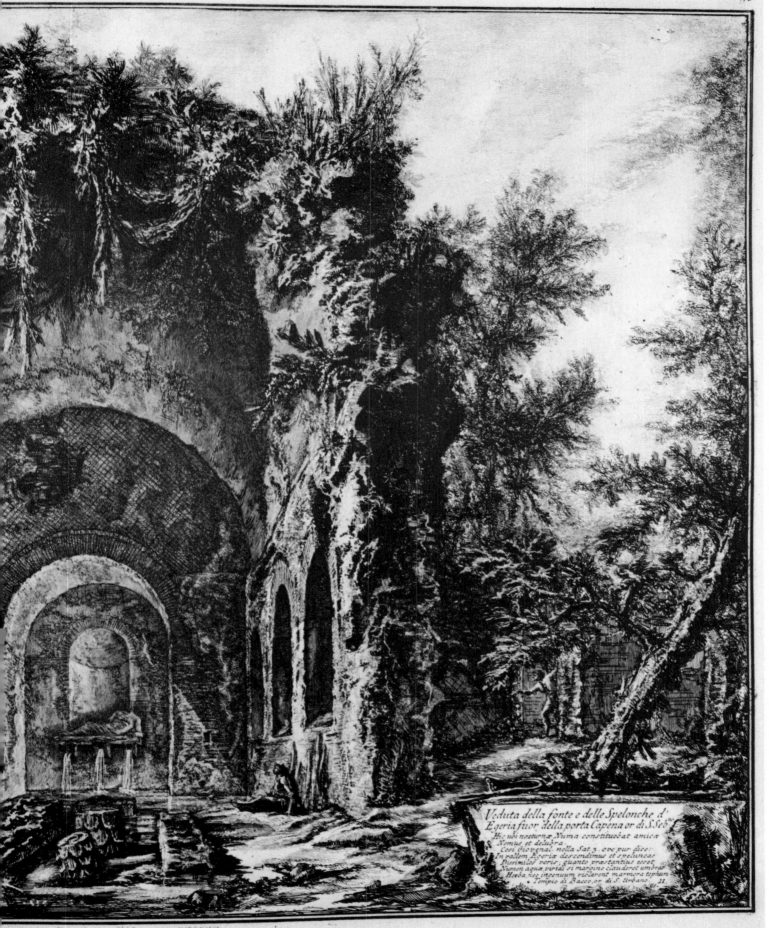

Veduta della fonte e delle Spelonche d'
Egeria fuor della porta Capena or di S.Seb.
Hic ubi nocturnæ Numa constituebat amicæ
Nemus et delubra
Cosi Giovenal nella Sat 3. ove pur dice:
In vallem Egeriæ descendimus et speluncas
Dissimiles veris: quanto præstantius esset
Numen aquæ viridi si margine clauderet umbras
Herba, nec ingenuum violarent marmora tophum
Tempio di Bacco, or di S. Urbano 31.

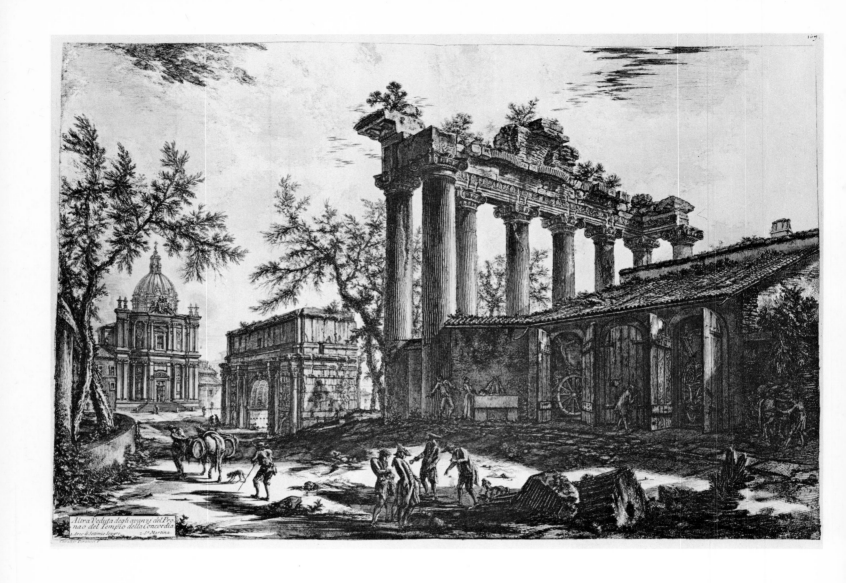

Altra Veduta degli avanzi del Pronao del Tempio della Concordia
1. Arco di Settimio Severo, 2. S.ª Martina.
Cavalier Piranesi f.

323. Temple of Saturn, *Vedute di Roma*

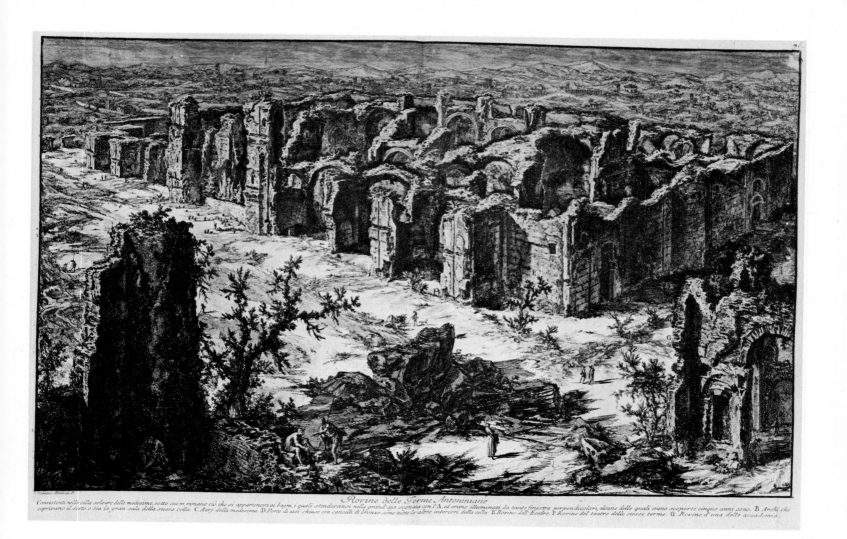

Rovine delle Terme Antoniniane

Consistenti nella cella solare delle medesime, sotto cui ni rimane ciò che si appartenera ai bagni, i quali stenderano nella grand' aja segnata con l'A, ed erano illuminati da tante finestre perpendicolari, alcune delle quali erano scoperte cinque anni sono. B Archi che coprirano il sito o sia la gran sala della stessa cella. C Atry della medesima. D Porte di esse chiuse con cancelli di bronzo come tutte le altre interiori della cella. E Rovine dell'Esedre. F Rovine del teatro delle stesse terme G Rovine d'una delle accademie.

324. Baths of Caracalla, *Vedute di Roma*

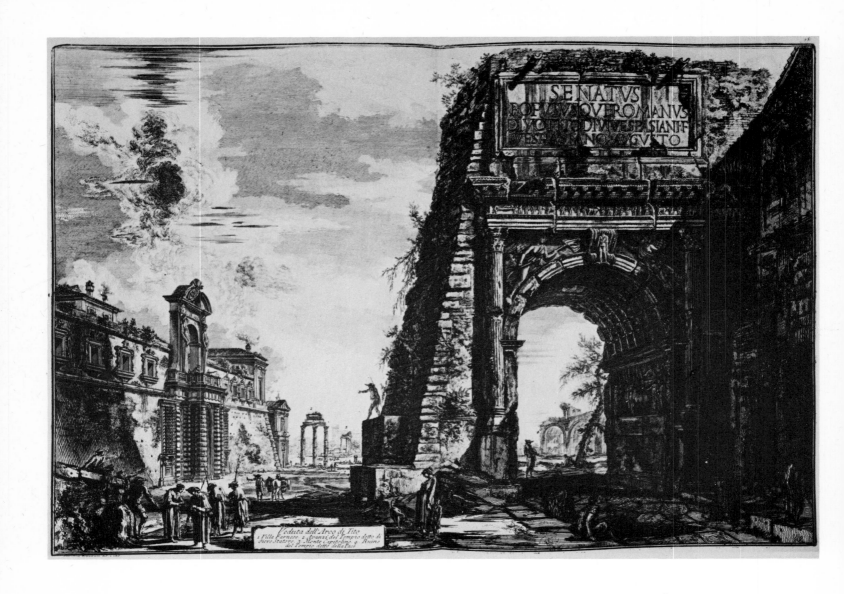

Veduta dell' Arco di Tito
1 Villa Farnese 2 Avanzi del Tempio detto di
Giove Statore 3 Monte Capitolino 4 Ruine
del Tempio detto della Pace

325. Arch of Titus, *Vedute di Roma*

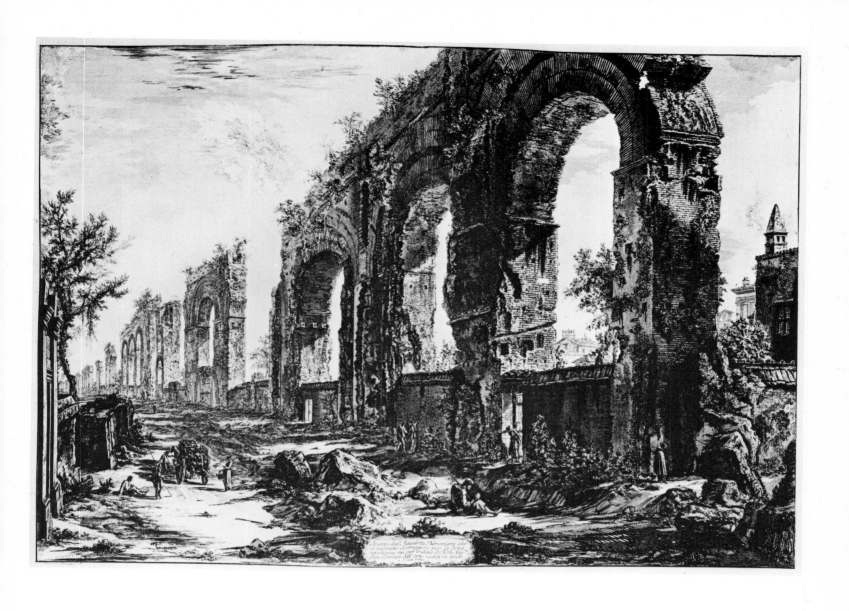

326. Aqueduct near S. Giovanni in Laterano, *Vedute di Roma*

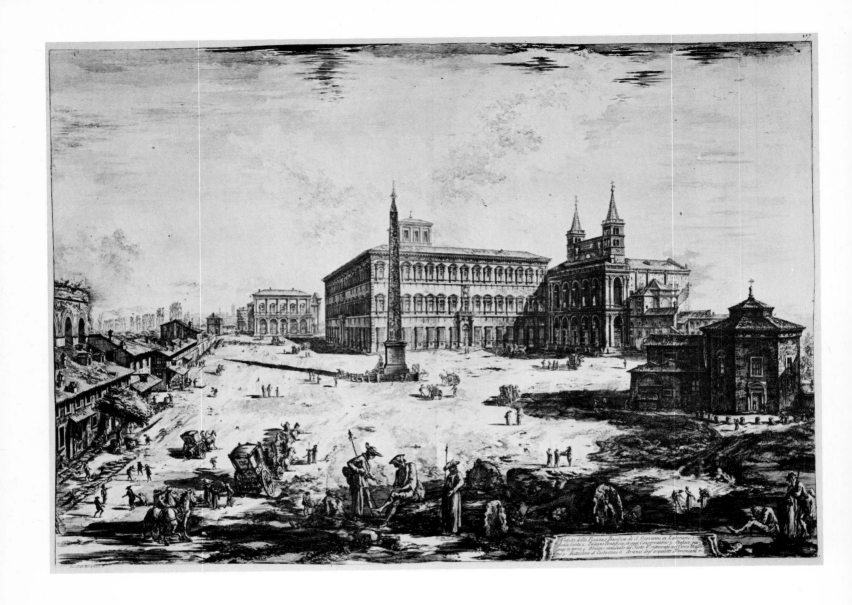

327. S. Giovanni in Laterano, *Vedute di Roma*

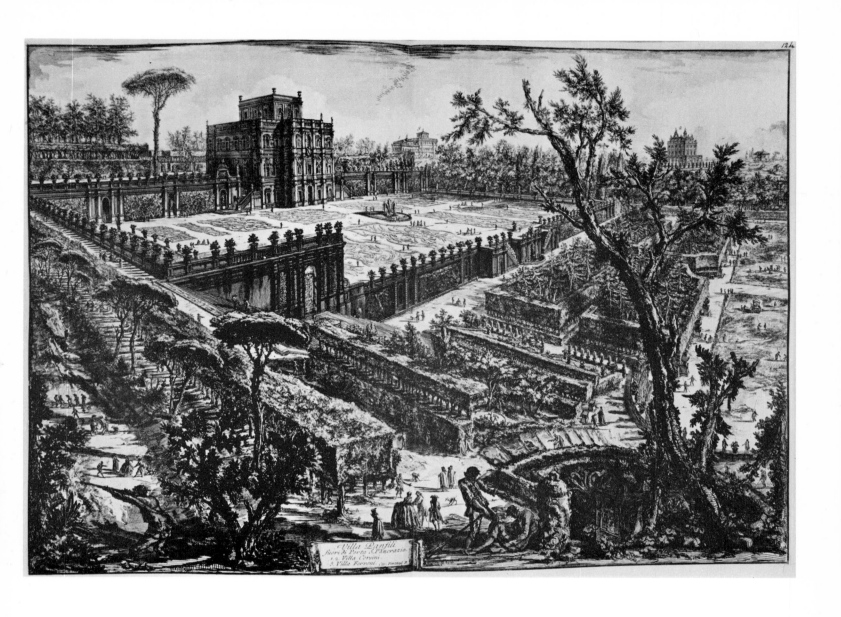

328. Villa Pamphili, *Vedute di Roma*

VEDUTA della Facciata della Basilica di S. Giovanni Laterano, architettura di Alessandro Gallilei. A Loggia, dalla quale i Sommi Pontefici ne giorni assegnati Festivi danno la Benedizione al Popolo sulla Piazza. B Palazzo Fabbricato da Sisto V. ora Conservatorio di Zitelle. Cav. Gio. Batta Piranesi F.

329. S. Giovanni in Laterano,
Vedute di Roma

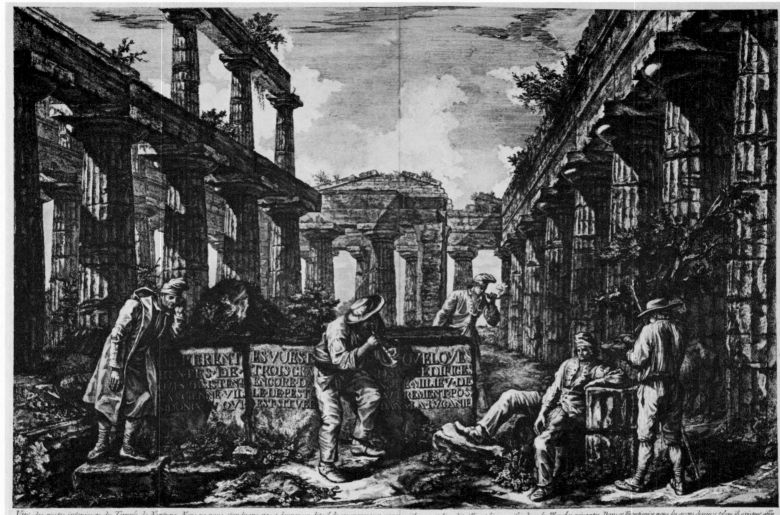

Vue des restes interieurs du Temple de Neptune. Nous ne nous etendrons pas a donner un Detail de ces morceaux, parce qu'ils seront bien detailles, et bien specifies dans les Planches suivantes. Dans ce Frontispice nous les avons dessines tel qu'ils existent affin d'en presenter un grand appareil uni a d'autres amas de ruines, que nous donnerons ci apres dans les Planches. Les Voyageurs connoisseurs auront egard par rapport a l'Architecture Grecque des Temples batis dans l'Ordre Dorique ceux de Pesto sont superieurs en beaute a ceux qu'on voit en Sicile et dans la Grece et que sans se donner la peine, et la fatigue de longs voyages, ceux ci peuvent suffire pour contenter la curiosite, et qu'enfin cette grande et majestueuse Architecture donne en son genre l'idee la plus parfaite de ce bel art.

Francesco Piranesi fecit

330. Francesco Piranesi, Title page, *Pesto*

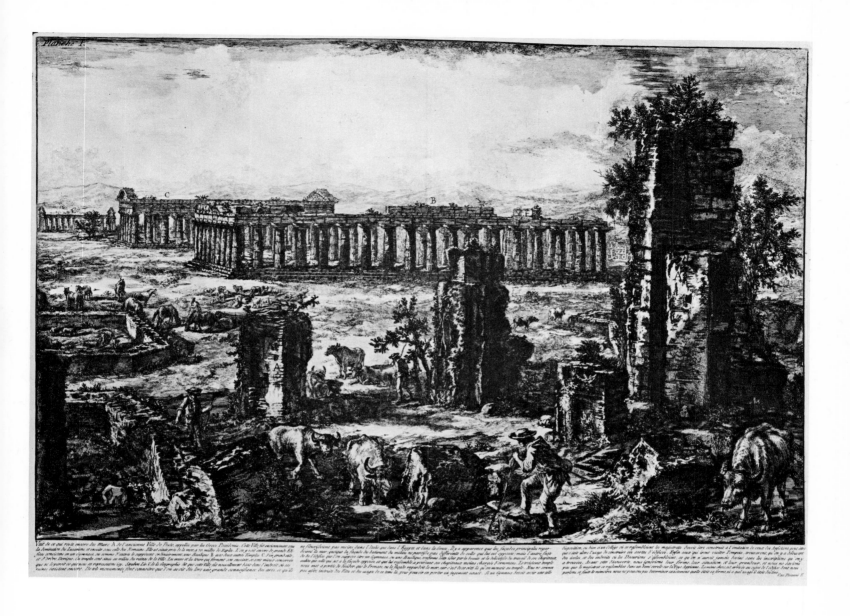

Vue de ce reste encore des Murs B. de l'ancienne Ville de Pesto, appellée par les Grecs Posidonia. Cette Ville fut anciennement sous la domination des Lucaniens, et ensuite sous celle des Romains. Elle est située près de la mer a 70 milles de Naples. Il n'y a voit encore de grands Edifices consistant en un Gymnase, ou comme d'autres le supposent, vraisemblablement, une Basilique B. avec deux autres Temples C. l'un grand suite et d'ordre Dorique. On remarque ces colonnes au milieu des ruines de la Ville. Les murs et les terres qui forment cet enceinte se sont mieux conservés que le reste et on voit en les représentant icy. Strabon Liv. VI. le Géographe dit que cette Ville fut nouvellement bâtie dans l'endroit, ou en ruines, existent encore. De tels monuments, font connoistre que l'on avoit du lors une grande connoissance des arts, et qu'ils

ne s'enorgueilloient pas moins dans l'Italie, que dans l'Asie, que dans la Grèce. Il y a apparences que les Façades principales regardaient la mer, quoique les Façades du batiment du milieu ne paroisse pas différentes de celles qui lui est opposée; mais d'autre Façade de l'Edifice que l'on suppose être un Gymnase, ou une Basilique, renferme cette idée par la beauté et la délicatesse du travail et en chapiteaux autres que celles qui ont à la façade opposée, et qui lui ressemble; pourtant aux chapiteaux moins chargés d'ornemens. Le troisième Temple nous mont à portée de hauteur que le Premier ou la Façade regarde la mer, c'est être mis là, en un memoire au temple. Nous ne connoissons pas assez entente des Villes et les usages de ce tems là, pour pouvoir en porter un jugement exact. Si ma supposition avoit être une telle

disposition, ou bien si en l'Edifice ou se rassembloient les magistrats Pouvoit être comparée à l'imitation de ceux des Anciens, pour être que c'etoit alors l'usage de construire ces sortes d'Edifices. Enfin ceux qui voudront visiter Pompeii, trouveront qu'il n'y a tels autres les ecoles, et les endroits ou les Decurions s'assembloient, ce qu'on n'auroit jamais formée sans les inscriptions qui s'y sont trouvées. Avant cette Découverte, nous ignorions leur formes, leur situation, et leur grandeur, de même au contraire pas que le troisième se rassemblent dans un lieu couvert, sur la Place Publique. La même chose est arrivée au sujet de l'edifice dont nous parlons, et faute de mémoire nous ne pouvons pas déterminer exactement quelle était sa forme ni à quel usage il étoit destiné. Jean Piranesi F.

331. The three Temples, *Pesto,* Plate I

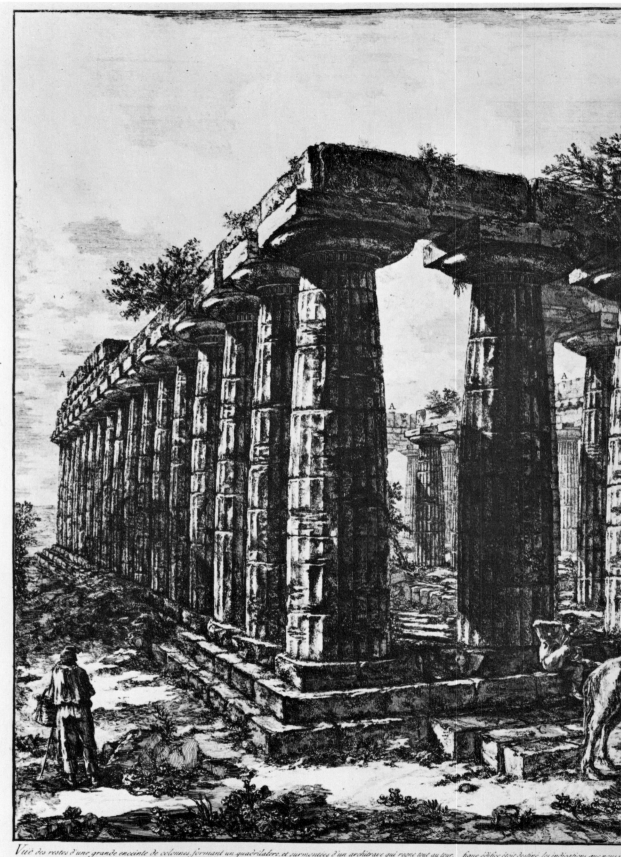

332. Remains of Colonnade, *Pesto,* Plate II

Vuë des restes d'une grande enceinte de colonnes formant un quadrilatere, et surmontées d'un architrave qui regne tout au tour, avec d'autres morceaux qui formoient une partie de la frise A. La pierre dont cet édifice étoit bati ressemble au travertine, et elle étoit enduite d'un plâtre tres fin, pour en mieux couvrir les deffauts et les inégalités. Le Diametre des colonnes, est a peu près de la grandeur d'un homme ordinaire. Sur la frise, il n'y a pas de triglifes, mais les stries, et l'entasis, ou renflement des colonnes, avec la variété et la finesse des moulures qui décorent les chapiteaux, la proportion des hauteurs et des Saillies, semblent donner a cette architecture un caractere, qui s'approche de l'ordre Dorique. Les trois divers socles B regnent tout au tour de l'enceinte. Ce n'a point été pour servir de montée, qu'on les a placés ici, mais pour donner plus de liaison, et plus de majesté aux colonnes, et en même temps pourque cet édifice qui étoit public, fut distingué des édifices particuliers. Quoique sa montée C soit ruinée, il est pourtant resté des morceaux qui indiquent le lieu où paroissoit ses Degrés, comme en pareil cas cela se voit aussi à Pompeia dans les restes d'un ancien temple d'ordre Dorique. L'on ne scai pas a quel usage ce magnifique édifice étoit destiné. les indications que nous qu'elles appartiennent plutôt aux connoissances ichées, que cela nous donnerie de sa forme, pourvou tes interieures de cet édifice desinées plus en grand, observent l'intérieur de l'édifice divisé en deux par tica des Deux Pronaos, et à celle du milieu des Deu tel nombre impair de colonnes dans un édifice p Il ne nous reste plus aucun model de pareils édifice parlant des ouvrages publics, comme Basileques Curies,

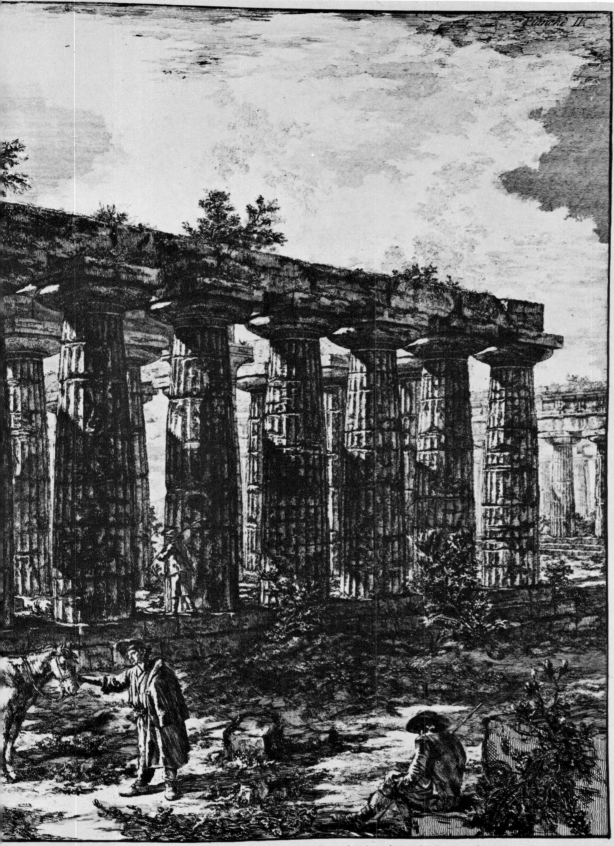

ne sont pas suffisantes pour nous éclaircir sur ce point, parce
étoit encore quelque partie du comble ou de la charpente, les
rmer ses conjectures sur son usage. L'on verra par après les par-
vois du nombre impair des neuf colonnes qui sont le front, mais ce
colonnes restées en pied répondent directement à celle du mi-
situé au lieu de l'entrecolonnement. Il paroit évident qu'un
eux n'étoit pas un défaut, mais une disposition nécessaire.
De la Grèce, ou de l'Italie, Vitruve dans son traité l'architecture en
ation des colonnes sur le front de ces édifices n'a jamais proscrit le nombre impair.

Il est bien vrai cependant que pour les côtés l'on a employé assez indifféremment les colonnes en nombre pair et en nombre impair. Il faut donc chercher
quelqu'autre dénomination que celle que nous donne Vitruve. Quelqu'un dira le Pronaos intérieur est construit selon que cela se pratiquoit pour
les temples, mais le Pronaos des temples avoient la porte dans le milieu qui conduisoit dans la cella, et non pas une colonne au lieu de por-
te. Nous ne sommes pas assez instruits des Rites, et des usages de ce temps là, pour juger si cet édifice devoit avoir la
disposition d'un Gimnase, ou bien d'un Collège, où se rassembloient les Magistrats à l'imitation de ceux des Anfictions. Enfin
ceux qui iront visiter Pompeia trouveront qu'on y a découvert des écoles en forme de demi cercle, où les Décuri-
ons se rassembloient, ce qu'on n'auroit jamais deviné sans les inscriptions qu'on y a trouvé. Avant cette découverte
nous ignorions leur forme, leur situation, et leur grandeur. La même chose est arrivée au sujet de l'édifice dont nous parlons,
et faute de memoires nous ne pouvons determiner exactement ni sa forme, ni à quel usage il étoit destiné.

Cav. Piranesi F.

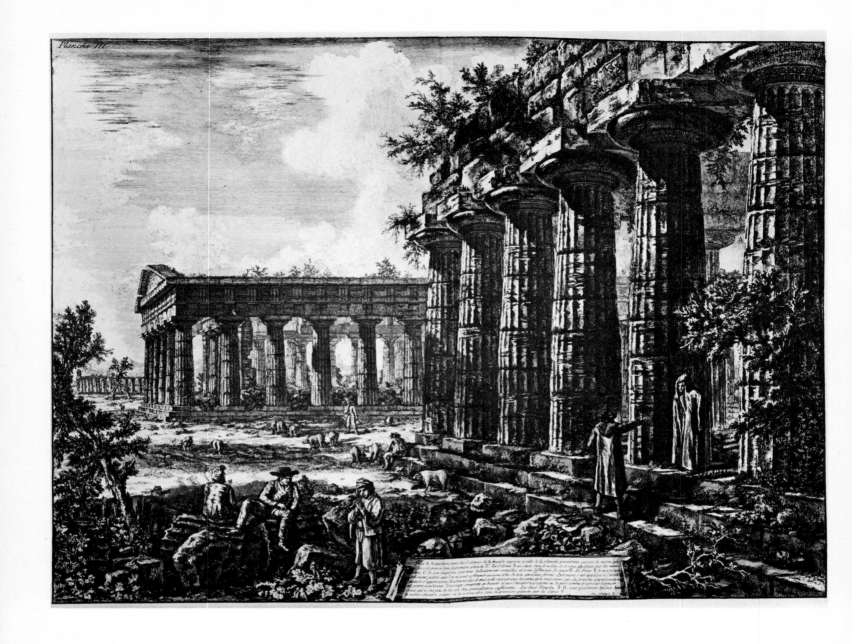

333. The three Temples, *Pesto*, Plate III

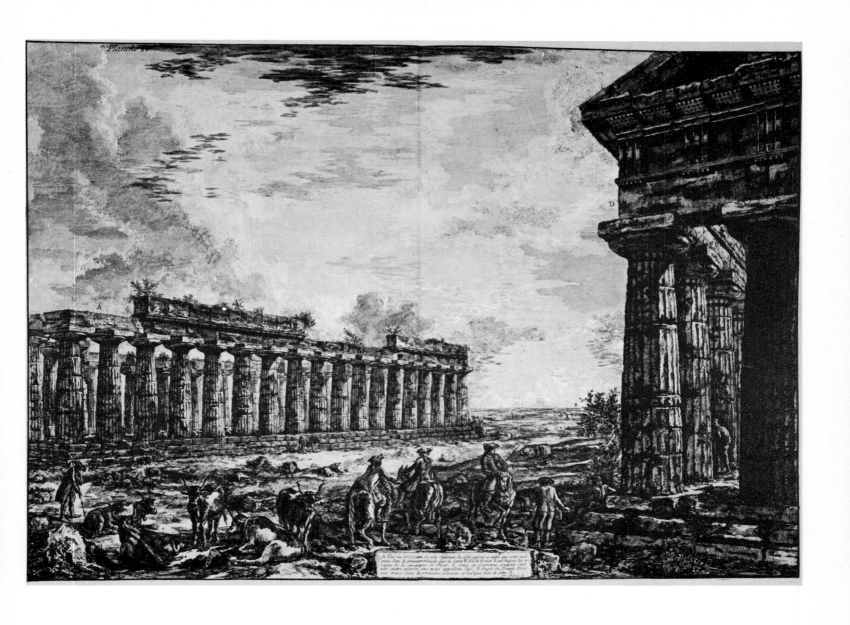

334. View of Columns, *Pesto,* Plate IV

Planche VII.

Vüe intérieure du Collège supposé des Anfictions. A Colonnes latérales externes de l'édifice
dentes. Les restes des jonctions des traversans C indiquent la continuation du mur. D trois
petites. Il est à supposer, qu'elles soutenoient un autre rang de colonnes au dessus de leurs

335. View of Columns,
Pesto, Plate VII

A

Cav. Piranesi F.

térieure du Pronaos et qui est opposée à celle qui a déja été décrite dans les deux planches précé
s dans le milieu de l'édifice, correspondantes à celle Y du milieu du Pronaos; mais qui sont plus
pour former un second ordre propre a soutenir le comble de l'édifice.

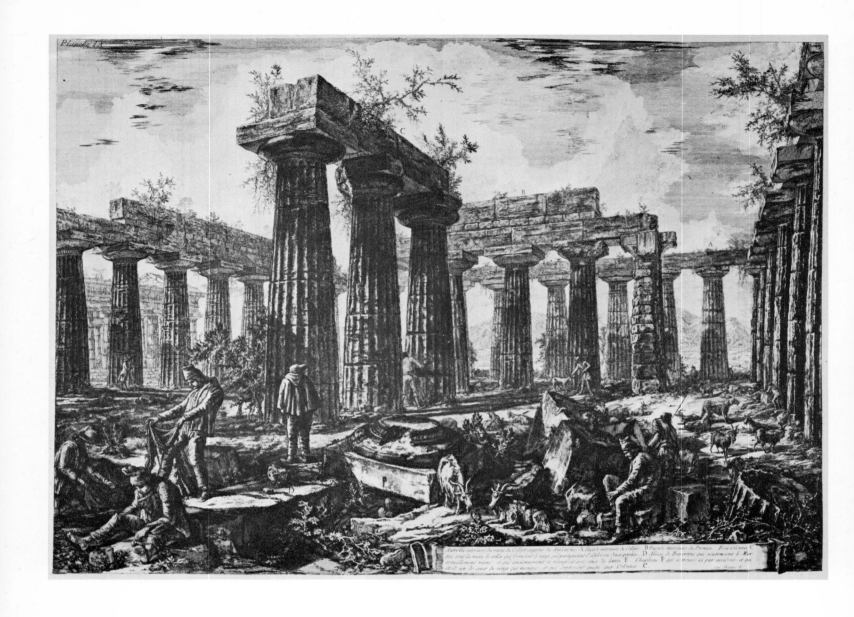

336. View of the interior of the so-called College, *Pesto,* Plate IX

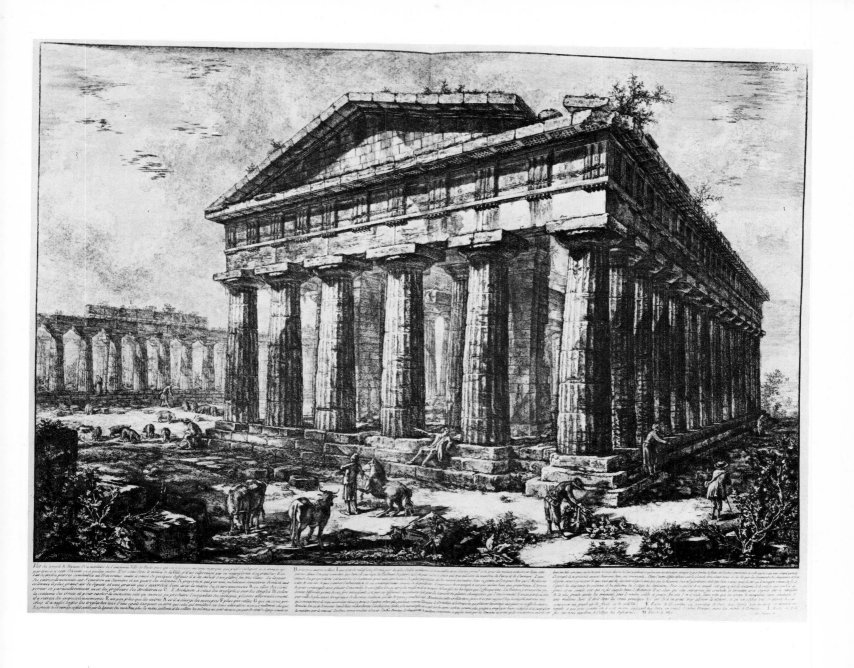

337. Temple of Neptune, *Pesto,* Plate X

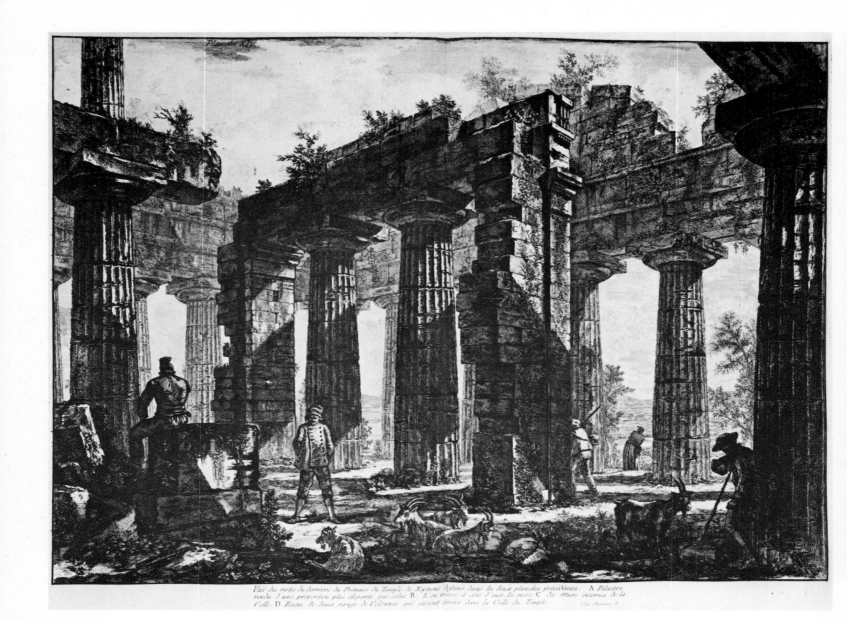

338. Temple of Neptune, *Pesto,* Plate XIV

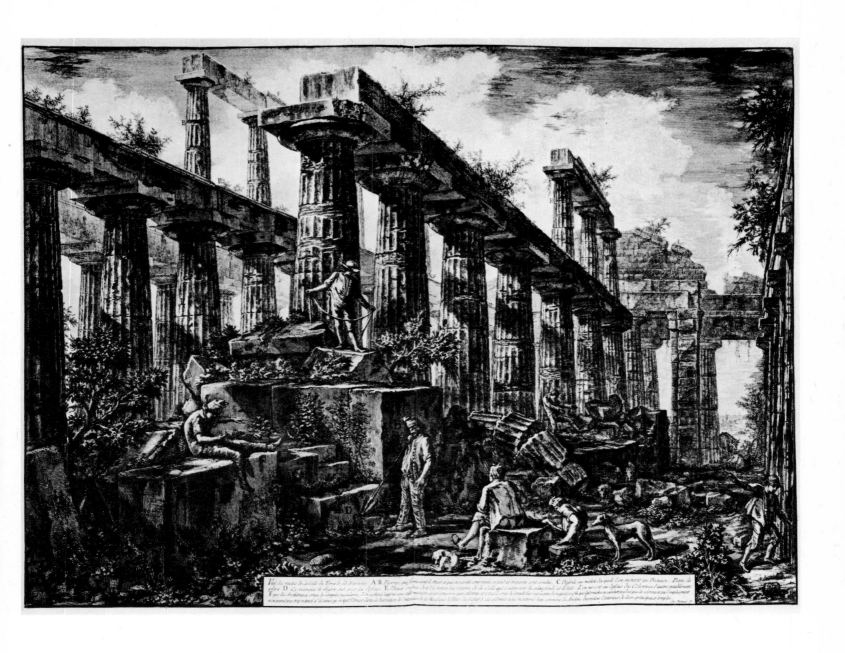

339. Temple of Neptune, *Pesto*, Plate XV

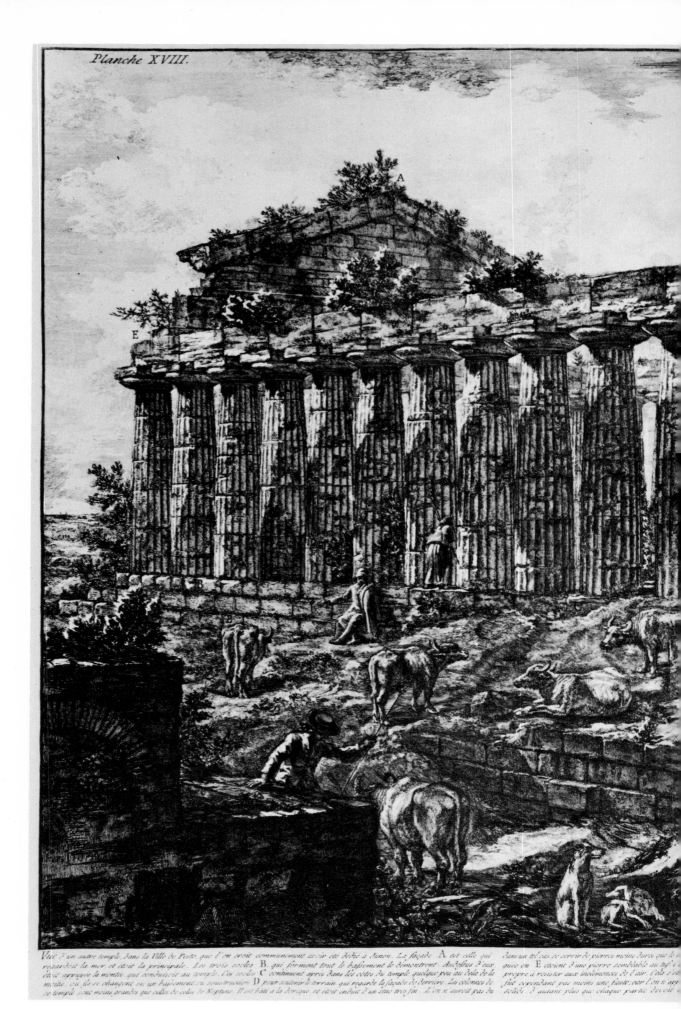

Vûe d'un autre temple, dans la Ville de Pesto, que l'on croit communement avoir ete dedié à Junon. La façade A est celle qui
regardoit la mer, et etoit la principale. Les trois socles B qui forment tout le basement le demontrent. Au dessus d'eux
etoit appuyée la montée qui conduisoit au temple. Ces socles C continuent après dans les côtés du temple quelque peu au delà de la
moitié, où ils se changent en un basement ou construction D pour soutenir le terrain qui regarde la façade de Derriere. Les colonnes de
ce temple sont moins grandes que celles de celui de Neptune. Il est bâti à la dorique et etoit enduit d'un stuc très fin. L'on n'auroit pas du

Dans un tel cas se servir de pierres moins dures que celles
que en E etoient d'une pierre semblable au tuf. Cela a été
propre à resister aux inclemences de l'air. Cela a été
cependant pas moins une faute; car l'on n'ap
solide d'autant plus que chaque partie de cette

340. Temple of Juno,
Pesto, Plate XVIII

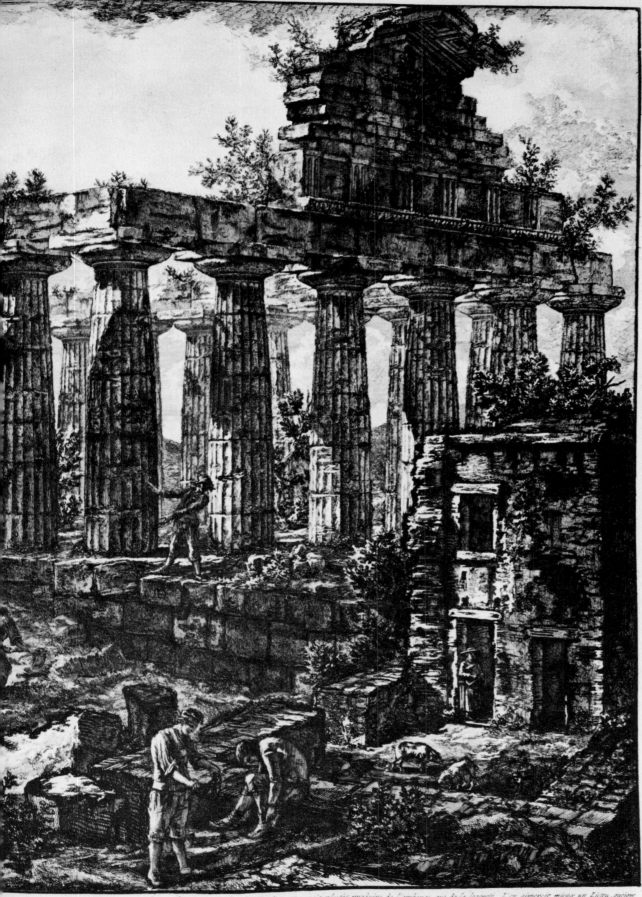

G

ouches de pierres qui composent la gorge renversée mar- rier l'ordre Dorique, et variée plutôt produire de l'embarras, que de la legereté. L'on aimeroit mieux un Liteau, quoique
d'huy tombe en poussiere fait bien voir qu'elle etoit que d'un usage ancien, qu'une telle nouveauté. La corniche F est tellement ruinée, que l'on n'en peut prendre aucune idée
mettre de la variété dans les marbres, mais cela n'en Celle du passage, ou fronton G se decouvre en partie, elle a des saillies unies à des lambris. Ouvrage dont il n'est pas pos-
l'on substitue une pierre moins dure à une autre plus sible de rendre raison; le caprice seul avoit dirigé l'architecte dans son execution. Il est vraisemblable que ce n'est pas
Ce membre d'architecture introduit ici, semble contra le même, qui a construit le temple de Neptune, que l'on a decrit cy devant

Cav. Piranesi F.

341. Details of plates 44, 146, 46 and 37

CHAPTER TEN
Piranesi the Artist

LEGRAND says that in his youth Piranesi painted 'in the manner of Benedetto Castiglione, of Piazzetta, of Tiepolo and of Canaletto'. No example of his work as a practising artist in oils is now traceable although an architectural *capriccio* in the Accademia di S. Luca has been attributed to him.[1] Since he was so eclectic in his choice of models it is not surprising that, if any of his early efforts on canvas survive, they probably now pass unrecognised as the work of the school of Marco Ricci or of Pannini.

Drawings, however, cover all aspects of his career. From his early years there are examples of his first stilted exercises in stage design; there are sketches dating back to his Venetian period in the Tiepolo studio, and there are a large number of *capricci,* some related to the *Carceri* and many more to the grandiose architectural fantasies with which he continued the *Prima Parte*. At one stage he thought highly of his early drawings because he enclosed quite a number of them in ruled borders and signed them as if for presentation. Later, however, he seems to have become too busy to spend much time on imaginative exercises of this sort. After about 1760 most of his surviving drawings relate to etchings for his published work or to his architectural practice, although he still occasionally indulged himself in imaginative *capricci,* as we can judge from the superb drawings at Gorhambury one of which is signed 'Cavaliere', and he continued to produce figure sketches for his relaxation.

Since his output of etchings was in the region of 1000 plates and since we are told that he never stirred from home without a pencil and paper in his pocket, it is disappointing that more drawings do not survive. Sketches by his contemporaries, the Tiepolo and Guardi families, for instance, are much more

342. Drawing of an imaginary mausoleum

numerous. The move to Paris is the principal reason for this scarcity. Although Francesco and Pietro took with them on their hasty flight from Rome the firm's most valuable asset, the copper plates, they had to leave behind the rest of their possessions including twenty-four volumes of drawings by their father, 300 drawings of Pompeii, Herculaneum and the Museum of Portici, and 250 drawings by him and by Francesco of Hadrian's Villa, which were all packed up by the army of liberation and sent to Naples. Pietro returned to Italy in 1801 to liaise for the return of the family property and had some success, but he seems to have been more concerned in getting a financial indemnity (he was claiming 278,325 francs or £11,160) and although he must have recovered some drawings, he probably did not manage to bring them all back. Then, when Francesco died in 1810 and the family collection was dispersed, his father's Baroque flights of fancy and his less formulated sketches would have been out of key with contemporary fashion in the sharp elegance of the Empire and more drawings may have been lost at that time. It is quite possible that some exciting folios may one day emerge from a private collection in Naples or Paris or Rome. There is said to have been a collection of drawings related to the *Carceri* on the art market in the 1950s and the designs for S. Giovanni in Laterano are a recent discovery.[2]

A more fundamental reason for the comparative rarity of his drawings was Piranesi's own artistic style and temperament. He regarded the etching as the main (and most profitable) objective of his business and any drawing was merely a means to an end rather than an end in itself. The design of an etching would be pricked or traced (generally the former) from the large final drawing, which was completely spoiled in the process. Apart from the Paestum series which, as we have seen, may have been executed for rather a special purpose, almost all the large drawings of *vedute* which survive are views of scenes which he intended to etch but had not yet started at the time of his death. The preparatory sketches from which he built up the large drawings for his etchings were very hastily conceived and probably did not leave his possession because they were too slight to be of interest to collectors. Legrand records the astonishment of his contemporaries at the artist's technique. 'He never made detailed sketches, a broad stroke of red chalk which he reworked in pen or brush and even then only in parts was enough to secure his ideas, but it is almost impossible to make out what he thought he was putting on the paper because it is nothing but a chaos out of

343. Drawing of an elaborate garden

which with his admirable art he only extracted a few elements for his plate. The artist Robert, with whom he sometimes used to draw in the countryside, and who was well able to appreciate his talent, could not understand how he could manage with such slight sketches. Seeing his astonishment Piranesi said, "The drawing is not on my paper, I agree, but it's all here in my head. You'll see it in the plate."'

These speedy jottings were the result of detailed preliminary observations made on the spot each day. He would return to the site 'in the full blaze of the sun and again by moonlight when the masses of the architecture seemed to increase their strength and produced effects of solidity but also of softness and harmony far superior to the glare of light in the day time. He learned these effects by heart from studying them both close at hand and from a distance and at all hours.' Because of the importance in his plates of the contrast between light and darkness he took particular care to capture the right shading effects. 'He used to come and watch the play of the shadows at different hours of the day and especially by moonlight, but if he was asked why he did not make a more detailed drawing with all the shadows marked in, he used to reply, "I'd be sorry to do that. Don't you see that if my drawing was finished, my plate would only be a copy? It's

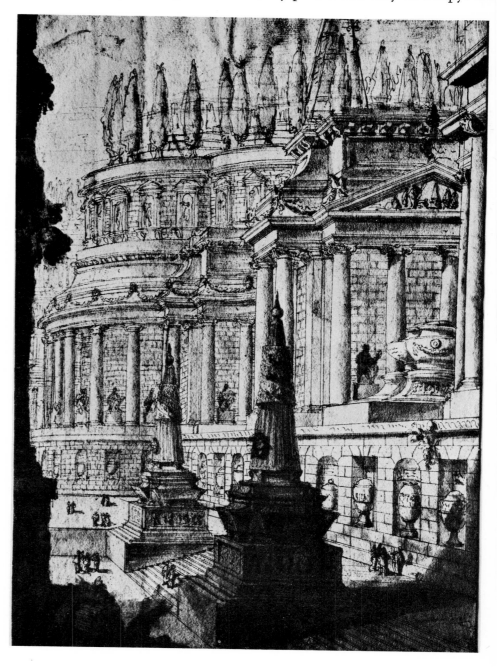

344. Drawing for Ancient Mausoleum in *Prima Parte*

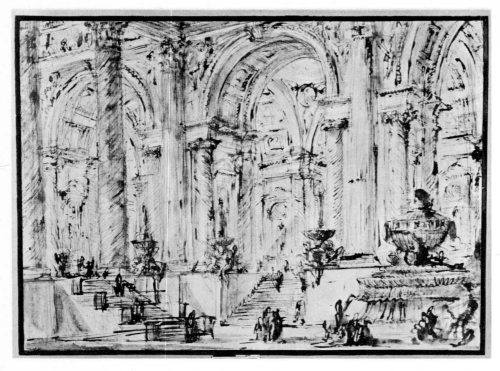

345. Architectural *capriccio* drawing

quite different. When I create the effects on the copper I am producing something original."' Kennedy confirms the account of his nocturnal work. 'Though not repeated by the son, tradition reports . . . that it was a frequent plan with him, having previously selected the particular object of study so as to have his mind well imbued with the minutiae of the buildings, to complete his designs of the vast architectural piles at the period of the full moon, and effect those bold and masterly productions.'[3]

In preparing drawings for his large plates he generally concentrated on the architectural composition, its setting and the encroaching vegetation. The figures were very lightly adumbrated, a mere scratch being sufficient to indicate where a beggar was to moulder among the fallen capitals or where the group of tourists was to pose, admiring the view. But he never ceased to enjoy making separate figure sketches, a habit which dated back to his student days when he preferred to draw cripples and hunchbacks instead of the Laocoon or the Apollo Belvedere. His figure studies are comparatively numerous, and are clearly the exercises with which he used to amuse himself while sitting at a coffee house window or as momentary relaxation from his exacting architectural studies. His ragged grotesques are often impossibly distorted, as his critics complained, with elongated arms extended like simian scarecrows but they are in tattered sympathy with the ruins among which they are usually located in the etchings. He probably kept a portfolio of his jottings of gesticulating peasants or Trasteverini, young *milordi* in their tricorn hats and Roman matrons with their children. When he came to people his *vedute* it seems that he would extract figures from this collection to try them for size among the ruins, shifting them round the page to find the right position. Such a practice would account for the odd shapes into which some of the drawings are cut. At first it seems anomalous that no such sketches correspond exactly to any of the figures in the *vedute,* but none of them would. The figure sketches which survive are either too large for his etchings or else they are rejects which were never in the end copied onto a plate. If they had been, the drawing would have been spoiled in the transfer and would have been thrown away.

When he had worked out the design in every detail and had prepared a final large drawing the size of the etching, he carefully spread a coating of hard varnish with a wax and linseed oil base onto a sheet of copper and then darkened it with candle smoke. Onto this surface he pricked or traced the design from his drawing.[4] Then the complex process began. With a sharp point of his etching needle he

346. Drawing of a woman

347. Figure studies

scraped the outline of his drawing through the smoked varnish to the copper below. When the whole of the design had been redrawn as it were in negative form the plate was ready for the *acqua forte*. This acid eats into the copper where the surface has been exposed while the varnish preserves the remaining area unbitten. The immersion in the acid bath is the most crucial part of the operation because the intensity of the blacks in the print depends on the depth to which the line has been bitten and this in turn depends on the number of bitings to which the plate is exposed. Piranesi used to dab the plate with varnish on the end of a paint brush to protect those areas which were to be lightly bitten, painting the surface like an artist touching in the highlights of a picture. 'He applied the acid with a care and patience with which it was hard to credit him', says Legrand, 'covering the parts to be shaded one by one and repeating the process ten or twelve times in some plates. "Gently does it," he used to say, "I'm making three thousand drawings in one go."' When the plate had been cleaned, it was ready to be inked for the pulling of the first proof. It was a matter of experiment in the early years and some plates, like the *Fall of Phaethon,* were failures, but he soon acquired mastery of the technique so that he could visualise the effects he wanted and knew precisely how to create them.

Etching is a very exacting art which calls for great powers of concentration and considerable technical skill. It is a discipline to which Piranesi's reckless and violent temperament and headlong speed of composition can only have been accommodated by the exercise of great self restraint, and yet he knew by instinct that this was the medium in which he could best express his emotional response to antiquity. Only through etching was it possible to create those effects of light and darkness, the subtle gradations of scale and texture by means of which he could transform an accurate photographic record of the Colosseum or Hadrian's villa or the temples of Paestum into an intense and personal vision of the past.

Black suited his melancholy so well that he never felt the need to use colour in his views.[5] Indeed, in an accurate oil painting it would not have been possible to show all the effects which can legitimately be brought out in an etching. The glare of the Italian sun creates shadows which obscure all the details of the masonry in the recesses and make it hard to differentiate between stone and brickwork. In fact, on several occasions I have first been made aware of decoration or changes in material in his plate and have only observed them for myself on a subsequent visit. He is a most unusual artist in that, having taken to etching at an early stage of his career, he never branched out into other media. Partly this was a money matter. He started etching as a means of earning a living on his return to Rome in 1745 and it was not for some time that his financial situation was sufficiently

348. Drawing of the tomb of Cecilia Metella

297

349. Drawing of a tomb near Tivoli

secure to enable him to diversify into other areas. Subsequently, however, his energies were diverted into quite different fields, archaeology, architecture and antique dealing. Etching was also a more profitable use of his time. He could produce very rapidly a plate of the Forum which would be a continuing and certain source of revenue for many years. "It is as easy for me to do an etching as it is for you to give a blessing", he told the Pope. A detailed drawing of the same scene would have taken almost as long and could only have been a one-off sale.

His early works, the *Prima Parte* and the first small *vedute* for Amidei, were conventional in technique. The contrast between them and the *Grotteschi* and the *Carceri* is startlingly abrupt. The sudden sense of freedom seems to have developed after his stay with Tiepolo, although even the *Varj Capriccj* of the Venetian master are restrained by comparison, and there is nothing in the work of his influential seventeenth-century predecessors like Callot or Rosa or Castiglione to suggest the dash and bravura with which the young man started to tackle the plate soon after his return to Rome. He formed an entirely personal calligraphy quite unlike the linear conventions of the Venetian *vedutisti* or the curved flecks with which Tiepolo built up his etchings. It is a medley of free hatching and long zig-zag strokes, of peppered dots and loose round curls scattered over the plate with an orderly but impressionistic vigour to give shading or texture. At first he worked over the lines of his drawings with a needle of a single thickness and the only other aid he employed was a little comb-like tool for tracing furrows of equal parallel lines to produce cloud effects and some forms of shading. In this he was following Canaletto, Tiepolo and his first instructor, Vasi, all of whom used a single fine-pointed needle in their etchings, differences of shading and intensity being achieved by cross-hatching or a closer application of the lines. In his later plates, however, Piranesi employed a variety of needles of differing thickness. He used a fine point lightly to scratch the plate for more delicate details and for the backgrounds, hardly breaking the surface of the varnish, but when he wanted to introduce darker shadows, to add emphasis to a boulder or to break up the foreground he took much thicker instruments to gouge deep claw marks onto the plate and used repeated bitings of the acid. This variety of texture and the mannerisms of this calligraphy produce fascinatingly varied compositions, enlargements of which create some startling abstract patterns; the striations of his columns can take on the flickering complexity of a Bridget Riley.

His plates broke new ground in composition and style as well as in etching

350. Detail of Temple of Saturn, *Vedute di Roma* (323)

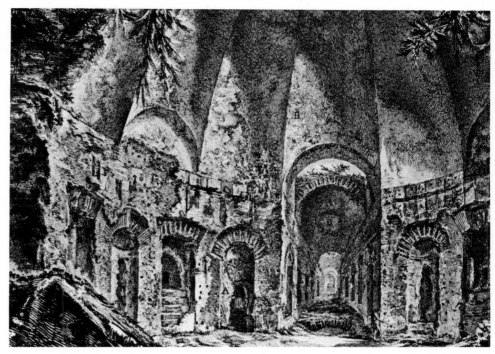

351. Detail of Canopus, Hadrian's Villa, *Vedute di Roma* (*239*)

352. Detail of Cistern near Castel Gandolfo, *Antichità d'Albano* (*204*)

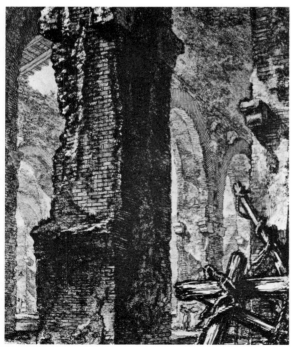

technique. For a start they were far larger than the conventional *veduta* (although Canaletto's nephew Bellotto, produced a series of views of comparable dimensions in the 1760s and Vasi later produced some very large Roman panoramas). I think that he may have chosen this scale in the first place because he needed to produce something which would at once distinguish his work from the views on which Vasi was working in his *Magnificenze*. Besides, the very much larger size of his *Vedute* enabled him to go into greater architectural and archaeological detail so that his plates could be of use to architects and scholars as well as being tourist souvenirs. The composition of his views was also novel. He chose his view point with a stage designer's eye. It was often necessary to sketch the buildings of Rome at an angle because the narrowness of the streets rarely permitted direct frontal views but, even where it was possible, he generally avoided drawing a façade full on. It is paradoxical that whereas at first, when he was fresh from his apprenticeship in stage design, his views were evenly lit under a clear bright sky, as time went by, his light effects became increasingly theatrical, one side of the building in sunlight, the other in heavy shade. The picturesque and gloomy decay of his ivy-covered towers is in the direct tradition of the seventeenth-century master, Salvator Rosa, whose fronds of trailing ivy and lightening splintered pines were the very essence of the eighteenth century's concept of the sublime. This is the source from which the atmospherics and incidental furniture of Piranesi's later etchings are derived. It is a view far removed from the alternative convention of classical topography, the broad, calm expanses of Claude or Van Bloemen and Pannini's picturesque but undramatic stage arrangements of ruins. It is equally remote from the placid summer lagoons which Canaletto had etched in the year of Piranesi's return from Venice and from the exactly ruled and tedious façades depicted by Giovanni Battista Falda and by Gian Giacomo and Domenico de'Rossi, the predecessors of Vasi. Piranesi's etchings of Rome put all the view painters out of business. Whereas there is an abundance of little souvenir canvases of Venice and Naples, there are comparatively few such paintings of Rome, those that there are often being oil copies of Piranesi etchings.[6]

If he had restricted himself to views of Renaissance and Baroque Rome, he would be remembered as an exceptional *vedutista* with an eye for the picturesque. It was his vision of antiquity that elevated him to the front rank. The essence of this vision was his ability to understand the structures and the architectural qualities of the shattered fragments of Roman grandeur, and then, when he had clinically studied the anatomy of the ruins, like Stubbs examining the skeletons

of the animals which he painted, his ability to reclothe the bare bones with a cloak of romanticism and to breathe into them the vigour of his own enthusiastic imagination. "I need to produce ideas on a grand scale," he said. "I think that if someone asked me to design a new universe, I'd be mad enough to undertake the task." And yet this grandiose and romantic vision of antiquity came half a century before its time; it was alien to the orderly mind of the neo-classical connoisseur who recognised Piranesi's abilities but rather wished that the 'great but excentric genius' had given a more conventional and undramatised view of the ruins: cascading creepers and begging derelicts were appropriate to the savage mountains of Rosa but not to the familiar architectural fragments lying around the Forum.[7]

His style was far too individual to form the basis of any school. Only Francesco was bold enough to try to imitate his father on occasions but his *Destruction of Pompeii,* aping the style of the *Carceri,* is coarse and muddled and his *Vedute* are pedestrian by comparison. There was no one able to succeed the man to whom even his critics gave the title of 'the Rembrandt of the ancient ruins'.[8]

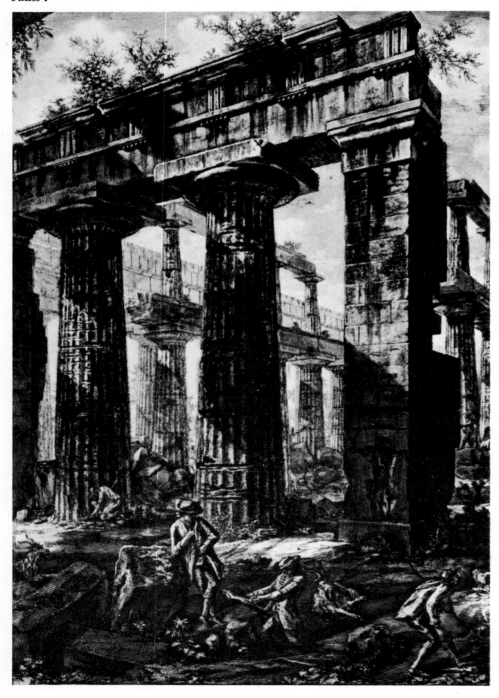

353. Detail of *Pesto,* Plate XII rejected first state *(301)*

Notes to the Text

Chapter one

1. Sources. The principal source for Piranesi's life is the biography by J. G. Legrand (1743–1807). The manuscript in the Bibliothèque Nationale in Paris, some forty-five pages long, is inaccurate in several particulars but contains a great deal of information based on conversations with Piranesi's children about a quarter of a century after their father's death and with Legrand's brother-in-law, C. L. Clérisseau, who was one of Piranesi's artist friends in Rome. The manuscript is reprinted both in G. Morazzoni's *G. B. Piranesi Notizie biographiche* (undated but published in Milan in 1921, which also quotes from other contemporary sources such as parish registers) and in *Nouvelles de l'estampe*, 1969, 5, p. 191 ff. Most unacknowledged quotations in the preceding pages are from Legrand. J. Kennedy (d. 1859), a barrister, was M.P. for Tiverton 1832–5 and wrote a book entitled *England and Venice Compared*. His account of Piranesi in *Library of the Fine Arts* is short but accurate. The discovery in a country house library of Francesco Piranesi's manuscript which Kennedy owned is an exciting improbability to be prayed for. G. L. Bianconi (1717–81) was a doctor by profession and spent some years as court physician to Augustus III of Saxony in Dresden where he first met Winckelmann. He returned to Italy in 1764 and contributed many articles to *Antologia Romana* including obituaries of Piranesi and of Mengs to whom he is much more sympathetic. Being a friend of Winckelmann he disapproved of Piranesi's eccentricity and his deviations from the correct canons of neo-classical taste; he therefore exaggerates Piranesi's bizarre characteristics and has only reluctant praise for his merits. The only other account based on contemporary sources is P. Biagi's *Sull'incisione e sul Piranesi*, 1820. It contains one or two pieces of authentic Venetian gossip and quotes an interesting letter from Piranesi to his sister. Unfortunately when Piranesi's sons fled to Paris in 1799 their father's correspondence and business papers were removed to Naples. Although they may have recovered some property, their own collection was later dispersed in France. It is possible that something may emerge from Naples one day.

We get more insights from British and French visitors to Rome than we do from Italians. This is partly the result of Piranesi's predilection for the English and French and partly because there does not appear to be any Italian equivalent of the British Historical Manuscript Commission which might publish the archives of the great Italian families. In any case tourists are more likely to record their observations of distinguished citizens whom they have met than are the natives. A prophet is not without honour. . . .

Of modern accounts, A. Samuel's *Piranesi,* published in London in 1910, was the first. It was a start but often inaccurate.

This was followed by Henri Focillon's *Giovanni Battista Piranesi,* which came out in Paris in 1918, an exceptionally sympathetic and attractive biography, naturally giving prominence to Piranesi's French associations. Focillon also produced a complete catalogue of the etchings. A. Hind included some not wholly accurate notes with his fundamental catalogue of the large *Vedute* in 1922. I have usually referred to plates by their numbers in Focillon (F.) and also, in the case of the large *Vedute,* by their numbers in Hind (H.). I have referred to the *Carceri* and Paestum plates by the numbers which Piranesi himself gave. More recently there was a good brief biography by A. Hyatt Mayor, published in U.S.A. in 1952, and an excellent account of Piranesi's drawings by Hylton Thomas, *The drawings of Giovanni Battista Piranesi,* 1954.

An Italian translation of Focillon's biography and catalogue, produced by Maurizio Calvesi and Augusta Monferini in 1966, contains an exhaustive bibliography up to that date. Peter Murray's lecture *Piranesi and the Grandeur of Ancient Rome* was published in 1971 and many articles have appeared subsequently. I have referred in these notes to most of the ones which I have seen. I have generally avoided the technical field of the numerous different states of Piranesi's etchings. The catalogues of Messrs. Craddock and Barnard and P. & D. Colnaghi & Co. provide a great deal of information on this subject and there is a compendious article by A. Robison in *Nouvelles de l'estampe*, 1970, 4, pp. 180–98.

2. Mogliano. His birthplace is given on the base of the bust of Piranesi by Antonio d'Este which Antonio Canova, a fellow Venetian, placed in the Pantheon. It is inscribed GIAMBATTISTA PIRANESI ARCHITETTO INCISORE DA MOJANO NEL TERRITORIO DI MESTRE NATO M.DCC.XX MORTO M.DCC.L.XXVIII and ANTONIUS D'ESTE VENETUS FECIT ANTONIUS CANOVA DE PECUNIA SUA P.C. AN. M.DCCC.XVI. The bust was moved from the Pantheon to the Capitoline Museum four years later. Mayor, *op. cit.,* suggests that Piranesi was born at Mogliano while his father was supervising building work there. It would be amusing to link Piranesi with Joseph Smith, but the British consul does not seem to have taken his villa at Mogliano until 1730.

3. Angelo Piranesi. Anzolo Piranese and Giacomo Bragato are both referred to as *maestro* in receipts for the building of Domenico Rossi's Palazzo Corner della Regina on the Grand Canal in 1728, E. Basi, *Architettura del sei e sette cento a Venezia,* 1962, p. 226.

4. Matteo Lucchesi (1705–76). His aristocratic connections are mentioned by G. Fontana, *Cento Palazzi fra i più celebri di Venezia,* 1865, p. 379. His architectural work comprised the Saletta della Musica in the Ospedaletto and S. Giovanni Nuovo in Venice and the Villa Polcenigo and the Monte di Pietà at S. Daniele on the *terra firma.* See D. Lewis, *Bolletino dei Musei Civici Veneziani,* ii, 1967, pp. 17–48 and C. Furlan, *Arte Veneta,* xxv, 1971, p. 292 ff.

5. The suggested connection between the Murazzi and Piranesi's archaeological work is again Mayor's. For Goethe's description see *Italian Journey,* translated by W. H. Auden and Elizabeth Mayer, Penguin Classics, 1970, p. 99.

6. His attack on Maffei published in 1730 is entitled *Riflessioni sulla pretesa scoperta del sopraornato Toscano espostaci dall'autore dell'opera: Degli anfiteatri.* Maffei, however, also made claims for the Etruscans. Biagi, *op. cit.,* says that both Lucchesi and his nephew were '*di un genio stravagante*'.

7. Giovanni Antonio Scalfarotto (c. 1690–1764). S. Simeone, which was consciously built, c. 1718, as a counterpoint to the Salute at the other end of the Grand Canal, was immediately popular to judge from the number of times it appears in tourist *vedute* of the eighteenth century. Scalfarotto was also employed on the restoration of the interior of S. Rocco in 1725.

8. Carlo Zucchi (1682–1767). He etched *vedute* for Domenico Lovisa's *Meraviglie della città di Venezia* or *Il gran teatro,* 1721. Membership of the guild of 1719 was to be hereditary although new members could be accepted if they had served a suitable period of apprenticeship to a *maestro* and had given proof of their technical ability in front of four union members, see R. Gallo, *L'incisione nel' 700 a Venezia e a Bassano,* 1941. The list of union members is given by Tommaso Temanza, the eighteenth-century art historian who was, incidentally, Scalfarotto's nephew; the list includes Piranesi's future companion in Rome, Felice Polanzani, then working as an engraver of letters, and Giovanni Antonio Faldoni '*nelle carceri*'.

9. Descriptions of Venice. Travel books on Italy were as popular in the eighteenth century as they are today. My small selection includes:
Charles de Brosses, *Selections from the letters of de Brosses,* translated by Lord Ronald Sutherland Gower, 1897.
Jean Marie Roland de la Platière, *Lettres écrites de Suisse, d'Italie, de Sicile et de Malthe . . . en 1776, 1777 et 1778,* published anonymously 1780.
Samuel Sharp, *Letters from Italy . . . in the years 1765 and 1766,* 1767.
Giuseppe Baretti, *An Account of the Manners and Customs of Italy,* 1768.
Tobias Smollett, *Travels through France and Italy,* 1766.
John Moore, *A view of Society and Manners in Italy,* 1781.
Lady Anne Miller, *Letters from Italy . . . by an English Woman 1770–71,* published anonymously 1776.
Mrs. Piozzi, *Glimpses of Italian Society in the Eighteenth Century,* 1892.

John Northall, *Travels through Italy,* 1766.
William Beckford, *Italy; with sketches of Spain and Portugal,* 1834. For the segregation of tourists from the natives see F. Haskell, *Patrons and Painters,* p. 245, a fascinating book which unfortunately does not cover eighteenth-century Rome in Piranesi's time. Venetian courtesans were not what they had been, complained John Moore, 'the best of the business, as is said, being now carried on for mere pleasure by people who do not avow themselves of the profession'.

For genealogical claims see the egregious passage in the first edition of Burke's *Commoners,* ii, 1836, under the family of M'Carty of Carrignavar. When Napoleon asked the Principe Massimo if it was true that he was descended from Quintus Fabius Maximus Cunctator, he was answered, "C'est un bruit qui court depuis plus de deux mille ans dans notre famille." Mrs. Piozzi also believed such claims and said of the Venetian nobility that 'the true *amor patriae* never glowed more warmly in old Roman bosoms than in theirs, who draw, as many families here do, their pedigree from the consuls of the commonwealth'.

The quotation about sumptuous edifices is from Isaac Ware's translation of Palladio's *Four books of Architecture.*

10. Antonio Corradini (1668–1752). After working as official sculptor to the Venetian republic and for the Hapsburgs in Vienna, he came to Rome in 1740. During his Roman stay he did decoration for a chapel in Lisbon designed by Vanvitelli and Salvi. In about 1744 he moved to Naples where he continued to work until his death in 1752, executing his best known work in the Capella Sansevero. He specialised in curious tours de force of veiled figures wrapped in clinging drapery, see A. Riccoboni, *Arte Veneta,* vi, 1952, p. 151 ff.

11. The Valeriani. Bianconi says that Piranesi studied under the Valeriani in Rome. They were certainly working in the city in 1738 when they are recorded as living in Strada Paolina, now the Via del Babuino (*Studi Romani,* April–June, 1972, p. 228 ff.) The brothers worked at the Stupinigi 1731–1733. Giuseppe etched views for *Il Gran Teatro* and contributed to the series of imaginary tombs commissioned by Owen McSwiny in Venice in the 1720s. He went out to St. Petersburg in 1742 on a three-year contract as *primo ingegnere, pittore teatrale e inventore di macchine* to the Empress Elizabeth and continued his architectural and theatrical career in Russia until his death in 1762.

12. Giuseppe Vasi (1710–82). For Vasi's work see A. Petrucci, *Le Magnificenze di Roma di Giuseppe Vasi,* 1949. Piranesi may have become sufficiently reconciled to Vasi to collaborate on his huge *Prospetto della alma Città di Roma visto del Monte Gianicolo,* 1765, see E. Bier, 'Vasi – Piranesi', *Maso Finiguerra,* 1938, iii, pp. 48–51, but this seems unlikely and the enormous preliminary drawing for this view currently on loan to the R.I.B.A. library in London owes nothing to Piranesi. Vasi was sent 460 *scudi* by the King of France for this plate even though it was dedicated to his Spanish cousin.

13. Felice Polanzani (1700–c. 1783). He later provided the portrait which served as frontispiece for Piranesi's *Opere Varie*. He produced a number of engravings including twenty-two plates of the life of the Virgin after Poussin and others.

14. Lady Anne Miller in her *Letters from Italy 1770–1771* complains of the prevalence of butcher's meat. 'The Corso lies along the main streets; where the cattle being frequently killed at the doors of the butchers' shops, during the time of airing, renders this recreation odious to me. The living oxen are witness to the murders of their innocent companions; their bellowing, and this barbarous custom shocked me . . .'

15. Nicola Salvi (1697–1751). He was responsible for the additions to Bernini's palazzo Chigi-Odescalchi and for the high altars of S. Eustachio and of S. Lorenzo in Damaso. **Luigi Vanvitelli (1700–1773).** Son of the Dutch artist Gaspar van Wittel, he was born in Naples and became Salvi's assistant in Rome. He executed various commissions throughout Italy before returning to Naples. Piranesi cannot have made a great impression on Vanvitelli because he bought no more of his works after the *Prima Parte* until he wrote to Piranesi in 1772 asking for a set of unbound copies of the archaeological works, R. Mormone, *Bolletino di storia dell'arte*, 1952, 2, pp. 89–92.

16. Bianconi says that Piranesi blamed Vasi for his lack of success with *Prima Parte*, hence his attack. Not for the first time he was disappointed by his patron's financial response to a dedication and in later editions it was cancelled. He was over-optimistic if he was hoping for large architectural commissions because no one had the money to build. The Lateran façade and the Trevi fountain were only completed out of the proceeds of a lottery.

17. Luca Giordano (1632–1705). A Neapolitan by origin, he travelled all over Italy working in Rome, Florence, Venice and Bergamo. He was known as 'Fa Presto' because of the remarkable speed at which he covered a ceiling. Piranesi would have known from his youth his three altar pieces commissioned in 1685 for the Salute in Venice.

Francesco Solimena (1657–1747). Giordano's pupil and himself the master of many eighteenth-century artists who studied under him at Naples, he produced acres of tumultuous biblical frescoes in the South.

18. Legrand says Carlo Maderna which is quite wrong because the architect of that name died in 1629. Paderni, who was in charge of the excavations had a poor reputation as an archaeologist among contemporary scholars, see W. Leppmann, *Winckelmann*, p. 169.

19. The Roman money system in the eighteenth century was:

10 *baiocchi*	= 1 *paolo*		= 6d.	= 2½p.
10 *paoli*	= 1 *scudo*		= 5s.	= 25p.
2 *scudi*	= 1 *zecchino*	= 10s.	= 50p.	

I have throughout converted Italian currency into British money at the exchange rate prevalent in the eighteenth century

and then converted the British £.s.d. into decimals. I have not attempted to give the modern equivalent values adjusted for changes in the purchasing power of the £. The *baiocco* was a copper coin, the *paolo* silver and the *zecchino* gold.

20. Giovanni Gaetano Bottari (1689–1775). He moved from Florence to Rome in 1730 on the election of Pope Clement XII and lived in the Palazzo Corsini at the foot of the Janiculum. He was the friend and correspondent of international connoisseurs like Algarotti and Mariette and ultimately became the chief Vatican Librarian. He wrote a number of scholarly works, *Sculture e pitture sagre estratte dai cimiterj dei Romani*, 1737–54, and *Del Museo Capitolino*, 1741–55. Piranesi's letter, which is preserved in the Corsini library, is given in full, F. Cerroti, *Lettere . . . della Corsiniana*, 1860, p. 51.

21. Bianconi mentions two trips back to Venice, but it is more likely that there was only one. It would not be incongruous for Piranesi to have painted furniture also, although the furniture makers' trades union tended to object. Jacopo Amigoni designed furniture and there are painted doors in Venice attributed to Tiepolo.

22. Giambattista Tiepolo (1696–1770). He was the unquestioned first genius of Italian painting until fashion changed with the ascendancy of Mengs and neo-classicism.

The dating of Tiepolo's etchings is a contentious subject, see H. Diane Russell's Catalogue to the Washington Exhibition, *Rare etchings of G. B. and G. D. Tiepolo*, 1972 and G. Knox, 'G. B. Tiepolo: the Dating of the *Scherzi di Fantasia* and the *Capricci*', *Burlington Magazine*, cxiv, 1972, pp. 837–42. Tiepolo's Roman history scenes are described by F. Haskell, *op. cit.*, p. 353.

23. Luca Carlevaris (1663–1730). He was a landscape artist in the tradition of Salvator Rosa as well as a painter of scenes of Venetian pageantry such as the arrival of the British ambassador, Lord Manchester, in 1707. He is said to have taught **Giovanni Antonio Canaletto (1697–1768)**, the most famous of Italian *vedutisti* who, like Piranesi, was trained in stage design and went early to Rome. In 1746 he left Venice for a visit to England which was prolonged but not wholly successful. **Antonio Visentini (1688–1782)** was an architect and an artist as well as an etcher. He was later to disapprove of Piranesi's architectural style. **Michele Marieschi (1710–43)** worked in Germany before returning to Venice where he was a successful view painter. **Gian Francesco Costa (1711–72)** produced some charming views of the villas on the *terra firma*, *Delizie del fiume Brenta*. He wrote some little booklets on architecture and, benefitting from the instruction of Mengozzi-Colonna, became theatrical designer to the King of Poland in 1765.

24. Joseph Wagner (c. 1706–1786). He was born at Thalendorf on Lake Constance. After spending some years in France and in London, he arrived in Venice in 1739 and opened a print shop in the market of S. Giuliano. When he applied for exclusive sales rights for the productions of his own press ten years later,

the Riformatori dello Studio di Padova were so impressed by his efforts to improve the standard of printing in Venice that they gave him a fifteen-year copyright. His pupils included Bartolozzi who later worked both for the Adams and for Piranesi, Berardi who did some fine etchings of scenes by Canaletto, and many others, see R. Gallo, *op. cit.,* p. 24 ff. Piranesi took 500 Venetian ducats' worth of stock from Wagner.

25. Piranesi's words to his father were, "Chi ha testa, cappello non gli manca."

Chapter two

1. Paolo Anesi (c. 1690–1765) worked on the Villa Albani frescoes and did landscapes in the manner of Pannini. Francesco Zuccarelli was one of his pupils. He had already produced a little set of twelve views of Rome in 1725; some of these and the frontispiece were altered and reused for the *Varie Vedute* to which Piranesi later contributed, see Craddock and Barnard, Catalogue 122. **Philothée-François Duflos (1710–1746)** won the Prix de Rome in 1729 and stayed on in Rome after leaving the French Academy but had to leave on account of ill health in 1745, and died the following year. For Le Geay, another student at the French Academy, see below, p. 305. **Jérôme Charles Bellicard (1726-1786)** won the Prix de Rome in 1747. His miniature illustrations to a little work on the antiquities of Herculaneum coincided with Piranesi's first archaeological work and his architectural plates to Charles-Antoine Jombert's *Méthode pour apprendre le dessin,* 1784, are influenced by Piranesi's *Parere* designs. Later he took to gambling and died in poverty.

2. If the earlier dating were to be allowed I would add one or two of the unsigned views in Amidei's collection to Piranesi's work (the Palazzo Borghese, the Ripetta and the Archigymnasio). I think that it is unlikely that he allowed young artists of the French Academy to borrow his name for their efforts as has been suggested (L. Donati, *Maso Finiguerra,* v, 1940, pp. 261–270), although the uncertain signature on some prints could be an argument for an early dating. There are three little drawings by Piranesi now in the Biblioteca Ambrosiana in Milan which are very much in the manner of Francesco Guardi; two of them (the temple of Minerva Medica and the Baths of Caracalla) he etched himself and the third formed the basis for a plate done by Bellicard in 1750. These drawings must have been done after his return from Venice. The 'furry' technique is also used in some of the early large *Vedute,* e.g. H.17, 18, 33–35, 51 and 56. For a list of the guide books illustrated by Piranesi's views, see the Catalogue of the Piranesi exhibition at P. & D. Colnaghi & Co., December, 1973.

3. For the Aosta arch see M. McCarthy, 'Sir Roger Newdigate and Piranesi', *Burlington Magazine,* cxiv, 1972, pp. 466–72. Francesco later added a view of the temple of Minerva Medica to the series.

4. The solecisms include Diano for Giano, Metela for Metella and Sipioni for Scipioni. The mis-spellings of proper names in the *Carceri* and the misquotation of Terence in one of the

designs for *Parere su l'architettura* reinforce the point. Legrand says that 'his favourite books to which he listened while working were Livy, Plutarch, Pausanias, Pliny, Aulus Gellius, Pirro Ligorio, Nardini and the notes of the sculptor Flaminio Vacca'. I feel that he must have had translations of the ancient authors read to him.

5. He also included in *Archi trionfali* two views from drawings by the seventeenth-century Frenchman, Isaac Silvestre, which are exact and painstaking in the manner of his small *vedute* for Amidei and are much akin to the work of Jacques Callot. They must have been done while studying with his friends from the French Academy several years earlier. There are drawings by Piranesi of other scenes in Italy (Fondi, Ravenna and Spoleto) all of which could have been made on his journey home, (Hylton Thomas, *op. cit.,* p. 20).

6. Giambattista Nolli (1692-1756) and his son Carlo published a large-scale map as well as a smaller version, (A. P. Frutaz, *Le Piante di Roma,* i, 1962, p. 236 and iii, p. 419). Legrand says that Piranesi gained his intimate knowledge of Rome through accompanying Nolli when he was surveying the city. An unsigned etching of views of the Tiber bridges illustrating Nolli's map of the river is also attributed to Piranesi (L. Donati, *Maso Finiguerra,* iv, 1939, pp. 121–3).

7. Descriptions of Rome may be culled from the same sources as the descriptions of Venice. I should add, however:
Ridolfino Venuti, *Accurata e succinta descrizione topografica e istorica di Roma moderna,* 1766.
Giovanni Pietro Rossini, *Il Mercurio Errante,* 1693.
 These last two are sometimes illustrated by Piranesi's small *vedute.* Piranesi's two series of *Vedute,* Vasi's *Magnificenze* and his enormous view from the Janiculum provide a complete illustrated survey of the city. The emptiness of large areas within the walls can be seen from Piranesi's plates of the Baths of Caracalla and of Titus (H.76 and 123) and the desolation beyond from the views of St. Peter's and S. Giovanni (H.120 and 122).
 The seven great basilicas were the churches which, since medieval times, have comprised the pilgrims' essential tour: S. Pietro in Vaticano, S. Giovanni in Laterano, S. Maria Maggiore, S. Croce in Gerusalemme, S. Paolo fuori le Mura, S. Lorenzo fuori le Mura and S. Sebastiano.
 The herb seller's remark on the Queen of Naples is recorded by Mrs. Piozzi, *op. cit.,* but a similar story is told in Count Stolberg's *Travels.*

8. The large *Vedute* are numbered up to 135 but the first two plates consist of the title page and a *capriccio* of antiquities, so there are only 133 views.

9. The dating of these plates is admirably dealt with by A. Robison, *Princeton University Library Chronicle,* xxxi, 3, Spring 1970. Hind in the introduction to his catalogue of the *Vedute* mistakenly accepts the dating given by Piranesi's son Francesco in the list of his father's work published in 1792. Several of these dates are manifestly impossible and it is clear from the post-

dating of plates included in the *Magnificenze,* published in 1751, that Francesco had no idea of the exact years in which his father had issued the early *Vedute* prior to the publication of the first catalogue in 1761. The 59 plates listed in the 1761 catalogue are grouped not in date order as Francesco wrongly supposed but by subject matter, starting with the seven pilgrimage basilicas, then giving the sights of modern Rome and concluding with the antiquities.

The nineteen earliest *Vedute* are H.1–4, 7–9, 14–17, 19, 35, 38, 40, 50–2 and 56. These were all issued by about 1748. By the time of the *Magnificenze* three years later, fifteen more had been added, (H.5, 18, 28, 29, 33, 37, 41, 43, 45, 46, 49, 53, 54, 58 and 59) and H.32 and 34 came shortly thereafter. H.6, 10–13, 20–7, 30, 31, 36, 39, 42, 44, 47, 48, 55 and 57 were issued prior to the first catalogue in 1761. Thereafter the dates of new plates can be gauged more accurately both by reference to the last plate issued when the catalogue is updated to take account of the publication of a new book and to Francesco's catalogue of 1792 in respect of plates issued at a time when he had started to take an active part in the business.

10. Via del Boschetto runs off the modern Via Nazionale, but it has been substantially rebuilt since Piranesi's day. The anecdote is from Legrand.

11. Piranesi in these first *Vedute* only allowed himself some distortions in his view of the interior of St. Peter's (H.4) where he sketched the nave from the entrance door but moved half-way down towards the high altar so as to be able to include the piers of the dome and he also clarified the detail of the side aisles by a slight shift of position. Lady Anne Miller, *op. cit.,* objected to Piranesi's minute accuracy. 'He is so ridiculously exact in trifles, as to have injured the fine proportions of the columns of the portico to the Pantheon, by inserting, in his gravings, the papers stuck on them, such as advertisements, etc. *(320).* Many other silly particulars of this nature have confused his designs; yet they are esteemed the best here; and we have made an ample collection of the most valuable of them.'

12. James Northall, *op. cit.,* warned that the customs officials at the Dogana in the Hadrianeum 'tumble the things about, under a pretence of searching to the bottom for contraband goods, but a small present prevents any insolence of this kind'. He also advised visitors to beware of the breed of bear leaders or *ciceroni* 'who offer themselves to strangers of quality, to serve them as guides in surveying the curiosities of the place. Too many of our young English noblemen have been deceived and imposed upon by these persons.'

John Moore explained what a tourist should expect. (His party, which included the Duke of Hamilton, had the knowledgeable James Byres as *cicerone*.) 'What is generally called a regular course with an Antiquary generally takes up about six weeks; employing three hours a day, you may, in that time, visit all the churches, palaces, villas and ruins worth seeing in or near Rome – but ... if you do not visit the most interesting again, your labour will be in vain through confusion however distinctly everything may have been explained by the Antiquarian.'

Eighteenth-century visitors made much longer visits than our fortnight package tours. A continental trip might take two or three years, at least one of which was mandatorily spent in Italy. There was in fact a regular seasonal programme for the visitor to observe: Easter in Rome, then south to Naples, the autumn in Venice and then, by way of Florence, down to Rome again for Christmas. For the whole subject of the grand tour see, for instance, C. Hibbert, *The Grand Tour,* 1969.

Chapter three

1. The original plates were the title page, *Grand Sculpture Gallery, Dark Prison, Ancient Mausoleum, Ruins of a Tomb, Magnificent Bridge, Room for the ancient Romans, Ancient Capitol, Group of Stairs, View of a Royal Court, Vestibule of an Ancient Temple, Ancient Forum* and *Doric Hall.* The plates added in the second edition were the *Group of Columns, Ruins of Ancient Buildings, Ancient Altar, Ancient Temple* and *Burial Chamber;* the *Doric Hall* was omitted. There is an incomplete copy of the very rare first edition lacking four of the plates in the Corsini library in Rome. Another partial copy is in the Avery Architectural Library, Columbia University, New York.

2. The titles in the second edition were changed from those indexed in the first and Piranesi added a fuller descriptive text below the plates. In the title page *(72)* the E of Giobbe has not been erased from the stone on which the new title is inscribed '*The first part of architecture and perspective drawn and etched by Giambatista Piranesi, architect of Venice, among the Arcadians Salcindio Tiseio*'. At a later date, probably in the late 1760s, Piranesi added some further small imaginary views to the *Opere Varie,* including altered versions of five of the small plates from his *Lettere di giustificazione* of 1757.

3. Ferdinando Galli Bibiena (1657–1743). For the work of this artist and his family see A. Hyatt Mayor, *The Bibiena Family,* 1945, and W. Jeudwine, *Stage Designs,* 1968. His son Giuseppe was in Venice in 1742. The descriptions of some of the stage sets of Giovanni Carlo Bibiena quoted by Jeudwine, *op. cit.,* p. 27, read just like Piranesi's descriptive texts in the *Prima Parte.*

4. Filippo Juvarra (1678–1736). My favourite architect without question, he was the last of the great universal artists of princely stature like Bernini and Rubens. His churches and palaces in Turin are amongst the grandest and most imaginative in Italy. For his stage designs see M. Viale Ferrero, *Filippo Juvarra,* 1970 and the catalogue to *Mostra del Barocco Piemontese,* 1963. The Valeriani are the obvious link with Piranesi, but it could be Vasi, who etched some Juvarran designs for a royal tomb in 1739. Piranesi refers to Juvarra in the introduction to *Prima Parte* as 'the great Juvarra'.

5. Jean Laurent Le Geay (c. 1710–c. 1786). For the work of this intriguing character see J. Harris, 'Le Geay, Piranesi and International Neo-classicism 1740–50', *Essays presented to Rudolf Wittkower,* 1967, i, p. 189 ff., and the catalogue of the London exhibition, *The Age of Neo-classicism,* 1972, p. 585.

Some of Le Geay's etchings of urns are very close to those in J. B. Fischer von Erlach's book; similarities with Piranesi's work may thus be purely coincidental. I agree, however, with Harris' dating of Le Geay's etchings of vases, tombs, etc. which could have been executed in about 1742 and then re-dated some 25 years later when they were first published. (There are odd spacings round the dates on the title pages of these works and the box in which they are inset looks like a reworking; besides, it is otherwise hard to explain the Italian titles.) A sheet of drawings from Piranesi's early period is preserved in New York in which he sketches many of the principal ancient monuments from the German encyclopaedia; it is interesting that he omits the oriental pagodas and hanging bridges, the minarets of Constantinople and the monoliths of Stonehenge to skip straight to the Egyptian vases at the end of the book. An English edition of Fischer von Erlach's work appeared in 1730. For the drawing by Piranesi, see F. Stampfle, 'An unknown group of drawings by Giovanni Battista Piranesi', *The Art Bulletin*, 1948, pp. 122–141. This article discusses the large and very interesting collection of Piranesi drawings in the Pierpont Morgan library. For the list of the possessions confiscated from Piranesi's sons, see p. 320.

6. The French Academy was founded by Colbert in 1666. It was moved to the Palazzo Mancini under Vleughels, the predecessor of de Troy and brother-in-law of Pannini.

The Pierpont Morgan library has a careful measured drawing of the Palazzo Farnese which was probably done on one of the French Academy's instructional sketching parties, see F. Stampfle, *op. cit.*

For Piranesi's French friends see J. Harris, *op. cit.*, R. P. Wunder, 'A forgotten French festival in Rome', *Apollo*, lxxxv, 1967, p. 354 ff. (which explains the background to the ceremonies of the Chinea), *The Age of Neo-classicism, op. cit.*, and Wend Graf Kalnein and M. Levey, *Art and Architecture of the Eighteenth Century in France*, 1972, *passim*.

Claude-Joseph Vernet (1714–1789) went to Rome at the age of 20 where he settled, marrying an Irish wife and enjoying English patronage. In 1753 he returned to France where his decorative Claudian landscapes were deservedly popular. **Charles Michel Ange Challe (1718–1778)** won the Prix de Rome in 1741 and stayed in Italy until 1749. His decorative schemes for festivals in Rome were a prelude to similar work in France. Jeudwine *(op. cit.)* illustrates some of his Piranesian drawings in the R.I.B.A. collection. **Ennemond Alexandre Petitot (1727–1801)** who became architect to the Bourbons of Parma, is the subject of a biography by Marco Pellegri, 1965.

Joseph Marie Vien (1716–1809), another scholar of the French Academy, arrived in Rome in 1744 and left in 1750, but returned as director in 1776. He was one of the first artists to make use of decorative details from the excavations at Herculaneum in his pictures, most of which are of classical subjects. **Hubert Robert (1733–1808),** came to Rome in 1754 and stayed eleven years. His large canvases of ruins owe much to Pannini. **Charles-Louis Clérisseau (1721–1820)** arrived in Rome in 1749 and, after a turbulent period at the Academy, he was taken up as his artistic instructor by Robert Adam, and he also accompanied James Adam on his tour of Italy. Legrand says

that he helped Piranesi with *Della Magnificenza* (presumably the illustrations). He later returned to France and was variously consulted by Thomas Jefferson and Catherine the Great. **Jacques Saly (1717–1776),** was a favourite of de Troy but the caricature of him by Ghezzi in the Vatican makes him look a very dour creature. There is a pretty portrait bust by him possibly of de Troy's daughter in the Victoria and Albert Museum.

7. **Sir William Chambers (1723–1796)** arrived in Rome late in 1750, the year in which the design referred to was published in *Opere Varie;* the strict accuracy of the anecdote therefore sounds rather dubious. Lord Charlemont with whom Piranesi had his famous dispute was one of Chambers' best patrons, hence the tone. His architectural works include Somerset House in London and the pagoda at Kew.

8. **Marco Ricci (1676–1729),** nephew of Sebastiano, actually came from Belluno but he spent much of his time in Venice. His set of etchings, issued posthumously in 1730, includes some ruinscapes similar to the series of imaginary tombs of the heroes of the Whig enlightenment commissioned by Owen McSwiny on which Ricci, in common with Canaletto, Pittoni, Creti, the Valeriani and several other artists had also worked, see F. Haskell, *op. cit.,* p. 287 ff. Piranesi's *Burial Chamber* from the *Prima Parte* is a very similar composition.

Giovanni Benedetto Castiglione (c. 1610–c. 1665), a delightful artist from Genoa was of great influence on the Tiepolo family (see H. Diane Russell, *op. cit.*) and some of his etchings were in Domenico Tiepolo's sale. A similar influence can be traced not only in Piranesi's etching technique in some of the *Prima Parte* plates but in the iconography of the *Grotteschi*. I should like to connect the plumes and trumpet in *Grotteschi* IV with the lovely etching of *The Genius of Castiglione*.

9. I cannot accept the ingenious theory of M. Calvesi in the introduction to the Italian edition of Focillon's *Piranesi* and developed in the Catalogue to the exhibition of Giovanni Battista and Francesco Piranesi at the Calcografia Nazionale in 1967. According to this, Piranesi was a freemason and the *Grotteschi* are full of masonic or hermeneutical symbols. The theory is largely based on the appearance of a small medallion showing two clasped hands on the sarcophagus in plate III *(85)*. This is not a masonic symbol but a Roman imperial coin type emphasising concord. Calvesi's syllogism (Some Englishmen are freemasons: masonry is contagious: Piranesi knew Englishmen: therefore Piranesi was a freemason) is not valid.

A bucranion is a stylised ox skull, generally used as decoration on temples and altars. This macabre decoration is derived from the ancient practice of hanging up the heads of the animals killed in temple sacrifices. The tomb of Cecilia Metella down the Appian Way took its name of Capo di Bove from the frieze of ox skulls beneath the battlements. The drawing of the satyrs is in the Pierpont Morgan library in New York, see F. Stampfle, *op. cit*

10. The shady garden which lies off the steep ramp up to the Acqua Paola still exists and may be visited with permission. For a history of the society see Vernon Lee, *Studies of the Eighteenth Century in Italy*, 1907. Goethe was a member under the pseudonym of Megalio Melpomenio. Baretti, *op. cit.,* was unenthusiastic about the society and said that the prime purpose of the *Custode Generale* was 'to make a penny of his place . . . by sending Arcadian patents to the English travellers on their arrival at Rome' who then had to buy them at a cost of ten shillings (50p). Piranesi kept up his membership until his death when one of his fellow shepherds, the abbé Paolo Paolini, produced a pastoral elegy which is quoted by Biagi. Like Angelica Kauffmann, an Arcadian shepherdess, he perhaps maintained the connection in order to make contact with potential customers among the new members.

11. *The Fall of Phaethon* is described by M. Calvesi in the Calcografia Nazionale exhibition catalogue, *op. cit.* It is on the back of H.9 and H.15 which were amongst the earliest of Piranesi's large *Vedute*, see above p. 305.

12. For the visual ambiguities see P. May Sekler, 'Giovanni Battista Piranesi's *Carceri* etchings and related drawings', *The Art Quarterly,* xxv, 1962, 4, pp. 331–63. See also M. Yourcenar, *Le cerveau noir de Piranèse*, 1962 and U. Vogt-Göknil, *Giovanni Battista Piranesi, Carceri,* 1958.

13. For the reworking in the second edition proofs, see A. Robison, *op. cit.* For the different states of the *Carceri* see K. Mayer, Exhibition Catalogue of P. & D. Colnaghi & Co., 1968.

14. De Quincey and Aldous Huxley are the most distinguished British contributors on the subject of the *Carceri*. I do not think that Huxley is on the right lines but his essay, *Prisons, with the "Carceri" etchings by G. B. Piranesi,* is a splendid literary exercise.

15. In the second edition of the *Prima Parte* Piranesi noted in the descriptive text under the plate of the *Ancient Roman Forum (75)* that one colonnade leads to the imperial palace and the other to the prisons; both colonnades are identical and Piranesi mentioned the prisons not because he was still under the influence of the *Carceri* but because he wanted to show his knowledge of Palladio and ultimately of Vitruvius who say that the palace should be linked to the main *piazza* as well as to the mint, the treasury and the prisons.

16. The underside of bridges is viewed in several strong drawings by Piranesi in the British Museum. For the same subject, quite differently treated, compare a drawing by Canaletto from the Giorgio Cini Foundation in Venice exhibited at the Heim Gallery, 1972, No. 38.

17. The Juvarran 'dream' from the Tournon collection and other comparable drawings are illustrated by A. Griseri, 'Itinerari Juvarriani', *Paragone*, 1957, viii, 93, p. 40 ff. Many prison scenes by Juvarra are illustrated by M. Viale Ferrero, *op. cit.*

18. **Carlo Lodoli (1690–1761).** The influence of this eccentric has been discussed by several scholars, E. Kaufmann, 'Piranesi, Algarotti, Lodoli; a controversy in 18th century Venice', *Gazette des Beaux Arts,* xlvi, 1955, pp. 21–8, F. Haskell, *op. cit.,* pp. 320–2, 364–8, and E. Kaufmann, 'Memmo's Lodoli', *Art Bulletin,* xlvi, 1964, p. 159 ff. I quote from Algarotti's garbled precis of his theories given in *Saggio sopra l'architettura,* 1753. It is hard to push Lodoli as an influence very strongly; no buildings could be less functional than Piranesi's prisons.

19. For the influence of opium on creative minds see A. Hayter's interesting account *Opium and the Romantic Imagination,* 1968.

Chapter four

1. **Raphael Mengs (1728–1779).** He first arrived in Rome to study under Benefial in 1740, the same year as Piranesi. Thereafter he moved between Rome and the courts of Saxony, Naples and Spain. He was made a *cavaliere* by Benedict XIV in 1758. His Parnassus ceiling in the Villa Albani was finished in 1761.

2. Besides the children who survived their father, there were Faustina, born 1761 and named after her godmother, the Principessa Faustina Savorgnan, wife of the Pope's nephew, Lodovico Rezzonico, Pietro, born 1768, and Aloysius, born in 1775.

3. **Laurent Pecheux (1729–1821).** He arrived in Rome in 1753 where he studied under Mengs and Batoni. He became official court painter first in Parma and then in Turin. When in Rome he was involved in the decoration of the Villa Borghese. With Clérisseau he was one of Robert Adam's artistic instructors.

4. The letter from James Adam is quoted in John Fleming's *Robert Adam and his Circle,* 1962, p. 374, by far the best study of eighteenth-century Rome that I know. It is a great pity that the Adam correspondence from the Clerk of Penicuik papers in H.M. Register House, Edinburgh, has not been published in its entirety.

James Adam (1730–1794). He was less hard-working than his brother, Robert, and his Roman tour, 1760–3, was more that of a grand nobleman than a working architect's period of study. Piranesi admired his plan for a new Parliament house.

Bianconi says that Piranesi's 'unjust suspicions' drove him to buttonhole anyone he came across to force him to listen to his imaginary wrongs.

5. **Francesco Bianchini (1662–1729).** His other archaeological work is *Del palazzo dei Cesari,* published posthumously in 1738. As *Presidente delle antichità* he carried out excavations on the Aventine in 1705. His astronomical reputation was made by the erection of the meridian on S. Maria degli Angeli. After a visit to England, when he was presented by Newton with a copy of his *Opticks,* he was so impressed with the intellectual climate that he started to learn English with Clementina Sobieski, the Pretender's wife. The Etruscan scholar, Antonio Francesco Gori, also produced an account of the tomb in 1727 under the title

Monumentum sive columbarium libertorum et servorum Liviae Augustae.

6. This is a very rare work of which there is a copy in the Soane Museum. It must have been issued after 1751 because otherwise the plates would have been included in the *Magnificenze.*

7. Lord Charlemont (1728–1799). For his life see M. J. Craig, *The Volunteer Earl,* 1948, and the *Historical Manuscripts Commission, Charlemont MSS.* He later devoted himself successfully to Irish politics. While in Italy he consulted Vanvitelli on architectural projects.

8. Richard Dalton (c. 1715–1791). He visited Rome 1741–2 and revisited Italy 1758–9 when he was making purchases for the royal collection. Robert Adam complained that in Rome 'those of true taste esteem him one of the most ignorant of mortals. He went with Lord Charlemont to Greece, Athens &ca, and on his return published a book of the temples &ca. he had seen there which is so infamously stupid and ill done that it quite knocked him on the head and entitled him to that name of Dulton which is generally given him.' John Fleming, *Robert Adam,* p. 223.

9. John Parker (d. c. 1765) came to Rome in about 1739. Lady Hertford describes him at this period as 'a gentleman that goes about with the English to show them what is most remarkable, assisting them also in buying what pictures, prints and other curiosities they fancy most. He also hires lodgings, servants, etc. for which he has a present of some zechins (the gold coin here) when they go away.' In 1756 he was elected to the Accademia di S. Luca to which he presented his portrait four years later. While in Rome he painted an altarpiece of St. Silvia for the church of S. Gregorio as well as a number of classical and historical works. See John Fleming, 'Some Roman Cicerones and Art Dealers', *The Connoisseur Year Book,* 1959.

The British Academy had to be closed in 1752 because of the students' misbehaviour.

10. There is a preliminary sketch for the second dedicatory plate in the British Museum and a version of the fourth was sold at Christie's, 30th March, 1971 *(124 and 127).*

11. Robert Adam (1728–1792). The most distinguished member of the architectural family, he visited Rome 1754–7. He remained in contact with Piranesi after he left Rome because the latter provided plates of the decoration at Syon for the second volume of *Works in Architecture,* published in 1779.

12. Robert Wood (1716–71) made a voyage to the Levant in 1750 the fruits of which comprised *Ruins of Palmyra,* 1753 and *Ruins of Balbec,* 1757.

13. Peter Grant (1708–1784). For details of this amusing character see John Fleming, *Robert Adam, passim.* He entered the Scottish College in Rome in 1726 and returned to Scotland as a priest but he was back in Rome in 1737 and stayed there until he died. Clement XIII, who was very fond of him, would have made him a cardinal had he lived longer.

14. This witness was the 'foreign nobleman', the so-called Baron d'Hanau, who had offered a large sum to secure the dedication of the *Antichità* for himself. In 1759 when he ran off from Rome with a large sum of stolen money it was revealed that he was an impostor who had been *valet de chambre* to the Prince of Liechtenstein. He must have been plausible enough because he was 'remarkable for his fine linen' and kept a coach and two servants. (Parker to Charlemont, 20th August, 1759, *HMC Charlemont*).

15. The details of the Charlemont affair are contained in Piranesi's *Lettere di giustificazione,* in the letters from Parker and Grant to Charlemont, *HMC Charlemont,* and in the manuscripts bound by Piranesi into the copy of the *Antichità* which he put on display in the Corsini library. See also L. Donati, 'Giovanni Battista Piranesi e Lord Charlemont', *English Miscellany,* 1950, i. pp. 231–42. Charlemont's biographer, Francis Hardy, says that he was later reconciled with Piranesi, *Memoirs of J. Caulfield, Earl of Charlemont,* 1810.

Lettere di giustificazione is dated 1757 but it is clear from *HMC Charlemont* that it was not widely circulated until the following year. A copy of the *Lettere* in a collection in the U.S.A. contains a manuscript list of the persons to whom Piranesi circulated the pamphlet. Part of it is quoted in the catalogue of the Piranesi exhibition, Smith College Museum of Art, Northampton, 1961. The recipients included artists and sculptors like Benefial, Mengs and Cavaceppi, Italian residents such as the Prince Altieri, the Baron Circi, Ridolfino Venuti and the Venetian ambassador as well as numerous foreigners; these comprised both visitors such as Lord Mandeville, Lord Brudenell and Sir Brook Bridges, and the resident expatriates like Sir William Hamilton, Horace Mann and the abbé Stonor. According to Parker, John Russell and Thomas Jenkins helped Piranesi to write the names of the English recipients on the presentation page in the front of each copy.

Chapter five
1. For the possibility that Piranesi was helped by friendly scholars see above p. 154. For doubts as to his knowledge of Latin see p. 304.

2. The mausoleum at Castle Howard in Yorkshire was built for the Earl of Carlisle by Nicholas Hawksmoor, 1729–36, while that at Cobham in Kent was built for the Earl of Darnley by James Wyatt, 1783. These, however, were isolated park ornaments. The effect of a whole road of such tombs would have been overpowering.

3. Some of the plates showing purely sculptural ornamentation were not done by Piranesi but by yet another French artist, Jean Barbault (c. 1705–1766).

4. Piranesi would have been helped in his reconstructions of ancient Roman building methods by *Castelli e Ponti,* a book of

practical engineering published in 1743, showing the ingenious contrivances of Nicola Zabaglia, the completely illiterate master builder who so impressed Winckelmann. Piranesi etched Ghezzi's caricature of him and the plate was later incongruously bound in with his collection of etchings of the drawings of Guercino.

5. Ridolfino Venuti (1703–1765). He lived with Cardinal Albani and was Winckelmann's predecessor as Papal Antiquary or Commissario delle Antichità della Camera Apostolica. His offending pamphlet, in which he inexcusably emasculated one of the figures on a relief to make the scene fit his theory, is entitled *Spiegazione de' bassirilievi che si osservano nell' urna sepolcrale detta volgarmente d'Alessandro Severo*, 1756. Among other works he also produced *Osservazioni sopra il fiume Clitunno*, 1753, illustrated by Vasi's etchings of drawings by Richard Wilson, and a standard guide to Rome, *Accurata e succinta descrizione topografica e istorica di Roma moderna*. Despite the disagreement over the interpretation of the sarcophagus, Piranesi sent Venuti a copy of the *Lettere di giustificazione*.

6. Natoire's letter dated 22nd February, 1757 is published in *Correspondance des Directeurs de l'Académie de France à Rome*, xi, p. 175, an interesting series which is a basic source of information about French activity in Rome at this time.

Pierre-Louis Moreau-Desproux (1727–1793) and **Charles de Wailly (1729–98)** were *pensionnaires* 1754–7 and knew Piranesi. For their Roman stay see John Fleming, *Robert Adam*, p. 362, and for their subsequent very successful architectural careers, see *The Age of Neo-classicism*, pp. 594–5 and 645–6.

7. Piranesi was proposed by the Bishop of Ossory, J. Theobald, P. Collinson, A. Cooper, A. Pond, H. Baker, C. Rogers and W. Norris, (Hind, *Piranesi*, p. 2). His election, of which he was inordinately proud, was the nominal excuse for correcting the error of Venuti who was also a Fellow.

8. Pietro Santi Bartoli (1635–1700). He studied as an artist under Poussin and Mariette had thirty-three of his drawings engraved in 1757. He produced a number of antiquarian works including *Admiranda Romanarum antiquitatum . . . vestigia*, publications on the columns of Trajan, Antoninus Pius and Marcus Aurelius, and a catalogue of the coin collection of Queen Christina. His work was continued by his son, Francesco, who was Papal Antiquary until his death in 1735.

9. Piranesi added a strip of foundations to the old plates from Bianchini's book. He was particularly proud of his view of the ruins of the Theatre of Marcellus, singling it out for special notice in the public letter to abbé Grant in the *Lettere di giustificazione*.

Chapter six

1. For the rediscovery of Greek architecture see J. Mordaunt Crook, *The Greek Revival*, 1972, which describes the adventures of the early travellers and the works of Dalton, Stuart and Revett.

2. Julien David Le Roy (1728–1803). After his Greek expedition he taught at the Académie d'Architecture. He also wrote *Histoire de la disposition et des formes différentes que les chrétiens ont données à leurs temples* and a number of books on navigation, ancient and modern. He experimented with the construction of unsinkable boats on the Seine.

3. Anne Claude Philippe de Tubières, Comte de Caylus (1692–1765). He served as a soldier in the war of the Spanish succession and then travelled to the Levant as French ambassador to the Sublime Porte. His principal work is the *Recueil d'antiquités* but he also collaborated with Mariette, Barthélemy and Rive in the publication of Santi Bartoli's collection of ancient Roman paintings and he was himself a prolific etcher.

4. Allan Ramsay (1713–1784). He was a deservedly successful portrait painter, who, like many of his compatriots, made a reputation in England as well as in his native Scotland. Piranesi honoured him with an imaginary tomb on the Appian Way in the dedicatory plate of the second volume of the *Antichità*. On 12th November, 1755 Ramsay wrote, 'We lodged for a month on our coming to Rome on the Monte della Trinita, afterwards we took a house and furnished it where we now live, upon the ridge of the Mons Viminalis, from which we have a view of the most remarkable places of Ancient Rome . . . But that which chiefly recommends the situation to me is the distance from the Piazza di Spagna, by which I am enabled to seclude myself a good deal from the English travellers without falling out with any of them, and to preserve the greater part of my time for painting, drawing and reading.' Back in London on 31st January, 1762, he wrote, 'My Dialogue on Taste has become remarkable by a large folio which it has given rise to by Peranese at Rome, and of which some copies are already come to London by land.' See Mrs. M. A. Forbes, *Curiosities of a Scots Charter Chest*, 1897 and John Fleming *Robert Adam*, *passim*, and 'Allan Ramsay and Robert Adam in Italy', *Connoisseur*, March, 1956, cxxxvii, pp. 79–84. A. Smart's biography *The life and art of Allan Ramsay*, 1952, gives a full account of his Roman visits and friends but is inaccurate on the controversy with Charlemont.

5. Johann Joachim Winckelmann (1717–1768). There is a biography by W. Leppmann, published in English in 1971, and a selection of extracts from his works on aesthetic theory collected by D. Irwin, *Winckelmann, Writings on Art*, 1972. Winckelmann pointedly ignored Piranesi: when, for instance, he wrote about the bosses for lifting stones in the Greek temples at Agrigento he made no reference to Piranesi's work on the subject in *Antichità romane*.

6. Cardinal Alessandro Albani (1692–1779). He was one of the greatest collectors of his time. The Villa Albani, now Torlonia, still contains much of his collection despite Napoleonic depredations.

7. Carlo Marchionni (1702–1786). He trained as a sculptor. His work includes the monument to Benedict XIII in S. Maria sopra Minerva in Rome and commissions in S. Rocco in Lisbon and the Chigi chapel in Siena cathedral. His other notable architectural work is the Sacristy of St. Peter's.

8. Robert Mylne (1734–1811). He was described by Parker as a 'scholar of Piranesi' *(HMC Charlemont)*. He arrived in Rome in 1755, winning the silver medal of the Accademia di S. Luca in 1758. For Piranesi's letter to Mylne see C. Gotch, 'The Missing Years of Robert Mylne', *Architectural Review,* September, 1951. In this letter Piranesi also thanks Mylne for procuring some purchasers of his works and refers to disputes with French students concerning the accuracy of Desgodetz. He also mentions the archaeological interests of the young George Dance, the future architect of the Piranesian Newgate Prison.

9. The portrait of Clement XIII is said to be by Piranesi but although he was responsible for the architectural background the portrait itself was probably someone else's work, perhaps that of Cunego who etched the plate jointly with Piranesi. **Domenico Cunego (1727–94)** was an engraver employed by James Adam during his Roman stay and subsequently by Gavin Hamilton. He also contributed to the plates for the Adams' *Works in Architecture.*

10. Legrand adds the improbable information that Pirmei, who seems to have been more a secretary than a co-author, used to discuss Piranesi's work with Winckelmann and Mengs.

11. *Della Magnificenza.* Piranesi said that it was absurd to put dolphins on the capitals of columns but he illustrated just such an example in the *Trofei di Ottaviano.* There is a drawing in the British Museum which must date to this period showing some grandiose public buildings on which Piranesi has written, 'A sketch to demonstrate how the Romans debased Greek styles.' His violent antipathy to Greek architecture was not unique. Sir William Chambers, for instance, was equally intemperate. 'They might with equal success oppose a Hottentot and a Baboon to the Apollo and the Gladiator as set up the Grecian architect, against the Roman.' *Lecture* II, p. 21. See John Harris, *Sir William Chambers,* 1970, p. 139 ff.

12. Following the excavations at Volterra, Corneto and Chiusi, Etruscan art was receiving increasing attention from scholars, fostered by the Academy of Cortona. The foundations, however, had been laid early in the previous century by Thomas Dempster (d. 1625), a rumbustious Scottish lecturer in law at Bologna, whose *De Etruria regali* was published posthumously a century later in Florence by Thomas Coke, Earl of Leicester, 1723–6. Scipione Maffei was another advocate for the Etruscans as was Antonio Francesco Gori (1691–1757) whose *Museum Etruscum,* 1737–43, gave a detailed description of the Etruscan sculpture and artefacts discovered in the recent excavations. Piranesi might also have come across Mario Guarnacci (1701–85), a scholarly ecclesiastic who had been in the service of Clement XIII in Rome some years earlier. He returned to Tuscany in 1757 and his *Origini Italiche, o siano Memorie istorico-Etrusche* did not start to appear in print for another ten years. Piranesi might, however, have met him either with his Venetian patron or through the Arcadians (Guarnacci published poems under the name of Zelalgo Arassione). He was a strong supporter of the antiquity of the Etruscans but he notably refrained from citing Piranesi's polemical works although quoting freely from Dempster, Maffei and Gori. Winckelmann, on the other hand, was rather hostile to the Etruscans whom he considered gloomy and superstitious, see the selection from his *History of Ancient Art,* 1764, in David Irwin, *op. cit.,* p. 109 ff. The Etruscan question was confused because many Greek vases were considered to be Etruscan.

13. Jean Pierre Mariette (1694–1774). He was a scholar of great repute and a considerable connoisseur who had advised Prince Eugène on his collection. He wrote works on Leonardo, St. Peter's and several catalogues to collections including the King's engraved gems. When aged over seventy he started to learn English so as to be able to translate Horace Walpole's *Anecdotes of Painting.* Some of his correspondence with Bottari is published in *Raccolta di lettere sulla pittura, scultura ed archi-tettura,* 1766. See especially Volume V, pp. 279, 292 and 296.

14. *Parere su l'Architettura* is the subject of a fundamental paper by Rudolf Wittkower, *Journal of the Warburg and Courtauld Institutes,* ii, 1938–9, p. 147 ff. *Della Introduzione e del Progresso delle Belle Arti* is a disappointing little essay three pages long which fizzles out into an attack on Mariette's comment on *Emissario del Lago Albano.*

15. The debate as to whether architecture derived from the primitive hut was a theological controversy which vexed the eighteenth century. The *Essai sur l'architecture,* published by a Jesuit, Marc Antoine Laugier, in 1753 was the classic statement that 'the little rustic hut . . . is the model out of which all the magnificences of architecture have been conjured'.

16. The plates following the text seem to be a later addition since they are signed 'Cavaliere', a title that Piranesi did not receive until October, 1766, see *Piranesi drawings and etchings at Columbia University,* 1972, pp. 106–7. There are further drawings in this manner in the Kunstbibliothek, Berlin and in the British Museum. Piranesi was inventing novel architectural schemes as early as 1760–1 when he included some of his odd banded columns and labels in the new *Carceri* Plates II and XVI.

17. Piranesi would probably not have seen the façades of Lecce but he was, of course, familiar with the ornate decoration of such Venetian churches as S. Moise, S. Maria del Giglio and the Ospedaletto, which is not dissimilar.

18. For claims for originality cf. J. F. Blondel, *Cours d'Archi-tecture,* 1771, i, p. 132, 'Sometimes you can and you must break certain rules. If you never want to break out of them, you risk falling into a dry sterility'; Robert and James Adam, *Works in Architecture,* 1773, i, 1. p. 6, 'Rules often cramp the genius and

circumscribe the idea of the master', hence their attempt 'to transfuse the beautiful spirit of antiquity with novelty and variety'; and Clérisseau, *Antiquités de la France*, 1778, p. XII, 'Let us learn from the ancients to make the rules themselves subordinate to genius. Let us do away with this stamp of slavery and imitation which detract from our efforts.'

19. The quotations from Winckelmann are from his *Essay on the Beautiful in Art*, 1763 and *Remarks on the Architecture of the Ancients*, 1762, D. Irwin, *op. cit.*, pp. 97 and 87.

Chapter seven

1. Piranesi first appears in the *Stato delle anime* registers of the parish of S. Andrea delle Fratte in 1761. He lived there with his growing family and a single maidservant until his death. He now deleted the address of Bouchard and Gravier from the large *Vedute* and substituted his own 'Presso l'autore a Strada Felice nel Palazzo Tomati vicino alla Trinita de' Monti.' It was near the Casa Guarnieri where the Adam brothers had stayed and which was renowned 'tant pour l'endroit écarté du grand bruit, tant pour l'air, qui est le meilleur de la ville', as Cardinal Albani said, see John Fleming, *Robert Adam*, p. 151.

2. *Acqua Giulia.* He had changed his mind about the trophies since the *Trofei di Ottaviano* and now ascribed them to the Sarmatian wars. Even in this little essay he belligerently attacked an acknowledged expert on water courses, Giovanni Poleni, who had published numerous works on the subject and had edited Frontinus.

3. *Lapides Capitolini.* The colophon of this work is re-used from the *Lettere di giustificazione*. The work is dated 1762.

4. *Campus Martius.* The Adam correspondence is quoted by John Fleming, *Robert Adam, passim,* and Damie Stillman, 'Robert Adam and Piranesi', *Essays presented to Rudolf Wittkower*, i, p. 197 ff. The *imprimatur* was given on 16th June, 1761, the same date as that for *Lapides Capitolini*. Originally Piranesi planned a Janus figure of himself and Robert Adam to go on the map but this was altered to the two profiles on a medallion. James Adam wrote on 29th August, 1761, 'I find from others that he (Piranesi) has been very unlucky of late in his offers in this way (i.e. of dedications).'

5. For Piranesi's view on caryatids see *Della Magnificenza* lxvi: 'Who could imagine that women like those caryatids (of the Erechtheion) could have supported so heavy a weight and, what is more, not only with so cheerful an expression but with such slender figures that, if they left their posts, you would mistake them for dancing girls?'

6. Natoire sent Hubert Robert to get the *Campus Martius*. See *Correspondance des Directeurs*, xi, p. 425.

7. *Emissario del Lago Albano. Acqua Giulia, Lapides Capitolini* and this work are referred to as '*tria haec opuscula*' by Piranesi in his dedication to Clement XIII. I am pleased to say that my

former tutor at Balliol, Robert Ogilvie, who lists the most recent articles on the tunnel in his edition of Livy's *Histories I–V*, confirms Piranesi's dating.

Piranesi's fisherman was luckier than the explorers described by de la Platière, *op. cit.*, v, p. 465–6, who says that an Englishman who had the water shut off advanced no further than 100 feet before retiring because of the cold, while 'a fisherman either from curiosity or for sport wanted to try the adventure; he went in but did not return. They waited until the following day before letting in the water. He was washed out dead at the exit of the tunnel.' De la Platière was critical as usual: 'Piranesi has etched the views of the entrance and outlet of the tunnel . . . he has relied heavily on conjecture and given it all a much greater effect than it really has.'

8. There is a beautiful drawing of one of the cisterns in a collection in Cambridge, U.S.A., reproduced in Hylton Thomas, *op. cit.,* pl. 52.

9. The sketch book of Hubert Robert in the collection of the marquis de Genay is mentioned by R. Parks in the catalogue of the Smith College Exhibition, 1961. A Jesuit, Giuseppe Rocco Volpi, had published *Antiche memorie appartenenti alla città di Cora* with crude cuts of the antiquities in 1732.

10. James Byres (1733–1817). He was taken from Scotland to France by his Jacobite father after the '45 and served in the French army. He went to study architecture in Rome where, like Mylne, he won the prize in the Concorso Clementino of the Accademia di S. Luca. Winckelmann described him as 'hypochondriacal, timid and shy' but he was a popular *cicerone* (Gibbon used him) and, as an antique dealer, he handled some masterpieces like Poussin's *Seven Sacraments* and the Portland Vase. See John Fleming, *Robert Adam* p. 378 and *The Connoisseur Year Book*, 1959. The illustrations for his *Hypogaei* or *Sepulchral Caverns of Tarquinia* were modelled on those in *Antichità romane,* giving general external and internal *vedute,* peopled with scholarly visitors, as well as ground plans and cross-sections of the tombs and details of the paintings. The editor, Frank Howard, published engravings of Byres' drawings without any text some years after the artist's death.

11. *Dimostrazioni dell'Emissario del Lago Fucino.* Perhaps Piranesi did not publish the plans of the Fucine Lake for fear that similarities between the Fucine and the Albano tunnels should be used as evidence that the two works were almost contemporary. The Fucine tunnel had been dug by the Emperor Claudius (A.D. 41–54) and some scholars claimed that the Albano tunnel was the work of the Emperor Domitian (A.D. 81–96). If substantiated this claim would have removed some of Piranesi's evidence that the Romans were capable of serious building work long before the conquest of Greece.

Francesco published the large double plate of the Fucine lake in 1791, dedicating it to Ferdinand IV and Maria Carolina of Naples. The plate is signed 'Cav. Gio. Batta. Piranesi delineo, e incise a l'aquaforti. Cav. Francesco Piranesi incise a bollino.'

12. The base of the column of Antoninus Pius used to stand in front of the Palazzo Montecitorio but was moved to the Vatican in 1789 when the present obelisk was erected. The other two columns are, of course, still in position. The title of the first work is *Trofeo o sia magnifica colonna coclide di marmo . . . ove si veggono scolpite le due guerre Daciche fatle (sic) da Trajano.* Hind, *op. cit.,* p. 86, states that there are rare examples of this work with a text but I have never seen an example. The views of the reliefs of the columns of Trajan and of Marcus Aurelius are generally to be found in a continuous roll each about ten feet long. Each column has been treated separately in a useful work by Pietro Santi Bartoli about a century earlier. The plaster casts used by Piranesi would have been those from Natoire's house, see above p. 246.

For a discussion of the problems of dating the plates of the three columns, see A. Monferini on Focillon's *Catalogue,* p. 320 ff. Clement XIV, whose portrait appears in some copies of *Trofeo,* died in September, 1774 but Francesco's Catalogue of 1792 dates the work to 1775. However, a copy of Piranesi's Catalogue sold at Sotheby's, 13th July, 1972, containing manuscript entries for the five *Vedute,* H.111–15, which are dated to 1774, shows that both the *Trofeo* and the map of Rome had been issued by that time. (Information supplied by Adrian Eeles.) *Colonna Antonina* and *Colonna eretta in memoria dell'apoteosi di Antonino Pio e Faustina* are dated 1776 and 1779 in Francesco's catalogue. Legrand says that Piranesi originally discussed a work on the columns with Pecheux as early as 1755–6.

13. The waterfall at Tivoli, the only dated *Veduta,* is signed 'Eques Piranesius del sculp 1766'. The new *cavaliere* signed the plate immediately after he had been knighted. The excavations at Hadrian's Villa gave a topicality to the Tivoli *Vedute.*

14. In the catalogue of Piranesi's effects, quoted by Morazzoni, *op. cit.,* there was a Salvator Rosa, a French landscape, probably by Hubert Robert or Clérisseau, and a *bambocciata* of Caravaggio, a sympathetic subject of the sort which he attempted himself in his early youth and traces of which are very evident in the tatterdemallions who populate his ruins.

15. Gavin Hamilton (1723–1798). He arrived in Rome shortly after Piranesi and, after working as an artist both in Naples and in London, he returned to Rome in 1756 where he had an extremely successful triple career as artist, specialising in Homeric subjects, as excavator and as antique dealer. He was excavating at Tivoli at the time when Piranesi was investigating the site and doing some excavations of his own. Piranesi published his *Schola Italica Picturae* in 1773. Hamilton's pastel portrait of Piranesi, which he showed to the Ramsays in Rome, has disappeared, A. Smart, *op. cit.,* p. 173, (as has a portrait bust by another British artist, Joseph Nollekens).

16. The map of Hadrian's Villa, which also marks the site of Gavin Hamilton's discoveries at Pantanello, is shown scratched onto a huge stone slab, kept in place by iron clamps. Legrand says that Piranesi himself was partly responsible for the six large plates. It was dedicated by Francesco to Stanislaus Augustus, King of Poland, in 1781.

17. Bertrand Capmartin de Chaupy (1720–1798). To escape involvement in the politics of Church and state, he moved to Rome where he lived for twenty years, returning to Paris in 1776. His three volumes on Horace's villa, *Découverte de la maison de campagne d'Horace,* 1767–9, illustrated by a single map, rambled far off his subject. He attributed the tunnel of Lake Albano to Domitian which would have annoyed Piranesi. His projected work on ancient Italy was abandoned on his return to France in favour of ecclesiastical polemics.

Giuseppe Baretti (1719–1789). Piranesi's reference is to the friend of Dr. Johnson, Giuseppe Baretti, whose *La Frusta Letteraria,* aimed at worthless publications, was banned in 1765 at the instigation of the Marchese Tanucci, chief minister of Naples, who was offended by the attacks on his Neapolitan archaeologists. Baretti had also taken up the cudgels on behalf of his native country against the slanderous description of Italy given by Samuel Sharp's *Letters from Italy . . . in the years 1765 and 1766,* to which he replied with *An Account of the Manners and Customs of Italy,* published in 1768 and dedicated to Charlemont.

18. For Adam's projected work see above p. 165. In January 1757 abbé Barthélemy wrote to de Caylus saying that Moreau-Desproux and de Wailly had drawn the Baths of Diocletian. 'They penetrated the underground quarters, climbed on the rooftops, made excavations as far as their resources allowed and seem to have reintroduced the careful and painstaking methods which we admire in Desgodetz.' They then moved on to study the Baths of Caracalla but only had time to draw the ground plan. They had intended to publish a supplement to Desgodetz but, in the meantime, their drawings were being sent back to Paris. 'I hope that you will be pleased with them', wrote Barthélemy, 'as was Piranesi who examined them with care.' *Correspondance des directeurs,* xi, pp. 171–3.

19. Giovanni Battista Antonio Visconti (1722–1784). He was a friend of Winckelmann who said that he was the only man fit to succeed him as Papal Antiquary. In this capacity he served Clement XIV and Pius VI well in collecting marbles for their new museum and in carrying out excavations. He was largely helped with the first volume of *Museo Pio-Clementino* which appeared in 1782 by his son and successor, Ennio Quirino Visconti.

For speculation that Piranesi might succeed Winkelmann, see the letter from Mengs in Madrid dated 19 July 1768, *J. J. Winckelmann, Briefe,* iv, 1957, p. 296.

Chapter eight

1. Legrand stresses the remarkable familiarity which Piranesi enjoyed with the Rezzonico family and says that he instructed the nephews in architecture. He acted as an intermediary, for instance, when one of them wanted an artist from the French academy to sketch the scene of a canonisation ceremony in St. Peter's in 1767 (*Correspondance des Directeurs,* xii, p. 163). One of the saints being canonised on this occasion was St.

Joseph of Copertino, a flying monk from Apulia whose strange exploits aroused considerable devotion (see, for example, the altarpiece by G. Cades dated 1777 in SS. Apostoli, Rome).

Don Abbondio was a courteous and popular governor, as Goethe attests (*op. cit.,* pp. 457 and 476). His wife, Ippolita Buoncompagni Ludovisi, was noted for her temper and her snobbery. There was a scandalous incident in 1782 when her coach and that of Henry Stuart, Cardinal Duke of York, were both approaching the entrance to the French Academy where Cardinal de Bernis was giving a reception. Her coach was about to enter first when the Cardinal's coachman dashed his torch before the other horses and slipped through in front. The princess was furious and would accept no apologies. "Tell his eminence that I shall have his lackey beaten by my servants and tell him that he is not a gentleman like his brother who, even though he claimed the British crown, gave right of way to the Duke of Gloucester when he met him in the Piazza Navona." C. Bandini, *La Galanteria nel gran mondo di Roma nel settecento,* 1930.

Don Abbondio had his official residence as Senator of Rome on the Capitol, where he was spendidly installed on taking office in 1766, and Cardinals Carlo and Giovanni Battista Rezzonico seem to have lived with their uncle on the Quirinal. There was, therefore, no need for a Palazzo Rezzonico. There is a portrait of the Pope with Carlo and Lodovico by Pietro Longhi in the Ca' Rezzonico, Venice. That splendid palace also, of course, contains Tiepolo's fresco celebrating the marriage of Lodovico to Faustina Savorgnan, the godmother of Piranesi's daughter, Faustina.

The Braschi *nipoti* of Pope Pius VI who built a new palace at the end of the Piazza Navona, 1791–1804, were the last papal family on the old scale. Although the great families no longer engaged in extensive building work, they were prepared to spend quite lavishly on entertainments for the large number of foreign royalties who visited Rome. There is, for instance, an elaborate design for the reception for Joseph II of Austria in 1769 in the Palazzo Doria Pamphili.

2. S. Maria del Priorato is invariably locked. Written permission to visit it must be obtained from the *Economo* of the Order in the palazzo at 68 Via Condotti, near the Piazza di Spagna. There is a full account of the architectural history of the church by R. Wittkower, Catalogue of the Piranesi Exhibition, Smith College, Northampton, 1961. Six drawings in the Pierpont Morgan Library are described by F. Stampfle, *Art Bulletin,* 1948, *op. cit.* There are others in the Kunstbibliothek, Berlin.

3. Tommaso Righi (1727–1804). He was elected to the Accademia di S. Luca in 1760 and was responsible for the troublesome monument to Pio Balestra in SS. Martina e Luca, see above p. 245. He went to work in Poland in 1784 and died there twenty years later.

4. F. Milizia, a fellow Venetian, said that the church qualified Piranesi to be regarded as one of the 'architetti nefandi'. Antonio Visentini, another Venetian enthusiast for Palladio, was equally hostile in his published and in his unpublished writings, see E. Basi, *op. cit.,* pp. 367–70.

5. Piranesi's designs for S. Giovanni in Laterano have been excellently published in the catalogue of the exhibition at Columbia University, 1972. There are others in the Pierpont Morgan library, see Stampfle, *op. cit.* The length of the extension to the basilica is, according to Piranesi's appended scale, 167 *palmi.* Taking 10 *palmi* as approximately 7 feet 6 inches, this works out at approximately 125 feet.

6. Although the mosaic in the apse is actually in large part a nineteenth-century restoration, it is still very impressive. Piranesi's views on the appropriate way to delineate the Deity are set out in *Diverse maniere,* p. 34: the Roman school 'requires that the eye, on the first glance that it casts on the image of a *Saviour* for example, should immediately behold in it something Divine, it requires that the character of the head, the action of the arms, the attitude of the body, the folds of the garments, the colour, and infine that the whole be not only conducted with wisdom, but that it be likewise accompanied with that dignity and gravity, suitable to the Divinity'.

7. Clement XIV (1705–1774). Following the suppression of the Jesuits, he was reputed to have been poisoned. He was a humane pope: when a Scottish zealot interrupted a ceremony in St. Peter's by shouting out that the Beast of Nature with seven heads and seven horns should throw away the cup of abominations, Clement sent him home instead of to the galleys because 'he had come a long way in the hope of doing good'. He suspended the obligation to kiss his slipper in the case of Protestant visitors to the indignation of the Duke of Hamilton who was looking forward to the rigmarole as 'the only amusing circumstance of the whole'. John Moore, *op. cit.*

8. Michelangelo Simonetti (1724–1781). For his architectural activities and the establishment of the Museo Pio-Clementino see *The Age of Neo-classicism,* catalogue pp. 627–8.

9. Piranesi was regarded as a Baroque architect which ruined his chances of success. For the same reason the designs of G. Pannini, son of the artist, for the church of S. Scholastica at Subiaco was rejected as being 'in the gusto of Borromini' as a result of which the commission went to Giacomo Quarenghi who rebuilt the church 1770–4, see Pierre Arizzoli-Clémentel, 'Giacomo Quarenghi à Subiaco', *Revue de l'art,* 19, 1973, p. 97 ff.

James Barry (1741–1806), the English artist, who did not at all approve of Piranesi's architectural efforts, wrote to Edmund Burke in 1769: 'With respect to Piranesi, I sincerely regard him as one of the best engravers that has ever appeared in the world, in the things he has generally employed himself about; and he will go down to posterity with deserved reputation, in spite of his Egyptian and other whimsies, and his gusto of architecture flowing out of the same cloacus (*sic*) with Borromini's, and other hair-brained moderns.' *The Works of James Barry,* 1809, i, p. 163. Barry was an important figure in British neo-classicism, his main work being the large allegorical scheme in the Royal Society of Arts.

10. Marchesa Gentili Boccapaduli (1735–1820). She was a noted blue stocking. Her portrait, painted by Piranesi's friend Laurent Pecheux in 1777, shows her extensive interests ranging from butterflies and goldfish to Greek vases and Egyptian furniture, see *The Age of Neo-classicism,* catalogue, pp. 133–4.

11. Photographs of the Trinità dei Monti ruin room are reproduced in an article by T. J. McCormick and John Fleming in *Connoisseur,* cxlix, 1962, pp. 239–43. Legrand says that Piranesi was too busy on his publications on the columns and on his *Vasi, candelabri, cippi* to illustrate the ruin rooms, which suggests that he was involved in de Breteuil's decorative scheme in the mid-seventies.

12. For a general account of the Egyptian revival see N. Pevsner, *Studies in Art, Architecture and Design,* 1968, i, pp. 212–35. The Camera dei Papiri in the Vatican was decorated with figures of Moses and Sphinxes by Mengs in 1770. Piranesi had shown interest in Egyptian decoration from an early date to judge from his copying of Egyptian urns from Fischer von Erlach's encyclopaedia.

13. Thomas Jones (1743–1803). He was a pupil of Richard Wilson. His journal, which is full of interesting information on contemporary Rome, was published by the Walpole Society, Vol. xxxii, in 1951.

In August 1777 he recorded: 'About this time I was introduced and got intimate with that great but excentric genius Piranesi.' Jones gave an amusing categorisation of foreign visitors: 'The Romans arranged their English Visitors into three Classes or degrees – like the Positive, Comparative and Superlative of the Grammarians – The first Class consisted of the *Artisti* or Artists, who came here, as well for Study and Improvement, as emolument by their profession – The Second, included what they termed *Mezzi Cavalieri,* – in this Class were ranked all those who lived genteely, independant of any profession, kept a servant – perhaps, – and occasionally frequented the English Coffeehouse – But the true *Cavalieri* or *Milordi Inglesi* were those who moved in a Circle of Superior Splendour – surrounded by a group of Satellites under the denomination of Travelling Tutors, Antiquarians, Dealers in *Virtu,* English Grooms, French Valets and Italian running footmen – In short, keeping a Carriage, with the necessary Appendages, was indispensable to the rank of a true English *Cavaliere.*'

Smollett, *op. cit.,* however said that 'No Englishman above the degree of a painter or cicerone frequents any coffee-house at Rome.'

14. The letter to Sir William Hamilton is quoted by Parks in the catalogue to the Smith College exhibition, 1961.

15. Piranesi complains that 'The design of the opposite Chimney, which I got executed in marble for the Earl of Exeter, has not succeeded so happily in the print as I could have wished . . . The plate does not only not do justice to the richness of the ornaments, but the clear-obscure does not express to my satisfaction that high and low, and those different degradations

of relievo, which are in the work it self.' The work must have been commissioned on Exeter's second visit to Rome which Mr. Brinsley Ford says took place in March, 1769.

16. John Hope was the father of Thomas Hope of Deepdene, the influential connoisseur of the regency period.

17. The Stowe chimney piece is mentioned on the plate from *Vasi, candelabri, cippi* illustrating a vase bought by George Grenville, later Marquis of Buckingham, from Gavin Hamilton's excavations at Hadrian's Villa. The chimney was of white marble and rosso antico with alternate pan's pipes and *bucrania* on the top and ormolu grapes and vine leaves down the side panels. It is illustrated in the catalogue of the Stowe sale, 1921. Grenville's vase was then sold for 22 guineas.

18. One might have expected Edward Walter to have ordered a chimney piece for himself but, to judge from photographs of Bury Hill shown to me by Humphrey Barclay whose family acquired the place in 1812 from Walter's heirs, the Grimstons, this was not the case. The Walters appear in no less than seven plates of the *Vasi.* As there is no trace of a payment for either chimney piece in the Gorhambury accounts (information kindly provided by Mrs. N. King), they were presumably given by the Walters to their daughter and son-in-law.

There is a drawing of the chimney piece from the drawing room at Gorhambury among the papers of the 4th Earl of Aylesford at Packington Hall in Warwickshire. It is an accurate rendering but the shelf is surmounted by a large relief of a Roman sacrifice which just does not quite correspond to the width of the chimney opening. The relief does not seem ever to have been incorporated in the Gorhambury decoration. Since the drawing is on Roman paper with the scale in Roman palms, I suspect that it was a studio design, subsequently executed but sold without the upper relief, and that Aylesford acquired it when he was in Rome in about 1771–3 together with a similar restrained Piranesian design also at Packington, which he brought home as possible models. Aylesford was an admirer of Piranesi and a talented amateur artist. In fact the bookplate which he etched for himself has actually been attributed to Piranesi and his drawings at Packington include a competent copy of part of one of Piranesi's Albano etchings. The fine Piranesian fireplace in the Pompeiian room at Packington which the present Lord Aylesford says may also be attributed to the 4th Earl is, however, an adaptation of the Arch of the Silversmiths in Rome and not derived from *Diverse maniere.* Although Piranesi did not design Aylesford's bookplate, Samuel says (*op. cit.,* p. 124) that he did do one for a Mr. Menzies.

There is also a very Piranesian chimney piece in the Great Drawing Room at Badminton which was redecorated towards the end of the eighteenth century. It is said to be a copy of one in the Palazzo Borghese but it might well be the chimney piece ordered in Rome by the dowager Duchess of Beaufort in 1774, a reference to which has been found by Mr. Brinsley Ford. The chimney piece is of white marble and rosso antico with a frieze of dancing maenads between *bucrania* and with ormolu foliage on the side panels. The coloured design for it, preserved at

Badminton, is a studio exercise and not a design by Piranesi himself. The duchess' daughter, Henrietta, had married Piranesi's patron Sir Watkin Williams-Wynn.

A number of sketches by Piranesi for other decorative schemes are in the Pierpont Morgan library and in the Kunstbibliothek, Berlin. Some of these contain manuscript colour notes.

19. For the influence of these designs on Robert Adam see D. Stillman, *op. cit.* Some of Cameron's interior decoration and furniture are illustrated in Victor and Audrey Kennett, *Palaces of Leningrad*, 1973, see especially pls. XII, 81 and 83.

20. For the side table and Lord Carlisle's coach see F. J. B. Watson, 'A side table by Piranesi', *The Minneapolis Institute of Arts Bulletin*, liv, 1965, pp. 19-29.

The coach illustrated in *Diverse maniere* appears in H.101.

21. Piranesi's 'Tuscan' decorative details are lavishly used both in the church and the *piazza* of S. Maria del Priorato.

22. The designs of *Diverse maniere* were too outlandish to have much impact on contemporary taste. A pair of small commodes of about 1775 from the Palazzo Barberini are about the closest that contemporary style approached Piranesi's ideas, see *The age of Neo-classicism*, p. 787. François-Joseph Bellanger did, however, produce some analogous designs and Thomas Hope specifically acknowledged his debt, see William Rieder, 'Piranesi's *Diverse maniere*', *The Burlington Magazine*, cxv, May 1973, p. 309 ff.

Chapter nine

1. Benedetto Mori. Francesco in a memorandum on the obscure Armfeldt spying affair in Naples wrote that his father had kept Mori with him for twelve years and on his death-bed had recommended him to his son, see M. Lizzani, 'Due dei tre Piranesi', *Capitolium*, 1952, 12, pp. 265-71.

2. The letter to his sister is quoted by Biagi, *op. cit.* The estimate of his fortune is so low that it raises suspicions that Piranesi was trying to avoid subsidising his Venetian relations. In Rome he was certainly reckoned to be extremely rich, although the bulk of his fortune was probably made from antique dealing rather than from his publications. Since his sons claimed that the studio properties were worth £11,160 (see below page 320) after the sale of their father's collection to Sweden for £3,126 (see below page 317) and excluding the copper plates which were later bought by the Vatican authorities for £6,000, Piranesi's own figure clearly underestimated his wealth.

The Duke of Gloucester, the young son of George III, received 'twenty seven volumes in folio richly bound of all the best stamps and works of Piranesi' on his visit to Rome in 1774, Mann to Horace Walpole, 23rd April, 1774.

3. In the letter to Charlemont Piranesi would obviously try to exaggerate the number of etchings he could print from a plate. It is, however, extremely difficult to estimate what might have been the maximum number obtainable. It is certainly quite possible that he could have produced even more than 4,000 copies of some of the most popular *Vedute* by reworking the delicate areas as they became worn and the impressions deteriorated in quality. 3,000 may be taken as an average figure if we can trust his remark, recorded by Legrand, about making '3,000 drawings in one go'. See above p. 297.

4. For Mylne as Piranesi's British agent, see C. Gotch, 'The Missing Years of Robert Mylne', *Architectural Review*, September, 1951. A letter from Francesco to an unnamed trade buyer, dated 1786, shows how the business dealt with its customers: 'I will send the two volumes of *Vedute di Roma* and some of the other works which sell best together with a catalogue from which you will be able to see the prices and then sell them either in complete sets or separately according to the taste of the connoisseurs.' See F. Cocconi, 'Tre lettere inedite di Francesco Piranesi', *Parma per l'Arte*, xiv, 1964, 3, p. 209 ff.

5. Hind, *op. cit.*, records thirteen updatings of the catalogue.

6. For Winckelmann's troubles in producing *Monumenti antichi inediti* in 1767, see W. Leppmann, *op. cit.*, p. 233, and for Hamilton's expenses 1766-7 with Hancarville's four volumes on his collection of vases, see Brian Fothergill, *Sir William Hamilton*, 1969, p. 113.

7. The map is a reworking of the one included in *Antichità romane*, with some additional notes. The work, being dedicated to Clement XIV, must have been issued before his death in September, 1774 and it is listed in a Catalogue issued in that year, see above p. 312: Francesco was wrong, therefore, when he dated it to 1778 in his catalogue of 1792. The map was often bound up with sets of the large *Vedute*.

8. Sir Robert Strange (1721-1792). He made his reputation by a portrait of the Young Pretender published during the '45. He was an active Jacobite who once escaped arrest by hiding from the Hanoverian soldiers under the hooped skirt of his future wife Isabella. He was pardoned and worked in London with considerable success, publishing prints of the old masters which were sold for between 20p and 75p each, considerably more than the price at which Piranesi sold his plates. He also did trade in Piranesi's etchings which were supplied to him from Rome by his brother-in-law, Andrew Lumisden, the secretary to the Young Pretender. In 1760 he left London to spend four years in Paris and Rome but returned to England subsequently and was knighted by George III.

9. The following extracts from Andrew Lumisden's letter book have been kindly supplied to me by Mr. Basil Skinner. All the letters are from Lumisden to Strange.
23rd February, 1763. 'Piranesi has received the two plates you sold him but seems to be little satisfied with his purchase. Abbé Grant, at his desire, writes to you on this subject. I told the Abbé, for I have not seen Piranesi, that I did not believe the plates were in the bad condition in which Piranesi represents them, as evidently appears from the last impressions of them

which you brought to Rome; that I was afraid there was no printer here that could print these plates with so much art and care as you had them done in Paris; nor could I conceive that Piranesi could steep and prepare paper on the very day of the arrival of the plates proper to take off the proofs. However I added that if Piranesi has made a bad bargain he has only himself to blame, for when he suspected that the plates might have been wore out or retouched you fairly offered to have an impression taken off each plate at Paris in presence of his agent, and the plates to be immediately sealed up, and if Piranesi after seeing such impressions was not satisfied, he might be off with the bargain. This he thought unnecessary upon which you told him, that as soon as the plates were consigned to his agent you would have no more to say to them. I think you told me that the plates had never been retouched but by D'Origny himself, and that they were such retouching as masters generally give to their own works. It is in every event to both of your advantages that this affair be kept private – Piranesi's to preserve the reputation of the plates, otherwise nobody will buy the impressions of them; and yours to prevent your enemies from saying that you had impos'd upon Piranesi in this bargain. If the plates are really in the condition Piranesi pretends, I should not oppose your giving him some abatement in order to preserve friendship, for you know what a dangerous enemy he is. What would you think to remit him the 30 copies of each plate he was to deliver to you?'

5th March, 1763. 'I observe all you say of Piranesi. The Abbé showed me your letter before he carried it to him. I approve much of it. He explained it to Piranesi in Italian and at his desire he is to translate it exactly to him. Piranesi could not deny the facts mentioned and always insisted on the goodness of his materials for printing and the skill of his printers. However he is to show your letter to some of his friends – the Abbé thinks he meant the Pope's nephews – and to advise with them what he should further do in the matter.'

9th March, 1763. 'The Pope's nephews, his counsellours, it seems are of opinion that he could have no legal claim against you. They doubt not he will be a loser on the bargain for which they blame his own conduct.'

26th March, 1763. 'Yesterday morning, before I delivered your letter to Abbé Grant, Piranesi called on me and gave me the inclosed letter to forward to you. I heartily congratulate with you on it, for it puts an end to the dispute about the two plates entirely to your honour. He acknowledges their goodness, he asks no abatement of the price, owns his ignorance, and amply declares your superior knowledge in these matters. Ashamed of his conduct, the only apology he could make for himself was the badness of the first proofs he took off which he said had so turned his head that he did not know what he was doing. At the same time I am against your having hereafter any considerable dealings with so wrong-headed and consequently dangerous a man.'

7th September, 1763. 'I wrote this chiefly to let you know that last Sunday you was received a member of the Academy of St. Luke, and on wh'h I congratulate with you. I hear Piranesi was chairman of the meeting and held forth very eloquently on your behalf.'

10. The two plates which caused all the trouble were by Dorigny. They were *The Descent from the Cross* by Daniele da Volterra and Raphael's *Transfiguration,* see James Dennistoun, *Memoirs of Sir Robert Strange ... and of his brother-in-law Andrew Lumsden,* 1855, i, p. 252.

11. **Francesco Bartolozzi (1728–1815).** He joined Wagner's studio at the age of twenty and stayed for six years. He was called to Rome by Bottari in 1760 but was persuaded to go to England by Richard Dalton in 1764. After a long and successful career in London he moved to Lisbon in 1801 on account of his son, Gaetano's, financial troubles.

12. **Thomas Jenkins (d. 1798).** Having started in London as a portrait painter, he came to Rome to study history painting but soon transferred his attentions to antique dealing. Even connoisseurs like Cardinal Albani, Mengs and Winckelmann consulted him and he was elected to the Accademia di S. Luca which still has his portrait. Legrand says that 'a foot, a leg, a fragment of a torso were enough for him to recompose a whole statue, but he would then break off an arm to increase its desirability in the eyes of some crazy enthusiast'. The profits of such transactions enabled him to entertain sumptuously in his villa at Castel Gandolfo. 'He was driven from Rome by the French who confiscated all they could find of his property. Having escaped their fury, he died at Yarmouth immediately on his landing after a storm at sea, in 1798.' James Dallaway, *Anecdotes of the Arts in England,* 1800, p. 364. See also J. T. Smith, *Nollekins and his times,* 1828, Thomas Jones, *op. cit.* and John Fleming, *The Connoisseur Year Book,* 1959.

13. *Raccolta di alcuni disegni del Barbieri da Cento.* This may well have been a sales catalogue for some of the drawings included (those belonging to Jenkins and to Piranesi himself) as much as a work for collectors. There were originally twelve plates by Bartolozzi, see A. Monferini, *op. cit.,* p. 363, but others were added by Piranesi himself, by Giovanni Ottaviani and by James Nevay. The collection had charmed connoisseurs, see the letter from Giacomo Carrara to Bottari, dated 1765, *Raccolta di lettere sulla pittura, scultura ed architettura,* v, p. 250. Two of the drawings included in the collection belonged to G. B. Tiepolo, but this does not prove that Piranesi had maintained his connections with his Venetian master. Bartolozzi might have copied the drawings in Venice and brought them with him to Rome. Francesco brought out a further collection of Guercino drawings etched by A. Bartsch in 1808.

14. For the collectors' enthusiasm see also the letter from James Byres to the Bishop of Killala, 24th August, 1785, in *H.M.C. Belvoir Castle MSS,* iii, p. 236: 'The Pope has also collected a number of things that were scattered in private houses. The Vatican Museum is now, perhaps, the greatest collection in the world. Nobody would think it the work of a ruined state, for everything is done with the greatest magnificence. Prince Borghese is likewise repairing his villa. You know what a fine collection he has. It now looks more like the habitation of an Asiatic monarch than that of a European subject. I am told it

has not cost less than 120,000 l. sterling. Our countryman, Mr. Gavin Hamilton, has painted a room there representing the life of Paris.'

15. *Il Calzolajo Inglese in Roma,* written only a few years after Piranesi's death by Giovanni Gherardi de' Rossi, is an amusing comedy which shows three typical characters of the period, the penniless Roman *conte* who has to hire out his coach and introduce foreign visitors to the nobles for a gratuity in order to make ends meet, the charlatan English *cicerone* who acts in collusion with the *conte* to fleece the visitors and the London shoemaker who pretends to a peerage to gain acceptance into Roman society as he apes the nobleman on tour. The comedy contains the immortal exchange:

Rosbif (the *cicerone*) – We dashed passed the Colosseum and Milord who is very interested in architecture was most impressed.

Psctth (the shoemaker) – Oh very fine, very fine! It'll be a marvel when they've completed it. Just fill up the gaps and give it a coat of paint and it'll be prodigious.

16. There are frequent references to the activities of the excavators and dealers at this period. For a general description of archaeology in Italy 1750–1850 see *The Age of Neo-classicism,* p. xlvi ff. For Hamilton's excavations see R. Lanciani, *New tales of old Rome,* 1901, p. 301 ff. and A. Michaelis, *A Catalogue of the Ancient Marbles at Lansdowne House,* 1889 where some of Hamilton's letters are quoted. The reference to the mining rights of antiquarians is from James Dallaway, *Anecdotes of the Arts in England,* 1800, pp. 273–4.

17. It was catalogued twenty days after his death by Giuseppe Angelini, the sculptor of his funeral statue. Many of the pieces had curious histories: a relief of Jupiter, Mars, Juno and Diana was 'fished out of the Tiber by chance near the Marmorata by a friar of S. Carlo ai Catinari who used to probe the bed of the Tiber in different places with a claw-like device' and a head of Pan 'was stolen from the Villa Medici and hidden by a builder. Another builder, who had observed him, waited until he had gone and then took it himself to sell to Piranesi'. See A. Geoffroy, 'Essai sur la formation des collections d'antiques de la Suède', *Revue Archéologique,* xxix, 1896, p. 29 ff. The Pope visited the collection in 1782 but still could not prevent the sale to Sweden soon afterwards. The price agreed was 6253 *zecchini* but Francesco took payment at the rate of 630 *zecchini* per annum instead of a lump sum.

18. For Piranesi's bargaining see Hamilton's letter to Lord Shelburne in July 1773, quoted by A. Michaelis, *op. cit.,* 'Piranese is come down of his price of the candelabri to 130 Zechines, which he says is the lowest he can sell them for.' For Piranesi's sale to Newdigate see M. McCarthy, 'Sir Roger Newdigate and Piranesi', *Burlington Magazine,* cxiv, July 1972, pp. 466–72.

Elsewhere Barry is very rude about Piranesi's compositions (*Works,* 1809, i, p. 125), referring to capitals adorned 'in so fantastic a manner, with so little of the true forms remaining,

that they serve indifferently for all kinds of things, and are with ease converted into candelabras, chimney pieces, and what not. Examples of this kind of trash may be seen in abundance in the collection of Piranesi.'

James Grimston, writing from Rome to his brother William in the 1770s says that 'the Prints of the Antiquities by le *Chevalier Piranese* are fine & exact, I fancy I shall add them to my Raccolto; this Man is exceedingly clever as an Antiquarian & was ennobled the latter end of the last Pontificate; it is immense the sum of money he has got by the Statues, Vases, Tripodes &c that he has found by searching among the Ruins of the Villa Adriana; the greater Part may still lie undiscovered & may be found to astonish a future Age; it is nearly certain that the Tiber conceals in its Bed what would well repay its cleaning but they are afraid to venture on such a Work lest the stench arising from the Mud should breed some Pestilentious disorder in Rome'. Mrs. N. King kindly showed me this letter which is dated only '10th November' from the archives at Gorhambury.

19. Bartolommeo Cavaceppi (1716–1799). Although trained as a sculptor, he did little original work because he was too busy restoring antique pieces. He was a friend of Winckelmann and accompanied him on his fatal journey back to Germany.

20. General Schouvaloff (1727–1797). Ivan Ivanovitch was one of the three cultured Schouvaloff brothers. The favourite of the Empress Elizabeth, he rose to be a Lieutenant General and Grand Chamberlain. He founded the University of Moscow and the Russian Academy of Fine Arts and spent many years in Rome where he purchased antiquities for the imperial collection. He left Rome in June 1773. *Correspondance des Directeurs,* xii, p. 435.

Besides those already mentioned the following British visitors also appear as owners or dedicatees in *Vasi, candelabri, cippi:* George Aufrere, John Barber, Thomas Barrett, John Lewis Boissier, – Boyd, Arthur Boyer, James Byres, Lord Carmathen, William and Winifred Constable, John Corbett, John Cuthbert, – Dalton, Hugh Deane, Francis Dickins, Dyve (?) Downes, Giles and Margaret Earle, Lord Fortrose, Lady Maria Fox, Lord Holland, Gavin Hamilton, Thomas Jenkins, Edward Knight, Lord Lincoln, Charles Morris, Mathew Nulty, Thomas Palmer, William Patoun, John Peachey, John Rous, John Scawen, Thomas Moore Slade, Robert and William Smythe, John Staples, John Chetwynd Talbot, Thomas Mansell Talbot, John Taylor, Peter Traille, Robert and Mary Udney, Eliza Upton, William Vyse and whoever is misspelled as Jane Sijnott.

21. Students could attend classes at the Accademia di S. Luca free of charge but membership was elective. (Eighteenth-century scholars collected memberships of learned academies as their modern counterparts amass honorary degrees.) The Academy originated in the Università dei Pittori whose statutes dated to 1478. It was effectively reconstituted by Gregory XIII in 1577 and gained greater importance with the institution of the Concorsi Clementini in 1702; these lasted until 1869 but already by the second half of the eighteenth century they were declining in importance: according to Roland de la Platière, *op. cit.,* v,

p. 90, 'The Academy of S. Luca has no reputation because it deserves none. The prizes which are awarded on the Capitol no longer mean anything; the native Romans hardly ever win them.'

22. Piranesi's memorandum to Mengs is extensively quoted by Focillon, *op. cit.*

23. The saga of the casts of Trajan's column, the acquisition of which probably inspired the series of plates of the three imperial columns, is set out in *Correspondance des Directeurs*, xiii, pp. 387, 392, 393, 395 and 404. Vien, Natoire's successor, thought that Piranesi's death was a suitable occasion for renewing attempts to recover the reliefs which had been commissioned by Louis XIV. Cardinal de Bernis' good offices were sought at any rate to prevent a further sale by Piranesi's heirs but the French were frustrated because the casts ended up in Stockholm with other purchases from the Piranesi collection.

24. For the influence on Adam's style, see D. Stillman, *op. cit.* The plates of the Syon decoration are dated 1778, the year of Piranesi's death, and were published in the second volume of the *Works in Architecture* the following year. For the career of **Thomas Harrison (1744–1829),** a sadly frustrated architect who might have redesigned the Piazza del Popolo and the Sacristy of St. Peter's, see *The Age of Neo-classicism*, pp. 554–5. Soane is said to have acquired the drawings of Paestum from Francesco. The passages of his house in Lincolns Inn Fields are claustrophobically plastered with antique fragments arranged like one of the plates of *Della Magnificenza*.

25. This subject is fully treated by A. Robison, *Nouvelles de l'estampe*, 1970, 4. The reworking of the pyramid of Caius Sestius pre-dated the move to the Strada Felice.

26. Piranesi sensibly reckoned that tourists who bought his *Vedute* would be most unlikely to carry them round to the actual sites to make inconvenient comparisons. He sometimes deliberately altered the views for one of three purposes.

He exaggerated the magnificence of the ancients by reducing the scale of the contrasted human figures although maintaining the correct proportions of the architectural elements, e.g. in the *Emissario del Lago Albano*, H.82 (the portico of the Pantheon in which the bases of the columns are shown waist- rather than knee-high) and H.114 (the basilica of Maxentius, wrongly entitled the Casa aurea of Nero).

He just slightly altered the relative position of monuments to give greater clarity to his design or to frame the subject better, e.g. H.4, 110, 111 and 128 – a more venial inaccuracy.

He included different monuments or parts of a monument on the same plate even though they cannot be seen simultaneously, e.g. H.42 (he shows the whole of the massive wall of the so-called Forum of Nerva along Via Tor de' Conti although, from his viewpoint, the further section is hidden where it bends back round a corner), H.80 (the temple of Bacchus which looms on the hill top cannot be seen from the valley of the grotto of Egeria), H.93 (the framing walls on either side are viewed with

an impossibly wide-angled lens) and H.129 (there are two view-points used to produce this uncomfortably distorted interior of S. Maria degli Angeli). William Beckford and John Flaxman who both visited Rome soon after Piranesi's death complained that he had exaggerated the scale, but Goethe found the Cloaca Maxima even more impressive than Piranesi's views of it.

27. For Piranesi's Pompeian drawings, see Hylton Thomas, 'Piranesi and Pompeii', *Kunstmuseets Aarsskrift*, 1952–5, pp. 13–28 and the catalogue of the Christie's sale, 27th November, 1973.

Some of the arid and rather empty drawings with precisely ruled lines for the architectural details have been scored over with a different pen for the clouds, shadows and superimposed figures, some of them in classical dress, e.g. the drawing of the Temple of Isis in the British Museum. I would like to think that such architectural drawings were done by Francesco or Mori and were touched up by Piranesi himself. Unfortunately I have not seen any drawings by Francesco to check this. Alternatively, the architectural work might have been done by Mori while Francesco added the figures. This is perhaps slightly more probable since some of Francesco's etchings include figures in classical dress, whereas none of his father's *vedute* do. Francesco is careful to record which of his Pompeian etchings were after drawings by his father and which were from drawings by Desprez.

Biagi records that Piranesi's reconstruction of the theatre at Herculaneum, done from a brief visit to a small part of the excavation, was proved remarkably accurate when further excavation uncovered the whole area.

28. For details of the sketch for his tomb, dated 12th May, 1778, see A. H. Mayor, *Baltimore Museum News*, October, 1956. He chose a suitably antique burial place, S. Maria degli Angeli, a church constructed by Michelangelo in the Baths of Diocletian and refashioned by Vanvitelli in 1749. Salvator Rosa and Carlo Maratta were both buried there. However, the statue by Angelini was substituted for the candelabrum over his eventual tomb in S. Maria del Priorato and the candelabrum itself, which is shown in the background of the posthumous portrait by Pietro Labruzzi, ended up in the Louvre.

Legrand says that 'he was always afraid that the youth of his son would prevent the continuity of the order established in his workshops in which many draughtsmen and engravers worked under his immediate direction, each one carrying out the task he had been given, but Piranesi always kept the difficult parts himself and maintained the overall control'.

29. For earlier views of Paestum see S. Lang, 'The early publications of the temples at Paestum', *Journal of the Warburg and Courtauld Institutes*, xiii, 1950, p. 48 ff., and M. McCarthy, 'Documents of the Greek revival in architecture', *Burlington Magazine*, cxiv, November 1972, p. 760 ff., in which is quoted a letter from Charles Parker to Newdigate, dated 15th February, 1783: 'Poor Piranesi before he died took drawings of the temples at Pestum & Rosa went with him to take measures in order to form models in Cork.' The smaller models in the Soane Museum could well be Rosa's work.

The series of drawings of Paestum (15 are in the Soane Museum, London, one in the Rijksmuseum, Amsterdam, and one in the Bibliothèque Nationale, Paris) has always been a puzzle: Hind, *op. cit.*, p. 19, doubts whether Piranesi was wholly responsible whereas H. Thomas, *op. cit.*, p. 56, accepts them. There are a number of problems:

(1) The etchings are all signed by Piranesi except for plates XIX and XX and the title page, which are signed by Francesco, and yet there are attributions to Francesco on the frames of four of the Soane drawings, all for plates which are signed by the father. The drawings attributed to Francesco are not readily distinguishable from the others. Soane was in Rome 1778–80 and, if the tradition that he acquired the series from Francesco is correct, perhaps the young architect was told by Francesco that he had helped his father with certain drawings; Soane later forgot which ones these were but remembered that Francesco had said that he was largely responsible for some and the four drawings were given the misleading attributions in the nineteenth century.

(2) Although the Soane drawings look homogeneous, a closer inspection shows that they actually differ in technique. Some are obviously original drawings with alterations and figures inserted on top of the columns after the architectural part had been completed – and some of these figures differ from the ones inserted in the etchings. Other drawings are free of such alterations and seem to be copied from the etchings rather than the other way round. This is particularly the case with the drawings for Plates II, VII and XII: II is actually in the reverse direction and XII is an exact copy of the published etching but, significantly, not of the original plate of this view. A proof pull of this first plate, which is in the British Museum, shows the identical scene from a slightly lower view point, the columns of the background are differently disposed and the vegetation and the figures (much more akin to Piranesi's Albano characters) are quite different. Clearly this first plate became damaged and, when a new one was made of the same scene, the opportunity was taken to clarify some of the details and to add a longer descriptive text, extolling the virtues of architectural licence, as well as to change the figures. The first state of Plate XII, which was never completed and is not as closely grained and cross-hatched as the others, is very similar to Plate XV.)

(3) The Amsterdam drawing, which is of a plate etched by Francesco, seems to be in the father's hand.

I think that it is likely that Piranesi and his party sketched and measured (like the characters in Plate XV) and then Piranesi produced his definitive drawings on which the series of etchings was to be based. From his surviving drawings of other scenes which he intended to etch but never completed (e.g. of Hadrian's Villa) it is clear that he generally prepared a detailed drawing of the view but left the figures as mere blobs and he would add visitors to the scene from a separate collection of figure studies. Subsequently one or two of these finished Paestum drawings became damaged and Francesco or one of the workshop assistants made up the set again with drawings taken from the etchings. Piranesi had virtually completed all the etchings before his death but he left a substantial amount to be redone on the two plates of the so-called Temple of Juno, the least interesting

of the three, and, therefore, left till last. These Francesco completed and claimed as his own. He was also responsible, as Legrand tells us, for most of the figures in the etchings.

30. The monument is by **Giuseppe Angelini (1742–1811),** a sculptor who had just returned from England where he had worked for Nollekens. The inscription below the statue of Piranesi reads: ANGELICA. UXOR–VIRO. CARISSIMO–FRANCISCUS. ANGELUS. PETRUS–FILI. QUI. ET. HEREDES–PARENTI. OPTIME. MERITO–FAC. CUR.

Inscriptions on other side of the base record Piranesi's merits and the grant of knighthood by Clement XIII and of a burial place by Cardinal G.B. Rezzonico.

31. Legrand says that Piranesi instructed Francesco in Roman history and the Latin language as soon as he could draw. He was sent to study at the French Academy and was destined for the church but, since the Rezzonico pope died before he was old enough to take orders, that plan was abandoned. He adds that he learned architecture from his father's friend Pierre-Adrien Paris, drawing from Corvi of the French academy, landscape from Hackert and etching from Cunego and Volpato.

It is interesting to see how Francesco altered the balance of the firm's customers. He relied much less on the British connections and the dedications of, for instance, the plates of his edition of ancient statues were addressed to numerous Poles and Swedes and more Italians, especially from Venice, but Abbondio Rezzonico received a plate as did the Braschi cardinal who had succeeded G. B. Rezzonico as Majordomo to Pius VI.

The ship carrying Piranesi's copper plates is said to have been captured en route for France by a British squadron under the command of Admiral Sir Thomas Troubridge who interceded for Francesco and negotiated a free conduct to France, Samuel, *op. cit.*, pp. 165–6.

Chapter ten

1. The *capriccio* in the Accademia di S. Luca is illustrated in the catalogue of the exhibition in the Calcografia Nazionale, Rome, 1967.

2. Few of the drawings which Piranesi gave to his friends are now traceable: the *capriccio* given to Robert Adam (probably the one in the Soane Museum), the sketches given to the Walters and now at Gorhambury, and the preliminary sketch for the *Antichità romane* dedicatory plate once in the possession of Cavaceppi and now in Berlin. Alas, the Rezzonico collection seems to have vanished as has 'the large group of Piranesi drawings' which the late Fabio Mauroner told Hylton Thomas (*op. cit.*, p. 50) that he had seen in his youth in an unused room in the Palazzo Borghese. The bulk of the drawings in those bound volumes have also, it seems, disappeared. Good collections of drawings have, however, been assembled in the U.K. (British Museum, the Soane Museum, the Ashmolean) in Paris, Berlin, Florence, Copenhagen and New York.

Since many of the views of Pompeii which Francesco included in his *Antiquités de la Grande Grèce* were by the French artist, Jean Louis Desprez (1743–1804), it seems that Pietro only

recovered a portion of his father's work. Drawings of scenes in the kingdom of the Two Sicilies would have been popular in Naples and some of the views of Pompeii and Herculaneum may have been dispersed among interested Neapolitan connoisseurs before Pietro's return to Italy.

The claims of the Piranesi brothers occupied a considerable amount of the time of the officers of the French Academy who wrote frequently to Talleyrand and others in Paris about their protracted demands for compensation (*Correspondance des Directeurs,* xvii, *passim*). The claims steadily escalated from 150,000 francs (£6,014) to 278,325 francs (£11,160), a figure which, however exaggerated, is a better measure of the fortune amassed by their father than his letter to his sister quoted on page 239. In addition to the drawings, the Neapolitan forces removed the contents of 'a well stocked print shop, two antique marble candelabra about 10 feet high, a fine arts library, a quantity of drawings, all the furniture, paintings by famous artists, in fine, an establishment built up over sixty years'. The trunk of drawings by 'Legacq' is also mentioned as missing.

3. Kennedy, who comments how he 'worked with amazing rapidity', says that, 'He is said to have drawn his design upon the plate itself, completing it for the most part upon the spot, and performing the whole of the operation by the agency of the acquafortis alone, with but very immaterial assistance from the engraver's tool.' It is impossible that Piranesi could have attempted the delicate process of etching in the open air. The story seems a piece of romantic imagination.

4. Some of the early drawings for the etchings (e.g. for the *Ancient Mausoleum* in the *Prima Parte* and for some of the *Carceri*) are in the reverse direction, implying that at first Piranesi used to trace his drawings onto the plate. Drawings for the *Antichità romane* and the *Vedute* are never reversed and must have been pricked through the paper or else the paper was greased to make it transparent for tracing.

5. It is interesting to note how the colour of Piranesi's plates changed. At first he used a light black ink, but from the mid 1750s until about 1770 he tended to use a sepia colour before changing to deep black in his last years, see A. Robison, *Princeton University Library Chronicle,* xxxi, Spring 1970.

6. Bernardo Bellotto (1720–1780) issued his large views of Dresden and Pirna in 1766; three years later when in Warsaw he painted fourteen views of Rome from Piranesi's etchings. His uncle, Canaletto, had done some Roman scenes himself many years earlier. There are in the Doria Pamphili gallery in Rome a pair of small oil paintings copied from Piranesi's *Vedute* of the temple of Fortuna Virilis and of the Ponte Salario

(H.46 and 31). Antonio Jolli (c. 1700–77) and Giovanni Battista Busiri (1700–57) were the principle *vedutisti* of Rome apart from Pannini who died in 1765. Pannini himself generally produced his architectural views in imaginary groupings and, when he did paint a Roman scene, it was often only the incidental setting of some pontifical ceremony.

7. For a critical contemporary view on Piranesi's style see the comments by William Gilpin (1724–1804) in *Essay upon Prints,* 1768, pp. 162–4: 'PIRANESI has given us a larger collection of Roman antiquities, than any other master; and has added to his ruins a great variety of modern buildings. The critics say, he has trusted too much to his eye; and that his proportions and perspective are often faulty. He seems to be a rapid genius; and we are told, the drawings, which he takes upon the spot, are as slight and rough as possible: the rest he makes out by memory and invention. From so voluminous an artist, indeed, we cannot expect much correctness: his works complete, sell at least for fifty pounds. – But the great excellence of this artist lies in execution, of which he is a consummate master. His stroke is firm, free, and bold, beyond expression; and his manner admirably calculated to produce a good and rich effect. But the effects he produces are rarely seen, except in single objects. A defaced capital, a ruined wall, or broken fluting, he touches with amazing oftness, and spirit. He expresses even the stains of weather-beaten marble: and those of his prints, in which he has an opportunity of displaying expression in this way, are generally the best. His stroke has much the appearance of etching; but I have been informed that it is chiefly engraved, and that he makes very great use of the dry needle. – In a picturesque light PIRANESI's faults are many. His horizon is often taken too high; his views are frequently ill-chosen; his objects crowded; and his forms ill-shapen. Of the distribution of light he has little knowledge. Now and then we meet with an effect of it; which makes us only lament, that in such masterly performances it is found so seldom. His figures are bad: they are ill-drawn, and the drapery hangs in tatters. It is unhappy too, that his prints are populous: his trees are in a paultry style; and his skies hard, and frittered.' This criticism of Piranesi's handling of light seems unfair when we consider, for instance, his Albano plates but Gilpin, who was himself an enthusiast for the picturesque, probably refers to the early *Vedute*. It is surprising that he also objects to the trees and figures which derive from Salvator Rosa, a master of the sublime of whom he does approve. The complaint about the skies is also unfair: the freedom of the *Archi trionfali* would have been inappropriate to the large *Vedute*.

8. He was called by Thomas Jones 'that great but excentric genius' and by Bianconi 'the Rembrandt of the ancient ruins'.

Notes to the Illustrations

The numbers of all of Piranesi's etchings catalogued by Hind and Focillon are given as (H) and (F) respectively. All measurements are in centimetres, and, except in the case of obvious misprints, measurements of etchings are taken from Calvesi and Monferini's edition of Focillon.

Chapter One

1. Canaletto, *The Stonemason's Yard*.
National Gallery, London

2. A. Visentini, S. Simeone Piccolo, *Urbis Venetiarum Celebriores Prospectus*, 1735.
British Museum, London

3. Canaletto, The Market at Dolo, *Vedute, altre prese da i luoghi, altre ideate*, 1744.
Private Collection, London
The villa in the background is typical of the Palladian villas lining the waterway between Venice and Padua.

4. G. Vasi, Palazzo Venezia, *Magnificenze di Roma*, I, 1747.
British Museum, London

5. G. and D. Valeriani, A. Balestra and G. B. Cimaroli, *Allegorical Tomb to William III*. Engraved by N. Tardieu.
Private Collection, London

6. Piranesi, Grand Sculpture Gallery (F3), *Prima Parte di Architetture, e Prospettive*, 1743.
35 × 25. Ashmolean Museum, Oxford

7. Piranesi, Design for a pulpit.
50·8 × 75. Pierpont Morgan Library, New York
The left-hand part of the design was re-used for the title page of *Archi trionfali* in 1748.

8. Piranesi, Design for a *bissona* or festival gondola.
29·6 × 68·3. Pierpont Morgan Library, New York

9. G. B. Tiepolo, *Scherzi di Fantasia*.
Private Collection, London

10. Piranesi, Design for a title page.
27·9 × 19·7. British Museum, London

11. Piranesi, Drawing of orientals.
25·6 × 19·1. Ashmolean Museum, Oxford
This drawing may be a sketch for an Adoration of the Magi or it may be connected with Tiepolo's mysterious series of etchings of oriental magicians and philosophers.

Chapter Two

12. Piranesi, Palazzo Farnese (F116), *Varie Vedute*.

11·4 × 17·6. British Museum, London
This is the palace in which Vasi lived.

13. Piranesi, Trevi Fountain (F94), *Varie Vedute*.
11·3 × 16·3. British Museum, London
The statues had not at this stage been placed on either side of the central figure of Neptune. Compare the view (H19) from *Vedute di Roma*, plate 43.

14. Piranesi, Villa Lodovisi (F90), *Varie Vedute*.
10·7 × 19·1. British Museum, London
The 'furry' technique is used on the roofs and walls of the villa.

15. Piranesi, Curia Hostilia (F79), *Varie Vedute*.
11·6 × 19·4. British Museum, London
The church of SS. Giovanni e Paolo is to the left.

16. Piranesi, S. Stefano Rotondo (F77), *Varie Vedute*.
12·6 × 18·3. British Museum, London
In the foreground to the right is the ship fountain in front of the church of S. Maria in Domnica. The aqueduct leading from the Caelian to the Palatine is on the left.

17. Piranesi, Villa dell'Ambrogiana (F19), *Vedute delle ville e d'altri luoghi della Toscana*, 1744.
28 × 47. British Museum, London
This Renaissance villa, outside Florence, is now a decrepit mental asylum. Piranesi's etching is taken from a drawing by Giuseppe Zocchi.

18. Piranesi, Arch of Janus (F52), *Archi trionfali*, 1748.
13 × 26. Ashmolean Museum, Oxford
The arch of the silversmiths is to the left. Piranesi wrongly calls the main structure the arch of Diano, not of Giano. Was he thinking of Diana?

19. Piranesi, Arch of Constantine (F50), *Archi trionfali*.
13 × 26. Ashmolean Museum, Oxford

20. Piranesi, Bridge of Augustus at Rimini (F59), *Archi trionfali*.
13·5 × 26·5. Ashmolean Museum, Oxford

21. Piranesi, Arch of Trajan at Ancona (F70), *Archi trionfali*.
13·5 × 27. Ashmolean Museum, Oxford
This and the preceding plate must have been done from drawings made on Piranesi's way home to Venice or on his return to Rome.

22. G. B. Nolli and Piranesi, Map of Rome (F40), 1748.
47 × 68·8. British Museum, London

23. Piranesi, Piazza del Popolo (H14. F794), *Vedute di Roma*.
38 × 54. Ashmolean Museum, Oxford
This and plates 24–29 were all executed by about 1751.

24. Piranesi, The Forum or Campo Vaccino (H40. F803), *Vedute di Roma*.
38 × 54·5. Ashmolean Museum, Oxford
It is remarkable that the Forum, the centre of the ancient world, was still unexcavated and deep in rubble at this period.

25. Piranesi, The Capitol (H38. F807), *Vedute di Roma*.
38 × 53·5. Ashmolean Museum, Oxford
To the left is S. Maria in Aracoeli, the church beside which Gibbon 'sat musing amidst the ruins of the Capitol, while the barefooted friars were singing Vespers in the Temple of Juppiter' on the notable day in October, 1764, when the idea of writing *The Decline and Fall* came to him.

26. Piranesi, The Theatre of Marcellus (H33. F818), *Vedute di Roma*.
38 × 55. Ashmolean Museum, Oxford
In the background is the dome of S. Maria in Campitelli, a favourite church of the Stuarts, where masses were said for the conversion of Britain. Henry Stuart, Duke of York, who was the titular cardinal, employed Baldassare Galuppi as his choirmaster there.

27. Piranesi, The Pantheon (H17. F796), *Vedute di Roma*.
39 × 54·5. Ashmolean Museum, Oxford

28. Piranesi, The Quirinal (H15. F808), *Vedute di Roma*.
36·5 × 54. Ashmolean Museum, Oxford
The main Papal palace is on the right. In this plate Piranesi indulges in a distant sunset.

29. Piranesi, The Hadrianeum used as the Customs House (H32. F821), *Vedute di Roma*.
39·5 × 60. Ashmolean Museum, Oxford
Travellers' coaches are parked outside to unload visitors' baggage for inspection.

30. Piranesi, The Colosseum (F53), *Archi trionfali*.
12·5 × 27. Ashmolean Museum, Oxford

31. Piranesi, The Appian Way (F61), *Archi trionfali*.
12·5 × 27. Ashmolean Museum, Oxford

32. Piranesi, View of the Forum (F51), *Archi trionfali*.
12·5 × 26·5. Ashmolean Museum, Oxford

33. Piranesi, Arch of Titus (F47), *Archi trionfali*.
13 × 26. Ashmolean Museum, Oxford

34. Piranesi, The Amphitheatre at Verona (F67), *Archi trionfali*.
13 × 26. Ashmolean Museum, Oxford

35. Piranesi, Temple at Pola (F63), *Archi trionfali*.
11·5 × 25. Ashmolean Museum, Oxford

36. Piranesi, Frontispiece (H2. F786) to *Vedute di Roma*.
49·5 × 63. Ashmolean Museum, Oxford
This medley of antique fragments, compiled like the groupings of Pannini, also appears in *Opere Varie*.

37. Piranesi, View of St. Peter's (H3. F787), *Vedute di Roma*.
38 × 54. Ashmolean Museum, Oxford
The design of the coach closely resembles that of the earlier festival gondola which Piranesi drew in Venice a year or two earlier, see plate 8.

38. Piranesi, S. Giovanni in Laterano (H8. F790), *Vedute di Roma*.
37 × 54. Ashmolean Museum, Oxford

39. Piranesi, S. Maria Maggiore (H9. F791), *Vedute di Roma*.
37·5 × 53·5. Ashmolean Museum, Oxford

40. Piranesi, Piazza Navona (H16. F806), *Vedute di Roma*.
38·5 × 54·5. Ashmolean Museum, Oxford

41. Piranesi, Piazza di Spagna (H18. F795), *Vedute di Roma*.
38 × 59·2. Ashmolean Museum, Oxford
The Caffe degli Inglesi is on the left, opposite the Spanish Steps.

42. Piranesi, Palazzo Odescalchi (H26. F741), *Vedute di Roma*.
38·2 × 61·5. Ashmolean Museum, Oxford
The Palazzo Muti at the far end of the *piazza* was the residence of the Old Pretender, the titular James III, in his exile. This is a puzzling plate because, although published before 1761, it does not show the royal arms of Britain which were displayed outside the palace until 1766, when the Old Pretender died. Piranesi may have omitted them out of deference to his friends from England or the pro-Hanoverian, Cardinal Alessandro Albani.

43. Piranesi, Trevi Fountain (H19. F797), *Vedute di Roma*.
38 × 55. Ashmolean Museum, Oxford
Piranesi altered the statues on either side of Neptune in later versions of this plate. Perhaps the two shown in this first state of the plate were taken from Salvi's designs but, when the sculpture was eventually set in place, it differed from the original design and Piranesi had to alter his view. Compare the *Varie Vedute* view, plate 13, which shows the niches empty.

44. Piranesi, Castel S. Angelo and its bridge (H29. F793), *Vedute di Roma*.
35·5 × 58·5. Ashmolean Museum, Oxford

45. Piranesi, Arch of Septimius Severus (H54. F809), *Vedute di Roma*.
35·5 × 53·5. Ashmolean Museum, Oxford
The inscription on the arch was re-cut by Caracalla in the manner which Piranesi adopted when he re-worked his dedication of *Antichità romane*. To the right is the church of the Accademia di S. Luca, SS. Martina e Luca.

46. Piranesi, The Temple of Antoninus and Faustina (H49. F802), *Vedute di Roma*.
39 × 54. Ashmolean Museum, Oxford

Chapter Three

47. P. D. Olivero, Interior of the Teatro Regio, Turin, c. 1740. Museo d'Arte Antica, Turin
The scene is said to represent the inauguration of the theatre in 1740 when Giuseppe Bibiena designed the stage sets for the production of *Arsace*.

48. Ferdinando Galli Bibiena, Diagram, *Prospettiva Teorica*. Victoria and Albert Museum, London

49. G. Bibiena, Stage set, *Architetture, e Prospettive*, 1740. British Museum, London

50. F. Juvarra, View of stage set for *Teodosio il Giovane*.
Courtauld Institute, Witt Library

51. Piranesi, Drawing from Juvarra's stage set for *Teodosio il Giovane*.
26·5 × 41·1. British Museum, London

52. Piranesi, Ancient Capitol (F9), *Prima Parte*, 1743.
24 × 36. Ashmolean Museum, Oxford

53. Fischer von Erlach, The Mausoleum at Halicarnassus, *Entwürff einer historischen Architectur*, 1725.
British Museum, London

54. J. L. Le Geay, Vase.
British Museum, London

55. C. M. Challe, Stage set.
Royal Institute of British Architects, London

56. Piranesi, French Academy (H24. F739), *Vedute di Roma*.
38 × 61·5. Ashmolean Museum, Oxford
In the foreground a large statue is being dragged towards the Academy. Piranesi's lodgings were opposite the Academy and Bouchard's shop was further down the Corso by the church of S. Marcello.

57. M. Ricci, *Capriccio, Varia Marci Ricci . . . Experimenta*, 1730.
Private Collection, London

58. Piranesi, *Capriccio* (F23), *Grotteschi*.
39·5 × 54. Ashmolean Museum, Oxford

59. Piranesi, Drawing of Satyrs.
36·8 × 51·2. Pierpont Morgan Library, New York

60. Piranesi, Burial Chamber (F18), *Prima Parte*.
36 × 27. Ashmolean Museum, Oxford

60a. Piranesi, *Fall of Phaethon*.
Calcografia Nazionale, Rome

61. Piranesi, Drawing of a prison.
17·4 × 23·9. British Museum, London

62. Piranesi, *Carceri* XIV, first state, reversed.
41 × 53·5. Private Collection. Photo: Sotheby's
In this plate and in plates 64 and 66 the etching has been reversed for easier comparison with the related drawing.

63. Piranesi, Drawing of a prison.
18·3 × 13·3. Kunsthalle, Hamburg

64. Piranesi, *Carceri* VIII, first state, reversed.
54·5 × 40. Private Collection. Photo: Sotheby's

65. Piranesi, Drawing of bridges.
16·3 × 22·5. British Museum, London
This drawing shows clearly that the *Carceri* were not originally conceived solely in terms of prisons.

66. Piranesi, *Carceri* XI, first state, reversed.
40·5 × 54·5. Private Collection. Photo: Sotheby's

67. Piranesi, Drawing of a prison.
22·4 × 25·5. National Gallery of Scotland, Edinburgh

68. D. Marot, Prison d'Amadis, *Livre de decoration diferante*, 1702.
British Museum, London

69. Piranesi, Dark Prison (F4), *Prima Parte*.
36 × 24. Ashmolean Museum, Oxford

70. Ferdinando Galli Bibiena, Prison stage set.
Victoria and Albert Museum, London

71. Piranesi, Drawing of a colonnaded canal.
12·9 × 8·8. British Museum, London

72. Piranesi, Title page (F2) to *Prima Parte*.
35·5 × 25. Ashmolean Museum, Oxford
The 'E' of Giobbe, which was not erased from the dedication of the first state, can be seen at the lower right-hand corner of the slab.

73. Piranesi, Ruins of Ancient Buildings (F5), *Prima Parte*.
33·6 × 25·5. Ashmolean Museum, Oxford

74. Piranesi, Remains of an Ancient Tomb (F6), *Prima Parte*.
36 × 24. Ashmolean Museum, Oxford

75. Piranesi, Ancient Forum (F13), *Prima Parte*.
24 × 35. Ashmolean Museum, Oxford

76. Piranesi, Group of Stairs (F10), *Prima Parte*.
25 × 37. Ashmolean Museum, Oxford

77. Piranesi, Magnificent Bridge (F7), *Prima Parte*.
24 × 36. Ashmolean Museum, Oxford

78. Piranesi, Ancient Temple of Vesta (F17), *Prima Parte*.
34·5 × 25. Ashmolean Museum, Oxford

79. Piranesi, Ancient Mausoleum (F14), *Prima Parte*.
35 × 25. Ashmolean Museum, Oxford
The drawing for this design, in the reverse direction and with minor differences, is in Edinburgh, see plate 344.

80. Piranesi, Ancient baths (F126), *Opere Varie*.
14 × 20. Ashmolean Museum, Oxford
Most surprisingly, Piranesi allows himself to include a version of the despised Doric order.

81. Piranesi, Entrance to an ancient gymnasium (F123), *Opere Varie*.
14 × 21. Ashmolean Museum, Oxford

82. Piranesi, Porticos round a forum (F127), *Opere Varie*.
14 × 20·5. Ashmolean Museum, Oxford
These three small plates, together with another one and modified illustrations from the *Lettere di giustificazione* of 1757, must have been inserted into *Opere Varie* in the 1760s.

83. Piranesi, Plan for a Magnificent College (F121), *Opere Varie*.
61 × 45. Ashmolean Museum, Oxford
This is the plan which, according to Sir William Chambers, was drawn by Piranesi to demonstrate his architectural knowledge to the *pensionnaires* of the French Academy.

84. Piranesi, Magnificent Port (F122), *Opere Varie*.
40 × 55. Ashmolean Museum, Oxford

85. Piranesi, *Capriccio* (F22), *Grotteschi.*
39 × 54·5. Ashmolean Museum, Oxford

86. Piranesi, *Capriccio* (F21), *Grotteschi.*
39·5 × 55. Ashmolean Museum, Oxford

87. Piranesi, *Capriccio* (F20), *Grotteschi.*
39 × 54·5. Ashmolean Museum, Oxford

88. Piranesi, *Carceri* I, first state (F24).
54·5 × 41. Ashmolean Museum, Oxford

89. Piranesi, *Carceri* I, second state (F24).
54·5 × 41. Ashmolean Museum, Oxford

90. Piranesi, *Carceri* II, first state (F25).
55·5 × 42. Ashmolean Museum, Oxford

91. Piranesi, *Carceri* V, first state (F28).
56 × 41. Ashmolean Museum, Oxford
Plates II and V were additions to the series and do not appear in Bouchard's first edition of the *Carceri.*

92. Piranesi, *Carceri* III, first state (F26).
54 × 41. Ashmolean Museum, Oxford

93. Piranesi, *Carceri* III, second state (F26).
54 × 41. Ashmolean Museum, Oxford

94. Piranesi, *Carceri* IV, first state (F27).
55 × 41. Ashmolean Museum, Oxford

95. Piranesi, *Carceri* IV, second state (F27).
55 × 41. Ashmolean Museum, Oxford

96. Piranesi, *Carceri* VI, first state (F29).
54 × 40. Private Collection. Photo: Sotheby's

97. Piranesi, *Carceri* VI, second state (F29).
54 × 40. Ashmolean Museum, Oxford

98. Piranesi, *Carceri* VII, first state (F30).
55 × 41. Ashmolean Museum, Oxford

99. Piranesi, *Carceri* VII, second state (F30).
55 × 41. Ashmolean Museum, Oxford

100. Piranesi, *Carceri* VIII, first state (F31).
54·5 × 40. Private Collection. Photo: Sotheby's

101. Piranesi, *Carceri* VIII, second state (F31).
54·5 × 40. Ashmolean Museum, Oxford

102. Piranesi, *Carceri* IX, first state (F32).
55 × 40·5. Ashmolean Museum, Oxford

103. Piranesi, *Carceri* IX, second state (F32).
55 × 40·5. Ashmolean Museum, Oxford

104. Piranesi, *Carceri* X, first state (F33).
41 × 55. Soane Museum, London

105. Piranesi, *Carceri* X, second state (F33).
41 × 55. Ashmolean Museum, Oxford

106. Piranesi, *Carceri* XI, first state (F34).
40·5 × 54·5. Private Collection. Photo: Sotheby's

107. Piranesi, *Carceri* XI, second state (F34).

40·5 × 54·5. Ashmolean Museum, Oxford

108. Piranesi, *Carceri* XII, first state (F35).
41 × 56. Ashmolean Museum, Oxford

109. Piranesi, *Carceri* XII, second state (F35).
41 × 56. Ashmolean Museum, Oxford

110. Piranesi, *Carceri* XIII, first state (F36).
40 × 54·5. Ashmolean Museum, Oxford

111. Piranesi, *Carceri* XIII, second state (F36).
40 × 54·5. Ashmolean Museum, Oxford

112. Piranesi, *Carceri* XIV, first state (F37).
41 × 53·5. Private Collection. Photo: Sotheby's

113. Piranesi, *Carceri* XIV, second state (F37).
41 × 53·5. Ashmolean Museum, Oxford

114. Piranesi, *Carceri* XV, first state (F38).
40·5 × 55. Private Collection. Photo: Sotheby's

115. Piranesi, *Carceri* XV, second state (F38).
40·5 × 55. Ashmolean Museum, Oxford

116. Piranesi, *Carceri* XVI, first state (F39).
40·5 × 55. Ashmolean Museum, Oxford.

117. Piranesi, *Carceri* XVI, second state (F39).
40·5 × 55. Ashmolean Museum, Oxford

Chapter Four

118. F. Polanzani, Portrait of Piranesi, *Opere Varie.*
Private Collection
This portrait was first published in *Opere Varie* but also appears in some editions of *Antichità romane.*

119. Piranesi, Trophy from Acqua Giulia (F136), *Trofei di Ottaviano Augusto,* 1753.
60 × 40. Ashmolean Museum, Oxford
This is the right-hand one of the two trophies on the Capitol, shown on the balustrade in plate 25.

119a. Piranesi, Detail of decorative design for Syon House, *The Works in Architecture of Robert and James Adam,* 1779.
Private Collection
The Adams must have sent drawings to Rome from which Piranesi executed his plates of the decorations at Syon.

120. A. Buonamici, View of the tomb of the freedmen of Livia, originally published in F. Bianchini's *Camere ed Inscrizione sepulcrali de' Liberti . . . della Casa di Augusto,* and republished by Piranesi first in his *Camere sepolcrali,* in about 1752, and then as plate xxvi of *Antichità romane* III.
36·5 × 48·5. Ashmolean Museum, Oxford

121. W. Hogarth, Portrait of Lord Charlemont.
Smith College Museum of Art, Northampton, Mass.

122. Piranesi, Copy of the dedicatory plate to *Antichità romane* I, reproduced in *Lettere di giustificazione.*
14 × 21·5. Private Collection
The original is F144.

123. Piranesi, Second state of the dedicatory plate (F225) to *Antichità romane* II.
39·5 × 64. Ashmolean Museum, Oxford
In this plate, although Piranesi later deleted the imaginary tomb of John Parker, he left the inscription to Charlemont (on the left of the boar's head). He included tombs to two other British friends, Robert Adam (on the extreme left) and Allan Ramsay (in the centre behind the palm tree). The street is intended to represent a tomb-lined stretch of the Appian Way. Even here, Piranesi's theatre training shows in the view *a l'angolo*.

124. Piranesi, Drawing for the dedicatory plate to *Antichità romane* II.
40 × 63·5. British Museum, London

125. Piranesi, Second state of the dedicatory plate (F287) to *Antichità romane* III.
40 × 60. Ashmolean Museum, Oxford
In the first state, the inscription to Charlemont appeared in the circular altar in the centre, but it was subsequently altered to a dedication to Mars the Avenger.

126. Piranesi, Second state of the dedicatory plate (F338) to *Antichità romane* IV.
39·5 × 53·8. Ashmolean Museum, Oxford
In the first state, the inscription to Charlemont appeared below the pediment but it was altered to a dedication to 'The Champions and Protectors of the Fine Arts'.

127. Piranesi, Drawing of the dedicatory plate to *Antichità romane* IV.
39·3 × 53·8. Private Collection. Photo: Christie's
There are a few minor differences in the pediment and the background between this drawing and the final plate.

128. Piranesi, Third state of the dedicatory plate (F144) to *Antichità romane* I.
46 × 68. Ashmolean Museum, Oxford
The coat of arms has now been smashed and the new dedication inserted. In the second intermediary state, the inscription is deleted but the new one not substituted and Charlemont's arms have been erased but not smashed. Finally, when Francesco Piranesi brought out another edition later in the century, he dedicated it to King Gustavus of Sweden and placed the arms of Sweden on the smashed shield.

129. Piranesi, Title page to *Lettere di giustificazione*, 1757.
21·5 × 15. Private collection

130. Piranesi, Vignette, *Lettere di giustificazione*.
4·9 × 13·4. Private collection
This depicts Grant being carried to a pauper's burial ground in classical times—in mocking contrast to the grand imaginary tombs in the second dedicatory plate of *Antichità romane*.

131. Piranesi, Vignette, *Lettere di giustificazione*.
5·5 × 13·4. Private collection
This depicts Time uncovering Truth, with Parker, Murphy and Grant undergoing the Roman humiliation of passing under the spears, a prelude to being sold into slavery.

131a. Piranesi, *Capriccio* drawing.
38·8 × 53·2. Soane Museum, London
This drawing was probably given to Adam by Piranesi.

Chapter Five

132. Piranesi, Map of Rome with fragments of the *Topographia* from the Capitoline Museum (F153), *Antichità romane* I, 1756.
46·5 × 68. Ashmolean Museum, Oxford

133. Piranesi, Aurelian Wall (F158), viii b, *Antichità romane* I.
13 × 19·5. Ashmolean Museum, Oxford

134. Piranesi, House of Crescentius (F183), xxi a, *Antichità romane* I.
13 × 21·5. Ashmolean Museum, Oxford

135. Piranesi, The Colosseum (F215), xxxvii a, *Antichità romane* I.
12·5 × 26·8. Ashmolean Museum, Oxford

136. Piranesi, The interior of the Colosseum (F216), xxxvii b, *Antichità romane* I.
12·7 × 26·8. Ashmolean Museum, Oxford

137. Piranesi, Basilica of Maxentius, mistakenly called the Golden House of Nero (F208), xxxiii b, *Antichità romane* I.
10·2 × 26·8. Ashmolean Museum, Oxford

138. Piranesi, Porta Maggiore and the aqueduct systems (F176), xvii b, *Antichità romane* I.
12 × 20. Ashmolean Museum, Oxford

139. Piranesi, Interior of the Pantheon (F172), xv b, *Antichità romane* I.
12 × 26. Ashmolean Museum, Oxford
The decoration of the attic storey below the coffering of the dome was altered shortly after Piranesi made the drawing for this plate.

140. Piranesi, Plan of the Castro Pretorio (F218), xxxix, *Antichità romane* I.
35·5 × 25. Ashmolean Museum, Oxford
The discrepancy between the surviving remains and Piranesi's imagination is startling.

141. Piranesi, Plan of the tomb of Constantia (F243) xxi, *Antichità romane* II.
35 × 59. Ashmolean Museum, Oxford

142. Piranesi, Cross-section of the tomb of Constantia (F244), xxii, *Antichità romane* II.
34 × 46·5. Ashmolean Museum, Oxford
Once again, Piranesi's imagination exceeds reality in the layout of the forecourt of the tomb—now the church of S. Constanza whose charming mosaics are one of the least visited beauties of Rome. The design, however, is based on the plan in Desgodetz.

143. Piranesi, Plan and cross-section of the tomb supposed to be of Alexander Severus (F253), xxxi, *Antichità romane* II.
39·8 × 24·8. Ashmolean Museum, Oxford
There is a drawing in reverse for the column capitals in the Kunsthalle, Hamburg. Goethe drew a copy of this grouping.

144. Piranesi, Reconstruction of the tomb of Cecilia Metella (F335), liii, *Antichità romane* III.
35 × 52. Ashmolean Museum, Oxford

145. Piranesi, Cross-section of the Castel S. Angelo with its bridge (F344), vi, *Antichità romane* IV.
41 × 140. Ashmolean Museum, Oxford
An enormous plate. The reconstruction is quite fanciful. Note the detail of the lifting tackle at work in the top left corner.

146. Piranesi, Tomb of L. Arruntius (F232), x, *Antichità romane* II.
39·5 × 60. Ashmolean Museum, Oxford

147. Barbault, Stucco work in the tomb of L. Arruntius (F234), xii, *Antichità romane* II.
39 × 59·5. Ashmolean Museum, Oxford
This is one of several etchings of stucco work or sculptural details which Piranesi left to the French artist Jean Barbault.

148. Piranesi, Lifting tackle (F336), liv, *Antichità romane* III.
33·5 × 59. Ashmolean Museum, Oxford

149. Piranesi, Foundations of the Castel S. Angelo (F341), ix, *Antichità romane* IV.
87·5 × 45. Ashmolean Museum, Oxford

150. Piranesi, Foundations of the Theatre of Marcellus (F367), xxxii, *Antichità romane* IV.
39·5 × 59. Ashmolean Museum, Oxford

151. Piranesi, Ruins of aqueducts (F176), xvii b, *Antichità romane* I.
12 × 20. Ashmolean Museum, Oxford

152. Piranesi, Baths of Diocletian (F198), xxviii b, *Antichità romane* I.
9·6 × 27·5. Ashmolean Museum, Oxford

153. Piranesi, Baths of Titus (F197), xxviii a, *Antichità romane* I.
12.3 × 27·2. Ashmolean Museum, Oxford

154. Piranesi, Forum of Trajan (F199), xxix a, *Antichità romane* I.
12·8 × 20·5. Ashmolean Museum, Oxford

155. Piranesi, Trajan's Column (F200), xxix b, *Antichità romane* I.
12·5 × 19·9. Ashmolean Museum, Oxford

156. Piranesi, The Palatine from the Circus Maximus (F211), xxxv a, *Antichità romane* I.
13·6 × 27·4. Ashmolean Museum, Oxford

157. Piranesi, Tomb of the household of Augustus (F264), xlii, *Antichità romane* II.
37·5 × 51·5. Ashmolean Museum, Oxford

158. Piranesi, Tomb of L. Arruntius (F231), ix, *Antichità romane* II.
39·5 × 60. Ashmolean Museum, Oxford

159. Piranesi, Communal tomb (F238), xvi, *Antichità romane* II.
37 × 59. Ashmolean Museum, Oxford

160. Piranesi, Cinerary urns from the Villa Corsini (F279), lvii, *Antichità romane* II.
37 × 62. Ashmolean Museum, Oxford

161. Piranesi, Tomb of the Scipios (F250), xxviii, *Antichità romane* II.
37·5 × 52. Ashmolean Museum, Oxford

162. Piranesi, Ruins of the Tomb of Augustus (F285), lxiii, *Antichità romane* II.
35·3 × 52. Ashmolean Museum, Oxford
The tomb is shown in a reconstructed state together with some sculptural remains.

163. Piranesi, Tomb in the Campagna (F282), lx, *Antichità romane* II.
47 × 52·5. Ashmolean Museum, Oxford

164. Piranesi, Tombs on the Appian Way (F269), xlvii, *Antichità romane* II.
37·5 × 51·5. Ashmolean Museum, Oxford

165. Piranesi, Crematorium on the Appian Way (F291), vi, *Antichità romane* III.
37 × 60·2. Ashmolean Museum, Oxford

166. Piranesi, Tomb of the Metelli (F300), xv, *Antichità romane* III.
41 × 47. Ashmolean Museum, Oxford

167. Piranesi, Tomb of the Plautii (F297), xii, *Antichità romane* III.
38 × 60. Ashmolean Museum, Oxford
The tomb, which can be seen on the road to Tivoli, was crenellated as a castle in the middle ages like the Capo di Bove on the Appian Way.

168. Piranesi, The so-called Tomb of Nero (F299), xiv, *Antichità romane* III.
57 × 39·5. Ashmolean Museum, Oxford
The graffiti on the side of the tomb were not part of the original decoration.

169. Piranesi, Castel S. Angelo (F339), iv, *Antichità romane* IV.
37 × 65. Ashmolean Museum, Oxford

170. Piranesi, Ponte Ferrato (F356), xxi, *Antichità romane* IV.
36·4 × 59·3. Ashmolean Museum, Oxford

171. Piranesi, Gate inside Castel S. Angelo (F343), x, *Antichità romane* IV.
36·5 × 47·5. Ashmolean Museum, Oxford
Since the Mausoleum of Hadrian had been converted into a fort, the military accoutrements are a natural decoration. The slight distortion at the centre of this and some of the other illustrations in this book is inevitable when photographs are taken of plates bound in large folios. I have deliberately not sought out loose plates to photograph instead because such illustrations act as a reminder that many of Piranesi's plates were book illustrations and not prints for framing.

Chapter Six

172. J. D. Le Roy, View of the Erectheum, Athens, *Les Ruines des plus beaux monuments de la Grèce*, 1758.
British Museum, London

173. Piranesi, Villa Albani (H89. F853), *Vedute di Roma*.
43 × 69. Ashmolean Museum, Oxford
The villa, which belongs to the Torlonia family, still contains

part of the Albani collection. One of the *tempietti* is to be seen at the end of the wing to the right of the main block of the Villa.

174. Villa Albani, Tempietto Greco.
Mansell Collection
This odd building, designed by Marchionni, is singularly un-Greek and could well have earned Piranesi's contempt.

175. Angelica Kauffmann, Portrait of Winckelmann.
Kunsthalle, Zurich

176. Piranesi, Italian title page (F929) to *Della Magnificenza ed Architettura de'Romani*, 1761.
45 × 29. Ashmolean Museum, Oxford

177. Piranesi, Cloaca Maxima (F934), ii, *Della Magnificenza*.
39 × 23·5. Ashmolean Museum, Oxford

178. Piranesi, Roman column capitals (F949), xx, *Della Magnificenza*.
39 × 59. Ashmolean Museum, Oxford
Roman versions of the Ionic capital are contrasted with those from Greece. The *Bocca della Verità* from S. Maria in Cosmedin is included not because it has any relevance to the argument but because the mouth is popularly supposed to bite off the fingers of a liar, such as Le Roy, whose claim for the supposed superiority of Greek examples is quoted above.

179. Piranesi, Roman column bases (F943), xi, *Della Magnificenza*.
39 × 60. Ashmolean Museum, Oxford
The rich variety of Roman column bases is contrasted with those illustrated by Le Roy which are shown on the scrap of paper pinned at the top of the plate.

180. Piranesi, Reconstruction of a Tuscan building (F957),xxviii, *Della Magnificenza*.
36·5 × 23·5. Ashmolean Museum, Oxford
181. Piranesi, Reconstruction of a Greek building (F953), xxiv, *Della Magnificenza*.
37·5 × 23·5. Ashmolean Museum, Oxford

182. Piranesi, Temple of Concord at Agrigento (F951), xxii, *Della Magnificenza*.
34·5 × 23·5. Ashmolean Museum, Oxford
Piranesi is not known to have gone to Sicily. If he had, he would certainly have been tempted to illustrate some of the antiquities. The drawing for this view probably came from Mylne. It is delightfully appropriate that the favourite spot for wedding photographs in Agrigento is the steps of the Temple of Concord.

183. Piranesi, Title page (F967) to *Osservazioni . . . sopra la Lettre de M. Mariette*, 1765.
40 × 25·2. Ashmolean Museum, Oxford
Piranesi compares his own practical credentials with Mariette's scholar's pen—held in the left hand.

184. Piranesi, Drawing for *Parere su l'Architettura*.
67 × 47. British Museum, London

185. Piranesi, Temple of the London Society of Antiquaries (F969), *Parere*.
16 × 21·5. Ashmolean Museum, Oxford

186. Piranesi, Architectural fantasy (F982), *Parere*.
41 × 64·5. Ashmolean Museum, Oxford

187. Piranesi, Architectural fantasy (F979), *Parere*.
53 × 38·5. Ashmolean Museum, Oxford

188. Piranesi, Architectural fantasy (F978), *Parere*.
62 × 39. Ashmolean Museum, Oxford
The quotation from Terence is inaccurate. It should read VOS not VAS.

189. Piranesi, Architectural fantasy (F981), *Parere*.
39 × 54. Ashmolean Museum, Oxford

190. Piranesi, Architectural fantasy (F980), *Parere*.
53 × 38·5. Ashmolean Museum, Oxford
The quotation is from Ovid: 'Nature the innovator turns one shape into another.'

Chapter Seven

191. Piranesi, Catalogue (F1).
48 × 30. Soane Museum, London
Illustrations of the Catalogue in Calvesi and Monferini's edition of Focillon's *Piranesi*, show that the artist used to send out individually addressed copies to friends and clients after each up-dating. This plate shows the Catalogue as it stood immediately after Piranesi's death.

192. Piranesi, Cross-section of the fountain (F413), xii, *Acqua Giulia*, 1761.
39 × 21·2. Ashmolean Museum, Oxford

193. Piranesi, Plumbing system of the fountain (F416), xv, *Acqua Giulia*.
38·5 × 21. Ashmolean Museum, Oxford

194. Piranesi, Detail of map with portraits of Piranesi and Adam (F438), iii, *Campus Martius*, 1762.
Ashmolean Museum, Oxford

195. Piranesi, Plans of the Campus Martius (F439), iv, *Campus Martius*.
44·5 × 29. Ashmolean Museum, Oxford
These maps show Piranesi's reconstruction of the development of Rome at different periods of its history.

196. Piranesi, The Hadrianeum stripped of later building (F465), xxxv, *Campus Martius*.
23 × 34·5. Ashmolean Museum, Oxford
For the effect of this compare the actual view (H32), plate 29.

197. Piranesi, Reconstruction of the Theatres of Balbus and Marcellus (F479), xlviii a, *Campus Martius*.
11 × 28·7. Ashmolean Museum, Oxford

198. Piranesi, Baths of Sallust (F473), xliii, *Campus Martius*.
26 × 29·2. Ashmolean Museum, Oxford

199. Piranesi, Reconstruction of the Pantheon (F479), xlviii b, *Campus Martius*.
11 × 28·7. Ashmolean Museum, Oxford

200. Piranesi, Title page (F480) to *Emissario del Lago Albano* 1762.
41·5 × 26.5. Ashmolean Museum, Oxford

201. Piranesi, Reconstruction of the Theatre of Statilius Taurus (F479), xlviii c, *Campus Martius*.
11 × 28·7. Ashmolean Museum, Oxford

202. Piranesi, Plan, cross-section and view of the tunnel (F483), i, *Emissario del Lago Albano*.
40·5 × 50·5. Ashmolean Museum, Oxford

203. Piranesi, Grotto by Lago Albano (F500), viii, *Di Due Spelonche*.
60 × 91. Ashmolean Museum, Oxford

204. Piranesi, Cistern near Castel Gandolfo (F531), xxii, *Antichità d'Albano*.
40·5 × 61·5. Ashmolean Museum, Oxford

205. Piranesi, Fortifications of Cori (F540), i, *Antichità di Cora*, 1764.
78 × 55. Ashmolean Museum, Oxford
Like many of Piranesi's reconstructions, this enormous plate is rather fanciful but, although the visitor may be disappointed by the scale of the surviving fragments, the little town is well worth a visit.

206. Piranesi, Temple of Hercules (F544), iv, *Antichità di Cora*.
42·5 × 52. Ashmolean Museum, Oxford

207. Piranesi, Cross-section of the Temple of Hercules (F539), p. 16, *Antichità di Cora*.
29·5 × 26. Ashmolean Museum, Oxford
A typical detailed archaeological plate of which there are numerous examples in almost all of Piranesi's works.

208. Piranesi, Etruscan friezes (F974), i, *Della Introduzione e del Progresso delle Belle Arti*.
41 × 27. Ashmolean Museum, Oxford

209. Piranesi, Temple of the Sibyl, Tivoli (H63. F766), *Vedute di Roma*.
62 × 43·5. Ashmolean Museum, Oxford

210. Piranesi, Satyrical map of Horace's farm (F856), *Diverse maniere*.
16 × 21·8. Ashmolean Museum, Oxford
Piranesi scornfully shows the French scholar's map of Horace's farm as a dog dropping because Capmartin de Chaupy had disagreed with him in print on the dating of the tunnel of Lake Albano.

211. Piranesi, Title page (F396) to *Acqua Giulia*, 1761.
44·5 × 28·5. Ashmolean Museum, Oxford

212. Piranesi, Fountain of the Acqua Giulia, first state (H34. F822), *Vedute di Roma*.
38 × 60·5. Ashmolean Museum, Oxford
At first Piranesi entitled this plate the 'Acqua Marcia', but his researches showed that the aqueduct was for the Acqua Giulia and the title was changed. The plate appears both in the *Vedute di Roma* and in *Acqua Giulia*.

213. Piranesi, Aqueduct (F410), ix, *Acqua Giulia*.
21·2 × 40. Ashmolean Museum, Oxford

214. Piranesi, Italian title page (F429) to *Campus Martius*.
44·5 × 23·5. Ashmolean Museum, Oxford

215. Piranesi, Remains of the Saepta Julia stripped of accretions (F456), xxv, *Campus Martius*.
20·3 × 40·2. Ashmolean Museum, Oxford

216. Piranesi, Theatre of Marcellus stripped of accretions (F458), xxvii, *Campus Martius*.
23·2 × 35. Ashmolean Museum, Oxford
For the effect of this, compare the view (H33), plate 26.

217. Piranesi, Via Flaminia (F468), xxxviii, *Campus Martius*.
22 × 35. Ashmolean Museum, Oxford

218. Piranesi, Ruins of the Milvian Bridge (F470), xl, *Campus Martius*.
22·5 × 34·5. Ashmolean Museum, Oxford

219. Piranesi, Entrance to the tunnel (F487), v, *Emissario del Lago Albano*.
45 × 64. Ashmolean Museum, Oxford
The figures are reduced in scale so as to increase the massive effect of the already impressive masonry.

220. Piranesi, Inlet from the Lake (F488), vi, *Emissario del Lago Albano*.
41 × 55·5. Ashmolean Museum, Oxford

221. Piranesi, Outlet into the tannery (F491), ix, *Emissario del Lago Albano*.
40·5 × 55·5. Ashmolean Museum, Oxford

222. Piranesi, Grotto by Lago Albano (F494), ii, *Di due Spelonche*.
40 × 62. Ashmolean Museum, Oxford
It was while drawing this grotto that Piranesi was mistaken for a sorcerer and nearly lynched.

223. Piranesi, Tomb near Albano (F511), iii, *Antichità d'Albano*.
55 × 64. Ashmolean Museum, Oxford

224. Piranesi, Steps down to a cistern (F523), xiv, *Antichità d'Albano*.
39·5 × 28·5. Ashmolean Museum, Oxford

225. Piranesi, Ruins near Castel Gandolfo (F533), xxiv, *Antichità d'Albano*.
38·5 × 54. Ashmolean Museum, Oxford

226. Piranesi, Tomb near Albano (F512), iv, *Antichità d'Albano*.
39·5 × 56. Ashmolean Museum, Oxford

227. Piranesi, Viaduct on the Appian Way (F536), xxvii, *Antichità d'Albano*.
43 × 67. Ashmolean Museum, Oxford

228. Piranesi, The Appian Way (F534), xxv, *Antichità d'Albano*.
30 × 23. Ashmolean Museum, Oxford
The paving stones that survive along the Appian Way are not as vast as Piranesi represents them here, nor are such side blocks as remain quite so enormous.

229. Piranesi, A cistern (F526), xvii, *Antichità d'Albano*.

46·2 × 27. Ashmolean Museum, Oxford

230. Piranesi, Title page (F537) to *Antichità di Cora*.
41 × 27. Ashmolean Museum, Oxford

231. Piranesi, Temple of the Dioscuri, Cori (F541), ii, *Antichità di Cora*.
41 × 57. Ashmolean Museum, Oxford

232. Temple of Hercules, Cori (F545), v, *Antichità di Cora*.
38·5 × 54. Ashmolean Museum, Oxford

233. Piranesi, Temple of the Sibyl, Tivoli (H61. F764), *Vedute di Roma*.
40 × 63. Ashmolean Museum, Oxford

234. Piranesi, Temple of the Coughs (H70. F775), *Vedute di Roma*.
55 × 62·3. Ashmolean Museum, Oxford
This oddly named temple can be seen at the bottom of the hill from the terrace of the Villa d'Este. This view is dated 1764 in Francesco's catalogue.

235. Piranesi, Cascatelle, Tivoli (H92. F780), *Vedute di Roma*.
47 × 71. Ashmolean Museum, Oxford
This view has been totally altered in the interests of a hydro-electric scheme.

236. Piranesi, The waterfall, Tivoli (H75. F779), *Vedute di Roma*.
47 × 70. Ashmolean Museum, Oxford
This waterfall has now been diverted further from the town. The view is dated 1766.

237. Piranesi, Villa d'Este, Tivoli (H105. F826), *Vedute di Roma*.
46 × 69. Ashmolean Museum, Oxford
This view shows the gardens before the huge cypresses, which now prevent the visitor from taking in the whole garden layout as a unity, had grown up. This view is dated 1773 in Francesco's catalogue.

238. Piranesi, Stoa Poecile, Hadrian's Villa (H94. F824), *Vedute di Roma*.
45 × 58. Ashmolean Museum, Oxford

239. Piranesi, Canopus, Hadrian's Villa (H90. F844), *Vedute di Roma*.
44·5 × 58. Ashmolean Museum, Oxford
This view is dated 1769 in Francesco's catalogue.

240. Piranesi, Baths, Hadrian's Villa (H93. F785), *Vedute di Roma*.
45·5 × 58. Ashmolean Museum, Oxford
The arch at the top of the picture is splayed out on both sides so as to give an impossibly wide-angled view. The structure is now identified as part of the baths of the villa. This plate and plate 238 are dated 1770 in Francesco's catalogue.

241. Piranesi, Heliocaminus, Hadrian's Villa (H133. F847), *Vedute di Roma*.
42 × 60. Ashmolean Museum, Oxford
This view is dated 1777 in Francesco's catalogue.

242. Piranesi, Drawing of the Maritime Theatre, Hadrian's Villa.
39 × 61·7. Ashmolean Museum, Oxford

243. Piranesi, Drawing of Hadrian's Villa.
43 × 57. Galleria degli Uffizi, Florence

Chapter Eight

244. Piranesi and D. Cunego, Portrait of Clement XIII (F928), *Della Magnificenza*.
42·8 × 31·8. Ashmolean Museum, Oxford

245. Piranesi, View of Blackfriars Bridge, London (F991), 1766.
37 × 60. British Museum, London
The bridge, which was designed by Robert Mylne, was opened in 1769.

246. Façade of S. Maria del Priorato.
Gabinetto Fotografico Nazionale, Rome

247. Drawing of the façade of S. Maria before the destruction of the superstructure.
Soane Museum, London
Although not by Piranesi himself, this drawing shows that the Adams kept in touch with their Italian friend—assuming that is, that the drawing came to Soane from the Adams.

248. S. Maria del Priorato, interior.
Gabinetto Fotografico Nazionale, Rome

249. Piranesi, Design for the altar in S. Maria del Priorato.
47·2 × 36·5. Pierpont Morgan Library, New York

250. Piranesi, Drawing for the garden front of the Priory of Malta.
50·6 × 74·1. Kunstbibliothek, Berlin

251. Garden front of the Priory of Malta.
Mansell Collection

252. Piazza dei Cavalieri di Malta.
Mansell Collection

253. Piranesi, Design for the altar in S. Maria del Priorato.
30·4 × 18·6. Kunstbibliothek, Berlin

254. Piranesi, S. Giovanni in Laterano, interior (H88. F726), *Vedute di Roma*.
42·5 × 67·5. Ashmolean Museum, Oxford
Piranesi was to have demolished the tabernacle over the high altar and the apse with its mosaic at the far end of the basilica. This view is dated 1768 in Francesco's catalogue.

255. Piranesi, Design for S. Giovanni, viii.
58·7 × 89·8. Avery Architectural Library, Columbia University, New York

255a. Sala della Rotonda, Museo Pio-Clementino, Vatican.
Mansell Collection
This room was part of the new Vatican sculpture galleries designed by M. Simonetti.

256. Piranesi, Design for S. Giovanni, xv.
89·7 × 57·2. Avery Architectural Library, Columbia University, New York
Piranesi's version of the huge head of Christ is set at the back of the new apse.

257. Piranesi, Design for S. Giovanni, x.
87·6 × 56·4. Avery Architectural Library, Columbia University, New York

258. Piranesi, Decoration in the Caffe degli Inglesi (F906), *Diverse maniere*, 1769.
21 × 32. Ashmolean Museum, Oxford

259. Piranesi, Decoration in the Caffe degli Inglesi (F907), *Diverse maniere*.
21 × 27. Ashmolean Museum, Oxford

260. Piranesi, Drawing of a chimney piece and chair.
24·6 × 34. Pierpont Morgan Library, New York

261. Chimney piece at Gorhambury, Hertfordshire. Photo: *Country Life*.
On the chimney piece are three antique vases bought from Piranesi in Rome by Edward and Harriot Walter, whose daughter married the Lord Grimston who rebuilt Gorhambury. The vases are illustrated in *Vasi, candelabri, cippi*. The panels of porphyry inset into the chimney piece are edged with ormolu beading.

262. Piranesi, Detail of the view of St. Peter's (H101. F721), *Vedute di Roma*.
The coach is similar to the design in *Diverse maniere*. See plate 263.

263. Piranesi, Various designs (F920), *Diverse maniere*.
38·5 × 25·2. Ashmolean Museum, Oxford
The coffee pots on the side table are remarkably ungainly and, so far as I know, no such objects survive. The vehicle on the left is a sedan chair but none appear in Piranesi's prints. Perhaps they were only nocturnal conveyances.

264. Piranesi, Etruscan decorative details (F860), *Diverse maniere*.
38·2 × 25·3. Ashmolean Museum, Oxford
Many of these supposedly Etruscan ornaments appear both in the architectural fantasies of the *Parere* and in the decoration of S. Maria del Priorato and its *piazza*.

265. Piranesi, Shells (F858), *Diverse maniere*.
38·3 × 25·3. Ashmolean Museum, Oxford

266. C. L. Clérisseau, Drawing of a ruin room.
Fitzwilliam Museum, Cambridge
This room still survives in the convent attached to the Trinità del Monti.

267. Chimney piece at Burghley. Photo: *Country Life*.

268. Piranesi, Chimney piece for Burghley (F861), *Diverse maniere*.
34 × 24. Ashmolean Museum, Oxford
Piranesi complained that the etching did not give an adequate impression of the contrasting effects of the original. The Adamesque design above was not intended for Burghley.

269. Chimney piece for John Hope.
Rijksmuseum, Amsterdam

270. Piranesi, Chimney piece for John Hope (F862), *Diverse maniere*.
38·3 × 24·5. Ashmolean Museum, Oxford

271. Side table for Cardinal G. B. Rezzonico.
Rijksmuseum, Amsterdam
Its companion piece is in Minneapolis.

272. Piranesi, Various designs (F923), *Diverse maniere*.
39 × 25·5. Ashmolean Museum, Oxford
The two pendant swags on either side of the centre leg were omitted in the execution. The clock, urns, coffers and candelabra designed for the Cardinal have not yet been traced.

273. Piranesi, Title page (F854) to *Diverse maniere*.
48 × 71. Ashmolean Museum, Oxford
There is a drawing for this title page in the Kunstbibliothek, Berlin.

274. Piranesi, Design for a chimney piece (F874), *Diverse maniere*.
24·5 × 38. Ashmolean Museum, Oxford

275. Piranesi, Design for a chimney piece (F878), *Diverse maniere*.
24·5 × 38·5. Ashmolean Museum, Oxford
Piranesi notes the English use of decorated grates—such as the one at Burghley, decorated with Roman *fasces*.

276. Piranesi, Design for a chimney piece (F881), *Diverse maniere*.
24·5 × 38·5. Ashmolean Museum, Oxford

277. Piranesi, Design for a chimney piece (F863), *Diverse maniere*.
33·5 × 24·5. Ashmolean Museum, Oxford
The grotesques which Adam subsequently executed in the Etruscan room at Osterley are similar to those above the chimney piece.

278. Piranesi, Design for a chimney piece (F892), *Diverse maniere*.
24·5 × 38. Ashmolean Museum, Oxford

279. Piranesi, Designs for chimney pieces (F873), *Diverse maniere*.
40·5 × 26·5. Ashmolean Museum, Oxford

280. Piranesi, Various designs (F924), *Diverse maniere*.
39 × 25·3. Ashmolean Museum, Oxford

281. Piranesi, Various designs (F918), *Diverse maniere*.
39 × 25·3. Ashmolean Museum, Oxford

Chapter Nine

282. P. Labruzzi, Portrait of Piranesi.
Museo di Roma Gabinetto Fotografico Nazionale
This posthumous portrait shows Piranesi holding the title page of the new publication on Paestum and wearing the insignia of the order of the Sperone d'Oro. In the background is the candelabrum intended for his tomb.

283. A sculptor's workshop, B. Cavaceppi, *Raccolta d'Antiche Statue*, 1768.

The Warburg Institute, University of London

284. Piranesi, Title page (F983) to *Disegni del . . . Guercino*, 1764.
48 × 35·4. Private Collection

285. Piranesi, Candelabrum bought by Sir Roger Newdigate (F623), *Vasi, candelabri, cippi*.
67 × 42. Ashmolean Museum, Oxford
This plate is dedicated to the portrait painter John Zoffany.

286. Newdigate Candelabrum.
Ashmolean Museum, Oxford
This candelabrum, composed of fragments excavated at Hadrian's Villa, was bought by Sir Roger Newdigate and presented to Oxford University. It was originally kept in the Radcliffe Camera but is now in the Ashmolean together with its companion piece.

287. Newdigate Candelabrum.
Ashmolean Museum, Oxford
This was also bought by Newdigate for Oxford University.

288. Piranesi, Candelabrum bought by Sir Roger Newdigate (F704), *Vasi, candelabri, cippi*.
53·5 × 43. Ashmolean Museum, Oxford

288a. J. Zoffany, *Charles Towneley in his gallery with his friends*.
Burnley Borough Council
Towneley is depicted in the gallery of his London house surrounded by the choicest pieces of his collection.

289. Piranesi, Basilica of Maxentius, mistakenly called the Golden House of Nero (H45. F813), *Vedute di Roma*.
40 × 55. Ashmolean Museum, Oxford
This plate was executed in about 1750.

290. Piranesi, Basilica of Maxentius, mistakenly called the Golden House of Nero (H114. F751), *Vedute di Roma*.
48·5 × 70·5. Ashmolean Museum, Oxford
This view is dated 1774 in Francesco's catalogue.

291. Piranesi, The Colosseum (H56. F805), *Vedute di Roma*.
38·5 × 54. Ashmolean Museum, Oxford
This plate was executed by about 1748.

292. Piranesi, The Colosseum (H126. F759), *Vedute di Roma*.
49·1 × 71·5. Ashmolean Museum, Oxford
This view is dated 1776 in Francesco's catalogue.

293. Piranesi, Drawing of the Colosseum.
53 × 75. Kunstbibliothek, Berlin
This is one of several views of the Colosseum which Piranesi executed. The view point is from the direction of the Forum while in the etching it is from the Caelian Hill. The Colosseum must have been a rather more intelligible ruin before the passages under the arena were excavated.

294. Piranesi, Drawing of the Strada Consolare, Pompeii.
30·7 × 80·5. British Museum, London
When Francesco etched this drawing for his *Antiquités de la Grande Grèce*, he altered his father's figures into prim classical characters.

295. Piranesi, Drawing of the Temple of Isis, Pompeii.

52 × 76·5. Private Collection. Photo: Christie's
The heavy figures foreshadow the lumpish bucolics of Paestum. Francesco's rejected etching for this drawing is illustrated in M. Calvesi and A. Monferini's *Piranesi*, plate 254.

296. Piranesi, Drawing of the Temple of Isis, Pompei.
49 × 73. British Museum, London
The drawing is neater and more arid than is usual for Piranesi and the coarser shading and the figures, which have been added subsequently, suggest that the father touched up his son's detailed drawing or, perhaps, that Francesco made additions to a design by Mori. Piranesi did not usually draw figures in classical dress but the idea attracted Francesco who added classical inhabitants to several of his ruins in *Antiquités de la Grande Grèce*.

297. Piranesi, View of the so-called College (F587), v, *Pesto*.
49 × 67. Ashmolean Museum, Oxford

298. Piranesi, Drawing for plate v of *Pesto*.
48 × 65. Soane Museum, London

299. Piranesi, View of the so-called College (F588), vi, *Pesto*.
47 × 70·5. Ashmolean Museum, Oxford

300. Piranesi, Drawing for plate vi of *Pesto*.
46·5 × 69. Soane Museum, London

301. Piranesi, View of the Temple of Neptune, rejected first state, xii, *Pesto*.
45·5 × 67·8. Private Collection. Photo: Sotheby's

302. Piranesi, Drawing for plate xii of *Pesto*.
44·3 × 66. Soane Museum, London

303. Piranesi, View of the Temple of Neptune (F594), xii, *Pesto*.
45·5 × 67·8. Ashmolean Museum, Oxford
In this revised plate, the viewpoint is slightly altered, the figures are changed and a larger space is available for Piranesi's comments.

304. Piranesi, View of the Temple of Neptune, xvi, *Pesto*.
49·5 × 67·3. Ashmolean Museum, Oxford

305. Piranesi, Drawing for plate xvi of *Pesto*.
48·5 × 66. Soane Museum, London

306. Piranesi, Tripod from the Capitoline Museum (F698), *Vasi, candelabri, cippi*.
39 × 26. Ashmolean Museum, Oxford
The plate is dedicated fulsomely to Edward Walter.

307. Piranesi, Vase excavated at Hadrian's Villa (F614), *Vasi, candelabri, cippi*.
57 × 37·5. Ashmolean Museum, Oxford
This piece, acquired by George Grenville for Stowe, was splendidly reproduced in silver gilt by Rebecca Emes and Edward Barnard as the Doncaster Race Cup, 1828.

308. Piranesi, Throne from Piranesi's collection (F684), *Vasi, candelabri, cippi*.
39 × 53. Ashmolean Museum, Oxford

309. Piranesi, St. Peter's (H120. F720), *Vedute di Roma*.
45 × 70·5. Ashmolean Museum, Oxford
The emptiness of the area within the walls and of the Campagna beyond is very noticeable. The view is dated to 1775.

310. Piranesi, The Capitol (H39. F747), *Vedute di Roma*.
40 × 69. Ashmolean Museum, Oxford
This view was executed between 1751 and 1761.

311. Piranesi, Drawing of the Capitol.
55 × 76. British Museum, London

312. Piranesi, Pyramid of Caius Sestius, first state (H35. F810), *Vedute di Roma*.
38 × 54. Ashmolean Museum, Oxford
This view was probably executed by about 1748.

313. Piranesi, Pyramid of Caius Sestius, fourth state (H35. F810), *Vedute di Roma*.
38 × 54. Ashmolean Museum, Oxford

314. Piranesi, Ripa Grande, first state (H27. F742), *Vedute di Roma*.
38·2 × 61·5. Ashmolean Museum, Oxford
This view was executed after the publication of the *Magnificenze* in 1751 but before the first catalogue in 1761.

315. Piranesi, Ripa Grande, fourth state (H27. F742), *Vedute di Roma*.
38·2 × 61·5. Ashmolean Museum, Oxford

316. Piranesi, Forum of Augustus, mistakenly called the Forum of Nerva (H42. F749), *Vedute di Roma*.
48·5 × 61·5. Ashmolean Museum, Oxford
This and plates 317 and 319 were all executed between 1751 and 1761. The view is misleading: the street is much narrower and the wall bends to the left at the obtuse angle marked by the little canopied shrine in the centre, so that it is impossible to see both the further expanse of wall to the right and the arch to the left simultaneously.

317. Piranesi, Temple of Vesta (H47. F820), *Vedute di Roma*.
37 × 60. Ashmolean Museum, Oxford
The true dedication of this pretty little temple by the Tiber near S. Maria in Cosmedin is unknown but it is generally referred to as the Temple of Vesta. In Piranesi's day it was a church but was closely hemmed in by the operations of a blacksmith and a wheelwright. In the background can be seen the Priory of Malta where Piranesi was later to rebuild the church.

318. Piranesi, Arch of Titus (H55. F756), *Vedute di Roma*.
38·5 × 62. Ashmolean Museum, Oxford
The relief showing the procession of spoils from the Temple of Jerusalem was in better condition in Piranesi's day than it is now. The stands of the souvenir sellers beside it are, however, little changed.

319. Piranesi, Temple of Vespasian, mistakenly called the Temple of Jupiter (H44. F819), *Vedute di Roma*.
38 × 60. Ashmolean Museum, Oxford
It is surprising to see cow-ties immediately below the rear windows of the palace of the Senator of Rome.

320. Piranesi, The Pantheon (H60. F761), *Vedute di Roma*.
46·5 × 68·5. Ashmolean Museum, Oxford
The columns are disfigured by the bills which Lady Anne Miller considered Piranesi ought to have omitted. The two cupolas, 'the asses' ears', have now been moved. The view is dated 1761 in Francesco's catalogue.

321. Piranesi, Portico of the Pantheon (H82. F762), *Vedute di Roma*.
35·5 × 52·5. Ashmolean Museum, Oxford
The scale is exaggerated by diminishing the figures. The view is dated 1769 in Francesco's catalogue.

322. Piranesi, Grotto of Egeria (H80. F782), *Vedute di Roma*.
39·5 × 68. Ashmolean Museum, Oxford
This charming spot is one of the few ruins as romantically creepered now as in the eighteenth century and rather more deserted. The so-called Temple of Bacchus on the skyline is, however, invisible from here. The view is dated 1766 in Francesco's catalogue.

323. Piranesi, Temple of Saturn, mistakenly called the Temple of Concord (H110. F830), *Vedute di Roma*.
46 × 69. Ashmolean Museum, Oxford
In the background is the church of the Accademia di S. Luca in which was erected the troublesome monument to Balestra. The view is dated 1774 in Francesco's catalogue.

324. Piranesi, Baths of Caracalla (H76. F852), *Vedute di Roma*.
42 × 69. Ashmolean Museum, Oxford
Only an aerial view could convey an idea of the immense size of this monument. In the background can be seen various churches including S. Stefano Rotondo. The view is dated 1765 in Francesco's catalogue.

325. Piranesi, Arch of Titus (H98. F755), *Vedute di Roma*.
47 × 71. Ashmolean Museum, Oxford
The entrance to the Farnese gardens on the left has now been re-erected facing the Caelian Hill. The arch itself was restored by Valadier. The Basilica of Maxentius is brought in on the right although not visible from this viewpoint. The view is dated 1771 in Francesco's catalogue.
A fascinating proof print of this plate was sold at Sotheby's, 28th March, 1974. It shows that Piranesi had originally included a standing figure talking to the man sitting in the foreground; Piranesi, who must have touched up the proof himself, worked over this figure in red chalk and added some grey wash in the foreground by the two figures. The proof is much less heavily shaded, in this respect resembling some of the Paestum series which he would, perhaps, have similarly darkened had he lived to finish them.

326. Piranesi, Aqueduct near S. Giovanni in Laterano (H118. F850), *Vedute di Roma*.
48·5 × 70. Ashmolean Museum, Oxford
This portion of an aqueduct, extending from the *piazza* of S. Giovanni in Laterano towards S. Croce and the Porta Maggiore, was saved from demolition by Piranesi's personal intervention according to Legrand. The view is dated 1775 in Francesco's catalogue.

327. Piranesi, S. Giovanni in Laterano (H122. F724), *Vedute di Roma.*
48·5 × 70. Ashmolean Museum, Oxford
The empty spaces of the Campagna are again noticeable. The view is dated 1775 in Francesco's catalogue.

328. Piranesi, Villa Pamphili (H124. F840), *Vedute di Roma.*
49 × 70. Ashmolean Museum, Oxford
The view is dated 1776 in Francesco's catalogue. There is a partially completed drawing for this plate in the Uffizi.

329. Piranesi, S. Giovanni in Laterano (H117. F725), *Vedute di Roma.*
48 × 69·5. Ashmolean Museum, Oxford
The scale of the figures in the *piazza* is oddly muddled. Piranesi's rebuilding would have entailed the demolition of the apse which can be seen to the right of the arcade below the two spires. The view is dated 1775 in Francesco's catalogue.

330. Francesco Piranesi, Title page to *Pesto.*
44·5 × 67. Ashmolean Museum, Oxford

331. Piranesi, The three Temples (F583), i, *Pesto.*
44·5 × 67. Ashmolean Museum, Oxford

332. Piranesi, Remains of Colonnade (F584), ii, *Pesto.*
44 × 67. Ashmolean Museum, Oxford

333. Piranesi, The three Temples (F585), iii, *Pesto.*
49·5 × 62·5. Ashmolean Museum, Oxford

334. Piranesi, View of Columns (F586), iv, *Pesto.*
47 × 66·5. Ashmolean Museum, Oxford

335. Piranesi, View of Columns (F589), vii, *Pesto.*
45·5 × 67. Ashmolean Museum, Oxford

336. Piranesi, View of the interior of the so-called College (F591), ix, *Pesto.*
47 × 67. Ashmolean Museum, Oxford

337. Piranesi, Temple of Neptune (F592), x, *Pesto.*
48 × 70·7. Ashmolean Museum, Oxford

338. Piranesi, Temple of Neptune (F596), xiv, *Pesto.*
47 × 66·3. Ashmolean Museum, Oxford

339. Piranesi, Temple of Neptune (F597), xv, *Pesto.*
49·5 × 67·5. Ashmolean Museum, Oxford

340. Piranesi, Temple of Juno (F599), xviii, *Pesto.*
45 × 67. Ashmolean Museum, Oxford

Chapter Ten

341. Piranesi, Details from Castel S. Angelo (H29), *Vedute di Roma*; Tomb of L. Arruntius (F232), *Antichità romane* II; Temple of Antoninus and Faustina (H49), *Vedute di Roma*; St. Peter's (H120), *Vedute di Roma.* See plates 44, 146, 46, and 37.

342. Piranesi, Drawing of an imaginary mausoleum.
50·8 × 66. From the Gorhambury Collection, by permission of the Earl of Veralum
This drawing, like the chimney piece and antique urns, must have come to Gorhambury from the Walter family. The drawing probably dates from the 1770s and shows that Piranesi's architectural imagination was still vivid at that time. The huge wedding cake structure appears in the dedicatory plates to Lord Charlemont, see plates 123 and 125.

343. Piranesi, Drawing of an elaborate garden.
50·8 × 66. From the Gorhambury Collection, by permission of the Earl of Veralum
This splendid fantasy of an enormous garden with terraces and a water staircase shows Piranesi in an unexpected light. It is worth noting that his etchings of the elaborate gardens of the Villa d'Este and the Villa Pamphili both date to the 1770s. To the left of this scene is an imaginary tomb to Matthew Nulty, a friend to whom Piranesi dedicated one of the *Vasi* plates and an agent for the Walter family in collecting antiques.

344. Piranesi, Drawing for the Ancient Mausoleum in *Prima Parte.*
34·9 × 24·5. National Gallery of Scotland, Edinburgh
This is a drawing in the reverse direction for plate 79. The etching was slightly altered from the drawing.

345. Piranesi, Architectural *capriccio* drawing.
37·1 × 51·2. Ashmolean Museum, Oxford

346. Piranesi, Drawing of a woman.
26·2 × 19·2. From the Gorhambury Collection, by permission of the Earl of Veralum

347. Piranesi, Figure studies over drawing of a foot.
19·5 × 27·1. Ashmolean Museum, Oxford
This and the preceding drawing are typical of Piranesi's sketches of contemporary Romans.

348. Piranesi, Drawing of the tomb of Cecilia Metella.
48·2 × 70·2. Galleria degli Uffizi, Florence

349. Piranesi, Drawing of a tomb near Tivoli.
43 × 55·6. Galleria degli Uffizi, Florence

350. Detail from the Temple of Saturn (H110), *Vedute di Roma.*
See plate 323.

351. Detail of Canopus, Hadrian's Villa, (H90), *Vedute di Roma.*
See plate 239.

352. Detail of Cistern near Castel Gandolfo, *Antichità d'Albano.*
See plate 204.

353. Detail of Paestum, rejected first state of *Pesto,* xii, See plate 301.

Index

The numbers in italic refer to illustrations.

Academy of Cortona 153, 310
Accademia di S. Luca 108, 153, 240, 245–6, 247, 308, 310, 311, 313, 316, 317, 332
Accurata e succinta descrizione . . . di Roma 304
Acqua Giulia 163, 165, 215, 240, 311, 327, 328. *192–3, 211–13*
Adam, J. 106, 111, 152, 165, 169, 226, 251, 306, 307, 310, 311
Adam, R. 106, 109, 111, 121, 126, 127, 151, 159, 165, 166, 168, 169, 173, 177, 216, 225, 226, 241, 247, 304, 306, 307, 308, 311, 312, 315, 318, 319, 324, 325, 327, 330
Agrigento 153, 157, 309, 327. *182*
Albani, Cardinal A. 19, 107, 115, 152, 176, 244, 309, 316, 322
Albano 61, 123, 154, 169–74, 177, 311, 312, 328. *202–3, 219–24, 226, 229*
Algarotti, F. 303, 307
Allegrini, G. 17
Altieri, Prince 308
Amidei, F. 16, 17, 105, 298, 304
Amigoni, J. 303
Ancona 13, 17, 321. *21*
Anecdotes of Painting in England 56, 310
Anesi, P. 16, 304
Angelini, G. 219, 317, 318, 319
Antichità d'Albano 172–4, 215, 240, 250. *204, 223–9, 352*
Antichità di Cora 174–5, 240, 328, 329. *205–7, 230–2*
Antichità romane 17, 19, 27, 109–15, 117–27, 149, 163, 166, 167, 168, 177, 240, 248, 309, 320, 324, 325, 326. *123–8, 132–71*
Antichità romane de' tempi della repubblica, see *Archi trionfali*
Antichità siciliane 109
Antiquités de la Grande Grèce 250, 254, 319, 331
Antiquities of Athens 150
Aosta 17, 304
Appian Way 61, 107, 110, 111, 121, 173, 322, 326, 328. *31, 164–6, 227–8*
Arcadians 51, 305, 307, 310
Archi trionfali 17, 18, 19, 26, 27, 50, 55, 105, 240, 304, 321, 322. *18–21, 30–5*
Archinto, Cardinal 152
Architettura Civile 46
Architetture, e Prospettive 47, 322. *49*
Arnifeldt 315
Arpino, Cavaliere d' 221
Athens 108, 149, 156, 326. *172*
Aufrere, G. 317
Augustus II of Saxony 152
Augustus III of Saxony 154, 301
Aylesford, Lord 314

Badiali, G. 57
Badminton 314
Baker, H. 309
Balestra, A. 321. *5*
Balestra, P. 245, 313

Barbaro, D. 10
Barbault, J. 308, 326. *147*
Barber, J. 317
Barberi, G. 223
Barberini family 112
Baretti, G. 177, 302, 307, 312
Barrett, T. 317
Barry, J. 220, 243, 247, 313, 317
Barthélemy, abbé 309, 312
Bartolozzi, F. 241, 304, 316
Baths of the Romans 177
Batoni, P. 307
Beaufort, Duchess of 314
Beckford, W., senior 245
Beckford, W., junior 55, 302, 318
Bellanger, F. J. 315
Bellicard, J. C. 16, 304
Bellotto, B. 299, 320
Benedict XIV 10, 108, 109, 115, 117, 307
Benefial, M. 307, 308
Berardi, F. 304
Bernis, Cardinal de 313, 318
Biagi, P. 301, 307, 315, 318
Bianchini, F. 107, 108, 127, 307, 309, 324
Bianconi, G. L. 7, 12, 13, 14, 154, 157, 220, 245, 250, 301, 303, 307, 320
Bibiena, F. G. 46, 58, 305, 322, 323. *48, 70*
Bibiena, G. 305, 322. *49*
Bibiena, G. C. 305
Blackfriars Bridge 216, 329. *245*
Blondel, J. F. 159, 310
Blundell, H. 241
Boissier, J. L. 317
Borghese, Prince M. A. 241, 244, 316
Borghese family 20, 216
Borromini, F. 220–1, 313
Boswell, J. 245
Bottari, G. G. 14, 17, 52, 154, 157, 303, 310, 316
Bouchard, J. 16, 25, 26, 27, 49, 53, 105, 106, 112, 115, 311, 323
Boullée, E. L. 159
Boyd 317
Boyer, A. 317
Bragato, G. 301
Braschi family 313
Breteuil, Baillie de 223, 314
Bridges, Sir B. 308
Brosses, C. de 9, 19, 23, 24, 302
Brudenell, Lord 308
Brunelleschi 123
Brustolon 226
Buonamici, A. 107, 108, 324. *120*
Burghley 224, 330. *267–8*
Burke, E. 61, 220, 313
Bury Hill 245, 314
Busiri, G. B. 320
Byres, J. 175, 241, 245, 305, 311, 316, 317

Callot, J. 298, 304
Calzolajo Inglese, Il 242, 317
Cameron, C. 177, 225, 315
Campus Martius 106, 165–9, 240, 247, 311, 327, 328. *194–9, 201, 214–8*
Camere Sepolcrali 108, 109, 324
Canaletto 7, 10, 14, 15, 293, 298, 299, 303, 306, 307, 320, 321. *1, 3*
Canova, A. 301
Capmartin de Chaupy, B. 177, 246,

312, 328
Caravaggio, M. 312
Carceri 16, 25, 26, 45, 47, 52–61, 156, 158, 163, 171, 240, 293, 294, 301, 307, 310, 320, 323, 324. *61–7, 88–117*
Cardelli 241
Carlevaris, L. 15, 303
Carlisle, Lord 226, 315
Carmathen, Lord 317
Casanova, 10, 58
Castiglione, G. B. 50, 293, 298, 306
Castel Gandolfo 25, 61, 169, 172, 215, 222, 328. *204, 225, 352*
Castle Howard 122, 308
Catalogue 163, 240, 312, 315, 327. *191*
Catherine of Russia 177, 241, 306
Cavaceppi, B. 241, 244, 308, 317, 319, 330. *283*
Caylus, Comte de 150, 151, 155, 157, 309, 312
Challe, C. M. 49, 306, 323. *55*
Chambers, Sir W. 49, 108, 111, 163, 216, 226, 306, 310, 323
Charlemont, Lord. 108–16, 149, 165, 239, 306, 308, 312, 315, 324, 325. *121*
Chigi family 20
Chinea 49, 216, 306
Chippendale, T. 226
Chiusi 175, 310
Cimaroli, G. B. 321. *5*
Circi, Baron 308
Clement XI 152
Clement XII 10, 29, 303
Clement XIII 115, 154, 172, 215, 220, 222, 240, 308, 310, 311, 319, 329. *244*
Clement XIV 175, 222, 241, 242, 312, 313, 315
Clérisseau, C. L. 7, 49, 111, 159, 177, 216, 223, 301, 306, 307, 311, 312, 330. *266*
Clitumnus, temple of 17
Cobham mausoleum 122, 308
Coch de 241
Cochin, N. 47
Coleridge, S. T. 57, 61
Collection des plus belles statues 254
Collinson, P. 309
Colonna di Antonino Pio 175, 240, 312
Colonna di M. Aurelio 175, 240, 312
Colonna Trajana 175, 240, 312
Colonna family 20, 118
Confessions of an English Opium Eater 57
Constable, W. 317
Contarini family 9
Contucci, padre C. 154, 164, 215
Cooper, A. 309
Corbett, J. 317
Cori 174–5, 311, 328, 329. *205–7, 231–2*
Corner family 9
Corneto 175, 310
Corradini, A. 10, 13, 246, 302
Corsini, Cardinal 115
Corsini family 105, 112
Cortona, P. da 168, 245
Corvi 319
Costa, G. F. 15, 303
Creti, D. 306
Cunego, D. 310, 319, 329. *244*

Cuthbert, J. 317

Dalton, R. 108, 149, 156, 308, 309, 316
Dance, G. 310
Deane, H. 317
Dell'Emissario del Lago Albano, see *Emissario* . . .
Della Introduzione e del Progresso delle Belle Arti 157, 175, 310. *208*
Della Magnificenza 151–8, 163, 165, 166, 169, 215, 240, 243, 306, 310, 311, 318, 327. *176–82*
Dempster, T. 310
Desgodetz, A. 126, 310, 312, 325
Desprez, J. L. 318
Di due spelonche 172, 328. *203, 222*
Dialogue on Taste 151, 154, 157, 309
Dickins, F. 317
Différentes vues . . . de Pesto 175, 240, 251–4, 331, 333. *297–305, 330–40*
Dilettanti Society 149
Dimostrazioni dell' Emissario del Lago Fucino 175, 254, 311
Disegni del Guercino 240–1, 309, 316, 331. *284*
Diverse maniere 55, 154, 175, 215, 224–9, 239, 240, 243, 247, 315, 328, 330. *210, 258–9, 263–5, 268, 270, 272–81*
Dolcibene, V. 175
Dorigny 240, 316
Downes, D. 317
Duchêne, A. 126
Duflos, P. F. 16, 17, 304

Earle, G. 317
Edifices antiques de Rome 126
Elizabeth of Russia 11, 302, 317
Emissario del Lago Albano 170–2, 215, 310, 311, 318, 327, 328. *200, 202, 219–21*
Entwürff einer historischen Architectur 48, 323. *53*
Este, A. d' 301
Exeter, Lord 224, 245, 314

Facchineri, M. 7
Falda, G. B. 299
Faldoni, G. A. 302
Fall of Phaethon 52, 221, 297, 307, 323. *60a*
Fede, Conte G. 176
Ferdinand IV 311
Firmin-Didot 254
Fischer von Erlach, J. B. 48, 306, 314, 323. *53*
Flaxman, J. 318
Fortrose, Lord 317
Fox, Lady M. 317
Franzoni 241
Frederick of Prussia 241
French Academy 47, 49, 108, 111, 239, 304, 306, 309, 319, 320, 323. *56*
Frontinus 163, 311
Fucine Lake 175, 311
Fuga, F. 22

Galilei, A. 29, 220
Galliari family 57
Gautier, T. 57
Gazette Littéraire de l'Europe 157
Gellius, A. 304

Gentili Boccapaduli, Marchesa 223, 245, 314
George III 108, 152
Ghezzi, P. L. 127, 306, 309
Gibbon, E. 311, 322
Gilpin, W. 320
Gilray, J. 240
Giobbe, N. 12, 13, 45
Giordano, L. 13, 303
Giustiniani family 9
Gli Antichi Sepolchri 127
Gloucester, Duke of 313, 315
Goethe 7, 123, 245, 251, 302, 307, 318, 325
Goldoni, C. 7, 105
Gorhambury 224, 293, 314, 317, 319, 330, 333. *261*
Gordon, A. 173
Gori, A. F. 307, 310
Grant, abbé P. 113–6, 240, 245, 308, 309, 315, 316, 325
Gravina 52
Grenville, G. (later Marquis of Buckingham) 224, 245, 314, 331
Grimston, J. 317
Grimston, W., later Lord 224, 317, 330
Grotteschi 16, 26, 45, 50–2, 298, 306, 324. *58, 85–7*
Guardi, F. 14, 293, 304
Guarnacci, M. 310
Guercino 241
Gustavus of Sweden 241, 243, 254, 325

Hackert 319
Hadrian's Villa 61, 167, 176, 177, 239, 243, 294, 312, 314, 329, 331. *240, 242–3*. Academy 176. Canopus 176. *239, 351*. Heliocaminus 329, *241*. Lyceum 176. Stoa Poecile 176, 329. *238*. Tempe 176.
Hamilton, Duke of 305, 313
Hamilton, G. 177, 241, 242, 243, 245, 310, 312, 314, 317
Hamilton, Sir W. 175, 224, 240, 245, 308, 314, 315
Hanau, Baron d' 113, 308
Harrison, T. 247, 318
Herculaneum 13, 109, 177, 294, 304, 306, 318, 320
Hogarth, W. 108, 240, 324. *121*
Holland, Lord 317
Hollis, T. 224
Hope, J. 224, 231, 314, 330
Hope, T. 314, 315
Hugo, V. 57
Hume, D. 108
Huxley, A. 57, 307
Hypogaei 175, 311

Innocent XIII 152
Investigator, The 151, 154, 156
Imperiali, F. 151
Itinerarium Septentrionale 173

Jacquietti 241
Jefferson, T. 306
Jenkins, T. 241, 242, 245, 308, 316, 317
Johnson, S. 20, 108
Johnson, T. 226
Jolli, A. 320
Jones, T. 224, 241, 247, 314, 320

Joseph of Copertino, St. 216, 313
Juvarra, F. 13, 47, 60, 221, 305, 307, 323. *50*

Kauffmann, A. 307, 327. *175*
Kennedy, J. 7, 18, 105, 296, 301
Knight, E. 317

Labruzzi, P. 318, 330. *282*
Lapides Capitolini 164, 215, 311
Laugier, M. A. 310
La Vallée 223
Lecce 158, 310
Ledoux, C. N. 159
Le Geay, J. L. 16, 47–8, 305, 320, 323. *54*
Legrand, J. G. 7, 10, 13, 16, 27, 49, 57, 106, 154, 174, 177, 215, 239, 241, 294–7, 301, 304, 312, 314, 315, 316, 318, 319, 332
Legros, P. 246
Le Lorrain, J. F. 49
Le Magnificenze di Roma 26
Le Rovine del Castello dell'Acqua Giulia, see *Acqua Giulia*
Le Roy, J. D. 150, 151, 154, 156, 158, 159, 309, 326, 327
Les Ruines des plus beaux monuments de la Grèce 150, *172*
Lettere di giustificazione 114, 239, 305, 308, 309, 311, 315, 323, 324, 325. *122, 129–31*
Library of the Fine Arts, see Kennedy, J.
Ligorio, P. 304
Lincoln, Lord 317
Livre de decoration diferante 58
Livy 10, 55, 169, 253, 304
Lodoli, C. 60, 155, 307
Lovisa, D. 15, 302
Lucchesi, M. 7, 125, 127, 302
Lumisden, A. 240, 315

Maffei, S. 8, 108, 177, 302, 310
Magnasco, A. 175
Magnificenze di Roma 11, 25, 105, 305, 308, 332
Mandeville, Lord 308
Manin family 10
Mann, H. 308, 315
Marchionni, C. 152, 310, 327
Marieschi, M. 15, 17, 303
Mariette, P. J. 154, 157, 303, 309, 310, 327
Marigny, Marquis de 169
Marot, D. 58, 323. *68*
Massari, G. 10
Massimo family 20, 302
McSwiny, O. 302, 306
Memmo, A. 60
Mengozzi-Colonna, G. 13, 303
Mengs, A. R. 105, 152, 222, 245, 246, 301, 303, 307, 308, 310, 312, 314, 316, 318
Menzies 314
Mercurio Errante, Il 304
Milizia, F. 313
Miller, Lady A. 302, 303, 305, 332
Mogliano 7, 301
Montesquieu 150
Monumenti degli Scipioni 254
Moore, J. 9, 20, 302, 305, 313
Moreau-Desproux, P. L. 126, 309, 312
Mori, B. 239, 251, 315, 318, 331

Morison, C. 245
Morris, C. 317
Murphy, E. 113, 114, 325
Mylne, R. 153, 154, 173, 216, 239, 310, 315, 327, 329

Naples 13, 302
Nardini 304
Natoire, C. J. 118, 126, 169, 239, 246, 309, 311, 312, 318
Nevay, J. 316
Newdigate, Sir R. 17, 242, 243, 317, 318, 331
Nollekens, J. 241, 242, 312, 319
Nolli, C. 304
Nolli, G. 19, 117, 304, 321. *22*
Norris, W. 309
Northall, J. 302, 305
Nulty, M. 224, 241, 317, 333

Olivero, P. D. 322. *47*
Opere Varie 26, 45, 50, 54, 105, 303, 305, 306, 323, 324. *80–4*
Orlandi, C. 154
Orsini, Cardinal 115, family 20
Osservazioni sopra la lettre de M. Mariette 153, 327. *183*
Ossory, Bishop of 309
Osterley 247, 330
Ottaviani, G. 316
Ottoboni, Cardinal 47

Pacili 241
Packington 314
Paderni, C. 14, 303
Paestum 175, 251–3, 318, 319, 330, 331, 333. *297–305, 330–40, 353*
Palestrina 25, 224
Palladio, A. 8, 10, 107, 120, 121, 302, 307
Palmer, T. 317
Palmerston, Lord 241, 245
Pamphili family 20
Pancrazii 109
Pannini, G. 313
Pannini, G. P. 49, 293, 299, 306, 320, 322
Paolini, P. 307
Parere su l'architettura 157–9, 166, 169, 177, 221, 225, 310, 327. *184–90*
Paris, P. A. 319
Parker, J. 108–16, 149, 239, 308, 310, 325
Passariano 10
Passionei, Cardinal 108
Patoun, W. 317
Pausanias 304
Peachey, J. 317
Pecheux, L. 106, 111, 175, 307, 312, 314
Pelosini, G. 217
Pesto, see *Différentes vues . . . de Pesto*
Petitot, E. A. 49, 306
Petrachi 174
Peyre, M. J. 216
Piazzetta, G. B. 293
Piozzi, Mrs. 9, 216, 302, 304
Piranesi, Angelica 105, 106, 219, 319
Piranesi, Angelo, father 7, 15, 127, 301
Piranesi, Angelo, brother 10
Piranesi, Angelo Domenico 106, 319
Piranesi, Faustina 307, 313

Piranesi, Francesco 106, 175, 243, 249, 250–2, 254, 294, 300, 304, 311, 312, 315, 316, 317, 318, 325, 331
Piranesi, Laura 106, 254
Piranesi, Pietro 106, 254, 294, 319
Pirmei, abbé 154, 310
Pisani, A. 10
Pittoni, G. B. 306
Pius VI 241, 312, 317
Platière, J. M. R. de la 302, 311, 317
Pliny 13, 304
Plutarch 304
Pola 17, 322. *35*
Polanzani, F. 12, 105, 302, 303, 324. *118*
Poleni, G. 311
Pompeii 250, 294, 318, 319, 320, 331. *294–6*
Pond, A. 309
Portici 14, 294
Prima Parte di Architettura 12, 13, 14, 26, 45–50, 59, 221, 240, 293, 298, 303, 305, 306, 307, 320, 321, 323, 324. *6, 52, 60, 69, 72–9, 344*
Prospettiva Teorica 46, 322. *48*
Prospetto della alma Città di Roma 302

Quincey, T. de 57, 61, 307

Raccolta di alcuni disegni del . . . Guercino, see *Disegni del Guercino*
Raccolta d'antiche statue 244, 330. *283*
Raccolta di tempj antichi 254
Raccolta di Varie Vedute di Roma 16
Rambouillet 229
Ramsay, A. 111, 151, 309, 312, 325
Receuil d'antiquités 150, 151
Reiffenstein, F. 245
Revett, N. 149, 309
Rezzonico, A. 7, 215, 224, 228, 236, 237, 240, 245, 313, 319
Rezzonico, C., see Clement XIII
Rezzonico, Cardinal C. 313
Rezzonico, F. 245, 313
Rezzonico, Cardinal G. B. 159, 215, 217, 220, 221, 226, 232, 233, 240, 245, 254, 313, 319, 330. *271*
Rezzonico, L. 10, 307, 313
Ricci, M. 50, 175, 293, 306, 323. *57*
Righi, T. 219, 245, 246, 313
Riminaldi, monsignore 154, 245
Rimini 17, 18, 321. *20*
Robert, H. 49, 174–5, 223, 229, 295, 306, 311, 312
Rogers, C. 309
Roma moderna distinta per Rioni 16
Rome
 Acqua Claudia 163. Acqua Felice 22, 163, 228. Acqua Giulia 26, 106, 163, 324, 327. *212, 213*. Acqua Paola 52, 120. Amphitheatre of S. Taurus 169, 328. *201*. Arch of Constantine 26, 321. *19*. Arch of Janus 321. *18*. Arch of S. Severus 112, 322. *45*. Arch of Titus 149, 322, 332. *33, 318, 325*. Archigymnasio 304. Aurelian walls 118, 325. *133*. Aventine 23. Basilica of Maxentius 248, 318, 325, 331, 332. *137, 289–90*. Baths of Caracalla 23, 24, 111, 121, 304, 312, 332. *324*. Baths of Diocletian 22, 111, 121, 312, 318, 326. *152*. Baths of Sallust 169, 327. *198*. Baths of Titus 326.

153. Bocca della Verità 156, 327.
178. Borgo Vaticano 25. Bosco
Parrhasio 307. Caelian Hill 23, 331.
Caffe degli Inglesi 224, 225, 226,
314, 322, 330. *258–9.* Campo
Vaccino 18, 23, 26, 29, 247, 322.
24, 32. Campus Martius 20, 120,
165, 327. *195.* Capitol 22, 26, 215,
222, 224, 322, 332. *25, 279, 310–11.*
Casino Borghese 25, 307, 316.
Castel S. Angelo 24, 26, 28, 58,
124, 127, 322, 325, 326. *44, 145,
149, 169, 171.* Castro Pretorio 23,
121, 325. *140.* Circus of Maxentius
110. Circus Maximus 24, 155, 326.
156. Cloaca Maxima 119, 155, 318,
327. *177.* Column of Antoninus
Pius 312. Column of Marcus
Aurelius 26, 312. Column of Trajan
19, 26, 28, 221, 246, 312, 318, 326.
155. Colosseum 24, 26, 119, 149,
242, 247, 249, 317, 322, 325, 331.
30, 135–6, 291–3. Corso 10, 16, 20.
Curia Hostilia 55, 61, 118, 125, 321.
15. Dogana, see Hadrianeum.
Esquiline 23. Forum of Augustus
318, 332. *316.* Forum of Trajan
326. *154.* Gesu 246. Golden House
of Nero 119. Grotto of Egeria 318,
332. *322.* Hadrianeum 26, 28, 168,
305, 322, 327. *29, 196.* House of
Crescentius 118, 325. *134.* Janiculum
24. Mammertine Prison 58. Monte
Cavallo, see Quirinal. Museo Pio-
Clementino 222, 313, 316, 329.
255a. Palazzo Barberini 22. Palazzo
Borghese 20, 304, 314, 319. Palazzo
Braschi 313. Palazzo della
Cancelleria 20. Palazzo Corsini 303.
Palazzo Doria Pamphili 168, 313,
320. Palazzo Farnese 20, 306, 321.
12. Palazzo Mancini 306. Palazzo
Mattei 20. Palazzo Muti 322. *42.*
Palazzo Odescalchi 303, 322. *42.*
Palazzo Spada 20. Palazzo Venezia
10, 14. *4.* Pantheon 26, 28, 119,
120, 305, 318, 322, 325, 327, 332.
27, 139, 199, 320, 321. Piazza
Barberini 22. Piazza Navona 19,
20, 26, 28, 247, 313, 322. *40.*
Piazza del Popolo 20, 25, 318, 321.
23. Piazza di S. Ignazio 13. Piazza
di Spagna 20, 22, 26, 163, 224, 309,
322. *41.* Ponte Ferrato 127, 326.
170. Ponte Milvio 328, 218. Ponte
Palatino 24. Ponte Salario 320.
Ponte S. Angelo 24, *44.* Porta
Maggiore 325. *138, 151.* Portico
of Octavia 24. Priorato di Malta
217, 329, 332. *250–2.* Pyramid of
C. Sestius 26, 123, 248, 318, 332.
312, 313. Quirinal 22, 26, 27, 28,
222, 247, 322. *28.* Ripa Grande 248,
332. *314, 315.* Ripetta 304. S.
Andrea delle Fratte 106, 221, 254,
311. S. Carlino 22. S. Cecilia 118.
S. Croce 13, 19. S. Francesca
Romana 18. S. Giovanni in
Laterano 13, 16, 23, 26, 29, 220–2,
247, 249, 303, 313, 322, 329, 332,
333. *38, 254, 255–7, 327, 329.*
S. Ivo 221. S. Maria degli Angeli
254, 318. S. Maria in Ara Coeli
322, *25.* S. Maria in Campitelli

322, 26. S. Maria in Cosmedin
156, 327, 332. S. Maria Maggiore
13, 19, 22, 25, 322. *39.* S. Maria del
Priorato 163, 217–20, 245, 254,
313, 315, 318, 329, 330. *246–9,
253.* S. Maria in Via Lata 168. SS.
Martina e Luca 245, 313, 322, 332.
45, 323. S. Nicola in Carcere 167.
S. Paolo fuori la Mura 26. S.
Sebastiano 16. S. Stefano Rotondo
321, 332. *16.* St. Peter's 19, 25, 26,
247, 305, 310, 318, 322, 331. *37,
309.* Saepta Julia 168, 328. *215.*
Scala Santa 29. *38.* Scottish Seminary
22. Spanish Steps 13, 322. *41.*
Strada Felice 22, 106, 163, 176,
240, 311, 318. Temple of Antoninus
and Faustina 18, 322. *46.* Temple of
Bacchus 318, 332. *322.* Temple of
Cebele, see Temple of Vesta.
Temple of Fortuna Virilis 320.
Temple of Minerva Medica 304.
Temple of Saturn 332. *323, 350.*
Temple of Venus and Rome 26.
Temple of Vespasian 18, 332. *319.*
Temple of Vesta 24, 332. *317.*
Theatre of Balbus 118, 327. *197.*
Theatre of Marcellus 20, 119, 125,
127, 168, 309, 322, 326, 327, 328.
26, 150, 197, 216. Tomb of L.
Arruntius 326. *146–7, 158.* Tomb of
Augustus 24, 326. *162.* Tomb of
Cecilia Metella 167, 306, 325, 333.
144, 348. Tomb of Constantia 123,
126, 325. *141–2.* Tomb of freedmen
of Livia or household of Augustus
326. *157.* Tomb of the Metelli 326.
166. Tomb of Nero (so-called) 326.
168. Tomb of A. Severus 325. *143.*
Tomb of the Scipios 326. *161.*
Trastevere 24. Trevi Fountain 13,
17, 19, 26, 28, 247, 303, 321, 322.
13, 43. Trinità dei Monti 223, 314,
330. *266.* Via del Boschetto 27, 305.
Via Flaminia 328. *217.* Villa Albani
25, 152, 304, 307, 309, 326. *173–4.*
Villa Altieri 23. Villa Barberini 23.
Villa Belloni 118. Villa
Buoncompagni 23. Villa Corsini
326. *160.* Villa Lodovisi 321. *14.*
Villa Medici 23. Villa di Malta 223.
Villa Pamphili 333. *328.* Villa
Verospi 118.
Rosa, A. 251, 318
Rosa, S. 175, 298, 312
Rossi, D. 10, 301
Rossi, G. 107
Rossi, D. de' 299
Rossi, G. G. de' 299, 317
Rossi, L. F. de' 127
Rossini, G. P. 304
Rous, J. 317
*Ruines des plus beaux monuments de
la Grèce* 326. *172*
Ruins of Palmyra 111, 308
Russell, J. 308

Saggio sopra l'architettura 307
Sallust 159
Salvi, N. 13, 302, 303, 322
Saly, J. 49, 306
Santi Bartoli, P. 127, 309, 312
Savorgnan, Principessa F. 245, 307
313

Scalfarotto, G. A. 8, 10, 302
Scammozzi, V. 8
Scawen, J. 317
Scherzi di Fantasia 14, 15, 321. *9*
Schola Italica Picturae 241, 312
Schouvaloff, General I. 241, 244, 317
Sharp, S. 302, 312
Shelburne, Lord 241, 317
Sijnott, J. 317
Silvestre, I. 304
Simonetti, M. 222, 313, 329
Slade, T. M. 317
Smith, J. 15, 301
Smollett, T. 157, 216, 302, 314
Smythe, R. 317, W. 317
Soane, Sir J. 247, 318, 319, 329
Society of Antiquaries 126, 153, 224,
327
Solimena, F. 13, 151, 303
Stanislaus Augustus 312
Staples, J. 317
Stolberg, Count 304
Stonor, abbé 308
Storr, P. 244
Stowe 224, 314
Strange, Sir R. 240, 315
Stuart, H. Duke of York 313, 322
Stuart, J. (Athenian) 149, 309
Stubbs, G. 299
Syon 106, 247, 308, 318, 324. *119a*

Tacitus, 55
Talbot, J. C. 317
Talbot, T. M. 317
Talleyrand 320
Tanucci, Marchese 312
Taylor, J. 317
Taylor, Sir R. 224
Teatro di Ercolano 254
Temanza, T. 10, 302
Temple, Lord 224
Teodosio il Giovane 47
Theobald, J. 309
Tiepolo, D. 14, 306
Tiepolo, G. B. 9, 13, 14, 15, 50,
293, 298, 303, 306, 316, 321. *9*
Tirali, A. 10
Tivoli 175, 247. Cascatelle 175, 329.
235. Maecenas' Villa 175. Ponte
Lucano 175. S. Antonio 175. Temple
of the Coughs 175, 329. *234.* Temple
of the Sibyl 175, 329. *209, 233.*
Tomb of the Plautii 326. *167.* Villa
d'Este 329. *237.* Villa Gregoriana
175. Waterfall 175, 312, 329. *236*
Tomati, Conte 163, 311
Towneley, C. 241, 243, 245, 331.
288a
Traille, P. 317
Trofei di Ottaviano 106, 156, 163,
310, 311, 324. *119*
Trofeo o sia magnifica colonna coclide
312
Troubridge, Sir T. 319
de Troy, F. 47, 49, 306
Tsarskoe Selo 225
Turin 47, 305. *47*

Udney, R. 317
Upton, U. 317
*Urbis Venetiarum Celebriores
Prospectus* 321. *2*

Vacca, F. 304
Valadier, G. 20, 219, 332
Valeriani, D. and G. 11, 13, 47, 60,
302, 305, 306, 321. *5*
Van Bloemen, J. F. 299
Vanvitelli, L. 13, 302, 303, 308
Van Wittel, G. 303
*Varie Vedute di Roma Antica, e
Moderna* 16, 304. *12–16*
Varj Capricci 14, 298
Vasconi, G. 106
Vasi, candelabri, cippi 55, 239, 240,
244–5, 250, 314, 330, 331, 333.
285, 288, 306–8
Vasi, G. 11, 12, 17, 25, 27, 247,
298–9, 302, 303, 305, 309, 321. *4*
*Vedute, altre presi da i luoghi, altre
ideate* 321. *3*
Vedute di Roma 25–9, 163, 175, 240,
247–50, 301, 304, 305, 311, 312,
318, 320, 321, 322, 323, 326, 328,
329, 331, 332, 333. *23–9, 36–46,
56, 173, 209, 212, 233–41, 254, 262,
289–92, 309–29, 350, 351*
Vedute delle Ville . . . della Toscana
17. *17*
Venice. Ca' Rezzonico 7, 10, 313.
Murazzi 7, 125, 302. Ospedaletto
302, 310. S. Marco 155. S. Maria
del Giglio 310. S. Moise 7, 310.
S. Simeone 8, 302, 321. *2.*
Venuti, R. 125, 304, 308, 309
Vernet, C. J. 49, 306
Verona 18, 177, 322. *34*
Vien, J. M. 49, 306, 318
Villa dell'Ambrogiana 17, 321. *17*
Visconti, G. B. A. 177, 312
Visconti, E. Q. 312
Visentini, A. 15, 303, 313, 321. *2*
Vitruvius 10, 117, 155, 156, 166, 307
Vleughels, N. 306
Volpato 319
Volterra 310
Volterra, D. da 316
Volpi, G. R. 311
Vyse, W. 317

Wagner, J. 15, 16, 17, 241, 303, 316
Wailly, C. de 126, 216, 309, 312
Walpole, H. 56, 122, 310
Walter, E. 224, 245, 314, 319, 330,
331, 333
Walter, H. 225, 245
Weddel, W. 241, 245
Widman, Z. 7
Winckelmann, J. J. 152, 154, 157,
159, 177, 229, 240, 251, 253, 301,
309, 310, 311, 312, 315, 316, 317,
327
Wood, R. 111, 308
Works in Architecture 106, 247, 308,
310, 318. *119a*
Worsley, Sir R. 241
Wynn, Sir W. Williams 245, 315

Zabaglia, N. 309
Zanetti, A. 14
Zocchi, G. 17
Zoffany, J. 245, 247, 331. *288a*
Zucchi, A. 8
Zucchi, C. 8, 11, 302
Zucchi, F. 8